W9-BAV-978

The Grove Dictionary of Art

FOR REFERENCE

Do Not Take From This Room

From Renaissance to Impressionism

The Grove Dictionary of Art

Other titles in this series:

Praise for *The Dictionary of Art*

'It is hard to resist superlatives about the new *Dictionary of Art*... If this isn't the most important art-publishing event of the 20th century, coming right at its end, one would like to know what its plausible competitors are. In fact there aren't any....'
Robert Hughes, *Time Magazine*

'The *Dictionary of Art* succeeds in performing that most difficult of balancing acts, satisfying specialists while at the same time remaining accessible to the general reader.'
Richard Cork, *The Times*

'As a reference work, there is nothing to compare with *The Dictionary of Art*. People who work in the arts - lecturers, curators, dealers, researchers and journalists - will find it impossible to do their jobs without the magnificent resource now available to them.'
Richard Dorment, *The Daily Telegraph*

'These are whole books within books... An extraordinary work of reference.'
E. V. Thaw, *The Wall Street Journal*

'It's not at all hyperbolic to say the dictionary is the rarest kind of undertaking, one that makes you glad it happened during your life.'
Alan G. Artner, *Chicago Tribune*

The Grove Dictionary of Art

From Renaissance to Impressionism

Styles and Movements in Western Art, 1400–1900

Edited by Jane Turner

GROVEart

BOCA RATON PUBLIC LIBRARY
BOCA RATON, FLORIDA

From Renaissance to Impressionism

Copyright © 2000 by Jane Turner

All rights reserved. No part of this book may be used or reproduced
in any manner whatsoever without written permission except in the
case of brief quotations embodied in critical article or reviews.
For information, address

St. Martin's Press, Scholarly and Reference Division
175 Fifth Avenue, New York, NY 10010

First published in the United States of America in 2000

Reprinted in 2000

Printed in the United Kingdom

ISBN: 0-312-22975-5

Library of Congress Cataloging-in-Publication Data

The Grove dictionary of Art. From renaissance to impressionism : styles and movements
in western art 1400–1900 / edited by Jane Turner
 p.cm – (The GroveArt series)
 Includes bibliographical references and index.
 ISBN 0-312-22975-5 (cloth)
 1. Art, Renaissance–Dictionaries. 2. Art, Modern – 17th–18th centuries – Dictionaries.
 3. Art. Modern–19th Centuries–Dictionaries. I. Title: From renaissance to impressionism.
 II. Turner, Jane. III. Series

N6370.G76 2000
709–dc21 99-089533

Contents

JUN – – 2003

Preface

In these days of information glut, *The Dictionary of Art* has been a godsend, instantly relegating all its predecessors to oblivion. Within its stately thirty-four volumes (one for the index), the territory covered seems boundless. Just to choose the most amusingly subtitled of the series, *Leather to Macho* (vol. 19), we can learn in the first article not only about the way animal skins are preserved, but about the use of leather through the ages, from medieval ecclesiastical garments to Charles Eames's furniture. And if we then move to the last entry, which turns out to be a certain Victorio Macho, we discover that in the early 20th century, he graced Spanish cities with public sculpture, including a monument to the novelist Benito Pérez Galdós (1918) that many of us have passed by in Madrid's Parque del Retiro. And should we wish to learn more about Macho, there is the latest bibliographical news, bringing us up to date with a monograph of 1987.

Skimming the same volume, we may stumble upon everything from the art of the LEGA people in Zaïre and the use of artificial LIGHTING in architecture to somewhat more predictable dictionary entries such as LICHTENSTEIN, ROY; LONDON: WESTMINSTER ABBEY; LITHOGRAPHY; or LOS ANGELES: MUSEUMS. If browsing through one volume of *The Dictionary of Art* can open so many vistas, the effect of the whole reference work is like casting one's net into the waters and bringing back an unmanageable infinity of fish. Wouldn't it be more useful at times to single out in one place some of the myriad species swimming through the pages of *The Dictionary*? And then there is the question of cost and dimensions. In its original, complete form, the inevitably stiff price and the sheer size of all thirty-four volumes meant that it has fallen mostly to reference libraries to provide us with this awesome and indispensable tool of knowledge.

Wisely, it has now been decided to make this overwhelming databank more specialized, more portable, and more financially accessible. To do this, the myriad sands have been sifted in order to compile more modest and more immediately useful single volumes that will be restricted, say, to Dutch painting of the 17th century or to a survey of major styles and movements in Western art from the Renaissance to the end of the 19th century. So, as much as we may enjoy the countless delights of leafing through the thirty-four volumes in some library, we can now walk off with only one volume that suits our immediate purpose, an unparalleled handbook for a wide range of readers, especially for students and scholars who, rather than wandering through the astronomical abundance of art's A to Z, want to have between only two covers the latest words about a particular artist or 'ism'.

The great art historian Erwin Panofsky once said 'There is no substitute for information'. This new format of *The Dictionary of Art* will help many generations meet his sensible demands.

ROBERT ROSENBLUM
Henry Ittleson jr, Professor of Modern European Art
Institute of Fine Arts
New York University

List of Contributors

Aradi, Nóra
Arneil Walker, Frank
Baur, John I. H.
Beard, Dorathea K.
Bendiner, Kenneth
Berman, Patricia G.
Białostocki, Jan
Billcliffe, Roger
Bird, Alan
Block, Jane
Bohrer, Frederick N.
Bosomworth, Dorothy
Boyle-Turner, Caroline
Cariou, André
Chase, David
Clark, Jane
Clausen, Meredith L.
Cogger Rezelman, Betsy
Colvin, Howard
Connor, T. P.
Cox-Rearick, Janet
Crawford, Alan
Dinesen, Betzy
Dixon Hunt, John
Dogaer, Georges
Downes, Kerry
Evans, Stuart
Ewing, Dan
Fekete, Julius
Fernandes Pereira, José
Fitchett, R. H.
Floyd, Phylis
França, José-Augusto
Friedman, Alice T.
Galicki, Marta
Gardner, A. R.
Garnett, Oliver
Germann, Georg
Gisbert, Teresa
Gisella Calingaert, Efrem
Goddard, Stephen H.
Gournay, Isabelle
Gray Troyer, Nancy
Greg, Andrew
Grekov, Aleksandr U.
Gutiérrez, Ramón
Hamilton-Phillips, M.
Helland, Janice

Henderson Floyd, Margaret
Hobbs, Richard
Howard, Jeremy
Huys Janssen, Paul
John, Richard
Kalman, Harold
Kaplan, Julius
Kelly, Franklin
Kerspern, Sylvain
Kirichenko, E. I.
Laureati, Laura
Lavallée, Michèle
Leeuw, Ronald De
Levine, David A.
Lewis, Michael J.
McCarthy, Michael
MacCubbin, R. P.
McEvansoneya, Philip
McVaugh, Robert E.
Mannings, David
Marías, Fernando
Mead, Christopher
Mende, Matthias
Morgan, Hilary
Morton, Marsha L.
Mowl, Tim
Muthesius, Stefan
Newall, Christopher
Nicholls, Paul
Nilsén, Anna
Ottomeyer, Hans
Papp, Júlia
Payne, Christiana
Picone Petrusa, Mariantonietta
Pupil, François
Quiney, Anthony
Reyes-Valerio, Constantino
Riccardi-Cubitt, Monique
Rodgers, David
Rodríguez Ceballos, Alfonso
Rubin, J. H.
Schroder, Timothy
Schweikhart, Gunter
Scotti Tosini, Aurora
Seiberling, Grace
Service, Alastair
Shirley, Pippa
Sluijter, Eric J.

Spencer-Longhurst, Paul
Spicer, Joaneath A.
Stillman, Damie
Stocker, Mark
Sweetman, John
Talbot, Charles
Tattersall, Bruce
Tavernier, Ludwig
Thomson, Belinda
Treuherz, Julian
Tümpel, Astrid
Turpin, John

Ubeda De Los Cobos, Andrés
Vaughan, William
Veldman, Ilja M.
Watkin, David
West, Shearer
Wheelton Hind, Charles
Whiffen, Marcus
Wilton-Ely, John
Wundram, Manfred
Zanten, David Van
Zerner, Henri

General Abbreviations

The abbreviations employed throughout this book do not vary, except for capitalization, regardless of the context in which they are used, including the bibliographical citations and for locations of works of art. For the reader's convenience, separate full lists of abbreviations for locations, periodical titles and standard reference books and series are included as Appendices.

AD	Anno Domini	*d*	died	**inc.**	incomplete		
addn	addition	**ded.**	dedication,	**incl.**	includes,		
a.m.	ante meridiem		dedicated to		including,		
	[before noon]	**dep.**	deposited at		inclusive		
Anon.	Anonymous(ly)	**destr.**	destroyed	**Incorp.**	Incorporation		
app.	appendix	**diam.**	diameter	**inscr.**	inscribed,		
Assoc.	Association	**diss.**	dissertation		Inscription		
attrib.	attribution,	**Doc.**	Document(s)	**intro.**	introduced by,		
	attributed to	**ed.**	editor, edited (by)		introduction		
B.	Bartsch [catalogue	**edn**	edition	**inv.**	inventory		
	of Old Master	**eds**	editors	**irreg.**	irregular(ly)		
	prints]	**e.g.**	*exempli gratia* [for				
b	born		example]	**jr**	junior		
bapt	baptized	**esp.**	especially	**kg**	kilogram(s)		
BC	Before Christ	**est.**	established	**km**	kilometre(s)		
bk, bks	book(s)	**etc**	*et cetera* [and so on]				
BL	British Library	**exh.**	exhibition	**l.**	length		
BM	British Museum			**lb, lbs**	pound(s) weight		
bur	buried	**f, ff**	following page,	**Ltd**	Limited		
			following pages				
c.	circa [about]	**facs.**	facsimile	**m**	metre(s)		
can	canonized	**fasc.**	fascicle	**m.**	married		
cat.	catalogue	*fd*	feastday (of a saint)	**M.**	Monsieur		
cf.	confer [compare]	**fig.**	figure (illustration)	**MA**	Master of Arts		
Chap., Chaps		**figs**	figures	**MFA**	Master of Fine Arts		
	Chapter(s)	*fl*	*floruit* [he/she	**mg**	milligram(s)		
Co.	Company;		flourished]	**Mgr**	Monsignor		
	County	**fol., fols**	folio(s)	**misc.**	miscellaneous		
Cod.	Codex, Codices	**ft**	foot, feet	**Mlle**	Mademoiselle		
Col., Cols	Colour;			**mm**	millimetre(s)		
	Collection(s);	**g**	gram(s)	**Mme**	Madame		
	Column(s)	**gen.**	general	**Movt**	Movement		
Coll.	College	**Govt**	Government	**MS., MSS**	manuscript(s)		
collab.	in collaboration	**Gt**	Great	**Mt**	Mount		
	with, collaborated,	**Gtr**	Greater				
	collaborative			**N.**	North(ern);		
Comp.	Comparative;	**h.**	height		National		
	compiled by,	**Hon.**	Honorary,	**n.**	note		
	compiler		Honourable	**n.d.**	no date		
cont.	continued			**NE**	Northeast(ern)		
Contrib.	Contributions,	**ibid.**	*ibidem* [in the	**nn.**	notes		
	Contributor(s)		same place]	**no., nos**	number(s)		
Corp.	Corporation,	**i.e.**	*id est* [that is]	**n.p.**	no place (of		
	Corpus	**illus.**	illustrated,		publication)		
Corr.	Correspondence		illustration	**nr**	near		
Cttee	Committee	**in., ins**	inch(es)	**n. s.**	new series		
		nc.	Incorporated	**NW**	Northwest(ern)		

Occas.	Occasional	**red.**	reduction, reduced for			Santissimi
op.	opus			**St**	Saint, Sankt, Sint, Szent	
opp.	opposite; opera [pl. of opus]	*reg*	*regit* [ruled]			
		remod.	remodelled	**Ste**	Sainte	
oz.	ounce(s)	**repr.**	reprint(ed); reproduced, reproduction	**suppl., suppls**	supplement(s), supplementary	
p	pence			**SW**	Southwest(ern)	
p., pp.	page(s)	**rest.**	restored, restoration			
p.a.	per annum			**trans.**	translation, translated by; transactions	
Pap.	Paper(s)	**rev.**	revision, revised (by/for)			
para.	paragraph			**transcr.**	transcribed by/for	
pl.	plate; plural	**Rev.**	Reverend; Review			
pls	plates					
p.m.	post meridiem [after noon]	**S**	San, Santa, Santo, Sant', São [Saint]	**unpubd**	unpublished	
Port.	Portfolio			**v**	*verso*	
Posth.	Posthumous(ly)	**S.**	South(ern)	**var.**	various	
prev.	previous(ly)	**SE**	Southeast(ern)	**viz.**	*videlicet* [namely]	
priv.	private	**sect.**	section			
pseud.	pseudonym	**ser.**	series	**vol., vols**	volume(s)	
pt	part	**sing.**	singular	**vs.**	versus	
pubd	published	**sq.**	square			
pubn(s)	publication(s)	**SS**	Saints, Santi, Santissima, Santissimo,	**W.**	West(ern)	
R	reprint			**w.**	width	
r	*recto*					

Note on the Use of the Book

This note is intended as a short guide to the basic editorial conventions adopted in this book.

Abbreviations in general use in the book are listed on pp. x–xi; those used in bibliographies and for locations of works of art or exhibition venues are listed in the Appendices.

Author's signatures appear at the end of the articles. Where an article was compiled by the editors or in the few cases where an author has wished to remain anonymous, this is indicated by a square box (□) instead of a signature.

Bibliographies are arranged chronologically (within a section, where divided) by order of year of first publication and, within years, alphabetically by authors' names. Abbreviations have been used for some standard reference books; these are cited in full in Appendix C. Abbreviations of periodical titles are in Appendix B. Abbreviated references to alphabetically arranged dictionaries and encyclopedias appear at the beginning of the bibliography (or section).

Cross-references are distinguished by the use of small capital letters, with a large capital to indicate the initial letter of the entry to which the reader is directed; for example, 'He commissioned LEONARDO DA VINCI…' means that the entry is alphabetized under 'L'. Given the comprehensiveness of this book, cross-references are used sparingly between articles to guide readers only to further useful discussions.

Abramtsevo

Russian estate near Sergiyev Posad, 57 km north of Moscow, and site of an artists' colony. It was first recorded in documents between 1584 and 1586 under the name Obramkovo. In the 18th century it became the village of Abramkovo, part of a private estate known by the mid-19th century as Abramtsevo. In 1843 the estate was acquired by the writer Sergey Aksakov (1791–1859). He wrote his most successful works there and had numerous artists and writers as visitors, including Taras Shevchenko and Vissarion Belinsky. In 1870 the estate was acquired by the prominent industrialist and patron Savva Mamontov, who made it a major Russian artistic colony from the 1870s to the 1890s. Here, as at Princess Tenisheva's estate at Talashkino, an interest in national culture and antiquities flourished, and there was a revival of Russian folk art. Various well-known Russian artists lived at Abramtsevo at that time, among them Il'ya Repin, Mikhail Vrubel', Valentin Serov, Konstantin Korovin, Mikhail Nesterov, Yelena Polenova, Vasily Polenov and Viktor Vasnetsov. They formed the Abramtsevo/Mamontov artistic circle—an association of representatives of the most advanced artistic intelligentsia, who were creatively involved in the construction and decoration of the estate.

A collection of items of everyday peasant life was started, and in 1884 a joiner's workshop was organized on the estate, soon headed by Yelena Polenova. It united local craftsmen from the villages of Kudrino, Akhtyrka and Mutovki and initiated the production at Abramtsevo of caskets, dishes and furniture, decorated primarily with bas-relief carving (Abramtsevo/Kudrinskaya carving), which employs vegetable and geometrical ornament with representations of birds and animals. A number of exceptional folk artists came from among the students in the workshop, including Vasily Vornoskov (1876–1940), who created his own original style of carving and who taught many other craftsmen. In 1890 a ceramics workshop was also set up at Abramtsevo, which instigated the production of maiolica, although this had never been traditional in Russia. Mikhail Vrubel' produced notable examples of maiolica at the Abramtsevo workshop.

In what later became the Abramtsevo Museum-Estate are the main estate building, dating from the mid-18th century (rebuilt 1870–78), buildings in the 'Russian style' by Viktor Gartman (e.g. the Studio, 1872), Ivan Ropet (e.g. the Terem, 'Tower Chamber', 1873), Viktor Vasnetsov (e.g. the Church, 1881–2, and the 'Hut on Hen's Legs', 1883). These contain exhibitions and information about the activities of the Abramtsevo circle. The nearby town of Khot'kovo contains a factory producing carved artistic items, its craftsmen continuing the traditions of Abramtsevo-Kudrinskaya carving. The wood-carvers are taught in the Vasnetsov Abramtsevo Art College in the same town.

Bibliography

N. V. Polenova: *Abramtsevo* (Moscow, 1922)

N. Pakhomov: *Abramtsevo* (Moscow, 1969)

D. Z. Kogan: *Mamontovskiy kruzhok* [Mamontov's circle] (Moscow, 1970)

N. M. Beloglazova: *Abramtsevo* (Moscow, 1981)

O. I. Arzumanova and others: *Muzey-zapovednik v Abramtsevo* [The museum-estate at Abramtsevo] (Moscow, 1984)

ALEKSANDR U. GREKOV

Aesthetic Movement

Term used to describe a movement of the 1870s and 1880s that manifested itself in the fine and decorative arts and architecture in Britain and subsequently in the USA. Reacting to what was seen as evidence of philistinism in art and design, it was characterized by the cult of the beautiful and an emphasis on the sheer pleasure to be derived from it. In painting there was a belief in the autonomy of art, the concept of ART FOR ART'S SAKE, which originated in France as a literary movement and was introduced into Britain around 1860.

The Aesthetic Movement was championed by the writers and critics Walter Pater, Algernon Charles Swinburne and Oscar Wilde. In keeping with Pater's theories, the artists associated with it painted pictures without narrative or significant subject-matter. Dante Gabriel Rossetti took his inspiration from Venetian art because of its

emphasis on colour and the decorative. This resulted in a number of half-length paintings of female figures, such as the *Blue Bower* (1865; U. Birmingham, Barber Inst.) and *Beata Beatrix* (*c.* 1864–70; London, Tate; see fig. 1). James McNeill Whistler came closest to the ideals of the Aesthetic Movement. In such paintings as *Nocturne in Blue and Gold: Old Battersea Bridge* (*c.* 1872–5; London, Tate; see col. pl. I), he did not intend to achieve topographical accuracy: truth to nature was not one of the aims of the Aesthetic Movement. At the famous libel trial between John Ruskin and Whistler in 1878, Whistler said of this work, 'The thing is intended simply as a representation of moonlight. My whole scheme was only to bring about a certain harmony of colour' (Spencer, p. 85). Albert Joseph Moore used formalized Classical settings for his languorous female figures, which seduce the viewer by the harmonies of colour and form as well as the latent eroticism, as in *A Venus* (York, C.A.G.). The neutral titles of his pictures serve to distract from the content and discourage narrative readings. Frederic Leighton leaned even more heavily on the Classical past, and he often adopted mythological figures (e.g. *Bath of Psyche*, exh. 1890; London, Tate).

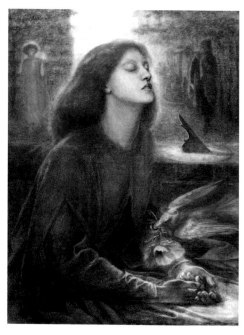

1. Dante Gabriel Rossetti: *Beata Beatrix*, *c.* 1864–70 (London, Tate Gallery)

The formal arrangement of Whistler's *Nocturne in Blue and Gold* was derived from Japanese art (*see* JAPONISME), which was an important influence on designers as well as painters. The furniture of E. W. Godwin, for example, is simple and elegant—solid balanced by void—occasionally with painted decoration. His preferred material was ebonized mahogany, which he used for the buffet that he designed originally for himself in 1867 (e.g. London, V&A), inset with panels of embossed Japanese leather paper. In the house in London that he decorated for himself there were Japanese fans on the ceiling and skirting, and Japanese vases. Such items were imported and sold at Liberty & Co. in London and could be found in fashionable 'Aesthetic' interiors of the 1870s and 1880s.

In 1876 F. R. Leyland commissioned Thomas Jeckyll to design the dining-room (now in Washington, DC, Freer) of 49 Princes Gate, London, which was to be the setting for his collection of porcelain and Whistler's painting *La Princesse du pays de la porcelaine* (1863–4). The walls behind Jeckyll's elaborate shelving were covered with Spanish leather, which Whistler overpainted in 1877 in gold on a blue ground with motifs based on the eye and tail-feathers of the peacock; opposite his picture, which hung over the fireplace, he painted two peacocks in full plumage. In the fireplace stands a pair of wrought-iron fire-dogs designed by Jeckyll in the form of sunflowers. With the peacock, the sunflower was a characteristic motif of the Aesthetic Movement, appearing in tiles painted by William De Morgan, embroidery designed by C. R. Ashbee, chintz and wallpaper designed by Bruce J. Talbert and in the painted face of a clock (1880; London, V&A) that was probably designed by Lewis Foreman Day.

The principal link between 'art' furniture, ceramics, metalwork and textiles of the Aesthetic Movement and the QUEEN ANNE REVIVAL style of architecture favoured by Godwin and Richard Norman

Shaw, among others, is the fact that their creators were, in the sophistication of their designs, elevating the form of their work to the status of fine art. They were creating 'artistic' objects and buildings. They were both reforming and informing taste, a matter that was of great concern to William Morris, who, though at odds with much of the philosophy of the Aesthetic Movement, helped to extend its influence to the USA. By 1870 Morris's wallpapers were on sale in Boston, and two years later *Hints on Household Taste* (1868) by Charles Locke Eastlake was produced in an American edition. This was important to the dissemination of the notion that art should be applied to all types of decoration. In 1876 the Centennial Exposition in Philadelphia did much to familiarize Americans with reformed taste in England, and in 1882–3 Wilde made a lecture tour of the USA. Though satirized for his effeteness and posturing, he increased awareness of the Aesthetic Movement.

In the USA Christian Herter produced his own version of Godwin's 'Anglo-Japanese' style (e.g. wardrobe, 1880–85; New York, Met.), and Ott &

Brewer of Trenton, NJ, made ceramics in the Japanese taste. Louis Comfort Tiffany designed jewellery and silver (e.g. silver vase, 1906–7; Newark, NJ, Mus.; see fig. 2), as well as glass and interiors, and must be regarded as one of the principal American exponents of the Aesthetic Movement, as he was to be of Art Nouveau. John La Farge contributed decorations to the Japanese Parlor (1883–4) of the house (destr.) of William Henry Vanderbilt in New York, which was the epitome of fashionable taste. In the fine arts Whistler's influence made a brief impact on the work of Winslow Homer (e.g. *Promenade on the Beach*, 1880; Springfield, MA, Mus. F.A.) and Elihu Vedder.

Bibliography

W. Pater: *Studies in the History of the Renaissance* (London, 1873, rev. 4/1893); rev. as *The Renaissance: Studies in Art and Poetry* (Berkeley, 1980)

W. Gaunt: *The Aesthetic Adventure* (London, 1945)

E. Aslin: *The Aesthetic Movement: Prelude to Art Nouveau* (London, 1969)

R. V. Johnson: *Aestheticism* (London, 1969)

R. Spencer: *The Aesthetic Movement* (London, 1972)

M. Gironard: *Sweetness and Light: The Queen Anne Movement, 1860–1900* (Oxford, 1977/R New Haven and London, 1984)

I. Small, ed.: *The Aesthetes: A Sourcebook* (London, 1979) [excellent intro. and reprints of texts]

In Pursuit of Beauty: Americans and the Aesthetic Movement (exh. cat., New York, Met., 1986)

☐

all'antica [It.: 'after the Antique']

Style of decoration in a work of art that mimics, quotes or derives from a Classical model.

☐

Ancients

Group of British painters and engravers active in the 1820s and 1830s. Samuel Palmer, the central figure of the group, first referred to 'the Ancients' in a letter to George Richmond in May 1827. They were drawn together by their admiration for William Blake and for 'the grand old men'— artists of the Renaissance, especially Dürer and Michelangelo—in preference to 'the moderns', the naturalistic landscape painters of the day. They

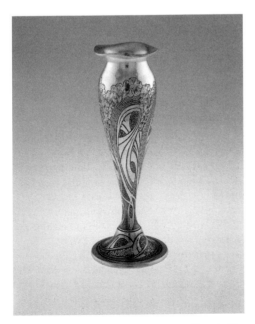

2. Louis Comfort Tiffany: *Silver Vase*, 1906–7 (Newark, NJ, Newark Museum)

met at Blake's house in London, stayed with Palmer in Shoreham, Kent, and continued their association with monthly meetings in London in the 1830s. The work of Palmer, Richmond and Edward Calvert in the 1820s and early 1830s represents their aesthetic ideals most fully: it is generally small in scale and elaborately worked, employing archaic media and a primitive, linear style. Their subject-matter was drawn from the Bible, or from a vision of a golden age of pastoral innocence and abundance that had both Christian and Vergilian overtones.

Characteristic examples are Palmer's *Moonlight, A Landscape with Sheep* (c. 1831–3; London, Tate; see fig. 3) Richmond's *Christ and the Woman of Samaria* (tempera, 1828; London, Tate) and Calvert's *Chamber Idyll* (wood-engraving, 1831). The other Ancients were Francis Oliver Finch (1802–62), who painted landscape watercolours in the style of Claude Lorrain; Welby Sherman (*fl* 1827–34), whose engravings were after, or closely indebted to, Palmer, Richmond and Calvert; Henry Walter (1799–1849), a portrait and animal painter; Frederick Tatham (1805–78), a sculptor and miniaturist; his brother, Arthur Tatham; and Palmer's cousin, John Giles. John Linnell was on the fringes of the group. All set a high value on imagination and visionary experience: their watchwords, according to Palmer's son Alfred H. Palmer, were 'Poetry and Sentiment' and

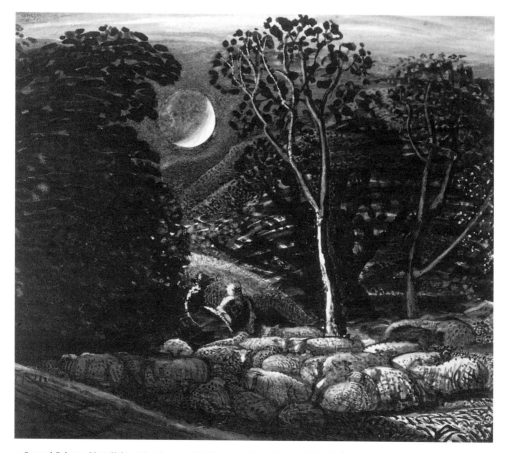

3. Samuel Palmer: *Moonlight, A Landscape with Sheep*, c. 1831–3 (London, Tate Gallery)

most were intensely religious, though of varying persuasions.

Bibliography

L. Binyon: *The Followers of William Blake* (London, 1925)
Samuel Palmer and his Circle: The Shoreham Period (exh. cat., ACGB, 1956)
H. Meltzer: *The Ancients* (diss., New York, Columbia U., 1975)
R. Wark, ed.: *Essays on the Blake Followers* (San Marino, 1983)
Samuel Palmer and 'the Ancients' (exh. cat., ed. R. Lister; Cambridge, Fitzwilliam, 1984)

CHRISTIANA PAYNE

Antwerp Mannerism

Style of painting and drawing practised by artists working in Antwerp during the period from c. 1500 to 1530. The term was coined by Max Friedländer in 1915 in his article 'Die Antwerpener Manieristen von 1520'. In this and subsequent publications (1921, 1933 and 1937) he attempted to bring order into a large body of anonymous Antwerp paintings (and some drawings) that had been gradually gathered under the name of Herri met de Bles, after an *Adoration of the Magi* (Munich, Alte Pin.) bearing a false Bles signature. Only a small proportion of these works could be sorted into recognizable hands. The principal anonymous masters identified by Friedländer were Pseudo-Bles (or Pseudo-Blesius), the author of the Munich painting, the Master of the Von Groote Adoration, the Master of the Antwerp Adoration, the Master of Amiens and the Master of 1518 (subsequently identified by Marlier as Jan Mertens). The outstanding known artist of the group is Jan de Beer. Friedländer also included Adriaen van Overbeke, the early work of Jan Gossart and the putative oeuvre of Jan Wellens de Cock as part of Antwerp Mannerism. Despite its name, Antwerp Mannerism is unrelated to Italian or later Flemish Mannerism; its mannerism, instead, is an expression of Late Gothic art.

A work such as the *Beheading of St John the Baptist*, attributed by Friedländer to Pseudo-Bles, exemplifies the main features of the style: histri-onic figural groupings, flamboyant costumes, elegant chromatic effects, technical virtuosity and fantastical architecture freely combining Gothic and Renaissance elements. Decorative invention is the keynote. Another characteristic of Antwerp Mannerism is the marked tendency towards repetition, whether of themes (the Adoration of the Magi being a kind of signature subject), of stock motifs and figures, or of entire compositions (copies and variants exist in large numbers). This aspect, as often noted, is probably a result of production for the Antwerp market. Much of Antwerp Mannerist output was intended for export, particularly the large retables in which Mannerists either provided painted wings for sculpted shrines (e.g. Jan Mertens's work for the carved wooden altarpiece, 1518; Lübeck, Marienkirche) or painted the entire polyptych themselves (e.g. the altarpiece of 1516, Västerås Cathedral, Sweden). Collaboration and mass production appear to have been common. While this has a definite levelling effect, Antwerp Mannerism nonetheless is not an entirely homogeneous phenomenon. The range of quality among works is broad, from the sophisticated chiaroscuro and colouristic refinement of de Beer's *Nativity* and the *Flowering of St Joseph's Rod* (both U. Birmingham, Barber Inst.), and the dazzling virtuosity of the Master of Amiens's Puy panel *'Au juste pois véritable balance'* (1518; Amiens, Mus. Picardie), to the crude workmanship of van Overbeke's altarpiece in Kempen, Germany (1513; parish church of St Anne) and the even more routine work of the many anonymous painters practising the style.

Friedländer dated the onset of Antwerp Mannerism to the first decade of the 16th century, emphasizing the guild entrance dates of its named practitioners: Gossart and Jan van Leyden (whom he identified with Jan de Cock) in 1503, de Beer in 1504 and van Overbeke in 1508. The fact that the earliest extant dated work (van Overbeke's Kempen altarpiece) dates to 1513 has led some (e.g. von der Osten) to conclude that Antwerp Mannerism cannot be shown to have existed before then, but Friedländer and others regard the presence of Mannerist elements in Gossart's work during his Antwerp years (1503–7/8) as evidence of

its earlier origin. With relatively few dated works surviving, and all of them from the second and third decades of the century, the origin and chronology of Antwerp Mannerism remains problematic. Silver has stressed the similarity of stylistic conventions found in Antwerp Mannerism and Brabantine sculpture of the late 15th century and the early 16th, finding indications of these conventions in Quentin Metsys's *Lamentation* altarpiece of 1508–11 (Antwerp, Kon. Mus. S. Kst.; see col. pl. II).

In its exclusive focus on religious themes and devotional iconography, and in its flamboyant style, Antwerp Mannerism was a manifestation of late medieval culture that did not survive beyond the third decade of the 16th century. In its day, however, it exerted a wide appeal among merchants and churchmen buying art in Antwerp and a broadly diffused influence on contemporary artists. In Antwerp itself, the impact of the style was occasionally registered on painters not otherwise associated with it: Gossart, Metsys, Joos van Cleve, Dirck Vellert, the Master of Frankfurt and Goswijnn van der Weyden. The early development of Pieter Coecke van Aelst shows connections with the work of Jan Mertens (the Master of 1518), who was perhaps his teacher (Marlier). Some of the paintings attributed to the Bruges artist Adriaen Isenbrandt incorporated Mannerist elements, and the influence of the style also extended to French stained-glass and manuscript production (Orth). Friedländer (1915) even detected traces of the style in contemporary German books. A more problematic case is Leiden painting of the period, particularly the work and circle of Cornelis Engebrechtsz., which shows striking connections with Antwerp Mannerism. Gibson suggests that influence may have been transmitted by the Master of the Vienna Lamentation, whom he believes arrived in Leiden from Antwerp c. 1512–14.

The term Antwerp Mannerism has often been regarded as unsatisfactory, and a number of attempts have been made to introduce alternative nomenclature (Baldass, Marlier, Faggin, Philippot). Of greater significance has been the recognition that the tendency towards mannered stylization was not limited to Antwerp but broadly characteristic of Late Gothic Netherlandish art as a whole (Baldass, Hoogewerff, Benesch). Closely related strains of Late Gothic Mannerism have also been identified in regional 16th-century French painting (Laclotte, Laveissière, Foucart). A complex phenomenon, Antwerp Mannerism has elicited strong and often conflicting responses from scholars. In iconography the style is generally conservative, and in execution it frequently betrays routine production values in the service of the market-place. At its best, though, Antwerp Mannerism is stylish, assured and extraordinarily vital, revealing a freedom of invention and technique that bears comparison with contemporary German Florid sculpture and Flamboyant Gothic architecture.

Bibliography

M. J. Friedländer: 'Die Antwerpener Manieristen von 1520', *Jb. Kön.-Preuss. Kstsamml.*, xxxvi (1915), pp. 65–91

—: *Die niederländischen Manieristen* (Leipzig, 1921)

—: *Die altniederländische Malerei* (Berlin, 1924–37); Eng. trans. as *Early Netherlandish Painting*, 16 vols (Leiden, 1967–76)

L. Baldass: 'Die niederländischen Maler des spätgotischen Stiles', *Jb. Ksthist. Samml. Wien*, n.s., xi (1937), pp. 117–38

G. J. Hoogewerff: *De Noord-Nederlandsche schilderkunst*, ii (The Hague, 1938), pp. 12–14

G. von der Osten: 'Studien zu Jan Gossaert', *De artibus opuscula XL: Essays in Honor of Erwin Panofsky* (New York, 1960), pp. 454–75 (460–61) [argues that Antwerp Mannerism does not predate 1513]

O. Benesch: *The Art of the Renaissance in Northern Europe: Its Relation to the Contemporary Spiritual and Intellectual Movements* (rev. London, 1965), pp. 79–100

G. Marlier: *La Renaissance flamande: Pierre Coeck d'Alost* (Brussels, 1966), pp. 109–16

M. Laclotte: 'Quelques Tableaux bourguignons du XVIe siècle', *Studies in Renaissance and Baroque Art Presented to Anthony Blunt* (London, 1967), pp. 83–5

G. T. Faggin: *La pittura ad Anversa nel cinquecento* (Florence, 1968), pp. 17–19

S. Herzog: *Jan Gossart called Mabuse (ca. 1478–1532): A Study of his Chronology with a Catalogue of his Works*, 3 vols (diss., Bryn Mawr Coll., PA, 1968), pp. 18–39 [Gossart's Antwerp work and Antwerp Mannerism]

P. Philippot: *Pittura fiamminga e rinascimento italiano* (Turin, 1970), pp. 101–5

W. S. Gibson: *The Paintings of Cornelis Engebrechtsz.* (New York, 1977), pp. 171–207 [the 'Jan de Cock problem' and the Master of the Vienna Lamentation]

D. Ewing: *The Paintings and Drawings of Jan de Beer*, 2 vols (diss., Ann Arbor, U. MI, 1978)

J. Foucart: 'Nouvelles acquisitions de peintures des écoles du nord', *Rev. Louvre*, xxix (1979), pp. 370–80 (370–71, 378)

S. Laveissière: 'Un Volet de retable du XVIe siècle retrouvé', *Rev. Louvre*, xxix (1979), pp. 362–4

E. Starcky: 'A propos d'un dessin maniériste anversois', *Rev. Louvre*, xxxi (1981), pp. 96–102 [observations on the character of Antwerp Mannerism]

L. Silver: *The Paintings of Quentin Metsys, with a Catalogue Raisonné* (Montclair, NJ, 1984), pp. 45–7

M. W. Ainsworth and M. Faries: 'Northern Renaissance Paintings: The Discovery of Invention', *Bull. St Louis A. Mus.*, xviii (1986), pp. 3–47 (31–7) [study of underdrawings of Master of 1518 with attributions of drgs]

J. R. Judson: 'Jan Gossaert and the New Aesthetic', *The Age of Bruegel: Netherlandish Drawings in the Sixteenth Century* (exh. cat. by J. O. Hand and others, Washington, DC, N.G.A.; New York, Pierpont Morgan Lib.; 1986–7), pp. 13–24 (14–17)

M. D. Orth: 'Antwerp Mannerist Model Drawings in French Renaissance Books of Hours: A Case Study of the 1520s Hours Workshop', *J. Walters A.G.*, xlvii (1989), pp. 77–90

DAN EWING

Arabesque style

Term used, mainly in France, to describe painted ornament in the late 18th century incorporating grotesques, Strapwork and the foliate scrollwork inspired by the Moresque style. Contemporaries referred to the style, which was in evidence from 1775 and developed until the collapse of the *ancien régime*, as 'goût étrusque' (*see* ETRUSCAN STYLE) or 'genre arabesque', or sometimes used the double appellation 'goût arabesque et étrusque'. It derives in part from surviving examples of the grotesque in Rome (*see* GROTESQUE) and is characterized by naturalistically shaped ornamental motifs, which pivot on a central axis to form a mirror image (*see* ARABESQUE). The principle of composition of the style lies in the curvilinear

Acanthus scroll, symmetrically aligned on an axis and rolling up to form a spiral. Spirals are also found in the scroll friezes, in scroll motifs turning in on themselves to become spirals and in flutings. This naturalistic imagery is diametrically opposed to the heavy forms, sober abstract friezes and the severe and solemn pictorial inventions of early Classicism and the *goût grec*.

One of the earliest examples of the style was the decoration by Charles-Louis Clérisseau for the salon of the Hôtel Grimod de la Reynière, Paris (1774). A contemporary account in the *Almanach des artistes* (Paris, 1977, pp. 84–6) describes the highly coloured decoration 'dipping into the maxims of the ancients, it is very easy to find a genre that suits us perfectly though it is very different from the ones we have adopted.' Clérisseau also used arabesque decoration for the salon of another mansion (1779–81; now probably London, V&A) on the Rue Boissy d'Anglas for Laurent Grimod de la Reynière. The court did not begin to adopt the arabesque style until after 1785. In 1787 Rousseau de La Rottière decorated a games-room and a boudoir with a 'cabinet turc' at Fontainebleau for Marie-Antoinette. These rooms represent the apogée of the French 'style arabesque', and some of the motifs employed in them formed a transition to Pompeian decoration (*see* POMPEIAN REVIVAL). In its late phase the arabesque style corresponds closely to the DIRECTOIRE STYLE.

Bibliography

L. Hautecoeur: *Rome et la renaissance de l'antiquité à la fin du XVIIIe siècle* (Paris, 1912)

E. Croft-Murray: 'The Hôtel Grimod de La Reynière: The Salon Decorations', *Apollo* (1963), p. 377

H. Ottomeyer and P. Pröschel: *Bronzearbeiten des Spätbarock und Klassizismus*, i (Munich, 1986), p. 217

HANS OTTOMEYER

Art à la Rue

Term used to refer to a movement or set of concerns espoused by a small number of left-wing artists and architects in the 1890s and early 1900s, mainly in Brussels and Paris. A significant number of leading Art Nouveau artists and

architects, including Victor Horta, Héctor Guimard and Frantz Jourdain (the main spokesman for the movement) were involved. Art à la Rue, which focused specifically on bringing art to the working classes, was part of a broader movement aimed at social reform, whose roots were in the French socialist movement, the political theories of the Russian anarchist Prince Kropotkin and William Morris's later essays. In challenging the élitist status of art, it urged those in the arts to forget the world of museums and collectors and to concentrate instead on relating art to everyday life, so that it assumed a more socially responsive role in society. The main arena for this was the street, where ordinary people spent most of their leisure time. Proponents of Art à la Rue, therefore, urged that the streets should be enlivened with bright colours by means of lithographic posters (e.g. those of Jules Chéret and Théophile-Alexandre Steinlen) and by artistically designed signs, lights and drinking fountains, in order to make the city a more pleasing place to live; the process would help to shape aesthetic sensibility. Such art was to be deliberately popular in appeal, accessible and intelligible to people of all ages and educational backgrounds. Decorated building façades and shop fronts, too, were singled out as an especially good means of transforming sombre streets into free outdoor museums. With its aim of social reform and its focus on the street as a means of bringing art to the people, to lift morale and to elevate popular taste, the Art à la Rue movement suggests that Art Nouveau was not just a new aesthetic ideal: it also had a strong urbanistic, moral component, which helped to set the stage for the modernists' social utopianism of the 1920s.

Bibliography

F. Jourdain: 'Art dans la rue', *Rev. A. Déc.*, xii (1891–2), pp. 211–14

L. Magne: 'L'Esthétique de la rue', *Mercure France*, lvi (1905), p. 170

M. L. Clausen: 'Architecture and the Poster: Toward a Redefinition of Art Nouveau', *Gaz. B.-A.*, n.s. 7, cvi (1985), pp. 81–94

MEREDITH L. CLAUSEN

Art for Art's Sake [Fr. *L'Art pour l'art*]

Concept that emphasizes the autonomous value of art and regards preoccupations with morality, utility, realism and didacticism as irrelevant or inimical to artistic quality. It was the guiding principle of the AESTHETIC MOVEMENT.

In France the phrase 'l'art pour l'art' first appeared in print in 1833, but the concept had been popularized earlier by Madame de Staël's *De l'Allemagne* (Paris, 1813) and Victor Cousin's philosophy lectures at the Sorbonne, *Du vrai, du beau et du bien* (1816–18; pubd Paris, 1836). Théophile Gautier was its main literary publicist, especially in the preface to his novel *Mademoiselle de Maupin* (Paris, 1835). Studies of *l'art pour l'art*, such as Cassagne's, concentrate on the Second Empire literary movement (1851–70) that included Charles Baudelaire, Gautier, Edmond and Jules de Goncourt and the Parnassian poets. The application of the term to art criticism and visual art is uncharted, but it seems to have been used sufficiently loosely to embrace stylistically opposed artists. Sloane linked it to Edouard Manet and his circle—Manet was technically innovative, treated his subjects with moral neutrality and was defended by Emile Zola in *L'Evénement* in 1866 in formalistic terms: 'He does not know how to sing or to philosophize: he knows how to paint, and that is all.' Classicizing painters of the 1840s and 1850s, including Paul Baudry, William Bouguereau, Alexandre Cabanel and Jean-Léon Gérôme, probably also upheld *l'art pour l'art*: they opposed realism and cultivated 'pure art' and 'style', and for this reason Gautier supported them.

The phrase 'Art for Art's Sake' first appeared in English in Algernon Charles Swinburne's *William Blake* (London, 1868) and in Walter Pater's review of William Morris's poetry in the *Westminster Review* (Oct 1868). The end of the review became the 'Conclusion' to Pater's *Studies in the History of the Renaissance* (London, 1873), a key book in the Aesthetic Movement. The concepts of aestheticism had been introduced to Britain from France around 1860 by Frederic Leighton, James McNeill Whistler and Swinburne. They became current in the tightly knit group of painters, poets and art critics around Whistler and Dante Gabriel

Rossetti and were controversial and avant-garde in the 1860s. Those who espoused Art for Art's Sake suggested that artistic quality lay in a work's formal organization rather than in its subject-matter. Aesthetic paintings therefore aimed at a decorative effect through composition and harmonious colour and frequently through the depiction of richly patterned surfaces and luxurious objects.

The exoticism associated with Art for Art's Sake became unfashionable by the late 19th century, but aestheticism influenced the development of formalist art criticism in the 20th century and the general acceptance of the autonomy of art.

Bibliography

W. Pater: *Studies in the History of the Renaissance* (London, 1873, rev. 4/1893); rev. as *The Renaissance: Studies in Art and Poetry* (Berkeley, 1980)

A. Cassagne: *Le Théorie de l'art pour l'art en France chez les derniers romantiques et les premiers réalistes* (Paris, 1906)

R. F. Egan: 'The Genesis of the Theory of "Art for Art's Sake" in Germany and England', *Smith Coll. Stud. Mod. Lang.*, ii/4 (1921), pp. 5–61; v/3 (1924), pp. 1–33

A. Guérard: *Art for Art's Sake* (New York, 1936)

J. C. Sloane: *French Painting between the Past and the Present: Artists, Critics and Traditions from 1848 to 1870* (Princeton, 1951)

J. Wilcox: 'The Beginnings of l'art pour l'art', *J. Aesth. & A. Crit.*, ii (1952–3), pp. 360–77

HILARY MORGAN

Artisan Mannerism

Term introduced by John Summerson to identify an architectural and decorative style, largely derived from north European MANNERISM, adopted by English artisans in the mid-17th century. Lugged architraves, broken pediments, grand and ornate gables, hipped roofs, heavy eaves-cornices and strongly demarcated string courses are among the idiosyncracies and embellishments that typify the style. More through available pattern books and the work of immigrant craftsmen than through travel abroad, English artisans, particularly in London, became increasingly aware during the 1620s and 1630s of recent develop-ments in architectural design on the Continent. They took their ideas from such books as Jacques Francart's *Premier livre d'architecture* (Brussels, 1616), Rubens's *Palazzi di Genova* (Antwerp, 1622) and Salomon de Bray's *Architectura moderna* (Amsterdam, 1631)—which illustrates the work of Hendrik de Keyser—but did not treat them as authoritative, although precise borrowings can be traced. Instead, individual workshops developed their own versions, regional differences grew and persisted, and early sources of design, such as the engraved books of Jacques Du Cerceau the elder, continued to be influential. Nicholas Stone, at his Goldsmiths' Hall in London (1635–8; destr.), was also among those who followed their own inclinations. The giant pilasters of several buildings in Kent, for example Sir George Sondes's Lees Court (begun c. 1640), near Faversham, the hipped roof of Sir John Harris's Balls Park (c. 1640), Herts, and the tall rectangular façade and mullioned windows of Thorpe Hall (1653–6), Cambs, built by Peter Mills for Oliver St John, are examples of the coarse classicism that characterizes the style. The period overlaps with the career of Inigo Jones, who had produced far purer forms of Renaissance architecture for more sophisticated courtly patrons.

Recent studies point to an interdependence of ideas and patronage—from London merchants and the Cromwellian regime—between these city builders and the later work of Jones and his successor John Webb. Their eclectic style began to decline after 1660. The Great Fire of 1666 provided the last opportunities for the style in London during wholesale rebuilding there, although the influence of Artisan Mannerism persisted in the provinces for a further generation.

Bibliography

J. Summerson: *Architecture in Britain, 1530–1830*, Pelican Hist. A. (London, 1969, rev. 7/1983), pp. 157–72

H. J. Lowe: 'Anglo-Netherlandish Architectural Interchange, c. 1600–1660', *Archit. Hist.*, xxiv (1981), pp. 1–23

C. Hind, ed.: *Inigo Jones and the Spread of Classicism* (London, 1987)

G. Worsley: 'Thorpe Hall in Context', *Georgian Group Journal* (1993), pp. 4–12

T. P. CONNOR

Artists Association of Pest
[Pesti Műegyesület; Pesther Kunst-Verein]

Hungarian association of artists, active in Pest from 1839 to 1869. It was established to organize fine art exhibitions. In 1838 Agoston Trefort (1817–88), with László Serenyi, Miklós Jósika (1796–1865) and József Eötvos (1813–71), began to plan an association that would support Hungarian artists and that would operate as a joint stock company. In November 1839 Trefort was made the first President, with László Szalay (1813–64) as Secretary. Although its primary task was to help those artists who wished to be free of the academic constrictions of the Vienna and Munich Artists Associations, it also wanted to awaken an interest in contemporary art and public art. Vince Grimm took on the role of dealer, since he had many connections with the Viennese art market. The association's first exhibition opened on 7 June 1840 in the Vigado Concert Hall in Pest. The organizers exhibited works by the most famous contemporary Hungarian artists, including Miklós Barabás (1810–98), Jakab Marastoni (1804–60), Bálint Kiss, János Rombauer (1782–1849) and Pál Balkay (1785–1846), and a larger number of works by well-known foreign painters (Carl Rottmann, Josef Danhauser, Friedrich von Amerling, Ferdinand Georg Waldmüller, Franz Jaschke) and by Károly Márkó, who was Hungarian but lived in Italy. Almost 9000 visitors were able to see the work of these foreign artists for the first time in Pest. The number of shareholders rose to 1200 after the success of the exhibition.

In 1841 the Association's leadership changed: András Fay became President, with Sándor Wagner as Committee President, Lajos Kossuth (1802–94) as Vice-President and Dániel Szekrényessy as Secretary. The Association's greatest achievement was its declaration of support for the National Picture Gallery Association (Nemzeti Képcsarnokot Létesítő; Egylet), formed in 1845. The Artists Association of Pest bought paintings, mainly through public subscriptions, directly from artists and not only strengthened the links between those artists and the National Museum in Pest, but also donated works to the museum's collection.

The Association published the paper *Évkönyv* every year, which helped to popularize the art of the period. The shareholders, for an annual membership fee, had the right to buy some of the pictures exhibited: this was done by holding a raffle. People who could not attend the exhibitions were free to view the exhibits in the Association's premises in Pest, where work was on display between shows. The greatest number of members at any time was 500.

From its inception the Association was severely criticized. The organizers were accused of being unpatriotic and of working in the interests of foreign artists instead of Hungarian ones; they were criticized for having a Pest warehouse for Viennese art dealers. This view was subsequently taken up by many art historians; not until the late 20th century has the Association been seen in a more favourable light. As a result of divisions within the Association it began to disintegrate in 1859 and finally broke up in 1869. Its role was taken on by the National Hungarian Fine Art Society (Országos Magyar Képzőművészeti Társulat), which had been formed as a rival to the Association in 1861.

Bibliography

J. Bayer: *A 'Pesti Műegylet' és első Kiállítása*, 1840-ben [The Artists Association of Pest and its first exhibition in 1840] (Budapest, 1916), pp. 257–76

B. Biró: *Pesti művészeti közélet száz év előtt* [Art life in Pest 100 years ago], *Képzőművészeti szemle*, xii (1930), pp. 234–42

G. Szvoboda: 'A Pesti Műegylet megalakulása és első Kiállítása 1840-ben' [The foundation of the Artists Association of Pest and its first exhibition in 1840], *A. Hung.*, ii (1980), pp. 281–321

K. Lyka: *Nemzeti romantika: Magyar művészet*, 1850–1867 [National romanticism: Hungarian art, 1850–1867] (Budapest, 1982), pp. 13–14

JÚLIA PAPP

Art Nouveau [Fr.: 'new art']

Decorative style of the late 19th century and the early 20th that flourished principally in Europe and the USA. Although it influenced painting and

sculpture, its chief manifestations were in architecture and the decorative and graphic arts, the aspects on which this survey concentrates. It is characterized by sinuous, asymmetrical lines based on organic forms; in a broader sense it encompasses the geometrical and more abstract patterns and rhythms that were evolved as part of the general reaction to 19th-century historicism. There are wide variations in the style according to where it appeared and the materials that were employed.

1. Introduction

Art Nouveau has been held to have had its beginnings in 1894 or 1895. A more appropriate date would be 1884, the year the progressive group Les XX was founded in Belgium, and the term was used in the periodical that supported it, *Art Moderne*: 'we are believers in Art Nouveau'. The origin of the name is usually attributed to S. Bing, who in December 1895 opened a gallery in Paris that he called L'Art Nouveau (*see* §4 below). The variety of other names by which the style is known are an indication of its multifarious character. They include: Glasgow style (Scotland); *Modern style*, *Style nouille*, *Style coup de fouet* (Belgium); *Style Jules Verne*, *Style Métro*, *Style 1900*, *Art fin de siècle*, *Art belle époque* (France); *Jugendstil* (Germany and Austria); *Sezessionstil* (Austria); *Arte joven* (Spain); *Modernisme* (Catalonia); *Arte nuova*, *Stile floreale*, *Stile Liberty* (Italy); *Nieuwe kunst* (the Netherlands); *Stil' modern* (Russia); Tiffany style (USA).

In each country there was a determination to break with the past and create a new style that could be incorporated into the design of objects in everyday use as well as architecture and interior decoration. Like those associated with PRE-RAPHAELITISM and the ARTS AND CRAFTS MOVEMENT in Britain, the proponents of Art Nouveau rejected the academic tradition and all forms of ornament based on Classical or Renaissance precedent. They believed, with William Morris, in the unity of all the arts and crafts and wanted to abolish the distinction between the major and minor arts. The influence of Japan is evident in the regard for simple outlines and asymmetry (*see* JAPONISME).

The decorative repertory of Art Nouveau was derived principally from the observation and imitation of nature, in particular of exotic flowers and plants. This is epitomized in the work of Victor Horta in Belgium and Emile Gallé and Hector Guimard in France. From Eugène-Emmanuel Viollet-le-Duc in France and John Ruskin and Morris in Britain came the idea of the alliance of form with need: that all the arts should have their roots in utility. The more angular manner of the later phase of Art Nouveau, after about 1904, apparent in the work of the Belgian, Henry Van de Velde, active in Germany, and the Austrian, Josef Hoffmann, looks forward to modernism.

The forms and designs of Art Nouveau were disseminated through the numerous periodicals that existed and were founded at the time; the best-known of these were *The Yellow Book*, *The Studio*, *The Savoy*, *La Plume*, *Jugend* and *Dekorative Kunst*. Such international events as the Exposition Universelle of 1900 in Paris and the Esposizione Internazionale d'Arte Decorativa Moderna of 1902 in Turin brought the style, in its various guises, to the notice of the public as well as architects, artists and designers.

2. Britain

Among the earliest examples of the flowing asymmetry associated with Art Nouveau are the book illustrations of A. H. Mackmurdo, Aubrey Beardsley (see fig. 4) and Walter Crane, in particular Mackmurdo's title page for his *Wren's City Churches* (1883). Mackmurdo, together with C. R. Ashbee, Voysey and M. H. Baillie Scott, all of whom practised as designers as well as architects, provide the link between the Arts and Crafts Movement and Art Nouveau in Britain; Voysey, however, later despised the continental version of the style that he so strongly influenced. In Scotland, the GLASGOW STYLE was a manifestation of Art Nouveau. Charles Rennie Mackintosh, Herbert Macnair and the sisters Margaret Macdonald and Frances Macdonald were all students of the Glasgow School of Art, the director of which, Francis Newbery (1855–1946), was much influenced in his ideas by the Arts and Crafts

General Secretary; in 1893 he organized the dissolution of Les XX and the foundation in its place of the LIBRE ESTHÉTIQUE. Those invited to exhibit in the first year included Toulouse-Lautrec and Seurat, and of singular importance to the development of Art Nouveau was the fact that Morris's and Beardsley's book illustrations and objects designed by Ashbee were given equal prominence to the paintings. With Claude Debussy playing his music at the opening, the exhibition was seen as an attempt to establish a relationship between all the arts.

The architect Victor Horta is regarded as the 'father' of Belgian Art Nouveau. A disciple of Morris, he took charge of the interior decoration as well as the furnishings of his buildings. He made designs for woodwork, glass, textiles and, most notably, ironwork, in which the ideas put forward by Viollet-le-Duc are discernible. The inspiration for his style was nature itself (the only source of imitation he considered permissible), on which he based the interlacing *coup de fouet* (whiplash) that characterizes his work. Throughout the 1890s Horta worked towards the twin goals of creating a new type of formal expression and finding a logical and clear solution to the problems of construction. He achieved the first in the curvilinear, non-representational style of the Maison Tassel (1893), taking it a step further in the Hôtel Solvay (1894), both in Brussels. The second he achieved in the Maison du Peuple (1895–9; destr. 1964), Brussels, which incorporated the first iron and glass façade in Belgium. In this building Horta put into practice Viollet-le-Duc's theory that the future of architecture lay in the honest use of iron.

Paul Hankar, another of the creators of Belgian Art Nouveau, was influenced both by Japanese art and the Arts and Crafts Movement. His early work was in a traditional neo-Renaissance manner; the most important Art Nouveau characteristic of his later work was his treatment of façades as decorative ensembles, as in the façade (1897) of Niguet's Shirt Shop in Brussels.

The other leading figure in Belgian Art Nouveau was Henry Van de Velde, who became a member of Les XX in 1888. He gave up painting

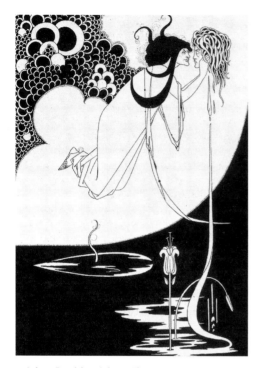

4. Aubrey Beardsley: *Salome: The Dancer's Reward*, 1894 (London, Victoria and Albert Museum)

Movement. They came together as the Four. Their cool, attenuated designs for interiors, furniture, bookbindings and needlework were much admired on the Continent and particularly in Vienna (*see* §6 below), where they were an important influence on the development of a geometrical version of Art Nouveau. Mackintosh was an exhibitor at the international exhibition of 1902 in Turin, and his work was illustrated in the German magazine *Dekorative Kunst*.

3. Belgium

In 1881 the lawyer Octave Maus co-founded the magazine *Art moderne*, the chief aim of which was to introduce art into every aspect of everyday life. The editors called themselves 'the Art Nouveau faithful'. In 1884 the first exhibition took place in Brussels of Les XX (*see* VINGT, LES), a group of 20 artists seeking to show their work outside the official Salon. They chose Maus as

for design in 1892 and, much influenced by Ruskin and Morris, was one of the most important forces in Europe for the reform of design from the late 19th century. In 1895—without experience as an architect—Van de Velde built his own house, Bloemenwerf (completed 1896), near Brussels, and was himself responsible for even the smallest details, including all the furnishings. The house represents a manifesto against the 'lies' constituted by the use of forms borrowed from historic styles. Van de Velde had a particular feeling for harmony without symmetry, and the outstanding feature of his work is the use of a dynamic line that ensures the homogeneity of his forms. Conscious of the disparity between his social and political convictions and his love of craftsmanship (by means of which only unique and expensive pieces could be produced), he set up a company in Brussels in 1898 in an attempt to coordinate the production and distribution of his work. He is remarkable for the multiplicity of his talents, being as successful as a designer of furniture as of lamps, wallpaper, textiles, fashion, silverware, porcelain and jewellery. He moved to Germany in 1899, and his style grew more sober and less ornamental after about 1902.

4. France

French Art Nouveau flourished most fully in the field of the applied arts rather than in architecture. Providing encouragement in the development of the style was the well-established tradition of craftsmanship in France and the support that the well-to-do gave to it. Another factor that contributed to its development was the existence of the Union Centrale des Beaux Arts Appliqués à l'Industrie (later the Union Centrale des Arts Décoratifs), founded in 1864, which from the outset professed the aim of 'supporting in France the cultivation of those arts that pursue the creation of beauty in utility'. The two centres where French Art Nouveau was created and from which the style was disseminated were Nancy and Paris and they witnessed the development of two rather different tendencies: while the former leaned towards the floral, the latter favoured the more symbolic aspects of Art Nouveau.

The Union Centrale exhibition of 1884 marked the birth of the floral style and proved to be a showcase for the ceramics and glassware of Emile Gallé. He wasted no time after winning two gold medals, one for ceramics and one for glass, at the exhibition in promoting his work and that of his colleagues. A glassmaker, potter and cabinet-maker, Gallé combined a poetic spirit with determined industrial enterprise. At the same time as he developed techniques for creating his unique and expensive pieces, he set up a business for the commercial production of his glassware, using one activity to finance the other.

An interest in nature lies at the heart of the style associated with Nancy (see fig. 5), but there were two other factors that played a role of undeniable importance: a pronounced taste for the Rococo (Nancy was substantially built during the reign of Louis XV) and for Japanese art. The latter was introduced to Nancy in the most direct manner, when, in 1885, the Japanese scholar Takasima came to study botany at the school of forestry. Takasima was both a scientist and an artist, and he and Gallé became friends.

In 1901 the Alliance Provinciale des Industries d'Art (later called the Ecole de Nancy) was founded, under Gallé's direction. Other important figures included the designer Victor Prouvé who replaced Gallé as head of the Ecole de Nancy on the latter's death; the glassmakers Auguste Daum and Antonin Daum; the *ébéniste* Louis Majorelle, who, in describing the source of his inspiration, remarked 'my garden is my library'; and the furniture designer and architect Eugène Vallin. After the Villa Majorelle was built in 1901 by Henri Sauvage the Nancy group of 'botanist-decorators' concentrated on architecture. Emile André, Lucien Weissenberger (1860–1929) and Vallin created the first Art Nouveau ensembles in France, and they never forgot the words of Gallé, who had told his colleagues in 1901 that 'painters and ornamental artists, we are one and all priests serving the same religion, worshippers of natural beauty spread through the world'.

From the beginning of the 19th century architecture in Paris had been dominated by Neo-classicism. Hector Guimard, who studied at

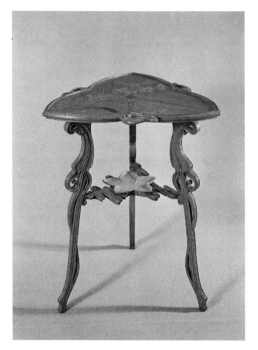

5. Emile Gallé: Salon Table in the Form of a Waterlily,
c. 1900 (Paris, Musée des Arts Décoratifs)

the Ecole des Beaux-Arts, instead of undertaking the traditional pilgrimage to Greece and Rome, went to Britain to study architecture and in 1895 visited Brussels, where he met Horta. On his return he re-worked a project begun in 1894, which he completed in 1897—the Castel Béranger, an apartment block in Paris. Here Guimard broke with the character of the surrounding buildings to give pride of place to sculpture and to colour, both on the exterior and in the interior. He designed every detail—the stained glass, ceramic panels, doors, locks, wallpaper and the furniture. The profusion of detail and the twisting and turning of lines is more pronounced than in the work of Horta or Van de Velde. All the contradictions that Guimard tried to resolve during the course of his career as an architect were expressed in the Castel Béranger: the opposition of structure and ornament, of abstract and figurative design, and the tension between rationalism and its relationship with naturalism. Although nature was

the only model that could be evoked to find some unity in Guimard's designs, his was not the nature of Gallé and the Ecole de Nancy but rather that of Horta, who wrote 'I discard the flower and the leaf, but I keep the stalk'. Although he did not win the competition in 1896 to design the Métro stations in Paris, Guimard was nonetheless awarded the commission. The entrances are remarkable for the integration of decorative elements into the structure. Their appearance was halfway between that of a pavilion and a pagoda constructed of glass and iron. They were to make Guimard a household name and gave rise to the term *Style Métro*. Other architects, among them Frantz Jourdain, who created the Samaritaine department store (1905–10) in Paris, and Jules Lavirotte, designed buildings that belong to Art Nouveau, with leanings towards the Rococo or a floral style, but only Guimard left a consistent body of work amounting to a true expression of architectural conviction.

At the end of 1895, S. Bing opened his new gallery in Paris, *L'Art Nouveau*, for which Van de Velde designed three rooms and Louis Comfort Tiffany executed the stained glass. It became a rallying-point for the creators and devotees of Art Nouveau. Bing, one of the principal promoters of the style, brought together a number of artists and designers, among them Georges de Feure, Edouard Colonna and Eugène Gaillard. All three designed rooms for Bing's pavilion (destr.) at the Exposition Universelle in Paris in 1900: de Feure's furniture for the model sitting room of a modern house included a gilt-wood sofa, its undulating lines abstracted from plant shapes. Their work was greeted with enthusiasm by the *Revue des arts décoratifs*: 'The contrast of their modernism excites the eye and seduces the intellect ... nothing in the foreign or French displays of decorative art, nothing is superior to this exhibition of Art Nouveau.' An article such as this and the enormous success of the exhibition led Parisians to believe that Art Nouveau was a typically French style; it was not a coherent style, though, but rather a juxtaposition of individual elements.

After 1900 the Art Nouveau style in France was expressed mainly in interior decoration, notably

in the shop (1900–01; destr.) in Paris designed by Alphonse Mucha for the jeweller Georges Fouquet. Art Nouveau restaurants, such as Maxim's (remodelled 1899; architect Louis Marnez, painter Léon Sounier), and boutiques proliferated until about 1910. Edouard Niermans introduced Art Nouveau to the architecture of brasseries, restaurants and casinos (1894–1914) and also theatres, particularly in Paris and on the Côte d'Azur. Originality in French Art Nouveau culminated in objects of vertu, such as those designed by Félix Bracquemond, and the sublime jewellery and accessories designed by René Lalique (e.g. a buckle in the shape of a water-nymph).

5. Germany

Art Nouveau in Germany came into being as a reaction to the historic eclecticism epitomized by the castles built for Ludwig II, King of Bavaria. In the 1890s there was activity in various quarters. Van de Velde received a series of commissions, including one for the Havana Cigar Shop in Berlin, in 1899 where he settled. Also in Berlin, Alfred Messel began work on the building of the Wertheim department stores in Berlin, taking his ideas for the second of them, in the Leipzigstrasse (1896–7; destr. 1944), from buildings constructed in iron and glass in France and Chicago. At the same time a minor event in diplomatic circles occurred that was to have important repercussions: Hermann Muthesius was sent to London as technical attaché at the German embassy with the specific brief of gathering information about architecture and the decorative arts in Britain.

New periodicals played a more significant role in Germany than elsewhere, and they appeared in considerable numbers: in Berlin in 1895 the critic Julius Meier-Graefe founded *Pan*, a magazine devoted to the fine and applied arts in Europe. In January 1896 *Jugend: Illustrierte Wochenschrift für Kunst und Leben* was launched; this was to give its name to the Art Nouveau movement in Germany, *Jugendstil*. This was a pacifist, anticlerical magazine advocating a new art and aesthetic freedom, a national rebirth drawing inspiration from international currents in art. Almost

in parallel with *Jugend*, the famous satirical magazine *Simplizissimus* was founded, giving space to the artists of the Art Nouveau movement. This was followed in 1897 by *Deutsche Kunst und Dekoration* and *Dekorative Kunst*, and in 1899 by *Die Insel*; support for modernity among intellectuals and in the media flourished with astonishing vigour.

Although Germany lagged behind the rest of Europe as far as painting was concerned, there were sudden developments in the graphic and applied arts, occurring almost simultaneously in all the major cities but in particular in Munich, Berlin, Weimar and Darmstadt. Most of the important figures associated with *Jugendstil* followed Morris and Van de Velde in abandoning painting to devote themselves to decorative art. Otto Eckmann was, with Peter Behrens, August Endell, Hermann Obrist, Bruno Paul and Richard Riemerschmid, one of the founders of *Jugendstil* in Munich. He stopped painting in 1894 and began to study nature; some of his imaginative floral compositions were published in *Pan* and *Jugend*. He became interested in printer's type and made his name by developing the typeface known as the Eckmann type. The newly established periodicals promoted the move into graphic art, *Jugend*, for example, employing 75 illustrators during its first year of publication. In the first issue of *Deutsche Kunst und Dekoration*, its founder, Alexander Koch, appealed for the integration of all the arts and a return to craftsmanship. *Jugendstil* manifested itself in the designs that appeared not only in magazines but in programmes and posters, revolutionizing the country's graphic art to such effect that it soon acquired an international reputation.

In glass, jewellery and ceramics German craftsmen generally did not compare favourably with the French, although there were a few exceptions, among them the glassmaker Karl Kaepping (1848–1914) and the potters Max Laeuger (1864–1952) and Julius Scharvogel (1854–1938). They excelled in furniture-making, however: Riemerschmid, Endell and Obrist were all part of the tendency that strove for overall unity in interior decoration, one of the principal aims of Art Nouveau

internationally. All three made interesting sets of furniture, like Van de Velde eventually abandoning a floral style for simpler forms. Each of this group practised as architects, Riemerschmid building a house for himself in 1896, but only Endell designed buildings of any note: the most remarkable was the Elvira photographic studio (1896–7; destr.; see fig. 6) in Munich, which had a splendid asymmetrical motif across the façade and fantastical decorations in the stairwell. The group in Munich broke up around 1899–1900, and its members dispersed to Berlin, Weimar and Darmstadt.

A feature of *Jugendstil*, one that enabled the movement to extend from the graphic arts into other media, was the patronage it received from the ruling families and from leading industrialists. In Weimar, Graf Harry Kessler was behind Van de Velde's decision to move there in 1902 from Berlin. In Darmstadt, Ernest Ludwig, Grand Duke of Hesse-Darmstadt, commissioned Baillie Scott and Ashbee to decorate several rooms in the Neue Palais in the Art Nouveau style, which caused something of a stir. Encouraged by Koch, he promoted the idea of establishing an artists' colony and offered both land at Mathildenhöhe and money for this purpose. Several artists joined the Künstler-Kolonie, including the Austrian Joseph Maria Olbrich (*see* §6 below), who designed the Hochzeitsturm (1905) at Mathildenhöhe, Hans Christiansen (1866–1945), known for his designs for textiles and carpets, the architect and designer Patriz Huber (1878–1902) and Behrens.

At the Esposizione Internazionale d'Arte Decorativa Moderna of 1900 in Turin the German contribution stood out thanks to Behrens's Hamburg Vestibule. In 1903 Muthesius returned from London and brought current British ideas to the

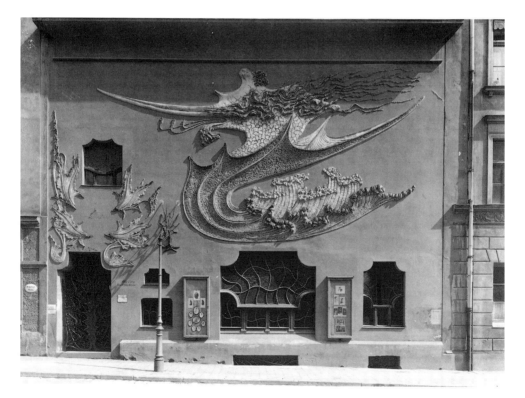

6. August Endell: Façade of the Elvira Photographic Studio, Munich, 1896–7 (destr.)

attention of German designers by means of such publications as *Das Englische Haus* (1904–5). In 1907 Behrens became artistic adviser of AEG in Berlin: the electricity company's founder, Emil Rathenau, supported avant-garde artists. Behrens, by this time, was moving towards a more rationalist, abstract and geometrical style.

6. Austria

Art Nouveau made its appearance in Austria later and more abruptly than elsewhere in Europe in the form of the *Sezessionstil*. It was dominated by two figures: Gustav Klimt, in his decorative paintings (see col. pl. III), and Otto Wagner, in his architecture. On 25 May 1897 Klimt and 18 other artists left the Künstlerhaus in Vienna to found the Vereinigung Bildender Künstler Österreichs, the Viennese Secession; Klimt was its first President. From the first this new association, which gave its name to the *Sezessionstil*, took note of artistic currents abroad and was receptive to new ideas in every branch of art. An exhibition hall was constructed under the direction of Joseph Maria Olbrich and was ready for the second Secession exhibition in 1898. Over the entrance was the inscription 'To each age its art, to art its freedom'. One of the first statements published by the group of artists set out principles very close to those of Viollet-le-Duc and Morris: 'We do not recognize any difference between great and minor art, between the art of the rich and that of the poor. Art belongs to all.'

The magazine *Ver Sacrum* was founded by the Secession in January 1898, with one of the artists responsible for designing the cover for each issue. They also produced the illustrations inside, which are of exceptionally high quality. Although publication of *Ver Sacrum* ceased in 1903, its impact on the spread of Art Nouveau in Austria was considerable; here as in Germany, the style began as a revolution in the graphic arts and in surface decoration. The same principles of spatial organization in a page from *Ver Sacrum* are present in the design of the Majolikahaus (1898) in Vienna by Otto Wagner, for example.

Wagner joined the Secession in 1898. He developed a very personal approach in his architecture, combining traditional elements with revolutionary practices and use of materials in order to meet contemporary requirements. He had believed since 1890 that the 'style of the future' would be the *Nuzstil*, or utility style, and in 1896 had brought out the magazine *Moderne Architektur*, in which he wrote that 'nothing that is not practical can ever be beautiful'. In his apartment houses in Vienna at 38–40 Linke Wienziele (1898–9) he demonstrated what a modern house should look like. He expressed himself best, as did Guimard, in a project that was primarily functional—the Vienna Stadtbahn, a major public commission that occupied him and a large team for several years. Here he achieved what he would like to have seen everywhere; as he wrote in the magazine *Der Architect*, 'not a station, not a shop, not a viaduct, not a bridge should be built without having been designed in the studio in an artistic and modern fashion'. Wagner made his mark on the centre of Vienna with this project, in particular with the Karlplatz station (1894), but his most important buildings were the church of St Leonard in the Am Steinhof Lunatic Asylum (1904–7) and the Postsparkasse building (1904–6, 1910–12) in Vienna, for which he also designed the furniture. Olbrich, a founder-member of the Secession, was Wagner's assistant from 1893 to 1898, the year he completed the Secession building, and was involved in illustrating *Ver Sacrum*. He left Vienna in 1899 for Darmstadt, where he executed several buildings for the artists' colony (*see* §5 above). In spite of his connections with the Viennese Secession, he remained in Germany and took part in the foundation of the Deutscher Werkbund in Düsseldorf.

In 1892 Josef Hoffmann entered the Academie der Bildenden Künste in Vienna, where Wagner was his teacher. In 1898 he was employed on the Stadtbahn project and joined the Secession. He taught architecture and interior decoration at the Kunstgewerbeschule, and in 1900 he designed the Secession display at the Exposition Universelle of 1900 in Paris. He discovered the work of Mackintosh (*see* §2 above) on a visit to Scotland, and Mackintosh was to be an important influence on the Wiener Werkstätte, founded by Hoffmann and Kolo Moser in 1903. Moser was a prolific

designer of furniture, textiles, posters, stamps and jewellery, among other items. He was one of the most productive of the collaborators on *Ver Sacrum* and designed the windows and altar of Wagner's church at Steinhof. The character of his work was stimulated by trips to Germany, Belgium, France and Britain. He was the organizer of more than 20 exhibitions and contributed to changes in interior decoration through his involvement with the Werkstätte.

The principal aim of the Wiener Werkstätte was to re-introduce art into objects of everyday use, revitalize the workers' love of their craft and give them a role in the design and distribution of the objects they made, all of which was close to the theories of Morris. In addition to manufacturing utilitarian objects, clothing, postcards and furniture, the Werkstätte executed such buildings as the sanatorium at Purkersdorf (1903–5; remodelled) and the Palais Stoclet in Brussels between 1905 and 1911 from designs by Hoffmann. The latter, conceived as an aesthetic whole, was the most perfect expression of the group's true inclinations, partly due to the fact that the financier Baron Adolphe Stoclet, who commissioned the building, gave the designer *carte blanche*.

The last purely ornamental and curvilinear elements in Austrian Art Nouveau disappeared with Adolf Loos, who spent three years in the USA before settling in Vienna in 1896. He returned strongly influenced by American architecture, culture and lifestyle in general. His career was a succession of confrontations, one of the first being an article published in 1898 in *Ver Sacrum* entitled 'Die Potemkinsche-stadt', which comprised a violent polemic against historicism. He was the architect of various houses and apartments in Vienna, for some of which he designed the furniture as well. One of his most important projects at the beginning of the 20th century was the Goldman & Salatsch Building (Looshaus, 1910), Vienna; by 1910 the bare outlines of his Steiner Haus in Vienna foreshadowed the architecture of the 1930s.

7. Other

Art Nouveau left its mark on the whole of the Western world and on some European colonies,

but its effects were less coherent and much less deeply felt outside the five countries referred to above. The presence of nationalist elements, particularly in Eastern Europe, gave rise to hybrid developments. Only a few isolated and atypical artists proved exceptions to this rule, but their work did not lie wholly within the historical and stylistic framework of Art Nouveau.

In Italy, where the version of Art Nouveau was known as *Arte nuova*, *Stile floreale* or *Stile Liberty* (after Liberty & Co., the shop in London), Giuseppe Sommaruga, designer of the Palazzo Castiglioni (1900–03), Milan, was the most important representative in architecture; other designers and architects who should be mentioned include Carlo Bugatti, Gino Coppede (1866–1927), noted for his use of extravagant detail, and Raimondo D'aronco, who worked in Turkey for a while and was more influenced by Orientalism. Architecture in the Netherlands and Scandinavia was little touched by Art Nouveau, although in interior decoration and furniture there was a tendency within Dutch *Nieuwe Kunst* that related to curvilinear Art Nouveau elsewhere in Europe, exemplified in the work of Gerrit Willem Dijsselhof. H. P. Berlage left some interesting work belonging to the alternative, more austere tendency. In Russia the workshops in the artistic centre of Talashkino deserve mention; and the countries of the Austro-Hungarian empire are studded with buildings by students of Wagner.

In Spain there emerged the isolated phenomenon of Catalan *Modernisme*, closely associated with the city of Barcelona. The last years of the 19th century were dominated there by the figure of Antoni Gaudí. His contribution to Art Nouveau was highly personal and original. The Palau Güell (1885–9), the Casa Batlló (1904–6) and the cathedral of the Sagrada Familia (taken over by Gaudí in 1883 and incomplete at his death) exemplify his fantastical style incorporating encrusted organic forms, which came from nowhere and were copied by nobody.

In the USA, Louis Comfort Tiffany was the leading designer and interior decorator in the Art Nouveau style, often known there as the Tiffany style (see fig. 2). Many of his designs for electric

lamps, made of bronze, his own 'Favrile' glass or mosaics of opalescent glass are based on natural forms. He was an influential designer of furniture, textiles, wallpaper, silver and jewellery as well as glass. In architecture the contribution of Louis Sullivan extended far beyond the swirling ornament of the entrance to his Carson, Pirie, Scott & Co. department store (1903–4) in Chicago, but the decorative elements in his work that relate to Art Nouveau are an isolated phenomenon.

8. Conclusion

Art Nouveau was born of the desire by a section of society to reject historicism and to abolish the distinction between the major and minor arts. It was to lead on the one hand to Art Deco and on the other to Modernism in architecture. The end of Art Nouveau came with World War I, but there had been some strong opposition to it much earlier. In 1901 Guimard had been criticized for the 'extravagance' of his designs for the Métro, for example; in 1903 Art Nouveau was described by Crane in the *Magazine of Art* as 'this strange decorative disease'; and the editors of *Art et décoration* were of the opinion that the Glasgow style, as represented at the Esposizione Internazionale of 1902 in Turin, 'does not appear to be in harmony with our artistic aspirations or our everyday needs'. Gaudí, like Mackintosh, thought little of Art Nouveau, although both had played a part in its development. In the 1920s and 1930s in France it was referred to dismissively as the *Style branche de persil* (stick of parsley style) or the *Style guimauve* (marshmallow style). It was not until the 1960s, through a series of exhibitions, that the reputation of Art Nouveau was re-established and that it was seen as more than a transitory phase linking 19th-century historicism and 20th-century Functionalism.

Bibliography

F. Schmalenbach: *Jugendstil: Ein Beitrag zu Theorie und Geschichte der Flächenkunst* (Würzburg, 1935)

J. Grady: 'A Bibliography of Art Nouveau', *J. Soc. Archit. Hist.*, xiv/2 (1955), pp. 18–27

S. Tschudi Madsen: *Sources of Art Nouveau* (Oslo and New York, 1956, rev. New York, 1976)

H. Seling: *Jugendstil: Der Weg ins 20. Jahrhundert* (Heidelberg, 1959)

Les Sources du XXe siècle (exh. cat., intro. J. Cassou; Paris, Mus. N. A. Mod., 1960)

J. Cassou, E. Languy and N. Pevsner: *Les Sources du XXe siècle* (Paris, 1961; Eng. trans., London, 1962)

C. E. Schorske: *Fin-de-siècle Vienna: Politics and Culture* (New York, 1961/R London, 1980)

R. Schmutzler: *Art Nouveau: Jugendstil* (Stuttgart, 1962)

Henry Van de Velde, 1863–1957 (exh. cat. by R.-L. Delevoy, Brussels, Pal. B.-A., 1963)

R.-H. Guerrand: *Art Nouveau en Europe* (Paris, 1965)

M. Rheims: *L'Art 1900 ou le style Jules Verne* (Paris, 1965)

R. Barilli: *Il Liberty* (Milan, 1966); Eng. trans. as *Art Nouveau* (Feltham, 1969)

N. Pevsner: *The Sources of Modern Architecture and Design* (London, 1968)

F. Borsi and P. Portoghesi: *Victor Horta* (Rome, 1969)

G. C. Argan: *L'arte moderna, 1770–1970* (Florence, 1970)

F. Borsi and H. Weiser: *Bruxelles: Capitale de l'Art Nouveau* (Brussels, 1971)

Pionniers du XXe siècle: Guimard, Horta, Van de Velde (exh. cat. by Y. Brunhammer, M. Culot and R.-L. Delevoy, Paris, Mus. A. Déc., 1971)

R. Bossaglia: *Le Mobilier Art Nouveau* (Paris, 1972)

F. Borsi: *Bruxelles 1900* (Brussels, 1974, rev. 1979)

S. Tschudi-Madson: *Sources of Art Nouveau* (New York, 1975)

L. V. Masini: *Art Nouveau: Un'avventura artistica* (Florence, 1976)

R. Kempton: *Art Nouveau: An Annotated Bibliography* (Los Angeles, 1977)

R. Billcliffe: *Charles Rennie Mackintosh: The Complete Furniture, Furniture Drawings and Interior Designs* (Guildford, 1979, rev. London, 3/1986)

F. Russell, ed.: *Art Nouveau Architecture* (London, 1979)

F. Loyer: *Le Siècle de l'industrie* (Geneva, 1983)

J.-P. Bouillon: *Journal de l'Art Nouveau* (Geneva, 1985)

Vienne, 1880–1938: Naissance d'un siècle (exh. cat., Paris, Pompidou, 1986)

K. J. Sembach: *L'Art Nouveau* (Cologne, 1991)

Guimard (exh. cat., ed. P. Thiebaut; Lyon, Mus. A. Déc.; Paris, Mus. d'Orsay; 1992)

MICHÈLE LAVALLÉE

Arts and Crafts Movement

Informal movement in architecture and the decorative arts that championed the unity of the arts,

the experience of the individual craftsman and the qualities of materials and construction in the work itself.

1. Introduction

The Arts and Crafts Movement developed in the second half of the 19th century and lasted well into the 20th, drawing its support from progressive artists, architects and designers, philanthropists, amateurs and middle-class women seeking work in the home. They set up small workshops apart from the world of industry, revived old techniques and revered the humble household objects of pre-industrial times. The movement was strongest in the industrializing countries of northern Europe and in the USA, and it can best be understood as an unfocused reaction against industrialization. Although quixotic in its anti-industrialism, it was not unique; indeed it was only one among several late 19th-century reform movements, such as the Garden City movement, vegetarianism and folksong revivals, that set the Romantic values of nature and folk culture against the artificiality of modern life.

The movement was not held together by a statement of ideas or by collective goals and had no manifesto; its members simply shared, more or less, certain attitudes. The scalding critique of industrial work by John Ruskin in *The Stones of Venice* (1851–3) taught them to see factory work as soulless and degrading; the pleasure in working in the traditional crafts was the secret of the object's beauty. They condemned the decorative arts of their own day as revivalist in style, machine-made and heavy with meaningless ornament, and looked instead for fresh, unpretentious design, honest construction and appropriate ornament. They wanted to break down the hierarchy of the arts, challenging the supremacy of painting and sculpture and rejoicing in the freedom to work in wood, metal, enamel and glass. The philanthropists among them saw the crafts as therapy for the poor, educationalists saw them as a way of learning about materials. It was in some ways a serious movement, in others merely playful and self-indulgent, and its professed ideals did not always accord with its practices.

2. British Isles

The earliest, and perhaps the fullest, development of the movement was in the British Isles, where its history falls into four phases. Its beginnings, in the 1850s, 1860s and 1870s, can be seen in the encouragement of church craftsmanship by GOTHIC REVIVAL architects, in the growth of a public taste for progressive decorative arts during the AESTHETIC MOVEMENT, in such art potteries as that of the Martin brothers and above all in the work of William Morris, who was an inspiration to the whole movement, less for his pattern designs than for his exploration of old or abandoned craft techniques and his lecturing on the decorative arts (see col. pl. IV). In 1883 Morris became an active Socialist. He was, arguably, taking Ruskin's critique of industrial society to its proper conclusion, but only a few Arts and Crafts people followed him.

In the 1880s the pace quickened; the movement acquired its name—the phrase 'Arts and Crafts' was coined by T. J. Cobden-Sanderson (1840–1922) in 1887. In addition, some of its principal organizations were founded: the ART WORKERS' GUILD (1884), a club that served as the social focus of the movement in London; the Arts and Crafts Exhibition Society (1888), which brought members' work before the public in its annual and later roughly triennial exhibitions; and the Home Arts and Industries Association (1884), which encouraged craft classes for the urban poor and the revival of such rural industries as lacemaking. Alongside the named designers there were many anonymous workers, including amateurs and middle-class women excluded from the world of work by the code of gentility.

In its third phase, during the 1890s and 1900s, the movement grew in extent, but it did not change its character greatly. Important workshops were started, such as that of Ernest Gimson, Ernest Barnsley and Sidney Barnsley (1865–1926). The movement influenced teaching in art schools, particularly at the Central School of Arts and Crafts in London under W. R. Lethaby, and it flourished outside London, for example in Haslemere, Surrey, and in Birmingham. In Scotland there was an extraordinary flowering of Arts and Crafts

talent at the Glasgow School of Art, marked by the separate character of the GLASGOW STYLE, while the Arts and Crafts in Ireland, though dependent on the movement in England for guidance and expertise, was a vehicle for Irish nationalism.

The work produced while the movement was at its height did not all look alike. Unlike Art Nouveau, the Arts and Crafts cannot be identified with a single style. There were debts of style in Arts and Crafts work to India, Japan, the Middle East, Scandinavia, Celtic Ireland, Byzantium, medieval Europe, Renaissance Italy and most of all to 16th- and 17th-century England. Many styles were used, but there were also common qualities, and there is a consistent, if not very precise, meaning in the phrase 'Arts and Crafts' when it is applied to objects.

Arts and Crafts people usually liked their designs to show how they worked and what the objects were made of: they thought of this as honesty. In Arts and Crafts houses the loose massing of the parts, irregular fenestration and ad hoc arrangement of gables, bays and other features are meant to suggest a house designed from the inside out, a relaxed assembly of different and comfortable spaces. In furniture and metalwork the jointing is often made obvious, in contrast to the long craft tradition of concealing it. In stained glass designers preferred a coarse and gritty glass that draws attention away from the pictorial and translucent qualities to the material of the window itself. Similarly ornament in metalwork is often confined in such a way as to direct the eye to the plain surfaces of silver, copper and brass.

The Arts and Crafts Movement looked both to the past and to the future, and the objects reflect this. The 'old work' that Arts and Crafts people sketched in the countryside and studied in museums provided them with models and meanings for their designs: the tradition and aura of the small English manor house stands behind many Arts and Crafts houses. They revived and adapted archaic decorative techniques, such as lustre painting and so-called Limoges enamelling. Yet they also looked forward. The mature furniture designs of M. H. Baillie Scott, C. R. Ashbee

and C. F. A. Voysey were usually deliberately fresh in style and anxious to underline their modernity. Taking old work as a point of departure, these designers used such novel forms as simple squared-off timbers and, in the case of Voysey, delicately tapered verticals. In the Arts and Crafts, tradition and modernity were not necessarily at odds. While most Arts and Crafts books, printed on handmade paper with dense typography, seem archaic, almost medievalizing, the Renaissance-inspired typography of the books printed at the Doves Press, though no less traditional, was so clear and fresh that it exercised a wide influence on English typography in the early 20th century.

There was much talk of the need for simplicity in design in Arts and Crafts circles and a streak of puritanism in Arts and Crafts taste. But not all Arts and Crafts designs were simple and austere. Most Arts and Crafts interiors were light and reserved, decorated with panelling and perhaps some plasterwork, but Baillie Scott and the architects Joseph Crouch (1859–1936) and Edmund Butler designed interiors hung with tapestries, gleaming with beaten metalwork and glowing with stained glass. The early metalwork of the Arts and Crafts was generally simple in character: W. A. S. Benson, in particular, produced tableware and lamps in brass and copper assembled from simple machine-made parts, while the silver tableware designed by Ashbee in the 1890s was sparingly decorated with coloured stones or enamel plaques. In the late 1890s and early 1900s, however, Henry Wilson, John Paul Cooper (d 1933), Alexander Fisher (1864–1936) and others began designing ceremonial silver encrusted with exotic materials and heavy with ornament. In pottery, conversely, the early work by William De Morgan and the Martin brothers was decorative, pots and tiles covered with naturalistic and figurative ornament; but then in the early 1900s W. Howson Taylor (1876–1935) and Bernard Moore (1850–1935) produced pots decorated with random, abstract glaze patterns in austere emulation of Oriental pottery.

Arts and Crafts objects are often rich in associations, carrying suggestions in their structure

and decoration of things beyond themselves. Most ornament consisted of natural forms conventionalized, but in the work of Morris and many others it is a nature somehow so fresh and real that it carries the mind out to the country. Gimson and Sidney Barnsley incorporated details from hay rakes and farm wagons in their sophisticated furniture with something of the same effect. Narrative ornament was also used, the stories being drawn from myth and legend, particularly the *Morte d'Arthur*. It is not surprising that the imagery of the movement should refer to the twin Romantic dream-worlds of the countryside and the past, for the Arts and Crafts was, in many ways, a late expression of Romanticism.

The Arts and Crafts was also an avant-garde movement and, as such, a movement of reaction against prevailing middle-class taste. Arts and Crafts designers looked at what was in the shops, condemned it as 'commercial' and went away and designed the opposite. Late 19th-century jewellery, for instance, was dominated by the diamonds mined in great quantities in South Africa, usually set in small gold mounts and surrounded by other pale stones. Arts and Crafts designers despised diamonds as a vulgar display of wealth. Their designs had large silver mounts set with enamel or cheap and colourful stones, the difference proclaiming them as art. The sturdy and often uncomfortable-looking furniture of the Arts and Crafts can also be seen as a gesture of protest against the spindly upholstered furniture of late Victorian drawing-rooms.

These qualities can be found, overlapping one another, in most Arts and Crafts objects. The decanter designed by Ashbee, for example, is simple in its construction, the silver wires being soldered into place without disguise or even refinement (see fig. 6). Ornament is concentrated around the finial, and otherwise the metal is left plain, the hammermarks on its surface witness to the fact that it was handmade. It belongs to the type of late Victorian handled decanter sold in the shops as a claret jug, all but the cheapest of which were decorated by faceting or cutting of the glass; Ashbee's design makes a point of being plainer. The design is both old and new, for it was based

on some glass bottles, probably of the late 17th century, that Ashbee found on the site of a house he was building in London. Yet with its linear elegance and hint of Art Nouveau, it is unmistakably *c.* 1900. Ashbee was able to add a further dimension to the design, for he thought the bottles he had found were Elizabethan, bringing with them connotations of bluff English hospitality—a clumsy and romantic view of history that was a characteristic feature of the Arts and Crafts.

The fourth and last phase of the movement in the British Isles ran from *c.* 1910 into the 1920s and 1930s. These were years of transition, for the Arts and Crafts movement was going out of fashion around 1910. Little radically new work was seen at Arts and Crafts Exhibitions, and in 1912 the Exhibition lost a good deal of money. The Arts and Crafts was edged out of the public mind by new developments, Post-Impressionism in art, the admiration for French classicism in architecture and in design by those associated with the Design and Industries Association, who wanted to apply the standards of the craft movement to the productive power of industry. The essence of the Arts and Crafts, however, was not to be fashionable, and after World War I it carried on in an altered mood. Some major figures, such as Eric Gill, went on working, and a second generation continued the decorative traditions. There were also important new figures, particularly among weavers, such as Ethel Mairet (1872–1952), and studio potters, such as Bernard Leach and Michael Cardew. They were more exclusively concerned with materials and technique, and there was no longer any hint of the anti-industrialism of Ruskin. Their work was essentially revived hand-craftsmanship, done for the sake of creative satisfaction.

3. Europe

The picture of Arts and Crafts activity in Europe is less clear than it is in the British Isles or the USA. The earliest continental Arts and Crafts activity was around 1890 in Belgium, where such artists and architects as Gustave Serrurier-Bovy and Henry Van de Velde were inspired by the freshness

of English Arts and Crafts work and the example of artists taking up the crafts: this seemed to be a less precious, more democratic art than easel painting. In 1894 the group of avant-garde artists known as Les XX reformed themselves as La Libre Esthétique with a new commitment to the decorative arts, and their first exhibition included work by Morris, Walter Crane, T. J. Cobden-Sanderson and Ashbee. Stylistically their work was influential in France, but it is not clear how large a part specifically Arts and Crafts ideas and practices played in the decorative arts in France, or indeed Spain or Italy. The main developments were in northern and central Europe.

The Arts and Crafts Movement in Germany was coloured by the strong spirit of nationalism following unification in 1871. The Arts and Crafts cult of the primitive and the vernacular was attractive to Germans, whose sense of national identity was rooted in a vigorous German culture of the past; local crafts, for example, were fostered by the Bund für Heimatschutz, founded in 1903 to preserve the traditional life and fabric of Germany. A progressive Arts and Crafts Movement could also contribute to Germany's struggle for industrial supremacy. Arts and Crafts workshops were set up in many parts of Germany; the two most important were the Vereinigte Werkstätten für Kunst im Handwerk, founded in Munich in 1897 by a group of artist–designers of whom Richard Riemerschmid and Bruno Paul were the most prolific, and the Dresdener Werkstätten für Handwerkskunst, started at Hellerau in 1898 by Karl Schmidt (1873–1954); both produced furniture, lighting, textiles and ceramics. Although modelled on English workshops, they had none of the scorn for trade that inspired and confined English Arts and Crafts, and they quickly developed into large commercial undertakings. In 1905 they both began producing standardized machine-made furniture with the idealistic purpose of reaching a larger public. Their business realism and experiments in standardization gave support to the reforming programme of Hermann Muthesius, who believed that if German industry could perfect pure, standardized Germanic designs, supremacy in world trade would follow, though in fact the Werkstätten themselves remained attached to the values of craft rather than industry, with machine production firmly under the control of the artist–designers.

The principal centre of Arts and Crafts in Austria was Vienna, a city whose cultural life, though long and distinguished, had become parochial in the late 19th century. Its younger artists looked eagerly to France, Belgium and the Netherlands and to English Arts and Crafts; they wanted to enlarge the scope of painters to include the decorative arts, and they made Viennese Arts and Crafts to some extent a painters' movement. In 1900, at the eighth exhibition of the Vienna Secession, the work of Charles Rennie Mackintosh and Ashbee was greeted with enthusiasm. In 1903 two leading Secessionists, Josef Hoffmann and Koloman Moser, set up craft workshops known as the Wiener Werkstätte. They were organized along the lines of the English and German Arts and Crafts, and their manifesto spoke of the dignity of everyday objects, pleasure in work and the value of fine workmanship. Their work, which consists of furniture, metalwork, jewellery and bookbinding, is in a distinctive manner, a stylish rectilinear version of Art Nouveau that contrasts with the deliberate naivety of English Arts and Crafts and with German experiments in cheap furniture; the Wiener Werkstätte catered to the luxury trade (see col. pl. V). There were also Arts and Crafts workshops in Prague, notably Artěl, founded in 1907, in whose work the influences of folk art and Cubism were mixed.

Folk art influenced Arts and Crafts design in other parts of central Europe and also in Scandinavia, partly because the movement in these countries was inspired by nationalism: where political independence was at stake, folk art became an emblem of national identity. This was the case in Hungary, dominated by Austria and the Habsburg emperors during the last quarter of the 19th century, and in Finland, which was an unwilling part of the Russian Empire. The nationalist impulse fostered both the practice of folk crafts in their traditional form and the incorporation of folk-art motifs in original

designs. At Hvittrask, for example, in the idyllic colony of artists' houses near Helsinki, designed by Gesellius, Lindgren & Saarinen, peasant motifs decorate the interiors.

4. USA

In the USA there was the same mixture of social concern and dilettantism and the rejection of historical styles in favour of a traditional simplicity. Many of the same groups of people, too, were involved: social reformers, teachers and women's organizations, as well as architects and designers. Ruskin and Morris were the prophets of craftsmanship for Americans as for Britons, though Thoreau, Ralph Waldo Emerson and Walt Whitman provided a sympathetic intellectual climate. Morris was also influential in book design and Voysey and Baillie Scott in architecture and furniture, and French artist–potters influenced their American counterparts. The Americans, however, were bolder than the British in making and selling large quantities. 'The World of Commerce', wrote Elbert Hubbard, 'is just as honorable as the World of Art and a trifle more necessary' (see 1987 exh. cat., p. 315). Compared with Europe, the American Arts and Crafts movement was much less influenced by Art Nouveau. There was a sturdy, four-square quality about much American Arts and Crafts that appealed, as Theodore Roosevelt appealed, to an American ideal of strong, simple manliness.

The movement in craftsmanship started in the 1870s and 1880s, in response to a demand from such architects as H. H. Richardson. The art pottery movement began in Cincinnati, OH, in the 1880s; in quantity and quality the work of, among others, the Rookwood Pottery, the Van Briggle Pottery and the Grueby Faience Co. claims pride of place alongside furniture in American Arts and Crafts. The East Coast was always more aware of British and European developments, and the first Arts and Crafts exhibition in America was held at Copley Hall in Boston in 1897. This was followed by the foundation of the Society of Arts and Crafts, Boston, which sponsored local exhibitions, salerooms and workshops with great success. The Society's Handicraft Shop produced fine silver-

ware, but it was in printing that Boston excelled: the city's tradition of fine printing fostered outstanding Arts and Crafts presses, notably the Merrymount Press run by Daniel Berkeley Updike. In Philadelphia the architects of the T-Square Club looked particularly to England and exhibited Arts and Crafts work in the 1890s, and in 1901 the architect William L. Price founded an idealistic and short-lived craft colony at Rose Valley, outside Philadelphia, devoted to furniture, pottery and amateur theatricals.

Upper New York State was another important centre of the Arts and Crafts, partly perhaps because of the attractions of the Catskill Mountains. At the Byrdcliffe Colony in Woodstock, for example, pottery, textiles, metalwork and furniture were produced in a romantic backwoods setting; the Arts and Crafts shared some of the pioneering mystique of the log cabin for Americans. The most important figure in the area, and arguably in American Arts and Crafts as a whole, was Gustav Stickley, a furniture manufacturer in Eastwood, Syracuse, NY, who began producing simple so-called Mission furniture about 1900. The design of Stickley's furniture was not as important as the scale of his operations and his power of communication. From 1901 he published *The Craftsman* magazine, which became the mouthpiece of the movement in America, and in 1904 he started the Craftsman Home-Builders Club, which issued plans for self-build bungalows; by 1915 it was estimated that ten million dollars' worth of Craftsman homes had been built. The furniture, house-plans and magazine together presented the Arts and Crafts as a way of life instead of a specialist movement. Simple, middlebrow, traditional, slightly masculine and slightly rural, it appealed to a large American market. The most flamboyant figure in New York State was Elbert Hubbard. At his Roycroft works in East Aurora, he produced metalwork, printed books and furniture very like Stickley's and published *The Philistine* magazine. Hubbard, too, created a powerful image for his craft enterprise, a slightly ersatz blend of bonhomie and culture, which made him seem almost a parody of Stickley or, more subtly, of himself.

In Chicago the focus of the movement was at first at Hull House, the settlement house run by the social reformer Jane Addams (1860–1935), where the Chicago Society of Arts and Crafts was founded in 1897. Here immigrants were encouraged to practise their native crafts, such as spinning and weaving, less to perfect the craft than to soften the shock of the new city. There were more Arts and Crafts societies and workshops in Chicago than in any other American city, a witness to its aspiring culture. Perhaps the most distinguished of the workshops were those of the metalworkers and silversmiths, such as the Kalo Shop, which was started in 1900 and continued production until 1970. It was in Chicago, also, that the Arts and Crafts made one of its most important contributions to American architecture, for Arts and Crafts influence can be seen in the work of the Prairie school architects Walter Burley Griffin, George Washington Maher (1864–1926), Purcell & Elmslie and most notably Frank Lloyd Wright. In their sense of materials, their creation of a regional style echoing the horizontals of the prairies and their interest in designing furniture, metalwork and decorative details in their interiors, they continued the Arts and Crafts tradition.

Arts and Crafts workshops and activities in California began only in the early 1900s and were often stimulated by architects and designers from the East settling in California. Although Californian Arts and Crafts showed a debt to the beauty of the landscape and to the building traditions of the Spanish Mission, it had no single stylistic character. It ranged from the richly carved and painted furniture made by Arthur F. Mathews and his wife Lucia in San Francisco, through the simple, almost monumental, copper table-lamps of Dirk Van Erp (1859–1933), to the outstanding work of the architects Charles Sumner Greene and Henry Mather Greene. Between c. 1905 and 1911 Greene & Greene designed a number of large, expensive, wooden bungalows in and around Pasadena and equipped them with fine handmade furniture. These houses lie along the contours of their sites, inside and outside merging in the kindness of the climate. Their timber construction, panelling and fitted and movable furniture all show the gentle and authoritative ways in which the Greene brothers could make one piece of wood meet another, with Japanese and Chinese jointing techniques transformed into a decorative Californian *tour de force*. Although most products of the American Arts and Crafts are strong and simple in character, the Greenes' finest houses, the masterpieces of American Arts and Crafts architecture, are delicate and exquisite.

5. Conclusion

In 1936 Nikolaus Pevsner published *Pioneers of the Modern Movement*, in which he traced the origins of Modernism among various European movements of the late 19th century and the early 20th, including the Arts and Crafts. Pevsner's book has influenced the study of the Arts and Crafts Movement more than any other, and much writing on the subject has concentrated on the movement's progressive elements, the tentative acceptance of machine production by some Arts and Crafts writers and the simpler designs that seem to reject ornament and historical styles in favour of functionalism. The Modernist view has subsequently come to seem incomplete; it ignored the fact that Arts and Crafts designs, without being any less modern in spirit, are almost always informed by a sense of the past, that ornament is central to much Arts and Crafts designing and that, whatever some theorists may have said, the practical bias of the movement, with its little workshops set apart from the world of industry, was anti-industrial. If the Arts and Crafts Movement is seen in its own time and context, and not just as part of the story of Modernism, it appears as a deeply Romantic movement with its roots in the 19th century, a movement that belongs as much to the history of anti-Modernism as of Modernism.

The most distinctive feature of the Arts and Crafts Movement was its intellectual ambition. Ruskin's attack on factory work uncovered a fundamental malaise in modern industrial society, which Karl Marx identified as alienation. When Morris tried to make art more accessible, giving as much attention to a table and a chair as to an

easel painting, he challenged the whole esoteric tendency of modern art. Arts and Crafts objects carry special, idealistic meanings; they tell the viewer about the value of art versus money, about how they are made, about nature or modernity or the satisfactions of hand work. Such idealism is incompatible with the world of manufacture, and if the Arts and Crafts Movement flourished it did so at the price of compromise and contradiction. In Britain the element of contradiction, or at least of inconsistency, was strongest. Arts and Crafts workers drew strength from Ruskin's words, which applied to all kinds of mechanized and factory work, but their own efforts were confined to the small (and relatively unmechanized) world of the decorative arts. In the USA compromise was sometimes the price that was paid. Stickley operated on so large a scale, Hubbard with such crude salesmanship, that it is sometimes hard to distinguish them from the enemy, from the industrial and commercial world that Ruskin denounced. The Arts and Crafts Movement was not always as radical as it aspired to be; and it is perhaps best understood, at the end of the day, as simply another movement of taste in the history of the decorative arts.

Bibliography

J. Ruskin: *The Seven Lamps of Architecture* (London, 1849)
—: *The Stones of Venice*, 3 vols (London, 1851–3)
Catalogues, Arts and Crafts Exhibition Society (London, 1888–)
W. R. Lethaby: *Architecture, Mysticism and Myth* (London, 1891)
W. Crane: *The Claims of Decorative Art* (London, 1892)
Arts and Crafts Essays, Arts and Crafts Exhibition Society (London, 1893)
The Studio (1893–)
H. Van de Velde: *Déblaiement d'art* (Brussels, 1894/R 1979)
—: *Aperçus en vue d'une synthèse d'art* (Brussels, 1895)
The Philistine (1895–)
Art and Life and the Building and Decoration of Cities, Arts and Crafts Exhibition Society (London, 1897)
Dek. Kst (1897–)
Dt. Kst & Dek. (1897–)
Kst & Ksthandwk (1898–)
H. Muthesius: *Die englische Baukunst der Gegenwart* (Leipzig, 1900)
D. Cockerell: *Bookbinding and the Care of Books* (London, 1901)
H. Van de Velde: *Die Renaissance in modernen Kunstgewerbe* (Berlin, 1901)
The Craftsman (1901–16)
H. Wilson: *Silverwork and Jewellery* (London, 1903)
The Artsman (1903–7)
H. Muthesius: *Das englische Haus* (Berlin, 1904)
T. J. Cobden-Sanderson: *The Arts and Crafts Movement* (London, 1905)
C. Whall: *Stained Glass Work* (London, 1905)
M. H. Baillie Scott: *Houses and Gardens* (London, 1906)
W. Crane: *An Artist's Reminiscences* (London, 1907)
C. R. Ashbee: *Craftsmanship in Competitive Industry* (London and Chipping Campden, 1908)
E. Johnston: *Writing and Illuminating and Lettering* (London, 1909)
T. Raffles Davison, ed.: *The Arts Connected with Building* (London, 1909)
H. Waentig: *Wirtschaft und Kunst* (Jena, 1909)
W. Morris: *Collected Works*, ed. M. Morris, 24 vols (London, 1910–15)
W. Crane: *From William Morris to Whistler* (London, 1911)
W. R. Lethaby: *Form in Civilization: Collected Papers on Art and Labour* (London, 1922)
W. R. Lethaby, A. H. Powell and F. L. Griggs: *Ernest Gimson: His Life and Work* (London, 1924)
W. Rothenstein: *Men and Memories*, 2 vols (London, 1931)
W. R. Lethaby: *Philip Webb and his Work* (London, 1935)
H. J. L. J. Massé: *The Art-Workers' Guild*, 1884–1934 (Oxford, 1935)
N. Pevsner: *Pioneers of the Modern Movement: From William Morris to Walter Gropius* (London, 1936); rev. as *Pioneers of Modern Design: From William Morris to Walter Gropius* (Harmondsworth, 1974)
G. Naylor: *The Arts and Crafts Movement: A Study of its Sources, Ideals and Influence on Design Theory* (London, 1971)
The Arts and Crafts Movement in America, 1876–1916 (exh. cat., ed. R. J. Clark; Princeton U., NJ, A. Mus., 1972)
California Design, 1910 (exh. cat., ed. T. J. Andersen, E. M. Moore and R. W. Winter; Pasadena, A. Mus., 1974)
P. Vergo: *Art in Vienna, 1898–1918* (London, 1975)
S. O. Thompson: *American Book Design and William Morris* (New York, 1977)
A. Callen: *Angel in the Studio: Women in the Arts and Crafts Movement, 1870–1914* (London, 1979)
P. Davey: *Arts and Crafts Architecture: The Search for Earthly Paradise* (London, 1980)

J. Sheehy: *The Rediscovery of Ireland's Past: The Celtic
 Revival,* 1830–1930 (London, 1980)
The Arts and Crafts Movement in New York State,
 1890s–1920s (exh. cat., ed. C. L. Ludwig; Oswego, SUNY,
 Tyler A.G., 1983)
M. Richardson: *Architects of the Arts and Crafts
 Movement,* RIBA Drawings Series (London, 1983)
A. Crawford, ed: *By Hammer and Hand: The Arts and
 Crafts Movement in Birmingham* (Birmingham, 1984)
The Glasgow Style, 1890–1920 (exh. cat., Glasgow, A.G. &
 Mus., 1984)
P. Stansky: *Redesigning the World: William Morris, the
 1880s, and the Arts and Crafts* (Princeton, 1985)
E. Boris: *Art and Labor: Ruskin, Morris and the Craftsman
 Ideal in America* (Philadelphia, 1986)
F. Borsi and E. Godoli: *Vienna, 1900: Architecture and
 Design* (London, 1986)
J. Heskett: *Design in Germany, 1870–1918* (London, 1986)
'*The Art that is Life': The Arts and Crafts Movement in
 America, 1875–1920* (exh. cat., ed. W. Kaplan; Boston,
 Mus. F.A., 1987)
E. Cumming and W. Kaplin: *The Arts and Crafts
 Movement* (London, 1991)
K. Trapp, ed.: *The Arts and Crafts Movement in California:
 Living the Good Life* (Oakland and New York, 1993)
Michael Conforti, ed.: *Art and Life on the Upper
 Mississippi, 1890–1915* (Newark, 1994)
Bert Denker, ed.: *The Substance of Style: Perspectives on
 the American Arts and Crafts Movement* (Winterthur,
 1996)
Marilee Boyd Meyer, ed.: *Inspiring Reform: Boston's Arts
 and Crafts Movement* (Wellesley, 1997)

ALAN CRAWFORD

Art Workers' Guild

English group of artists, designers, architects and craftsmen formed in 1884. In 1883 five young assistants from R. Norman Shaw's office formed the St George's Art Society. The Society discussed its worries about the growing practical and ideological separation of art and architecture, and the indifference to their ideas for reform in architecture, shown by the official institutions such as the Royal Academy and the Royal Institute of British Architects. They soon realized that there was a need for a larger, broader society. In 1884 these same architects—Gerald Horsley (1862–1917), W. R. Lethaby, Mervyn Macartney (1853–1932), Ernest Newton and E. S. Prior—joined with another

group, The Fifteen, led by Lewis F. Day and Walter Crane, to form the Art Workers' Guild. The Guild actively promoted the theory of the interdependence of the arts, and its members were encouraged through lectures and discussion to understand each other's profession. Designers, artists, architects and craftsmen were brought together as equals.

The Guild was never a studio or workshop, although its members often collaborated and continue to do so. In 1888 the Arts and Crafts Exhibition Society was formed by some members after the Guild had rejected the idea that they should sponsor exhibitions of designers' work. For over a hundred years, however, the Guild has provided an influential forum for discussion of techniques, styles and current issues in design, architecture and industry. Early Guild members included distinguished names from every artistic field, most of whom played a crucial role in the Arts and Crafts Movement: C. R. Ashbee, Edward Burne-Jones, Ernest Gimson, Edwin Lutyens, William Morris, J. D. Sedding and C. F. A. Voysey. The Guild had a number of temporary homes until a house in Queen Square, Bloomsbury, was purchased in 1913, where meetings are still held fortnightly.

Bibliography
H. J. L. J. Massé: *The Art Workers' Guild, 1884–1934*
 (Oxford, 1935)
I. Anscombe and C. Gere: *Arts and Crafts in Britain and
 America* (London, 1978), pp. 112–13
*Beauty's Awakening: The Centenary Exhibition of the Art
 Workers' Guild, 1884–1984* (exh. cat., Brighton, A.G. &
 Mus., 1984)

MARTA GALICKI

Assyrian Revival

Style of the second half of the 19th century and the early 20th, inspired by Assyrian artefacts of the 9th to 7th centuries BC. These were first brought to public attention through the excavations by Paul-Emile Botta (1802–70) at Khorsabad and Austen Henry Layard at Nimrud in the 1840s. By 1847 both the Louvre in Paris and the British

Museum in London had begun to display these objects, the size and popularity of which were such that the Louvre created a separate Musée des Antiquités Orientales, while the British Museum opened its separate Nineveh Gallery in 1853. The same popularity, fuelled by Layard's best-selling *Nineveh and its Remains* (London, 1849) and Botta's elaborate *Monument de Ninive* (Paris, 1849–50), led to further explorations elsewhere in Mesopotamia.

1. Areas of influence

Assyrian revivalism first appeared in England rather than France, which was then in political turmoil. The earliest forms of emulation can be found in the decorative arts, such as the 'Assyrian style' jewellery that was produced in England from as early as 1851 and flourished until at least the late 1870s. The 1853 revival of *The Death of Sardanapalus* by Lord Byron (1788–1824), produced by Charles Kean (1811–68) at the Princess's Theatre (destr.), London, took as its main claim to authenticity (and selling-point) the use of actual casts of Assyrian reliefs as part of the stage design, as well as costumes 'verified by the bas reliefs'. This representational strategy, in which exact attention to detail was intended to authenticate the whole, remained the prevalent scheme for visual representations of Assyria. Assyrianism in architecture was established most notably through James Fergusson's 'Nineveh Court' in the Sydenham Crystal Palace of 1854.

Commentators from Eugène Delacroix to Walter Crane praised Assyrian art especially for its representation of animals. By the late 19th century Assyrian art had clearly gained some currency in French animal sculpture: in 1889 Rodin said of Antoine-Louis Barye, who had specialized in images of wild beasts such as lions and tigers, 'One thinks of him and the Assyrians together, though it is not known that he knew anything about them.' There is no overtly Assyrian object in Barye's work, and it was only with his student Charles Valton (1851–1918), who continued and extended the tradition, that Assyrian imagery was introduced. Among Valton's many images of lions and tigers was a large-scale bronze based on the 'Wounded Lioness' relief from Nineveh, in the British Museum, London. This was placed prominently outside the City of Paris pavilion at the 1889 Exposition Universelle, and the sculpture jury, which included Rodin, awarded the artist a first-class medal.

Assyrian art may have influenced the stylistic canon of American Art Deco sculpture, particularly that of Paul Manship, yet there is little that can be described as directly Assyrian apart from a few animal groups. Indeed, within Manship's work Assyria was absorbed among several other stylistic influences, including Etruscan, Indian and Archaic Greek. A magazine cover design (*Der Bildermann*, iv, 20 May 1916) by August Gaul, perhaps the most prominent German animal sculptor of the early 20th century, demonstrates much stronger Assyrian influence in a detailed rendering of the dying lioness relief as the emblem of the German victory at Kut el-Amara in the Mesopotamian campaign of World War I. In English art there is evidence on a more monumental scale. The tomb of Oscar Wilde (1909–12; Paris, Père-Lachaise Cemetery) by Jacob Epstein was modelled after an Assyrian winged bull, as letters and early drawings confirm, and carved on a comparable scale from a 20-ton block of stone.

2. Works and motifs

The most numerous and varied Assyrian Revival works are two dimensional and approach the theme in much the same fashion as did the theatrical presentations. A watercolour by Ford Madox Brown, *The Dream of Sardanapalus* (1871; Wilmington, DE, A. Mus.), is a typical evocation of Assyria and one of a series of paintings and drawings, many now untraced. A number of costume details, such as the jewellery, helmet and dress of the Assyrian monarch, are taken directly from the reliefs. Sardanapalus wears a short, jutting 'Assyrian' beard, a style then current (its most famous wearer being Gustave Courbet) and derived from an idiosyncratic viewing of the reliefs.

Assyrian artefacts or elements can be found in many different contexts in late 19th- and early 20th-century art. Visual references were sometimes strictly limited to certain geographical and

historical contexts, a mode prevalent among late 19th-century French salon painters; for example, the *Assyrian Marriage Market* (1896; Attigny, Hôtel de Ville) by Louis Marie Doyen (*b* 1864) localizes in ancient Assyria the common Orientalist theme of the market of women; nearly every aspect of the setting and costume is derived from Assyrian artefacts. The master of this genre was Georges Rochegrosse, whose range of subjects encompassed prehistory, pagan antiquity, the Middle Ages and the Orient. His most famous Assyrian (and not at all Babylonian) work was the enormous, violent, recondite and popular *Fall of Babylon* (1891; ex-New York, Murray's Restaurant). The sources for his panoply of interior details included reliefs (such as the Gilgamesh Relief in the Louvre), a zoomorphic weight discovered by Botta (Paris, Louvre) and the Black Obelisk of Shalmaneser III (*reg* 858–824 BC) excavated by Layard (London, BM).

Assyria also had a certain symbolic standing as the exemplar of a historical civilization, and as such its remains (almost invariably the great winged bulls and lions; e.g. London, BM) appeared in images of universal history, such as those of Paul Chenavard. Biblical imagery, however, accounts for the widest promulgation of Assyrian artefacts and the greatest range of artistic production. Specific details of Assyrian artefacts were used in biblical illustrations from as early as Gustave Doré's *La Sainte Bible selon la Vulgate* (1866). In G. F. Watts's *Jonah* (1894–5; London, Tate) and Gustav Klimt's *Judith I* (1901; Vienna, Belvedere), settings derived from specific Assyrian reliefs are represented on a shallow field behind the biblical figure and serve to establish the character.

A certain Assyrian presence also developed in architecture. Fergusson's work and the Assyrian house in Charles Garnier's series of buildings depicting the history of housing at the 1889 Paris Exposition Universelle introduced the concepts of Assyrian buildings to a wide public, including other architects. The massive building styles of the early 20th century, with their low-relief decorations, may be compared with widespread theories of ancient Mesopotamian architecture (Künzl).

Perhaps the most direct connections are manifest in American Art Deco architecture. The elaborate brass entrance of the Fred French Building (1927, by T. Robinson), New York City, actually features Assyrian bulls. In Los Angeles the façade of the vast Samson Tire Company building (1929, by Morgan, Walls & Clements) is entirely based on Assyrian forms, featuring a crenellated roof-line with embossed mouldings, towers and corner pavilions, some with Assyrian relief figures (and pseudo-cuneiform inscriptions), and an elaborate entrance flanked by bulls and capped by a tower resembling a ziggurat.

The Assyrian Revival style cannot be compared in size and influence to the Gothic or Greek revivals. It was a limited but persistent thread in late 19th- and early 20th-century art, being absorbed into the period's depiction of antiquity. The contemporary view of Assyrian artefacts as embodying one of a series of newly found traditions and the use of the great winged bulls as a universal emblem are summed up in John Ruskin's remark in *The Stones of Venice* (1851–3), 'I hardly know whether most to admire the winged bulls of Nineveh, or the winged dragons of Verona' (E. T. Cook and A. Wedderburn, eds: *The Works of John Ruskin*, London, 1903–12, xi, p. 188).

Bibliography

C. Kean: *Sardanapalus, King of Assyria: A Tragedy . . . by Lord Byron, Adapted for Representation by Charles Kean* (New York, n.d.) [intro.]

A. H. Layard: *The Nineveh Court in the Crystal Palace* (London, 1854)

W. Crane: *William Morris to Whistler* (London, 1911), pp. 185–204

E. Porada: 'The Assyrians in the Last Hundred Years', *Bull. Met.*, n. s., iv/1 (1945), pp. 38–48

R. Alexander: 'Courbet and Assyrian Sculpture', *A. Bull.*, xlvii (1965), pp. 447–52

H. Künzl: *Der Einfluss des alten Orients auf die europäische Kunst besonders im 19. und 20. Jh.* (Cologne, 1973)

I. Krengel-Strudthoff: 'Archäologie auf der Bühne: Das wiedererstandene Ninive: Charles Keans Ausstattung zu "Sardanapalus" von Lord Byron', *Kleine Schr. Ges. Theatgesch.*, xxxi (1981), pp. 3–24

H. Tate and others, eds: *The Art of the Jeweller: A Catalogue of the Hull Grundy Gift to the British Museum: Jewellery, Engraved Gems and Goldsmiths' Works*, 2 vols (London, 1984), nos 950–51

The Jeweler's Eye (exh. cat., ed. D. C. Pack; Yonkers, NY, Hudson River Mus., 1986), nos 111–14

F. N. Bohrer: 'Assyria as Art: A Perspective on the Early Reception of Ancient Near East Artifacts', *Culture and History*, 4 (1989), pp. 7–33

——: 'The Times and Spaces of History: Representation, Assyria, and the British Museum', *Museum Culture: Histories, Discourses, Spectacles*, ed. D. Sherman and I. Rogoff (Minneapolis, 1994), pp. 197–222

——: 'Les Antiquités assyriennes au XIXe siècle: Emulation et inspiration', *De Khorsabad à Paris: La Découverte des Assyriens* (exh. cat., Paris, Louvre, 1994), pp. 248–59

FREDERICK N. BOHRER

Auricular style [Dut. *Kwabornament*; Ger. *Knorpelwerk, Ohrmuschelstil*]

Term used to describe a type of ornament popular in the 17th century, characterized by smooth, curved and rippling forms resembling the human ear. This highly plastic style evolved during the first two decades of the 17th century in Utrecht, and in its fully developed form is found only in metalwork. The style in this medium is characterized by the use of amorphous, lobate scrolls and embossed, relief ornament that emphasize the malleable nature of the metal. At its most extreme, it exaggerates this quality by suggesting that objects were modelled in a semi-molten state. The goldsmiths Adam van Vianen and Paulus van Vianen of Utrecht are credited with the invention of the style, although its origins seem to lie in the graphic designs of such 16th-century Italian Mannerist artists as Giulio Romano (e.g. drawing for a fish-shaped ewer; Oxford, Christ Church) and Enea Vico. The latter's designs for plate were published in the mid-16th century and may have been known in Utrecht.

The earliest intimations of the style appear on a tazza (1607; Amsterdam, Rijksmus.) by Paulus van Vianen, probably made under the patronage of Emperor Rudolf II in Prague. In this work the basic form of a late 16th-century vessel has been retained, but the strapwork of conventional Mannerism has been replaced by a pattern of scrolls that are much more fluid in conception. The embossed scenes on the underside of the bowl are separated by a novel kind of ornament resembling bones. Similarly, a ewer and dish (1613; Amsterdam, Rijksmus.) are decorated with relief scenes of the story of *Diana and Acteon*, which are contained within cartouches formed of fleshy scrolls and residual masks. The most dramatic and fully plastic of all the early works in the style is undoubtedly the silver-gilt ewer (1614; Amsterdam, Rijksmus.) made by Adam van Vianen in Utrecht in memory of his brother for the goldsmiths' guild of Amsterdam. The ewer was celebrated in its own time as a work of brilliant originality and technique: the entire body, which is modelled as a crouching monkey on a rippling base supporting a fleshy shell-like form, was raised from a single sheet of silver.

The Auricular style continued to enjoy some popularity during the second quarter of the 17th century, when it was promoted by such goldsmiths and designers as Christiaen van Vianen, Johannes Lutma and Gerbrand van den Eeckhout. Lutma published two series of Auricular ornament, *Veelderhande nieuwe compartmente* (1653) and *Verscheide snakeryen* (1654); his most notable works in the style are a silver ewer (1647; Amsterdam, Rijksmus.) and the brass choir-screen in the Nieuwe Kerk, Amsterdam. It also became a popular style for carved picture-frames and ornament on furniture until the mid-17th century, and designs for Auricular ornament for woodwork appear in Friedrich Unteutsch's *Neues Zieratenbuch* (c. 1650). Thereafter, the style was integrated with the developing mainstream Baroque style.

Bibliography
W. K. Zülch: *Entstehung des Ohrmuschelstils* (Heidelberg, 1932)

TIMOTHY SCHRODER

Bamboccianti

Group of painters active in mid-17th-century Rome who worked in the manner of Pieter van Laer,

called il Bamboccio, from whom the name derives. They specialized in *bambocciate*, small works representing trivial or base subjects related to contemporary Italian life (see fig. 7). Except for the native Roman Michelangelo Cerquozzi, the principal Bambocccianti were all of Dutch, Flemish, German or French origin. They included Jan Miel, Johannes Lingelbach, Andries and Jan Both, Karel Dujardin, Thomas Wijck, Michiel Sweerts and, for a time, Sébastien Bourdon, in addition to van Laer himself. Despised by such champions of the Grand Manner as Salvator Rosa, Andrea Sacchi and Francesco Albani, the Bambocccianti were nevertheless patronized by the Roman aristocracy and bourgeoisie. They had a profound influence on low-life painting in the Netherlands and in 18th-century Italy.

Bibliography

S. Rosa: *Satira terza* (Amsterdam, *c.* 1664), ii, pp. 232ff; ed. G. A. Cesareo as *Poesie e lettere edite e inedite di Salvator Rosa* (Naples, 1892), i, pp. 223–55

C. C. Malvasia: *Felsina pittrice* (1678); ed. M. Brascaglia (1971), ii, pp. 506, 509 [letters by Sacchi and Albani]

I Bambocccianti: Pittori della vita popolare nel seicento (exh. cat. by G. Briganti, Rome, Pal. Massimo alle Colonne, 1950)

Michael Sweerts e i Bambocccianti (exh. cat. by R. Kultzen, Rome, Pal. Venezia, 1958)

L. Salerno: *Landscape Painters of the Seventeenth Century in Rome*, trans. C. Whitfield and C. Enggas (Rome, 1977–80), i, pp. 296–306

G. Briganti, L. Trezzani and L. Laureati: *I Bambocccianti: Pittori della vita quotidiana a Roma nel seicento* (Rome, 1983, Eng. trans., 1983)

7. Pieter van Laer (attrib.): *The Ciambelle Seller* (Rome, Galleria Nazionale d'Arte Moderna)

D. A. Levine: *The Art of the Bamboccianti* (diss., Princeton U., 1984)

—: 'The Roman Limekilns of the Bamboccianti', *A. Bull.*, lxx (1988), pp. 569–89

Italianisanten en bamboccianten: Het italianiserend landschap en genre door Nederlandse kunstenaars uit de zeventiende eeuw (exh. cat. by G. Jansen and G. Luijten, Rotterdam, Boymans–van Beuningen, 1988)

I Bamboccianti: Niederländische Malerrebellen im Rom des Barock (exh. cat., ed. D. A. Levine and E. Mai; Cologne, Wallraf-Richartz-Mus.; Utrecht, Cent. Mus.; 1991–2)

DAVID A. LEVINE

Bande Noire

Group of painters active in France in the 1890s and noted for the generally dark tonality of their work. The term (or less frequently 'the Nubians', in contrast to the Nabis painters) became associated with the group following the exhibition of Charles Cottet's *The Burial* (Lille, Mus. B.-A.) at the Salon of 1894 in Paris. Cottet was inspired by the harsh life of the Breton fishermen to produce such works as *Sorrow*, the *Triptych of the Farewells* (both Paris, Mus. d'Orsay; see fig. 8) and *Low Mass* (Paris, Petit Pal.). Reaching beyond the confines of Impressionism, he sought to rediscover Gustave Courbet's realist style, constructing the dark, often black, masses of his compositions with vigorous brushstrokes. The artists closest to Cottet were Lucien Simon and André Dauchez (1870–1943); the three met in 1895 and formed a loose affiliation. Simon was more of a colourist than Cottet, yet such works as *The Procession* (1901; Paris, Mus. d'Orsay) show the latter's influence. Dauchez, whose *Seaweed Burners* (1898; Moulins, Mus. Moulins) is a striking example of his interest in Breton subjects, was primarily a draughtsman and engraver.

Many other extremely diverse painters have been associated with the group, such as Georges-Olivier Desvallières, Edmond Aman-Jean, René Ménard, René Xavier Prinet (1861–1946), Jacques-Emile Blanche, Walter Gay, Gaston La Touche, Henri Duhem (*b* 1860) and the painter and sculptor Constantin Meunier. All of these artists, some of whom were closely connected, exhibited in Paris at the Galerie Georges Petit, with the Société Internationale de Peinture et de Sculpture and the Société Nouvelle, and were involved in the exhibitions organized by Léonce Bénédite, curator of the Musée du Luxembourg. Contemporary critics thus grouped under the vague term 'Bande Noire' a generation of artists who tried, with considerable popular success, to change both the style and subject-matter of academic painting by introducing *intimiste* and realist themes. The strength of Cottet's personality and the innovation of his painting marked him out as the leader of this group. Their works are most fully represented in the Musée des Beaux-Arts, Quimper.

8. Charles Cottet: *Triptych of the Farewells*, 1898 (Paris, Musée d'Orsay)

Bibliography

J. Dupont: 'La Bande Noire', *Amour A.*, xiv (1933),
 pp. 60–65
Charles Cottet (exh. cat. by A. Cariou, Quimper, Mus. B.-A.,
 1984)

ANDRÉ CARIOU

Barbizon school

Group of French painters associated with the Forest of Fontainebleau near Paris and especially with the village of Barbizon. The main members of this informal group were Narcisse Diaz, Jules Dupré, Théodore Rousseau, Constant Troyon and Jean-François Millet; they formed a recognizable school from the early 1830s to the 1870s. Mainly concerned with landscape, they had little interest in the classical conventions of Claude and Poussin and were more influenced by Dutch landscape painting of the 17th century and by the works of John Constable, whose *Hay Wain* (1821; London, N.G.) had been exhibited at the Salon of 1824. Because their work did not change radically over the decades, the Barbizon painters have often been treated mainly as a transitional generation, helping to bridge the gap between classical landscape painting of the late 18th century and the early 19th and Impressionism. However, as the first generation of French landscape painters to focus truly on nature, they have an importance and originality of their own. Romantic in their desire to break with conventions, their anti-urban sentiment and, above all, their lyrical appreciation of nature, they were Realist in their avoidance of the heroic, their preference for humble themes and sometimes in their technique.

While not nearly as coherent a group as the name implies, the central nucleus of artists does exhibit a common aim and often a similar technique. The typical Barbizon work is a humble, unvarnished, down-to-earth landscape or peasant genre scene, lacking any sense of the heroic or the ideal and without conventional mythological figures. The technique is uniformly broad, painterly and rough; the colour tends to favour earth tones and greens. At times the style of the five main artists is so close that it would be easy to confuse the authorship of their paintings. A good example of this is the landscape by Rousseau, *Departure from the Forest at Fontainebleau at Sunset* (1850-51; Paris, Louvre; see fig. 9). There was also little change in style and subject-matter over the years; Dupré's lyrical *Plateau of Bellecroix, Fontainebleau Forest*, painted in 1830, with its simple, unpretentious subject and free technique, does not differ greatly from Rousseau's *Sunset near Arbonne* of 30 years later (*c.* 1863; New York, Met.).

Of all the artists associated with the Barbizon group, the best known, Jean-François Millet, is perhaps the least typical. Something of a late-comer to the Barbizon area, he arrived only in 1849; however, he soon became a permanent resident and a mainstay of the group. He rarely painted pure landscape and concentrated on scenes of peasant life and labour (see col. pl. VI). Charles Jacque, who arrived with Millet, is basically known as an animal painter; when animals do not dominate the landscape, his paintings are typically Barbizon in mood and technique (e.g. *Shepherdess with her Sheep*, undated). Other painters generally associated with the school exhibit less coherence. Charles-François Daubigny's style is consistent with that of other members of the nucleus of the group, but he preferred to paint the Dauphiné landscape and the Oise River rather than the Forest of Fontainebleau (e.g. *Pond of Gylieu near Optevoz, Isère*, 1853; Cincinnati, OH, A. Mus.). Camille Corot, often described as related to the Barbizon school, is something of an anomaly. Much of his most characteristic work is essentially in the classical tradition, and his constant interest in architecture and geometrical compositions distinguishes his pictures from those of the more typical Barbizon school painters. However, on those occasions when he painted in the Barbizon region, his works are reminiscent of Rousseau and Diaz (e.g. *Forest of Fontainebleau*, 1846; Boston, MA, Mus. F.A.).

Of course none of the Barbizon group worked exclusively in the one region. When it was financially possible, they made extensive forays to other picturesque areas; for example Rousseau and

9. Théodore Rousseau: *Departure from the Forest at Fontainebleau at Sunset*, 1850–51 (Paris, Musée du Louvre)

Dupré went to the Landes for five months in 1844. Generally these trips were to various regions of France, rather than to the traditional Italian destinations, as there was also a nationalistic aspect to Barbizon anti-classicism. Nevertheless, the Barbizon area remained the spot to which they returned summer after summer, partly because it was easily accessible from Paris, where with the exception of Millet most of the group retained winter studios. Group coherence must also have been fostered by the presence of Père Ganne's inn in Barbizon, which became the headquarters for many of these artists. Numerous strong friendships grew up among them, especially between Rousseau, Dupré and Millet; at the very least, they were all acquaintances.

Initially the Barbizon painters achieved a certain amount of success at the Salon. Their difficulties began in 1836 with Rousseau's first rejection. While almost all the Barbizon painters then experienced some Salon refusals, none was so systematically excluded as Rousseau, who achieved the dubious distinction of being known as 'le grand refusé'. His exclusion, which was perhaps an acknowledgement of his position as leader of the group, lasted until 1849. Following the Revolution of 1848, the situation improved greatly; the highpoint of the Barbizon painters' success was the first half of the 1850s, when they were regularly exhibited, won medals and gradually all received the Légion d'honneur.

The main significance of the Barbizon school lies in the move away from the classical conventions of formally composed landscape to more natural scenes, without staffage, and painted with a much freer technique. Their legacy is the *plein-air* landscapes of the Impressionists, which are difficult, if not impossible, to imagine without the presence and precedent of the Barbizon artists.

Bibliography

J. Mollett: *The Painters of Barbizon* (London, 1890)

P. Dorbec: *L'Art du paysage en France* (Paris, 1925)

M.-T. de Forges: *Barbizon* (Paris, 1962)

Barbizon Revisited (exh. cat., ed. R. Herbert; San Francisco, CA Pal. Legion of Honor, 1962)

J. Bouret: *The Barbizon School and 19th-century French Landscape Painting* (Greenwich, CT, 1973)

P. Miquel: *Le Paysage français au XIXe siècle: 1824–1874, l'école de la nature*, 3 vols (Maurs-la-Jolie, 1975)

The Spirit of Barbizon: France and America (exh. cat., ed. D. Rosenfeld and R. Workman; Providence, RI Sch. Des., Mus. A., 1986)

S. Adams: *The Barbizon School and the Origins of Impressionism* (London, 1994)

DORATHEA K. BEARD

Baroque

The principal European style in the visual arts in the 17th century and the first half of the 18th; generally considered to be characteristic of the period of Caravaggio, Rubens, Rembrandt, Giordano and Tiepolo in painting, Bernini in sculpture, and Borromini, Fischer von Erlach and Wren in architecture. Usage of the term is often extended to the whole period 1600–1750 without qualifying restrictions, or improperly to mean a florid and elaborate style in art, architecture, music or literature, of any date from late antiquity to the early 20th century.

1. Origins of the term and the concept

The history of the term has an important bearing on our present understanding of it. If classical art is seen—as its name implies—as representing aesthetic norms, then 'baroque', like 'gothic' and later 'romantic', has to be seen as in some way departing from or antithetical to those norms (Gombrich, pp. 81–98). Attempts have been made to trace the origins of the word in the terminology of formal logic, but, plausible though this derivation may be, it is not historically useful. The word began to be used specifically of the fine arts early in the Neo-classical period that developed in succession—and in reaction—to the Baroque. Winckelmann, in the riposte he added to his own *Gedanken über die Nachahmung der griechischen Werke in der Malerei und Bildhauerkunst* (1755, para. 113) derived the term *Barrockgeschmack* ('baroque taste') from a word used of 'pearls and teeth of unequal size'; he cited the 17th-century etymologist Gilles Ménage, and the Portuguese word *barroco* has this meaning. Thus in writing on art 'baroque' was initially a term of reaction and of opprobrium, as 'gothic' had been a century earlier. In 1758 the encyclopedist Diderot described 'baroque' specifically in relation to architecture as a 'nuance of bizarre' characterized by 'the ridiculous taken to excess' and exemplified in particular by the work of Borromini and Guarini. The same terms and examples recur in Francesco Milizia's *Dizionario delle belle arti* (1797), and thenceforth almost to the present day Borromini has been cited especially and consistently as the antithesis of the whole 18th-century Enlightenment. Modern scholarship has clarified the relation between rational means and mystical ends in Borromini's architecture, but it is surely significant that even some of his Roman contemporaries misconstrued and indeed attacked his work as bizarre and irrational.

Nevertheless, to see the Baroque merely as a reaction against Renaissance ideals or norms is simplistic, because both 17th-century and modern critics have identified in the Baroque clear signs of a return to Renaissance order and affirmation after the disorder and pessimism they perceived in the arts of Mannerism (Gombrich, pp. 99–106). The roots of this critical ambiguity in fact lie deep in Western art and thought, and they came to the surface a century after Winckelmann, when a generation capable of a longer historical perspective over the period began to distinguish stylistic interpretation from adverse criticism. In his artistic guide to Italy, *Der Cicerone* (1855), Jacob Burckhardt describes Baroque architecture as speaking 'the same tongue as the Renaissance, but in a dialect that has gone wild'. He was unprepared for the Italian Baroque: his brief reference to the geometry of Borromini's churches of S Carlino and the Sapienza calls them 'infamous', while of Bernini's *Ecstasy of St Teresa* (1645–52; Rome, S Maria della Vittoria, Cornaro Chapel;

see col. pl. VII) he wrote that 'one forgets mere questions of style at the shocking degradation of the supernatural'.

Burckhardt was not willing to dismiss so easily the architecture of Michelangelo, whose vestibule to the Laurentian Library in Florence he nevertheless called 'ever instructive', characterizing its blind windows as Baroque and the staircase as neck-breaking; in the 1867 edition of the *Cicerone* he summed up the whole as 'an incomprehensible joke of the great master'. Burckhardt's study of Rubens, written late in life and published posthumously in 1898, was based on long familiarity with Rubens's paintings; it is sympathetic and still worth reading; significantly, in the *Cicerone* he categorized Italian painting of the age of Rubens, from the Carracci and Caravaggio onwards, not as Baroque but as *modern*, 'partly eclectic, partly naturalistic'.

2. The modern concept

The acceptance of Baroque architecture as a legitimate field for study was signalled by Cornelius Gurlitt's *Geschichte des Barockstils in Italien* (1887) and his further volumes on France and Germany in the two following years, but a work of greater critical import was *Renaissance und Barock* (1888) by Burckhardt's pupil Heinrich Wölfflin. His Hegelian determinism, in which each style was seen as the product of the spirit of its age, led Wölfflin without hesitation to write of 'the Baroque' as something with motives, aims, actions and a will of its own. He sought through stylistic analysis to clear from it the stigma of decadence and to show that, far from being a debased dialect of the Renaissance, Italian Baroque architecture was radically different, a discrete and autonomous style in the same sense as Gothic or Renaissance, with an equal validity; but while over a century after Wölfflin it may still be possible to find acceptable his identification of Michelangelo as the 'father of the Baroque' (a paternity with which Borromini could have agreed), his choice of 'the year 1580 as a convenient starting point for the fully formed Baroque style' is now considered about 20 years too early.

Wölfflin identified two major factors in the recognition of Baroque art. First, he placed its origin not merely in Italy but specifically in the Rome of the late Renaissance, and indeed of the Counter-Reformation. In this, as also in his allocation of first place to architecture, he was followed by Alois Riegl (*Die Entstehung der Barockkunst in Rom*, 1908; based on lectures given in 1894–9). Second, the principal quality Wölfflin identified in Baroque architecture was that of the 'painterly' (*malerisch*), the term for which he is most famous among German language users. In 1897 August Schmarsow would put Wölfflin's term into the subtitle of his book *Barock und Rokoko: Über das Malerische in der Architektur*. Later, in *Kunstgeschichtliche Grundbegriffe* (Principles of art history), published in 1915, Wölfflin would oppose to this term that of 'draughtsmanly' or linear. Wölfflin's intention in this second book was to demonstrate, by the comparison of contrasting pairs of examples, what he called 'the double root of style' in different modes—not so much modes of representation as modes of vision or of (in his own preferred term) imagination, which preceded and informed representation. Subsequent generations of critics, concerned with the characterization of styles, found meaning and utility in the polarities that distinguish his five chapters: linear and painterly, plane and recession, closed and open form, multiplicity and unity, clearness and unclearness. Thus although with his first pair of examples, drawings of female nudes by Dürer and Rembrandt, he warned his reader that 'Rembrandt cannot forthwith be taken as equivalent to the 17th century', the 'Principles' came to be seen as a handy, if not always helpful, guide to the distinction between 'classical' and Baroque art.

Most accounts and definitions of Baroque art start from papal Rome, the city of Bernini, Borromini and Pietro da Cortona, and proceed to the painting of the exemplary Catholic artist Rubens. As long as the style was thought to begin with what we now call Mannerism, in the mid-16th century, it was plausibly linked with the Catholic Counter-Reformation (Werner Weisbach: *Der Barock als Kunst der Gegenreformation*,

Berlin, 1921), and the idea of a close and specific connection with the early Jesuits appealed in particular to those who disliked both Baroque art and the Society of Jesus. Walter Weibel's *Jesuitismus und Barockskulptur* (Strasbourg, 1909) supported a causal connection between the techniques of spiritual direction of St Ignatius Loyola and the art of Bernini, largely through the erroneous claim that the sculptor 'practised' the *Spiritual Exercises* of Loyola. Nevertheless, in publications contemporary with Weibel's, the Jesuit scholar Joseph Braun demolished the idea of a Jesuit style. The church of Il Gesù in Rome did not receive its Baroque decoration until late in the 17th century, although its compact Latin-cross plan became, for practical and symbolic reasons, a common pattern; but in general the Society's policy everywhere was to adapt as far as possible to local customs and styles, building 'Gothic' churches in the Rhineland to suggest continuity with pre-Reformation Christianity there. The unprecedentedly lavish decoration of the Jesuit church in Antwerp, supervised by Rubens and intended to contrast with the iconoclasm of Antwerp's Calvinist years, indeed drew a reprimand from headquarters in Rome.

The effect of the Council of Trent (1545–63) on religious art is most evident in the search for clarity both of form and of subject-matter in painting (Friedlaender, 1957). Caravaggio's humble apostles and Rubens's rapturous saints spoke unequivocally to peasant and prince alike, and a type of altarpiece was developed that stressed the sacrificial function of the altar and the chief point of contention (apart from the papacy) between Catholic and Protestant: the corporeal presence of Christ in the eucharistic host. In Rubens's great *Raising of the Cross* (1610–11; Antwerp Cathedral; see fig. 10) the divine body is lifted up as the consecrated wafer is elevated for the congregation to see, and Bernini's St Teresa manifests a union with her Lord analogous to (though more intense than) that of the communicant at the altar rail below. Parallels were also encouraged between the Passion of Christ and the sufferings of the martyrs, whether in ancient pagan Rome or in the contemporary non-Catholic and non-Christian

10. Peter Paul Rubens: *Raising of the Cross*, 1610–11 (Antwerp Cathedral)

worlds. Two qualifying remarks are, however, essential. First, the optimism of Baroque religious art belongs to the second (17th-century) phase of the Counter-Reformation, in which themes of love, joy and Heaven increasingly replaced justice, penitence and Hell, and in which the interior of Il Gesù changed from grey-white to coloured. Second, the desire for clarity after about 1590 is equally evident in secular art; one need only compare the Farnese Gallery of the Carracci (started 1597) with Francesco Salviati's frescoes (started 1549) of a generation earlier, in the Sala dei Fasti Farnesiane in the same building (Rome, Pal. Farnese). Truth to appearances and realism of gesture and presentation quickly put the obvious artifice of Mannerism out of fashion (Freedberg, 1983; 1986 exh. cat.).

3. Characteristics of the Baroque style

Baroque is the characteristic style of the 17th and early 18th centuries. It is a style of appearances

rather than essences, or of *Werden* (becoming) rather than *Wesen* (being). Rubens's *Raising of the Cross* is affective, dramatic, realistic almost to the point of illusionism, so that the viewer seems through a picture to be witnessing the actual event. The crucifix is displayed diagonally, both across the picture surface and in the represented depth; it is eternally about to reach the perpendicular, but can do so only in the viewer's imagination. All art reaches the intellect through the senses, for there is no other route; but Baroque art addresses the senses directly and reaches the intellect through the emotions rather than through reason.

In an unfinished paper on Bernini, Max Dvořák (1927–9, ii) emphasized the 'actuality' of Bernini's marble group of *Apollo and Daphne* (c. 1622; Rome, Gal. Borghese; see fig. 11). The versatility of touch and texture brings to the marble both the painterly, and indeed erotic, warmth and sensuousness of Titian's Ovidian mythologies and the cold chaste calm of antique models and in particular the *Apollo Belvedere* (Rome, Vatican, Mus. Pio-Clementino). There is no illusion: we are confronted by a piece of marble. Yet no trace remains of the original block shape sent down from the quarry; the actuality of the marble and that of the event, likewise the figures, their space and the critical instant of drama, are bound inseparably together. So too in the Cornaro Chapel, whose centrepiece is the *Ecstasy of St Teresa*, the beauty and the brilliance of Bernini's literal illustration of Teresa's account of her mystical experience raise it from the sensory to the spiritual level. It is no accident that Bernini's stated and achieved aim was the unification of the arts of painting, sculpture and architecture (Lavin, 1980), or that opera, the combination of vocal and instrumental music, dramatic speech, mime and visual effects, was developed in Italy early in the 17th century.

Baroque art expresses and affects with immediacy, by a variety of means, whether it be by Wölfflin's concept of unity, in which pictures and buildings alike are first apprehended in a single sweeping impression, or by the manipulation of the beholder into a particular viewpoint, or by devices that bridge the barrier between the world

11. Gianlorenzo Bernini: *Apollo and Daphne*, c. 1622 (Rome, Galeria Borghese)

of the image and that of the viewer. Critical scholarship has recently turned to the ideas underlying the work of painters such as van Dyck and Velázquez; nevertheless, their art in particular is indeed first and last one of sight, not of intellect, and its virtue lies more in the paint surface than in ideas. Their aim was to make beautiful pictures, as the Earl of Newcastle well understood when he wrote to van Dyck of his desire to be a hundred-eyed Argus, 'or all over but one eye, so it or they were ever fixed upon that which we must call yours'. However rational and deliberate the artist's procedure, it was the sensory effect that counted: Borromini's S Carlo alle Quattro Fontane in Rome is based on a geometry of circles and equilateral

triangles, but the first prior of the church noted that visitors, at once puzzled and fascinated by the plan, were drawn again and again to the building, an effect that he likened to the soul's aspiration to heaven.

One characteristic of the Baroque on which all agree is movement, whether it be the orthogonal and lateral movement in Maderno's archetypal façade of S Susanna in Rome (1597–1603; see fig. 12) whose consistent forward breaks of plane lead the eye to the centre, or the flickering chain of figures in Poussin's bacchanals, in which the movements of the dancers are complemented by the changing pattern of colours and shadows. There is also the movement of the spirit. Seventeenth-century writers were conversant with approaches to the emotions, and the materialist philosopher Thomas Hobbes formulated a mechanistic theory of what is now called the subcon-

12. Carlo Maderno: Façade of S Susanna, Rome, 1597–1603

scious. Sir Christopher Wren, while insisting on the geometrical basis of beauty, admitted also to the existence of another kind of beauty, that of association or evocation 'of things not in themselves beautiful', and he required the architect to visualize his designs in the perspective not of drawing but of the real world. Faced with Bernini's *David* (1623; Rome, Gal. Borghese), the spectator instinctively looks behind him for the object of the slinger's gaze. Rembrandt, seeking in his *Blinding of Samson* (1636; Frankfurt am Main, Städel. Kstinst. & Städt. Gal.) the greatest possible movement (his word, *beweechgelickheyt*, was ambiguous and meant both activity and emotion), seems to place the beholder inside the cave looking out past the horrific event to the blue sky, symbol of sight and freedom. In the Piazza of St Peter's and at Versailles the beholder's attention is captured; he is overwhelmed by the scale of his surroundings in relation to himself, and the messages respectively of an embracing mother-church and a monarch responsible only to God are inescapably borne in upon him. These two great ensembles became the model for rulers through the 18th century and beyond. In the 20th century the use of such imagery has been imperfectly understood by adherents of totalitarian ideology all over the world, who have imitated the vastness of Baroque prototypes in order to dehumanize the individual. For indeed, in the Piazza one may sit on the bases of the columns, and the focus of attention is human and of human size: the successor of Peter and (in the phraseology of papal documents ever since Gregory the Great) 'the servant of the servants of God'. Likewise at Versailles human scale informs not only the individual units of the vast design but also every detail of its decoration.

4. Two modes of imagination
In *Renaissance und Barock* Wölfflin had related 'linear' and 'painterly' to the distinction between things as they are and things as they seem to be, i.e. between essences and appearances. It is imperative to recognize—as Wölfflin himself was well aware—that this crucial distinction was not new: it has been made ever since Classical

antiquity, and its use as a key to the difference between Renaissance and Baroque art is a particular application of a much more general principle.

Ultimately these two modes of imagination have a physical basis in perceptual psychology and in the existence of different and complementary modes and regions of function in the human brain: on the one side analytical, symbolic, digital and linear, on the other side synthetic, concrete, spatial and holistic. Some of these differences were recognized, although their basis was not understood, by Renaissance writers. Alberti's theory of vision in *De pictura* (c. 1435) envisages separate kinds of rays to convey to the eye the outlines of things and their colours; this distinction can be related in particular to early Florentine painting, which is concerned with contours as a means of describing forms. Vasari's life of Titian, on the other hand, describes from a Florentine point of view the optical and non-linear basis of the great Venetian painter's later works, executed (as Vasari says) 'with coarse strokes and daubs, in such a way that from near by they cannot be made out, but from a distance they look perfect'. Modern experimental psychology has shown Alberti's concept to be closer to the truth than later theories of light and colour might suggest, for the visual cortex contains kinds of cells that respond to colours and others that respond to lines of various orientations. The basis of this diversity is biological, since, in a world perceived as patches of colour without contours, it would be impossible to distinguish obstacles and objects from their background; hence the popular association of certain Impressionist techniques with short-sightedness.

How far Florentine prejudice became the basis for critical and historiographical norms can be seen from both 16th- and 19th-century examples. Vasari quoted Michelangelo, on seeing Titian's *Danaë*, as saying of that artist that 'it was a shame that in Venice one did not start by learning to draw well . . . if he had the help of art and *disegno*, as well as that of nature, and most of all in drawing from life, he could not be surpassed'. *Disegno* means not only drawing but also design, implying order and structure, or 'a sense of form'. A little over three centuries later, Bernard Berenson suggested to the world that Florentine painting surpassed that of 14th-century Siena or 16th-century Venice because of its 'tactile values', the appeal to the sense of touch for which Riegl (using Greek rather than Latin) coined the term 'haptic' as opposed to 'optic'. In Vasari's Florence and in 17th-century Rome the prejudice was expressed as a preference for *disegno* rather than *colore*. A less biased view of the antithesis is to be found in the writing of Vasari's Venetian contemporary Lodovico Dolce; and in 17th-century

13. Guido Reni: *Aurora*, 1613–14 (Rome, Casino Rospigliosi-Pallavicini)

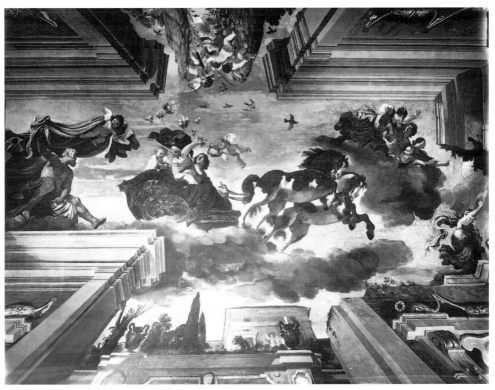

14. Guercino: *Aurora*, 1621 (Rome, Casino Ludovisi)

Holland Samuel van Hoogstraten was able to describe drawing, consciously in the context of Michelangelo's remark, as 'imitating things after life even as they appear' (*Inleyding tot de hooge schoole der schilderkonst*, Rotterdam, 1678).

By the beginning of the 17th century, however, such polarizing distinctions had become simplistic and misleading. With the range of models and exemplars offered in painting by (for instance) Raphael, Michelangelo, Correggio, Parmigianino, Titian and Tintoretto, or in architecture by Bramante, Michelangelo, Palladio and Vignola, no subsequent artist of any sensibility could rely exclusively on either *disegno* or *colore*–not at least in Rome, by then the centre of the European art world. The range may be illustrated by the ceiling paintings of two suburban garden pavilions made within a span of ten years. In Guido Reni's *Aurora* (1613–14; Rome, Casino Rospigliosi–Pallavicini; see fig. 13) the chariot of Dawn is driven across the sky in what is—though executed in fresco—virtually a framed easel picture transposed from wall to ceiling. In Guercino's fresco of the same subject (1621–3; Rome, Casino Ludovisi; see fig. 14) on the other hand, the chariot is seen diagonally from below, surrounded by *trompe l'oeil* architecture as if it really were flying above the viewer. Yet Reni is no mere imitator of Raphael: in colour, draughtsmanship and rhythm, and also in its overbearing scale in a relatively low room, the *Aurora* is quite different from Raphael's *Galatea* wall fresco of exactly a century earlier (Rome, Villa Farnesina); and on the other hand Guercino subsequently fell to the seduction of classicizing theory, and within a decade of his *Aurora* had totally changed his style.

Nevertheless, false antitheses are often presented either between the followers of Titian and those of Raphael (Annibale Carracci was both), or between the theatrical 'realism' of Caravaggio's paintings created directly on the canvas (and often from models recognizable between one painting and another) and the 'academicism' of the Carracci based on selection, idealization and the systematic use of preparatory drawing. This is not how their contemporaries saw them: the Roman collector Vincenzo Giustiniani, writing before 1620, placed both artists (with Guido Reni) in the highest class of painters, those 'who paint *di maniera* and also directly from life ... some have inclined more towards nature than *maniera* and some more towards *maniera* than nature, but without detaching themselves from either way of painting, rely on good *disegno* and true colouring, and give proper and true lighting' (Enggass and Brown, p. 19).

In 1665 Bernini gave praise for colour rather than drawing to the 'Lombards', meaning those outside the Tuscan–Roman tradition and including both the Venetians and the Emilian Correggio. Bernini was not alone in using *colore* to mean tone as well as chromatic hue; already by 1557 Dolce's *Aretino* implied a distinction between *colore* and *tinto*. Thus Federico Zuccaro's dismissal of Caravaggio's newly finished *Calling of St Matthew* (1599–1600; Rome, S Luigi dei Francesi) as 'nothing but the thought of Giorgione' is probably best understood as a reference to his chiaroscuro modelling.

Seventeenth-century artists were thus well aware, both in theory and in practice, of a diversity of modes; the cases of two 'classical' painters of the mid-century are illuminating: Nicolas Poussin and Andrea Sacchi. Poussin, whose work was highly esteemed by Bernini, the most Baroque of sculptors, is recorded as regarding colour as a distraction, like the beauty of sound in poetry; but in a famous letter discussing his theory of the 'modes' in painting he explained on the contrary that both colour and sound were essential to the narrative. Moreover, many of Poussin's drawings are colouristic, in the tonal sense, in the way that patches of shadow, and sometimes even pen outlines, overrun and obscure the contours of figures

and objects. Poussin has recently emerged as more impulsive in character and more intuitive in his art than Giovanni Pietro Bellori and the Académie Royale represented him, and indeed less of a philosopher than the urbane archetype of the Baroque painter, Rubens.

Sacchi, who has been justly characterized as a Baroque painter with the mental approach of a classical one (Harris, 1977), is most often remembered for the debate in which he engaged (c. 1636) with Pietro da Cortona on the number of figures required in a history painting. Sacchi defended the 'classical' theory that determined his own practice, that in using the fewest possible figures each could have the maximum effect in expression, gesture and movement; the analogue is with Classical tragedy. For Cortona, on the other hand, history painting was analogous to epic poetry, which is full of episodes and sub-plots: a large number of figures gave variety and richness both to forms—including light and shade—and to the telling of the story.

5. Later developments

In his comprehensive survey (1958) of the Italian Baroque, Wittkower adopted the name 'High Baroque classicism' for the work of Sacchi and his contemporaries the sculptors Alessandro Algardi and François Du Quesnoy, seeing its precursor in the earlier 'Baroque classicism' of the Roman followers of Annibale Carracci and its successor in the work of the third generation of 17th-century artists. In architecture Wittkower characterized 'Late Baroque classicism' by three features: 'its immense versatility' born of two and a half centuries' familiarity with antique and Renaissance vocabulary, grammar and metaphor; a 'deliberate scenic quality' in which buildings and spaces are often conceived as a succession of pictures or views; and in some cases the use of light broken colours applied artificially rather than derived from the structural materials. The paragon of this style, for Wittkower, is Carlo Fontana: industrious, methodical, ambitious, bookish and academic, and 'without the genius' of the earlier generation that included Borromini, Bernini and Cortona.

Nevertheless, as Wittkower admitted, Fontana's influence was enormous; through his studio passed architects as diverse as Filippo Juvarra, Matthäus Daniel Pöppelmann, Johann Lucas von Hildebrandt and James Gibbs. Illuminating analogies can be found, if not pressed too far, with Jules Hardouin Mansart in France and Christopher Wren in England, both highly accomplished architects, administrators and teachers. Architectural historians have found value in the concept of an 'International Baroque', analogous to the International Gothic of the early 15th century and marking in a similar way the last phase of a *lingua franca*, a style of long currency and wide familiarity (Downes, 1966; Blunt, 1973). In this way, in the early 18th century for example, Juvarra's Palazzo di Stupinigi, the Blenheim of Vanbrugh and Hawksmoor (see col. pl. VIII), Johann Dientzenhofer's Schloss Pommersfelden (1711–18) and the work of Germain Boffrand in France (see col. pl. XXXV) can be seen with equal validity as worthy successors to the work of the great Roman 17th-century masters. A phenomenon of this kind, transcending boundaries of territory, race, politics and religion, and extending to painting, sculpture and the decorative arts, could only come about when previously novel ways of seeing and representing had become familiar and teachable, when travel was widespread, and when images were widely available through reproductive engraving to those who stayed at home. The expulsion from France of Huguenot artists and craftsmen, culminating in the revocation of the Edict of Nantes (1685), especially benefited Britain, the Netherlands and the Rhineland, but in the 18th century economic rather than cultural necessity meant that Italian artists were spread as far as Portugal and Russia.

6. Historical context

Consideration of the political uses of architecture (a phrase already used by Wren) may conveniently introduce the question of underlying causes or explanations for the Baroque, other than those mainly formalist ones that have so far been discussed. From the earliest days of art history the identification of historical styles has been linked to the search for external causes of stylistic identity and stylistic change: Vasari attributed the origin of the Renaissance to the strength of Tuscan soil, which was his own and that of his patron, Cosimo I de'Medici, and the refinement of Tuscan air, and the compassion of Heaven. Subsequent explanations have been no less partisan, seductive or inadequate, and Hegel's *Zeitgeist* lives on not only in the popular cliché of the 'Spirit of the Age' but also in Marxist criticism and its parodies and derivatives. History cannot explain but only elucidate, and in practice a formalist historical model, in which the causes of change are seen in the desires of artists to outdo their forebears, is no more simplistic than social, economic or ideological ones. Two factors make this general discussion especially relevant to the Baroque. First, the unprecedented force of Baroque art in conveying ideas through the senses and the emotions. Second, the coincidence in time, around the end of the 19th century, between the growth of critical interest in Baroque art and the development of specific art-historical methods, of which those of Wölfflin, Riegl and Dvořák are but three examples.

Crude cultural explanations include the break-up of an old world order and the abandonment of traditional cosmology, both leading to scepticism and a rejection of essences in favour of appearances. The rehabilitation of pagan antiquity changed Western culture nowhere more radically than in architectural language and the representation of the human body in art. Nevertheless, antiquity formed part of medieval tradition, which itself shaped the Renaissance perception of antiquity. The political and social consequences of a divided Western Christendom were immense and led to a recolouring of the European map, but here again continuity with the past was claimed by both sides in the religious controversy. The collapse of the old cosmology had nothing to do with the roundness of the earth (which educated Europeans had understood for centuries) but resulted from quite different changes in scientific thought and observation. The vastness of outer space, and the realization that the true relative positions of the heavenly bodies are not as they

seem, were traumatic. On the other hand the idea that the everyday world was illusory was not then either new or common. Moreover, in the visual arts illusion continued to be distinguished from appearance, and reserved for the special circumstances of *trompe l'oeil* and the theatre. The heliocentric theory was contentious until Newton proved it from the Law of Gravity, and among its late opponents was Guarini, the architect whose buildings are spatially the most mysterious, although they depend on a brilliantly clear mathematical mind. Moreover, the hostility of Rome to the physics of Galileo was matched by that of Calvinist Holland to the philosophy of Descartes.

There can be no doubt that the new sceptical science of the 17th century was visual, or more generally sensory, being based on observation in preference to received ideas. There is a similarity between the understanding of what inventions of the age such as the telescope, the microscope and the barometer can reveal, and Hawksmoor's insistence on experiment in architecture 'so that we are assured of the good effect of it'. It is paradoxical, though not accidental, that in the 17th century were conceived both the idea of infinite space and the Cartesian system by which any point can be located in space by reference to numerical co-ordinates. Baroque architecture depends on the premiss that space as well as material can be moulded like clay; there is a mathematical basis to architectures both as rational as Wren's and as apparently irrational as that of Guarini. Borromini even conceived—although he did not achieve—the idea of a curved façade made of a single piece of terracotta. There were new spatial subtleties in painting too: in the almost infinite degradation of tone and colour in the distance of a Claude landscape, and in the interiors of Vermeer, where in depth projection the edges of things in different planes very nearly touch, while the space of the room continues indefinitely sideways beyond the boundaries of the picture frame.

A priori cultural theories have led to the identification of Baroque art with Catholic and courtly patronage, and even to the assertion that Wölfflin's Baroque unity and Classical multiplic-

ity correspond respectively to the absolutist monarchy and the republican democracy. Thus a contrast has been argued between the idealism of Italian 17th-century mythologies and Madonnas and the realism of 'bourgeois' Dutch landscapes, still-lifes and portraits. Such correspondences may be illuminating, but only so long as they are understood as fatally simplistic. Rubens worked in the same style for both princes and burghers. Church and state were no more closely linked in the papal territories than in the Venetian Republic, where St Mark's basilica was the Doge's chapel, or in the Dutch one, which owed its existence to a desire as much for religious as for political emancipation. In painting, Venice was the mother not only of Titian and Tintoretto but later also of Tiepolo and Piazzetta; in music Venice was the nurse of opera. In recent years the study of 17th-century Netherlandish art has turned to history and decorative painting and the theatre; the Dutch Republic acquired a hereditary principality early in the century, and, although Rembrandt did little work for the court in The Hague, it had never been possible to accommodate his oeuvre within the formula of Dutch realism. Not only is the *Blinding of Samson* a Baroque painting but also the *Night Watch* (Amsterdam; Rijksmus.): the latter's fleeting light effects, its free composition and its theatrically momentary action lift it out of the category of group portraiture altogether. Protestant architects (notably in the Calvinist Netherlands and the London of Queen Anne) experimented as freely with centralized church plans as their Roman and Piedmontese counterparts, even though religion denied them any comparable pictorial or sculptural embellishment. In one of the greatest achievements of decorative painting in the whole period, the ceiling of the Painted Hall of Greenwich Hospital, all the artifices of Catholic or absolutist *quadratura* were employed to deliver a nearly republican message in praise of the Glorious Revolution of 1688, and of the constitutional monarchy and the Protestant settlement that followed from it. The 17th-century Town Hall of Amsterdam is one of the great classical buildings of its age, in the three-dimensional

integrity of its planning, elevations and detailing, based on the Antique through Vincenzo Scamozzi. It is Baroque in its scale and in the relationship between ideas and imagery: these not only celebrate the greatness of Amsterdam and the Peace of Münster (concluded in 1648, the year of its foundation) but also heighten and solemnize the ordinary citizen's perception in his contacts with his city (Fremantle, 1959).

7. Conclusion: historical singularity

Seventeenth-century artists were not conscious of a break in history at some such date as 1590 or 1600; instead they saw themselves as belonging to 'modern' times, whether in distinction to antiquity or to what came to be called the Middle Ages. From the standpoint of either distinction they could see a continuity from the early Renaissance and the revival of antique culture into their own day. In *Die kirchliche Baukunst des Abendlandes* (Stuttgart, 1901) Georg Dehio, taking up a remark of Burckhardt, went so far as to claim that 'every architectural style has the Baroque as its last phase' (II, p. 190). The recognition of the Baroque as a late development has prompted the question whether a previous Baroque can be found in the art of late Roman antiquity (e.g. Lyttelton); this idea, however, suggests the ascendancy of methodology over observation. Certainly Imperial Roman art was considered 'decadent' for much of the 19th century, according to formal criteria not unlike those that at the same time condemned much art of the 17th century. Certainly late Roman sculpture and wall painting exhibit a kind of impressionism in technique, movement in rendering and pathos in expression for which analogies can be found in 17th-century Baroque. Certainly an architect like Borromini could find in Imperial Roman architecture a freedom of detail and a complexity of spatial planning, and claim them as authority for his own imagination. Certainly the dispersion of artistic ideas and images throughout the huge Roman Empire suggests parallels with the International Baroque. There is a fundamental difference, however, between the antique and the post-medieval eras. The grammar of Classical architecture was first constructed in the 16th

century, just as the grammar of Classical Latin as a 'dead' language had been constructed some centuries earlier by Irish monks, the first western Christian converts outside the Roman world's living tradition of Latinity. The Renaissance (and generally also the modern) concept of the Antique is not of a thousand years' development across the Mediterranean world but of a homogeneous body of cultural achievement. Thus early Renaissance artists thought that through the study of Vitruvius and of ancient remains they could discover the system by which, they believed, ancient Roman architects had created beautiful architecture. By the late 16th century, when it had become clear that no such system had existed in antiquity, architects and theorists had of necessity invented one of their own. There were Latin grammarians in the time of Cicero, but the poverty of Vitruvius' text is in itself witness to the scarcity of comparable authorities in architecture. With no canon of the art, there could in antiquity be no deviation or development of the kind that produced Mannerism and Baroque.

A style is 'of its age', not because the age has a guiding spirit but because the art is one of the components that define and characterize that age. The great difficulty generally found in making comparisons between the visual arts and others is due to the fact that they share neither common origins nor a common development; music, for example, has no comparable Antique, and 16th-century polyphony or the harmonies of Purcell and Bach were new inventions, never prefigured. The polarities named by Wölfflin may be useful indicators, and some historians have tried to apply them to such crafts as furniture and metalware, but they are neither watertight nor comprehensive.

The value of a stylistic definition decreases as its precision increases. The Baroque may, however, be characterized as a style based on a long tradition of growing familiarity with the canons and methods of the Renaissance, and through it with those of Classical antiquity. It is a style in which appearances take precedence over essences; familiarity allows the visual language to be adapted, as only a mother tongue can be, to

metaphor, wit, punning. It achieves its effects by a direct appeal to the senses, and through them to the emotions as much as to the intellect. Thus it is an art related more immediately to the beholder than to abstract principles. It has the richness and diversity of form and language that come at the end of a continuous period; not of any period or all, but specifically that of the Renaissance, on whose forms and language it depends.

Bibliography

H. Wölfflin: *Renaissance und Barock* (Basle, 1888, 4/1924; Eng. trans. of 1st edn, 1964)

A. Riegl: *Die Entstehung der Barockkunst in Rom* (Vienna, 1908/R 1977)

P. Frankl: *Die Entwicklungsphasen der neueren Baukunst* (Leipzig, 1914); Eng. trans. as *Principles of Architectural History* (Cambridge, MA, 1968)

H. Wölfflin: *Kunstgeschichtliche Grundbegriffe* (Munich, 1915); Eng. trans. as *Principles of Art History* (London, 1932/R 1984)

M. Dvořák: *Geschichte der italienischen Kunst im Zeitalter der Renaissance*, 2 vols (Munich, 1927–9)

H. Sedlmayr: *Oesterreichische Barockarchitektur* (Vienna, 1930)

G. F. Webb: 'Baroque Art', *Proc. Brit. Acad.*, xxxiii (1947), pp. 131–48

R. Stamm, ed.: *Die Kunstformen des Barockzeitalters* (Berne, 1956)

W. Friedlaender: *Mannerism and Anti-mannerism in Italian Painting* (New York, 1957)

R. Wittkower: *Art and Architecture in Italy, 1600–1750*, Pelican Hist. A. (Harmondsworth, 1958, rev. 3/1973)

K. Fremantle: *The Baroque Town Hall of Amsterdam* (Utrecht, 1959)

F. Haskell: *Painters and Patrons* (London, 1963, rev. New Haven and London, 1980)

G. C. Argan: *The Europe of the Capitals, 1600–1700* (Geneva, 1964)

E. Hempel: *Baroque Art and Architecture in Central Europe*, Pelican Hist. A. (Harmondsworth, 1965)

K. Downes: *English Baroque Architecture* (London, 1966)

E. H. Gombrich: *Norm and Form: Studies in the Art of the Renaissance* (London, 1966)

N. Pevsner: *Studies in Art, Architecture and Design*, 2 vols (London, 1968) [pt 1, 'Mannerism and Baroque'; articles originally pubd 1925–32]

R. Enggass and J. Brown, eds: *Italy and Spain, 1600–1750: Sources and Documents* (Englewood Cliffs, 1970)

J. Held and D. Posner: *Seventeenth- and Eighteenth-century Art* (New York, 1972)

R. Wittkower and I. B. Jaffé, eds: *Baroque Art: The Jesuit Contribution* (New York, 1972)

A. Blunt: *Some Uses and Misuses of the Terms Baroque and Rococo as Applied to Architecture* (London, 1973)

M. Lyttelton: *Baroque Architecture in Classical Antiquity* (London, 1974)

C. Dempsey: *Annibale Carracci and the Beginnings of Baroque Style* (Glückstadt, 1977)

A. S. Harris: *Andrea Sacchi* (Oxford, 1977)

J. R. Martin: *Baroque* (London, 1977)

A. Blunt, ed.: *Baroque and Rococo Architecture and Decoration* (London, 1978/R 1982)

I. Lavin: *Bernini and the Unity of the Visual Arts* (New York, 1980)

S. J. Freedberg: *Circa 1600* (Cambridge, MA, 1983)

The Age of Correggio and the Carracci: Emilian Painting of the 16th and 17th Centuries (exh. cat., Washington, N.G.A.; New York, Met.; Bologna, Pin. N.; 1986)

KERRY DOWNES

Baroque Revival [Edwardian Baroque; English Renaissance; Imperial Baroque]

Architectural style adopted widely in Great Britain and the British Empire from about 1885 until World War I, particularly for government, municipal and commercial buildings. Great Britain, with its nationalism, prosperity and extensive empire, was at this time boldly confident of its place in the world as a major power and adopted a style that reflected that confidence. Baroque Revival architecture is characterized by imposing classical façades, with much associated decorative sculpture, and it makes emphatic use of domes and towers, turrets and cupolas. Interiors are spacious and dignified and are also often decorated with sculpture and painting.

Known at the time as English Renaissance, Baroque Revival was a freely adapted version of the English Baroque architecture of the period 1700–20 by such architects as Christopher Wren, John Vanbrugh (see col. pl. VIII), Nicholas Hawksmoor and Thomas Archer. Its immediate source was perhaps Kinmel Park, Denbs, a country house designed by W. E. Nesfield (R. Norman

Shaw's partner) in 1866. The movement grew in stature through A. H. Mackmurdo's book *Wren's City Churches* (1883) and J. M. Brydon's acclaimed lecture 'The English Renaissance', delivered to the Architectural Association in London in 1889. Brydon spoke of the work of Vanbrugh, Hawksmoor and James Gibbs as being 'characterised by great vigour and picturesqueness, and by a freedom from restraint and an honesty of purpose'. These were formidable late Victorian virtues, and Brydon had already shown what he meant in the earlier part of Chelsea Town Hall (1885–7), London: the style matured in his Chelsea Polytechnic (1891), his three major buildings in the centre of Bath (1891–8) and the New Government Offices design (now the Treasury) of 1898 on the side of Parliament Square opposite Westminster Abbey, London.

Among the other pioneer designs of the Baroque Revival was the Institute of Chartered Accountants (1888) in the City of London, by John Belcher and A. Beresford Pite. This astonishingly fresh design, which involved two of the leading sculptors of the time, Hamo Thornycroft and Harry Bates, makes dramatic use of space inside, varying the scale of rooms and doorways. The originality of the competition entry (unexecuted) by Belcher and Pite for an extension to the Victoria and Albert Museum, with its long Baroque frontage, domes and turrets, influenced later architects. Other influential designs included Norman Shaw's Baroque country houses at Chesters, north of Hexham in Northumberland, and Bryanston in Dorset, both designed in 1889.

A typical work in the Edwardian Baroque Revival style is the Old Bailey (1900–06), the Central Criminal Court in London. Designed by E. W. Mountford and built of Portland stone, it has a confident façade, with the central dome derived from Wren's Royal Hospital at Greenwich, London; inside, the great hall beneath the dome has rich marble walls and columns with lunettes painted by Gerald Moira (1867–1959) and William Blake Richmond and pendentives by Frederick William Pomeroy. Other outstanding works in the Baroque Revival style in Great Britain include Belfast City Hall (1898–1906) by Alfred Brumwell

Thomas; Cardiff City Hall (1897–1906) by Lanchester, Stewart & Rickards; the War Office (1898–1906) in Whitehall, London, by William Young; the Piccadilly Hotel (now Le Meridien) façades to Piccadilly and Regent Street (1905–8), London, by Norman Shaw; the Mersey Docks Building (1903–7), Pier Head, Liverpool, by Arnold Thornely (1870–1953); and the Ashton Memorial (designed 1904, built 1907–9), Williamson Park, above Lancaster, by John Belcher. Other important architects who used Baroque Revival at some time in their careers include T. E. Collcutt, H. T. Hare (1860–1921), Edwin Lutyens and Aston Webb. Only Alfred Brumwell Thomas designed almost exclusively in the style.

Notable examples of the Baroque Revival outside Great Britain include, in India, the Victoria Memorial (1903–21) on the Maidan, Calcutta, by William Emerson; in South Africa, the Union Buildings (1910–12), Pretoria, and the Law Courts (1905), Bloemfontein, by Hawke and McKinley; in Australia, the Customs House (1898–1900), Rockhampton, Queensland, by A. B. Brady; and in Canada, the Legislative Building (1906–12), Edmonton, Alberta, by A. M. Jeffers. Articles in the *Architectural Review* from 1906 onwards attacked the extravagance of the Baroque Revival and praised the greater simplicity of 18th-century Neo-classicism, seen in the new Neo-Georgian style. Coinciding with an economic recession, these criticisms helped to curtail the artistic and financial extravagances of the Baroque Revival. Its swagger diminished steadily until 1914, when the period and the style came to an end.

Bibliography

A. Mackmurdo: *Wren's City Churches* (London, 1883)

J. M. Brydon: 'The English Renaissance', *AA Notes*, iii, (1889), p. 92

J. A. Gotch: *The Architecture of the Renaissance in England* (London, 1894)

R. Blomfield: *A History of Renaissance Architecture in England, 1500–1800* (London, 1897)

J. Belcher and M. Macartney: *Later Renaissance Architecture in England*, 2 vols (London, 1898–1901)

A. E. Richardson: *Monumental Classical Architecture in Great Britain* (London, 1914)

A. S. G. Butler: *The Lutyens Memorial: The Architecture of Sir Edwin Lutyens*, 3 vols (London and New York, 1950/R 1989)

C. Hussey: *The Lutyens Memorial: The Life of Sir Edwin Lutyens* (London and New York, 1950/R 1984)

H. S. Goodhart-Rendel: *English Architecture since the Regency* (London, 1953)

A. Service: *Edwardian Architecture*, World A. (London, 1977)

A. S. Gray: *Edwardian Architecture: A Biographical Dictionary* (London, 1985)

ALASTAIR SERVICE

Beaux-Arts style

Term applied to a style of classical architecture found particularly in France and the USA that derived from the academic teaching of the Ecole des Beaux-Arts, Paris, during the 19th and early 20th centuries. The style is characterized by its formal planning and rich decoration. The term is also found in writings by detractors of the Ecole's teaching methods and results: Frank Lloyd Wright, for example, called its products 'Frenchite pastry' ('In the Course of Architecture', *Archit. Rec.*, xxiii (1908), p. 163). For Paris-trained architects, however, issues of style were in general secondary to the more permanent tenets of the doctrine put forward by the Ecole (see below).

Beaux-Arts style is at its most spectacular in large public commissions (see fig. 15). On the main façades, monumentality is conveyed by colossal orders and coupled columns, dynamism by marked wall projections and decorative details in high relief, such as swags, garlands and medallions. Well detached from the elaborate rooflines, figure sculptures often terminate the main and secondary vertical axes. Overscaling (a device that characterizes Baroque more than classical architecture) prevents the Hôtel de Ville (1897–1904) in Tours by Victor Laloux from being a mere pastiche of a 17th-century *hôtel de ville*; the atlantids framing the main entrance are truly awe-inspiring, almost surrealistic. Less ornate is the façade on 42nd Street of Grand Central Station (1903–13), New York, by Warren & Wetmore

(with Reed and Stem); motifs, which are maximized against large areas of unadorned smooth stone, successfully address the scale and communal spirit of this area of Manhattan. While the best-known and most ridiculed examples of the Beaux-Arts style are major pavilions at the World's Columbian Exposition in Chicago (1893) and the Exposition Universelle of 1900 in Paris, its characteristic features may also be found in Parisian blocks of flats and offices, Manhattan townhouses and skyscrapers, Long Island and Newport country estates and London department stores.

When the Ecole des Beaux-Arts opened in 1819, amalgamating the special schools of architecture, painting and sculpture, it was unrivalled as a national training centre for artists of these disciplines. (Its official denomination changed slightly according to political regimes and bureaucratic reforms.) The architecture section was the descendant of the pre-revolutionary school of the Académie Royale d'Architecture, suppressed in 1793, and the curriculum remained virtually unchanged until 1968. Credits were attributed through a highly competitive system of the Concours d'Emulation; a major tenet of the design-orientated pedagogy was the practice of the *esquisse*, a preliminary sketch defining a *parti* (design orientation), to which competitors had to remain faithful. The teaching also emphasized the logical arrangement of programmatic requirements and the implementation of a suitable 'character' over stylistic and structural expression, social relevance and contextualism; projects for a specific site were exceptional. A basic rule for a successful composition was that visitors could find their way around any building without verbal orientation. Designs therefore represented carefully orchestrated sequences of circulation and transitional spaces; hierarchical arrangements of rooms according to their ceremonial and/or functional significance; and the expression of the axis and cross-axis in elevation section and plan by advancing and receding planes, flights of steps, floor markings etc. According to Egbert, students were required to give their design a general character, which was conveyed by principles of form

15. Union Station, Washington, DC, by Daniel H. Burnham, 1907

regarded as universally valid, such as a 'monumental', a 'public' or a 'French' character, as well as a 'type character', which was suggested by the particular programme of the building. Thus, far from being decorative, ornamentation was supposed to be symbolic in its suggestion of the appropriate character or characters.

The use of a classical heritage as a source for Beaux-Arts architecture was due to the stress given at the school on a thorough knowledge of the architecture of antiquity, the Renaissance and 17th- and 18th-century France. Students' interpretation of this evolved dramatically in the first half of the 19th century, from the uncompromising Neo-classicism promoted by Antoine Quatremère de quincy to Henri Labrouste's unconventional synthesis of historical references. A major impetus for multiplying the design precedents within this classical range, and for the departure from Vitruvian canons of proportions, was given by Charles Garnier's Opéra in Paris

(1860–75). Among Garnier's junior collaborators on this spectacular project were Henri-Paul Nénot, Jean-Louis Pascaland Julien Azais Guadet, soon to become prominent *patrons*, leaders of large studios at the Ecole.

During the Second Empire the Beaux-Arts style developed, as the school experienced an increase in the number of projects focusing on interior design and the decorative arts, which gave freer rein to personal expression and imagination. As heir to the SECOND EMPIRE STYLE, Beaux-Arts eclecticism peaked in the 1880s, and it was quickly disseminated worldwide, as the student body at the school became increasingly cosmopolitan. Over 400 Americans studied architecture in Paris between 1846 and 1918, and many more followed a French-inspired curriculum in the USA, where the Beaux-Arts style had its greatest impact outside France. It was associated with the City beautiful movement. The style made less impact in England, although a number of major buildings

were erected by, among others, J. J. Burnet and Thomas Tait. Around 1900, critics of Beaux-Arts style adopted anti-doctrinaire positions, which were best expressed in Guadet's *Eléments et théorie de l'architecture* (1907), but they were in marked contrast with the emerging theories of the Modern Movement. As the traditional Beaux-Arts style became obsolete after 1918, French academic methods seemed to lose touch with contemporary lifestyles and production methods. The late 20th-century rehabilitation of the style originated in the exhibition *The Architecture of the Ecole des Beaux-Arts*, organized by Arthur Drexler in New York, and many thereafter considered its monumentality, clarity, impeccable craftsmanship and attention to detail as a valid alternative to the International Style.

Bibliography

J. A. Guadet: *Eléments et théorie de l'architecture* (Paris, 1907)

L. Hautecoeur: *Histoire de l'architecture classique en France*, vii (Paris, 1957)

The Architecture of the Ecole des Beaux-Arts (exh. cat., ed. A. Drexler; New York, MOMA, 1975–6)

D. Drew Egbert: *The Beaux-Arts Tradition in French Architecture* (Princeton, 1980)

R. Middleton, ed.: *The Beaux-Arts and Nineteenth-century French Architecture* (Cambridge, MA, 1982)

R. B. Harmon: *Beaux Arts Classicism in American Architecture: A Brief Style Guide* (Monticello, IL, [1983])

ISABELLE GOURNAY

Beuron school [Schule von Beuron]

German school of painters, decorators and mosaicists, active from 1868 to the early 1900s. It was established in the Benedictine abbey of Beuron, near Tuttlingen in southern Baden-Württemberg. Its founder-members, all Benedictine monks, were Peter Lenz (Pater Desideratus; 1832–1928), Jacob Wüger (Pater Gabriel; 1829–92) and Fridolin Steiner (Pater Lucas: 1849–1906). They were influenced principally by the works of the Italian medieval and Renaissance painters and mosaicists, notably Giotto, and were part of a more general movement in 19th-century Europe

that involved the revival of large-scale religious themes, in oils, tempera or mosaics, for churches and chapels.

The group's initial project was the decoration (1868–70) of the St Maurus-Kapelle at Beuron, the plans of which were initiated by Lenz. The members also executed paintings in the Konradskapelle in Konstanz Cathedral and the decorations (1888–90) in the Klosterkirche St Gabriel, Prague. In the 1890s, several members, including Wüger, moved to the abbey of Montecassino, Italy. The school's principal project was undertaken here: the decoration in mosaic (1900–13) of parts of the underchapel of the abbey. In this, the members were assisted by Carl Gresnicht (Pater Adalbert; b 1877). The Dutch artist Jan Verkade (Pater Willibord), also a member, executed works (1895–7) in the Klosterkirche St Gabriel, Prague, from designs by Lenz, and worked at Montecassino in 1903–5. Through his friendship in Paris with two members of the Nabis, Paul Sérusier and Maurice Denis, artistic links were established between the Nabis and the Beuron school.

Bibliography

P. Keppler: *Die XIV Stationen des Heiligen Kreuzwegs nach Compositionen der Malerschule des Klosters Beuron* (Freiburg im Breisgau, 1892)

E. Bergmann and others, eds: *Lexikon der Kunst*, ii (Freiburg im Breisgau, 1987), pp. 140–41

Biedermeier

A term applied to bourgeois life and art in Germanic Europe, an extensive area embracing such cities as Copenhagen, Berlin, Vienna and Prague, from 1815 (the Congress of Vienna) to the revolutions of 1848. It originated as a pseudonym, Gottlieb Biedermeier, created by Ludwig Eichrodt (1827–92) and Adolf Kussmaul (1822–1902) for publishing poetry in the Munich journal *Fliegende Blätter* between October 1854 and May 1857. The connotations of the German adjective *bieder*—plain, solid, unpretentious—pointed to the gently parodic function of these poems, which were based on the work of Samuel Friedrich Sauter

(1766–1846), a Swabian schoolmaster and amateur versifier.

The Biedermeier period may very generally be divided into two phases, with the years around 1830 marking the moment of transition between a more restrained, cooler and more severe style (purer lines and more affinity to Neo-classicism in design, sparsely furnished interiors, and greater objectivity in painting) to a more complex, catholic and emotional one (greater historicism and eclecticism in design, more pattern and upholstery in interiors, and a more fluid style, greater sentimentality and the rise of anecdotal genre in painting). However, regional variation was very marked: the colour and drama of such Viennese genre scenes as Josef Franz Danhauser's *Indulgence* (1836; Vienna, Belvedere), which echoed the local Baroque heritage, is very distant from the calm of such interiors as *At the Mirror* (1827; Kiel, Christian-Albrechts U., Ksthalle) by the Dresden painter Georg Friedrich Kersting, which is more akin to the precise, severe and linear style of Berlin and Hamburg. The identity of Biedermeier is further confused by the fluid borders between it and the concurrent styles of Neo-classicism and Romanticism; it is best distinguished from either by a stronger link between the fine and the applied arts. Many artists worked in both areas, and such standards derived from craftsmanship as technical expertise were often applied to the appraisal of paintings.

Biedermeier painters were ideologically opposed to academic and religious painting; while establishment critics regarded their work as inferior, it was much appreciated and eagerly bought by a large middle- and upper-class public which, in turn, did much to establish its major characteristics. Biedermeier pictures were, on the whole, small and biased towards conveying specific content, documentary or narrative: in this, their close connection to both contemporary book illustration and the popular diorama is evident. Accordingly, Biedermeier titles for paintings, as for novels and plays, were often essential to the ironic or moralistic points being conveyed. Formally and technically, the most common traits were the use of separate, clear tones and a high degree of finish. The most popular subjects were portraits, landscapes and genre scenes, with still-lifes, especially of flowers, serving as a strong link to the decorative arts in designs for glass, porcelain and for textile patterns.

In portraiture, groups, especially families, were very popular, with the 18th-century English conversation piece often serving as a model. Portraits often approached genre; figures were shown in detailed interiors or in garden settings, as in Carl Julius Milde's *Pastor Rautenburg and his Family* (1833; Hamburg, Ksthalle). Characterization stressed an individual's interests, but little attempt was made at deeper psychological exploration. Landscape scenes often included identifiable monuments and stressed human and domestic associations; views were chosen to heighten a sense of enclosure through framing devices, as in *View of the Salzburg* (1837; Dresden, Grünes Gewölbe) by Julius Schoppe (1795–1868). Similar techniques were employed in architectural scenes documenting both the official side of a city as well as its back streets and the sites of human interaction in business transaction: for example Erdmann Hummel's *Corner Shop on the Schlossfreiheit* (1830; ex-Berlin, N.G.; destr.). Interiors were frequently shown, often as character portraits of the absent owner, as in *Studio Window* (1836; Vienna, Albertina) by Jakob Alt (1789–1872). Industrial architecture also became an interesting new theme with views of factories, mills and railroads, such as in Alfred Rethel's *Harkort Factory at Burg Wetter* (c. 1834; Düsseldorf, Demag AG priv. col., see Geismeier, p. 183). Genre scenes were especially popular and documented many aspects of middle-class life both at home and at places of public entertainment such as concerts or cafés or in parks, as in Hummel's *Granite Bowl in the Lustgarten in Berlin* (1831; Berlin, Neue N.G.). Military and peasant subjects, especially popular in Munich and Vienna, were invariably idealized, as in the *Scene in a Viennese Pub* (Vienna, Museen Stadt) by Michael Neder (1807–82) (see col. pl. IX).

Although the term Biedermeier has also been used to refer to painters outside Germanic Europe, such as Pavel Fedotov in Russia, Wouter Johannes van Troostwijk in Holland, Louis-Léopold Boilly in

France and George Caleb Bingham in America, they are probably better described in terms more relevant to their various and very distinct social and artistic contexts. No accepted definition of Biedermeier architecture and sculpture has yet been established. Both were primarily Neo-classical throughout the period and associated with public and representational purposes, for example the façades of the large housing blocks (1835–45) designed by Joseph Kornhäusel in Vienna, although many of the country villas of the period might well qualify as examples of Biedermeier style.

The Biedermeier period is best known for its furniture design which was determined by concern for comfort and practicality and reduced economic circumstances. It was influenced by both English Sheraton furniture and the early classicism of Louis XVI. The strongest influence, however, was the French Empire style, from which it took Neo-classical symmetry, a preference for simple geometric shapes and flat surfaces and an architectural vocabulary of columns, mouldings and pediments. It rejected ornate decoration, costly materials and aristocratic references. The aesthetic dimension came from the skills of fine craftsmanship: proportion, simplicity, formal clarity and the natural beauty of the materials. Favourite materials included fruitwoods, walnut and ash, with ebonized wood for accent. Comfort dictated the introduction of upholstery and new curved shapes for chair legs and backs. The most popular furniture types were those used for daily life: the sofa, chair, desk (especially secrétaire), cabinet, étagère—used to display collections of Biedermeier porcelain and glass—and such smaller pieces as plant-stand, night-table, wine cooler, wastebasket and needlework holder. Regional variations ranged from the elegant, delicate and imaginative Viennese designs typified by the work of Joseph Ulrich Danhauser (e.g. sofa, c. 1820; Vienna, Bundesmobiliensamml.) to the massive architectural forms of Berlin furniture under the influence of Karl Friedrich Schinkel. Furniture produced after 1830 had more historicizing ornamentation and more opulent materials, reflecting the increased prosperity of the middle classes.

The concern for comfort and convenience also dominated the design of the Biedermeier interior. Furniture was no longer aligned against the wall but was used to create groupings known as *Wohninsel*. These arrangements, usually composed of sofa-table-chair combinations, established small informal areas sympathetic to family life and abandoned the formality of Empire room design. From 1815 to 1830 furnishings were sparse; subsequently wallpaper, textile hangings, parquet floors and carpets became the norm. Floral arrangements and floral motifs in fabrics were especially popular, just as the garden itself became an extension of the interior living-space.

By the 1880s Biedermeier had come to be used pejoratively to characterize the reactionary bourgeois elements in society in the period and region concerned and, more specifically, to describe its furniture, interior decoration and fashions which were often seen as a provincial offshoot of the French Empire style. In 1896, however, with the Congress of Vienna exhibition, Biedermeier furniture and design began to receive positive reappraisal, largely motivated by the admiration of *Jugendstil* artists for products of the Biedermeier era. The application of the term to the fine arts began with the Berlin Centennial Exhibition of 1906; and its validity as a stylistic term for literature, music and philosophy was examined in the 1920s and 1930s. The more dogmatic definition of Biedermeier bourgeois society as one that deliberately withdrew into the private sphere and remained indifferent to social problems has subsequently been questioned. Certain aspects of the traditional view of the period have endured: celebration of the domestic realm, cultivation of a sense of order, sobriety and cheerfulness and rejection of heroic drama in favour of lyricism or of gentle humour poised between the sentimental and the ironic.

Bibliography

M. von Boehn: *Biedermeier: Deutschland von 1815–1847* (Berlin, [c. 1911–13])

P. F. Schmidt: *Biedermeiermalerei* (Munich, 1921)

K. Gläser: *Das Bildnis im Berliner Biedermeier* (Berlin, 1932)

K. Simon: 'Biedermeier in der bildenden Kunst',
 Dt. Vjschr. Litwiss. & Geistesgesch., xiii (1935),
 pp. 59–90
A. T. Leitich: *Wiener Biedermeier* (Leipzig, 1941)
R. Feuchtmüller and W. Mrazek: *Biedermeier in Österreich*
 (Vienna, 1963)
L. Schrott: *Biedermeier in München* (Munich, 1963)
P. Pötschner: *Genesis der Wiener Biedermeierlandschaft*
 (Vienna, 1964)
Wien, 1800–1850 (exh. cat., Vienna, Hist. Mus., 1969)
I. Wirth: *Berliner Biedermeier* (Berlin, 1972)
Berliner Biedermeier (exh. cat., ed. G. Bartoschek;
 Potsdam, Schloss Sanssouci, 1973)
G. Himmelheber: *Biedermeier Furniture* (London, 1974)
W. Geismeier: *Biedermeier* (Leipzig, 1979)
R. Krüger: *Biedermeier: Eine Lebenshaltung zwischen* 1815
 und 1848 (Vienna, 1979)
Vienna in the Age of Schubert: The Biedermeier Interior
 1815–1848 (exh. cat., London, V&A, 1979)
H. Kretschmer: *Biedermeier* (Munich, 1980)
Berlin zwischen 1789 *und* 1848: *Facetten einer Epoche*
 (exh. cat., Berlin, Akad. Kst DDR, 1981)
M. Bernhard: *Das Biedermeier: Kultur zwischen Wiener
 Kongress und Märzrevolution* (Düsseldorf, 1983)
R. Waissenberger, ed.: *Vienna in the Biedermeier Era*,
 1815–1848 (New York, 1986)
A. Wilkie: *Biedermeier* (Cologne, 1987)
Biedermeiers Glück und Ende . . .die gestörte Idylle
 1815–1848 (exh. cat., Munich, Stadtmus., 1987)
*Bürgersinn und Aufbegehren: Biedermeier und Vormärz
 in Wien* 1815–1848 (exh. cat., Vienna, Hist. Mus., 1987)
G. Himmelheber: *Kunst des Biedermeier* 1815–1835 (exh.
 cat., Munich, Bayer. Nmus., 1988)

M A R S H A L. M O R T O N

Bizarre silks

Name applied to a group of silks woven in Italy, France, England, and probably other countries, in the late 17th century and early 18th. The bizarre style had its origins in the rich mix of images provided by the goods imported into Europe from the Near and Far East by the Levant Company and the East India companies of France, Holland and England. An insatiable market for novelty and richness had been established at the courts of Louis XIV and Charles II, and other monarchs who followed their lead. The silks woven to satisfy that demand began to appear in the late 1680s; chinoiseries and vegetable forms derived from Indian textiles began to be mixed with European floral sprigs. By the mid-1690s, the plant forms, although still small, were becoming more angular and elongated, with an increasingly vigorous left-right movement. The patterns, typically asymmetrical, were brocaded with metal threads on damask grounds, which were already patterned with even stranger motifs.

From *c.* 1700 to 1705 the designs were at their most bizarre, incorporating strange gourds, serpentine vegetable stems, intertwined plants and unidentifiable shapes, some angular and others reminiscent of sea creatures or rock formations. They were brocaded with gold and silver threads and coloured silks on damask grounds and had repeats measuring as much as one metre. This exaggerated length suited the elongated lines of womens' dress in the early 18th century, and the silks were also used for covering furniture and wall panels.

The earliest English silk designs made by James Leman (1688–1745) in Spitalfields, London, from 1706 are in the bizarre style. They are the first of an unbroken line of designs that make it possible to follow the development of the style through a less bizarre phase, when clearer, but still strange, chinoiserie and japonaiserie motifs were combined with images derived from architecture and others taken from Indian floral filling patterns (e.g. of *c.* 1709; London, V&A). The repeats became shorter and, by *c.* 1712, vertical bands and more naturalistic flowers began to be introduced, ushering in what has been called 'the luxuriant bizarre period' (Thornton). Abundant foliage became the dominant feature; it was controlled by various forms of band or serpentine line, arranged symmetrically, in place of the asymmetrical plan of most bizarre silks. By *c.* 1720, the bizarre elements had virtually vanished.

Bibliography
V. Slomann: *Bizarre Designs in Silks: Trade and Tradition*
 (Copenhagen, 1953)
P. Thornton: 'The "Bizarre" Silks', *Burl. Mag.*, c (1958),
 pp. 265–70
M. King and D. King: *European Textiles in the Keir
 Collection* (London, 1990)

N. Rothstein: *Silk Designs of the Eighteenth Century* (London, 1990)

C. Buss: *Silk, Gold and Silver: Eighteenth-century Textiles in the Collection of Antonio Ratti* (Milan, 1992)

☐

Byzantine Revival

Term applied to a revivalist style that affected all the arts (including visual and literary), but primarily architecture and the decorative arts. The style was prevalent in Western and Eastern Europe and North America during the second half of the 19th century and into the early 20th. Its international nature was appropriate to the multicultural identity and geographical range of the Byzantine empire (early 4th century AD–1453). The initial impetus for the Revival came from 18th- and 19th-century accounts of travels to Italy, Greece and Turkey, containing descriptions of Early Christian and Byzantine buildings, and from early specialist books on Byzantine and Early Christian architecture. It received an additional stimulus from the fashion for the *Rundbogenstil*, which originated in Germany during the 1820s.

The growth of serious academic and architectural interest in the Byzantine style began in the 1830s. Thomas Hope's *An Historical Essay on Architecture* (1835) devoted 20 chapters to Early Christian and Byzantine architecture. Alexander Lindsay allocated a large section of *Sketches in the History of Christian Art* (1847) to Early Christian art. Both books received critical attention, notably from John Ruskin, stimulating further publication in this field. Ruskin's own three-volume *The Seven Lamps of Architecture* (1849) and *The Stones of Venice* (1851) were also both highly influential: the latter prompted an international public outcry over the restoration of the basilica of S Marco, Venice. The widespread public acceptance of the style dates from the 1850s. Matthew Digby Wyatt designed the Byzantine and Early Christian Court (1854; destr. 1936) in the Crystal Palace, London, as part of a series of historical displays created after the palace's re-erection at Sydenham. The University Church (1854–6), Dublin, conceived by John Henry Newman and designed and decorated

by John Hungerford Pollen was strongly based on the Early Christian basilicas of Ravenna. In mosaic decoration the Byzantine Revival was promoted by the Venetian firm of Salviati (founded 1859), who led an international revival of mosaic mural decoration, combining Byzantine pictorial imagery with industrialized methods of production.

By 1880 a more specific use of Byzantine as opposed to Early Christian idioms emerged. At Cardiff Castle, Wales, John Patrick Crichton-Stuart, 3rd Marquess of Bute, a leading patron of the Byzantine Revival, commissioned a private chapel, designed by William Burges. It contains a Byzantine-inspired baldacchino, and on its dome is depicted Christ Pantocrator in a Victorianized version of 12th-century Sicilian and Greek Byzantine decoration. The Greek Orthodox cathedral of St Sophia (1877–9), London, designed by John Oldrid Scott, has a centralized cruciform plan, surmounted by a dome supported on pendentives, and a full programme of mosaic decoration, based on 12th-century Greek Byzantine models. In Bavaria, King Ludwig II commissioned a richly decorated Byzantinesque throne-room (1885–6), also with strong Sicilian overtones, as part of his palace of Neuschwanstein, designed by Eduard Riedel (1813–85) and Georg von Dollmann.

The peak of the Byzantine Revival was between 1890 and 1914. W. R. Lethaby and Harold Swainson's monograph *The Church of Sancta Sophia, Constantinople* (1894) identified the mystical quality and symbolic spiritual significance of Byzantine architecture, pinpointing its *fin-de-siècle* appeal. The book provided a vital source for the design of the Roman Catholic Westminster Cathedral (begun 1895), London. The major study by Charles Texier and Richard Popplewell Pullan, *Byzantine Architecture* (1864), was the inspiration for Rice University (begun 1912), Houston, TX, by Ralph Adams Cram.

Bibliography

M. Praz: *The Romantic Agony* (London, 1933, rev. 2/1970), pp. 303–474

P. Julian: *Dreamers of Decadence* (London, 1971), pp. 149–61

D. Talbot Rice: *The Appreciation of Byzantine Art* (London, 1972)

Romantik und Restauration: Architektur in Bayern zur Zeit Ludwigs I., 1825–1848 (exh. cat., ed. W. Nerdinger; Munich, Stadtmus., 1987)

M. P. Dristel: *Representing Belief: Religion, Art and Society in Nineteenth Century France* (Philadelphia, 1992)

DOROTHY BOSOMWORTH

Cape Dutch style

Architectural style developed at the Cape of Good Hope, South Africa, during the period of Dutch East India Company rule (1652–1795). Despite subsequent British stylistic innovations, its use continued in country districts until the 1880s. The term was first acknowledged, with reservations, by G. E. Pearse in 1933 but was given authority only in 1953 by C. de Bosdari. It covers three main building types: farmhouses, town houses and public buildings.

The early development of both domestic types followed similar lines, with the availability of materials being the major determining factor. Local bricks were under-fired and insufficiently water-resistant, which led to the use of lime plaster on exteriors, creating a white-walled aesthetic. Experiments with tiled roofs were unsuccessful, resulting in the adoption of thatch. Roofs were hipped at first, but were gradually replaced with half-hipped or gabled ends; the latter were given decorative outlines from an early date. Most early houses were rectangular in plan and only one room deep. However, the larger residences of the officials had more complex plans and triple-gabled façades with a central full-height gable flanked by dwarf gables.

The Cape Dutch farmhouse was descended from these early prototypes and achieved its definitive form by 1750. A variety of plan types was used, the U-plan, the T-plan and the H-plan being the most common. These were characterized by wings meeting at right angles, necessitated by the limitations of roof span to about 6 m. All were entered from the centre of the façade and had an entrance hall (*voorhuis*) linked to an inner hall of the same width behind (*galderij* or *achterhuis*). A central gable was placed above the entrance, with end gables terminating the wings; by mid-century the flanking gables had been omitted. The entrance door was usually elaborated with mouldings and in later years was enclosed by a classical surround. It was reached from the *stoep*, a raised terrace extending the full width of the façade. Earlier houses had casement windows, but these were gradually replaced by sliding sashes. Notable examples of Cape Dutch farmhouses include Groot Constantia, Stellenberg, on the Cape Peninsula.

In contrast with the farmhouse, the town house, and La Provence, at Fransch Hoek took a form influenced by the narrowness of building plots and the fire risks inherent in the use of thatch. The adoption of flat roofs was first considered as early as 1717, but it was not until the 1770s that the majority of houses were rebuilt in this form. The flat roof permitted the introduction of the double-pile plan, with a two room depth, as the problem of valley gutters in parallel pitched roofs was eliminated. Other differences involved the use of a narrower *voorhuis* and a wider *achterhuis*. Town houses were also often extended to an upper storey, a rare occurrence in farmhouses.

The town house faced the street directly, separated from it only by the *stoep*. Like the farmhouse it usually had a symmetrical façade, but the decorative emphasis of a central gable was difficult to achieve with a flat roof. This was at first overcome by the use of a curvilinear parapet; in the 1780s the *dakkamer* was introduced: a gable-like extension of the wall surface above the cornice, with a room behind it for stability. In the 1790s a pediment, often containing relief sculpture, was used over the central bay of the façade, which was often articulated with pilasters.

The third category of Cape Dutch architecture is that of public buildings, of which few have survived. Most public buildings followed the academic classicism favoured by military engineers, notably Louis Michel Thibault (e.g. drostdy at Graff-Reinet; 1804), who had studied under Ange Jacques Gabriel in Paris. He worked closely with the sculptor Anton Anreith (1754–1822) from Freiburg im Breisgau and the builder Hermann Schutte from Bremen, both of whom also worked as architects in their own right.

Bibliography

G. E. Pearse: *Eighteenth Century Architecture in South Africa* (London, 1933)

C. de Bosdari: *Cape Dutch Houses and Farms* (Cape Town, 1953)

J. van der Meulen: *Die europäische Grundlage der Kolonialarchitektur am Kap der Guten Hoffnung* (Marburg, 1962)

H. Fransen and M. A. Cook: *The Old Buildings of the Cape* (Cape Town, 1980)

A. Obholzer, M. Baraitser and W. A. Malherbe: *The Cape House and its Interior* (Stellenbosch, 1985)

J. Walton: *Old Cape Farmsteads* (Cape Town, 1989)

R. H. FITCHETT

Celtic Revival

Style rooted in 19th-century antiquarian studies of ancient Celtic art in Britain and Ireland. It was a mainly decorative style and first appeared in the 1840s, remaining fashionable from the 1890s to *c.* 1914 and lingering on through the 1920s. Derived from the complex, intertwining, linear

16. St Matthew Opening Page, Books of Kells, *c.* AD 800 (Dublin, Trinity College Library)

motifs of ancient Celtic ornament, it was employed in metalwork, jewellery, embroidery, wall decoration, wood inlay, stone-carving and textiles. The Celtic Revival was closely related to the English Arts and Crafts Movement's aim of social and artistic reform and was part of the general upsurge of Romantic interest in the Middle Ages. Its chief characteristics were raised bosses, tightly enmeshed roundels and bands of sinuous, criss-crossing lines, similar to but more abstract than Art Nouveau designs. Sources of inspiration were such Celtic antiquities as the Tara Brooch and the Ardagh Chalice (both 8th century AD; Dublin, N. Mus.), the Battersea Shield (*c.* 2nd century AD; London, BM) and the Book of Kells (7th–8th centuries AD; Dublin, Trinity Coll. Lib.; see fig. 16), which was published in facsimile in Dublin in 1892.

In Ireland the Celtic Revival coincided with a renewed interest in the country's visual and literary heritage and in traditional Irish arts and crafts. Prominent in the revival was George Petrie, a topographical artist and antiquarian, who spent his early career recording Ireland's carved Celtic stones and wheel-head crosses in a series of travel-books. Celtic-style objects and 'archaeological' jewellery were popular from the 1840s. Scottish and Irish jewellers also excelled at creating reproductions of 8th-century Celtic body ornaments and utilized such indigenous materials as Irish gold, agates, cairngorms, amethysts, Connemara marble and river pearls (e.g. 'Arbutus Berry' torc shawl brooch made by G. & S. Waterhouse, *c.* 1851; London, V&A). In the 1850s G. & S. Waterhouse of Dublin made two copies of the Tara Brooch in parcel gilt (Belfast, Ulster Mus.) for Queen Victoria, which led to a vogue for jewellery with such Irish motifs as harps, Celtic crosses and Tara brooches, carved from Irish bogoak with gold or silver mounts. Both the Belleek Porcelain Factory and W. H. Goss Ltd of Hanley, Stoke-on-Trent, manufactured souvenir Celtic crosses of Parian porcelain from the 1850s, and Irish stonecutters did a lively local and export business in carved gravestones copied from old Celtic wheel-head crosses (examples at Glasnevin and Mount Jerome cemeteries, Dublin; Maynooth, Co. Kildare). Among Irish

architects who adopted Celtic ornament for carved stone capitals was George Coppinger Aslin (1837–1921), for example in his stone monument (1887) to Cardinal McCabe (d 1885) in Glasnevin cemetery. Ecclesiastical and domestic embroidery in Celtic and medieval designs was also produced (e.g. banners by Susan Mary Yeats (1866–1949) for Loughrea Cathedral, 1902–3).

The Celtic Revival reached the height of its popularity in the 1890s throughout Britain and Ireland. The silversmith Edmond Johnson (fl 1881–1927) adapted Celtic ornament in his metalwork and jewellery, shown at the Irish Arts and Crafts Society's first exhibition in Dublin in 1896 (e.g. Ardagh silver sugar sifter and bowl, c. 1896; priv. col., see Sheehy, p. 150). In Scotland, Tudor floral motifs and modified Celtic interlaced ornament appeared among the designs of Charles Rennie Mackintosh and the artists working in the Glasgow style. In England, Arthur Lasenby Liberty achieved great success with his distinctive Cymric range of Celtic-style silver objects and jewellery, launched at the Liberty & Co. store, London, in 1899, followed in 1903 by his Tudric line of pewterware. Silver and pewter objects were inset with blue or green enamel, hardstones or mother-of-pearl and decorated with interlaced strapwork (e.g. casket set with heart-shaped opal matrix by Archibald Knox, 1903; London, V&A); the inlays, exposed rivets and hammered surfaces gave the desired handmade look. Among Liberty's designers were Archibald Knox, who had studied Celtic and Runic monuments on the Isle of Man and in Ireland, Rex Silver (1879–1965) and Bernard Cuzner (1877–1956). Some studio pottery sold by Liberty & Co. also bore Celtic motifs, for example the Compton Pottery's moulded terracotta garden wares. In 1903 the Grafton Galleries in London mounted an exhibition entitled *Modern Celtic Art*, and such was the style's popularity that Liberty continued to produce Cymric and Tudric designs into the 1920s.

Bibliography

M. Amaya: *Art Nouveau* (London, 1966, rev. 2/1985)

A. J. Tilbrook: *The Designs of Archibald Knox for Liberty & Company* (London, 1976)

V. Arwas: *The Liberty Style* (London, 1979)

J. Sheehy: *The Rediscovery of Ireland's Past: The Celtic Revival, 1830–1930* (London, 1980)

J. V. S. Megaw and M. R. Megaw: *Celtic Art: From its Beginnings to the Book of Kells* (London, 1989)

D. Krasner: *Celtic Living in Scotland, Ireland and Wales* (London, 1990)

☐

Century Guild of Artists

English group of painters, designers and craftsmen, active between c. 1883 and 1892. It was one of the earliest Arts and Crafts groups and initiated the practice of attributing designs to individual craftsmen, which became a firm principle of the ARTS AND CRAFTS MOVEMENT. Its platform was the 'unity of the arts', and its aim was 'to render all branches of art the sphere, no longer of the businessman, but of the artist'. Although output was limited and sporadic, the group had considerable influence by exhibiting its products and publishing a quarterly magazine, the *Century Guild Hobby Horse* (1884–92). Perhaps 20 craftsmen in all were associated with the Guild, but the only members were A. H. Mackmurdo, Herbert Horne and Selwyn Image.

The Guild's work was mainly domestic. It offered textiles, wallpapers, furniture, stained glass, metalwork, decorative painting and architectural design, all of which were displayed at the *Inventions Exhibition* (London, 1885), the *Exhibition of Navigation and Manufacture* (Liverpool, 1886) and the *Royal Jubilee Exhibition* (Manchester, 1887). The style adopted was formal and based on 18th-century sources, although some patterns were of an Art Nouveau character. The Guild influenced designers such as C. F. A. Voysey and Charles Rennie Mackintosh. The Guild's work at Pownall Hall (1886–7; Cheshire) is regarded as its major commission, but only fragments of this scheme survive. The Arts and Crafts Exhibition Society (founded 1888) offered an alternative to the Guild which, although it still functioned in 1890, was defunct by 1892. Its work is represented in the collection of the William Morris Gallery, London.

58 Century Guild of Artists

Bibliography
'Inventions Exhibition: Furniture by the Century Guild',
 Builder, xlix (1885), pp. 216–17
S. E. Overal: *Catalogue of A. H. Mackmurdo and the
 Century Guild Collection*, London, William Morris Gal.
 cat. (London, 1967)
S. Evans: 'The Century Guild Connection', *Art and
 Architecture in Victorian Manchester*, ed. J. H. G.
 Archer (Manchester, 1985), pp. 250–68
 STUART EVANS

Château style

Term used to describe an architectural style
adopted for public buildings in Canada in the late
19th century and early 20th; also, more generally,
a style practised in North America during that
period (the latter is also called Châteauesque).
Buildings in the Château style are usually asym-
metrical and are characterized by picturesque sil-
houettes created by steep hipped roofs, dormer
windows, towers, turrets and tall chimneys. The
Canadian prototype was the wood-framed Banff
Springs Hotel in the Rocky Mountains at Banff,
Alberta (1886–8; destr. 1925), designed for the
Canadian Pacific Railway (CPR) by Bruce Price. It
was inspired by Scottish Baronial architecture of
the 16th and 17th centuries and French châteaux
of the Renaissance. It also showed an awareness
of recent European sources such as George Gilbert
Scott's Midland Grand Hotel at St Pancras Station,
London (1866–76). The CPR subsequently used the
style for brick hotels on picturesque sites, such as
the Château Frontenac, Quebec City (1892–3; sub-
sequent additions to 1924), the sources for which
were Loire Valley architecture as well as the work
of H. H. Richardson in the USA. Another major
example is the Empress Hotel, Victoria, British
Columbia (1904–8; many additions), by Francis
Mawson Rattenbury, a building with façades of
flat relief that culminate in the style's character-
istic steep roofs and dormer windows. The CPR
also built stations in the style, such as the second
Vancouver Station (1897–8), designed by Edward
Maxwell. The rival Grand Trunk Railway quickly
adopted the style for such hotels as the Château
Laurier, Ottawa, Ontario (1908–12), by Ross &

MacFarlane, and the Fort Garry Hotel, Winnipeg,
Manitoba (1911–13), by the same architects.
 The Château Laurier was originally L-shaped
(but was later extended), with a stone exterior and
five floors of hotel rooms above the ground floor
and mezzanine. The top floor is enlivened by
corbels and balustrades; above that rises a richly
ornamented roof with gabled and hipped dormers
and two tall towers. Additions in 1927–9 by
Archibald & Schofield created a U-shape above
the ground floor; further alterations were made
during the 1980s. The Château Laurier inspired
the promotion of the Château style as a national
style for federal government buildings in the
capital city of Ottawa and across Canada. A Federal
Plan Commission (1915) chaired by Hubert S. Holt
(1856–1941) advocated public buildings 'with vig-
orous silhouettes [and] steep roofs' recalling the
Gothic Revival Parliament Buildings and 'the
external architecture of the Chateau Laurier'. An
official report urged 'the adoption of the French
Chateau style of architecture, of which the
Chateau Laurier is a modernized type' (*Report to
Council*, 27 April 1927, p. 3). Federal government
buildings in the style in Ottawa include the
Confederation building (1927–30) and the Justice
building (1935–9), both designed by the Depart-
ment of Public Works.
 The Château style was also used for residences
in the USA and Canada, but it never became a sig-
nificant force. The use of Late Gothic and
Renaissance forms to associate the grand house
with the European castle is seen at Biltmore
(1890–95), the grand country residence designed
by Richard Morris Hunt for G. W. Vanderbilt at
Asheville, NC, and at Bois-de-la-Roche (1896–9), a
smaller-scaled country house at Senneville, near
Montreal, designed by Edward Maxwell for Senator
Louis Forget.

Bibliography
*Report of the Federal Plan Commission on a General Plan
 for the Cities of Ottawa and Hull*, 1915 (Ottawa, 1916)
 [The Holt Report]
H. Kalman: *The Railway Hotels and the Development of
 the Château Style in Canada* (Victoria, BC, 1968)
 HAROLD KALMAN

and Félicien Rops. Like its predecessor, it provided an alternative to the official Salon. Founded by Arthur Hannay, a government bureaucrat, the group welcomed an eclectic mix of Belgian artists, musicians and singers. Its name, illustrated by the vignette designed by Rops for the invitation to the first exhibition, uses the image of the emerging butterfly to predict the success of new art over academic work. Its exhibitions were immediately successful; they showed works that were personal responses to nature rather than historical or religious subjects in the academic tradition. The first exhibition in November 1876 paid homage to Hippolyte Boulenger, a leading independent artist, and included works criticized as 'sketchy' by conservatives. Other exhibitions occurred in March 1878 and June 1881. La Chrysalide had close ties to the advanced literary group that published a journal of the same name edited by Théo Hannon (1851–1916) and Camille Lemonnier (1844–1913), critics who had been closely associated with the Société Libre des Beaux-Arts. The journal was sympathetic to young writers and included colour lithographs by contemporary Belgian and French artists. La Chrysalide provided an early showcase for young Belgian artists such as Fernand Khnopff, James Ensor and Alfred William Finch, subsequently participants in L'Essor and founding members of Les XX. Even though La Chrysalide's eclecticism made it unwieldy and unfocused and its life was short, its example, together with that of the journal, prompted subsequent avant-garde publications such as *La Jeune Revue littéraire* and exhibition groups such as Les XX, which viewed La Chrysalide as an artistic and spiritual predecessor.

Bibliography

'Feu "La Chrysalide"', *A. Mod.* [Brussels] (10 Dec 1899), pp. 412–13

S. M. Canning: *A History and Critical Review of the Salons of 'Les Vingt', 1884–1893* (diss., Philadelphia, U. PA, 1980), pp. 20, 38, 45, 47, 50, 58, n. 22

J. Block: *Les XX and Belgian Avant-Gardism, 1868–1894* (Ann Arbor, 1984), pp. 4–5, 9, 11, 16, 40, 142–52

JULIUS KAPLAN

18. José Benito de Churriguera: Altar, St Esteban Monastery, Salamanca

Churrigueresque

Term used from the late 18th century to denote the most exuberantly ornamental phase of Spanish architectural decoration, lasting from *c.* 1675 to *c.* 1750. The term derives from the Churriguera family, the principal exponents of the style, who worked mostly in Salamanca. The origins of the style, however, can be traced back to the painter and sculptor Alonso Cano, who was a pioneering exponent of a highly ornamental style that began to characterize much Spanish art at the end of the 17th century. Most important in the propagation of the style were a number of sculptors, wood-carvers, cabinetmakers and carpenters who began to be highly influential in the field of architecture at this time, much to the chagrin of the more classically-minded specialist architects, such as Juan de Herrera. These sculptors and other craftsmen were chiefly responsible for the design and construction of the ephemeral structures built for coronations and other celebrations around this time. These were generally

Pevsner and Sigfried Giedion, evoked Chicago, it was in these terms, and Sullivan and Wright were presented as emanations of a broader Chicago mentality. Between the two World Wars more insular American critics, such as Fiske Kimball (*American Architecture*, 1928) and Tallmadge (*The Story of Architecture in America*, 1927), depicted Sullivan and Wright as romantics attempting (but failing) to create an 'American' style, while Lewis Mumford saw them in the same terms in his *Sticks and Stones* (1924) and *Brown Decades* (1931) but believed that their cause would succeed.

The consequence of seeing Sullivan and Wright as the products of a technological Chicago was to denigrate the aesthetic, humane element in their work: Sullivan's exuberant ornament; Wright's effort to blend his houses with their environment. In his *Space, Time and Architecture* (1941), Giedion argued that Sullivan's skyscrapers should be seen as a particularly frank expression of their inner-steel skeletons and that Wright's houses should be appreciated as compositions of geometric forms in space, thus summing up 50 years of critical interpretations of Chicago's contribution beginning with: H.-R. Hitchcock, *The Buildings of Frank Lloyd Wright* (1928) and *Modern Architecture: Romanticism and Reintegration* (1929); R. Neutra, *Amerika* (Vienna, 1930); H. Morrison, *Louis Sullivan: Prophet of Modern Architecture* (1935); N. Pevsner, *Pioneers of the Modern Movement* (1936). The final result was the doctrine of Carl Condit's *Chicago School of Architecture* (1964), namely that there is a consistent, almost inevitable, Chicago tradition of industrial architecture extending from Jenney to Mies van der Rohe, in which Sullivan and Wright are mere incidents. Other art historians have held that the intentions of Sullivan and Wright should be seen in their immediate historical context, an attitude initiated by Vincent Scully, who treated Sullivan as a humane ornamentalist (*Perspecta*, v, 1959) and Wright as a symbolist (*Frank Lloyd Wright*, New York, 1960). Since then have come Sherman Paul's *Louis Sullivan: An Architect in American Thought* (1962), Narciso Menocal's *Architecture as Nature* (1981) and Lauren Weingarden's essays on Sullivan, as well as Norris

Kelly Smith's *Frank Lloyd Wright: A Study in Architectural Content* (1966) and Neil Levine's *The Architectucture of Frank Lloyd Wright* (1996). What remains to be addressed, once a more subtle and historically accurate definition of these men's enterprise has been arrived at, is an expansion of the idea of a 'Chicago school' to embrace Daniel H. Burnham with his World's Columbian Exposition work of 1893, as well as his Chicago plan of 1909, and thus to include popular imagery as well as technique in the conception. Chicago's role in the emergence of an unprecedented and revolutionary American visual culture in the late 19th century and early 20th was pervasive and complex; more exploration of this cultural phenomenon is still needed.

Bibliography

Industrial Chicago, 6 vols (Chicago, 1891–6)

Catalogues of annual exhibitions, Chicago Architectural Club (Chicago, 1894–1923)

T. E. Tallmadge: 'The Chicago School', *Archit. Rev.* [Boston], xv (1908), pp. 69–74

S. Giedion: *Space, Time and Architecture* (Cambridge, MA, 1941)

F. A. Randall: *History of the Development of Building Construction in Chicago* (Urbana, 1949)

C. Condit: *The Rise of the Skyscraper* (Chicago, 1952)

—: *The Chicago School of Architecture* (Chicago, 1964)

M. Peisch: *The Chicago School of Architecture: Early Followers of Sullivan and Wright* (New York, 1965)

H. A. Brooks: *The Prairie School: Frank Lloyd Wright and his Midwest Contemporaries* (Toronto, 1972)

G. Wright: *Moralism and the Model Home* (Chicago, 1980)

C. S. Smith: *Chicago and the American Literary Imagination, 1880–1920* (Chicago, 1984)

K. Sawislak: *Smoldering City* (Chicago, 1995)

DAVID VAN ZANTEN

Chrysalide, La

Belgian avant-garde exhibition society (1875–1881). It continued the principles and traditions of youthful rebellion and artistic freedom established by the Société Libre des Beaux-Arts and included many of its members, such as Guillaume Vogels, Théodore Baron (1840–99), Constantin Meunier, Louis Artan de Saint-Martin (1837–90),

from decorative eclecticism, in his massive Marshall Field Wholesale Store (1885–7; destr. 1930), with its plain, rusticated façade and windows grouped under round arches. In 1886–9 Richardson's approach was echoed in the exterior of Sullivan and Adler's Auditorium Building (see fig. 17); it was Sullivan who was responsible for the design and ornament. By contrast, Burnham and Root in their brick Monadnock Building (1889–91), the most celebrated example, avoided ornament.

These two characteristics did not necessarily occur together: the Monadnock Building has no skeleton; the Home Insurance Building is disappointingly over-decorated. They might, however, coincide, and at that moment the masterpieces of the moment appeared, such as the steel and terracotta Reliance Building (1891–5) by Burnham and Charles Atwood (with John Wellborn Root), or the skyscrapers of Adler and Sullivan, beginning with the Wainwright Building (1890–91) in St Louis.

In 1893 the World's Columbian Exposition was held in Chicago, re-establishing the popularity of classicism; in addition, restrictions were placed on the height of buildings in the city. Some critics consider this to be the effective end of the Chicago school, although for others this era is considered as its beginning.

2. Second generation

When Tallmadge first selfconsciously defined the term 'Chicago school' in 1908, he characterized the school's style as the avoidance of historical forms, the invention of original ornament based on real botanical species and acceptance of boxy, geometric massing. He located the formulation of these ideas among the younger Chicago draughtsmen gathering at the Chicago Architectural Club, which organized design competitions and exhibitions, and identified its leaders as George W. Maher, Richard E. Schmidt (1865–1958), Hugh M. G. Garden, George C. Nimmons (1869–1947), Robert C. Spencer, George R. Dean (1864–1919), Dwight H. Perkins (1867–1941), Myron Hunt (1868–1962) and especially Frank Lloyd Wright. Important examples of their work include Maher's

Patten House (1901; destr.), Evanston, IL; Schmidt and Garden's Madlener House (1902), Chicago, and Perkins's work as architect of the Chicago School Board (1905–10), especially his Carl Schurz High School (1908).

This selfconscious, second-generation 'Chicago school' was of short duration, having emerged c. 1895 when most of the members first set up practice, and was already showing signs of dissolution when Tallmadge wrote in 1908. It was a basically unsuccessful attempt to make a system of the intensely personal contribution of Sullivan, who had been recognized as the creator of a new, anti-historical manner by influential critics Barr Ferree and Montgomery Schuyler early in the 1890s on the basis of his Wainwright Building (1890–91), St Louis, and in Chicago the Schiller Building (1891–3) and the Transportation Building (1891–3) at the World's Columbian Exposition (1893). By 1900, however, Frank Lloyd Wright, in what he called his 'Prairie Houses', was already developing a very different and equally personal style and, like Sullivan, was soon proclaimed the founder of another and equally ephemeral school, christened in the 1960s the Prairie school. This included Walter Burley Griffin and Marion Mahony Griffin, William E. Drummond and John S. Van Burgen (1885–1969).

The flaw in the formulation of these schools would seem to lie in their effort to reduce to systems the manner of two individualists, when what was most fertile was the mentality and technology of the locality. In the 1830s Chicago carpenters had invented the balloon frame. The city had also been at the forefront of the development of fireproof commercial buildings following the Great Fire of 1871 (see §1 above). The architects themselves were aware of their accomplishment (Root in particular), and visitors and writers saw these structures as powerful and characteristic expressions of the city's spirit: Henry Blake Fuller in *The Cliff Dwellers* (1893); Achille Hernant in the *Gazette des Beaux-Arts* (1893–4); Paul Bourget in *Outre-Mer* (1895); and Theodore Dreiser in *Sister Carrie* (1900). When in the 1930s advocates of the European International Style, such as Henry-Russell Hitchcock, Richard Neutra, Nikolaus

17. Adler & Sullivan: Auditorium Building, Chicago, IL, 1886–9

Chicago school

Term applied today to an informal group of architects, active mainly in Chicago in the late 19th century and early 20th. The architects whose names have come to be associated with the term include Dankmar Adler, Daniel H. Burnham, William Holabird, William Le Baron Jenney, Martin Roche and, primarily, Louis Sullivan. All these architects were linked by their use of the new engineering and construction methods developing in high-rise buildings from the 1880s (sometimes described as 'Chicago construction') and by a new approach to the articulation of façades. In its original use, however, as defined in 1908 by the architect and writer Thomas E. Tallmadge (1876–1940), the term was applied to the work of architects of the next generation (see §2 below).

1. First generation

In the more general use of the term 'Chicago school', the first common and uniting element for

the architects concerned was their use of the steel skeleton for constructing buildings. In the aftermath of the Great Fire of 1871, which devastated Chicago, rapid expansion took place. The high cost and limited availability of sites meant that architects developed the high-rise building and sought new ways to make buildings fireproof; even cast-iron frame buildings had been vulnerable. William Le Baron Jenney pioneered the use of an iron and steel skeleton clad with masonry, which rendered it more heat-resistant, in the Home Insurance Building (1883–5; destr. 1931). Five years later Burnham and Root built the Rand–McNally Building, for which they employed the steel skeleton.

The second identifying characteristic of 'Chicago construction' is simple exterior decoration, often in red brick or terracotta, and the use of blocky volumes. It was the Bostonian H. H. Richardson who provided the influential model for the stylistic development and the move away

made of wood or cloth, allowing all manner of capricious and bizarre experiments with ornamentation. Some of these Baroque experiments were later taken up and applied in stucco or brick to such architectural elements as façades, walls, vaults, doors and cupolas and in sculptural ensembles such as retables, for example at the church of S Esteban, Salamanca.

In the early 18th century the Churriguera family, together with such other artists as Pedro de Ribera in Madrid and Narciso Tomé in Toledo, took up this ornamental style and brought it to its logical conclusion, adding such new decorative elements as the *estípite* (a tapering pilaster, shaped like an inverted pyramid and derived from Mannerist architecture) and solomonic (or spiral) columns (see fig. 18). The *estípite* was to become the dominant form. Tomé's designs were particularly ornamental and laden with sculptural decoration, including fluffy clouds and angels' heads on column shafts, entablatures and cornices. The style also had its followers outside the central region of Spain. These included Leonardo de Figueroa and his son Ambrosio de Figueroa (1700–50) in Seville, Francisco Hurtado Izquierdo and his group of followers in Córdoba and Granada, and Domingo Antonio de Andrade (1639–1712) and Fernando de Casas y Novoa (both of whom worked on the cathedral of Santiago de Compostela) in Galicia. It was also subsequently introduced into Latin America, especially Mexico, by Jerónimo de Balbás, Lorenzo Rodríguez and others. Although the late phase of the Churrigueresque coincided with the Rococo movement in Spain, the two styles should not be confused: while both styles were essentially decorative, using ornamentation to disguise weak architectural structure, Churrigueresque consisted in heavy, contorted decoration whereas Rococo was lighter and more curvaceous.

The Churrigueresque style was heavily criticized in the second half of the 18th century, particularly by the leading figures in the Spanish Enlightenment, many of them members of the Real Academica de Bellas Artes de S Francisco, founded in Madrid in 1752. These critics, who included Antonio Ponz and Juan Agustin Céan Bermudez, ridiculed and opposed the style through their writings and worked to eliminate it by exercising control over all public, state, ecclesiastical and private building. Permission for building was often withheld until revisions were made, and the academy also reserved the right to bestow the titles of Architect and Master of Works, which had previously been granted by the council of Castile, the various city councils and the guilds. The arts were considered to have fallen into a state of degeneration and to be a symbol of political, economic and cultural decadence. The main target for their attack, though, was the Churriguera family, the poor taste of whose architecture was reflected in the neglect of the Classical principles of harmony, solidity and utility, in their incorrect use of Vitruvius' canonic orders and in their absurd ornamentation. According to the theorists of the Enlightenment, the abuses and infringements of established rules that the Churrigueresque represented had originated in the architecture of Borromini, whose style—they believed—had been assimilated by such artists as José Jiménez Donoso and Francisco de Herrera, who probably trained in Rome c. 1650. They also criticized such painters as Sebastián de Herrera Barnuevo and Alonso Cano, who had introduced a new decorative approach into their painting, even if they had never been to Italy. In fact, however, the influence of Borromini on Churrigueresque was minimal. His work appears to have been virtually unknown to the members of the Churriguera family: his name appears only once in their writings, in a passing reference made by José Benito de Churriguera in a letter to Bernini.

Bibliography

EWA: 'Churrigueresque Style'

G. Kubler: *Arquitectura de los siglos XVII y XVIII*, A. Hisp., xiv (Madrid, 1957)

A. R. Ceballos: *Los Churriguera* (Madrid, 1971)

—: 'L'Architecture baroque espagnole vue à travers le débat entre peintres et architectes', *Rev. A.*, lxx (1985), pp. 41–52

ALFONSO RODRÍGUEZ CEBALLOS

Clique, the

British group of painters active in the 1830s. It was a short-lived group of young like-minded artists who first met as students at the Royal Academy Schools, London, in the late 1830s. The Clique comprised Richard Dadd, Augustus Egg, W. P. Frith, H. N. O'Neil and John Phillip. Associated with them were Thomas Creswick, Alfred Elmore, Thomas Joy, E. M. Ward and William Bell Scott. The original members were united by friendship, shared aspirations and idealistic career aims. Their initial disenchantment with the functions of the Royal Academy also unified them, but it soon faded. All of the original members, except Dadd, later became ARAs or RAs.

The group met weekly to sketch a chosen subject, to discuss their work and to socialize. 'We were not', wrote Frith, 'a mutual admiration society.' The sketches were often judged by a non-artist friend, John Imray. He noted retrospectively the individual artistic interests of the group, the diversity of which increased as their association diminished in the 1840s. Some retained closer links than others: Dadd, Egg, Frith and O'Neil were among the founder-members of the Painters' Etching Society in 1842. The Clique had no set programme or manifesto and its activities were equally social and artistic. It should not be confused with the St John's Wood Clique, which had a completely different membership.

Bibliography

W. P. Frith: *My Autobiography and Reminiscences*, 3 vols (London, 1887–8)

J. Imray: 'A Reminiscence of Sixty Years Ago', *A. J.* [London], n.s. (1898), p. 202

Richard Dadd (exh. cat. by P. Allderidge, London, Tate, 1974)

PHILIP MCEVANSONEYA

19. Emile Bernard: *Picking Apples*, 1890 (Nantes, Musée des Beaux-Arts de Nantes)

Cloisonnism [Fr. *cloisonnisme*]

Style of painting practised in the late 1880s by such French artists as Louis Anquetin, Emile Bernard, Paul Gauguin and Paul Sérusier. Essentially it involves the use of strongly out-

lined planes of minimally modelled, bright colour with simplified drawing (see fig. 19). These features undermine the three-dimensionality both of individual objects and of the pictorial space. Cloisonnism represented the rejection of *trompe l'oeil* painting in favour of an attempt to express the inner character of the subject-matter. Its stylistic elements were soon incorporated into the broader style of Synthetism, which, in turn, formed a current within Symbolism. The term is derived from the cloisonné enamelling technique, in which thin bands of metal are used to outline flat areas filled with coloured enamels. Stained glass, another influence, uses the same principle, with lead creating the distinct outlines around pieces of coloured glass. The French critic Edouard Dujardin was the first to publish the word 'Cloisonnism' as descriptive of a new style in art in his essay on Anquetin in *La Revue indépendante* (1 March 1888, p. 490): 'The painter traces his design with enclosing lines, within which he places his various tones juxtaposed in order to reproduce the desired sensation of general colouration. Drawing predicates colour and colour predicates drawing. And the work of the painter will be something like painting by *compartments*, analogous to cloisonné, and his technique consists in a sort of *cloisonnisme*.'

Gothic enamelled jewellery and stained glass enjoyed a revival in the late 19th century as part of a general reawakening of interest in all arts of the Gothic period, including popular prints, architecture and furniture. Emile Bernard, in particular, was fascinated by medieval art and culture, equating its design elements with his nostalgia for the simplicity of a more pious, chivalrous era. While Gothic art provided a historical reference for Cloisonnism as practised by Bernard and Anquetin, its most immediate stylistic influence was Japanese prints. Many of these woodcuts flooding the French art market in the 1880s used bright, occasionally non-naturalistic colours and flat forms delineated by dark outlines. Modelling and realistic detail were either non-existent or distorted to create flat, geometric patterns. From 1887 Bernard and Anquetin adopted these stylistic devices in their paintings.

Cloisonnism allowed the artist freedom to distort or rearrange natural colour patterns. Bernard credited Anquetin's *Mower at Noon: Summer* (1887; Paris, Léon Velluz priv. col., see exh. cat., p. 237) as their first exercise in the use of colour to express pure emotion. The painting was inspired by the fields around the artist's family summer home in Etrépagny, as seen through the coloured glass of a window. The warm yellow tonality of the entire painting ignores natural colour in favour of creating a particular mood. Anquetin's *Avenue de Clichy: Five O'clock in the Evening* (1887; Hartford, CT, Wadsworth Atheneum) uses a simple palette of blue and orange in order to suggest the feeling of a warm shop beckoning customers on a wet, chilly evening. Contemporary theories of colour, for example those of Michel-Eugène Chevreul and Ogden Rood, as practised by the Neo-Impressionists, were certainly an influential factor in Anquetin's stylistic development. Bernard's Cloisonnist paintings consistently employ a Prussian blue outline around each form. In such compositions as the *Rag-pickers: Iron Bridges at Asnières* (1887; New York, MOMA), he leans heavily on Japanese design principles, with pronounced diagonals, cropped forms and an emphasis on geometric construction. His working method usually consisted of first drawing the outlines of his shapes in thin Prussian blue oil paint on to a canvas primed with white. Colours were then applied in small, rectangular strokes, with minimum modelling of forms. Finally, a broad Prussian blue outline was traced over the edges of the colour areas.

Friendships with other artists of the Parisian avant-garde, including Vincent van Gogh, Henri de Toulouse-Lautrec and Paul Gauguin, enabled Bernard and Anquetin to introduce Cloisonnism to a small group of interested artists and critics. Gauguin, for example, may have seen their exhibition at the Grand Restaurant-Bouillon, Paris, in November 1887. In such paintings as *On the Riverbank, Martinique* (1887; Amsterdam, Rijksmus. van Gogh), Gauguin was already making use of flat shapes and outlines, but not to the degree of abstraction attained by his younger colleagues. When Gauguin and Bernard met in Pont-Aven in the summer of 1888, they discussed Bernard's *Breton*

Women in the Meadow (1888; Paris, priv. col.). The work's limited palette appealed to Gauguin, as did the denial of three-dimensional space and the pronounced Cloisonnist line around most of the forms. His response was the *Vision after the Sermon: Jacob Wrestling with the Angel* (1888; Edinburgh, N.G.; see col. pl. XXXIX), which has many of the formal characteristics found in Bernard's painting. The two artists enthusiastically explored the ramifications of this new style: their forms became flatter, the brushstrokes more regular, compositions bolder and colours more saturated. While adhering to basic Cloisonnist principles, the style was amplified and personalized by each artist. Bernard mostly concentrated on the formal, more decorative qualities of Cloisonnism; Gauguin was selective in what he adopted. For example, he preferred richly nuanced rather than unmodulated areas of colour to enliven the surface; only rarely did he go back over his forms to reinforce the outlines, more often simply letting the juxtaposition of colour areas define the outline of a particular shape. Like Bernard, however, he achieved a flow of linear patterns over the entire surface of the canvas, independent of the subject-matter or pictorial space.

By the mid-1890s, Bernard and Anquetin had abandoned Cloisonnism in favour of a style incorporating more naturalistic modelling and realistic colouring. Gauguin, however, continued to retain an interest in patterns of line and colour, as did most of his followers, although his work soon went beyond a narrow definition of Cloisonnism in which the heavy outline must be present. The Synthetist work of Gauguin and his followers after 1888 includes elements of the Cloisonnist ideas of Bernard and Anquetin, but its stress on expressing emotional and psychological elements links it to Symbolism.

Bibliography

E. Dujardin: 'Aux XX et aux Indépendants: Le Cloisonnisme', *Rev. Indép.*, vi (1888), pp. 487–92

E. Bernard: 'Louis Anquetin', *Gaz. B.-A.*, n. s. 5, xi (1934), pp. 108–21

Vincent van Gogh and the Birth of Cloisonnism (exh. cat. by B. Welsh-Ovcharov, Toronto, A.G. Ont.; Amsterdam, Rijksmus. van Gogh; 1981)

CAROLINE BOYLE-TURNER

20. McKim, Mead and White: Cochrane House (257 Commonwealth Ave.), Boston, MA, 1895

Colonial Revival

Term applied to an architectural and interior design style prevalent in the late 19th century and early 20th in the USA and Australia, countries formerly colonized by Britain. The style, used mostly for domestic architecture, was based on buildings of early colonial periods and had much in common with the contemporary Neo-georgian tendency in Britain; later developments on the west coast of the USA drew on Spanish styles. It became popular in response to a reaction against the ornate eclecticism of late 19th-century architecture and the search for a new: Colonial Revival was promoted as a 'national' style, rooted in the foundations of the nations and suited to their environment and culture (see fig. 20). A similar stimulus produced revivals of colonial

styles in other countries, such as South Africa, where the Cape Dutch style was revived in work by Herbert Baker around the end of the 19th century, and Brazil, where features of Portuguese colonial architecture appeared in the work of Lúcio Costa.

In the USA scattered praise of colonial architecture had appeared in architectural publications from the 1840s, and from the 1870s such architects as Robert Swain Peabody and Arthur Little emphasized the appropriateness and picturesque qualities of colonial architecture and advocated its revival. Such views were consolidated by the Centennial International Exhibition (1876) in Philadelphia, which crystallized national aspirations towards a simpler way of life, with nostalgia for the values of a pre-industrial society becoming associated with a revival of the building and furnishing styles adopted by the colonists. Two buildings at the exhibition attracted particular attention: the Connecticut House by Donald G. Mitchell, which was intended to suggest a colonial farmstead, and the New England Log House, which had a kitchen with a low-beamed ceiling and colonial furniture, where traditional boiled dinners—advertised as the kind 'the old Puritans grew strong on'—were served. Two British buildings in a half-timbered style by Thomas Harris were influential in validating the use of a vernacular style. Colonial Revival also drew inspiration from the contemporary resurgence of academic classicism. During the next decades a trend towards greater historical accuracy emerged, with the publication of many illustrated articles and measured drawings of colonial buildings.

The development of resorts in New England provided the opportunity for the Colonial Revival style to be used in settings similar to those experienced by the colonists. Early examples in Newport, RI, include the remodelling (1872) of the Robinson House, Washington Street, by Charles Follen McKim and other buildings by Mckim, Mead & White, and Richard Morris Hunt's own house (1870–71); the latter combined elements from colonial architecture and the SHINGLE STYLE, as did the F. W. Andrew House (1872; destr.) at Middletown, RI, by H. H. Richardson, which had

shingles on the upper storey and clapboard below. In Litchfield, CT, the Mary Perkins Quincy House (1904) by Howells and Stokes is a clapboard building with green shutters, which harmonizes with its colonial neighbours.

Colonial Revival was adopted for both large and small houses. The simplicity of the New England prototypes and the use of timber as a building material made it a popular, inexpensive choice and led to its widespread use for suburban housing, with several characteristics in common with the late 19th-century QUEEN ANNE REVIVAL style. From the late 1880s architects in Philadelphia turned to regional models, such as old Pennsylvania farmhouses, and they employed undressed local stone, often whitewashed, as a building material. Among them were Wilson Eyre, Walter Cope (1860–1902) and the practice of Duhring, Okie & Ziegler, whose William T. Harris House (completed by 1915) in Villa Nova, PA, is a sturdy two-storey building of local stone combining a simple vernacular exterior with a sophisticated interior layout. Colonial Revival developed later in the southern states, where local models were again adopted; the J. H. Boston House (c. 1913), Marietta, GA, by Joseph Neel Reid, for example, evokes an ante-bellum mansion. The style was also used for other building types. Examples include additions (1870) to Harvard Hall, Harvard University, Cambridge, MA, by Ware & Van Brunt; the Post Office (1902), Annapolis, MD, by James Knox Taylor; and the Unitarian Meeting House (before 1914), Summit, NJ, by John Wheeler Dow, a white clapboard structure with a wooden portico and tower.

Two distinctive variants of American Colonial Revival developed on the west coast of the USA: Mission Revival (from the 1890s) and Spanish Colonial Revival (from the early 1920s). Mission Revival drew freely on the old Roman Catholic mission buildings of California and was first popularized after the success of the California Building by A. Page Brown (1859–96) at the World's Columbian Exposition (1893) in Chicago. Typical features included balconies, verandahs and arcades, towers and courtyards. Walls were plastered and roofs pantiled, and there was an almost complete absence of architectural mouldings.

Examples of this approach include John Kremple's Otis House (1898), Wilshire Boulevard, Los Angeles, and the Union Pacific Railroad Station (1904), Riverside, CA, by Henry Charles Trost (1860–1933). Spanish Colonial Revival is distinguished from Mission Revival by the considerable use of carved or cast ornament, classically derived columns, window grilles and elaborate balcony railings of wrought iron or turned spindles, all elements that are found in Spanish colonial architecture in Mexico. Popularized after its appearance at the Panama–California Exposition (1915) at San Diego, the style had become a craze within ten years. One of its most notable practitioners was George Washington Smith, who designed Sherwood House (1925–8), La Jolla, CA.

In Australia the Colonial Revival resulted from a new sense of national identity that followed federation of the states in 1901 and led to a search for a 'national style'. The movement was based in Sydney, and its main practitioners included W. Hardy Wilson, Robin Dods (also active in Brisbane), John D. Moore (1888–1958) and Leslie Wilkinson, Australia's first professor of architecture (1918–47) at the University of Sydney. Wilson made the first scholarly studies of colonial Georgian architecture and incorporated such features as sash windows, shutters, fanlights and columned verandahs in his simply planned houses (e.g. Eryldene, 1913–14, Gordon, Sydney). A notable variation was seen in the work of Wilkinson, who combined Australian colonial elements with loggias inspired by Mediterranean architecture (e.g. Greenway, 1923, Vaucluse, Sydney).

While other styles became popular in the 1920s and 1930s, the Colonial Revival remained part of the domestic vernacular in both the USA and Australia and was reinterpreted in later housing projects, particularly towards the end of the 20th century.

Bibliography

C. F. McKim: *New York Sketch Book of Architecture* (Montrose, NJ, 1874)

R. S. Peabody: 'Georgian Houses of New England', *Amer. Architect*, 2 (1877), pp. 838–9

W. B. Rhoades: *The Colonial Revival*, 2 vols (New York and London, 1977)

P. Cox and C. Lucas: *Australian Colonial Architecture* (East Melbourne, 1978), pp. 227–55

K. J. Weitze: *California's Mission Revival* (Santa Monica, 1984)

A. Axelrod: *The Colonial Revival in America* (Winterthur, DE, 1985)

BETZY DINESEN

Consulate style

Term used to describe the continuation in the decorative arts of the Neo-classical style (*see* NEO-CLASSICISM) in France between 1800 and 1805 under Napoleon Bonaparte (First Consul; 1799–1804). His Consulate was an era of renewal in the furniture, porcelain and metalwork industries in France, greatly encouraged by the patronage of Napoleon, who sought a model for his position in the magnificence of ancient Rome. While little actual building took place, the period was important for such changes in interior decoration as the lavish use of draperies—begun during the 1790s—that established the Consulate and the Empire styles; although these terms were invented by later art historians to denote the change in political systems, in fact the styles to which they refer are virtually indistinguishable. Furniture was similar to that of the preceding DIRECTOIRE STYLE, but forms took on a heavier appearance, materials were used more lavishly, and there was a fresh emphasis on ornamentation. An influential figure was the archaeologist Vivant Denon, Napoleon's camp follower in Egypt and Syria (1798–9), who helped inspire the Egyptomania that swept France and England with his book *Voyage dans la basse et la haute Egypte*, published in Paris in 1802 (*see* EGYPTIAN REVIVAL).

Bibliography

S. Grandjean: *Empire Furniture*, 1800–1825 (London, 1966)

J.-P. Samoyault: 'Furniture and Objects Designed by Percier for the Palace of Saint-Cloud', *Burl. Mag.*, cxvii/868 (1975), pp. 457–65

Cranbrook Colony

Group of English painters working *c.* 1855–1900. The name was attached in the early 1860s to an informal group of genre painters who spent their summers working in the village of Cranbrook in Kent. The brothers George Hardy (1822–1909) and Frederick Daniel Hardy (1826–1911) were disciples of Thomas Webster. F. D. Hardy first settled in Cranbrook about 1854. Webster moved there in 1857 and introduced his friend J. C. Horsley to the Hardys. G. B. O'Neill, who had married Horsley's cousin, joined them in the late 1850s. Augustus E. Mulready and G. H. Boughton (1833–1905) were also frequent visitors.

Cranbrook's attractions were the same as those of other contemporary artistic centres in the home counties: picturesque countryside, a wealth of old houses and cottages and easy access to London by railway. This was an important consideration for such artists as Horsley and O'Neill who also had houses in London.

Although Dutch 17th-century genre painting was a fundamental influence on the whole group, it was united more by family links than by artistic sympathies. In terms of stylistic cohesion, talent and sophistication, its artists had little in common. Horsley was the most successful. F. D. Hardy's earliest cottage interiors reveal an almost Pre-Raphaelite seriousness and objectivity, but he and O'Neill seldom rose above the anecdotal. The Cranbrook Colony was primarily a social group, but important professional contacts could be established through it. For example, Richard Norman Shaw owed the foundation of his country-house practice to the additions he made to Horsley's house in Cranbrook, Willesley, in 1864–9.

Bibliography

The Cranbrook Colony (exh. cat., ed. A. Greg; Wolverhampton A.G., 1977)

ANDREW GREG

Cuzco school

Term used to refer to the Peruvian painters of various ethnic origins active in Cuzco from the 16th to the 19th century. When Viceroy Toledo reached Cuzco in 1570, he commissioned a series of paintings (destr.) to be sent to Spain, which included depictions of the conquest and capture of Atahuallpa (*d* 1533) and portraits of the Inca rulers. These works were painted by Indians who had been taught by such Spanish masters as Loyola. From the beginning of Spanish colonization until the end of the 16th century, two currents existed in painting in Cuzco: that of the Spanish masters, influenced by Netherlandish and Late Gothic art; and the indigenous tradition. Both influences persisted simultaneously until Roman Mannerism reached Peru through the work of three Italian painters based in Lima: Mateo Pérez de alesio, Bernardo Bitti and Angelino Medoro. Bitti, a Jesuit, worked in Cuzco with, among others, two disciples of Medoro: the Indian Loayza and the Lima painter Luis de Riaño (*b* 1596). The influence of Bitti and the popularity of Flemish engravings as inspiration for compositions overwhelmed indigenous art, which was evident only in the drawings in the *Primer nueva crónica y buen gabierno* (*c.* 1580–1613) by Guaman Poma de Ayala. Medieval styles were also perpetuated through the work of such monks as Diego de Ocaña, who popularized the image of the *Virgin of Guadalupe*.

Despite these influential models, the Indian painter Diego Quispe Tito, who took pride in his Inca ancestry, created a personal style in his landscapes embellished with gold leaf and abounding with birds. He lived outside the city itself and maintained a distance from foreign tendencies. His followers included such Indian masters as Chihuantito, Chilli Tupac and the Master of the *Procession of Corpus Christi* (before 1700; Cuzco, Mus. A. Relig.), one of the most important social, historical and artistic documents of Cuzquenian art. Another Indian painter, Basilío de Santa Cruz Pumacallao, produced paintings for Bishop Manuel de Mollinedo y Aungulo (*d* 1699). The latter had seen works by Velázquez and Rubens, and the works of Pumacallao were similar to paintings being produced in Europe at that time. They were also often superior to those of the Spanish and creole artists active in Cuzco, among whom

Marcos Ribera is notable for his use of dramatic chiaroscuro.

Wall painting was practised from the 16th century, following the Indian tradition and using Italian influences. It had developed in the poorer towns, where canvases would have been too expensive for church decoration. The most important groups include those by Riaño at the church in Andahuaylillas (1618–26), inspired by the priest Juan Pérez de Bocanegra, and those by Tadeo Escalante at S Juan, Huaro (1802). Escalante also painted portraits of 12 Incas and of noble Indian women at a mill in Acomayo. Pumacahua, the chief of Tinta, commissioned a wall painting on the façade of his village church, which depicted the battle in which he conquered Tupac Amaru, and portraits of him and his family.

Spanish and creole painters were in the same guild as Indian painters until 1684, when the latter group objected to a compulsory examination that required knowledge of the architectural orders and the drawing of a male and a female nude. The Indians began to work independently under the patronage of local leaders, who dedicated themselves to selling their works in other towns, including the mining centres of the Audiencia de Charcas (now Bolivia). Works from this school also reached the north of Argentina, Chile and Lima. The Indian painters abandoned European perspective and returned to characteristically flat compositions filled with figures, birds and trees, which they also gilded.

In the 18th century such Indians as Mauricio García y Delgado (fl c. 1760) set up large workshops, which produced up to 100 paintings per month. The quality and colouring of the paintings declined, but their prices also fell, allowing their work to become popular among even the poorest. Marcos Zapata painted c. 200 works on the *Litanies of the Virgin* for Cuzco Cathedral (1755) and a series on the *Life of St Ignatius* (c. 1762) with Cipriano Toldeo y Gutiérrez (fl 1762–73) for the church of La Compañía in Cuzco (both *in situ*). Antonio Vilca, another notable painter, was apprenticed to Zapata. The popular secular theme of portraits of the Inca kings continued until well into the 19th century. They were initially painted alongside those of the Spanish kings until the latter were discontinued, and the Inca dynasty continued from Manco Capar to Atahuallpa. Cueva and Juan y Ulloa made engravings on the theme; Ulloa's was published in *Viaje a la América meridional*.

Bibliography

C. del Pomar: *Pintura colonial* (Lima, 1928)

R. Vargas Ugarte: *Ensayo de un diccionario de artífices de la América meridional* (Lima, 1947)

Mariategui: *Pintura cuzqueña del siglo XVII* (Lima, 1951)

E. Marco Dorta: *Arte en América y Filipinas* (Madrid, 1973)

P. Macera: 'El arte mural cuzqueño, de los siglos XVI al XX', *Trabajos Hist.*, ii (1977), pp. 343–460

J. Mesa and T. Gisbert: *Historia de la pintura cuzqueña*, 2 vols (Lima, 1982)

J. Bernales Ballesteros: *Historia del arte hispanoamericano: Siglos XVI a XVIII*, ii (Madrid, 1987)

C. Dean: 'Ethnic Conflict and Corpus Christi in Colonial Cuzco', *Colon. Amer. Rev.*, ii/1–2 (1993), pp. 93–120

T. Benavente Velarde: *Pintores cusqueños de la colonia* (Cuzco, 1995)

L. E. Wuffarden: *La procesión del Corpus Domini en el Cuzco* (Seville, 1996)

TERESA GISBERT

Danube school

Group of German and Austrian artists c. 1500–50, of which Albrecht Altdorfer and Wolfgang Huber were two of the central figures. The term came into use following an observation by Theodor von Frimmel (1853–1928) in 1892 that painting in the Danube region around Regensburg, Passau and Linz possessed certain common characteristics that entitled one to speak of a Danube style (*Donaustil*). This point was taken up by Hermann Voss in *Der Ursprung des Donaustils* (Leipzig, 1907). Once the early, Viennese works (c. 1500–05) of Lucas Cranach the elder were recognized as having provided the formative stage of this stylistic development, the name Danube school (*Donauschule*) took deeper root. The name also carried associations of the regional landscape (*Donaulandschaft*) and of the art born of that region (*Kunstlandschaft*), evoking what critics saw

21. Lucas Cranach: *Crucifixion*, 1503 (Munich, Alte Pinakothek)

Munich, Alte Pin.), landscape dominates the scene, and in drawings such as the *Danube at Sarmingstein* (1511; Budapest, Mus. F.A) it was the sole subject of the work. These examples were followed by etchings and paintings of landscapes by Altdorfer from *c.* 1520 that mark the birth of landscape as an autonomous theme in European art (see col. pl. X). No less important than the thematic emphasis on nature is the subjective portrayal of it and of human experience itself. Danube school landscapes are those not of scientific naturalists but rather of artists who were expressing the power and state of becoming in nature. There is movement in the mountainous topography, burgeoning growth in the forests and explosive radiance in the heavens. Cranach's *Crucifixion* (1503; Munich, Alte Pin.; see fig. 21), another example of landscape in a leading expressive role rather than simply background, also shows how such handling of nature reinforces the artist's subjective presentation of the religious theme. No frontal symmetry or formal hierarchy mitigates the view of suffering and approaching storm.

In depicting the human figure, artists of the Danube school paid little heed to anatomical accuracy or skeletal structure. The treatment of both figures and landscape is emphasized in the literature as evidence for what distinguishes this art from that of Dürer or the Renaissance in Italy, although prints by Dürer and Italian engravings were important sources for Cranach, Altdorfer, Huber and other artists of the Danube school. The contorted bodies and turbulent drapery patterns, especially as seen in Cranach's early woodcuts and paintings of the *Passion*, indicate that the Danube school had roots in Late Gothic Bavarian and Austrian art, especially that of Jan Polack in Munich and the Austrian paintings of Jörg Breu.

as its nature-orientated quality. 'Danube school' and 'Danube style' established themselves as terms of reference too convenient to be dislodged, despite the demurs of many critics. The leading artists did not form a school in the usual sense of the term, since their communality derived from neither a single workshop nor even a particular centre, and the geographical limits of the school or style are even less precise. Nevertheless, continuing discussion over the idea of a Danube school has given *de facto* acknowledgement that it does exist as a stylistic phenomenon.

1. Characteristics

The defining characteristics of the Danube school are, on the one hand, the prominence of nature and the manner of representing it, and on the other the relationship of the human figure or human events to nature. In Altdorfer's early works, such as *St George and the Dragon* (1510;

2. Extent

The roster of artists considered part of the Danube school has grown with the literature over the past century. Ernst Buchner (1892–1962) assembled works by many of these artists in the exhibition he dedicated to Altdorfer in 1938, but for only a few of the included artists, such as Erhard

Altdorfer and Michael Ostendorfer, can an association with Altdorfer and/or Regensburg be assumed certain. For most of the others, largely anonymous masters, there is no evidence of a connection with either Altdorfer or Regensburg. In his *Malerei der Donauschule* (Munich, 1964) Alfred Stange offered an anthology of works according to individual hands and renewed consideration of their common regional character. In the exhibition of 1965 in Linz and St Florian, *Die Kunst der Donauschule*, and in the related essays, *Werden und Wandlung, Studien zur Kunst der Donauschule* (Linz, 1967), the geographical scope of the Danube school was expanded to reach all of central Europe, Switzerland and parts of northern Germany. Some critics have seen this expansion of the Danube school as yet another reason to be sceptical about the validity and coherence of this term. Nevertheless, when Erhard Altdorfer left the Danube region for Mecklenburg and Georg Lemberger moved from Landshut to Saxony, they produced woodcuts that are still easily recognized as having characteristics of the Danube school. On the other hand, when Cranach left Vienna for Wittenberg in 1504–5, those qualities of his art that had originally defined much of the Danube school rapidly diminished.

3. Media

Although the art of the Danube school was essentially the work of painters, drawings and prints were the primary vehicles for pictorial ideas. The development of landscape in the graphic arts can be explained partly by the licence of prints and drawings to deal with subjects not yet considered appropriate for the thematically conservative medium of painting, but also by a special affinity between etching and the portrayal of landscape, as the nine landscape etchings by Altdorfer demonstrate. This component of the Danube school, carried into the 1540s and 1550s by Augustin Hirschvogel and Hanns Lautensack, led the way for subsequent generations of landscape etchers from Pieter Bruegel the elder to Rembrandt and beyond.

Sculpture and architecture have also figured in studies of the Danube school, especially at the time of the Linz exhibition (1965) and afterwards. Visual and historical connections between works of Hans Leinberger and Albrecht Altdorfer can clearly be seen, particularly in Leinberger's free-standing figures of the Virgin and the vigorous movement and modelling of drapery but also in his pictorial handling of reliefs. Master I.P. is the main representative of several anonymous carvers active in Passau, Salzburg and Prague who, using boxwood and fine-grained fruit woods, produced small scenes with forest settings in the manner of the Danube school. Master I.P.'s *Fall of Man* (1521; Vienna, Belvedere) defines this category of sculpture, with its engraving-like detail of foliage and other landscape motifs translated into delicate, three-dimensional forms.

Bibliography

T. von Frimmel: review of M. Friedländer: *Albrecht Altdorfer* (Leipzig, 1891), *Repert. Kstwiss.*, xv (1892), pp. 417–21

H. Voss: *Der Ursprung des Donaustils*, Kunstgeschichtliche Monographien, vii (Leipzig, 1907)

O. Benesch: 'Die Tafelmalerei des 1. Drittels des 16. Jahrhunderts in Österreich', *Bild. Kst Österreich*, iii (1938), pp. 137–48; repr. in *Collected Writings*, iii, ed. E. Benesch (London, 1972), pp. 3–11

Albrecht Altdorfer und sein Kreis (exh. cat. by E. Buchner, Munich, Neue Staatsgal., 1938), pp. 147–9

A. Stange: *Malerei der Donauschule* (Munich, 1964)

Alte & Mod. Kst, x (1965), part 80 [special edn devoted to essays on the Danube school]

Die Kunst der Donauschule, 1490–1540 (exh. cat., St Florian, Abbey; Linz, Schlossmus.; 1965)

Werden und Wandlung: Studien zur Kunst der Donauschule (Linz, 1967)

Prints and Drawings of the Danube School (exh. cat., ed. K. Holter and O. Wutzel; New Haven, CT, Yale U. A.G., 1969)

R. Janzen: *Albrecht Altdorfer: Four Centuries of Criticism*, ix of Stud. F.A.: Crit. (1980)

H. Schindler: 'Albrecht Altdorfer und die Anfänge des Donaustils', *Ostbair. Grenzmarken*, xxiii (1981), pp. 66–73

Altdorfer and Fantastic Realism in German Art (exh. cat., ed. J. Guillaud and M. Guillaud; Paris, Cent. Cult. Marais, 1984), pp. 10–47, 149–64

B. Decker: *Das Ende des mittelalterlichen Kultbildes und die Plastik Hans Leinbergers*, Bamberger Studien zur

Kunstgeschichte und Denkmalpflege, iii (Bamberg, 1985), pp. 33–54

G. Goldberg: *Albrecht Altdorfer. Meister von Landschaft: Raum, Licht* (Munich, 1988)

Albrecht Altdorfer: Zeichnungen, Deckfarbenmalerei, Druckgraphik (exh. cat. by H. Mielke, W. Berlin, Kupferstichkab., 1988)

CHARLES TALBOT

Delft school

Name given to the Dutch painters active in Delft in the second half of the 17th century who specialized in either realistic architectural paintings or genre scenes. Before *c.* 1650 there was no coherent group of painters in Delft; each artist specialized in his own genre. However, in the late 17th century, the city became the centre of a remarkable artistic flowering that included both these genres, each of which attained special distinction. Gerrit Houckgeest, Hendrick van Vliet and Emanuel de Witte concentrated from 1650 onwards on the depiction of the interiors of Delft churches, frequently taking the mausoleum of William of Orange, in the Nieuwe Kerk, or the grave of Piet Heyn in the Oude Kerk as their subjects. In most of these works the vanishing-point is no longer located on the central axis, but instead to one side, thereby creating a more natural viewing angle. There is a more illusionistic character to these paintings than is found in those of Pieter Saenredam, who had first introduced the genre. De Witte, in particular, excelled in his control of chiaroscuro effects.

Carel Fabritius, who settled in Delft *c.* 1650, after a period of study with Rembrandt, was also expert in the use of perspective, with a sensitivity to atmosphere and light effects. Although he was killed in the great gunpowder explosion of 1654 at Delft, his work can be considered as the basis for the Delft school genre painters, who are exemplified in the work of Pieter de Hooch and Johannes Vermeer. De Hooch came to Delft in 1653 and worked there until 1661; during this period he produced the best and most characteristic work of his career. His work centres around scenes of daily life: burghers in and around

22. Pieter de Hooch: *Courtyard of a House in Delft* (London, National Gallery)

their houses against a carefully composed background of views reaching through to the distant background (see fig. 22). Like Fabritius, de Hooch strove for a subtle use of well-observed, natural light, combined with the expert use of perspective. Johannes Vermeer came to Delft in 1632, probably after studying with the Utrecht Caravaggisti. Although he began by producing narrative pieces, from 1656 until his death in 1675 he specialized primarily in interiors containing only one or two figures, in which the interior itself is an important element of the composition. A typical feature of the Delft school is the use of a camera obscura in order to create the most realistic scene possible.

Bibliography

I. Manke: *Emanuel de Witte, 1617–1692* (Amsterdam, 1963)

A. K. Wheelock: 'Gerard Houckgeest and Emanuel de Witte: Architectural Painting in Delft around 1650', *Simiolus*, viii (1975–6), pp. 168–85

——: *Perspective, Optics and Delft Artists around 1650* (New York and London, 1977)

P. C. Sutton: *Pieter de Hooch* (New York and Oxford, 1979)

C. Brown: *Carel Fabritius* (Oxford, 1981)

W. A. Liedtke: *Architectural Painting in Delft: Gerard Houckgeest, Hendrick van Vliet, Emanuel de Witte* (Doornspijk, 1982)

J. M. Montias: *Artists and Artisans in Delft: A Socioeconomic Study of the Seventeenth Century* (Princeton, 1982)

B. Haak: *Dutch Painters of the Golden Age* (Amsterdam and New York, 1984), pp. 438–53

A. Blankert, J. M. Montias and G. Millard: *Johannes Vermeer* (Amsterdam, 1987)

J. M. Montias: *Vermeer and his Milieu: A Web of Social History* (Princeton, 1989)

Perspectives: Saenredam and the Architectural Painters of the 17th Century (exh. cat., Rotterdam, Boymans-van Beuningen, 1991)

ILJA M. VELDMAN

Directoire style

Style fashionable in France, especially in Paris, named after the short-lived Directoire period (Oct 1795–Nov 1799). It was marked at first by the collapse of the French economy and then by the rapidly growing wealth of financial speculators, although Ride Felice wrote: 'Many styles are misnamed, none more so than this one; even if it exists . . . was ever a style established in such a short time?' (Felice, n.d.). The style itself displayed elements of the classicism that had prevailed in the later part of the 18th century and had been known in the ARABESQUE STYLE, GROTESQUE and ETRUSCAN STYLE. A new austerity was introduced after the Revolution, and reflecting the taste of the new class of military officials, politicans and financial speculators, it became rapidly more opulent. Under the influence of Charles Percier and Pierre François Leonard Fontaine it was developed into the flourishing EMPIRE STYLE.

The Directoire style is exhibited mainly in interior decoration (see Krafft and Ransonette) and in the applied arts. Distinguishing characteristics are the use of colour that is light in tone and of grotesque motifs shown in outline. The classical forms of the lightly built furniture, by such cabinetmakers as Georges Jacob the younger, show restrained use of materials (e.g. chair, ebony; 1796–7, Paris, Mus. A. Dec.). Decorative motifs also included such Revolutionary symbols as the Phrysian bonnet or cap of Liberty, clasped hands as an emblem of Fraternity, fasces and oak leaves, applied to furniture, ceramics and textiles. In Germany the style was promoted in F. Bertuche's journal *Journal des Luxus und der Moden*, which published interior decorative schemes and fashion designs (Weimar, 1793–1810).

Bibliography

R. Felice: *Le Meuble français sous Louis XVI et l'empire* (Paris, n.d.)

J. C. Krafft and N. Ransonette: *Plans, coupes et élévations des plus belles maisons et hôtels construits à Paris et dans les environs, au IX–X* (Paris, 1771–1802)

F. Coutet: *Intérieurs Directoire et Empire* (Paris, 1932)

G. Janneau: *Le Style Directoire* (Paris, 1938)

HANS OTTOMEYER

Divisionism

Term invented by Paul Signac to describe the Neo-Impressionist separation of colour into dots or patches applied directly to the canvas. Following the rules of colour-contrasts laid out by Ogden Rood and Michel-Eugène Chevreul, this method was intended to produce maximum brilliance scientifically and to avoid the muddiness caused by physically mixing colours before applying them to the canvas. Seen close to, a Divisionist canvas is a mass of contrasting dots: at a distance, the colours enhance each other to produce an effect of shimmering luminosity. Divisionism refers to the general principle of the separation of colour, unlike the term POINTILLISM, which refers specifically to the use of dots. Employed in France by members of the Neo-Impressionist group, Divisionism was also popular in Belgium among Les XX and in the Netherlands. In Italy the use of Divisionism, stimulated by Vitorio Grubicy, characterizes the advanced experiments of such

painters as Angelo Morbelli, Giovanni Segantini, Giuseppe Pellizza da Volpedo, Gaetano Previati and Plino Nomelli; a Divisionist phase also marked the early works of the Futurist artists Umberto Boccioni, Giacomo Balla, Carlo Carrà and Gino Severini, among others.

AURORA SCOTTI TOSINI

Dürer Renaissance

Term used since 1971 for the phenomenon of increased interest in Albrecht Dürer that occurred in Europe between 1570 and 1630 and resulted in numerous copies and imitations of his work. It was previously thought that such works were created exclusively as forgeries. In practice there are still difficulties in distinguishing some late 16th-century and early 17th-century copies and imitations from 19th-century forgeries, but the Dürer Renaissance and the works it generated are now seen as one of the most striking developments in European Mannerism. Even within the phenomenon there are subtle distinctions: the ingenious variant produced around 1600 is ranked higher than the repetitive copy. The concept most appreciated is 'imitatio', in which the example of the older master is mingled with contemporary taste and trends.

1. Literary origins

Within 40 years of Dürer's death (1528), authors created a literary basis for the retrospective consideration of his achievements. Comments and texts by Lambert Lombard (as recorded by his pupil Domenicus Lampsonius in 1565) and Vasari (1568) were particularly influential, as well as those by Giovanni Paolo Lomazzo (1585) and Karel van Mander I (1604). They saw in Dürer a '*uomo universale*' (Vasari). His gift of visual inventiveness was admired, and his ability as a craftsman (especially as an engraver) was praised, as was his honest character. The Counter-Reformation hailed Dürer as an artist who remained a Catholic: a decree of the last session (1563) of the Council of Trent on the question of pictures named him a model artist, alongside Cimabue, and in 1582 Cardinal Gabriele

Paleotti counted him among the saints and blessed. New editions and translations of his three books on art theory were published, and important sections of his other written work, which was not printed until the end of the 18th century (particularly the so-called diary of the journey to the Netherlands in 1520–21), were copied and circulated. At the same time he was attributed with sculptural work, which even led connoisseurs to consider him a great northern wood-carver. He appeared as an established theoretician and experienced practical man, as in the engraving by Lucas Kilian of *Temple of Honour* after Dürer (1617; Hollstein, no. 177).

2. Regional developments

The Dürer Renaissance has been seen incorrectly as a predominantly courtly phenomenon, based on its importance at the imperial court at Prague and the Wittelsbach court in Munich. But this view fails to take account of developments in countries such as Italy, Spain, England and the Netherlands and in towns such as Nuremberg, Augsburg and Antwerp. In the 1570s, Dürer's home town of Nuremberg must have been the centre of the studying and copying of his work. Most of his paintings could then still be found there, and the majority of his surviving drawings were in the collection of Willibald Imhoff the elder. The late 16th-century and early 17th-century collector Paulus Praun of Nuremberg owned more than 150 drawings, including many imitations by the painter Hans Hoffmann, who set both the qualitative and the quantitative standard of Dürer imitations (see fig. 23). Hoffmann, who was a citizen of Nuremberg in 1576, is now seen as the most important master of the Dürer Renaissance. When he left Nuremberg for Munich in 1584, he made room for other Dürer imitators. In 1613 the Council of Nuremberg enlisted the best of these—Paul Juvenel I, Jobst Harrich (c. 1580–1617) and Georg Gärtner II (c. 1575/80–1654)—to restore and complete Dürer's frescoes in the assembly room in the town hall.

After Nuremberg, Prague developed as a centre of the Dürer Renaissance. The Holy Roman

Emperor Rudolf II brought artists from different countries to Bohemia, among them specialists who copied Dürer's work, including Hoffmann, who arrived in 1585. The Prague court style spread through engravings after drawings by Dürer in the imperial collection, such as those by Aegidius Sadeler II. Meanwhile in Munich, Maximilian, Elector of Bavaria, became a serious competitor as a collector of works by Dürer. After the Nuremberg collection was split up, his agents sought Dürer's pictures as far away as Italy and Scandinavia. A peculiarity of the Munich Dürer Renaissance was the tendency to improve and over-paint original Dürer paintings, a practice apparently thought to increase their value. Paraphrases of his work, such as those signed by Georg Vischer, are exceptional: most of the pictures and drawings produced during the Dürer Renaissance are unsigned or bear a false AD monogram. After Dürer's death his prints were also copied, for instance by the Hopfer family in Augsburg, to satisfy the continuing demand for his graphic work.

In Italy, interest in Dürer's work persisted throughout the whole of the 16th century and well into the 17th; his prints, in particular, were used by such leading masters as Ludovico Carracci, Caravaggio and Guido Reni. The emphasis placed on Dürer by the Council of Trent was important for artists in the Iberian peninsula: Spanish painters copied his woodcuts, and in the work of El Greco, especially, there are occasional traces of his influence. Dürer's impact on art life in England c. 1600 has yet to be clarified, but he was praised by Nicholas Hilliard and Richard Haydocke (fl 1598–1640).

The situation is better known in the Netherlands, where deceptive copies of engravings and woodcuts were made, particularly by the Wierix brothers. Antwerp, where Dürer's visit of 1520–21 was never forgotten, became a centre of copying his work. Alongside direct copies of his engravings and others made in reverse, masterful paraphrases of his work were created in which the borders between respectful imitation and deceptive forgery were blurred, as in prints of Hendrick Goltzius.

23. Hans Hoffman: *Hare* (after Dürer) (Rome, Galleria Nazionale d'Arte Antica)

3. Transmutations

The most speculative products of the Dürer Renaissance include works based on Dürer but transferred to another medium. For example, his engraving *Knight, Death and the Devil* (1513; B. 98) was transformed into paintings (Karlsruhe, Staatl. Ksthalle; Nuremberg, Ger. Nmus.), as was the engraving of the *Fall of Man* (1504; B. 1). Graphic images of the Virgin became small reliefs (Frankfurt am Main, Liebieghaus). Some painters also developed creative fantasies that isolated details in Dürer's well-known self-portraits and put them together into new 'Dürer' portraits. Similarly, contemporary portrait medals of the artist were enlarged by Hans Schwarz and Mathes Gebel and varied by Hans Petzold.

Bibliography

Hollstein: *Ger.*

A. von Bartsch: *Le Peintre-graveur* (1803–21) [B.]

M. Mende: *Dürer-Bibliographie* (Wiesbaden, 1971), pp. 544–7

G. Goldberg: 'Zur Ausprägung der Dürer-Renaissance in

München', *Münchn. Jb. Bild. Kst*, xxxi (1980), pp. 129–75

Dürers Verwandlung in der Skulptur zwischen Renaissance und Barock (exh. cat., ed. H. Beck and B. Decker; Frankfurt am Main, Liebieghaus, 1981)

H. G. Gmelin: 'Illuminierte Druckgraphik um 1600: Ein Phänomen der Dürerrenaissance?', *Städel-Jb.*, ix (1983), pp. 183–204

Albrecht Dürer und die Tier- und Pflanzenstudien der Renaissance (exh. cat. by F. Koreny, Vienna, Albertina, 1985; Eng. trans., Boston, MA, 1988)

T. DaCosta Kaufmann: *The School of Prague: Painting at the Court of Rudolf II* (Chicago and London, 1988)

B. Decker: 'Im Namen Dürers: Dürer-Renaissance um 1600', *Pirckheimer-Jb.*, vi (1991), pp. 9–49

MATTHIAS MENDE

Düsseldorf school

Group of painters studying and working from the mid-1820s to the 1860s in Germany at the Düsseldorf Kunstakademie. Among the principal artists were Carl Friedrich Lessing, Ferdinand Theodor Hildebrandt (1804–74), Johann Wilhelm Schirmer, Johann Peter Hasenclever, Karl Wilhelm Hübner, Andreas Achenbach (1815–1910), Ludwig Knaus and Carl Ferdinand Sohn. Several had been pupils of Wilhelm Schadow in Berlin and had followed him to Düsseldorf after he became Director of the Kunstakademie in 1826. Schadow increased the prestige of the school, and his programme of instruction, which involved extreme naturalness of representation, attracted large numbers of students. By 1850 the school had replaced the Dresden Akademie as the favoured place in Germany to study art. Lessing, Hildebrandt and Hübner are best known for their large, carefully staged and somewhat melodramatic paintings of the 1830s and 1840s that often have political content, for example Lessing's *Hussite Sermon* (1836; Düsseldorf, Kstmus.; on loan to Berlin, Alte N.G.). Achenbach and Schirmer were among those who painted landscapes, executing works in which a clear, often brittle, light helps to localize the scene, as in Schirmer's *German Landscape* (1854; Essen, Mus. Folkwang). Group portraits, for example Sohn's the *Bendemann Family and their Friends* (c. 1832; Krefeld, Kaiser-Wilhelm Mus.), are often cramped in composition and have sitters who only occasionally psychologically interact. The artists of the Düsseldorf school admired the subject-matter and the meticulous style of the Lukasbrüder and were also influenced by the Biedermeier painters, particularly Ferdinand Georg Waldmüller. Because of Düsseldorf's proximity to the Netherlands, strong influences of the work of such 17th-century Dutch masters as Gerrit Dou and Gabriel Metsu and such contemporary Dutch and Belgian genre painters as Ferdinand De Braekeleer are also present in their work. By the 1850s much of the work produced by the Düsseldorf school consisted of sentimental and anecdotal genre scenes, for example Knaus's *The Cardsharp* (1851; Düsseldorf, Kstmus.). This type of painting was practised well into the 1880s by some of the original members and their followers. The literal and precise painting taught at the Akademie attracted the Americans Richard Caton Woodville and Eastman Johnson. The Hungarian Mihály Munkácsy, the Swiss Benjamin Vautier and the Norwegian Adolph Tidemand also studied in Düsseldorf and took back to their respective countries the forthright style and approach learnt as students.

Bibliography

F. Novotny: *Painting and Sculpture in Europe, 1780–1880*, Pelican Hist. A. (Harmondsworth, 1960, 2/1970)

W. Hult: *Die Düsseldorfer Malerschule, 1819–1869* (Leipzig, 1964)

I. Markowitz: *Die Düsseldorfer Malerschule* (Düsseldorf, 1969)

Die Düsseldorfer Malerschule (exh. cat., ed. W. von Kalnein; Düsseldorf, Kstmus.; Darmstadt, Ausstellhallen Mathildenhöhe, 1979)

W. Vaughan: *German Romantic Painting* (New Haven and London, 1980)

Werke der Düsseldorfer Malerschule: Gemälde, Aquarelle (exh. cat., Düsseldorf, Gal. Paffrath, 1986)

□

Dutch Italianates

Term conventionally used to refer to the school of Dutch painters and draughtsmen who were active in Rome for more than a hundred years, starting

from the early 17th century. These artists produced mainly pastoral subjects bathed in warm southern light, set in an Italian, or specifically Roman, landscape. The term is also often applied, but wrongly, to artists who never left the northern Netherlands but who worked primarily in an Italianate style. The origins of the use of the term date to the early 20th century, when art historians began to distinguish between the native landscapes of Dutch painters such as Jan van Goyen or Jacob van Ruisdael and those of their compatriots, such as Herman van Swanevelt or Jan Both, who travelled to Italy. The Italianates are sometimes confused with the group of artists known as the BAMBOCCIANTI, a name that, although occasionally used as a substitute, correctly refers only to artists in the immediate circle of the Dutch artist Pieter van Laer (called il Bamboccio), who was active in Rome from 1625 to 1639 and painted scenes of popular Roman life. At least some of the Bambiccianti are included in the group of Dutch Italianates.

For northerners arriving for the first time in Rome, its ruins of past splendour excited both interest and admiration, tinged perhaps with a certain nostalgia. Visitors were also inspired by the natural environment, which seemed so varied and lively compared to the flat, uniform landscape of the Low Countries, and the warm, golden glow of Italy had no parallels in the grey light of northern Europe.

The group of artists called Italianate were not the first northern artists to visit Italy. Among the pioneers were the early and mid-16th-century artists Jan van Scorel, Jan Gossart and Maarten van Heemskerck, whose promotion of Italian Renaissance ideals resulted in a style often called ROMANISM. The Flemish artist Paul Bril travelled to Italy c. 1580; his earliest landscapes were highly Mannerist, but those painted after c. 1605 were far more naturalistic and served as important sources of inspiration for the Dutch Italianates. At the beginning of the 17th century a small group of painters from Utrecht (later known as the UTRECHT CARAVAGGISTI), including Gerrit van Honthorst and Hendrick ter Brugghen, settled in Rome, where they were profoundly influenced by the new ideas

introduced by Caravaggio. By the mid-1620s the Utrecht artists were on their way back to the northern Netherlands, just as the first Dutch Italianates were setting out.

The first group of Italianate artists, made up of artists born between 1595 and 1600, including Cornelis van Poelenburch and Bartholomeus Breenbergh (to whom one may add Herman van Swanevelt as a transitional figure), was active in Rome and Florence during the late 1620s and the 1630s. They painted mainly mythological, Arcadian landscapes set in a Roman countryside filled with ruins that were often imaginary (e.g. Poelenburch's *Mercury and Battus*, Florence, Uffizi; see col. pl. XI). Besides the late work of Bril, other influences included the small, accurately observed landscape backgrounds in paintings by the German artist Adam Elsheimer, who had died in Rome only a few years earlier, and the light and open landscapes of the Italian Filippo Napoletano. Shortly after 1620 Poelenburch and Breenbergh helped establish the SCHILDERSBENT, a confraternity for northern artists in Rome, the main purpose of which was to oppose the stringent rules of the local Accademia di S Luca.

This first generation was followed by a second group of artists, born c. 1615–25, which was active in Rome or the Netherlands between the 1630s and the 1650s: these included Jan Asselijn, Thomas Wijck, Jan Both, Jan Baptist Weenix, Nicolaes Berchem, Karel Dujardin and Adam Pynacker (see fig. 24). In the work of these artists the repertory based on ancient architecture was tempered by the introduction of contemporary buildings, while mythological subjects were replaced increasingly by pastoral and low-life (*bambocciate*) scenes in either an urban or a country setting.

The third generation was formed of landscape artists born in the mid-17th century, including Johannes Glauber, Aelbert Meyeringh, Jan Frans van Bloemen, Isaac de Moucheron, Jacob de Heusch (1657–1701) and, to a lesser degree, Gaspar van Wittel, all of whom were active at the end of the 17th century or during the early years of the 18th. Apart from van Wittel, who continued the tradition of the naturalistic Italianate landscape, these painters sacrificed the close

who never left the Low Countries, a phenomenon particularly well observed in the effect that Jan Both, who was in Rome from 1636 to *c.* 1641, had on such pupils as Willem de Heusch and Frederick de Moucheron, both of whom painted only Italianate landscapes.

As a genre, Dutch Italianate landscape paintings were highly prized in the northern Netherlands during the 17th and 18th centuries. In the 17th century they fetched higher prices than native Dutch landscapes (see price tables in Chong), and according to Houbraken they were also more popular in the early 18th century. However, during the 19th century these works were dismissed and their authors accused of having given rise to a hybrid style that was neither Dutch nor Italian. Appreciation of their work diminished still further during the Impressionist period, when renewed interest was shown in the local Dutch school and in artists such as Jacob van Ruisdael and Meindert Hobbema, who were seen as precursors of painting *en plein air.* Evidence for renewed interest in the Dutch Italianates dates to the 1920s, when Hoogewerff carried out detailed archival research that established which 17th-century northern artists actually spent time in Italy and for how long, but it was Stechow's critical re-evaluation of 1953 that defined the group and the nature of their art. The use of the stylistic label was codified by the important exhibition *Nederlandse 17e eeuwse Italianiserende landschapschilders* held in Utrecht in 1965.

24. Adam Pynacker: *Landscape with Rising Sun* (Paris, Musée du Louvre)

observation characteristic of the earlier Italianates and produced mainly idealized classical landscapes inspired by Gaspard Dughet and Nicolas Poussin.

Drawing played a prominent part in the work of most of the Dutch Italianate artists. The large number of drawings by Breenbergh, Asselijn, Berchem and Wijck, for example, reflects the intense curiosity and interest they experienced in a natural environment so radically different from that of their homeland. They spent much time and painstaking effort in documenting the views in Rome and in the surrounding Campagna, and the drawings often provided a repertory of motifs that could be used in later paintings, including those executed back in the Netherlands.

The contact with Italy brought about a clear change of direction in the art of those artists who made the journey south. Once back home, many continued to work in an Italianate vein. Their work also stimulated stylistic changes in artists

Bibliography

A. Houbraken: *De groote schouburgh* (1718–21)

G. J. Hoogewerff: *Nederlandsche kunstenaars te Rome, 1600–1725: Uittreksels uit de parocchiale archieven* (The Hague, 1942–3)

W. Stechow: 'Jan Both and the Re-evaluation of Dutch Italianate Painting', *Mag. A.,* xlvi (1953), pp. 131–6; R in *Actes du XVIIème congrès international de l'histoire de l'art: The Hague,* 1953, pp. 425–32

Italy through Dutch Eyes: Dutch Seventeenth-century Landscape Artists in Italy (exh. cat. by W. Stechow, Ann Arbor, U. MI, Mus. A., 1964)

Nederlandse 17e eeuwse Italianiserende landschap-
schilders (exh. cat., ed. A. Blankert; Utrecht, Cent.
Mus., 1965); rev. and trans. as Dutch 17th-century
Italianate Painters (Soest, 1978)

J. Rosenberg, S. Slive and E. H. ter Kuile: Dutch Art and
Architecture, 1600–1800, Pelican Hist. A.
(Harmondsworth, 1966)

W. Stechow: Dutch Landscape Painting of the Seventeenth
Century (London, 1966/R 1981)

L. Salerno: Pittori di paesaggio del seicento a Roma, 3 vols
(Rome, 1977–80)

R. Trnek: Niederländer und Italien: Italienisante
Landschafts- und Genremalerei von Niederländern des
siebzehnten Jahrhunderts in der Gemäldegalerie der
Akademie der bildenden Künste in Wien (Vienna,
1982)

G. Briganti, L. Trezzani and L. Laureati: The Bamboccianti:
Painters of Everyday Life in 17th-century Rome (Rome,
1983)

B. Haak: The Golden Age: Dutch Painters of the
Seventeenth Century (New York, 1984), pp. 143–6

Die Niederländer in Italien: Italienisante Niederländer des
17. Jahrhunderts aus österreichischem Besitz (exh. cat.
by R. Trnek; Salzburg, Residenzgal.; Vienna,
Gemäldegal. Akad. Bild. Kst.; 1986)

A. Chong: 'The Market for Landscape Painting in
Seventeenth-century Holland', Masters of
17th-century Dutch Landscape Painting (exh. cat.
by P. C. Sutton and others; Amsterdam, Rijksmus.;
Boston, MA, Mus. F.A.; Philadelphia, PA, Mus. A.;
1987–8), pp. 104–20

P. C. Sutton: '"The Capital of Pictura's School": The Pre-
Rembrandtists Poelenburch and Breenbergh', ibid.,
pp. 28–32

—: 'Birds of a Feather: The Second Generation of Dutch
Italianates', ibid., pp. 41–5

Italian Recollections: Dutch Painters of the Golden Age
(exh. cat. by F. J. Duparc and L. L. Graif, Montreal, Mus.
F.A., 1990)

LAURA LAUREATI

Eastlake style

Late 19th-century style of American architecture
and furniture. It owed its name to the furniture
designs of Charles Locke Eastlake, which became
widely known because of his book *Hints on
Household Taste in Furniture, Upholstery and
Other Details*, first published in London in 1868
and in Boston, MA, in 1872. The book was an
immediate success in the USA, and six more
American editions appeared in the next eleven
years. In the preface to the fourth English edition
(1878), Eastlake wrote of his dismay at finding
'American tradesmen continually advertising
what they are pleased to call "Eastlake" furniture
. . .for the taste of which I should be very sorry to
be considered responsible'. Eastlake-style furni-
ture of the 1870s by such firms as Mason & Hamlin
was decorated profusely with heavily carved
Gothic ornament, whereas Eastlake's own furni-
ture had decoration that was simpler and more
sparingly applied to emphasize function.

The Eastlake style in architecture was a trans-
formation of the Stick style, or more often the
Queen Anne Revival, by the use of forms derived
from furniture: columns resembled table legs,
and there was a profusion of curved brackets, spin-
dles, knobs of various shapes and ornament
consisting of circular perforations. It flourished
in the USA from the mid-1870s to c. 1890, with
a large number of examples in California. Eastlake
recorded his amazement and regret in the
California Architect and Building News in 1882.
There was a similar development in England,
which has been little noticed. Most Eastlake-
style architecture is anonymous street archi-
tecture. Three houses in California that show
something of the variety of the style are the
Baldwin Guest House (1881) in the County
Arboretum, Los Angeles, by Albert A. Bennett
(1825–90); the Carson House (1884–6), Eureka, by
Samuel Newsom and Joseph Cather Newsom; and
the Haas-Lilienthal House (1886), San Francisco, by
Peter Schmitt.

Bibliography

C. L. Eastlake: Hints on Household Taste in Furniture,
Upholstery and Other Details (London, 1868; Boston,
MA, 1872/R New York, 1969)

H. Kirker: California's Architectural Frontier: Style and
Tradition in the Nineteenth Century (San Marino, CA,
1960/R Salt Lake City, UT, 1986)

Eastlake-influenced American Furniture, 1870–1890 (exh.
cat. by W. J. S. Madigan, Yonkers, NY, Hudson River
Mus., 1973)

MARCUS WHIFFEN

Eclecticism

Term used to describe the combination in a single work of elements from different historical styles, chiefly in architecture and, by implication, in the fine and decorative arts. It was an important concept in Western architecture during the mid- and late 19th century, and it reappeared in a new guise in the latter part of the 20th century. The term is sometimes also loosely applied to the general stylistic variety of 19th-century architecture after Neo-classicism (i.e. from c. 1820), although the revivals of styles in that period have, since the 1970s, generally been referred to as aspects of HISTORICISM. Eclecticism is a term that plays an important role in critical discussions and evaluations but is somehow distant from the actual forms of the artefacts to which it is applied, and its meaning is thus rather indistinct. The simplest definition of the term—that every work of art represents the combination of a variety of influences—is so basic as to be of little use. In some ways Eclecticism is reminiscent of Mannerism in that the term was used pejoratively for much of the period of its currency, although, unlike Mannerism, Eclecticism hardly ever amounted to a movement or constituted a specific style: it is characterized precisely by the fact that it was not a particular style.

The term, which originated in antique philosophy, was revived in the 18th century, notably by Denis Diderot, in connection with Enlightenment attitudes to freedom from prejudice and authoritarianism, leaving each individual to search for truth, guided only by reason. The philosopher Victor Cousin (1792–1867) rejected the continual search for new ideas, advocating instead that philosophers should carefully select from, and combine afresh, all the doctrines that already existed. This seemed highly appropriate to the situation in which architecture found itself in the 1840s. The key issues were style and the prevailing tendency to define architecture in terms of style. While an ever-widening plurality of historical styles had come into general use, encouraging complete stylistic freedom, academic revivalists, especially A. W. N. Pugin and later adherents of the Gothic Revival, demanded absolute allegiance to one style for all types of buildings. Alongside these opposing views a search began for a style that was not an imitation of the past but an expression of the 'new age'. Eclecticism seemed to offer a solution: its proponents used it to argue away the stigma attached to copyism, at the same time stressing that by skilfully combining the best features of all styles of the past, they could fulfil the demands of modernity for all types of buildings.

Similar trends, in which the term itself was not used, were apparent, for example, in the buildings and writings of Jean-Nicolas-Louis Durand, who proposed a solid, arcuated style derived from disparate sources. Out of this arose the RUNDBO-GENSTIL (round arch style), which was supported by, among others, Heinrich Hübsch. In England Thomas Hope voiced similar convictions, and there was a rise in popularity of the 'in-between' revival styles—such as Elizabethan and Jacobean—for those who found Neo-classicism old-fashioned but did not want to commit themselves to 'churchy' Gothic Revival. In Munich in the 1850s Maximilian II, King of Bavaria (reg 1848–64), fostered a self-consciously mixed 'Maximilian style', which consisted largely of a cross between Venetian Renaissance and polychrome Gothic. In all countries the Greek and Roman classical revivals were enriched with motifs from various versions of the Renaissance style.

In the mid-19th century, however, a theory of 'l'éclectisme' was explicitly formulated by César-Denis Daly, the editor of the first French architectural periodical, Revue générale de l'architecture et des travaux publics (1840–90). Daly had reported faithfully all opinions in the heated debate of the 1840s between Raoul Rochette, the classicist, and Jean-Baptiste Lassus, the most ardent of the French Gothic Revivalists, and Daly formulated his conciliating theory of 'l'éclectisme' ('L'éclectisme, c'est à dire l'usage libre de tout le passé') during the years leading up to its main pronouncements in the 1850s (Rev. Gen. Archit., xi, 1853, col. 213; xvi, 1858, col. 5). The English architectural press, especially The Builder,

25. Alfred B. Mullett: State, War and Navy Building, Washington, DC, 1871–86

followed these efforts closely, and an equally vigorous debate ensued in England. The futility of competing revivalisms seemed finally to be demonstrated in the wrangling from 1856 over the style of the Foreign and India Offices and the Home and Colonial Offices, London, designed by George Gilbert I Scott. Not all of the new mediating solutions were described as eclectic, but one of the most fervent English users of the term was A. J. B. Hope, who preached a 'Liberal' or 'Progressive Eclecticism' in *The Common Sense in Art* (London, 1858).

It is not easy to pinpoint actual designs that fit the new theory precisely. There were, in fact, few proposals that literally combined motifs from a number of diverse sources in such a way that they remained individually recognizable. One of the most extraordinary was the design (1886; unexecuted) for Liverpool Cathedral by James M. Hay (1823–1915). The small-scale combi-

nation of recognizably different decorative details in one façade was also rare, although it was apparent in the competition design (1858; unexecuted) for Chelsea Vestry Hall, London, by Sydney Godwin (1828–1916) and Henry Godwin (1831–1917) (see *The Builder*, xvi, 1858, p. 851). A more systematic fusion of motifs, for example of classical 'horizontality' and Gothic 'verticality' and arched forms, was proposed by G. E. Street and George Gilbert I Scott in the 1850s for secular projects; this represented an eclectic strain within the Gothic Revival, although Street and Scott would not have called themselves 'eclectics'. Similarly, for many French architects the fusion of several different classical styles was seen as part of a generally Rationalist attitude towards construction and form (for discussion and illustration *see* RATIONALISM), rather than primarily an eclectic attitude towards the selection of stylistic motifs. In practice, eclecticism amounted

largely to a continuation of the various 'mixed' styles that had been initiated earlier, for example the Jacobean and French Renaissance, whether of the 'French Château' or Paris Louvre type. The latter was frequently called the Second empire style, a truly eclectic label; one of its most important examples was the extension from 1852 of the Louvre, Paris, under Emperor Napoleon III. Outside France the Second Empire style was practised chiefly in the USA, for example in the State, War and Navy Building (from 1871; see fig. 25), Washington, DC, by Alfred B. Mullet and others, as well as for much commercial architecture, especially for hotels in Great Britain (*see* Knowles). From the 1870s to the early 1890s most of the more richly decorated commercial façades and many public buildings in Britain and the USA adopted mixed styles.

The emergence of the English QUEEN ANNE REVIVAL movement in the late 1860s at first appeared as a victory for eclecticism over dogmatic Gothic Revivalism, but it also contained a new element of vernacular revivalism. The same applied to the new German 'Deutsch-Renaissance' movement from the 1870s. Indeed, the seriousness of such neo-vernacular styles and of the Arts and Crafts Movement marked the end of mid-19th-century urbane liberalism. Art Nouveau, the Beaux-Arts style of 1900, the European Secession and subsequent advent of Modernism had one major aim in common: to overcome what was then seen as the arbitrariness of all 19th-century stylistic diversity, whereby there seemed no need to distinguish between eclecticism, historicism or revivalism. In the 1960s, however, disillusion with the rigid functionalism of the International Style led to the emergence of new attitudes towards the use of decoration and stylistic elements derived from past sources— or, indeed, any source—and some architects of the 1970s and 1980s, such as Philip Johnson, referred to themselves as 'eclectic'. There was a new stress on 'arbitrariness' and multiform decoration, as in the Portland Public Services Building (1978–82), Portland, OR, by Michael Graves.

Bibliography
Diderot–d'Alembert
H. Hübsch: *In welchem Style sollen wir bauen?* (Karlsruhe, 1828/*R* 1984)
V. Cousin: *Cours de philosophie. . .sur le fondement des idées absolues du vrai, du beau et du bien* (Paris, 1836); Eng. trans. by O. W. Wight as *Lectures on the True, the Beautiful and the Good* (Edinburgh, 1853)
P. Collins: *Changing Ideals in Modern Architecture, 1750–1950* (London, 1965)
J. M. Crook: *The Dilemma of Style: Architectural Ideals from the Picturesque to the Post Modern* (London, 1987)
M. Soboya: *Presse et architecture au XIXe siècle: César Daly et la Revue générale de l'architecture* (Paris, 1991)
W. Herrmann, ed.: *In What Style Should We Build? The German Debate on Architectural Style* (Chicago, 1992)

STEFAN MUTHESIUS

Edwardian style

Term used to describe the architecture produced in Great Britain and its colonies in the period from 1890 to 1914, with the reign of Edward VII (1901–10) at its core, hence its name. It covers a multiplicity of styles, with five main strands: the GOTHIC REVIVAL, which continued to dominate church architecture; a range of approaches for domestic architecture that may usefully be grouped together as 'free style', developed by architects of the ARTS AND CRAFTS MOVEMENT; the Neo-georgian style, a revival of 18th-century British classical domestic architecture; the BAROQUE REVIVAL, used particularly for public buildings; and a French influence derived from the BEAUX-ARTS STYLE, found mostly in opulent buildings for commerce and entertainment. The question of appropriate style had been a constant preoccupation among Victorian architects. While many agreed on the need for a generally accepted national style for Britain, there was no consensus on what that style should be. From this confused background these five strands emerged.

By the 1890s the older Victorian architects were producing a new type of Gothic Revival church,

lighter and airier than before. Around the same time the leaders of the next generation were experimenting with an intensely original adaptation in the Arts and Crafts style. Notable examples include E. S. Prior's Holy Trinity (1887), Bothenhampton, Dorset, and W. R. Lethaby's All Saints' (1901–2), Brockhampton, Hereford & Worcs. The other important development in church architecture of the 1890s was the use of Byzantine or Early Christian forms, for example J. F. Bentley's Roman Catholic cathedral (begun 1895), Westminster, London; this was part of a BYZANTINE REVIVAL.

In domestic architecture and occasionally in larger buildings, the attempt to create a distinctive national style led several architects to seek freedom from foreign historical precedents and also to adapt local materials and forms, drawing on specifically English styles, such as the Elizabethan work of Robert Smythson and his contemporaries. Leonard Stokes, for example, used an Elizabethan window grid in the central tower of All Saints' Convent (1899–1903), near London Colney, Herts. The leading designers of this 'free style' were Lethaby, Prior, C. F. A. Voysey, Charles Rennie Mackintosh and, at the beginning of his career, Edwin Lutyens. Mackintosh produced his own masterpiece in designing the Glasgow School of Art (begun 1896) and its library (begun 1907), which in essence encapsulate the free style. Important domestic examples include Lutyens's Deanery Garden (1901), Sonning, Berks, and several by Prior, for instance Kelling Place (1903–5; now Home Place), Holt, Norfolk.

The Neo-Georgian style was similarly developed by architects associated with the Arts and Crafts Movement, such as Ernest Newton and Stokes from 1895. The many excellent Neo-Georgian houses include Frithwood House (1900), Northwood, Middx, designed by Mervyn Macartney (1853–1932), and Newton's Luckley (1907), Wokingham, Berks. This style and its associated forms in the decorative arts were much loved by generations of the British middle class. However, its vast spread and popularity over the succeeding decades, often in alternating groups with free style houses in suburban streets, led to its debasement and association with reactionary trends.

Although the fourth style characteristic of Edward VII's reign is usually now called Baroque Revival, it was then typically described as English Renaissance style or the Wren Manner. Surprisingly, this style also had its origins with architects close to the Arts and Crafts Movement. John Belcher and A. Beresford Pite showed in their Institute of Chartered Accountants building (1888–93), London, the artistic possibilities of the Baroque in combining the best contemporary building design, sculpture, painting and craftsmanship. It was, however, J. M. Brydon who planted the idea that the Baroque of Christopher Wren, Nicholas Hawksmoor and John Vanbrugh c. 1710, although classical in its origins and therefore foreign, had been transformed into something specifically British. Through its association with buildings such as Vanbrugh's Blenheim Palace (see col. pl. VIII) and hence with the Duke of Marlborough's military victories, it was deemed an appropriate style for Britain and its Empire at its peak. Thus it was widely used for government and other public buildings, monuments and educational institutions, banks and head offices of large companies. Outstanding works in this style include Belfast City Hall (1898–1906) by Alfred Brumwell Thomas and the War Office (1898–1906), Whitehall, London, by William Young.

The influence of France and of Beaux-Arts style came to bear on some opulent blocks of flats, department stores, theatres and grand hotels. The first major building to reflect it was the Ritz Hotel (1903–6), Piccadilly, London, by Mewès & Davis. It has many Parisian characteristics, and its well-planned interior is reflective of the Beaux-Arts scheme; it was also one of the first large steel-frame buildings in London. Other similar buildings are the Royal Automobile Club (1908–11), Pall Mall, London, also by Mewès & Davis, and the Waldorf Hotel (1906–8), Aldwych, London, by Alexander Marshall MacKenzie and Alexander George Robertson MacKenzie.

British architects were slow to participate in the early 20th-century worldwide movement away from details of style and towards the frank expression of structure. In 1903 J. J. Burnet had dared to abandon elaborate stonework for the simplified

rear facade of the steel frame of the Civil Service Stores in Edinburgh. In 1910, with Thomas Tait, he went even further in the front elevations of the Kodak Building, Kingsway, London. The frontage is like a severe elegant temple, stripped of all decoration. The outbreak of World War I in 1914 inevitably brought an abrupt halt to the way of life that had sustained much Edwardian architecture, large country houses, lavish hotels and even municipal display. By the 1920s a simplified, pared-down style had become the predominant one for public building.

Bibliography

J. M. Brydon: 'The English Renaissance', *AA Notes*, iii (1889), p. 92

W. R. Lethaby: *Architecture, Mysticism and Myth* (London, 1891)

R. N. Shaw and T. G. Jackson, eds: *Architecture: A Profession or an Art?* (London, 1892)

J. A. Gotch: *The Architecture of the Renaissance in England* (London, 1894)

R. Blomfield: *A History of Renaissance Architecture in England, 1500–1800* (London, 1897)

J. Belcher and M. Macartney: *Later Renaissance Architecture in England*, 2 vols (London, 1898–1901)

H. Muthesius: *Das englische Haus* (Berlin, 1904–5)

J. Belcher: *Essentials in Architecture* (London, 1907)

L. Weaver, ed.: *Small Country Houses of Today* (London, 1910)

N. Pevsner: *Pioneers of the Modern Movement* (London, 1936)

H. S. Goodhart-Rendel: *English Architecture since the Regency* (London, 1953)

R. Macleod: *Style and Society* (London, 1971)

G. Naylor: *The Arts and Crafts Movement* (London, 1971)

A. Service, ed.: *Edwardian Architecture and its Origins* (London, 1975)

—: *Edwardian Architecture* (London, 1977)

A. S. Gray: *Edwardian Architecture: A Biographical Dictionary* (London, 1985)

ALASTAIR SERVICE

Egyptian Revival

Neo-classical style of architectural and interior design; as Egyptomania or *Egyptiennerie* it reached its peak during the late 18th century and early 19th. Napoleon's campaign in Egypt (1798) coincided with emerging tastes both for monumental and for richly ornamental forms, enhanced by the literary and associational concerns of Romanticism. Unlike its Greek and Gothic counterparts, the Egyptian Revival never constituted a coherent movement with ethical or social implications. Indeed, since its earliest manifestations occurred in the later Roman Empire, the Revival itself can be seen as one in a series of sporadic waves of European taste in art and design (often linked to archaeological inquiry), acting as an exotic foil to the Classical tradition with which this taste was and remains closely involved. On a broader plane of inquiry, the study of Egyptian art and architecture has continued to promote a keen awareness of abstraction in design and a decorative vocabulary of great sophistication. These are among the most enduring contributions of ancient Egypt to Western art and design.

1. Origins and early developments, to 1760

Even before the Roman conquest of Egypt in 30 BC, the forms, rituals and architectural concepts of Egyptian civilization were being gradually absorbed into the Classical world. In time, aspects of the cults of Isis and Osiris were assimilated by early Christianity, while Imperial Rome itself became a major repository for Egyptian monuments and art. This collection of artefacts was to play a considerable role in later phases of the Revival. Hadrian may be considered to have been one of the first Egyptian revivalists through the creation around AD 130 of the Canopus area of his villa at Tivoli. This complex with its Serapeum and its telemon figures—two of which, recovered during the papacy of Pius II (*reg* 1458–64), became major features of the Vatican collections from Raphael's time—commemorated the town on the River Nile where Antinous, Hadrian's favourite, drowned in AD 122.

Although certain motifs, such as obelisks and sphinxes, recur in funerary art during the Middle Ages, the Arab conquest of Egypt in 641 had made access extremely difficult for Europeans in later centuries. This situation encouraged extravagant conceptions to proliferate among scholars and

humanists until these were partly dispelled by published accounts of European travellers in Egypt in the 16th century. By this time there was a fresh interest in Egyptian imagery, as can be seen, for example, in Bernardino Pinturicchio's recondite fresco scheme in the Appartimenti Borgia of the Vatican (1492–5), ingeniously tracing Alexander VI's descent from the sacred Apis bull. Apart from scattered motifs in frescoes by Raphael, Giulio Romano and their followers, a major addition to Egyptian Revival iconography was provided by the rediscovery c. 1520 of the Mensa Isiaca, also known as the Tabula Bembi after Cardinal Pietro Bembo (Turin, Mus. Civ. A. Ant.). This bronze tablet (itself a revival artefact from the time of Claudius) with its hieroglyphics and decorations contained a wide range of new information, and a description by Enea Vico was first published in 1559 (Lorenzo Pignoria's more sophisticated edition appeared in 1669).

During the 17th century and the early 18th two opposing aspects of Egypt's appeal for Western scholars and artists began to emerge. The imaginative world of fantasy was fuelled by the copious illustrated writings of the German Jesuit Athanasius Kircher, whose tendentious publications, mainly issued between 1643 and 1679, promoted the mystical theories of Rosicrucianism and, much later, those of Freemasonry. Such an approach was to lead to the speculative reconstructions of Egyptian monuments, including the Great Pyramids, in Johann Bernhard Fischer von Erlach's *Entwurff einer historischen Architektur* (1721). This work stimulated architects and landscape designers such as Nicholas Hawksmoor and John Vanbrugh in, for example, their early 18th-century pyramidal structures amplifying the landscape setting of Castle Howard, N. Yorks. On the other hand, far more sober scholarship developed from John Greaves's *Pyramidographia* (1646), which offered the first systematic study of the celebrated tombs at Giza. This academic tradition culminated in a work that greatly deepened the understanding of Egyptian art and architecture for the West—Bernard de Montfaucon's *L'Antiquité expliquée et représentée en figures* (1719–24). In addition to this comprehensive archaeological

compendium, various travel accounts were published in the mid-18th century, exemplified by Frederik Norden's *Voyage de l'Egypte et de Nubie* (1755), which, based on his first-hand studies, provided the most accurate images of the monuments hitherto available.

Significantly, a major turning-point in the fortunes of the Revival was reached during the age of Neo-classicism with its concern for the phenomenon of historical styles. By means of his *Recueil d'antiquités égyptiennes, étrusques, grecques, romaines et gauloises* (1752–67), A.-C.-P. de Tubières, Comte de Caylus, not only offered a formidable corpus of detailed illustrations but for the first time analysed the aesthetic properties of Egyptian art. He saw Egypt as representing the cultural roots of European civilization, which subsequently passed through Tuscany to Greece and then to Rome. For him its salient qualities were grandeur, primitiveness, simplicity and massiveness—characteristics that have largely dominated conceptions of the Revival ever since.

2. Interior decoration and furnishings, 1760–1820

Within this intellectual context occurred the first attempt to create a fully integrated style of interior design, supported by a far more radical theory than that of Caylus. During the early 1760s the Venetian designer Giovanni Battista Piranesi created a highly original painted interior in the Egyptian taste for the Caffè degli Inglesi in the Piazza di Spagna, Rome. He employed a plethora of motifs derived from the Vatican collections and various publications—from those on the Mensa Isiaca to that by Caylus—but Piranesi's novel setting, recorded in two etched plates, excited little enthusiasm at the time. The plates were included, along with 11 bizarre chimney-piece designs in the Egyptian style, among the 67 illustrations of his *Diverse maniere d'adornare i cammini* (1769). This folio treatise, advocating a broadly eclectic style for contemporary designers and their patrons, was preceded by a remarkable essay in which Piranesi not only stressed the decorative range of Egyptian design but also discussed the process whereby their art had been abstracted from nature, keenly observed. While it is often

said that Piranesi's compositions have a Rococo levity, this misconception is swiftly corrected once the etched compositions of the *Diverse maniere* are set against earlier work, such as the 'Apis Altar' (1731; Dresden, Grünes Gewölbe), a cabinet made by the goldsmith Johann Melchior Dinglinger for Augustus the Strong, Elector of Dresden. Where Piranesi's designs show a far greater understanding of the potential weight and formal variety of Egyptian decorative forms, Dinglinger's attractively capricious cabinet is embellished with canopic vases, sphinxes, obelisks and hieroglyphics that bear little organic relationship to the supporting structure.

Within the next two decades the tentative signs of a sustained stylistic revival are discernible for the first time, initially in the applied and decorative arts. With the exception of Anton Raphael Mengs's scheme (*c.* 1770) for the Camera dei Papiri in the Vatican, Piranesi's etched compositions were used mainly as a quarry for random ornamental motifs, as seen for example in François-Joseph Bélanger's (unpublished) chimney-piece designs of 1770 or in Pierre Gouthière's furniture of the 1780s. In England, meanwhile, Josiah Wedgwood was also deriving ideas from Bernard de Montfaucon and Caylus, while producing his Egyptian wares from the 1770s onwards.

By the 1790s the taste of Neo-classicists for a more severe and monumental style was growing more sympathetic to the full implications of Piranesi's system of design. The Billiard Room at Cairness House, Grampian—the first Egyptian Revival interior in Britain—which used three-dimensional features such as a stepped chimney-piece and battered doorcases, was devised by James Playfair in 1793, shortly after his return from Rome. In the last three decades of the 18th century, the scope of the architectural imagination to extend these ideas to a sublime scale was realized in the visionary compositions of Revolutionary French designers, notably Louis Jean Desprez, Jean-Jacques Lequeu, Etienne-Louis Boullée and Claude-Nicolas Ledoux. Of all the elemental forms derived from antiquity, the stern geometry of the pyramid was the most favoured

(e.g. Boullée's projected design for a Chapelle des Morts (*c.* 1780; Paris, Bib. N.).

After visiting Rome in the mid-1770s and Egypt in 1796, the English designer Thomas Hope produced the most accomplished interior of the Egyptian Revival. Refashioning the main rooms of his house (destr. 1850) in Duchess Street, off Portland Place, London, he created his 'Egyptian' or 'Black Room' between 1779 and 1801: happening to possess several Egyptian antiquities, wrought in variously coloured materials, such as granite, serpentine, porphyry, and basalt, of which neither the hue nor the workmanship would have well accorded with those of my Greek statues . . ., I thought it best to segregate the former, and to place them in a separate room, of which the decoration should, in its character, bear some analogy to that of its contents.

A suite of highly imaginative furniture and the decorative setting was set off with 'that pale yellow and that blueish-green which holds so conspicuous a rank among the Egyptian pigments; here and there relieved by masses of black and gold'.

By 1807, when Hope published these comments to accompany illustrations to his *Household Furniture and Interior Decoration Executed from Designs by Thomas Hope*, he was able to pay tribute to a new source—the fruits of Napoleon's campaign in Egypt. In 1798 Napoleon had appointed a commission of scholars, scientists and surveyors to record Egyptian antiquity in all its aspects. The resulting *Description de l'Egypte*, issued in 20 volumes between 1809 and 1828, not only represented a landmark in archaeology but, together with Baron Vivant Denon's equally magnificent *Voyage dans la basse et la haute Egypte pendant les campagnes du Général Bonaparte* (1802), impelled the Revival as far as the third decade of the new century. As had been the case with an earlier phase, new influences were first reflected in the applied arts, ranging from François-Honoré-Georges Jacob-Desmalter's suite of furniture, designed by Charles Percier for Denon himself in 1809, to the highly ambitious 'Service égyptienne' in Sèvres (1810–12), originally made to Napoleon's directions and later given by Louis XVIII to Arthur Wellesley, 1st Duke

of Wellington (now London, Apsley House). In both instances, the closeness of the forms concerned to those new published sources is often in marked contrast to the licence taken by Piranesi, and even Hope, in their acts of imaginative transposition. The emerging Egyptian Revival taste proved to be as international a style as the Pompeian and Greek counterparts, as exemplified respectively by the furniture designed by the Sienese Agostino Fantastici and the English Charles Heathcote Tatham.

3. Architecture and design since 1810

Notwithstanding John Soane's strictures against serving 'that monster, Fashion', by the second decade of the 19th century architects had begun to follow suit. Instances of civic, commercial and engineering structures include William Bullock's Egyptian Hall (1811; destr.), Piccadilly, London, with a façade by Peter Frederick Robinson (1776–1858) that was inspired by the Temple of Hathor, Dendara; the Egyptian Hall by John Foulston (1772–1842) in Devonport Library (1823), Devon; Isambard Kingdom Brunel's Clifton Suspension Bridge (1831), near Bristol; and, perhaps most original of all, the Temple Mill (1842), Leeds, also derived from Dendara by Joseph Bonomi. But it was in funerary architecture that the mature style of the Revival was universally applied in a variety of buildings and tombs at cemeteries from Père Lachaise in Paris and Mount Auburn in Cambridge, MA, to Kensal Green and Highgate, both in London. Predictably, this latter phenomenon incurred A. W. N. Pugin's wrath in *An Apology for the Revival of Christian Architecture in England* (1843) as displaying evidence of pagan utilitarianism.

Parallel with the applied arts and architecture, the romantic imagery of Egypt was also influencing stage design on the one hand and masonic ritual on the other; themes closely allied in Mozart's opera *Die Zauberflöte*, first produced in Vienna in 1791 and given particularly fine panoramic stage sets by Karl Friedrich Schinkel at the Königliches Theater, Berlin, in 1816. Masonic lodges, first associated with Egyptian symbolism and ceremony in the late 18th century, continued to reflect this as late as 1900, when P. L. B. Henderson (1848–1912) created the opulent Chapter Room for the Royal Arch Chapter of Scottish Freemasons in Edinburgh.

In contrast, the mystery surrounding the meaning of hieroglyphics had finally been dispelled in the 1820s through Jean-François Champollion's research on the trilingual Rosetta Stone (London, BM). While Egyptology was henceforward to be established on a firm documentary basis, the romantic exploits of Giovanni Belzoni's excavations between 1815 and 1819, under the benevolent rule of Mohammed Ali Pasha, captured the public imagination. The consequent arrival in Britain of the colossal head of Ramesses II (London, BM) and the sarcophagus of Sethos I (London, Soane Mus.), acquired by Soane, helped to inspire the histrionic paintings of John Martin, as exemplified by *Belshazzar's Feast* (1821; version, New Haven, CT, Yale Cent.). Archaeological interest also gave rise to a new generation of illustrated travel books, which reached a high level of accuracy and artistic calibre in the lithographs of David Roberts's *Egypt and Nubia* (1846–9). Salon paintings on evocative themes continued into the later decades of the century: Edward John Poynter's *Israel in Egypt* (London, Guildhall A.G.) was a sensation at the Royal Academy in 1867.

The High Victorian phase of the Revival in England also found a place in the campaign of improved art education promoted by Henry Cole and his circle. Reflecting Gottfried Semper's current design teaching, Owen Jones and Joseph Bonomie provided an Egyptian Court with large-scale exemplars of art and architecture in the Crystal Palace, rebuilt at Sydenham after London's Great Exhibition of 1851 (destr. 1936). Egyptian material also played a major role in Jones's magisterial *The Grammar of Ornament* (1856), in which the author, echoing Piranesi's respect for the Egyptian genius in natural abstraction, wrote that 'we are never shocked by any misapplication or violation of a natural principle'. Jones considered the Egyptian style, although among the oldest, to be the most perfect: 'the language in which it reveals itself to us may seem foreign, peculiar, formal and rigid; but the ideas and the

teachings it conveys to us are of the soundest'. Contemporary designers, such as Christopher Dresser, also drew attention to the functional properties he discerned in Egyptian utensils and furniture in his *The Principles of Decorative Design* (1873), and he produced several chairs based on ancient prototypes.

The perennial influence of basic Egyptian forms and patterns continued to recur in the 20th century. Transcending the more ephemeral impact on jewellery and costume, as well as on several Hollywood films, of Howard Carter's discovery of Tutankhamun's tomb at Thebes in 1922, certain formal influences affected design: Art Deco interiors (e.g. the foyer of Oliver P. Bernard's Strand Palace Hotel, London (1930, destr. 1967–8; parts now London, V&A)); Modernist office, cinema and industrial buildings (e.g. J. J. Burnet's Adelaide House, 1924–5; and Collins & Parri's Arcadia Works for Carreras, 1927–8; both in London). The most persistent of all Revival images, the pyramid form, provides the focal point, in glass, of I. M. Pei's controversial extension to the Musée du Louvre, Paris; completed in 1989, it represents a discourse across two centuries with the 'architecture parlante' of Ledoux.

Bibliography
J. Greaves: *Pyramidographia* (London, 1646)
B. de Montfaucon: *L'Antiquité expliquée et représentée en figures*, 10 vols (Paris, 1719–24)
J. B. Fischer von Erlach: *Entwurff einer historischen Architektur* (Vienna, 1721)
A.-C.-P. de Tubières, Comte de Caylus: *Recueil d'antiquités égyptiennes, étrusques, grecques, romaines et gauloises*, 7 vols (Paris, 1752–67)
F. Norden: *Voyage de l'Egypte et de Nubie*, 2 vols (Copenhagen, 1755; Eng. trans., 1757)
G. B. Piranesi: *Diverse maniere d'adornare i cammini. . .* (Rome, 1769); repr. in *The Polemical Works*, ed. J. Wilton-Ely (Farnborough, 1972)
D. V. Denon: *Voyage dans la basse et la haute Egypte pendant les campagnes du Général Bonaparte* (Paris, 1802)
T. Hope: *Household Furniture and Interior Decoration* (London, 1807/R New York, 1971)
E. F. Jomard and others, eds: *Description de l'Egypte*, 20 vols (Paris, 1809–28)
O. Jones: *The Grammar of Ornament* (London, 1856)
C. Dresser: *The Principles of Decorative Design* (London, 1873)
H. Honour: 'The Egyptian Taste', *Connoisseur*, cxxxv (1955), pp. 242–6
J. S. Johnson: 'Egyptian Revival in the Decorative Arts', *Antiques*, xc (1966), pp. 420, 428
N. Pevsner and S. Lang: 'The Egyptian Revival', *Studies in Art, Architecture and Design*, ed. N. Pevsner, i (London, 1968), pp. 212–48
R. Wittkower: 'Piranesi and Eighteenth-century Egyptomania', *Studies in the Italian Baroque* (London, 1975), pp. 259–73
R. G. Carrott: *The Egyptian Revival: Its Sources, Monuments and Meaning, 1808–1858* (London, 1978)
P. Clayton: *The Rediscovery of Egypt* (London, 1982)
J. S. Curl: *The Egyptian Revival: An Introductory Study of a Recurring Theme in the History of Taste* (London, 1982)
The Inspiration of Egypt: Its Influence on British Artists, Travellers and Designers, 1700–1900 (exh. cat., ed. P. Conner; Brighton, A.G. & Mus., 1983)
D. Syndram: *Ägypten-Faszinationen; Untersuchungen zum Ägyptenbild im europäischen Klassizismus bis 1800* (Frankfurt, 1990)
J. Wilton-Ely: *Giovanni Battista Piranesi: The Complete Etchings* (San Francisco, 1984), pp. 886ff
W. L. Macdonald and J. Pinto: *Villa Adriana, Tivoli* (in preparation)

JOHN WILTON-ELY

Elizabethan Revival

Term used to describe an antiquarian style popular in England from the 1830s to the 1860s, inspired by the ELIZABETHAN STYLE of the 16th century. Designs for Elizabethan-style furniture first appeared in Rudolf Ackermann's *Repository of Arts* in 1817, although the style was not widely popular until the 1830s. The English architect most closely identified with the style was Anthony Salvin, who designed Harlaxton Manor, Lincs (1831–8). The entire vocabulary of gables, octagonal turrets, tall chimney-stacks, pinnacles, leaded-paned windows and heraldic ornament was used at Harlaxton, which was based on the Elizabethan E-plan. Salvin's other notable works in this style include Mamhead (1828–33), Devon, and Scotney Castle (1835–43), Kent. Mentmore Towers (1851–4), Bucks, was designed by Joseph Paxton and George Henry

Stokes for Baron Mayer Amschel de Rothschild (1818–74) and is possibly the most elaborate manifestation of the Elizabethan Revival style.

In interiors the great hall was revived as the most important room in the house. Fireplaces were 16th century in style: the wainscot was oak, and plaster ceilings were of lozenge design with pendant bosses. By the 1850s there was a preference for furniture in darker woods; early oak pieces were collected or new furniture was made that incorporated the Elizabethan and Jacobean styles. Buffets, cupboards and four-poster beds were popular; high-backed chairs had spool- or spiral-turned uprights and carved cresting in the spirit of 17th-century vernacular furniture. A large collection of Elizabethan Revival furniture can be seen at Charlecote Park, Warwicks, NT. Two manufacturers well known for their production of Elizabethan Revival furniture were John Gregory Crace and W. Gibbs Rogers (1792–1872).

In silverware and ceramics there was a revival of Elizabethan-style covered salts, beakers and tankards. Plain surfaces are predominant, the decoration being confined to coats of arms, strapwork, bands of cinquefoils, egg-and-tongue or overlapping laurel leaves. Women's toilet cases from this period have silver or silver-gilt mounts imitating Flemish strapwork, and travelling writing cases were often shaped like caskets. Snuff-boxes in the shape of a boar's head or pointed Elizabethan shoes were also popular. Potteries in Staffordshire reintroduced salt glazes, which gave an authentic mottled appearance to stoneware jugs, mugs and tankards. A few studio potteries made tiles and platters decorated with coloured earthenware slip trailed or combed in the manner of such 17th-century potters as Thomas Toft (d 1689). The style persisted in the decorative arts until the 1920s and 1930s.

☐

Bibliography

C. Hussey: 'Harlaxton Manor, Lincolnshire, 1831–8', *Country Life*, cxxi (April 1957), pp. 704–7, 764–7

H. Bridgeman and E. Drury: *Encyclopedia of Victoriana* (London, 1975)

Elizabethan style

Term used to describe British art and architecture produced during the reign (1558–1603) of Elizabeth I. The dominant characteristics in all media are flatness and linearity; in representational art, surface decoration, high colour and complex silhouettes are preferred over plastic form or naturalistic three-dimensional depiction. There is evidence that Nicholas Hilliard, Elizabeth I's favoured portrait miniaturist, and such other court painters as George Gower, Marcus Gheerhaerts and Isaac Oliver consciously suppressed their knowledge of contemporary Italian and Flemish naturalism to produce their own distinctive iconic portraits (see fig. 26). As for sculpture, the Dutch and Flemish masons who visited or settled in England, such as Garat Johnson and Richard Stevens, tended to dominate. Their recumbent effigies carved for alabaster funerary monuments (often richly coloured) were conventional in design and modelling, while ornamental motifs owed much to the influence of Mannerist Flemish pattern books, such as those by Hans Vredeman de Vries. Among the decorative arts, embroidery in particular was highly prized and widely practised to an exemplary standard in later 16th-century England: the realistic portrayal of fruits and flowers, boldly coloured and within complex formed designs, epitomizes the Elizabethan style in textiles.

The leading architect of the Elizabethan period was Robert Smythson, who synthesized traditional English planning and Renaissance classicist detailing and external symmetry. At such prodigy country houses as Longleat House (from 1570), Wilts, Wollaton Hall (1580–88), Notts, and Hardwick Hall (1590–97), Derbys, working with masons associated with the Office of Works, he created a style of architecture that is characterized by symmetry and clear, blocky massing as well as extensive fenestration and carved ornamental strapwork.

Bibliography

J. Summerson: *Architecture in Britain, 1530–1830*, Pelican Hist. A. (Harmondsworth, 1953, rev. 7/1983)

E. K. Waterhouse: *Painting in Britain, 1530–1790*, Pelican Hist. A. (Harmondsworth, 1953, rev. 4/1978)

E. Mercer: *English Art, 1553–1625*, Oxford Hist. Eng. A. (Oxford, 1962)

M. Whinney: *Sculpture in Britain, 1530–1830*, Pelican Hist. A. (Harmondsworth, 1964, rev. 2/1988 by J. Physick)

ALICE T. FRIEDMAN

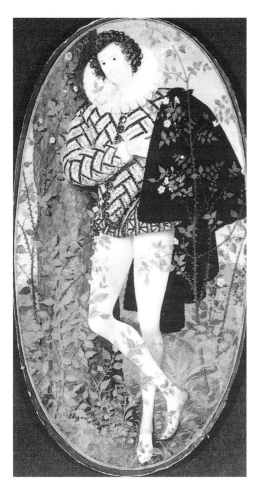

26. Nicholas Hilliard: *Young Man Leaning against a Tree among Roses*, c. 1588 (London, Victoria and Albert Museum)

Empire style

Term used to describe a French style of artistic production that lasted from the mid-18th century until c. 1840. The name derives from the first French Empire under Napoleon I. The dates defining the period of the Empire historically (1804–14) and the duration of the style itself are at variance: the early phase, referred to by contemporaries as 'le goût antique', was a late form of Neo-classicism and became more developed as the chaos resulting from the French Revolution subsided c. 1796. The DIRECTOIRE STYLE and the CONSULATE STYLE—terms similarly derived from political periods in France—were both part of the development of the Empire style.

The term was originally applied to architecture, but because Napoleon rejected the building of new castles and palaces as wasteful, the style was especially used in interior design and decoration, later being extended to other decorative arts and fashion. There was strong conscious allusion to the civilization of ancient Rome through the building forms and motifs used by the first Roman emperors, who pursued goals of internal peace and a new order together with an expansionist military policy, as did Napoleon. Personal taste and comfort became of secondary importance to the demonstration of wealth and power. The Empire style spread throughout Europe and acquired fresh impetus with the Napoleonic conquests.

1. Formulation and early phase

The formulation of the style was the work of two architects, Charles Percier and Pierre-François-Léonard Fontaine, and the first use of the term was linked directly with them (Delacluze, p. 400). Their refurbishment of the Hôtel de la Victoire, Paris (1797), Percier's designs for the redecoration of the house (1798) of the banker Récamier and their collaboration at the Château de Malmaison, the country residence of Napoleon and Josephine Bonaparte (1800–02) represented the decisive beginning of the Empire style. At Malmaison they had under their direction a team of craftsmen that included François-Honoré-Georges Jacob-Desmalter, Bernard Molitor, Pierre-Philippe

Thomire, Jean Baptiste Claude Odiot and Martin-Guillaume Biennais, who subsequently adhered to the style.

Architectonic structure and ornament were subordinate to a strict axial symmetry that united the ensemble and defined the hierarchy of its component parts. Conspicuously expensive and elaborately worked materials were combined with a massiveness of scale and a 'truth to materials' aesthetic. There was a clear distinction between the flat surfaces of the walls and furniture cases and the ornament applied to them, in terms of materials, colour and texture. Percier and Fontaine's album of designs, the 'bible of the Empire style', *Recueil de décorations intérieures comprenant tout ce qui a rapport à l'ameublement* (Paris, 1801), played a vital part in establishing the new decorative language, based on a repertory of antique forms. They introduced the vogue for chaises longues with scrolled ends, X-framed stools, klismos chairs and the Egyptian throne-chair with lion monopode legs, as well as circular tripod stands and sarcophagus-shaped cabinets and wine coolers. They also set the fashion for walls, windows and beds draped or hung with plain or patterned silks or damasks, with seat furniture upholstered *en suite* to match. Patterned wallpapers by such companies as Zuber & Cie became increasingly fashionable and often imitated the effect of draped fabrics. Symbols of majesty and abundance were fully exploited in furniture, ceramics, metalwork, textiles and wallpaper; motifs included eagles, swans, cornucopias, fasces of arms, winged torches and such Napoleonic motifs as bees and large Ns within laurel wreaths. The arms and front legs of chairs were often decorated with carved and gilded wood or cast-bronze figures of caryatids or terms, winged griffins or sphinxes. Sofas of huge proportions were placed against walls; important suites of sofas and chairs were upholstered in satin-silk woven in Lyon or in tapestry (e.g. side chair upholstered in Beauvais tapestry, 1804; Malmaison, Château N.). The *méridienne*, a sparsely upholstered day bed with curled, upturned ends, became fashionable for ladies' boudoirs and was popularized by David's portrait of *Madame Récamier* (1800; Paris, Louvre; see fig. 58). Other popular furniture types were the *athénienne*, a tripod-based stand for holding wash-basins or jardinières (e.g. *c.* 1804–10; New York, Met.), and the *psyché*, a free-standing mirror in an ornate frame, probably introduced by Percier. *Lits bateaux* were moved from their traditional position at right angles to walls or in alcoves and positioned with their long sides against the wall, surmounted with tentlike draperies of silk and muslin. The commode was increasingly used as bedroom furniture, while circular pedestal tables, console tables and secrétaires graced drawing-rooms.

2. Subsequent development

As the Empire style developed it moved away from the lively, linear use of grotesque ornament that typified the period around 1800. From 1804–5 the overall architectonic forms became heavier, and ornament became increasingly simple and subordinated to the display of luxurious materials: 'she [Josephine] no longer wants chimaera, lions' heads and gilded arabesques . . . she wants a new, completely smooth mahogany dressing-table, . . . a piece of furniture in solid gold would cost no less' (St Hilaire, 1831).

The style was disseminated throughout Europe in the imperial palaces, for example the salons of the Casa del Labrador at the Aranjuez Palace, Spain (1805; *in situ*), the Royal Palace, Amsterdam (1808; *in situ*), and the restoration of the palace at Laeken, near Brussels (*in situ*). Such students of Percier and Fontaine as Louis Joseph Adrien Roelandt adhered to the strict Empire style in their own projects (e.g. auditorium for Ghent University, 1826). Important decorative schemes in France included the Caryatid Rooms at the Tuileries (destr. 1870) and those at the châteaux of Fontainebleau and Compiègne (1806), the Grand Trianon and the Hôtel de Rambouillet. It was popularized by such journals as *Meubles et objets de goût* (Paris, 1802–35), *Journal des Luxus und Moden* (Weimar, 1793–1810) and *Konst och Nyhetmagazin* (Stockholm, 1818–). In America, the cabinetmaker Duncan Phyfe was producing furniture with Empire details in 1808 and sub-

sequently produced suites of furniture in the Empire style that *c.* 1815 followed the American Federal style.

However, the dominance of the established, academically based repertory of forms propagated by Percier and Fontaine meant that there was little evolution in the Empire style, and it is often impossible to use formal stylistic criteria as a basis for deciding the date of a work of art from the first decades of the 19th century. Even from the beginning, this canon of official good taste resulted in the creation of subsidiary styles such as the Troubadour style, the 'goût turc' and, most important of all, the Egyptian style (*see* EGYPTIAN REVIVAL). As the industrial revolution got under way, craftsmen trained over a long period were drawn into the growing number of factories, where they continued to work to the high standards obtaining for luxury goods under the *ancien régime*. Only as the craft-trained older generation gradually left the factories was there a clear and noticeable decline in quality.

Bibliography

M. de St Hilaire: *Les Petits Appartements des Tuileries, de Saint-Cloud et de la Malmaison*, vol 2 (Paris, 1831), p. 35

E. Delacluze: *Louis David: Son école et son temps* (Paris, 1855)

F. Benoit: *L'Art français sous la Révolution et l'Empire* (1897)

P. Lafond: *L'Art décoratif et le mobilier sous la République et l'Empire* (Paris, 1900)

J. Vacquier: *Le Style Empire*, 2 vols (Paris, 1912)

W. Hessling: *Style Empire: Meubles et intérieurs* (Paris, 1913)

M. von Boehn: *Das Empire: Die Zeit, das Leben, der Stil* (Berlin, 1925)

P. Marmottan: *Le Style Empire*, 3 vols (Paris, 1925–30)

E. Bourgeois: *Le Style Empire: Son origine, ses caractères* (Paris, 1930)

P. Lavedan: 'Napoléon I, urbaniste', *Histoire de l'urbanisme*, iii (Paris, 1952)

L. Hautecoeur: *Histoire de l'architecture classique en France*, v of *Révolution et Empire, 1793–1815* (Paris, 1953)

G. Hubert: *La Sculpture dans l'Italie napoléonienne* (Paris, 1964)

S. Grandjean: *Empire Furniture, 1800–1825* (London, 1965)

G. Jannear: *L'Empire* (Paris, 1965)

H. Honour: *Neo-classicism* (Harmondsworth, 1968, rev. 1977)

W. Becker: *Paris und die deutsche Malerei, 1750–1840* (Munich, 1971)

C. Isermayer: *Empire* (Munich, 1977)

HANS OTTOMEYER

Essor, L'

Belgian exhibiting society (1876–91), originally founded as the Cercle d'Elèves et anciens Elèves des Académies des Beaux-Arts. A group consisting of Emile Hoeterickx (1858–1923), Julien Dillens, Amédée Ernest Lynen (1852–1938) and 17 other artists adopted the name L'Essor in November 1879 to avoid the academic associations of its previous title. Organized like the official Salon, with numerous rules enforced by a president and a 20-member governing committee, which also acted as a jury, the society sponsored 15 exhibitions between 1876 and 1891, drawing inspiration and members from the previous Société Libre des Beaux-Arts and the coexisting La Chrysalide. Its motto 'Unique art, unique life' stressed originality and the link between art and life; as a society it was anti-academic yet eclectic, admitting conservative artists. It was liberal enough to produce an immediate breakout of conservative members, who formed their own group, Union des Arts, in 1876. Dedicated to selling numerous works of art to large audiences, L'Essor ran a successful lottery and a raffle of art works. This encouraged artists to please the public; L'Essor's receptivity to both conservative and avant-garde artists accounts for its longevity. King Leopold II's purchase of paintings in 1881 and 1882 marked the end of the official ostracism of previous independent exhibition groups and assured public success. Open at first to young artists like James Ensor, its rejection in 1882 of his Impressionist style in favour of Realism led to a division in the group. The inclusion of paintings such as *Psyche* (1882; Tournai, Mus. B.-A.) by Léon Herbo (1850–1907) caused more advanced artists like Frantz Charlet (1862–1928),

Théo Van Rysselberghe and Willy Schloboch (1864–1951) to join with 17 other artists including Ensor, Fernand Khnopff, Georges Lemmen and Guillaume Vogels in withdrawing and founding Les XX. Conservative artists like Lynen and Léon Frédéric (1856–1940) remained with L'Essor, which became a foil to the more liberal faction in Les XX. While L'Essor lost many of its most adventurous members to Les XX, it also influenced it, providing a pool of members, including Jan Toorop and Henry De Groux, and a model for the notion of accompanying art exhibitions with musical events and lectures.

Bibliography

S. M. Canning: *A History and Critical Review of the Salons of 'Les Vingt', 1884–1893* (diss., Philadelphia, U. PA, 1980), pp. 20, 462, 484

J. Block: *Les XX and Belgian Avant-gardism, 1868–1894* (Ann Arbor, 1984), pp. 5–8, 13–15, 18–20, 43, 142–52

JULIUS KAPLAN

Estilo desornamentado [Sp.: 'stripped or unornamented style']

Term used to describe a phase in Spanish architecture in the 16th century and the early 17th, which developed in reaction to the excessive decoration of the PLATERESQUE STYLE. Emphasis was placed on the correct use of Classical orders, the composition of masses, walls and spaces and contemporary Italian practice. *Estilo desornamentado* owed much to the influence of Italian and Portuguese military engineers and to the anti-decorative functionalism of the first Jesuits. Starting in the 1540s, it reached its summit with Juan de Herrera's work (1563–84) at the Escorial, spreading thereafter throughout almost all of Spain (except Andalusia) and differing from the Portuguese *Estilo chão* ('plain style') in that it enjoyed less freedom from academic rules and the styles derived from Italy.

The term was apparently in use in Spain in the later 19th century; it was subsequently applied by C. Justi (1908) to describe the monastery of the Escorial and was taken up by G. Kubler. It was coined to replace the various terms—Herreran, Escurialense, Viñolesco, Tridentine and Mannerism—used by Spanish architectural historians to describe the Escorial and its sequels. Its use has been limited to English and American historians, although J. B. Bury declared himself radically opposed to it (1986). Spanish writers have preferred to use the term 'classicism' to describe this last phase of 16th-century architecture in Spain, keeping the phrase *estilo desornamentado* to designate Renaissance detailing before the construction of the Escorial, where decoration (known as Plateresque) using candelabra and grotesques was abandoned. This detailing is then contrasted with that of the Renaissance buildings that employed such ranges of decoration and were dubbed *ornamentado* ('ornamental').

The tendency to reject the practice of superimposing such decoration on Renaissance structures, leaving the Classical orders as the only decorative element in this type of architecture, seems to have been encouraged by the publication in 1537 and 1540 of books II and IV of Sebastiano Serlio's *Regole generali di architettura sopra le cinque maniere degli edifici* (Venice, 1537–51) and their translation into Spanish by Francisco de Villalpando (1552). Architects from the 1540s, such as Alonso de Covarrubias and Luis de Vega, or Diego de Siloé later on, tried to forgo the use of superficial decoration and limit themselves to employing the orders, together with rustication, as the sole characteristics of a style of architecture that they claimed was 'Roman' or 'ancient'. During the same period, architects such as Rodrigo Gil de Honañón, working in a Gothic Survival tradition, tried to divest their Gothic structures of any kind of ornament, including the orders, as they considered decoration to be superfluous and prized the structural design ('the plan') above any type of additional element ('art').

Although this state of affairs did not apply uniformly, an important departure in Spanish architecture clearly occurred towards 1560, centred on the court of Philip II. The arrival of Juan Bautista de Toledo from Naples and the brief presence of Francesco Paciotto (1562) signified a renewal of Italian models (the last Spaniards to come from

Italy, such as Diego de Siloé or Pedro Machuca, had returned *c.* 1520). In an attempt to apply the principles of Vitruvius and the 16th-century theory of Classical orders correctly, stress was laid on architecture composed of well-proportioned masses, walls and spaces. There was wide use of Italian forms (not excluding, however, contributions from Flanders), where surfaces were articulated by using Classical orders or linear ensembles of very simple geometric figures, thereby producing a gradual simplification of the orders that reduced them often to a minimum, giving rise to the expression 'reductive classicism'.

The most direct disciples of Herrera's school —Juan de Valencia and Francisco de Mora— continued to work in the style established by Herrera at the monastery of the Escorial. Within court circles in Madrid, the Carmelite Fray Alberto de la Madre de Dios (*fl* 1610) and Juan Gómez de Mora also continued the style until the mid-17th century. An important centre for the style was also formed in Toledo by other disciples or assistants of Herrera, such as Diego de Alcántara (*d* 1587), Nicolás de Vergara (ii) and Juan Bautista Monegro and their respective followers. Herrera's plans for Valladolid Cathedral (1580) gave rise to another centre in that city, whose chief representatives, Juan de Ribero Rada (*d* 1600), Juan de Nates (*fl* 1620) and Diego and Francisco de Praves (1586–?1637), transmitted its characteristics to the architecture of old Castile, León, Asturias, Cantabria, the Basque country and, through Salamanca, to Galicia. Herrera's influence, through both his own designs and those of certain disciples, reached regions such as Valencia and soon touched Andalusia and even Aragon. Here, as in Catalonia, architecture developed characteristics similar to those encouraged by the court, thus promoting exceptional stylistic consistency throughout Spain.

Despite some local opposition and divergences around 1600 and 1620, the style, with its geometrical characteristics and stress on mathematical elements, prevailed throughout the 17th century. From the 1640s, however, the notion of enriching buildings began slowly to be accepted via a new wave of decorative art, which nevertheless res- pected the composition of the structures and the treatment of the orders.

Bibliography

J. de Castilho: *Lisboa antiga: O bairro alto* (Lisbon, 1879, 3/1954–62)

C. Justi: *Miscellaneen aus drei Jahrhunderten spanischen Kunstlebens*, 2 vols (Berlin, 1908)

J. de Contreras: *Historia del arte hispánico*, i (Barcelona and Buenos Aires, 1945)

G. Kubler and M. Soria: *Art and Architecture in Spain, Portugal and their American Dominions*, Pelican Hist. A. (Harmondsworth, 1959)

——: *Portuguese Plain Architecture, between Spices and Diamonds, 1521–1706* (Middletown, CN, 1972)

C. Wilkinson: 'The Escorial and the Invention of the Imperial Staircase', *A. Bull.*, lvii (1975), pp. 65–90

G. Kubler: *Building the Escorial* (Princeton, 1982; Sp. edn, Madrid, 1983)

A. Bustamante García: *La arquitectura clasicista del foco vallisoletano: 1561–1640* (Valladolid, 1983)

G. Kubler: *Mexican Architecture of the Sixteenth Century* (New Haven, 1948, rev. 1972; Sp. trans., Mexico City, 1983)

F. Marías: *La arquitectura del renacimiento en Toledo: 1541–1631*, 4 vols (Toledo and Madrid, 1983–6)

J. Rivera Blanco: *Juan Bautista de Toledo y Felipe II: La implantación del clasicismo en España* (Valladolid, 1984)

S. Sebastián López, J. de Mesa Figueroa and T. Gisbert de Mesa: *Arte iberoamericano desde la Colonización a la Independencia* (Madrid, 1985)

C. Wilkinson: 'Planning a Style for the Escorial: An Architectural Treatise for Philip of Spain', *J. Soc. Archit. Hist.*, xliv (1985), pp. 37–47

El Escorial en la Biblioteca Nacional (exh. cat., Madrid, Bib. N., 1985)

J. B. Bury: 'Juan de Herrera and the Escorial', *A. Hist.*, ix/4 (1986), pp. 428–49

Herrera y el clasicismo (exh. cat., Valladolid, Pal. Santa Cruz, 1986)

F. Marías: *El largo siglo XVI: Los usos artísticos del renacimiento español*, (Madrid, 1989)

V. Fraser: *The Architecture of Conquest: Building in the Viceroyalty of Peru, 1535–1635* (Cambridge, 1990)

J. Bérchez: *Arquitectura mexicana de los siglos XVII y XVIII* (Mexico City, 1992)

M. Sartor: *Arquitectura y urbanismo en Nueva España: Siglo XVI* (Mexico City, 1992)

FERNANDO MARÍAS

Etruscan school [It. Scuola etrusca]

Group of Italian and English landscape painters. It was formally associated in Rome only during the winter of 1883–4; the name of the group was never widely accepted and came to refer retrospectively to the landscapes that artists in this circle painted and exhibited together from the 1860s. They were united by an affection for the countryside of Italy. Under the influence of Giovanni Costa they revived the tradition of landscape painting that derived from Claude Lorrain and Nicolas Poussin and that Thomas Jones, Pierre Henri Valenciennes and Jean-Baptiste-Camille Corot had explored. The aesthetic principles that determined the nature of the paintings of the Etruscan school were first discussed by Costa with George Heming Mason and Frederic Leighton, whom he had met in 1852 and 1853 respectively. From 1877 Costa exhibited landscapes at the Grosvenor Gallery, London, in the company of George James Howard (later 9th Earl of Carlisle), Matthew Ridley Corbet (1850–1902), Edith Corbet (c. 1850–1920), William Blake Richmond, Edgar Barclay (1842–1913) and Walter Maclaren (fl 1869–1903) and the Italians Gaetano Vannicola (1859–1923) and Napoleone Parisani (1854–1932). These painters, with the addition of Norberto Pazzini (1856–1937), were the original members of the Etruscan school. Their style of painting is characterized by breadth of handling and a fondness for the subdued tonalities of panoramic distances. Costa instructed his followers that the purpose of the landscape artist is to evoke and describe the emotions and affections felt for his native land; sentiment is to be regarded as the most important element in a painting; 'the study which contains the sentiment, the divine inspiration, should be done from nature,' he is recorded as saying. Then, 'from this study the picture should be painted at home, and, if necessary, supplementary studies be made elsewhere' (Agresti, p. 213). From 1888 the members of the group transferred their allegiance from the Grosvenor Gallery to the New Gallery, London, exhibiting there until 1909. Other painters who joined the Etruscan school or were influenced by Costa include Walter Crane, Thomas Armstrong and the American Eugene Benson (1839–1908).

Bibliography

O. R. Agresti: *Giovanni Costa: His Life, Work and Times* (London, 1904)

The Etruscan School (exh. cat., ed. P. Skipwith; London, F.A. Soc., 1976)

Nino Costa ed i suoi amici inglesi (exh. cat. by S. Berresford and P. Nicholls, Milan, Circ. Stampa, 1982)

The Etruscans: Painters of the Italian Landscape, 1850–1920 (exh. cat. by C. Newall, York, C.A.G.; Stoke-on-Trent, City Mus. & A.G.; London, Leighton House A.G. & Mus.; 1989)

CHRISTOPHER NEWALL

Etruscan style

Type of delicate, painted Neo-classical decoration, derived mainly from the shapes, motifs and colours of antique vases. It was part of the quest in Europe in the last quarter of the 18th century for a contemporary expression in interior design and the applied arts. The term is applied loosely to various schemes of decoration inspired by Classical sources, involving Renaissance GROTESQUE ornament, as well as themes inspired by discoveries made at Herculaneum and Pompeii in the 18th century, or frequently a mixture of these sources. This fact serves to underline the complex antecedents of this style, which was originally based on the misidentification of imported Greek vases dug up in southern Italy and thought to have been made by ancient Etruscans, a culture promoted in some quarters as having been the original fount for the whole of Classical antiquity. Indeed, the Etruscan style derived little direct artistic influence from that culture as such, except for certain potent historical associations promoted by the controversies concerning cultural debts. Initially represented by Josiah Wedgwood's black basaltes ware, the Etruscan style was developed by James Wyatt and the Adam brothers during the 1770s as a means of embellishing their intimately scaled rooms. Apart from scattered manifestations on the Continent and the use of the term for classicizing

furniture of the Louis XVI period, this style remained substantially an English phenomenon. It survived until the last decades of the 18th century when it was eclipsed by the more vigorous and archaeologically exact taste of the mature POMPEIAN REVIVAL.

1. Historical accounts of Etruscan art

One of the earliest discussions of Etruscan art since antiquity occurred in Vasari's preface to his *Vite* (1550), to support his claims for the outstanding creative history and destiny of Tuscany. However, it was a Scottish historian, Sir Thomas Dempster, who produced the pioneering study of Etruscan culture in *De Etruria regali*, written in 1616–25 but not published until 1723–5 by Thomas Coke, later 1st Earl of Leicester. This work, and the writings of the Neapolitan philosopher Giambattista Vico, who first suggested the autonomy of Roman civilization as derived from the Etruscans in his *Scienza nuova* (Naples) of 1725, helped to promote a growing patriotic movement in 18th-century Italy. Encouraged by this 'Etruscheria', early excavations were followed by the foundation of the Accademia Etrusca at Cortona in 1726 and the Museo Guarnacci at Volterra in 1750. During the same period, new finds were evaluated in a substantial body of publications by such Italian scholars as Filippo Buonarroti, Anton Francesco Gori, Giovanni Battista Passeri, Abbé Mario Guarnacci (1701–85) and the Comte de Caylus. By the early 1760s this material had assumed a new significance for early Neo-classical designers searching for fresh sources of inspiration.

Around 1760 the British dealer Thomas Jenkins began excavating tombs at Corneto (Etruscan Tarquinia), accompanied on occasion by his associate, the architect and engraver Giovanni Battista Piranesi. In 1761 Piranesi portrayed the Etruscans as Rome's chief source of inspiration, when he countered the arguments of Johann Joachim Winckelmann and the Philhellenic cause in his *Della magnificenza ed architettura de' Romani*. 'Etruscheria' was swiftly transformed into 'Etruscomania' and, from the confusion of evidence, extravagant claims were made concern-

ing the influence of Greek or Etruscan culture on the Romans. In 1765 Piranesi issued three etched plates of wall decorations derived from tombs at Corneto and Chiusi in a further polemical work, grandly entitled *Della introduzione e del progresso delle belle arti en Europa ne' tempi antichi*. At this time the Scottish antiquarian James Byres was inspired by the idea of preparing a 'History of the Etruscans'. The engraved plates based on his drawings of Etruscan tombs were in circulation by the later 1760s, although not actually published until 1842 as *'Hypogaei', or the Sepulchral Caverns of Tarquinia*.

Among Byres's correspondents concerning these plates was Sir William Hamilton, the eminent connoisseur and Envoy Extraordinary at Naples, who had been accumulating a major collection of antiquities, mainly found in southern Italy. This included a quantity of painted vases (London, BM) that were widely believed to be Etruscan. Between 1766 and 1776 Hamilton published this material in a lavish four-volume *Collection of Etruscan, Greek and Roman Antiquities* (discussed and illustrated with coloured plates by the scholar Baron d'Hancarville), with the explicit intention of providing model designs for contemporary artists and craftsmen.

2. Wedgwood

Proof plates of Hamilton's collection were in circulation in the 1760s, and they were seen not only by Piranesi but also by the potter Josiah Wedgwood. He was then experimenting with a traditional form of Staffordshire blackware or basaltes, as it subsequently became known. Initially 'Etruscan' was Wedgwood's term for certain basalt vases in a substance meant to imitate that civilization's bronze vessels, made through a process involving lightly fired metallic gold. He soon went on to use basaltes as the basis for other wares decorated with encaustic and enamel paintings; these he also described as being in the 'Etruscan style', and they were closely based on Hamilton's plates. In 1769 Wedgwood and his partner Thomas Bentley (1731–80) celebrated the opening of Etruria, their new factory at Burslem, Staffs, by producing six commemora-

tive 'First Day' painted vases, each inscribed *Artes Etruriae renascuntur* ('The arts of Etruria are reborn'). The resulting range of objects in basaltes was to parallel in extent and to become even more popular than Wedgwood's other stoneware, called Jasper, being cheaper to produce and offering an ideal medium for displaying shape and fine modelling. Wedgwood followed up his vases with antique plaques and large cameos, advertised as in 'black basaltes with Etruscan red burnt-in grounds, and in polished Biscuits with brown and grey grounds'. By 1773 the first *Catalogue of Cameos, Intaglios, Medals, and Bas Reliefs, with a General Account of Vases and Other Ornaments after the Antique* included 'Etruscan' ornaments as 'fit either for inlaying, as Medallions, in the Pannels of Rooms, as Tablets for Chimney Pieces, or for hanging up as ornaments in libraries . . . or as Pictures for Dressing Rooms'.

3. Interior design

Hamilton's ideals and Wedgwood's initiatives were extended to interior design as a whole. From the 1760s a succession of painted interiors that combined grotesque ornaments with designs based on new material recovered from Herculaneum were undertaken in close rivalry by James Stuart and Robert Adam and James Adam. James Wyatt followed suit with his Cupola Room at Heaton Hall (1775–8), Lancs, and he appears to have been the first to have devised an Etruscan-style interior. This was for a modest fishing-pavilion at Fawley Court, Bucks, in 1771. Its pale green walls were given the appearance of being hung or inlaid with Antique terracotta figures, medallions and plaques in the Wedgwood manner. The scheme was probably executed by Biagio Rebecca (1735–after 1784), who was to be closely associated with the diffusion of the Etruscan style.

Predictably, the Adam brothers were swift to adopt Wyatt's idea and in 1773 they decorated the Dressing Room of the Countess of Derby's house in Grosvenor Square, London, in the new taste. They published engraved designs (frequently issued in colour) for the ceiling and chimney-piece in the second volume of their *Works in Architecture* (1779). While flagrantly claiming to have invented the style, they did for the first time identify by name this decorative system and attempted a definition of its essentials as involving 'colour [i.e. terracotta and black] . . . both evidently taken from the vases and urns of the Etruscans'.

Despite the characteristic opportunism of the Adam brothers, their work in at least eight interiors designed between 1773 and 1780 should also be seen as a considered response to Piranesi's call for a modern style in interior design, based on a broadly eclectic use of antique sources. In his *Diverse maniere d'adornare i cammini ed ogni altra parte degli edifizi* (1769), much of Piranesi's lengthy preface further developed his theories concerning the Etruscan creative genius and its Roman legacy. Piranesi, like Wedgwood, had recognized the possibilities for transposing vase motifs for use in other decorative functions. At least two of Piranesi's opening plates, demonstrating this principle in wall compositions with chimney-pieces, clearly influenced Robert Adam's Etruscan interiors, particularly the finest to survive, at Osterley Park House, near London (see fig. 27). This was carried out mainly around 1775–6 as a dressing room for the banker Robert Child (1739–82) and his wife Sarah. Over 35 surviving drawings (1772–9; London, Soane Mus.) are devoted to this integrated scheme, one that involved not only the room's four walls, two doors and ceiling, but also its carpet (no longer extant), eight chairs, a chimney-board, a firescreen and the curtain cornices of the two windows. The painted wall decoration, on sheets of paper pasted on to canvas, was executed mainly in colours of terracotta and black on a pale blue-grey ground and incorporates highly coloured medallions of Classical subjects. Apart from Antonio Zucchi's central roundel on the ceiling, the painting, which extended to the furniture, was carried out by Pietro Maria Borgnis (1739/43–after 1810).

Contemporaries were swift to identify Adam's sources for Osterley's Etruscan Room; Horace Walpole in 1778 acidly noted resemblances to Wedgwood's ware, while in 1788 Mrs Lybbe-Powys noted debts to Herculaneum. Adam's wall

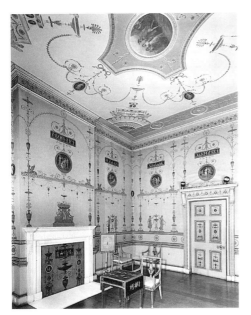

27. The Etruscan Dressing Room, designed by Robert Adam, with painted decorations by Pietro Maria Borgnis and Antonio Zucchi, Osterley Park House, London, *c.* 1775–6

compositions certainly owed much to the pergola or trellis-like themes of Pompeian second-style wall paintings, and the intermingling of Roman and 'Etruscan' contributions reflected the fertile complexity of Piranesi's own eclectic system.

In addition to those at Derby House and Osterley Park, Etruscan Rooms by Adam included the partially surviving scheme at Home House (20 Portman Square), London, and a small room under the stairs of Osterley's garden front. Others are recorded for Cumberland House (1780) and 'Mr Adamson's Parlour' (possibly at the Adelphi), both in London, as well as at Harewood House and Byram House, both in Yorkshire. Furthermore, a particularly striking example of the application of the Adam system by another designer can be seen at Woodhall Park, Herts, where in the 1770s Thomas Leverton provided the India administrator, Sir Thomas Rumbold (1736–91), with a marble-floored saloon in the Etruscan taste. There, the main emphasis was placed on a striking umbrella dome with appro-

priate terracotta and black ornaments, matched by walls with panels and medallions probably painted by Borgnis. The marble chimney-piece was enriched not only with painted panels but also with a form of scagliola inlay.

By the 1780s in France painted interiors after the Antique had been fully absorbed by the Louis XVI style, introduced by such designers as Charles-Louis Clérisseau. There is no trace of the 'Etruscan Room' Clérisseau is recorded in 1764 as having produced for Cardinal Alessandro Albani in Rome; he subsequently designed grotesque schemes for Laurent Grimod de la Reynière in Paris in the 1770s. A more specifically Etruscan manner appeared in interiors by F.-J. Bélanger and J.-D. Dugourc, and it was also applied to furniture by Georges Jacob (1739–1814), profusely embellished with palmettes and other ornaments. A set of Jacob's chairs, made to Hubert Robert's designs in 1787 for Marie Antoinette's Laiterie at Rambouillet, was described by Jacob as 'de forme nouvelle de genre étrusque'. Similarly, in Italy the 'Etruscan' dinner service (examples in Windsor Castle, Berks, Royal Col.) produced at the Royal Neapolitan Porcelain factory in 1785–7 justified the epithet only insofar as it was decorated with paintings of antique vases.

In England the Etruscan style underwent a new and astringent interpretation by Wyatt in a small anteroom at Heveningham Hall, Suffolk, completed before 1784. This was part of an extensive scheme for the interior of Sir Robert Taylor's building, commissioned by the banker Sir Gerard Vanneck. In what may be regarded as the purest expression of the Etruscan style, Wyatt (probably in close collaboration with Rebecca) purged the residual traces of illusionistic devices derived from Herculaneum and from the grotesque. Pale green walls with white wood or plaster enrichments offered an austere context for terracotta-coloured, figurative panels. Included in the accompanying suite of painted furniture was a pair of idiosyncratic candelabra set in opposing niches. Each took the form of a tapering pedestal surmounted by a vase with metal branches attached to ram's heads at the angles. The achieved balance between ingenuity of detail and

overall restraint at Heveningham makes the later Etruscan interiors of Adam appear by comparison overwrought and somewhat effete.

4. Decline

Hamilton published his second collection in 1791, illustrated by Wilhelm Tischbein's severe line-engravings. Recent scholarship had identified his vases as largely Greek in origin, and Hamilton justified his own change of opinion in the text. Nevertheless, misconceptions persisted, even among such specialist designers as C. H. Tatham: writing from Rome to Henry Holland in 1796 Tatham described illustrations he had made as being 'in the Etruscan style, precisely copied from Sir Wm. Hamilton's Vases and applied to small rooms and cabinets'. By then fresh revelations at Pompeii had begun to replace those at Herculaneum as a new focus of interest, encouraging a taste for bolder, more strongly coloured interior schemes, as supported by archaeological evidence. This was vividly demonstrated by the remarkable Pompeian Gallery at Packington Hall, Warwicks, executed in 1785-8 to the combined designs of Heneage Finch, 4th Earl of Aylesford, and Joseph Bonomi.

The waning of the Etruscan style's popularity by 1790 was closely paralleled by a change from Etruscomania to the sober discipline of Etruscology. This was largely established by the researches in Florence of the Abbé Luigi Lanzi, author of the magisterial *Saggio di lingua etrusca e di altre antiche d'Italia* of 1789. This work was followed in 1806 by *Dei vasi antichi dipinti volgarmente chiamati Etruschi*, his highly systematic analysis of vase paintings, which categorically refutes those persisting errors that had originally done so much to promote the Etruscan style. When it made one rare reappearance in Italy during the 19th century, the Etruscan style was by then sufficiently distant from earlier emotive associations to be treated as just one among many historicist modes of expression. In 1834 Pelagio Palagi and Carlo Bellosio (1801-49) created an Etruscan Room (complete with antique vases) in the Castello Reale di Racconigi, near Turin, as one of the refashioned interiors for King Charles-Albert of Piedmont (*reg*

1831-49). In this small room, richly painted themes from vases were framed by a highly eclectic vocabulary of ornament with all the heavy opulence of the late Empire Style.

Bibliography

T. Dempster: *De Etruria regali*, 7 vols (Florence, 1723-5)

A. F. Gori: *Museum Etruscum exhibens insignia veterum etruscorum monumenta*, 3 vols (Florence, 1737-43)

——: *Museum Cortonense* (Florence, 1750)

C.-P. de Caylus: *Recueil d'antiquités égyptiennes, étrusques, grecques, romaines et gauloises*, 7 vols (Paris, 1752-67)

M. Guarnacci: *Origini italiche ossiano memorie istorico-Etrusche sopra l'antichissimo regno d'Italia*, 3 vols (Lucca, 1767-72)

G. B. Passeri: *Picturae etruscorum in vasculis*, 3 vols (Rome, 1767-75)

L. A. Lanzi: *Saggio di lingua etrusca e di altre antiche d'Italia*, 2 vols (Rome, 1789)

——: *Dei vasi antichi dipinti volgarmente chiamati etruschi* (Florence, 1806)

J. Byres: 'Hypogaei', or the Sepulchral Caverns of Tarquinia (London, 1842)

W. Mankowitz: *Wedgwood* (London, 1953)

R. Bloch: 'The History of Etruscology', *The Etruscans* (London, 1958), pp. 19-47

F. J. B. Watson: *Louis XIV Furniture* (London, 1960)

E. Harris: *The Furniture of Robert Adam* (London, 1963)

D. Stillman: *The Decorative Work of Robert Adam* (London, 1966)

B. Fothergill: *Sir William Hamilton* (London, 1969)

E. Croft-Murray: *Decorative Painting in England, 1537-1837*, ii (London, 1970)

J. Wilton-Ely, ed.: *G. B. Piranesi: The Polemical Works* (Farnborough, 1972) [reprints Piranesi's main publications on the Greco-Roman debate]

J. Wilton-Ely: 'Vision and Design: Piranesi's 'Fantasia' and the Graeco-Roman Controversy', *Piranèse et les français, 1740-90*, ed. G. Brunel (Rome, 1978), pp. 529-52

E. Harris and J. M. Robinson: 'New Light on Fawley', *Archit. Hist.*, xxvii (1984), pp. 263-5

J. Hardy and M. Tomlin: *Osterley Park House*, V&A guidebook (London, 1985)

L'accademia etrusca (exh. cat., ed P. Barocchi and D. Gallo; Cortona, Pal. Casali, 1985)

R. Reilly: *Wedgwood*, 2 vols (London, 1989)

J. Wilton-Ely: 'Pompeian and Etruscan Tastes in the Neoclassical Country-house Interior', *The Fashioning and*

Functioning of the British Country House, ed. G. Jackson and others (Washington, DC, 1989), pp. 51–73

Exchange Club [Amateur Photographic Exchange Club]

American photographic society founded in 1861 and open only to amateur photographers. The three founder-members, all from New York, were Henry T. Anthony (1814–84) as President, F. F. Thompson as Secretary and Correspondent, and Charles Wager Hull. Its membership was originally restricted to 20 and, though this rule was later dropped, the members never numbered many more than this. Nevertheless they were from all over the USA and soon included most of the prominent American amateurs of the day. Among them were August Wetmore and Lewis M. Rutherford of New York; Coleman Sellers, Professor Fairman Rogers and Constant Guillou of Philadelphia; Titian R. Peale of Washington; Robert Shirner of Cumberland, Maryland; John Towler of Geneva, New York, author of *The Silver Sunbeam* (New York, 1864), and Professor E. Emerson of Troy, New York. The physician and writer Oliver Wendell Holmes (1809–94) was an honorary member on the strength of his achievements as a photographic pioneer. The Club's existence reflected the enormous popularity of photography in the USA in the 1860s.

One of the main interests of the Exchange Club's members was stereoscopic photography; Wendell Holmes was the inventor of the most widespread version of the stereoscopic viewer, though single plate images were also produced. While the exact activities of the Club are not clear, its rules stated that 'every member shall forward each other member on or before the 15th of January, March, May, July, September and November, at least one stereoscopic print, a copy of which has not been sent before, mounted and finished'. Anyone failing to fulfil this condition would be struck off the membership list. Each member was required to keep an account-book showing all the prints sent and received. On 1 February 1863 Thompson published the first of seven issues of the Club's official journal, *The Amateur Photographic Print*, the last of which appeared on 1 September 1863.

The photographs produced by members of the Exchange Club were of variable interest, often consisting of single and group portraits and landscapes (see Taft, p. 206). As a mark of membership each member designed his own label, which was stuck on to the back of any print sent. The contents of the labels varied from basic descriptions of the subject, as in those of John Towler (see Darrah, fig. 9), to more detailed technical records about how the work was taken, as in those of Coleman Sellers (see Darrah, fig. 10). The Club was active only until late 1863, by which time the American Civil War and the increased availability of commercial prints had virtually brought it to an end. References to the activities of the Club appeared in Wendell Holmes's article 'The Doings of the Sunbeam' in *Atlantic Monthly*, though it was not mentioned by name. In 1888 a more detailed account was published by one of its most energetic members, Sellers, in a series of articles in *Anthony's Photographic Bulletin*.

Bibliography
O. Wendell Holmes: 'The Doings of the Sunbeam', *Atlantic Mthly*, xii (1863), no. 69, pp. 1–15
C. Sellers: 'An Old Photographic Club', *Anthony's Phot. Bull.*, xix (1888), no. 10, pp. 301–4; no. 11, pp. 338–41; no. 12, pp. 356–61; no. 13, pp. 403–6
R. Taft: *Photography and the American Scene: A Social History, 1839–1889* (New York, 1938, R/1964), pp. 213–16, 222
W. Culp Darrah: *Stereo Views: A History of Stereographs and their Collection* (Gettysburg, 1964), p. 4, figs 9–11

Federal style

Architectural and decorative arts style that flourished in the USA from shortly after the acknowledgement of independence in the Treaty of Paris (1783) until *c*. 1820. The term is derived from the period surrounding the creation of the federal constitution in 1787 and was in use in a political sense by that year. Essentially it was a form of Neoclassicism, strongly influenced by manifestations of that style in England and, to a lesser extent, in France; but at times certain more conservative

qualities inherited from the previous Colonial period are also present. The inspiration of European, and especially English, Neo-classical architecture was to be expected in a society grounded in that of 18th-century England; but an added impetus was the association often cited at the time between the fledgling American republic and the ancient Roman one.

Although a few indications of European Neo-classical influence are found in the American colonies before the Revolution began in 1776, these were almost exclusively restricted to an occasional appearance in such interior decorative details as ceiling patterns, as in the stair-hall ceiling of the Chase-Lloyd House (c. 1771–72) in Annapolis, MD, and in silver. Generally a Palladian style with certain Baroque and Rococo decorative treatments characterized American architecture in the third quarter of the 18th century. After the Revolution, in the second half of the 1780s, a substantial infusion of Neo-classical taste reached the USA, and this began to mix with and in some cases replace the Colonial style.

1. Architecture

The importation of newer architectural books, the influence of patrons directly acquainted with European Neo-classicism and the arrival of craftsmen and architects trained in this new manner all helped to establish the Federal style. The earliest examples of the new approach include: John Penn's Solitude (c. 1784–5) and William Hamilton's Woodlands (1786–8), both country houses outside Philadelphia; William Bingham's town house in that city (c. 1785–6; destr.), probably by the English architect John Plaw; and the Virginia State Capitol, Richmond (c. 1785–96), designed by the statesman and architect Thomas Jefferson with some help from the Frenchman Charles-Louis Clérisseau. Shortly thereafter the style appeared throughout the country, from Salem, MA, to Charleston, SC.

The specific adaptation of Roman buildings (as in the Virginia Capitol, based on the Maison Carrée, Nîmes) is relatively rare. Much more common is the transformation of the Colonial Palladian style by the introduction of attenuated proportions and

flatter surfaces, as well as such Neo-classical decorative details as fanlights, chimney-pieces and, occasionally, oval rooms and projections. This type of Neo-classicism is found extensively from Maine to Georgia and as far west as Indiana and Kentucky. Among its leading practitioners were Samuel McIntire in Salem, Charles Bulfinch in Boston, Asher Benjamin in western Massachusetts and later in Boston, John McComb jr in New York and Gabriel Manigault (1758–1809) in Charleston, SC.

Still another form of Neo-classicism, derived not so much from the work of Robert Adam as from the more austere aesthetic popularized in the 1790s by George Dance and John Soane in England and by Claude-Nicolas Ledoux (see fig. 37) and Etienne-Louis Boullée in France, reached the USA with the arrival from London in 1796 of Benjamin Henry Latrobe, the first professionally trained architect to practise in the USA. In buildings such as the Bank of Pennsylvania, Philadelphia (1799–1801; destr. 1867), and the Roman Catholic Cathedral, Baltimore (1805–20), Latrobe introduced not only the powerful plain walls, saucer domes and concealed lighting effects of Dance or Soane but also certain more archaeological features, including the Greek Ionic order of the Erechtheion. This brand of Neo-classicism, though derived more from Ledoux and Boullée, was also brought to America by the Frenchman Maximilian Godefroy, as in his Unitarian Church, Baltimore (1817–18). It was practised as well by Latrobe's pupil Robert Mills, for example in his Monumental Church, Richmond (1812–17).

Although he supported Latrobe and his interpretation of Neo-classicism, Jefferson created yet a different facet of the Federal style. Apart from his Virginia Capitol, which was an exercise in Roman Revivalism tempered by the needs of the state government, he also transformed (1796–1809) his own house, Monticello, near Charlottesville, VA; built a number of other houses in Virginia for himself and friends, including Poplar Forest (1806–12); and both laid out the plan and designed the buildings for the University of Virginia, Charlottesville (1817–26). In all of these other works he combined the Palladian influences of his youth with such Neo-classical features as curved

and canted projections, saucer domes and an appreciation of certain archaeological details.

Among the other major monuments of the Federal style are the plan of the city of Washington, DC, and its two principal public buildings, the Capitol and the President's House (the White House). The city itself was laid out in 1791 by Pierre-Charles L'Enfant, utilizing grand French Baroque *allées* and *rond-points* overlaid by a grid. The Capitol (1792–1835; wings and dome, 1850–65) was designed by William Thornton, but various changes were made by a series of executing architects, the most important of whom was Latrobe. The White House was designed by James Hoban and completed by him in 1802 (altered by Latrobe and Hoban, 1807 and 1824) (see col. pl. XII).

Although various characteristics of the Federal style, especially its modified simplifications of the Adam style, continued into the 1830s and beyond, it had begun to be supplanted by the Greek Revival by 1820 (*see* GREEK REVIVAL, §3). Motivated more strongly by both archaeology and Romanticism, this new style became dominant in the second quarter of the 19th century.

Bibliography

F. Kimball: *Domestic Architecture of the American Colonies and of the Early Republic* (New York, 1922)

—: *Mr. Samuel McIntire, Carver: The Architect of Salem* (Portland, ME, 1940/R Gloucester, MA, 1966)

T. Hamlin: *Greek Revival Architecture in America* (New York, 1944)

S. Boyd: *The Adam Style in America, 1770–1820* (diss., Princeton U., 1967)

—: 'The Adam Style in America, 1770–1820', *Amer. Assoc. Archit. Bibliog.: Pap.*, v (1968), pp. 47–68

W. H. Pierson: *American Buildings and their Architects: The Colonial and Neo-classical Styles* (Garden City, NY, 1970)

J. Quinan: *The Architectural Style of Asher Benjamin* (diss., Providence, RI, Brown U., 1973)

W. H. Adams, ed.: *The Eye of Thomas Jefferson* (Washington, DC, 1976)

L. Craig and others: *The Federal Presence: Architecture, Politics and Symbols in the United States Government Buildings* (Cambridge, MA, 1978)

B. Lowry: *Building a National Image: Architectural Drawings for the American Democracy, 1789–1912* (Washington, DC, 1985)

C. E. Brownell and J. A. Cohen, eds: *The Architectural Drawings of Benjamin Henry Latrobe* (London and New Haven, 1994)

P. Norton: *The Papers and Drawings of Samuel McIntire* (in preparation)

D. Stillman: *Neo-classicism in America: The Architecture of the Young Republic, 1785–1825* (in preparation)

2. Decorative arts

Like the architecture in which they were used, the decorative arts of the Federal period reflect the inspiration of Classical antiquity, and even more of Neo-classical England and France, tempered by existing, often conservative traditions. This can be seen most readily in metalwork and furniture, but it is also true of glass, ceramics and textiles. The appeal of antiquity is clearly indicated by the use of such Classical motifs as urns, garland swags and fasciae and such antique shapes as the klismos chair or urn- or helmet-fashioned teapots and sugar bowls. Specific motifs associated with the new American republic are less common than those reflecting antiquity, but they were sometimes employed (eagles, for example, inspired by the Great Seal, were especially popular). Such other patriotic motifs as the liberty cap were used occasionally, and there is even a card-table (Winterthur, DE, Du Pont Winterthur Mus.), made in New York, with a glass decorative panel featuring the names of the Democratic–Republican party candidates for President and Vice-President in 1800, Thomas Jefferson and Aaron Burr. As with architecture, a new lightness and delicacy first appeared, modified towards the end of the period by an increased heaviness and a somewhat more archaeological approach. Again, as with buildings, there is a heightened homogeneity in the decorative arts made in different areas of the new country, but regional differences and the individual characteristics of specific artist-craftsmen can be detected.

Although in general the new style did not appear until after the conclusion of the American Revolution in 1783, it can be found before then in metalwork, especially silver, as in a presentation tea urn (Philadelphia, PA, Mus. A.) made in 1774, on the eve of the Revolution, in Philadelphia by

Richard Humphreys (1750–1832) and inscribed to Charles Thomson, the secretary to the Continental Congress. Fashioned in the shape of an urn and ornamented with fluted bands and rosettes, as well as having a square base and squared handles and spout, it epitomizes the Neo-classical taste that is synonymous with the Federal style. After the Revolution, a similar taste could be found, for example, in tea services made in Boston by Paul Revere (1735–1818) in 1792 (Minneapolis, MN, Inst. A.) and in Philadelphia by Simon Chaudron (1758–1846) and Anthony Rasch (1778–1857) in 1809–12 (Winterthur, DE, Du Pont Winterthur Mus.), as well as in such objects as a jug shaped like a wineskin, made for Jefferson by Anthony Simmons (d 1808) and Samuel Alexander (d 1847) in Philadelphia in 1801 (Monticello, VA, Jefferson Found.), or a plateau (or tray) executed in New York by John Forbes (1781–1864) and presented to De Witt Clinton in 1825 (priv. col., on loan to New York, Met.).

In furniture the Federal style flourished throughout the country from Salem, MA, to Charleston, SC, and westward into Kentucky and Louisiana. The most direct inspiration was from the pattern books of George Hepplewhite and Thomas Sheraton, but later influences include Thomas Hope, George Smith and Pierre La Mésangère (1761–1831). The presence of French as well as English source books was paralleled by the activity of a number of French-trained cabinet-makers working in Federal America, including Charles-Honoré Lannuier in New York and Michel Bouvier (1792–1874) in Philadelphia, just as Chaudron represents French silversmiths working in the latter city.

Indications of the new style are found in oval- and shield-back chairs, often with delicately tapered or sabre legs; a host of Neo-classical motifs from urns and Classical orders to putti and pat-erae; and refined inlay and exquisite ormolu mounts. Such mounts were employed especially by French émigrés, but Americans and cabinet-makers from Britain also used them. Representa-tive examples of chairs include those with carved shield-backs made in Salem by Samuel McIntire in the 1790s (e.g. Winterthur, DE, Du Pont Winterthur Mus.); scroll-back and sabre-leg models created by Duncan Phyfe in New York in 1807 (Winterthur, DE, Du Pont Winterthur Mus.); painted oval-backed chairs with Prince of Wales feathers (e.g. New York, Met.) ordered from Philadelphia in 1796 by Salem merchant Elias Haskett Derby (1739–99); and rectangular ones enlivened with scenes of country houses near Baltimore (c. 1800–10; Baltimore, MD, Mus. A.) executed by John Finlay (1777–1840) and Hugh Finlay (1781–1831). Tables range from deli-cately inlaid Pembroke or breakfast tables made in Salem by Elijah Sanderson (1751–1825) and Jacob Sanderson (1757–1810) in the 1780s or 1790s (Winterthur, DE, Du Pont Winterthur Mus.), to card-tables with gilded winged figures by Lannuier (c. 1815; Baltimore, Mus. & Lib. MD Hist.; New York, Met.). Examples of Federal style cabinets include an inlaid semicircular commode by John Seymour and Thomas Seymour of Boston (c. 1809; Boston, MA, Mus. F.A.); a carved double chest with numer-ous Neo-classical motifs on top and a more Rococo bombe-shaped lower half, made by William Lemon (fl c. 1796–1827) and carved by McIntire (c. 1796; Boston, MA, Mus. F.A.); or a lady's dressing-table with inlay of fine woods and painting on glass, topped by urns and an eagle (Baltimore, Mus. & Lib. MD Hist.), made in Baltimore in the first decade of the 19th century and attributed to William Camp (1773–1822).

The most noteworthy glass of the period was that made by John Frederick Amelung at his New Bremen Glassmanufactory near Frederick, MD. Established in 1784, this glassworks produced a number of high-quality pieces between c. 1788 and 1792. These are not characterized by Neo-classical motifs but rather by a refined elegance, as in an amethyst-covered sugar bowl (Winterthur, DE, Du Pont Winterthur Mus.) or a clear glass tumbler of 1792 (priv. col., see Cooper, 1980, fig. 175), which sports an engraving of the Great Seal of the USA. Other Federal period glass includes the products of Bakewell & Co., founded in Pittsburgh in 1808; the New England Glass Co., established in Cambridge, MA, in 1818; and a number of glasshouses in southern New Jersey.

Neo-classical ceramics used in the USA during the Federal period were mostly wares imported

from England, France and China. Earthenwares were made, some of which, such as a black-glazed coffeepot by Thomas Haig & Co. of Philadelphia (*c.* 1825; New York, Met.), reflect the influence of English Regency and French Empire silver and porcelain. Only in 1826 did the china manufactory founded by William Tucker in Philadelphia begin to produce similarly inspired porcelain wares. The most fashionable textiles in the Neo-classical taste were also imported from England and France, but both hand-embroidered and machine-printed fabrics, notably the printed calicoes of John Hewson (1744–1821) of Philadelphia, were produced in the USA during this era.

Bibliography

B. Tracy and W. H. Gerdts: *Classical America, 1815–1845* (Newark, NJ, 1963)
C. F. Montgomery: *American Furniture: The Federal Period* (New York, 1966)
19th-Century America: Furniture and Other Decorative Arts (exh. cat., New York, Met., 1970)
W. Cooper: *In Praise of America: American Decorative Arts, 1650–1830* (New York, 1980)
B. Garvan: *Federal Philadelphia, 1785–1825: The Athens of the Western World* (Philadelphia, 1987)
B. Cullity: *Arts of the Federal Period* (exh. cat., Sandwich, MA, 1989)
S. Feld: *Neo-classicism in America: Inspiration and Innovation, 1810–1840* (New York, 1991)
G. Hood: 'Early Neoclassicism in America', *Antiques*, cxl (1991), pp. 978–85
W. Garrett: *Classical America: The Federal Style and Beyond* (New York, 1992)
W. Cooper: *Classical Taste in America, 1800–1840* (Baltimore, New York and London, 1993)
J. Bell: 'Georgetown's Temple of Liberty', *A. & Ant.*, iv (1996), pp. 81–5
K. L. Ames: 'Surface Charm: Inlay Played a Major Role in Defining American Furniture', *A. & Ant.*, xx (1997), pp. 46–54

DAMIE STILLMAN

Fontainebleau school [Fr. *Ecole de Fontainebleau*]

Term that encompasses work in a wide variety of media, including painting, sculpture, stuccowork and printmaking, produced from the 1530s to the first decade of the 17th century in France. It evokes an unreal and poetic world of elegant, elongated figures, often in mythological settings, as well as incorporating rich, intricate ornamentation with a characteristic type of strapwork. The phrase was first used by Adam von Bartsch in *Le Peintre-graveur* (21 vols, Vienna, 1803–21), referring to a group of etchings and engravings, some of which were undoubtedly made at Fontainebleau in France. More generally, it designates the art made to decorate the château of Fontainebleau, built from 1528 by Francis I and his successors, and by extension it covers all works that reflect the art of Fontainebleau. The principal artists of the school were Rosso Fiorentino, Francesco Primaticcio, Nicolò dell'Abate, Antonio Fantuzzi, Antoine Caron and, later, Toussaint Dubreuil, Ambroise Dubois and Martin Fréminet. With the re-evaluation of MANNERISM in the 20th century, the popularity of the Fontainebleau school has increased hugely. There has also been an accompanying increase in the difficulty of defining the term precisely.

1. Introduction

When Francis I returned from his imprisonment in Madrid (1525–7) by the Holy Roman Emperor Charles V, he chose to live in and near Paris rather than in the Loire Valley as he had done in the first part of his reign. For that purpose he embarked on a large campaign of building residences in the Ile-de-France, beginning in 1527. His favourite residence soon became Fontainebleau, approximately 65 km south-east of Paris, where he owned a ruined medieval castle in the middle of excellent hunting grounds. The structure was rapidly rebuilt and expanded without great architectural distinction; however, for the interior the King decided on an ambitious programme of painted decoration to be executed in the Italian manner. Earlier in his reign he had attempted to attract well-known Italian artists to his court but had been turned down by both Raphael and Michelangelo. Leonardo had accepted his invitation in 1516, but, no longer able to paint, he died in 1519 near Amboise. In 1518 Andrea del Sarto

was brought to France, but he returned to Florence the following year. The King was more successful with a younger generation of artists. It was probably partly on the advice of Pietro Aretino that he invited Rosso Fiorentino, who arrived in 1530 and worked for him until his suicide in 1540. In 1532 Primaticcio arrived, a younger and still unproven artist sent from Mantua by Giulio Romano, who was too preoccupied with work to come himself. In 1553 Nicolò dell'Abate joined Primaticcio at Fontainebleau, where they were both active until their deaths in the early 1570s. After this time artistic activity was very reduced at Fontainebleau because of political instability and the Wars of Religion (1562–98). However, from 1595 activity resumed under Henry IV (*reg* 1589–1610) with a new group of artists who constituted what is sometimes called the second Fontainebleau school.

2. First Fontainebleau school

(i) Work of Rosso and Primaticcio. The first phase of work, which ended with Rosso's death in 1540, was the most innovative and complex. For practical reasons, the first projects executed were for the living-quarters of the King and his queen Eleanor and were entrusted not to Rosso but to Primaticcio. Initially this seems surprising, as Rosso was a much better-known artist and had arrived before Primaticcio. However, it is generally accepted that the reason for this apparent anomaly lay with Primaticcio's having brought with him a project for the Chambre du Roi that had been established by Giulio Romano in Mantua. Giulio was not only Raphael's heir—and therefore more authoritative than Rosso—but was also much more experienced in executing monumental decorations. Rosso and Primaticcio are often thought of as strongly contrasting artistic personalities, but in the 19th century critics frequently confused their works. This is significant if one is to understand the kind of currency that the term 'Fontainebleau school' has acquired. Indeed, at Fontainebleau the two artists were in close contact, and the younger Primaticcio perhaps learnt more from Rosso than is generally assumed. Although Primaticcio worked independently of Rosso, and each had a team of assistants from

France and other countries, they worked closely together and collaborated on the decorative scheme for the Pavillon de Pomone (destr.) and the Galerie François I (1532–9; see col. pl. XIII and fig. 28). This complicates an assessment of their respective contributions to the most striking innovation of the 1530s at Fontainebleau: a type of decoration in which a combination of painting and stucco relief is placed above a high wainscoting.

Louis Dimier, in *Le Primatice* (Paris, 1900), proposed that the initiatives came from Rosso and that the Galerie François I was the one decisive work. The exuberant and original decoration of this extremely long and narrow room is still fairly well-preserved. The Chambre du Roi (1533–5), however, has been destroyed. Its decoration was carried out on the basis of a project designed by Giulio and apparently brought to France by Primaticcio; the walls were wainscoted up to about 2 m, and frescoes above depicted the *History of Psyche* encased in a rich framework of gilt stucco with subsidiary pictures. Here, the main elements of the characteristic Fontainebleau scheme were already in place. There is, of course, a long way between drawings for the project and the final execution. The placement over high wainscoting, for instance, was certainly a decision made in relation to French habits, and it would not be clear from the drawing that the framework was to be in full stucco relief. Nor should one exaggerate the importance of this priority because the Galerie François I was surely already being planned while the Chambre du Roi was being decorated. Rosso may have been consulted about final decisions for the Chambre, and Primaticcio's expertise in stuccowork could have helped in planning the very complex scheme of the Galerie. Rather than individual responsibilities, what is important is that the work done at Fontainebleau, by transplanted Italian masters assisted by French, Italian and Flemish artists and craftsmen catering to French patrons, has a different appearance from comparable decorations in Italy. It is this new 'look'—hard as it may be to define—and the contacts between many artists of various nationalities gathered in a somewhat isolated place that are the basis of what can be called the Fontainebleau school.

28. Rosso Fiorentino: *Venus Scolding Cupid*, 1534-6 (Fontainebleau, Musée National du Château de Fontainebleau, Galerie François I)

The death of Rosso in 1540 marked a new phase in the art of Fontainebleau. Rosso's art was most often characterized by an extremely unconventional, bizarre and almost extravagant fantasy and a taste for the rare and unexpected that affected both his subject-matter and treatment of figures. Primaticcio, who had been trained in the discipline of Raphael transmitted through Giulio Romano, produced much more classicizing work. He became the uncontested leader of court art during the last years of Francis I's reign (1540–47), and when Rosso died he was in fact in Rome collecting antique sculptures for the King and making moulds of some of the best-known Classical works to have them cast in bronze at Fontainebleau. For this task he brought back with him the young Jacopo Vignola as a technical assistant. Other new arrivals from Italy, among them the Florentine goldsmith Benvenuto Cellini and the Bolognese architect and theorist Sebastiano Serlio, could only reinforce Primaticcio's classicizing tendencies. Cellini crafted the salt cellar of Francis I (1540–43; Vienna, Ksthist. Mus.; see fig. 29) and secured his reputation as a significant bronze sculptor with the *Nymph of Fontainebleau* (?1543; Paris, Louvre) planned for the entrance gate of the château. He was set up in Paris rather than at Fontainebleau and had troubled relations with the French. It is difficult to say how much of an impact his rather unsuccessful stay made in France beyond the production of a handful of masterpieces.

For Primaticcio, these years were a time of astounding productivity. As well as the arduous task of supervising the making of casts (Fontainebleau, Château) of such antique sculptures as the *Laokoon* (Rome, Vatican, Mus. Pio-Clementino) and *Sleeping Ariadne*, he executed frescoes (early 1540s; part destr.) for the vestibule of the Porte Dorée, decorated the bedchamber of the Duchesse d'Etampes (1541–4) and much of the Galerie d'Ulysse (late 1540s; destr. 1738), the latter his largest and most complex painted decoration. The most spectacular commission must have been a suite of baths known as the Appartement des Bains (1544–7; destr.), a series of six rooms for bathing and relaxation set up beneath the Galerie François I. In these rooms such masterpieces of the King's collection as Leonardo's *Virgin of the Rocks* (commissioned 1483; Paris, Louvre) and Andrea del Sarto's *Charity* (1518; Paris, Louvre) were displayed, encased in stucco frameworks. The central room, with a small pool in the middle, was decorated with the story of *Jupiter and Callisto*, and apparently several murals had explicitly erotic content. This extraordinary ensemble can be understood as the synthesis of a strongly vernacular and medieval tradition of having public and princely baths on the one hand and a humanistic tradition of ancient Roman baths on the other. Although the rooms were destroyed, we have some records of the decoration through drawings and prints. While the subject-matter was partly playful, the style was in a grand antique manner.

29. Benvenuto Cellini: Salt Cellar of Francis I, 1540–43 (Vienna, Kunsthistorisches Museum)

(ii) Role of printmaking. The production of prints is one of the most original aspects of the Fontainebleau school, although it is not known exactly when or how it started. According to Vasari, engravings of Rosso's work were made in France while he was still alive. This seemed unlikely, although recent evidence appears to confirm it. Pierre Milan, possibly an Italian immigrant, was certainly making engravings in Paris by 1540. Rosso was in Rome before the city was sacked in 1527 and was deeply involved in printmaking, drawing compositions specifically to be engraved by Giovanni Jacopo Caraglio. In France he may have decided to renew this practice by collaborating with craftsmen in Paris. Etchings probably began to be made at Fontainebleau in 1542, a time when frenetic decorative activity was taking place. Antonio Fantuzzi, a painter from Bologna and one of Primaticcio's principal assistants, may have had the initiating role and was certainly the most productive, along with Léon Davent, a professional printmaker, and Jean Mignon, a French painter employed at Fontainebleau. Prints executed there have a characteristic appearance: they are quickly made, experimental and apparently uncommercial in intention. Most reproduce compositions by Rosso, Primaticcio and Giulio Romano. Primaticcio himself, whatever his degree of involvement, must have at least tolerated this activity, since he surely controlled most of the drawings that were reproduced. Other artists at Fontainebleau, notably Geoffroy Dumonstier and Domenico del Barbiere, produced prints of their own compositions. Printmaking at Fontainebleau seems to have lasted for only a few years. After 1545, when Fantuzzi produced fewer etchings, the character of the production changed, becoming more careful and commercial, and Luca Penni became the main provider of compositions. Eventually, the whole activity seems to have moved to Paris, possibly when Francis I died in 1547. Meanwhile, the production of burin engravings in Paris continued in the workshop of Pierre Milan, who employed René Boyvin, the plates made by the two being indistinguishable at this time. Later, Boyvin signed his prints and continued to produce them at least until 1580. Most of the designs engraved by the Milan–Boyvin workshop were by Rosso; by Léonard Thiry, Rosso's Flemish assistant at Fontainebleau, who worked in his master's style (e.g. the *Livre de la conqueste de la toison d'or*, probably done in the 1540s but not published by Boyvin until 1563); and by Penni, who apprenticed his son Lorenzo Penni (*fl c.* 1557) to Boyvin.

Printmaking made a major contribution to the Fontainebleau school. To a certain extent, the production of prints balanced the stylistically diverse contributions to 16th-century French court art, giving it greater homogeneity than it would otherwise have had. More significantly, perhaps, prints—especially Fantuzzi's—were an important factor in the conversion of Rosso's monumental decorations into an ornamental style that could be applied to all kinds of works, from architecture to jewellery.

(iii) Dispersion of artists from Fontainebleau. Fontainebleau also functioned as a school in the more literal sense, in that it was the training-ground for many artists. Pierre Bontemps, a sculptor who worked at Fontainebleau in the late 1530s and probably finished his training there, was later employed on royal projects for many years. The marble *Monument for the Heart of Francis I* (1550–56; ex-Abbey of Les Hautes-Bruyères; Paris, Saint-Denis Abbey) is a characteristic example of the Fontainebleau school, having strapwork ornament derived from Rosso and relief compositions with elongated, pliant and sensuous figures reminiscent of Primaticcio. It is unclear to what extent Bontemps himself was responsible for the figures, the architectural design in all likelihood being by Philibert de L'Orme. Even artists who arrived as fully trained professionals altered their manner when in contact with Rosso or Primaticcio. This must have been the case with Luca Penni, who worked with his brother-in-law Perino del Vaga in Genoa before coming to France. Although Penni first worked with Rosso, he was much more affected by Primaticcio, whose manner he adapted to his more ponderously Roman taste. *The Justice of Otto* (Paris, Louvre), the only

painting generally accepted as by his hand, was thought in the 18th century to be by Primaticcio. Léonard Thiry, however, adopted Rosso's stylistic peculiarities and continued to produce many compositions in his manner for a decade after the master's death.

In many cases, artists who were of considerable repute then are little known today, for example Lorenzo Naldini, a Florentine sculptor who had considerable success in France, and the sculptor and painter Simon Le Roy (*fl* 1534–42), who had moved to Paris by 1542. When an actual work is identified, it can be disconcerting. The *Deposition* (originally Orléans Chapel at the Celestins; now Paris, Ste Marguerite) had long been attributed to Francesco Salviati (another Florentine painter who came to France, although little is known of his activity there) but has since been identified as a work by Charles Dorigny, a painter active at Fontainebleau under Primaticcio. Generally Florentine in character, with distant echoes of the work of Andrea del Sarto, it has little to do with what is generally thought of as characteristic of the Fontainebleau school. One cannot therefore assume that all those who worked at Fontainebleau practised what would be recognized as art of the Fontainebleau school; nevertheless, the great numbers of artists who participated in the programmes of decoration there undoubtedly played an important part in spreading the style. In the 1540s in particular there was a veritable diaspora of artists who had worked there. After Rosso's death several sculptors probably left because there was much less work for them. More dramatic changes were brought about by the death of Francis I in 1547. Henry II (*reg* 1547–59), his successor, was much less attached to Fontainebleau, and artistic activity there during his reign was drastically reduced, with the result that a number of artists sought work elsewhere. The centre of gravity of artistic life moved to Paris. In addition, Henry was much less interested in painted decorations of the Italian type and rather more attracted to architecture and to sculptural decoration; he was also more inclined to patronize French artists.

(iv) **Influence.** The strong classicizing tendency of the 1540s was the dominant trend, although the more playful and fantastic art of Rosso was not forgotten. Jean Cousin *le père*, who moved from Sens to Paris probably shortly before 1540, was influenced by Fontainebleau. His production of the 1520s and 1530s is unknown, but works of the 1540s, especially his cartoons for tapestries depicting the *Life of St Mamas* (Langres Cathedral; Paris, Louvre), clearly echo the new classicizing style. Significantly, several etchings from his designs of the mid-1540s have long been considered as products of the Fontainebleau school. This would probably also have happened to *Eva Prima Pandora* if its attribution to Cousin had not always been perpetuated by his distant relatives who owned it until it entered the Musée du Louvre. François Clouet, whose court portraits betray his southern Netherlandish ancestry, also painted pictures in the Fontainebleau manner: for example, the *Bath of Diana* (Rouen, Mus. B.-A.) and the *Lady in her Bath* (?*Marie Touchet*) (*c.* 1570; Washington, DC, N.G.A.). Such anonymous paintings as the *Toilet of Venus* (Paris, Louvre) combine borrowings from Rosso and Primaticcio almost as a deliberate demonstration of their compatibility and their validity as works of the Fontainebleau school. The few monumental painted decorations commissioned show the success of Fontainebleau: several rooms at the château of Ancy-le-Franc (Yonne) attributed to Primaticcio and dell'Abate; the 12 painted overmantels at the château of Ecouen (Val d'Oise) done for Anne, Duc de Montmorency; and the paintings of episodes from Virgil's *Aeneid* in the gallery of the north wing of the Grand Ecuyer of Claude Gouffier's château of Oiron (Deux-Sèvres) by Noël Jallier, an otherwise entirely unknown painter who was clearly aware of Fontainebleau but also, it seems, of recent developments in Rome.

In spite of these examples, painted murals of the type prominent in Italy did not become popular in France. During the reign of Henry II the authority of Primaticcio was reduced, and the French architects Philibert de L'Orme and Pierre Lescot controlled most royal patronage; they

preferred sculpted decoration, which was more traditional in France. The impact of Fontainebleau was nevertheless considerable. The exuberant decoration of Lescot's façade of the Cour Carrée of the Palais du Louvre, with its exquisite figures in relief (1547–50) carved by Jean Goujon, would be unthinkable without the example of Primaticcio. The fact that much of the sculptural decoration at Diane de Poitiers's château of Anet (Eure-et-Loire) was attributed to Jean Goujon points to a similar source of inspiration, even if the attribution itself is discredited. Indeed, the well-known statue of *Diana with a Stag* (ex-château of Anet; Paris, Louvre), sometimes attributed to Goujon, with its graceful curves and tapering limbs, is the epitome of the Fontainebleau style. Domenico del Barbiere, who had worked at Fontainebleau, established a practice in Troyes and strongly inflected the great local sculptural tradition of Champagne towards the new court style.

(v) Later developments. The later works of Primaticcio have a slightly new character due partly to personal evolution and continued contacts with developments in Italy but also probably to the arrival in France in 1552 of Nicolò dell'Abate, a skilled painter from Modena who had already established his reputation in Italy. A virtuoso draughtsman and an original colourist, dell' Abate's Emilian training in the tradition of Correggio and Parmigianino prepared him for his new position as Primaticcio's almost exclusive executant for painting. Primaticcio's works of this time display bolder decorative schemes with complex perspective effects and a warmer, more lively and less classicizing manner, as in the decorations (1552–6) for the Galerie Henrie II (Salle de Bal) at Fontainebleau. Being less favoured by Henry II, he was able to work for others, especially the Guise family. For the residence of François de Lorraine, 2nd Duc de Guise (1519–63), in Paris (now Hôtel de Soubise) he decorated the chapel with a spectacular *Adoration of the Magi* (destr.) that filled the walls of the choir. Such paintings had limited impact outside immediate court circles, in part because they were not reproduced by printmakers. However, the charming but weak *Birth of Cupid* (New York, Met.), one of a group of paintings by anonymous masters, is in the style of the Fontainebleau school and is indebted to both Primaticcio and dell'Abate. The MASTER OF FLORA, often considered to be the artist, is the result of an assemblage of works, the common authorship of which seems difficult to sustain. Dell'Abate himself produced independent paintings in France (e.g. the *Rape of Proserpina*; Paris, Louvre; see fig. 30) that show that he was not impervious to Primaticcio's example, thus reinforcing the coherence of the Fontainebleau school. In paintings such as these and in destroyed decorations for Fontainebleau he also developed an original landscape style. Antoine Caron is—with the exception of contemporary portrait painters—the first French artist with a substantial body of easel paintings. His tiny figures, gesticulating in a balletic manner, are reminiscent of dell'Abate's, but his art—especially his strange sense of colour—is his own, and he is the most typical artist working in the last decades of the reign of the Valois kings.

Catherine de' Medici assumed much power after the death of her husband Henry II in 1559, and Primaticcio once again became a favourite, succeeding de L'Orme as surveyor of the royal works. In this capacity he controlled not only buildings and their painted decoration but also the work of sculptors, notably those working on royal tombs. It was within this framework that Germain Pilon formed his mature style under Primaticcio's direct guidance, continuing the full impact of the art of Fontainebleau until 1590.

(vi) General character. The term 'Fontainebleau school' has been applied so loosely, referring to any 16th-century Italianate work with elongated forms, especially within a market-place eager to give a more precise appellation to mediocre anonymous products, that it can appear meaningless. Nevertheless, used more prudently it points to an important phenomenon: the creation of an original kind of court art in France under Francis I and its partial transformation and diffusion over the next 40 years. While its components may seem disparate to the

30. Nicolò dell'Abate: *Rape of Proserpina* (Paris, Musée du Louvre)

scholar of Italian art, it must be remembered that for the French, who had come from a tradition of late Flamboyant work and *mille fleurs* tapestries, this must have seemed very new and highly classical in style. As has been noted, there were also such homogenizing factors as the production of prints and the training of artists at Fontainebleau. Other artists were instrumental in giving currency to the art of the court, principally the architect and engraver Jacques Androuet Du Cerceau and the goldsmith and engraver Etienne Delaune. Through various channels, the art of Fontainebleau affected all areas of visual production, from monumental buildings to the design of jewellery. The decorative arts

had always had an important tradition in France, and this continued, though with the adoption of the new style from Fontainebleau. While the Italian artists at court were occasionally occupied with the decorative arts, Jean Cousin—although always designated as a painter—was in fact mostly occupied with projects for tapestries, stained-glass windows, Limoges enamels, luxury vessels and armoury for execution by various craftsmen. Thus, the 'Fontainebleau school' affected the whole visual environment of upper-class society.

To see this phenomenon as mere fashion belittles its importance. It has deep ideological implications. Through its origins and associations, what

might be called the 'classicizing Mannerism' of the Fontainebleau school was very much a royal style. As such, it made royal power manifest and thereby reinforced it, contributing to a sense of national identity at a particularly important time in the history of France, when there was great instability. In that sense the phenomenon of the Fontainebleau school is an active element in the complex establishment of the modern or 'absolute' monarchy. On the other hand, display was a prime method of establishing prestige on the European stage, making luxury a necessity.

3. Second Fontainebleau school

The Wars of Religion and the dynastic crisis caused by the death in 1589 of Henry III, last king of the Valois line, marked a caesura in French life. Once peace was restored by the new Bourbon king Henry IV, a deliberate effort was made to re-establish continuity as a marker of legitimacy. Painters had never entirely abandoned Fontainebleau; Henry IV undertook its vigorous rejuvenation, as well as that of a few others such as the château of Saint-Germain-en-Laye and the Palais du Louvre. An artist of great talent, Toussaint Dubreuil ensured real continuity by collaborating with Ruggiero de Ruggieri (*fl* 1557–97), one of Primaticcio's Italian assistants, who had become Premier Peintre to the King. Dubreuil's references to Primaticcio and the art of the great reigns of Francis I and Henry II are clear and deliberate. *Cybele Awakening Morpheus* (Fontainebleau, Château), for example, is a paraphrase of Primaticcio's composition in the vestibule of the Porte Dorée. However, Dubreuil was a fertile and elegant composer in his own right who, like Primaticcio, did not execute the paintings himself. His decorative projects have all been destroyed, but his drawings and descriptions of them (Paris, Louvre and Ecole N. Sup. B.-A.; Amsterdam, Rijksmus.) show that he was inventive and original. Unfortunately, this heir to Primaticcio died prematurely in 1602. Concurrently with Dubreuil, Ambroise Dubois from Antwerp produced fluent, if less original, work. He is supposed to have arrived in France fully trained, but his art shows that he may have had close contact with the earlier Fontainebleau style. However, this may have been because Fontainebleau and Paris were requisite stops for northern European artists on their training journeys to Rome. Some did not feel it necessary to go further south. After Dubreuil's death Henry IV recalled Martin Fréminet from Italy, where he had spent several years. In Rome he had been particularly attentive to Michelangelo and had formed a vehement style with highly pliable figures that also recalls the art of such northern European artists as Bartholomäus Spranger, although it is difficult to know whether this was due to direct contacts or to an independent synthesis of similar elements. Fréminet's decoration (1606–19) of the chapel of the Trinity at Fontainebleau is the most important decorative ensemble surviving from the period. His death in 1619, a few years before Rubens's execution of the cycle of paintings of the *Life of Marie de' Medici* (Paris, Louvre) for the Palais du Luxembourg, marked the end of an era.

During Henry IV's reign the deliberate return to the art of the earlier Fontainebleau school is strikingly felt in a series of erotic pictures, the most famous of which is *Gabrielle d'Estrées and her Sister, the Duchesse de Villars* (Paris, Louvre), where the anonymous artist combined two earlier prototypes, François Clouet's *Lady in her Bath* and *Lady at her Dressing-table* (Worcester, MA, A. Mus.), for Henry's mistress. In this case, the sense of a second Fontainebleau school seems proclaimed in an almost programmatic way.

Bibliography

L. de Laborde: *La Renaissance des arts à la cour de France*, 2 vols (Paris, 1850–55)

L. Dimier: *Le Primatice, peintre, sculpteur et architecte des rois de France* (Paris, 1900)

—: *French Painting in the Sixteenth Century* (London and New York, 1904)

S. Béguin: *L'Ecole de Fontainebleau: Le Maniérisme à la cour de France* (Paris, 1960)

W. M. Johnson: 'Les Débuts du Primatice à Fontainebleau', *Rev. A.*, 6 (1969)

H. Zerner: *L'Ecole de Fontainebleau: Gravures* (Paris, 1969; Eng. trans., London and New York, 1969)

Actes du colloque international sur l'art de Fontainebleau. L'Art de Fontainebleau: Paris, 1972

S. Béguin and others: 'La Galerie François Ier au château de Fontainebleau', *Rev. A.*, 16–17 (1972) [double issue]

L'Ecole de Fontainebleau (exh. cat., ed. S. Béguin; Paris, Grand Pal., 1972–3)

H. Zerner: *Italian Artists of the Sixteenth Century (1979)*, 32 [XVI/i] of *The Illustrated Bartsch*, ed. W. Strauss (New York, 1978–)

J.-J. Lévèque: *L'Ecole de Fontainebleau* (Neuchâtel, 1984)

Fontainebleau et l'estampe au XVIe siècle: Iconographie et contradictions (exh. cat. by K. Wilson-Chevalier, Nemours, Château Mus., 1985)

De Nicolò dell'Abate à Nicolas Poussin: Aux sources du classicisme, 1550–1650 (exh. cat., ed. B. Grinbaum; Meaux, Mus. Bossuet, 1988)

K. Wilson-Chevalier: 'Women on Top at Fontainebleau', *Oxford A. J.*, xvi/1 (1993), pp. 34–48

The French Renaissance in Prints from the Bibliothèque Nationale de France (exh. cat. by C. Buckingham and others, Los Angeles, UCLA, Grunwald Cent. Graph. A.; New York, Met.; 1994–5)

HENRI ZERNER

François Ier style [François Premier style; Francis I style; Fr. *Style François Ier*]

Term used to describe the architecture and sculpture of the first phase of the French Renaissance, which coincided with the late rule of Louis XII and the early rule of Francis I (1515–*c.* 1530). The style was revived in the 19th century for architecture and the decorative arts. In architecture it is a hybrid style characterized by an overlay of imperfectly understood Italian ornamentation on traditional Gothic forms. An important early example is the château of (1508–10) built by Cardinal Georges I d'Amboise; others, built mainly for courtiers and patricians, are the châteaux (or parts of them) at Oiron, Vendeuvre, Chenonceaux, Bury, Azay-le-Rideau (see fig. 31) and elsewhere. These works feature an adoption of the decorative vocabulary of Milanese Quattrocento architecture, an ornamented mode of pilasters, medallions and

31. Château of Azay-le-Rideau, exterior, 1518

grotesques, to which French architects trained in the Flamboyant style readily responded. This style was continued in Francis I's châteaux in the Loire valley, such as Blois, where the wing that bears his name (1515–24) has novel Renaissance-style elements: a monumental staircase and double-tiered loggias based on Bramante's at the Vatican. Chambord (1519–1550) has a more Italianate character and monumentality, but its roof has turrets, chimneys and dormers of differing designs in the spirit of Flamboyant style but adorned with Italian architectural motifs. In sculpture the François Ier style was also a highly ornamented hybrid style, exemplified by Girolamo Viscardi's sculptures at the abbey church of La Trinité Fécamp Abbey (1507–8), which is Late Gothic in structure but Italianate in its carved decoration. Major tombs in this style are the tomb of *Louis XII and Anne of Brittany* (1516–31) by Antoine Giusti (1479–1519) and Jean Giusti (1485–1549) in Saint-Denis Abbey, where the disposition of the elements, with the kneeling king and queen above and the *gisants* in an arcaded enclosure, follows tradition, but the tomb's Virtues and Apostles show Florentine influence; and the tomb of *Georges I d'Amboise and Georges II d'Amboise* (begun 1515; Rouen Cathedral) by Roulland Le Roux, whose abundant ornamentation and mixture of modes epitomizes the François Ier style.

Bibliography

A. Blunt: *Art and Architecture in France, 1500–1600*, Pelican Hist. A. (Harmondsworth, 1971, rev. 1982)

W. Prinz and R. G. Kecks: *Das französische Schloss der Renaissance: Form und Bedeutung der Architektur, ihre geschichtlichen und gesellschaftlichen Grundlagen* (Berlin, 1985)

J. Guillaume: 'La Première Renaissance, 1495–1525', *Le Château en France*, ed. J. P. Babelon (Paris, 1986)

JANET COX-REARICK

Frankenthal school

Term used to refer to a group of landscape artists living in Frankenthal, Germany, from *c*. 1586 to the 1620s. In 1562 the Elector Palatine Frederick III established an asylum for Protestant refugees at Frankenthal. By *c*. 1586 the growing community included a number of landscape painters, chiefly émigrés from Flanders and Brabant, who had fled religious persecution after the fall of Mechelen and Antwerp to the Spanish in 1585. Sponsel and Plietzsch proposed that there was actually a 'colony' of painters, a 'Frankenthal school'; however, more recent research (Krämer, 1975) suggests that the small, shifting group of landscape painters—of which Gillis van Coninxloo III was the most important member (see fig. 32)—may not have counted more than a few artists at any one time.

Even with the possibility of marginal employment by compatriot tapestry-weavers active there, Frankenthal did not offer a very fertile environment for painters. The Electors Palatine were not noted patrons, in contrast to many contemporary princes. Van Coninxloo, who had arrived in Frankenthal by 1587, was probably urged to come by family members already there. The three other important landscape painters known to have stayed there are Pieter Schoubroeck, Antoine Mirou and Hendrik Ghysmans (before 1560–1611). Schoubroeck was the son of a Protestant clergyman who settled in Frankenthal in 1586. In the 1590s, Kramer affirms that he travelled to Rome and then worked in Nuremberg, moving to Frankenthal in 1600 to collect an inheritance. Mirou came to Frankenthal with his pharmacist father, who was there by 1586. Ghysmans, already a master in Antwerp in 1581, was in Frankenthal by 1586; he is recorded as supplying several paintings to the courts in Brussels and Dresden, though his known oeuvre consists of only a few signed drawings reflecting his Mechelen origins.

General characteristics associated with the Frankenthal school can be seen from a comparison of van Coninxloo's only known painting datable to his stay in Frankenthal, *Landscape with the Judgement of Midas* (1588; Dresden, Gemäldegal., Alte Meister), with the representative compositions by Schoubroeck, *Wilderness with Travellers* (1604; Munich, Alte. Pin.), and Mirou, *Forest with the Temptation of Christ* (1607; Munich, Alte Pin.). These have wide views full of variety and contrasts, with hilly open spaces and

32. Gillis van Coninxloo: *Wooded Landscape*, 1598 (Vaduz, Sammlung der Fürsten von Liechtenstein)

sometimes thrilling rock formations or a distant river, all structured in planes of light and shadow and framed by dense woods. The whole is animated by tiny villagers or hunters, depicting some mythological moment of truth or an edifying biblical scene. The works delight the viewer by offering a fantasy of myriad resting-points for the eye rather than by recording a unified experience of nature. This break-up of the surface is counteracted in the work of van Coninxloo by his freer brushstrokes but increased in the others' work by minute handling.

Some anonymous works, especially drawings, assigned to this 'school' may be by painters known only as names in church records (such as Jan van Bossche or Daniel de Weerdt), by followers of van Coninxloo in Holland after 1595 or by other Flemish artists who joined the diaspora and who may (or may not) have stopped in Frankenthal. The paintings of Schoubroeck and Mirou show affinities to those of Jan Breughel the elder, who must

have passed through the region on many occasions. Other landscape artists who fled Mechelen or Antwerp and whose work shows similar stylistic and iconographic interests include Pieter Stevens, who worked for the Holy Roman Emperor Rudolf II in Prague, or the peripatetic Frederick van Valckenborch. The notion that early landscapes painted by Adam Elsheimer in Frankfurt were influenced by the Frankenthal school has been discarded due to the reattribution of these works to the Antwerp landscape painter Adriaen van Stalbemt.

Bibliography

J. L. Sponsel: 'Gillis van Coninxloo und seine Schule', *Jb. Kön.-Preuss. Kstsamml.*, x (1889), pp. 57–71

E. Plietzsch: *Die Frankenthaler Maler: Ein Beitrag zur Entwicklungsgeschichte der niederländischen Landschaftsmalerei* (Leipzig, 1910/R Soest, 1972)

Die Frankenthaler Maler (exh. cat., Mannheim, Städt. Reiss-Mus.; Frankenthal, Staatl. Gym.; 1962)

H. G. Franz: *Niederländische Landschaftsmalerei im*

Zeitalter des Manierismus, 2 vols (Graz, 1969)
M. Krämer: *Pieter Schoubroeck: Maler in Frankenthal* (diss., U. Hamburg, 1975)
—: 'Die Probleme einer Malerschule in Frankenthal', *Zeichnung in Deutschland, deutsche Zeichner 1540–1640* (exh. cat. by H. Geissler and others, Stuttgart, Staatsgal., 1979)

JOANEATH A. SPICER

Georgian style

Term used to describe the diverse styles of architecture, interior decoration and decorative arts produced in Britain and Ireland during the reigns of George I (1714–27), George II (1727–60) and George III (1760–1820). What might more accurately be named the Georgian period is, on occasion, further subdivided into Early (1714–1730s), Mid (1740s–1750s) and Late (1760s–1790s) periods. The term REGENCY STYLE is applied to works of the period *c.* 1790 to 1830 and refers generally to the period when George, Prince of Wales (later George IV), was Regent (1811–20).

In architecture and interior design, the dominant aesthetic in Britain during the Georgian period was derived from classicism, but it took many different forms. The English Baroque that was current at the beginning of the 18th century was replaced at first by what became known as Palladianism, introduced by *c.* 1715 and championed by Richard Boyle, 3rd Earl of Burlington and 4th Earl of Cork. By the middle of the century the Rococo style had developed, and the increasingly eclectic approach that this helped foster led to the use of the Gothick (and, later, the Gothic Revival), Chinoiserie and other exotic styles. In the second half of the century, however, most major architectural schemes used some form of Neo-classicism, which was accompanied by the rise of such interior design styles as Pompeian Revival and the Etruscan style. Between 1760 and 1790 Robert Adam, William Chambers and James Stuart were the most notable architects and interior designers, each creating a distinctive and influential style, and they, together with numerous lesser architects and builders, provided an exceptionally wide range of designs and models for public buildings, town houses, country houses, villas and garden buildings (see fig. 27).

The most significant survivals of the Georgian period are the vast numbers of plain, well-proportioned, usually astylar, domestic buildings erected throughout the United Kingdom and much of the English-speaking world, particularly the eastern seaboard of North America. These buildings were often modified to suit local conditions or building materials, for example in India, southern Africa and Australia. The plain exteriors often contained elaborate woodwork or plasterwork reflecting current fashions. Major planning developments were also characteristic of the Georgian period, with uniform facades of terraced houses often designed to present a single monumental unit. Particularly successful examples of these can be seen in the streets, crescents and circuses built in Bath in the middle of the 18th century, most notably by the Wood family. Ideas taken from these developments were influential later in London, Edinburgh and elsewhere.

In the decorative arts the production of gold and silver ware, and to a much lesser degree ceramics, adopted the form and decoration associated with some of these phases. Furniture production more closely parallelled many of the various styles but is often defined by the designer's name, as in 'Kentian', Chippendale, Hepplewhite, and Sheraton pieces. The high quality of design and good standards of craftsmanship are especially notable in works of art and in architectural detailing produced throughout the period. What is particularly characteristic of the period, however, is the enormous number of publications, ranging from ornament and pattern books, design books and directories, to manuals for builders and craftsmen, guides for decorators and books on architecture and travel. The extensive range of publications available, added to the experience and knowledge gleaned on the Grand Tour, led to a greater awareness of historical periods and styles, which were drawn on unashamedly and supplied the basis for the revivalist movements. In this, the role played by such amateurs as Richard Boyle and Horace Walpole was extremely influential. In the late

20th century Georgian or Neo-georgian has come to describe architecture, interiors and works of art produced in an 18th-century fashion that referred back to any of the styles current in the Georgian period.

Bibliography

J. Summerson: *Georgian London* (London, 1945, rev. 2/1962)

—: *Architecture in Britain, 1530–1830*, Pelican Hist. A. (London, 1953, rev. 7/1983)

The Age of Neo-Classicism (exh. cat., ACGB, 1972)

J. Fowler and J. Cornforth: *English Decoration in the 18th Century* (London, 1974)

Rococo: Art and Design in Hogarth's England (exh. cat., ed. M. Snodin; London, V&A, 1984)

BRUCE TATTERSALL

Ghent–Bruges school

Term referring to the manuscript illumination of the southern Netherlands (modern Belgium) from approximately the last quarter of the 15th century until the mid-16th. It was first used by Destrée (1891), who referred to 'manuscripts decorated in the Ghent–Bruges manner', and by Durrieu in an article of the same year. Durrieu also defined the Ghent–Bruges school as that of the Grimani Breviary (Venice, Bib. N. Marciana, MS. lat. I. 99), but this second definition has never found a niche in the study of southern Netherlandish manuscript illumination. Some thirty years later, Winkler suspected that the predominant role in Flemish illumination was taken more by Bruges than by Ghent, and he accordingly referred to the 'Ghent–Bruges' or 'Bruges school'.

Although the term 'Ghent–Bruges school' is almost universally accepted, a more accurate term would be the 'so-called Ghent–Bruges school', because this style of illumination was also practised in other centres; in this context Destrée in a later publication mentioned the Duchy of Brabant and the County of Hainault, although it is not clear why he referred specifically to these two areas and he did not provide any supporting evidence. Whatever the case may be, a gradual and remarkable change did indeed take place in south-

ern Netherlandish illumination between *c.* 1475 and *c.* 1485, replacing the courtly style of *c.* 1440–74 that is found in manuscripts connected with the court of Philip the Good and his son Charles the Bold, who ruled in succession over the southern Netherlands. The luxurious manuscripts executed for the Burgundian court were frequently preceded by a prologue and an initial miniature or frontispiece that shows the patron ceremoniously receiving the book from the hands of the scribe, translator or author, who is usually shown in a kneeling position—for example, the *Chronicles of Hainault* of Philip the Good (*c.* 1450–1500; Brussels, Bib. Royale Albert 1er, MS. 9242-4). The text or full-page miniature was usually surrounded by a broad decorative border that acted as a frame, the white, undyed parchment or paper being sprinkled with acanthus leaves and flowers and including occasional comical illustrations. The motto and arms of the patron were also often illustrated.

Around 1475-85 a significant change took place in both the miniatures and the marginal decorations. The wooden, clumsily painted stock-figures were replaced by realistically painted figures, shown as accurately as possible in an intimate interior setting or a colourful landscape. Sometimes the human figures were painted on a larger scale, and gradually more half- or full-length portraits appeared, following the example of Netherlandish panel painters. The work of Hugo van der Goes of Ghent was often copied by the illuminators of the Ghent–Bruges school, and they also frequently copied their own work and that of their colleagues. The miniatures are also characterized by their attractive, bright colouring and the increasing use of pastel shades, which contrasts sharply with the palette of their predecessors, who worked mainly in primary colours (see col. pl. XIV).

The stylistic change in the miniatures also affected the marginal decorations. Instead of using uncoloured parchment as a background and ornament consisting chiefly of acanthus leaves, they were decorated with *trompe l'oeil*. Flowers and other objects threw shadows on the painted backgrounds of the borders, giving a

33. *Saint Anne, the Virgin and Christ Child*, Da Costa Hours, Bruges, *c.* 1515, ms 399, *f* 322v (New York, Pierpont Morgan Library)

rabbit-warrens, peacocks' tails and shells. Shortly after 1500 there began to appear in both miniatures and marginal decorations a number of Renaissance motifs that can be found earlier in the work of such painters as Hans Memling and Gerard David: arabesques, cartouches, medallions, grotesques, putti and garlands of fruit. From around the second decade of the 16th century, miniatures also appeared without marginal decoration; instead, the illustrated border was replaced by an ordinary fluted, gilded frame, so that the illumination resembled a miniature painting.

Very few illuminators are known by name; they include, for example, Gerard Horenbout and Simon Bening, while the work of others, for example Sanders Bening, cannot be identified. Other masters are named after the manuscripts associated with them, for example the master of the dresden prayerbook, the master of the prayerbooks of *c.* 1500 and the master of mary of burgundy.

three-dimensional effect (see fig. 33). The decorative margin, particularly the generous bottom and outer margins, became broader. The backgrounds were at first ornamented only with goldenyellow, then later also with a variety of colours that transformed the margins into veritable botanical gardens. Different types of flowers, usually scattered about informally, cast their shadows on the coloured parchment and gave the borders of the pages an impression of depth and space. The inventiveness of these miniaturists was soon imitated, with varying degrees of success, in other European countries. Although the Netherlandish illuminators first concentrated on realistic floral decorations, they soon began to fill the borders with other objects, including architectural elements, the *Arma Christi*, pilgrimbadges, miniature animals, death's-heads, precious stones, little narrative scenes, inscriptions,

Bibliography

J. Destrée: 'Recherches sur les enlumineurs flamands', *Bull. Comm. Royale A. & Archéol.*, xxx (1891), pp. 263–98

P. Durrieu: 'Alexandre Bening et les peintres du Bréviare Grimani', *Gaz. B.-A.*, v (1891), pp. 353–67; vi (1891), pp. 55–69

F. Winkler: *Die flämische Buchmalerei des XV. und XVI. Jahrhunderts* (Leipzig, 1925, rev. Amsterdam, 1978)

——: 'Neuentdeckte Altniederländer I: Sanders Bening', *Pantheon*, xxx (1942), pp. 261–71

La Miniature flamande: Le Mécénat de Philippe le Bon, 1445–1475 (exh. cat., ed. L. M. J. Delaissé; Brussels, Bib. Royale Albert 1er, 1959)

G. Dogaer: L'"Ecole ganto-brugeoise", une fausse appellation', *Miscellanea Codicologica F. Masai dicata* (Ghent, 1979), pp. 511–18

A. von Euw and J. M. Plotzek: *Die Handschriften der Sammlung Ludwig*, ii (Cologne, 1982)

T. Kren: 'Flemish Manuscript Illumination, 1474–1550', *Renaissance Painting in Manuscripts: Treasures from the British Library* (exh. cat., ed. T. Kren; Malibu, CA, Getty Mus.; New York, Pierpoint Morgan Lib.; London, BL; 1983–4), pp. 1–85

J. H. Marrow: 'Simon Bening in 1521: A Group of Dated Miniatures', *Liber Amicorum Herman Liebaers* (Brussels, 1984), pp. 537–59

G. Dogaer: *Flemish Miniature Painting in the 15th and 16th Centuries* (Amsterdam, 1987)
Flämische Buchmalerei (exh. cat., ed. D. Thoss; Vienna, Österreich. Nbib., 1987)

GEORGES DOGAER

Glasgow Boys

Loosely associated group of Scottish artists, active principally in Glasgow in the late 19th century. In 1890 the critics of an exhibition of Scottish painting at the Grosvenor Gallery, London, identified several common traits in the work of those artists associated with Glasgow and gave them the sobriquet 'Glasgow school'. These artists, none of them over 35 and not all born or living in Glasgow, preferred the more familiar term 'The Boys', which did not imply the close stylistic ties and unity of purpose of the term 'school'.

By the end of the 1870s the Royal Scottish Academy in Edinburgh firmly controlled the artistic establishment of Scotland. All Academicians and Associates were expected to live in Edinburgh and the Academy manipulated the artistic taste of Scotland by rejecting all works submitted to its annual exhibitions that did not conform to its own narrow preferences. To many of the younger generation of painters working in Glasgow (those born in the 1850s and 1860s) this situation was unacceptable. They were ambitious both professionally and socially but had no wish to move to Edinburgh or conform to the taste of the Academy. Glasgow was the largest and most prosperous city in Scotland and by 1900 was second only to London in the British Empire, and they wished to exploit the opportunities offered them by the large and active group of collectors and patrons living in the city. Although London would usually offer them refuge (and many Scottish painters had settled there rather than confront the Academy), these Glasgow artists considered that they should be allowed to paint and live as and where they wished.

In rejecting academic taste, a primary source for the work of the Glasgow Boys was the realism of Scottish painters such as Thomas Faed, who avoided excessive sentiment and pathos while recording the life of mid-19th-century Scotland.

From Faed and his contemporaries came a more painterly handling and strength of colour that had become a feature of Scottish painting by 1880. French Realism had a particular impact, notably the work of Jean-François Millet and the Barbizon school, whose paintings could be seen regularly at the Glasgow Institute of the Fine Arts and in the dealers' galleries in Glasgow. The development of this style of painting by Jules Bastien-Lepage was crucial to the Boys, and almost all adopted his naturalist palette, handling and compositions. The square brushstrokes and the signatures in large block capitals became as important to the Boys as they were to Bastien-Lepage. Finally, the tonal harmonies and sense of pattern of James McNeill Whistler, whose portrait of *Thomas Carlyle* (1872; Glasgow, A.G. & Mus.) was bought for the city of Glasgow in 1890 on the Boys' recommendation, along with his insistence on the independence of the artist in choice of subject, was to prove most lasting of all as many of the group turned to portraiture after 1890.

By 1885 three separate groups of progressive artists could be identified in Glasgow. W. Y. Macgregor and James Paterson (1854–1923) had been painting together in a low-keyed manner since 1876, selecting Realist subjects from the towns and countryside of Scotland. Slightly older (and wealthier) than the other painters of the group, they offered encouragement, assistance and a studio in which to gather in Glasgow. The second group was centred around James Guthrie, Joseph Crawhall, George Henry and E. A. Walton. Since 1880 these painters had worked together during summer painting tours in Scotland and England. After discovering the work of Bastien-Lepage, probably in 1882, they concentrated on painting, in a naturalist manner, single figures or small groups of rural labourers seen at their daily tasks. A third group, including John Lavery, William Kennedy (1859–1918), Thomas Millie Dow (1848–1919) and Alexander Roche (1861–1921), had studied in Paris (usually at the Académie Julian) and then painted at Grez-sur-Loing. Here a number of British and American painters adopted the French naturalist manner pioneered by Bastien-Lepage.

In 1885 all three groups came together in the annual exhibition of the Glasgow Institute and were able for the first time to consider each other's work. Although naturalism had become their predominant style, by 1887 the painters began to follow separate paths. Their realistic paintings of rural life did not sell easily and Lavery began to paint scenes of middle-class life, which were more popular and gained him new commissions. Like Guthrie, Walton and, later, Henry, he gradually moved towards portraiture. The group diversified even more as Henry introduced another young painter to the group, E. A. Hornel. Together they explored a more Symbolist manner in the late 1880s and 1890s, their palette inspired by the Edinburgh painter (but honorary Glasgow Boy) Arthur Melville. By the time of the exhibition at the Grosvenor Gallery in 1890 several of the Boys were considering leaving Glasgow. The success of this exhibition established them in London and led to invitations to show in Munich, Berlin, St Petersburg, Barcelona, Venice, Paris, Pittsburgh, Chicago, St Louis, New York and elsewhere in Europe and North America. This growth in fame and reputation ensured that by 1900 only two or three of the school remained in Glasgow, the others settling mainly in Edinburgh and London as they achieved artistic respectability and social success. They had, however, overcome the dominance of the Royal Scottish Academy, which dropped its residential and stylistic restrictions in 1888 with the election of Guthrie, who was to become President in 1902.

Bibliography

D. Martin: *The Glasgow School of Painting*, intro. F. H. Newbery (London, 1897)

G. B. Brown: *The Glasgow School of Painters* (Glasgow, 1908)

J. L. Caw: *Scottish Painting: Past and Present, 1620–1908* (Edinburgh, 1908)

The Glasgow Boys, 2 vols (exh. cat., ed. W. Buchanan; Edinburgh, Scot. A.C., 1968–71)

D. Irwin and F. Irwin: *Scottish Painters: At Home and Abroad, 1700–1900* (London, 1975) [with excellent bibliog.]

Guthrie and the Scottish Realists (exh. cat., ed. R. Billcliffe; Glasgow, F.A. Soc., 1982)

R. Billcliffe: *The Glasgow Boys: The Glasgow School of Painting, 1875–1895* (London, 1985) [most comprehensive account and selection of pls]

ROGER BILLCLIFFE

Glasgow style

Term denoting the style of works of art produced in Glasgow from *c.* 1890 to *c.* 1920 and particularly associated with Charles Rennie Mackintosh, Herbert Macnair and the Macdonald sisters, Frances and Margaret. The style originated at the Glasgow School of Art, where Francis H. Newbery (1853–1946) became director in 1885. Influenced by the ARTS AND CRAFTS MOVEMENT, Newbery had a commitment to excellence in art that combined functionalism with beauty while encouraging individuality and experimentation among his students. Within three years he had brought in the Century Guild of Artists' chief metalworker, William Kellock Brown (1856–1934), to teach modelling and metalwork at the School. Kellock Brown had an intimate understanding of A. H. Mackmurdo's approach to art, as articulated in the journal *The Hobby Horse* (launched in spring 1884), which voiced a desire for the unification of the old with the new and for an artistic relationship between abstract lines and masses that would reflect the harmonious whole found in nature. The development of the style was given further impetus by the fact that Celtic revivalism had already taken root in Glasgow, later coming to fruition with the publication of Patrick Geddes's review *The Evergreen* in the mid-1890s. In addition, an understanding of such contemporary European art movements as Symbolism and ART NOUVEAU became possible when the first issue of *The Studio* appeared in 1893. These factors combined to provide Newbery's students at the School with the fertile ground needed for the emergence of an innovative and distinctive art.

The new style appeared as early as the autumn of 1893 in a student exhibition that featured the works of Herbert MacNair, Charles Rennie Mackintosh, Margaret Macdonald and Frances

Macdonald, whose painting *Ill Omen* (1893; U. Glasgow, Hunterian A.G.) epitomizes the style and was probably hung in the exhibition. The art produced by these artists, known as The Four, represents the core of the Glasgow style. Glasgow critics considered the art to be eccentric, inspired by Aubrey Beardsley and William Blake, individual and 'weirdly new' (the reference here being to the New Woman) but nonetheless remarkable. Later, when The Four and their contemporaries exhibited at the Vienna Secession (1900) and the Turin Esposizione Internazionale d'Arte Decorativa (1902), German critics commented on the 'alien aspects' of the art but also on its poetic, mystical and spiritually expressive qualities. Purples, greens and blues complemented the elongation and distortion and added to the perceived mystery of the work. Although plant forms, particularly the rose, provided an impetus for design, it was a unique linear style that characterized paintings, furniture, metal panels, needlework, bookbinding, gesso panels, interior design and (with Mackintosh) architecture, and reflected the Scots' eclecticism but also their originality. The narrow, tall, white Mackintosh chairs and the slender, elongated women on Margaret Macdonald's embroidered panels demonstrate an understanding of continental Art Nouveau but move a step beyond the floreated curves most often associated with that style.

Although The Four and Francis H. Newbery are central to an understanding of the Glasgow style, several other Glaswegian artists, including Jessie Newbery, Talwin Morris (1865–1911), Jessie M. King and James Guthrie, also produced art that is representative of this style. By the end of World War I the Glasgow style was supplanted by a burgeoning modernism.

Bibliography

The Glasgow Style, 1890–1920 (exh. cat., Glasgow, Museums & A. Gals, 1984)

J. Burkhauser, ed.: *'Glasgow Girls': Women in Art and Design, 1880–1920* (Edinburgh, 1990)

W. Eadie: *Movements of Modernity: The Case of Glasgow and Art Nouveau* (London, 1990)

JANICE HELLAND

Gnome, the [Latv. Rūkis]

Latvian group of artists active in St Petersburg in the 1890s. It was founded (1892–3) by Latvian students attending the principal art institutions in St Petersburg, apparently on the suggestion of Kārlis Pētersons (1836–1908), a Latvian art teacher in the city. Established simultaneously with the growth of the Russian Revival movement and new Russification policies in the Baltic region, the group chose a name synonymous with hard work and oppression. It aimed democratically to express and promote national identity through art, and to this end it utilized both a realistic approach and a number of motifs from Latvian history, folk art and ethnography. It also sought to establish and promote a high professional standard for Latvian artists. Led by Ādams Alksnis (1864–97), who graduated from the St Petersburg Academy of Arts in 1892, the group was comprised of students from the Academy: the painters Arturs Baumanis (1865–1904), Pēteris Balodis (1867–1914), Jānis teodors Valters (chairman of the group after Alksnis's death), Janis Rozentāls and Vilhelms Purvītis; students of the Baron Stieglitz Central Institute of Technical Drawing: the graphic artists Richard Zarriņš (1869–1939), Gotlībs Lapiņš (1859–after 1939) and Ernest Zīverts (1879–1937); the designers Jūlijs Madernieks (1870–1955), Jānis Libergs (1862–1933) and Jūlijs Janunkalniņš (1866–1919); and the sculptors Teodors Zaļkalns and Gustavs Šķilters (1874–1954). Students of music at the St Petersburg Conservatoire were also members: the composers Alfrēds Kalniņš (1879–1951), Emilis Melngailis (1874–1954), Pēteris Pauls Jozuus (1873–1937) and Pāvuls Jurjāns (1866–1948).

Backed by wealthy members among the large number of Latvians in St Petersburg, the activities of the Gnome involved regular studio meetings, musical sessions and the organization of exhibitions, lectures and communal discussions on art and socio-political issues. Its first exhibition took place in Riga in 1896 and was organized to coincide with the 10th All-Russian Archaeological Congress, for which the Gnome members were also active in arranging the unprecedented Latvian Ethnographic Exhibition. Members also

sought to have their work published in such local periodicals as *Austrums* (Latv.: 'The spirit of the dawn') and, in some cases (most notably that of Alksnis), attempted to live out their ideals in rural Latvia upon their return home from St Petersburg. Through these activities, as well as the members' subsequent founding of the Latvian Society for the Promotion of Art (Latviešu mākslas viecināsanas biedrība), the Gnome laid the groundwork for the development of an indigenous school of art in Latvia. Inspired by Alksnis's idealism and his sensitive tolerance of a variety of approaches, and furthered by the pragmatism of Richard Zarriņš, who was its secretary, the Gnome (as distinct from the *Kunstverein*, its German–Latvian-orientated predecessor) was the first group to promote Latvian artists *per se*.

The art of the group was highly diverse. Alksnis tended to paint as a Realist, often depicting the toil of rural life in which humans and animals blend with brown, ploughed fields and overcast skies in an expression of organic unity (e.g. *On the Way*, c. 1895; Riga, Latv. Mus. F.A.). Baumanis preferred to depict group scenes from both mythological sources and from contemporary life. His works reveal his inclination towards German Romanticism, especially in the *Kurs Cremate their Dead* (1890s; Riga, City A. Mus.) and the *Horse of Fate* (1890s; Riga, Latv. Mus. F.A.). Purvit was attracted to Impressionist landscapes, and others such as Rozentāls and Valters, who saw the assimilation of progressive, international trends as a way forward for Latvian art, experimented with more decorative approaches and with a wider variety of subject-matter. Similarly, the early portrait busts and figures by Šķilters and Zaļkalns, while often depicting Latvians, show a greater debt to Rodin and Emile-Antoine Bourdelle than to indigenous forms, as in Šķilters's *Head of a Poet* (bronze, 1903; Riga, Latv. Mus. F.A.). Madernieks's work, drawn from vernacular sources, is based on the transference of folk motifs from such traditional media as embroidery and carving to graphic art and various forms of applied art. His incorporation of image, text and pattern into a highly stylized overall design is the most comprehensive and successful expression of Latvian *Jugendstil* by an artist, as seen in his book *Ornaments* (Latv.: 'Ornaments'; Riga, 1913). In contrast, Zarriņš illustrated and published Latvian folklore but, for the most part, retained a dry, refined academic approach to composition (e.g. *Latvju dainas*: 'Latvian folk-songs', Jelgava, 1894).

Bibliography
J. Siliņš: *Latvijas māksla, 1800–1914* [Latvian art, 1800–1914], ii (Stockholm, 1980), pp. 12–196
D. Blūma and others: *Latviešu tēlotāja māksla, 1860–1940* [Latvian fine art, 1860–1940] (Riga, 1986), pp. 42–63

JEREMY HOWARD

Gothick

Term used in a more or less discriminatory way to identify the 18th-century works of the GOTHIC REVIVAL in British architecture and interior design. Some historians use the term as a convenient shorthand for the 18th-century phase of the Revival; others intend it to highlight the ways in which the 'Gothick' of the 18th century—the fanciful and thinly decorative architecture associated with dilettanti and antiquaries—is manifestly distinct from the more historicist works of the 19th-century 'Gothic Revival', whose architects not only drew upon different forms or styles of medieval Gothic but were motivated by liturgical, religious and social concerns rather than by 18th-century Associationist aesthetics. Both spellings were used in the 18th century, but during the 19th century 'Gothick' became obsolete: Eastlake (1872) wrote only of 'Gothic' and Clark (1928) followed his example. That preference has been maintained by such historians as Macaulay (1975) and McCarthy (1987), while others, notably Crook (1983), have sought to revive the obsolete form and with it the distinctions between the architecture of the 18th century and that of the 19th. In the introduction to his edition (1970) of Eastlake's study Crook proposed a further subdivision: 'Rococo Gothick' for the early to mid-18th century and 'Picturesque Gothick' for the later. Other labels were introduced by Davis (1974), whose 'Georgian Gothick' incorporates the whole of the 18th century, and Harris (1983), who identified as 'Kentian Gothick'

the innovative style of the influential 18th-century architect William Kent. Whatever merit such coinages may have, research on the origins of the Gothic Revival has established that historicism and asymmetry—acknowledged features of its 19th-century phase—were already significant characteristics during the 18th century, for instance at Horace Walpole's remodelled home, Strawberry Hill (1750s), Twickenham, Middx. (see col. pl. XV).

Bibliography

C. L. Eastlake: *A History of the Gothic Revival* (London, 1872); ed. J. M. Crook (Leicester, 1970)

K. Clark: *The Gothic Revival: An Essay in the History of Taste* (London, 1928, rev. 1950)

P. Breman, ed.: *The Gothic of Gothick: English Church Building in Nineteenth Century Theory and Practice*, B. Weinreb, Architecture Catalogue, 14 (London, 1966)

T. Davis: *The Gothick Taste* (London, 1974)

J. Macaulay: *The Gothic Revival, 1745–1845* (Glasgow, 1975)

Gothick, 1720–1840 (exh. cat., ed. D. Simpson; Brighton, A.G. & Mus., 1975)

J. M. Crook, ed.: *A Gothick Symposium* (London, 1983) [incl. J. Harris: 'William Kent's Gothick']

M. McCarthy: *The Origins of the Gothic Revival* (London, 1987)

G. Worsley: 'The Origins of the Gothic Revival: A Reappraisal', *Trans. Royal Hist. Soc.*, 6th ser., iii (1993), pp. 105–51

M. Aldrich: *Gothic Revival* (London, 1994)

MICHAEL MCCARTHY

Gothic Revival

Term applied to a style of architecture and the decorative arts inspired by the Gothic architecture of medieval Europe. It has been particularly widely applied to churches but has also been used to describe castellated mansions, collegiate buildings and houses. The Gothic Revival has also been described by many scholars as a movement, rather than style, for in the mid-19th century it was associated with and propagated by religious and political faith. From a hesitant start in the mid-18th century in England and Scotland, in the 19th century it became one of the principal styles of building throughout the world and continued in

some huge projects until well into the 20th century (e.g. Episcopal Cathedral, Washington, DC, 1908–90; by G. F. Bodley and others). 'Gothic Revival' became the standard English term when Charles Locke Eastlake published *A History of the Gothic Revival* (1872). The word 'Gothic' had by then definitely mutated from a depreciatory ephithet into the denomination of a style or period of medieval architecture. To distinguish medieval Gothic from modern Gothic, most European languages used the prefix 'neo-' (e.g. Dut. *neogotiek*; Fr. *néo-gothique*; It. *neogotico*; Ger. *Neogotik*, *Neugotik*). Thus the term 'neo-Gothic' is sometimes used in English translations of texts in other languages or when dealing with Gothic Revival architecture outside the UK.

Art historians have subdivided the successive manifestations of the Gothic style roughly into 'Gothic' (*c.* 1120–*c.* 1550), Gothic Survival (*c.* 1550–*c.* 1750) and Gothic Revival (from *c.* 1750). Although the Gothic Revival spread throughout the world, this article concentrates on the history and development of the style in Europe and North America.

I. ARCHITECTURE

1. History

(i) Transition from 'Survival' to 'Revival'. During the 16th and 17th centuries Gothic style was slowly reduced to a series of such features or elements as the pointed arch, tracery window, battlement, fan and rib vault, buttress and pinnacle. The result of this reduction, which varied from country to country, is generally referred to as GOTHIC SURVIVAL. There was, however, an intermediate stage between Survival and Revival, when medieval buildings, mainly large churches, were restored or completed, for example Westminster Abbey by Christopher Wren (repairs, 1698–1722) and later Nicholas Hawksmoor (west gable and towers, 1734–45); Orléans Cathedral (early 17th century to 1793) by Pierre-Adrien Pâris and others; the abbey church of Corbie, near Amiens, by a gifted but anonymous architect; and Milan Cathedral by Luigi Vanvitelli (designs, 1745; unexecuted) and

other architects. All these architects continued designing and building in an obsolete style in order to render their work consistent with existing parts and to guarantee the harmony of the whole edifice. In so doing, they followed the time-honoured device of conformity. Most of the gothicizing work of Giovanni Santini, too, was reshaping of medieval Gothic churches, such as Kladruby (1712–26), though in a much more 'baroque' manner than Wren, with whom Santini may have been acquainted, since he had travelled in England.

The rebuilding of colleges in conformity with surviving medieval parts required (or at least allowed) a more synthetic style. Wren justified his 'Gothic' Tom Tower at Christ Church, Oxford, in a letter of 1681 (V. Fürst: *The Architecture of Sir Christopher Wren*, London,1956, p. 51): 'I resolued it ought to be Gothic to agree with the Founders worke.' It was for the same reason that Hawksmoor chose the 'Gothick' for the design of the north quadrangle (1715–56) of All Souls College, Oxford. The Codrington Library wing has a central feature comprising twin towers in the manner of a cathedral front, and the opposite wing is interrupted by a gateway (1734) surmounted by a cupola that Hawksmoor described as being in 'ye Monastick manner' (K. Downes: *Hawksmoor*, London, 1969, p. 162), an expression that seems to have been coined to express associative rather than formal qualities.

(ii) **Early development**. The Gothic Revival proper began when buildings were erected inspired by Gothic for its own sake, rather than being modelled on Gothic to conform to earlier examples. These included garden buildings in particular. In Nymphenburg, near Munich, in the grounds of the summer residence of the Bavarian Electors, the French-trained architect Joseph Effner built the Magdalenenklause (1725–80), a hermitage that exhibits elements of a sham ruin and a grotto containing a fairly 'Gothic' chapel, decorated with shellwork and frescoes and consecrated by the Archbishop of Cologne. The first English 'Gothick' garden pavilions are of a 'political' or 'patriotic' nature: the Gothic Temple (after 1717), Shotover,

Oxon, attributed to William Townesend, a vaulted arcade of three bays erected for James Tyrell to celebrate the Whig triumph over arbitrary government; and Alfred's Hall (1721–32), Cirencester Park, Glos, a battlemented two-storey lodge with two round towers built for the 1st Earl of Bathurst, a Tory. Other examples of Gothick garden buildings include the Temple to the Liberty of our Ancestors or Gothic Temple (1741–7), Stowe, Bucks, built by James Gibbs for Richard Temple, 1st Viscount Cobham, a leading Whig; the Cuttle Mill (*c.* 1740), Rousham, Oxon, by William Kent; and Edgehill Castle Tower (1745–7), Radway, Warwicks, built for himself by Sanderson Miller, an amateur architect whose buildings included several sham castles and other Gothick works. Kent was also responsible for Esher Place, Surrey, a late 15th-century gatehouse that he enlarged and transformed by the addition of wings (1729–33; destr.) into a Rococo–Gothic villa. The early phase of the Gothic Revival that is linked with the Rococo is often distinguished from the 19th-century 'archaeological' Gothic Revival (in England, at least) by being called GOTHICK.

The best documented (and therefore sometimes perhaps overrated) Early Gothic Revival villa is Strawberry Hill, on the River Thames at Twickenham, Middx. (see col. pl. XV). It was originally a small, two-storey, undistinguished house but was reshaped from 1730 by its owner, Horace Walpole, into a model for domestic architecture. Walpole was helped in his undertaking by the amateur architect John Chute, the illustrator Richard Bentley (1708–82) and also Johann Heinrich Müntz, possibly the most gifted designer among them. When finished in 1776, Strawberry Hill was as much a picture gallery as a villa, for Walpole excelled not only as the author of the first Gothic novel (*The Castle of Otranto*, 1764) and of a history of English art but also as a collector. The major innovation that he produced at Strawberry Hill was the asymmetry of its plan. He was also ahead of his time in stressing its archaeological accuracy or at least dependence on medieval models, even if transformed in reuse (e.g. ceiling in the Round Room, 1766–7, by Robert Adam, based on a window in Old St Paul's Cathedral, London).

The earliest Gothic Revival work outside Great Britain is the Gotische Haus (1773; later extensions), Wörlitz, by Georg Christoph Hesekiel (1732–1818), the first of a series of buildings in this style around Dessau. The house is a two-storey art gallery and incorporates much Swiss and German 16th- and 17th-century stained glass. The Kanalfront or main façade was modelled on that of S Maria dell'Orto, Venice. The landscape garden at Wörlitz, commissioned by the most enlightened German prince of his day, Francis, Prince of Anhalt-Dessau, owes much to English models; the Prince visited the British Isles four times (1763–4, 1766, 1775, 1785). By the time of its construction, the English style of garden design was being accepted across Europe, as were 'Gothic' garden buildings, though to a lesser extent. The French painter Hubert Robert, for example, designed the garden of Betz (Oise) in 1780 with a ruined Gothic tower and with a small Gothic chapel (both extant). As with the Gothic Survival, the Gothic features of many Gothic Revival buildings were reduced to crenellations or battlements. As early as 1707, John Vanbrugh proposed to the 4th Earl of Manchester to give his seat at Kimbolton, Hants, 'Something of the Castle Air, tho' at the Same time to make it regular', an intention that he eventually realized by dismissing columns and pilasters and by using battlements instead of a classical cornice. At his own house at Greenwich (1718–19), London, the turrets and the battlements justify its name, Vanbrugh Castle. Around 1720 he designed a scheme for Inveraray, Argyll, in the same style. Vanbrugh never, however, crossed the dividing line between 'castellated' and 'Gothic', for he never used pointed arches or other borrowings from ecclesiastical architecture, and his Gothic effects were achieved more by massing than by detail.

It is a significant comment on the change of taste in the second quarter of the 18th century that Inveraray Castle, although loosely modelled on Vanbrugh's castellated design, was eventually built (from 1745) in full Gothic Revival form by Roger Morris. It is a stern, rectangular building with an elevated central hall and four round corner towers, all regularly pierced by tracery windows and, of course, battlemented. As the first large Gothic Revival building in Europe it deserves special attention. It may justly be argued that, as the highland residence of Archibald Campbell (1682–1761; from 1743 3rd Duke of Argyll), an eminent Whig politician and later the chief of the most powerful of all Scottish clans, Inveraray Castle was simultaneously intended to be, and understood as, the model of a fashionable country seat and the traditional symbol of a landowner's authority.

The first battlemented building of the 18th century in Germany was the Nauener Tor (1755; altered), Potsdam, a city gate erected after the medievalizing rather than Gothic Revival design of Frederick the Great. None of the castellated Gothic buildings of the 18th century in present-day Germany and Austria was intended to be a residence, not even the two largest ones: the Löwenburg (1793–1801), Wilhelmshöhe, Kassel, by Heinrich christoph Jussow; and the Franzensburg (1798–1801), Laxenburg, near Vienna, by Franz Jäger (1743–1809). The climax of 18th-century secular Gothic Revival was the huge and ephemeral Fonthill Abbey (1796–1817), Wilts, by James Wyatt. It was ruined by the collapse (1825) of its 84-m high tower, so that today it is known mainly through literary and visual records. It was built for William Beckford, who originally wanted no more than a pleasure house 'in the shape of an abbey'; whereas many English country seats were labelled 'Priory' or 'Abbey' after a pre-existing monastery on the estate, Fonthill was probably the first to be so named purely due to the whim of its proprietor. Beckford retained its character and name, however, after it grew into a full-sized mansion, housing a spectacular art collection. With its windmill-like plan and slender central tower, Fonthill resembled stage scenery rather than either a medieval abbey or a comfortable dwelling.

The churches of the early, 18th-century phase of the Gothic Revival are few, and far from being conspicuous. From *c.* 1720 the gothicizing completion of medieval churches was more and more seconded by Gothick furnishings, such as Giovanni Santini's reredos in Kladruby church,

Bohemia, and William Kent's screen (1741; destr.) in Gloucester Cathedral (*see also* §II below). A completely new church was St Mary's (1753–8; ruined), Hartwell, Bucks, by Henry Keene for Sir William Lee, of octagonal form with fan vault. Parallel to the secular development of the style, English ecclesiastical architecture was affected by the archaeological spirit. James Essex, who carried out scholarly restorations of Ely Cathedral (1757–62) and Lincoln Cathedral (1762–5) was the first practising architect to take an antiquarian interest in medieval architecture, and his knowledge of Gothic construction methods was unique until the 19th century.

Early Gothic Revival churches in Germany were the result of princely whims, for example Löwenburg church (1795–6), near Kassel, by Jussow; Hohenheim church (1797; re-erected at Monrepos, Ludwigsburg, 1803; ruined since 1940s) by Nikolaus Friedrich von Thouret; and Paretz church (1797), Ketzin, Potsdam, by Friedrich Gilly.

(iii) Growth, theory and alliance with nationalism. Gothic Revival theory emerged from, and tried to influence, the 19th-century society and public opinion of Britain and her counterparts on the European and American continents. Never before, and perhaps never since, have architectural competitions and judgements been discussed as extensively and relentlessly as they were in this period. Hence a great deal of architectural writing is concerned with controversy and criticism rather than with aesthetics. It should also be borne in mind how many prolific architectural writers on the Gothic Revival movement were politicians. No wonder that Gothic Revival theory was closely related, as we shall see, to the topics of the day: national identity, industrialization, demography, religious controversy and the preservation of national monuments. This theory may be defined as the system of ideas, topics, principles and arguments underlying the whole writing of the Gothic Revival movement's protagonists and competing with the theories of other movements, factions and schools of 19th-century architecture.

The politicians interested in the Gothic Revival and in propagating it by polemical writing included: in England, A. J. B. Hope, son of the Neo-classicist Thomas Hope and a Conservative Member of Parliament, President of the Ecclesiological Society and later of the Royal Institute of British Architects, and author of *The English Cathedral of the Nineteenth Century* (1861); in France, Charles Forbes René de Montalambert, a Roman Catholic Liberal, member of the Chambre des Pairs, and author of an article in the *Revue de deux mondes* (1833) entitled 'Du Vandalisme en France', in which he called for the preservation and imitation of medieval architectural monuments; and in Germany, August von Reichensperger, a lawyer and member of the parliament in Frankfurt am Main, later deputy of the Reichstag, founder of the Roman Catholic Zentrumspartei and editor of the *Kölner Domblatt* for many years. He was also a friend of A. W. N. Pugin, Montalambert and Hope, but remarkably he ignored the critic John Ruskin, despite sharing many of his ideas, especially concerning traditional crafts.

If the Gothic Revival of the mid-19th century was an international movement, one may then question how it was possible to ascertain, as its theorists did, that the Gothic was the only proper and national style or, at least, the necessary precondition for the emergence of a new national style, regardless of building type. Nationalism based itself upon civilization, language and history. After the end of the Napoleonic Wars in 1815 there was a general tendency to idealize the Middle Ages. They were considered as the epoch when the modern languages supplanted Latin, when the civilization of Western Europe equalled those of Classical Antiquity, when builders created the Gothic style, the antipode of the Greek, and when the history of the northern nations began.

The Gothic was by then conceived as a series of national idioms and sometimes named accordingly: 'Early English', '*le style Philippe-Auguste*', or '*deutsche Baukunst*'. Some nomenclature also emphasized the common religious background: 'Christian architecture', '*christlich-germanische Baukunst*'. The 18th-century Gothic Revival in the British Isles may be seen as the stylistic continuation or at least an imitation of the Late Gothic

of the 15th and early 16th centuries. Contemporary European architects often copied English models and pattern books. The Neo-classical ideals of simplicity and grandeur, however, harmonized better with the Gothic of the 13th and 14th centuries than with the later Flamboyant or Tudor Gothic, and for a short time *c.* 1845 the theorists of the Gothic Revival movement advocated a return to the style of *c.* 1250 and, of course, also to 'national' models. Very soon, however, earlier models took the lead, the taste for 'early' periods and 'primitivism' being a common bias of the critics ready to approve of early Florentine art and architecture or early Netherlandish painting. In the 1850s it was hoped that a new style would develop from the very roots of the Gothic.

The Gothic Revival could not fulfil its role as the alternative to the classical styles until it was applicable to every building type. No one expressed this better than George Gilbert I Scott, arguably one of the style's most prolific exponents. In his *Remarks on Secular and Domestic Architecture, Present and Future* (1857), dedicated to A. J. B. Hope, Scott pointed out what he called 'the absurdity of the theory that one style is suited to churches and another to houses, and of the consequent divorce between ecclesiastical and secular architecture'. He went on to show that he aimed 'at developing upon the basis of the indigenous architecture of our own country, a style which will be pre-eminently that of our own age'. As the number of good models for civic architecture proved to be too small, Scott included foreign and Late Gothic buildings, for example English colleges, as well as Flemish and Italian town halls.

During the 19th century the Gothic Revival became the standard style for a wide range of building types, its acceptability encouraged by religious and moral considerations. In the first years of the century ecclesiastical authorities and conservative Christians reclaimed their positions held before 1789 and associated themselves with the genius of the Middle Ages: in 1802 François-René Châteaubriand published his major book *Le Génie du Christianisme*. In 1804 Charles Percier and Pierre-François-Léonard Fontaine chose Gothic Revival decoration for Napoleon's coronation in Notre-Dame, Paris. In 1805 Benjamin Henry Latrobe submitted alternative designs for the Roman Catholic Cathedral in Baltimore, MD, one 'Gothic' (rejected), the other 'Greek' (built 1804–14). In 1815 Karl Friedrich Schinkel proposed the construction of a 'Gothic' cathedral in Berlin (unexecuted), intended to be a monument to the Napoleonic Wars, the sepulchre of the Prussian kings and a Protestant church. From 1814 German writers postulated the completion of Cologne Cathedral as a national monument, initiating one of the greatest enterprises of the Gothic Revival (completed 1842–80; by Ernst Friedrich Zwirner and Richard Voigtel). In contrast, however, the National Monument (begun 1824; incomplete) at Calton Hill, Edinburgh, by William Henry Playfair and C. R. Cockerell, and the Walhalla (1830–42), near Regensburg, by Leo von Klenze, a Pantheon of 'Germanic' heroes of different eras, social classes and public virtues, followed the model of the Parthenon, with Periclean Athens providing an alternative ideal for public life and order.

The increase in populations and growth of urban areas caused by industrialization necessitated church-building programmes, virtually all over the Christian world. In London the population rose from 1 million in 1801 to over 3.8 million in 1871, and the built-up area expanded from a radius of 8 miles to 13 miles. Other large towns in Britain spread no less dramatically. Migration created new communities of various denominations, the most conspicuous being the Roman Catholic community in England and Anglican groups in colonies abroad of both commercial and tourist origin (e.g. Stuttgart and Rome). The British way of countering revolutionary fervour was by strengthening the established Church of England. New manufacturing centres frequently had no churches within easy reach. In 1818 Parliament passed a Church Building Act enabling a special commission (hence the name 'Commissioners' churches') to subsidize the building of *c.* 600 churches in the first half of the century. The Commissioners' most prolific architect was Thomas Rickman, who could design with equal facility in Gothic or classical style, but who invented the terminology for the comparative

classification of Gothic architecture. An important contemporary of Rickman's in this early archaeo-logical phase of the Gothic Revival was Anthony Salvin. In Ireland a vast church-building pro-gramme for the Protestant Church of Ireland began (slowly) in the late 18th century but peaked in the 1820s and 1830s. Almost all the churches built during the British programme were in Gothic Revival style, even those abroad, as if to compensate for the feeling of homelessness of life outside Britain. The best known is All Saints (1880–85), Rome, by G. E. Street, inspired by Italian models.

In the USA and Canada towns were also sup-plied with countless Gothic Revival churches. An early example is St John's Protestant Episcopal Cathedral (1809–10; later enlarged), at Providence, RI, still in the Batty Langley manner, by John Holden Greene. An early 19th-century Gothic Revival Canadian church is the Roman Catholic Notre-Dame at Montreal (1823–9; later enlarge-ments and alterations) by James O'Donnell (1774–1830), an Irish Protestant converted to Roman Catholicism.

Many European churches of interest at this period owe their Gothic Revival style to patronage. These include the abbey church of Hautecombe, Savoie, France, remodelled (1824–43) in the Gothic Revival style by Ernesto Melano as the sepulchre of the Sardinian royal family; the Friedrich-werdersche-Kirche (1824–30; now the Schinkel-museum), Berlin, by Schinkel, the style suggested by the Crown Prince Frederick William; the Mariahilfkirche (1831–9), Auvorstadt, near Mun-ich, by Daniel Ohlmüller for King Ludwig I; the church of Notre-Dame-de-Laeken (begun 1852), Brussels, by Joseph Poelaert for King Leopold I; and the Votivkirche (1856–79), Vienna, by Heinrich von Ferstel under the patronage of the Emperor's brother Ferdinand Max.

For associational reasons in a difficult post-Napoleonic world, the Gothic Revival also became fashionable for royal and imperial residences, including Windsor Castle, remodelled (1824–40) by Jeffry Wyatville; the English Tudor style Schloss Babelsberg (1833–48), near Potsdam, by Schinkel and Ludwig Persius for Prince William of Prussia,

later Emperor William I; Schloss Hohenschwangau (1833–7), near Füssen, Bavaria, by Domenico Quaglio and Ohlmüller for Prince Maximilian, later King Maximilian II (reg 1848–64); Schloss Stolzenfels (1836–42), near Koblenz, by Schinkel for the Crown Prince, later King Frederick William IV of Prussia; the château of Pierrefonds (1858–70), near Compiègne, by Viollet-le-Duc for Emperor Napoleon III; and Schloss Marienburg (1858–67), near Hannover, by Conrad Wilhelm Hase for Mary, Queen of Hannover.

Royal residences had by then partly lost their public character, whereas parliaments and admin-istrations required new settings, shaped on, or at least evoking the image of, older building types, such as late medieval castles, mansions, town halls and guild halls. The Gothic Revival style was thus especially in demand. The winning competition design (1835) by Charles Barry for the Houses of Parliament (built 1840–65) had a modern and logical plan but was 'Perpendicular Gothic' in detail, thus following the stipulation 'that the style of the building be either Gothic or Elizabethan'. American, French and many other parliaments after 1789 looked to classical pre-cedents, and they were housed accordingly in Neo-classical buildings, whereas the British Parlia-ment vindicated time-honoured continuity, which was expressed on the one hand by a national style, on the other hand by preserving some of the medieval remains of the old Palace of Westminster, including the Lower Chapel of St Stephen's Chapel and Westminster Hall. At least two other parliamentary buildings followed the Westminster precedent: the Canadian Parliament House (1861–7), Ottawa, by Thomas Fuller and Chilion Jones (1835–1912) with administrative blocks by Augustus Laver (1834–98) and Thomas Stent (1822–1912); and the Hungarian Parliament House (1884–1904), Budapest, by Imre Steindl.

Little mention has been made hitherto of the Gothic Revival in France and Italy. France, which could claim to be the birthplace of Gothic archi-tecture, was a latecomer in its revival, partly due to the Beaux-Arts tradition in French architectural education and the centralism of the French government. The restored Bourbon dynasty had a

preference for a spindly form of Gothic Revival called the Troubadour style, but it was not until 1842 that the first French Gothic Revival building reached completion: the church of Notre-Dame-de-Bonsecours (1840–44), Blosseville, Rouen, by Jacques-Eugène Barthélemy (see fig. 34). In Italy, of course, the revival of her own medieval vocabulary was preferred.

Supported by members of the national parliaments and by influential institutions, such as the Roman Catholic and the Anglican Churches, a considerable number of architects specialized in the Gothic Revival style, especially between the 1840s and the 1860s. They dominated church building, college building and the restoration of medieval monuments. They all considered the Gothic of the 13th and 14th centuries as the best style to be imitated first and then to be adapted and developed into an appropriate expression of modern life. This

34. Church of Notre-Dame de Bonsecours, Blosseville, Rouen by Jacques-Eugène Barthélemy, 1840–44

marked the evolution from the imitative revival to eclecticism and the passion for overall design. The prototype of a universal designer was A. W. N. Pugin, in many respects the central figure of the Gothic Revival, responsible for the internal decoration of the Houses of Parliament as well as a series of Roman Catholic churches, such as St Mary's Cathedral (1842–1912), Killarney. He was followed by other versatile architects, such as William Burges, the architect of St Finbar's Cathedral (1865–79), Cork, and the restorer of Castel Coch (1875–91) for the Marquess of Bute; Eugène-Emmanuel Viollet-le-Duc in France; and in Germany Georg Gottlob Ungewitter and August Ottmar von Essenwein, the Director of the Germanisches Nationalmuseum, Nuremberg. Contemporary critics recognized William Butterfield as the most inventive architects of the Gothic Revival movement. He moved rapidly from the picturesqueness of his Vicarage (1845) at Coalpit Heath, Glos, to the highly sophisticated 'ugliness' of All Saints' (1850–59), Margaret Street, London; G. E. Street, who began as a church builder but crowned his career with the construction of the Law Courts (1874–82) in The Strand, London; P. J. H. Cuypers, better known for his Northern-Renaissance Revival Rijksmuseum, Amsterdam, than for the restorations and Roman Catholic church buildings that dominated his work, such as the church of Onze Lieve Vrouwe Onbevlekt Ontvangen (1860–63; 'Posthoorn' church), Amsterdam; Friedrich von Schmidt, who trained under Zwirner in Cologne and became a major church builder, whose principal civic works, the Akademisches Gymnasium (1863–6; see fig. 35) and the Rathaus (1872–83), are both in Vienna; and, in France, Jean-Baptiste Lassus, whose enthusiasm for the Gothic of Chartres Cathedral reached its most complete expression in the church of the Sacré-Coeur (1849–81), Moulins.

If the North American architecture of the 1840s still followed the English taste, its achievements also began to keep abreast of the foremost buildings of Great Britain. The prominent architects of the Gothic Revival in the USA distinguished themselves as designers of Protestant Episcopal churches; they included Richard Upjohn, architect

35. School building by Friedrich von Schmidt: entry hall of the Akademisches Gymnasium, Vienna, 1863-6

of Trinity Church (1839-46), New York, and St Mary's (1846-54), Burlington, NJ; and John Notman, who designed St Mark's (1847-52), Philadelphia, PA, with unplastered walls of hammer-dressed stone and a dark, open timber roof. It was not until James Renwick designed the Roman Catholic cathedral of St Patrick (1858-79; twin spires completed 1888), New York, that French models, both medieval and modern, were introduced to American church building. English architects had by then also turned to continental models, especially for competitions outside the British Isles. The first to do so was George Gilbert Scott. With his competition design for the Nikolaikirche (1846-63; destr. 1943, except tower), Hamburg, he eclipsed his German rival Gottfried Semper. Scott's most popular works in London are the Albert Memorial (1863-72) and the St Pancras Station Hotel (1868-74).

By around the last quarter of the 19th century younger architects, such as Street's pupils Philip Webb and Richard Norman Shaw, when they designed domestic architecture, had begun to turn from 'Gothic' to 'vernacular', from 'revival' to 'tradition'. Every style of architectural history was by then 'available' and seemed worthy of imitation, especially transitional styles, which were understood as models of, or starting-points for, syntheses, such as Late Romanesque used for H. H. Richardson's Trinity Church (1874-7), Boston or Alfred Waterhouse's National History Museum (1872-81), London.

(iv) Later developments. Until World War II most church buildings of all denominations remained openly, allusively or secretly 'Gothic', from the Sagrada Familia, Barcelona (taken over by Antoni Gaudí in 1883, partially completed), to Notre-Dame-du-Raincy (1922-3), Paris, by Auguste Perret, and the Roman Catholic church of St John the Baptist (1922-7), Neu-Ulm, by Dominikus Böhm. Many post-1918 secular buildings of North America have Gothic Revival characteristics, even including two skyscrapers, the *Chicago Tribune* Building (1922-5) by John Mead Howells and Raymond Hood, and the Cathedral of Learning (1926-7), University of Pittsburgh, by Charles Z. Klauder (1872-1938), designed in the deeply rooted collegiate Gothic style. Monumental brick architecture of the 20th century often has Gothic overtones, for example the Beursgebouw (1896-1903), Amsterdam, by H. P. Berlage, the Town Hall (1911-22), Stockholm, by Ragnar Östberg, and the Museum of National Art (1912-38; now Romanian Peasant Museum), Bucharest, by Nicolae Ghika-budeşti.

2. *Literature*

In some ways comparable to the Greek Revival, the Gothic Revival was in many respects dependent on historical and archaeological accounts of buildings illustrated by measured drawings. The works of James Cavanah Murphy (1760-1814) on Batalha Priory, Portugal (1792-5), and of Sulpiz Boisserée on Cologne Cathedral (1821-32) tried to eclipse James Stuart and Nicholas Revett's standard work on Greek architecture, *Antiquities of Athens* (1762-1816). Pattern books modelled on the works of Sebastiano Serlio or Jacopo Vignola or Hans

Blum, such as Batty Langley's *Ancient Architecture Restored, and Improved* (1742), or the *Gothisches A-B-C-Buch* (1840) by Friedrich Hoffstadt (1802–46), had at first a big impact as well but were then replaced by collections of medieval details such as Vincenz Statz and Georg Gottlob Ungewitter's *Gothisches Musterbuch* (1856–61). Modern Gothic schemes, whether executed or not, appeared in separate works such as *A Collection of Designs for Rural Retreats, as Villas, principally in the Gothic and Castle Styles of Architecture* (1802) by James Malton (*d* 1803) and in the rapidly growing number of illustrated periodicals such as *The Builder* (from 1843) on the one hand or the High-Church *The Ecclesiologist* (from 1841) on the other. Like *The Builder*, the French *Revue générale de l'architecture* (from 1840) and the Viennese *Allgemeine Bauzeitung mit Abbildungen* (from 1836) were by no means exclusive publicists of the Gothic Revival, but nevertheless they published perhaps more, and more important, Gothic Revival designs than the *Annales archéologiques* (from 1844) and the *Organ für christliche Kunst* (from 1851), which were biased towards genuine medieval aspects of the Gothic.

Stage-coaches and railways facilitated architectural tours, so that gradually every facet of medieval Gothic was recorded. One could copy details from topographical works such as *The Architectural Antiquities of Great Britain* (1807–26) by John Britton, architectural compositions from sketchbooks like that of the widely travelled Rev. John Louis Petit (1810–68), *Remarks on Church Architecture* (1841), technical hints from the structural analysis of Eugène-Emmanuel Viollet-le-Duc's *Dictionnaire raisonné de l'architecture française du XIe au XVIe siècle* (1854–68) and add further ideas from one's own drawings.

Besides architectural history, which was about to organize the accumulated knowledge of Gothic architecture, there emerged an architectural theory regularizing the design and execution of modern Gothic. Horace Walpole thus justified the Gothicism of Strawberry Hill and succeeded in making it fashionable through *A Description of the Villa of Mr Horace Walpole at Strawberry-Hill* (1784). A. W. N. Pugin developed a theory based, as he thought, on principles (*The True Principles of Pointed or Christian Architecture*, 1841). August Reichensperger followed his lead (*Die christlich-germanische Baukunst*, 1845). Finally, John Ruskin's major book on the nature and social impact of medieval Gothic architecture (*The Seven Lamps of Architecture*, 1849) and his criticism of 19th-century building attracted an ever-growing bourgeois public.

Charles Locke Eastlake's *History of the Gothic Revival* (1872) appeared shortly after the movement had reached its peak. Naturally enough, Eastlake eulogistically treated the movement as a continuous process. Two generations later Kenneth Clark published what has become a standard work on the subject, *The Gothic Revival: An Essay in the History of Taste* (1928).

Bibliography

B. Langley: *Ancient Architecture Restored, and Improved* (London, 1742); rev. as *Gothic Architecture, Improved by Rules and Proportions* (London, 1747)

H. Walpole: *A Description of the Villa of Mr Horace Walpole at Strawberry-Hill* (Strawberry Hill, 1784)

J. C. Murphy: *Plans, Elevations, Sections, and Views of the Church of Batalha in the Province of Estremadura in Portugal* (London, 1792–5)

F. R. de Chateaubriand: *Le Génie du Christianisme* (Paris, 1802)

J. Malton: *A Collection of Designs for Rural Retreats, as Villas, Principally in the Gothic and Castle Styles of Architecture* (London, 1802)

J. Britton: *The Architectural Antiquities of Great Britain*, 5 vols (London, 1807–26)

S. Boisserée: *Geschichte und Beschreibung des Doms von Köln, nebst Untersuchungen über die alte Kirchenbaukunst, als Text zu den Ansichten, Rissen und einzelnen Theilen des Doms von Köln*, 2 vols (Stuttgart and Paris, 1823–32) [pls pubd 1821–32]

C.-R. de Montalambert: 'Du Vandalisme en France', *Rev. Deux Mondes* (1 March 1833); also repr. in *Œuvres*, vi (Paris, 1861), pp. 7–75

F. Hoffstadt: *Gothisches A-B-C-Buch*, 2 vols (Frankfurt am Main, 1840)

J. L. Petit: *Remarks on Church Architecture*, 2 vols (London, 1841)

A. W. N. Pugin: *The True Principles of Pointed or Christian Architecture* (London, 1841)

A. von Reichensperger: *Die christlich-germanische Baukunst* (Trier, 1845)

J. Ruskin: *The Seven Lamps of Architecture* (London, 1849)

E. E. Viollet-le-Duc: *Dictionnaire raisonné de l'architecture française du XIe au XVIe siècle*, 10 vols (Paris, 1854–68)

V. Statz and G. G. Ungewitter: *Gotisches Musterbuch*, 2 vols (Leipzig, 1856–61)

G. G. Scott: *Remarks on Secular and Domestic Architecture, Present and Future* (London, 1857)

A. Beresford-Hope: *The English Cathedral of the Nineteenth Century* (London, 1861)

C. L. Eastlake: *A History of the Gothic Revival* (London, 1872)

PERIODICALS

Allg. Bauztg Abbild. (1836–)
Rev. Gén. Archit. (1840–)
The Ecclesiologist (1841–)
The Builder (1843–)
Köln. Dombl. (1843–)
An. Archéol. (1844–)
Organ Christ. Kst. (1851–)
Rev. A. Chrét. (1857–)

GENERAL

K. Clark: *The Gothic Revival: An Essay in the History of Taste* (London, 1928)

P. Collins: *Changing Ideals in Modern Architecture, 1750–1950* (London, 1965)

G. Germann: *Gothic Revival in Europe and Britain: Sources, Influences and Ideas* (London, 1972, rev. and Ger. trans., Stuttgart, 1974)

N. Pevsner: *Some Architectural Writers of the Nineteenth Century* (Oxford, 1972)

R. Wagner-Rieger and W. Krause, eds: *Historismus und Schlossbau* (Munich, 1975)

C. Baur: *Neugotik* (Munich, 1981)

C. Mignot: *L'Architecture au XIXe siècle* (Fribourg, 1983)

L. J. Sutthof: *Gotik im Barock: Zur Frage der Kontinuität des Stiles ausserhalb seiner Epoche* (Münster, 1990)

NATIONAL STUDIES

Austria

R. Wagner-Rieger: *Wiens Architektur im 19. Jahrhundert* (Vienna, 1970)

Belgium

C. van Gerwen: *De neogotische beeldhouwkunst in de Onze-Lieve-Vrouwekathedraal van Antwerpen* (Antwerp, 1977)

P. Colman: 'L'Architecture néo-gothique en Wallonie et à Bruxelles: Conflits d'hier, d'aujourd'hui et de demain', *Bull. Cl. B.-A. Acad. Royale Sci. Lett. & B.-A. Belgique*, n. s. 4, lxviii (1986), pp. 18–35

J. de Maeyer, ed.: *De Sint-Lucasscholen en de neogotiek, 1862–1914* (Leuven, 1988) [Eng. and Fr. summaries]

Czech Republic

V. Kotrba: *Česká barokní gotika: Dílo Jana Santiniho-Aichla* [The Baroque Gothic in Bohemia: the work of Giovanni Santini-Aichl] (Prague, 1976)

France

P. Lavedan: 'Eglises néo-gothiques', *Archvs A. Fr.*, n. s., xxv (1978), pp. 351–9

Viollet-le-Duc: Architect, Artist, Master of Historic Preservation (exh. cat. by F. Bercé and B. Foucart, Washington, DC, Trust Mus. Exh., 1988)

J. -M. Leniand: *Viollet-le-Duc ou les délires du système* (Paris, 1994)

Germany

A. Neumeyer: 'Die Erweckung der Gotik in der deutschen Kunst des späten 18. Jahrhunderts: Ein Beitrag zur Vorgeschichte der Romantik', *Repert. Kstwiss.*, xlix (1928), pp. 75–123, 159–85

P. Korneli: 'Die Anfänge der Neugotik in Anhalt, Sachsen und Thüringen', *Sächs. Heimatbl.*, x (1964), pp. 37–53, 323–40; xi (1965), pp. 70–84

W. D. Robson-Scott: *The Literary Background of the Gothic Revival in Germany: A Chapter in the History of Taste* (Oxford, 1965)

S. Muthesius: *Das englische Vorbild: Eine Studie zu den deutschen Reformbewegungen in Architektur, Wohnbau und Kunstgewerbe im späteren 19. Jahrhundert* (Munich, 1974)

H. J. Giersberg: 'Zur neugotischen Architektur in Berlin und Potsdam um 1800', *Studien zur deutschen Kunst um 1800*, ed. P. Betthausen (Dresden, 1981), pp. 210–32

O. Dann, ed.: *Religion–Kunst–Vaterland: Der Kölner Dom im 19. Jahrhundert* (Cologne, 1983)

H. Mai: *Kirchen in Sachsen: Vom Klassizismus bis zum Jugendstil* (Berlin and Leipzig, 1992)

M. J. Lewis: *The Politics of the German Gothic Revival: August Reichensperger* (Cambridge, MA, and London, 1993)

Hungary

D. Komárik: 'A gótizáló romantika épitészete Magyar-országon' [Gothic Romantic architecture in Hungary], *Épités- & Épitészettudomány*, xiv (1982), pp. 275–319

J. Sisa: 'Steindl, Schulek und Schulcz: Drei ungarische
Schüler des Wiener Dombaumeisters Friedrich von
Schmidt', *Mitt. Ges. Vergl. Kstforsch. Wien*, xxxvii/3
(1985), pp. 1–8

A. Hung., xv/1 (1987) [special issue on Historicism, with
contributions by I. Bibó, D. Komárik and J. Sisa; Ger.
summaries]

Italy

C. L. V. Meeks: *Italian Architecture, 1750–1914* (New Haven
and London, 1966)

R. Wittkower: *Gothic versus Classic: Architectural Projects
in Seventeenth Century Italy* (London, 1974)

*Cultura figurativa e architettonica negli stati del re di
Sardegna (1773–1861)* (exh. cat. by E. Castelnuovo and
M. Rosci, Turin, Pal. Reale, Pal. Madama and Promot.
B.A., 1980)

*Gotico, neogotico, ipergotico: Architettura e arti
decorative a Piacenza, 1856–1915* (exh. cat., Piacenza,
1984)

Netherlands

H. P. R. Rosenberg: *De 19de-eeuwse kerkelijke bouwkunst
in Nederland* (The Hague, 1972)

P. A. M. Geurts and others, eds: *J. A. Alberdingk Thijm
(1820–1889), Erflater van de negentiende eeuw*
(Nijmegen, 1992)

Poland

T. S. Jaroszewski: *O siedzibach neogotyckich w Polsce*
[On neo-Gothic country houses in Poland] (Warsaw,
1981) [Eng. summary]

P. Krakowski: 'Architektura neogotycke w Krakowie'
[Neo-gothic architecture in Kraków], *Fol. Hist. A.*,
xx (1984), pp. 137–81 [Fr. summary]

M. Kühn, ed.: *Karl Friedrich Schinkels Lebenswerk:
Ausland, Bauten und Entwürfe* (Munich, 1989)

Romania

G. Ionescu: *Arhitectura pe teritoriul României de-a
lungul veacurilor* [Architecture on Romanian
territory over the centuries] (Bucharest, 1982)
[Eng. summary]

Sweden

K. Malmström: *Centralkyrkor: Inom svenska kyrkan,
1820–1920. Med en byggnadsantikvarisk inventering*
[The principal churches within the Swedish Church,
1820–1920. With a historic buildings inventory]
(Stockholm, 1990) [Eng. abstract, Ger. summary]

Switzerland

A. Meyer: *Neugotik und Neuromantik in der Schweiz: Die
Kirchenarchitektur des 19. Jahrhunderts* (Zurich, 1973)

P. Bissegger: *Le Moyen Age romantique au Pays de Vaud,
1825–1850: Premier Épanouissement d'une architec-
ture néo-médiévale* (Lausanne, 1985)

United Kingdom

C. L. Eastlake: *A History of the Gothic Revival: An Attempt
to Show How the Taste for Mediaeval Architecture
which Lingered in England during the Two Last
Centuries Has since Been Encouraged and Developed*
(London, 1872/R Leicester and New York, 1970 [with
209 additional pages containing intro., updated
bibliog. etc. by J. M. Crook])

H.-R. Hitchcock: *Early Victorian Architecture in Britain*, 2
vols (New Haven, 1954)

P. Breman: 'The Gothic of Gothick: English Church
Building in Nineteenth Century Theory and Practice',
B. Weinreb, Architecture, Catalogue 14 (London, 1966)

Victorian Church Art (exh. cat., London, V&A, 1971)

G. L. Hersey: *High Victorian Gothic: A Study in
Associationism* (Baltimore and London, 1972)

S. Muthesius: *The High Victorian Movement in
Architecture, 1850–1870* (London and Boston, 1972)

J. Macaulay: *The Gothic Revival, 1745–1845* (Glasgow, 1975)

R. Dixon and S. Muthesius: *Victorian Architecture*
(London, 1978)

H. Wischermann: *Fonthill Abbey: Studien zur profanen
Neugotik Englands im 18. Jahrhundert* (Freiburg im
Breisgau, 1979)

N. Miller: *Strawberry Hill: Horace Walpole und die
Ästhetik der schönen Unregelmässigkeit* (Munich and
Vienna, 1986)

J. M. Crook: *The Dilemma of Style: Architectural Ideas
from the Picturesque to the Post-Modern* (London,
1987)

M. McCarthy: *The Origins of the Gothic Revival* (New
Haven and London, 1987)

P. Fontaney, ed.: *Le Renouveau gothique en Angleterre:
Idéologie et architecture: Introduction, anthologie
bilingue, notes* (Bordeaux, 1989)

P. Atterbury and C. Wainwright, eds: *Pugin: A Gothic
Passion* (New Haven and London, 1994)

P. Spencer-Silver: *Pugin's Builder: The Life and Work of
George Myers* (Hull, 1994)

USA

P. B. Stanton: *The Gothic Revival and American Church
Architecture: An Episode in Taste, 1840–1856*
(Baltimore, 1968)

W. Andrews: *American Gothic: Its Origins, its Trials, its Triumph* (New York, 1975)

C. Loth and J. T. Sadler jr: *The Only Proper Style: Gothic Architecture in America* (Boston, 1975)

D. Shand-Tucci: *Ralph Adams Cram: American Medievalist* (Boston, 1975)

W. H. Pierson jr: *Technology and the Picturesque, the Corporate and Early Gothic Styles*, ii of *American Buildings and their Architects* (Garden City, NY, 1978)

GEORG GERMANN

II. DECORATIVE ARTS

Alongside architectural developments, the Gothic Revival was adopted as a suitable style for interior design and then extended to all forms of the applied arts. In the 18th century the applied arts had figured alongside architecture most famously in England in the furnishings designed for Strawberry Hill (from 1753), and William Beckford's Fonthill Abbey (from 1796), which were both characterized by a picturesque interpretation of Gothic motifs. In the 19th century, when the Gothic Revival was at its most significant as an intellectual, moral and artistic phenomenon, the concept of the integrated interior and the crucial design role of architects meant that architecture and the decorative arts were closely entwined. England remained at the forefront of the movement, influencing developments in Europe and North America as a more archaeological and historically correct approach gained momentum. A decorative vocabulary that drew upon Gothic architectural features—pointed arches, lancets, tracery, crockets, quatrefoils and trefoils, and naturalistic foliage—was applied to furniture, metalwork (including silver, ironwork and jewellery), ceramics (including porcelain and earthenware), glass and stained glass, textiles and wallpapers. These objects were often designed to complement a contemporary architectural shell. The use of colour was also important. The Gothic Revival, however, meant more than purely surface decoration. In some cases, for example for furniture and metalwork, the reintroduction of medieval structures and techniques, as far as

they were known, became part of the philosophy of the movement. Scholarship and collecting added impetus and helped to fuel the academic debate that played a key role in determining the course of the Revival; literature, embodied by Sir Walter Scott's novel *Waverley* (1814), contributed to the popularity of the style. There was a general romantic interest in the medieval period, characterized by the Eglington Tournament of 1839. During the 19th century the burgeoning wealth of the middle class put the Gothic interior within reach of a greater number of people.

The chronology of the Revival falls into several distinct phases. In England the early part of the 19th century was characterized by a greater degree of exploration of medieval forms. The architect Lewis Nockalls Cottingham, who established a private collection of medieval architectural fragments, published *Working Drawings of Gothic Ornaments, etc., with a Design for a Gothic Mansion* (London, [1824]), one of the most powerful documents of Gothic Revival ornament. He also designed a wide range of Gothic furniture, often incorporating original, medieval fragments. A. C. Pugin also developed a specialized knowledge of Gothic style in a series of important sourcebooks. His furniture designs also appeared in Rudolph Ackermann's influential *Repository of Arts* (1809–28) from 1825.

In the same period the Gothic Revival was gaining pace in continental Europe. In northern Europe nationalist and religious regeneration helped create a climate in which the Gothic Revival could thrive. In France Gothic was being identified as a 'national' style, partly as a rejection of Napoleon's espousal of Neo-classicism as his court style. The TROUBADOUR STYLE or 'Style cathédrale', a romantic evocation of medieval chivalric and courtly life that extended to the decorative arts, was the main expression of this interest. In 1823 the Sèvres Porcelain Factory embarked on the ambitious 'Service de la Chevalerie', and such patrons as the Duchesse de Berry ordered furniture and porcelain in the 'style gothique'. Gothic was also being reevaluated as the national style in Germany, with the encouragement of such literary figures as Johann Wolfgang von Goethe, as part of the surge of

nationalism after the Prussian War of Liberation of 1813. A symbol of this was the National Monument to the Liberation known as the Kreuzberg for the Tempelhofer Berg, Berlin, designed as a massive pinnacled cross in 1817–18 (completed 1821) and forged in cast iron by the architect and designer Karl Friedrich Schinkel. Schinkel also produced Gothic designs for furniture, for example for Prince William of Prussia, at Schloss Babelsburg, Potsdam, from 1833, and for silver, manufactured by the Berlin goldsmith George Hossauer, in particular the three presentation cups made for the medieval tournament festival the 'Magic Spell of the White Rose' in 1830. Although decorated with Gothic ornament, the basic shape of the cups is classical, a contradiction then still considered perfectly acceptable. This eclectic attitude was overturned in England in the second phase of the Revival, from the late 1830s to 1850s, which was dominated by A. W. N. Pugin. Pugin's contribution to the Revival was fundamental in terms of design (see §I above). As a result, the religious emphasis of the Revival became more pronounced, particularly after Pugin's conversion to Roman Catholicism in 1835. During the 19th century there was a boom in the building of churches needed for the growing industrial centres. Owing to Pugin's influence the majority of these were in the Gothic style. One of Pugin's main concerns was honesty—that objects should reflect their medieval prototypes in design and structure, which should not be disguised, hence his approval of the 'X'-frame construction for chairs, and his opinion that pattern should be bold, colourful and appropriate to the context—for example that flat objects should have two-dimensional patterns. These views were elaborated in his publications *Gothic Furniture in the Style of the 15th Century Designed and Etched by A. W. N. Pugin* (London, 1835), *Designs for Gold and Silversmiths* and *Designs for Iron and Brass Work in the Style of the XV and XVI Centuries Drawn and Etched by A. W. N. Pugin* (both London, 1836). His influence spread: the Belgian architect and designer Jean-Baptiste Charles François Bethune absorbed the ideology, and furniture designs were copied in Germany and the USA.

Pugin used a circle of craftsmen to execute his designs: the firm of John Hardman of Birmingham made secular and ecclesiastical plate including chalices and candlesticks, jewellery and monumental brasses from 1838. Ceramics, including tableware and medieval-style encaustic tiles, were provided by Herbert Minton from 1840. Stained glass was made by Thomas Willement (1786–1871) and John Hardman Powell (1827–95), and furniture by several firms including John Webb and John Gregory Crace, for whom Pugin also designed wallpaper, textiles and carpets. Other manufacturers capitalized on the growing popularity of the Gothic Revival. For example, the Staffordshire potteries produced such stoneware jugs with relief figures in Gothic niches as the Minster Jug (1842; London, V&A) by Charles Meigh of Hanley.

Among Pugin's many commissions for Gothic interiors, the New Palace of Westminster, for which he designed the furnishings and decoration, stands out as a symbol of the Revival. The other major monument to Pugin's influence was his arrangement of the Medieval Court at the Great Exhibition in London in 1851, which acted as a showcase for manufacturers of Gothic Revival decorative arts and received widespread acclaim. The *London Illustrated News* commented that it demonstrated 'the applicability of Mediaeval art in all its richness and variety to the uses of the present day'. The Great Exhibition also highlighted continental developments. The firm Carl Leistler & Son in Vienna showed an immense architectural bookcase (London, V&A) that, along with an oak cabinet (London, V&A) by Pugin, was thought to be the most important piece of Gothic Revival furniture.

From 1841 the Ecclesiological Society (formerly the Cambridge Camden Society), founded out of concerns for the preservation of church fabric and fittings, made influential pronouncements in its magazine *The Ecclesiologist*. It also produced a design series for church metalwork and furniture called *Instrumenta Ecclesiastica* (1844–7 and 1850–52/1856). This was edited by William Butterfield, who provided all of the designs for the first series, and the society later employed first G. E. Street and then William Burges as official

metalwork designers. The same role was performed in Germany by the *Kölner Domblatt* and in France by the periodical *Annales archéologiques*. The creation of the Musée de Cluny, in the 15th-century Hôtel des Abbés de Cluny, Paris, by Alexandre Du Sommerard in 1832 provided medieval models for designers and was symptomatic of a growing interest in antiquarianism. Jean-Baptiste Lassus, architect and designer in a scholarly medieval style, encouraged craftsmen, among them the metalworker Achillé Legost, to rediscover such medieval techniques as champlevé enamelling. As in England, the church was a major patron of Gothic Revival decorative arts, supplied by such goldsmiths as Placide Poussielgue-Rusand (1824–89) in Paris and Thomas-Joseph Armand-Calliat (*fl c.* 1862–81) in Lyon. François-Désiré Froment-Meurice (1802–55) produced fine metalwork and jewellery, winning a medal at the Great Exhibition of 1851. Like many manufacturers, he did not work exclusively in the Gothic manner, and his style was not particularly archaeological.

The influence of Eugène-Emmanuel Viollet-le-duc was a key factor in the credibility of the Revival. His publications, notably the *Dictionnaire du mobilier* (6 vols, Paris, 1858–75), illustrated his commitment to French 13th-century Gothic and proved indispensable to designers. He designed for a range of materials, including stained glass for the Sèvres Porcelain Factory, and the prestige of some of his commissions, notably the château of Pierrefonds (from 1858) for Emperor Napoleon III, raised the profile of the Gothic style. A similar role was played in Germany by Georg Gottlob Ungewitter, an architect and designer who propagated the Gothic Revival through teaching at the Höhere Gewerbeschule in Kassel. He published furniture designs in *Entwürfe zu gothischen Möbel* (1851), some of which were based on original models. This was followed by the *Gothisches Musterbuch* (1856–61), which included designs for metalwork and stained glass. In Belgium, where A. W. N. Pugin's influence was particularly strong, there were some notable examples of buildings both domestic and religious with complete interiors all in the Gothic Revival style. Examples include the Loppem Castle (design, 1856), near Bruges, by E. W. Pugin and Bethune and the Roman Catholic complex SS Mary and Philip with the church of the Nativity of Vive-Kapelle (1860–69), also by Bethune.

In the USA the Gothic Revival took longer to take hold. The first published evidence of the style was the sideboard used as a frontispiece to Robert Conner's *The Cabinet Maker's Assistant* (New York, 1842), although developments in Europe had already been absorbed by the architect and designer Alexander Jackson Davis. Davis designed a number of houses in the Gothic taste for wealthy patrons, including Lyndhurst (originally 'Knoll'; from 1838) at Tarrytown for General William Paulding, the Mayor of New York. Davis also designed the furniture for the mansion, including beds, which lent themselves to the application of Gothic ornament. Although inspired by Pugin, he was an advocate of 'carpenter's Gothic', or decoration of furniture not necessarily Gothic in form by Gothic mouldings and ornament. Considerable quantities of Gothic Revival furniture were made in the 1840s and 1850s by such firms as John and Joseph W. Meeks. The aesthete and landscape architect A. J. Downing, a prolific author on taste, also propagated the style. In *The Architecture of Country Houses* (1850), he debated the suitability of Gothic for domestic interiors, concluding that it was appropriate for libraries, halls and bedrooms. Very little Gothic Revival silver was produced in the USA. The Boston & Sandwich Glass Co. (est. 1825) in Sandwich, MA, did, however, produce pressed and moulded jugs, decanters and dishes incorporating arcading and tracery patterns.

During the 1860s there was a further change in the direction of the Gothic Revival with the introduction in England of 'Reformed Gothic' under the influence of such architects and designers as William Butterfield, G. E. Street, Richard Norman Shaw and, most importantly, William Burges. The stress was still on honesty, but using 13th-century French models to design new forms appropriate to the needs of the 19th century, rather than the pure 14th-century sources advocated by Pugin. Examples of the style were first seen at the Medieval Court at the 1862

International Exhibition in London. The architect George Gilbert I Scott, who designed extensive fittings for churches, displayed a polychromed wrought-iron chancel screen (London, V&A) for Hereford Cathedral made by the silversmith Francis Skidmore's Art Manufactures Co. in Coventry. The interiors designed by Burges for Cardiff Castle from 1868 are among the finest expressions of the style. Such pattern books as Bruce J. Talbert's *Gothic Forms Applied to Furniture, Metal Work and Decoration for Domestic Purposes* (Dundee, 1867) and Owen Jones's *The Grammar of Ornament* (London, 1856) provided a readily available corpus of decoration. Charles Locke Eastlake's *Hints on Household Taste in Furniture, Upholstery and Other Details* (London, 1868) was a popular manual of decoration based on the work of such designers as Street and J. P. Seddon, advocating honesty of construction and materials. It had a dramatic impact in the USA.

By the 1870s the use of the Gothic Revival for domestic interiors was waning, although it remained important for ecclesiastical buildings and fittings until well into the 20th century. In England, William Morris, whose roots were firmly in the Gothic style, had already established Morris, Marshall, Faulkner and Co. (from 1875 Morris & Co.), the genesis of the ARTS AND CRAFTS MOVEMENT. By the early 1880s the Aesthetic Movement was under way. In Germany the Munich Exhibition of 1876 indicated a revival of German Renaissance styles. There were exceptions. Schloss Neuschwanstein, near Füssen, built between 1868 and 1886 for Ludwig II, King of Bavaria, was provided with elaborate Gothic interiors by Julius Hoffmann. Hermann Robert Bichweiler designed Gothic interiors for the furniture manufacturer H. C. Wolbrandt from 1872 and set up a highly successful art factory in Altona in 1878, which included Gothic patterns among its output. A further variant was the *Alte deutsche* style that developed in the last quarter of the century, manifested in the work of such goldsmiths as Gabriel Hermeling of Cologne and Alexander Schönauer of Hamburg, who produced replicas of Late Gothic lobed beakers, and was part of a surge in interest in medieval collecting that led to the production of many interesting fakes. By the 1890s revivalist styles in general were outmoded, as indicated by the emergence of the Art Nouveau and *Jugendstil*.

Bibliography

The Industry of All Nations, 1851: The Art Journal Illustrated Catalogue (exh. cat., London, Great Exhibition, 1851)

T. S. R. Boase: *English Art, 1800–1870* (Oxford, 1959)

J. B. Waring: *Masterpieces of Industrial Art and Sculpture at the International Exhibition, 1862*, 3 vols (London, 1963)

Nineteenth-century America: Furniture and Other Decorative Arts (exh. cat., ed. B. B. Tracy; New York, Met., 1970)

M. Girouard: *The Victorian Country House* (Oxford, 1971)

Victorian Church Art (exh. cat., London, V&A, 1971)

G. Germann: *Gothic Revival in Europe and Britain: Sources, Influences and Ideas* (London, 1972)

Victorian and Edwardian Decorative Art: The Handley-Read Collection (exh. cat., London, RA, 1972)

High Victorian Design (exh. cat., ed. S. Jervis; Ottawa, N. Museums, 1974)

The Gothic Revival Style in America, 1830–1879 (exh. cat. by K. S. Howe and D. B. Warren, Houston, TX, Mus. F.A., 1976)

Historismus in Hamburg und Norddeutschland: Höhe Kunst zwischen Biedermeier und Jugendstil (exh. cat., ed. H. Jedding; Hamburg, Mus. Kst & Gew., 1977)

L'Art en France sous le Second Empire (exh. cat., Paris, Grand Pal., 1979)

Le 'Gothique' retrouvé avant Viollet-le-Duc (exh. cat., Paris, Hôtel de Sully, 1979)

B. Mundt: *Historismus: Kunstgewerbe zwischen Biedermeier und Jugendstil* (Munich, 1981)

S. Jervis: *The Penguin Dictionary of Design and Designers* (Harmondsworth, 1984)

L. de Gröer: *Les Arts décoratifs de 1790 à 1850* (Fribourg, 1985); Eng. trans. as *Decorative Arts in Europe, 1790–1850* (Fribourg, 1986)

Art and Design in Europe and America, 1800–1900, London, V&A cat. (London, 1987)

C. Wainwright: *The Romantic Interior: The British Collector at Home, 1750–1850* (New Haven and London, 1989)

Of Knights and Spires: Gothic Revival in France and Germany (exh. cat. by P. Hunter-Stiebel, New York, Rosenberg & Stiebel Inc., 1989)

M. Aldrich, ed.: *The Craces: Royal Decorators, 1768–1899* (Brighton, 1990)

Un Age d'or des arts décoratifs, 1814–1848 (exh. cat., Paris, Grand Pal., 1991)

M. J. Lewis: *The Politics of the German Gothic Revival: August Riechensperger* (Cambridge, MA, 1993)

P. Atterbury and C. Wainwright, eds: *Pugin: A Gothic Passion* (New Haven and London, 1994)

PIPPA SHIRLEY

Gothic survival

Term used to describe the survival of Gothic architecture in western Europe, a phenomenon that was more widespread and more prolonged than is generally recognized. Interested in the first manifestations of a new style rather than the last recurrences of an old one, architectural historians have tended to pay too little attention to the persistence of Gothic forms alongside those introduced in the Renaissance. What are often seen as isolated anachronisms prove on investigation to be so numerous and so widespread as to represent an alternative tradition that cannot be dismissed as of no significance. In any case, in northern Europe the assimilation of the Renaissance was a long-drawn-out process that was not fully accomplished until the latter part of the 17th century. Until then much new building, especially in rural areas, was basically medieval in form, though often with classical details added, such as doorways and altarpieces. Each country clung to some different feature from the past that had become too deeply embedded in its architectural consciousness (or sub-consciousness) to be easily dispensed with: in France it was the high-pitched roof sustained by an intricate mass of carpentry; in northern Germany the stepped gable; in England the battlemented parapet; in Scotland the fortified tower-house; in Spain the frenetic elaboration of decoration that, when classicized, became the Plateresque.

1. Background and characteristics

Much of this Late Gothic architecture was due simply to conservatism: peasant farmers and country clergy have rarely been prone to artistic innovation, and the masons they employed were slow to assimilate classical ideas. But an informed architectural conservatism could also be found in some more sophisticated circles. The most striking instance of this is the Jesuit Order, which built a number of Gothic churches during the 17th century in northern France, western Germany and the Netherlands. This must have been a conscious choice, for Jacopo Vignola's Il Gesù in Rome (begun 1565) was one of the most celebrated classical churches of the Counter-Reformation and the first Jesuit church in the Low Countries (at Douai, 1591) had also been built in the classical style. It was only in subsequent years that the decision was made to build Gothic churches at Arras, Lille, Luxembourg, Tournai, Valenciennes and elsewhere. What led the Jesuits to favour the Gothic style is not clear, but elsewhere it was, paradoxically, a humanist principle that often lay behind the desire to build in Gothic. All over Europe there were major churches begun in the later Middle Ages that were still incomplete when they were overtaken by new ideas in the Renaissance. They came to be seen as outdated in style, but the doctrine of harmony and consistency that was basic to the Renaissance theory of design required their completion in the same manner. So here the Gothic style was deliberately (if sometimes reluctantly) adhered to for aesthetic reasons. Thus in Italy in the late 15th century, such outstanding designers as Leonardo da Vinci and Bramante favoured a Gothic format for the central tower of Milan Cathedral, and when the design for its façade was under consideration in the mid-17th century, no less a person than Bernini commended a solution that was Gothic in detail, though classical in organization. At Bologna, in the same way, a whole series of Gothic designs for the façade of S Petronio was made during the 16th century by architects as distinguished as Baldassare Peruzzi and Vignola in an attempt to build it in a manner that would conform to the style of the 15th-century nave. In France, not only were there cathedrals still incomplete but there were others severely damaged in the Wars of Religion that had to be rebuilt.

No other type of building presented quite the same problem of stylistic consistency as churches. Palaces often retained an ancient core within a

complex of buildings of various styles and dates, but most major churches of the late Middle Ages represented a single conception that did not lend itself easily to stylistic modification. Hence, in the 16th and 17th centuries, great Gothic churches could still be seen slowly progressing towards completion on the lines laid down in the 14th or 15th centuries. It was no doubt partly for this reason that Gothic came to be seen as a style especially appropriate for churches, if for no other purpose. Thus in France it is noticeable that when monasteries were rebuilt after destruction by the Huguenots, their churches were Gothic, but the refectories, chapter houses and other conventual buildings were classical in style. This link between Gothic and church-building was implicit in the minds of the fellows of St John's College, Cambridge, when they resolved in 1623 to adopt 'the old fashion of church window' for their new library, and it is noticeable that in early 17th-century England, symbolic representations of 'the Church' invariably show the figure of 'Ecclesia' accompanied by a Gothic church.

A different, but equally sophisticated, attitude to Gothic architecture is represented by some buildings in which Gothic and classical elements were mixed in a way that was obviously deliberate. Examples of this include the church of St Etienne-du-Mont (1610), Paris, Heriot's Hospital (begun 1628), Edinburgh, and the chapel and library (begun 1656) of Brasenose College, Oxford. In such buildings as these the Renaissance ideal of harmony was flouted by architects who evidently saw in the stylistic clash a new opportunity to achieve Mannerist effects. It is perhaps to this category that the churches built by Bishop Julius Echter von Mespelbrunn of Würzburg, such as Dettelbach (1610–13), should be assigned. Gothic forms are also to be found among the engravings in that most Mannerist of pattern books, Wendel Dietterlin's *Architectura* (1598).

In 16th- and 17th-century Europe there was no lack of technical ability to build in the Gothic style. In France the tradition of expertise in vaulting was manifested at Orléans, Saint-Maixent and elsewhere and continued to be exploited in such 18th-century churches as St Vaast (begun *c.* 1750),

Arras, that are wholly classical in vocabulary. In England as late as *c.* 1640 a London mason was able to build the spectacular fan-vault over the staircase at Christ Church, Oxford, which rivalled, in the elegant exiguity of its support, the most daring achievements of the past. But in general, although 16th- and 17th-century masons were capable of continuing incomplete buildings or reinstating damaged ones in a variety of Gothic manners (and occasionally even in Romanesque), their work rarely shows any evidence of new invention. It is difficult to point to any stylistic development that can be regarded as generally characteristic of Late Gothic. Motifs from the past were often used in a way that was historically 'incorrect'. In England church towers sometimes have Perpendicular windows at ground level and Decorated ones above (e.g. Dalham, Suffolk, 1635). In France, Flamboyant tracery may be found in combination with mouldings of earlier or later character (e.g. St Eustache, Paris). There was, of course, no possibility of a more consciously accurate historicism, because no one had yet worked out that sequence of architectural forms that Arcisse de Caumont in France and Thomas Rickman in England established only in the 19th century. Until then Gothic (a term first employed in the early 17th century) was seen as an old way of building, embracing many varieties of moulding and tracery that could be combined at will. The result was a retrospective Gothic whose practitioners had none of the missionary zeal of the Gothic Revivalists of the 19th century and whose products were later to be either mistaken for genuine medieval work or else despised as 'debased' perversions of it. Only now can the phenomenon of Gothic survival be seen dispassionately as a characteristic feature of European architecture in the 16th and 17th centuries.

2. Geographical extent

In England the Dissolution of monasteries and chantries in the 1530s and 1540s removed a major source of architectural patronage, while Lichfield, Staffs, was the only cathedral that needed major repair after the Civil War in the 1640s. Late Gothic in England is therefore represented chiefly by

parish churches and, in Oxford and Cambridge, by college buildings such as halls and chapels. Few completely new churches were built. Low Ham (1620), Somerset, St Katherine Cree (completed 1630), London, Staunton Harold (1653), Leics, and Charles Church (1665), Plymouth, are examples. But many church towers were rebuilt, either to replace ones that had collapsed, or to render them capable of standing up to stresses caused by the new fashion for change-ringing. A representative selection might include Cullompton (1548), Devon; St Mary's (1594–1624), Reading; St John's (1612), Peterborough; Godmanchester (1623), Hunts; Christow (1630), Devon; Calne (1639–50), Wilts; Barholme (1648), Lincs; Deddington (1683–5), Oxon; and Dursley (1708–12), Glos. In France important churches completed or reconstructed in the Gothic style in the 16th and 17th centuries include the cathedrals of Auch (tower completed 1678), Blois (1680–1730), Luçon (façade c. 1700), Mende (partly reconstructed 1599–1620), Montpellier (1634), Nantes (completed 1660), Orléans (1601–1829) and Tours (completed 1547). Others include the abbey churches of Celles-sur-Belle (1668–76), Poitou; Corbie (1701–32), Somme; Evaux (c. 1660), Creuse; Figeac (1636 on), Guyenne; and Saint-Maixent (1670–82), Poitou; the collegiate church of Aire-sur-la-Lys (nave completed c. 1600), Pas de Calais; the parish church of Mézières (1499–1615), Ardennes; and many other churches in various parts of the country, especially in Roussillon. In Artois and Picardy, the Beauvaisis and the Valois, many towers and spires were built or rebuilt, notably that of Beauvais Cathedral, 153m high and Flamboyant in style, which collapsed in 1573, only a few years after its completion. More repre-sentative examples, usually following the pattern of the medieval steeple of Senlis Cathedral, were Béthisy-Saint Pierre (1520), Hadrancourt-le-Haut-Clocher, Montagny-Sainte-Félicité and Versigny.

In Germany the outstanding examples of Late Gothic (*Nachgotik*) are the Jesuit churches of Mariä Himmelfahrt (1618–c. 1630), Cologne, St Georg (1614–18), Molsheim, and Unsere Liebe Frau at Halle (begun 1529). In the Low Countries, in addition to the Jesuit churches already mentioned,

there are examples of Late Gothic at Antwerp in St Just's Chapel of the Virgin (1642–6), in parts of St Bavo's Cathedral and of St Peter's Abbey at Ghent, the church of St Hubert (1525–67) in the Ardennes and the hall-church at the former abbey of Lobbes (1550–1624). In Scotland the tradition of fortified domestic architecture continued well into the 17th century, and such castles as Crathes and Craigievar (both Grampian) represent the survival and indeed vigorous development of late medieval architectural forms better than the few Gothic churches. The latter, however, include the north-west steeple of Dunfermline Abbey Church (c. 1590), the apsidal east end of Terregles Church (1585), Dumfries & Galloway, and the churches of Dairsie (1621) and Fordell Castle (1650), both in Fife, the latter with Flamboyant tracery. In Spain the great series of late medieval cathedrals continued into the 16th century with Salamanca (begun 1512), Almería (1524–73), Segovia (1525–c. 1570), Saragossa, La Seo (nave 1546–59) and Gerona (nave completed 1598). At Gerona the external west front was classical, but at Salamanca a decision was made in 1588 to complete the façade in Gothic rather than in the classical style.

Bibliography
J. H. Parker: 'On the Late, or Debased, Gothic Buildings of Oxford', *ABC of Gothic Architecture* (Oxford, 1881), pp. 219–56
H. M. Colvin: 'Gothic Survival and Gothick Revival', *Archit. Rev.* [London], ciii (1948), pp. 91–8
A. W. Clapham: 'The Survival of Gothic in Seventeenth-century England', *Archaeol. J.*, cvi (1952), pp. 4–9
A. Woodger: 'Post-Reformation Mixed Gothic in Huntingdonshire Church Towers and its Campanological Associations', *Archaeol. J.*, cxli (1984), pp. 269–308
G. W. Bernard: 'The Dating of Church Towers: Huntingdon Re-examined', *Archaeol. J.*, cxlix (1992), pp. 344–50
G. Durand: 'Clochers picards, avec flèches gothiques des XVII et XVIII siècles', *Congr. Archéol. France*, lxxii (1906), pp. 623–36
E. Lefèvre-Pontalis: 'Les Clochers du XIIIe et du XVIe siècles dans le Beauvaisis et le Valois', *Congr. Archéol. France*, lxxii (1906), pp. 592–622
Canon Chenesseau: 'Cathédrale d'Orléans', *Congr. Archéol. France*, xciii (1931), pp. 11–51

L. Hautecoeur: *Architecture classique* (1943–57), i/1, pp. 2–96

P. Héliot: 'La Fin de l'architecture gothique en France durant les XVII et XVIII siècles', *Gaz. B.-A.*, n. s. 6, xxxiii (1951), pp. 111–27

——: 'L'Héritage médiéval dans l'architecture de l'Anjou et de l'Aquitaine aux XVII et XVIII siècles', *An. Midi*, lxvii (1955), pp. 143–59

J. Guerot: 'Eglises gothiques des XVII et XVIII siècles en Roussillon', *Bull. Mnmtl*, cxxi (1963), pp. 93–5

G. Giordanengo: 'La Reconstruction des églises paroissiales dans le diocèse d'Embrun, XVe siècle–milieu du XVI siècle', *Congr. Archéol. France*, cxxx (1974), pp. 162–81

J. Braun: *Die Kirchenbau der deutschen Jesuiten* (Freiburg im Breisgau, 1908–10)

W. Buchowiecki: *Die gotischen Kirchen Österreichs* (Vienna, 1952), pp. 403–9

H. R. Hitchcock: *German Renaissance Architecture* (Princeton, 1981)

R. Wittkower: *Gothic Versus Classic: Architectural Projects in Seventeenth-century Italy* (London, 1974)

L. Serbat: 'L'Architecture gothique des Jésuites au XVII siècle', *Bull. Mnmtl*, lxvi (1902), pp. 315–70; lxvii (1903), pp. 84–134

J. Braun: *Die belgischen Jesuitkirchen* (Freiburg im Breisgau, 1907)

S. Brigorde: *Les Eglises gothiques de Belgique* (Brussels, 1947)

D. MacGibbon and T. Ross: *The Castellated and Domestic Architecture of Scotland*, 5 vols (Edinburgh, 1887–92)

G. Hay: *The Architecture of Scottish Post-Reformation Churches* (Oxford, 1957)

L. T. Balbás: 'Arquitectura gotica', *A. Hisp.*, vii (1952), pp. 369–84

J. Harvey: *The Cathedrals of Spain* (London, 1957)

HOWARD COLVIN

Goût grec

Stylistic term for the first phase of French Neo-classicism. Contemporary usage was loose as regards both the objects referred to (even coffee and hair lotion were advertised as 'à la grecque') and their style (which might only have the faintest classicizing flavour). It is correctly applied only to those examples of French decorative arts and architecture dating from the mid-1750s to the late 1760s that are severely rectilinear, with chunky classical details, such as Vitruvian scrolls, Greek-key frets and geometrical garlands. The style was effectively inaugurated by a set of furniture, comprising a combined writing-table and cabinet and a clock (Chantilly, Mus. Condé), made for the Parisan financier Ange-Laurent de La Live de Jully from designs (1756–8) by the painter and amateur architect Louis-Joseph Le Lorrain. The monumental and unfrivolous style of these pieces, executed in ebony-veneered oak with heavy gilt bronze mounts, was quite different from the current Rococo idiom. The Comte de Caylus, Europe's foremost antiquary and Le Lorrain's influential mentor, praised the furniture extravagantly. Another key role in the creation and dissemination of the *goût grec* was played by the engravings of the architect Jean-François de Neufforge, a member of Caylus's circle and a collaborator with Le Lorrain on the publication of Julien-David Le Roy's *Les Ruines des plus beaux monuments de la Grèce* (Paris, 1758). This early, extreme phase of Neo-classicism was attacked by Charles-Nicolas Cochin *le fils* and Jacques-François Blondel and was parodied in Ennemond-Alexandre Petitot's *Mascarade à la grecque* (Parma, 1771). The brief but intense flowering of the *goût grec* soon gave way to the less rigorous Louis XVI style.

Bibliography

S. Eriksen: 'La Live de Jully's Furniture "à la Grecque"', *Burl. Mag.*, ciii (1961), pp. 340–47

——: *Early Neo-classicism in France* (London, 1974)

RICHARD JOHN

Grand Manner [Great Style]

Term given to the imposing style of history painting advocated by the teaching academies throughout Europe from the late 17th century onwards, based on the art of Raphael, Poussin and the Carracci. The idea of an elevated style of writing, deriving from Classical rhetoric, was applied to visual art by late Renaissance theorists, especially Giovanni Pietro Bellori, who in 1664 urged 'noble' artists to form in their minds 'an example of superior beauty and, reflecting on it, improve upon nature until it is without fault'. He made it clear that this was an élite style, appreciated only by 'higher spirits' and not understood by the pop-

ulace, who 'praise things painted naturalistically' and 'approve of novelty'.

As such, the Grand Manner formed the basis for the official aristocratic style of the French Académie Royale de Peinture et de Sculpture under the directorship of Charles Le Brun, and in England it was recommended by Anthony Ashley Cooper, 3rd Earl of Shaftesbury (1713), and Jonathan Richardson the elder (1715). However, the most lucid exposition of its aims and means was given by Joshua Reynolds in his *Discourses*, especially the 3rd (1770) and 4th (1771). Reynolds called it the 'Great Style' and defined it as the pursuit of perfect form, as opposed to the realistic imitation of particulars, in composition, expression, colouring and drapery. The subject must be 'generally interesting ... There must be something either in the action, or in the object, in which men are universally concerned, and which powerfully strikes upon the publick sympathy'. In practice this meant incidents from ancient history or the Bible. A composition should include only a

few figures, preferably but not necessarily life size, their poses and proportions adapted from Classical sculpture. Expression should be achieved mainly through gesture, and facial movements should be restrained (consistent with Renaissance ideals of gentlemanly conduct): Reynolds criticized Gianlorenzo Bernini's *David* (Rome, Gal. Borghese) for biting his lip in an undignified way. The aim is absolute clarity in story-telling, but within the limits of strict decorum, which Shaftesbury called 'decency of manners'. Colours should be strong, with a preference for primaries, disposed in broad, undifferentiated masses. Drapery should fall in large, simple folds, as in Classical sculpture, and the depiction of specific textures (e.g. fur, silk) should be avoided.

In Britain the Grand Manner was followed, up to a point, by Reynolds himself, George Romney, Gavin Hamilton, James Barry and Benjamin Robert Haydon; it was strongly revived by the Victorian Neo-classicists, such as G. F. Watts, Alfred Stevens and Frederic Leighton. In Italy it left intermittent traces on the work of Carlo Maratti and Pompeo Girolamo Batoni. But the supreme master, combining perfect form with intense feeling, was the French Neo-classical painter Jacques-Louis David (see fig. 36). This was recognized by Diderot, who said of his *Belisarius* (Salon 1781): 'That young man shows great style (grande manière) in his handling of the work. He has sensibility. His heads have expression without affectation. His attitudes are noble and natural.'

36. Jacques-Louis David: *Death of Marat*, 1793 (Brussels, Musées Royaux des Beaux-Arts)

Bibliography

G. P. Bellori: *Vite* (1672); ed. E. Borea (1976)

A. A. Cooper, 3rd Earl of Shaftesbury: 'Notion of the Historical Draft or Tablature of the Judgment of Hercules', *Characteristics of Men, Manners, Opinions and Times*, 3 vols (London, 1711, rev. 1714)

J. Richardson: *An Essay on the Theory of Painting* (London, 1715)

E. G. Holt: *A Documentary History of Art*, ii (New York, 1958), pp. 243–59 [reprints Shaftesbury's essay]

J. Reynolds: *Discourses on Art*, ed. R. R. Wark (San Marino, 1959/*R* New Haven and London, 1975)

D. Diderot: *Salons*, ed. J. Seznec and J. Adhémar, iv (Oxford, 1967), p. 377

DAVID MANNINGS

Greek Revival

Term used to describe a style inspired by the architecture of Classical Greece that was popular throughout Europe and the USA in the early 19th century, especially for the design of public buildings; it was also employed for furniture and interior design. Its gradual spread coincided with and was dependent on the growth of archaeology in Greece in the 18th and 19th centuries. Such archaeologist–architects as James Stuart (known as 'Athenian' Stuart in his lifetime) and Nicholas Revett, William Wilkins and C. R. Cockerell in England, Jacques-Ignace Hittorff and Henri Labrouste in France and Leo von Klenze in Germany were responsible for generating a remarkably selfconscious architectural revival; Cockerell used the term 'Greek revival' at least as early as 1842 in his lectures delivered as Professor of Architecture at the Royal Academy. The style was first used in mid-18th-century England for garden buildings in such houses as Hagley Hall (Hereford & Worcs) and Shugborough (Staffs) by James Stuart. It later came to be seen as the most appropriate architectural style for the expression of civic virtues, and it was widely adopted for new urban-planning schemes and important public buildings during the first half of the 19th century.

1. Origins and development in France and England (c. 1670–c. 1800)

It is extraordinary that although theorists from the Renaissance onwards paid lip-service to the merits of Classical Greek architecture, no-one investigated surviving Greek buildings until the late 17th century, when a group of Frenchmen began to seek a new basis for French classicism. In 1674 the Marquis de Nointel, a French diplomat, explored Athens and several of the Greek islands. His party included the artist Jacques Carrey who, in a series of not very alluring drawings (Paris, Bib. N.), was the first to record the sculptures of the Parthenon. Nointel sent back to France some notes by the Jesuit missionary J.-P. Babin, and these inspired Dr Jacob Spon, a French Classical scholar, to travel to Greece, financed by Jean-Baptiste Colbert, Louis XIV's chief adviser. He was accompanied by the English botanist George Wheler. On their return Spon published *Voyage d'Italie, de Dalmatie, de Grèce et du Levant* (1678), an influential work that remained for nearly 70 years the best account of the buildings of Athens, although it contained only one engraving of the Parthenon; despite its poor quality, this revealed the fluted Greek Doric column as heavy and baseless, attributes that seemed primitive to those accustomed only to the more elaborate Roman Doric. Wheler's *Journey into Greece* (London, 1682), dedicated to Charles II of England, gave further publicity to Spon's engraving of the Parthenon.

The next important development was the publication of drawings of some of the monuments of Athens in Richard Pococke's *Description of the East and Some Other Countries* (1743-5) and Richard Dalton's *Antiquities and Views in Greece and Egypt* (1751). The initiative then passed to England, where it was to remain for a century thanks largely to the Society of Dilettanti. Founded by a group of noblemen and gentlemen in 1732, this society institutionalized the obsession with the Antique that had previously been a private concern of Richard Boyle, 3rd Earl of Burlington, and his circle. In extending the Grand Tour from the familiar Italy to the unknown Greece, the wealthy members of the Society of Dilettanti were inspired by what they called 'Greek taste and Roman spirit'. By promoting and subsidizing the excavation and publication of numerous Classical sites, they made a profound architectural and archaeological impact on Europe. The most celebrated of the projects with which they were associated was the publication of *The Antiquities of Athens* by James Stuart and Nicholas Revett, the first volume of which appeared in 1762; this publication and the *Ruines des plus beaux monuments de la Grèce* (1758) by Julien-David Le Roy were the first attempts to provide full and accurate surveys of ancient Greek architecture.

When Stuart returned to London in 1755 from Athens, where he had spent four years measuring the Classical remains, he was much patronized by members of the Society of Dilettanti anxious to demonstrate their knowledge of the latest antique

discoveries. As an architect, however, Stuart was essentially a miniaturist who excelled in the design of garden buildings, furniture and interior decoration. His chief contribution to the development of the Greek Revival style was to provide a decorative language based on the ornamental detailing of such Athenian buildings as the late 4th-century BC choregic monument of Lysikrates and the Erechtheion. Nevertheless, the Greek Doric portico with which he fronted a little temple (1758) in the park at Hagley Hall for George Lyttelton (1709–73), later 1st Earl of Lyttelton, set a pattern for countless Greek Revival buildings in which a simple box was lent spurious grandeur by an applied portico.

Architects who responded in the 1780s and 1790s with more vigour than Stuart to the expressive potential of Greek Doric included Joseph Bonomi, John Soane and Benjamin Henry Latrobe. Buildings inspired by the 'sublime' power of the primitive Doric found at Paestum (Poseidonia), South Italy, especially as captured in Piranesi's atmospheric engravings published in 1778, are Bonomi's church (1789–90) at Great Packington, Warwicks; Latrobe's Hammerwood Lodge (begun before 1792), East Grinstead, Sussex; and Soane's vestibules at Tyringham Hall (c. 1793), Bucks, and at Bentley Priory (1798), Stanmore, Middx. Similar buildings in Paris include Charles de Wailly's crypt at the church of St Leu-St Gilles (1773–80) and Claude-Nicholas Ledoux's Barrière de la Villette (1789; see fig. 37). Such buildings were a rarity at the time, especially in France, where, inspired by the doctrines of Marc-Antoine Laugier, architects were more interested in understanding the supposed principles of Greek architecture than in imitating its accidental appearance.

2. Early development in Germany (c. 1750–1800)

German scholars and architects, after those of France and England, made the greatest contribution to the nascent Greek Revival style. Over them all towered the figure of Johann Joachim Winckelmann, whose books, beginning with *Gedanken über die Nachahmung der griechischen Werke in der Malerei und Bildhauerkunst* (1755),

were important not only for promoting Greek art as an expression of 'noble simplicity and quiet grandeur' but also as the product of ideal men leading an ideal way of life. Ludicrously, Winckelmann had not even visited Rome, still less Athens, when he wrote his *Gedanken*. Although widely influential, his vision of Greek culture was charged by an obsession with the perfect male body and was expressed aesthetically in terms of his favourite artist, Raphael. Responding enthusiastically to the recent discovery of the primitive Doric temples of Sicily, he wrote in 1762 in *Anmerkungen über die Baukunst der Alten Tempel zu Girgenti in Sicilien*, his account of the temples at Akragas (Agrigento), that 'as elegance is added to architecture, beauty declines'.

Winckelmann's impact on architecture was evident in Germany as early as 1788–91 in the Brandenburg Gate, Berlin. One of the earliest monuments of the Greek Revival in Europe, this was designed by Carl Gotthard Langhans, who modelled it on the Propylaia in Athens, or rather on Le Roy's ideal reconstruction of the building in his *Ruines*. The Brandenburg Gate was seen as embodying the heroic ideals with which Greek art was becoming identified in the German Romantic imagination. Langhans, moreover, was one of a number of German architects and artists whom Frederick William II, King of Prussia, had summoned to Berlin in 1787 in an attempt to turn a capital that had long been influenced culturally by France into a centre of German culture.

In 1796 the tenth anniversary of the death of Frederick the Great of Prussia prompted the Akademie in Berlin to announce a competition for a monument to his memory that would specifically promote 'morality and patriotism'. Greek Doric seemed the natural language with which to express this stern idealism, and the young architect Friedrich Gilly produced a design in 1797 that captivated the imaginations of Schinkel and Klenze, the leading German architects of the next generation. Gilly's unexecuted temple, intended to be raised high above its solemn precinct in the Leipziger Platz in Berlin, proclaimed a devotion to moral endeavour that, although deeply rooted in the Prussian national consciousness, had a

37. Claude-Nicolas Ledoux: Barrière de la Villette, exterior with two of the four pediments of the façade, axial view, Paris, 1789

timeless quality that was part of the appeal of Greek Doric.

3. An international expression of public order (c. 1800–c. 1850)

One of the first to develop the monumental manner that, implicit in the Brandenburg Gate, came to characterize the Greek Revival at its height was the English architect Thomas Harrison. He did so in his partially executed projects for Chester Castle (1788–1815), a combination of law courts, prison and barracks. His designs echoed the daunting scale of French Grand Prix designs, but they were handled with a new Greek austerity of detail. Working far from London, Harrison exercised little influence, however; instead it was William Wilkins, an architect of lesser ability but wider contacts, who, in the face of much professional controversy, produced the archetypal building of the early Greek Revival: Downing College (1804/5–22), Cambridge. This was a commission for which Wilkins was largely indebted to the connoisseur Thomas Hope, who combined first-

hand knowledge of Greek architecture with enthusiasm for the doctrines of Marc-Antoine Laugier.

Wilkins was an archaeologist of some distinction who in 1807 published an important study of the monuments of the Greek world. The ambitious Greek Doric entrance gateway in the form of the Propylaia in Athens that he planned for Downing College was unfortunately never executed. All that was built were two long, low ranges in an architecturally subdued style characterized by plain wall surfaces, innocent of decorative pilasters and relieved only by chastely detailed porticos in the Erechtheion Ionic order. This under-stated sobriety, partly due to Laugier's rationalist influence, reappears in countless Greek Revival buildings, including Robert Smirke's Theatre Royal, Covent Garden (1808–9; destr. 1856), General Post Office (1824–9; destr. 1912) and British Museum (1823–48), and Wilkins's University College (1826–30) and National Gallery (1832–8), all in London. A somewhat livelier design was developed for Grange Park (c. 1808–9), the templar house that

Wilkins built for the eccentric banker Henry Drummond. With its colossal portico modelled on the Hephaisteion (then known as the Theseion) and side elevations inspired by the choregic monument of Thrasyllus, both in Athens, this is probably the most grandiose if least convenient residence produced by a Greek Revival architect.

Early Greek Revival buildings in Scotland included William Stark's Glasgow Justiciary Court House (1809–11), while Edinburgh took to the style with such enthusiasm that, thanks to such talented local architects as Thomas Hamilton and William Henry Playfair, it became known as the 'Athens of the North'. Hamilton designed the Burns Monument (1820–23) and the Royal High School (1825–9), while Playfair provided the Royal Institution (now the Royal Scottish Academy; 1822–6 and 1832–5) and, with C. R. Cockerell, the National Monument (1824–9), a version of the Parthenon crowning Calton Hill that was left unfinished. A similar transformation occurred in Berlin during this period: following its humiliating occupation by Napoleon from 1806 to 1813, the city was revitalized by Karl Friedrich Schinkel with a new royal guardhouse (Neue Wache; 1816–18), theatre and museum (1823–30). These buildings were among the most imaginative monuments of the Greek Revival anywhere in Europe. In the Neue Wache, which was influenced by Gilly, the Greek Doric order was used to symbolize the function of a public building dedicated to safe-guarding social order exactly as in Ledoux's Barrières and Salines de Chaux. Klenze left a similar impression on the city of Munich, where, with the active support of his patron, Ludwig I, King of Bavaria, he provided the Glyptothek (1816–30) and two Greek Doric buildings, the Ruhmeshalle (1843) and Propyläen (1854–62). Klenze's Walhalla (1830–42) is an imposing Greek Doric shrine for busts of great Germans; built above the Danube near Regensburg in Bavaria, it was inspired by Gilly's unexecuted monument to *Frederick the Great*.

The Greek Revival was enthusiastically adopted throughout Europe and the USA by architects who were anxious to express a growing sense of national identity. The forms of Greek architecture, unused from the ancient world to the 18th century, were free of all association with the aristocratically and ecclesiastically organized institutions of Europe before 1789. Nowhere was this freedom more appreciated than in the USA after the signing of the Declaration of Independence in 1776 and the close of the revolutionary war seven years later. The Greek Revival in the USA began in earnest with the Bank of Pennsylvania (1799–1801), built by Benjamin Henry Latrobe in Philadelphia, the capital of the nation from 1790 to 1800. This austere Greek Ionic temple of commerce was effective as a durable symbol of the wealth and probity of the new democrats. At the Capitol in Washington, DC, Latrobe provided further poetic statements of the power of Greek architecture to express the freshness and gravity of the American experiment. As a result, Thomas Jefferson himself wrote to Latrobe in July 1812 (Washington, DC, Lib. Congr.) that the Capitol was 'the first temple dedicated to the sovereignty of the people, embellishing with Athenian taste the course of a nation looking far beyond the range of Athenian destinies'. Jefferson must have had in mind such interiors by Latrobe as the House of Representatives (completed 1811), with 24 columns inspired by those of the choregic monument of Lysikrates, and the Supreme Court Chamber (1809; rebuilt 1815–17), where primitive Greek Doric columns support a trio of arches beneath a half umbrella-dome, a haunting disposition recalling the dreams of Ledoux, Soane and Gilly.

Although there were numerous skilled architects ready to follow Latrobe's path, especially his pupils Robert Mills and William Strickland, and Strickland's pupil Gideon Shryock, none had quite his ability. This resulted in the first half of the 19th century in an astonishing number of competent Greek Revival buildings expressing high ideals of civic order, which were supposedly in conformity with those of Athens in the 5th century BC. Mills made his name with the Washington Monument at Baltimore, MD (1813–42), an unfluted Greek Doric column of tremendous height. The most characteristic examples of the new style are the government buildings in Washington, DC, which include the Federal

Treasury and Patent Office (both begun 1836) and Old Post Office (1839-42) by Mills. Scarcely less imposing was Strickland's contribution to Philadelphia, where his Second Bank of the United States (1818-24; see col. pl. XVI), built in marble, echoes the Parthenon, and his Philadelphia (or Merchants') Exchange (1832-4) boasts an elegant semicircular colonnade surmounted by a lantern based on the choregic monument of Lysikrates. A later work, the Tennessee State Capitol (1845-59), Nashville, had isolated picturesque elements hinting at the subsequent development of Greek Revival forms. Greek Revival was also widely popular for domestic architecture in the USA, as can be seen, for example, in Andalusia, a house near Philadelphia remodelled in 1831 for Nicholas Biddle. Here the architect Thomas U. Walter, who designed a wing in the form of the Hephaisteion, provided a worthy parallel to Wilkins's Grange Park for a remarkable patron who believed that 'there are but two truths in the world—the Bible and Greek architecture' (Crook, p. 41).

These buildings were designed in what became the international language of architecture, adopted in the early 19th century by countless architects for modernizing European cities with public buildings and urban-planning schemes. In addition to Schinkel in Berlin and Klenze in Munich, such architects included Andrey Voronkhin, Thomas-Jean de Thomon and Andreyan Zakharov in St Petersburg; I. D. Gilgardi, Afanasy Grigor'yev and Osip Bove in Moscow after the fire of 1812; Jakob Kubicki and Antoni Corazzi in Warsaw; C. F. Hansen and Gottlieb Bindesbøll in Copenhagen; Christian Henrich Grosch in Oslo; and Carl Ludwig Engel in Helsinki. The centre of Helsinki is one of the most harmonious and attractive of these Greek Revival ensembles. The city was established as the capital in 1812, following the incorporation of Finland into Russia as a Grand Duchy in 1809. Johan Albrecht Ehrenström (1762-1847) drew up the city plan, while Schinkel's disciple, Engel, provided a range of public buildings from 1818 to 1845; the climax is Senate Square, with an imposing domed Lutheran cathedral flanked by the Senate and the University, both boasting superb Greek Doric staircases.

Ironically the Greek Revival style was taken to Athens as a foreign importation following the liberation of Greece from Turkish rule in 1829. Otto von Wittelsbach, who became the first king of Greece (*reg* 1832-62), took to Athens from his native Bavaria two of its leading Neo-classical architects: Klenze, who drew up an urban plan for Athens in 1834, and Friedrich von Gärtner, from whose designs the Royal Palace (1836-41; now the Parliament) was executed in a subdued Greek style. With the change in 1862 to a Danish dynasty in Greece, the Danish architects Christian Hansen and his brother Theophilus Hansen initiated a more comprehensive programme of Greek Revival public buildings in the centre of the new city of Athens. Their principal achievement is the imposing group of three adjacent buildings: the University (1837-49), Academy (1859-87) and National Library (1859, 1885-91).

4. The implications of polychromy (c. 1825–50)

A new phase of the Greek Revival style was stimulated by the discovery of polychromy in Greek architecture. This had wider ramifications than might first appear: the discovery that Classical Greek buildings were brightly painted, and the fact that such decoration was essentially impermanent, immediately overthrew Winckelmann's image of the timeless purity of the Greek temple. From the time of Stuart and Revett, archaeologists had noticed traces of colour on Greek sculpture but had drawn no conclusions from this. Informal archaeological work at Aigina and Bassai in 1811-12 by an international group including Cockerell, Karl Haller von Hallerstein and Otto von Stackelberg (1787-1837) had resulted in the excavation of architectural fragments with colours that soon faded on exposure to the air. One of the earliest reconstructions of ancient polychromy was Klenze's painted plaster relief of a Doric temple front created in 1830 in the Aigina room of his Glyptothek in Munich. Here it formed a suitable backdrop to the pedimental sculpture from the Temple of Aphaia at Aigina, which had been restored and painted by Bertel Thorvaldsen.

In 1823 the English architect Samuel Angell (1800–66) discovered fully coloured metopes at Temple C at Selinus (Selinunte) in Sicily, which he published in 1826. The French architect Hittorff, who saw this sculpture in 1823, then discovered and excavated Temple B, the so-called Temple of Empedokles, at Selinus, and in 1824 he exhibited in Rome and Paris some drawings (Cologne, Wallraf-Richartz-Mus.) in which he restored this as a stuccoed and lavishly painted limestone temple combining Doric and Ionic orders. These and other imaginative restorations of the building were published in 1827 and 1851, but French architects in the 19th century were no more interested in attaching correctly detailed Greek porticos to otherwise conventional neo-Palladian buildings than architects had been in the 18th century. Just as Le Roy in his *Ruines* of 1758 had offered broad historical theory rather than the material for a stylistic revival, so in the 1820s and 1830s Hittorff and Henri Labrouste subjected ancient Greek architecture to a revolutionary new theoretical and practical analysis, sparked off by the discovery of polychromy.

In Paris in 1829–30 Hittorff delivered lectures and exhibited drawings in which he claimed that Greek temples had originally been painted yellow, with patterns, mouldings and sculptural details in bright red, blue, green and gold. His own use of colour, however, in his Rotonde des Panoramas (1838; destr. 1857) and Cirque National (1839–41), both in Paris, was not very successful. During his stay in Sicily in 1823–4 he had also made a detailed study of the Temple of Olympian Zeus at Akragas, 'the St Peter's of paganism' as he later called it, although it was generally known as the 'Temple of the Giants'. Klenze published a restoration of this massive and enigmatic temple in 1821 and Cockerell another in 1830. Its giant atlantids, polychromatic embellishment and concealed iron beams in the architraves were all an influence on Hittorff's masterpiece, the church of St Vincent-de-Paul (1832–44), Paris. The most striking polychromatic adornment of this church was the set of 13 enamel panels designed in 1844 to cover most of the west façade behind the portico. The nude figures depicted on them proved controversial, however, and they were removed in 1861.

In the meantime Henri Labrouste made drawings of a proposed restoration of the three temples at Paestum, which he submitted to the Académie des Beaux-Arts as his fourth-year *envoi* and exhibited in Paris in 1829. These and a series of cityscapes painted in the same year, for example one of Akragas, shocked the academicians for a range of reasons but especially because they seemed to rob Greek architecture of its mystique. Labrouste's emphatic polychromy resembled a kind of barbaric graffiti, while the first Temple of Hera at Paestum, shown in the restoration drawing by Labrouste as a secular basilica, was hung with notices and military trophies like a French provincial market hall. Labrouste's drawings, made just before the July Revolution of 1848 that finally deposed the French monarchy, interpreted Greek buildings as part of a historical process related to the development of societies. In the principal work of his career, the Bibliothèque Ste Geneviève (1839–51), Paris, he gave idiosyncratic but powerful expression to his new system of historical interpretation. In the library, as in his measured drawings of the basilica at Paestum, he separated the functional elements from the elements descriptive of function. Thus the wall panels on the library façade were carved with the names of 810 authors, suggesting the presence of the bookshelves immediately behind them. Bindesbøll, an admirer of Hittorff, provided a curious parallel to the essentially legible character of the Bibliothèque Sainte-Geneviève in his Thorvaldsens Museum (1839–47), Copenhagen. With its brightly painted architectural members, this partly Egyptian, partly Greek building is enlivened by an external painted frieze depicting the transport from Rome to Copenhagen of the works by Bertel Thorvaldsen that the museum was built to house.

Outside France, the response to Greek architecture of C. R. Cockerell was perhaps the most serious contemporary parallel to those of Hittorff and Labrouste. Although Cockerell played a significant role in the early investigation of polychromy, he was more influenced as an architect

by his involvement in the discovery in 1811–12 of the pedimental sculpture at Aigina and of the figured frieze and uniquely curvilinear Ionic order at Bassai. Moreover, as a result of his exceptional sensitivity to the subtle lines of Greek architecture, he also seems to have been the first to notice the presence of entasis on the columns of the Parthenon, Erechtheion and Temple of Aphaia at Aigina. Stuart and Revett had shown such columns as completely straight, but in December 1814 Cockerell wrote to Robert Smirke from Athens enclosing a diagram in which he set out the curvature of the columns of the Parthenon (see Watkin, 1974, p. 17). These discoveries made Cockerell profoundly aware of the sculptural basis of Greek design. He was thus deeply hostile to the work of such contemporary Greek Revival architects as Smirke, Wilkins, George Dance (ii), William Inwood and Henry Inwood, who, in his opinion, did not understand the spirit of Greek design. He was opposed to their attempt to restrict the stylistic range of modern buildings to a limited number of approved Greek sources. His belief in the orders as the basis of architecture in all periods was given triumphant expression in his masterpiece, the Ashmolean Museum and Taylorian Institution (1839–45) in Oxford, a powerfully inventive sculptural combination of numerous historical references.

5. After c. 1850

For a hundred years from the mid-18th century the study of ancient Greek architecture and the consideration of its application to contemporary architectural problems were pursued with a consistency that makes it possible to speak with confidence about a coherent Greek Revival. The impact of Greece did not end in 1850, however. In particular, German architecture in the first half of the 20th century was intimately bound up with a powerful image of Greek culture as a purifying force. German archaeologists of the later 19th century, such as Heinrich Schliemann, Theodor Wiegand and Adolf Furtwängler, had brought a fresh understanding to Classical and pre-Classical architecture. This found expression in the work of Peter Behrens, for example the Haus Wiegand

(1911–12), Berlin, a convincing neo-antique house in the stern Doric style practised by Gilly, which was built for Dr Theodor Wiegand, an archaeologist who had excavated at Priene, Miletos and Samos, and who was Director of Antiquities of the Royal Prussian museums.

A similar mood in Scandinavia and Finland at this time produced a revival of interest in the masters of Nordic Neo-classicism of a century earlier. In their search for a national style, such architects as Carl Petersen, Hack Kampmann, Ivar Tengbom and Gunnar Asplund, working in the first 30 years of the 20th century, responded with a rare subtlety to the Nordic Doric sensibility that they found in the work of C. F. Harsdorff, C. F. Hansen and Bindesbøll. Indeed, it is improbable that Greece will ever cease to colour the imagination of architects. Such philosophers as Nietzsche and architects as varied as Adolf Loos, Le Corbusier and Albert Speer all devised a rhetorical language in which they could appeal to Greece as a source of inspiration.

Bibliography

J. Spon: *Voyage d'Italie, de Dalmatie, de Grèce et du Levant*, 3 vols (Lyon, 1678)

G. Wheler: *Journey into Greece* (London, 1682)

R. Pococke: *A Description of the East and Some Other Countries*, 2 vols (London, 1743–5)

R. Dalton: *Antiquities and Views in Greece and Egypt* (London, 1751)

Comte de Caylus: *Recueil d'antiquités*, 7 vols (Paris, 1752–67)

M.-A. Laugier: *Essai sur l'architecture* (Paris, 1753)

J. J. Winckelmann: *Gedanken über die Nachahmung der griechischen Werke in der Malerei und Bildhauerkunst* (Dresden, 1755); Eng. trans. by H. Fuseli as *Reflections on the Painting and Sculpture of the Greeks* (London, 1765/R 1972)

J.-D. Le Roy: *Les Ruines des plus beaux monuments de la Grèce* (Paris, 1758)

J. Stuart and N. Revett: *The Antiquities of Athens*, 4 vols (London, 1762–1816)

J. J. Winckelmann: *Anmerkungen über die Baukunst der alten Tempel zu Girgenti in Sicilien* (Leipzig, 1762)

—: *Geschichte der Kunst des Alterthums* (Dresden, 1764); Eng. trans., ed. G. H. Lodge, 4 vols (London, 1849–72; rev. in 2 vols, 1881)

T. Major: *The Ruins of Paestum* (London, 1768)

S. Riou: *The Grecian Orders of Architecture* (London, 1768)

R. Chandler and others: *Ionian Antiquities*, 4 vols (London, 1769–1881)

G. B. Piranesi and F. Piranesi: *Différentes vues . . . de Pesto* (Rome, 1778/*R* Unterschneidheim, 1973)

J.-J. Barthélémy: *Voyage du jeune Anacharsis en Grèce dans le milieu du quatrième siècle avant l'ère vulgaire*, 5 vols (Paris, 1787); Eng. trans. by W. Beaumont as *Travels of Anacharsis the Younger in Greece* (London, 1791)

W. Wilkins: *The Antiquities of Magna Graecia* (Cambridge, 1807)

A.-C. Quatremère de Quincy: *Le Jupiter olympien, ou l'art de la sculpture considéré sous un nouveau point de vue* (Paris, 1815)

L. von Klenze: *Der Tempel des olympischen Jupiter zu Agrigent* (Stuttgart and Tübingen, 1821, rev. 1827)

S. Angell and T. Evans: *Sculptured Metopes Discovered among the Ruins of Selinus, 1823* (London, 1826)

P. H. Brøndsted: *Voyages et recherches dans la Grèce*, 2 vols (Paris, 1826–30)

O. M. von Stackelberg: *Der Apollotempel zu Bassae in Arcadien* (Rome, 1826)

J.-I. Hittorff and L. von Zanth: *Architecture antique de la Sicile* (Paris, 1827)

C. R. Cockerell and others: *Antiquities of Athens and other Places of Greece, Sicily, etc.* (London, 1830)

A. Blouet: *Expédition scientifique de Morée*, 4 vols (Paris, 1831–8)

F. Kugler: *Über die Polychromie der griechischen Architektur und Skulptur und ihre Grenzen* (Berlin, 1835)

J.-I. Hittorff: *Restitution du temple d'Empédocle à Sélinonte, ou l'architecture polychrome chez les grecs* (Paris, 1851)

C. R. Cockerell: *The Temples of Jupiter Panhellenius at Aegina, and of Apollo Epicurius at Bassae* (London, 1860)

L. Cust and S. Colvin: *History of the Society of Dilettanti* (London, 1898/*R* 1914)

E. M. Butler: *The Tyranny of Greece over Germany* (Cambridge, 1935)

T. Hamlin: *Greek Revival Architecture in America* (New York, 1944/*R* 1966)

N. Pevsner and S. Lang: 'Apollo or Baboon', *Archit. Rev.* [London], civ (1948), pp. 271–9

F. Saxl and R. Wittkower: *British Art and the Mediterranean* (Oxford, 1948)

T. Spencer: *Fair Greece, Sad Relic* (London, 1954)

W. St Clair: *Lord Elgin and the Marbles* (London, 1967)

D. Wiebenson: *Sources of Greek Revival Architecture* (London, 1969)

J. M. Crook: *The Greek Revival* (London, 1972)

The Age of Neo-classicism (exh. cat., Council of Europe exh., London, 1972)

D. Watkin: *The Life and Work of C. R. Cockerell, R.A.*, (London, 1974), p. 109

A. Drexler, ed.: *The Architecture of the Ecole des Beaux-Arts* (London, 1977)

D. Van Zanten: *The Architectural Polychromy of the 1830s* (New York, 1977)

R. Middleton, ed.: *The Beaux-Arts and Nineteenth-century French Architecture* (London, 1982)

Nordisk klassicism, 1910–1930 (exh. cat., Helsinki, Mus. Fin. Archit., 1982)

Paris, Rome, Athènes: Le Voyage en Grèce des architectes français aux XIXe et XXe siècles (exh. cat., Paris, Ecole N. Sup. B.-A., 1982)

D. Constantine: *Early Greek Travellers and the Hellenic Ideal* (Cambridge, 1984)

Paestum and the Doric Revival, 1750–1830 (exh. cat., Florence, 1986)

D. Watkin and T. Mellinghoff: *German Architecture and the Classical Ideal, 1740–1840* (London, 1987)

R. G. Kennedy and M. Bendtsen: *Greek Revival America* (New York, 1989)

M. Bendtsen: *Sketchings and Measurings: Danish Architects in Greece, 1818–1862* (Copenhagen, 1993)

DAVID WATKIN

Grotesque

French term derived from the Italian *grottesco*, describing a type of European ornament composed of small, loosely connected motifs, including scrollwork, architectural elements, whimsical human figures and fantastic beasts, often organized vertically around a central axis.

1. Origins

Grotesque ornament was inspired by the archaeological discovery at the end of the 15th century, of the ancient Roman interiors of the Domus Aurea of Nero in Rome, and by subsequent finds of other palaces, tombs and villas in and around Rome and Naples. The interior walls and ceilings of these underground rooms, known as *grotte*,

were painted in a light and playful manner previously unknown to those familiar only with the formal grammar of Classical ornament derived from more accessible antique ruins. A ceiling in such a room might be covered with an interlocking arrangement of compartments containing mythological or allegorical scenes depicted as *trompe l'oeil* cameos, or it might be subdivided into areas dominated by a single such compartment with the remaining space filled with a variety of motifs, symmetrically organized but otherwise unrelated either by scale or subject-matter. Vitruvius, in his treatise *On Architecture* (*c.* 15 BC), Book VII, had contemptuously described this kind of painting: 'Reeds are substituted for columns, fluted appendages with curly leaves and volutes take the place of pediments, candelabra support representation of shrines, and on top of their roofs grow slender stalks and volutes, with human figures senselessly seated upon them.' This play of fantasy and appeal to the realm of the senses, as opposed to the monumental solemnity of much rediscovered Roman architecture and sculpture, captured the imagination of Renaissance artists and revived the medieval predilection for the fanciful and the monstrous seen in the ornament in the margins of medieval manuscripts or the stone gargoyles of abbeys and cathedrals.

2. 1480–1529

Soon after its discovery at the end of the 15th century, Classical grotesque ornament was copied and disseminated by the drawings of Italian artists, mostly from Umbria and Florence. However, many artists were uncomfortable with the loose organization of unconnected elements and sought to impose a structure that would enable them to use the motifs in a more orderly manner. They therefore employed a vertical format based on the pilaster and traditional candelabrum type of framework, with individual motifs placed one above the other and connected by a central axis; the engravings of Giovanni Pietro da Birago (late 15th-century; London, V&A) are some of the earliest examples of this format. The decorative candelabrum also appeared in such

frescoes as those (1489–93) by Filippino Lippi in the Carafa Chapel in S Maria sopra Minerva in Rome, in the Collegio del Cambio (1499), Perugia, by Perugino, in the chapel of the Assumption (1499–1503) at Orvieto Cathedral by Luca Signorelli, and in the fresco cycle (1492–4) of the Appartamento Borgia in the Vatican by Bernardino Pinturicchio. Engravings of grotesque designs were also circulated to craftsmen in other media: silversmiths, goldsmiths and sculptors adapted the designs engraved by Nicoletto da Modena, Giovanni Antonio da Brescia, Agostino dei Musi, Enea Vico and by Marcantonio Raimondi and his school. In Raphael's painted interiors in the Vatican, the *stufetta* (1516) of Cardinal Bernardo Bibbiena and the Vatican Loggia (1518–19), grotesque ornament was developed into complete decorative schemes (see col. pl. XVII and fig. 38). In the Loggia, the candelabrum motif was used extensively, dividing the entire surface of the wall into some 200 vertical strips within which a compendium of Classical motifs mingled with fantastic birds and animals, fruit and foliage, scrollwork and abstract ornament. A new element was also introduced in the irregularly shaped compartments of the vaulted ceiling by allowing sections of the bandwork border to penetrate the space of the design, producing a kind of internal scaffolding on which individual motifs could be supported. This innovation was developed further by Raphael's successors in bandwork and strapwork that firmly enclosed and anchored the whimsical grotesques. His style was immediately imitated by his assistants: Giovanni da Udine at the Villa Madama in Rome (1525), and Giulio Romano at the Palazzo del Te in Mantua (mid-1520s–*c.* 1535).

3. 1530–1600

In 1530 Francis I invited Rosso Fiorentino to decorate his new château at Fontainebleau. Rosso was joined in 1532 by Francesco Primaticcio, and together they created a new, more elaborate form of ornament and a richer variation on the grotesque theme for the decoration of the Galerie (*in situ*; see col. pl. XIII). The Strapwork or bandwork used by Rosso and Primaticcio at

38. School of Raphael: Grotesque design with panel for the vault of the Vatican Loggia, 1518–19 (Rome, Vatican Palace)

Fontainebleau enclosed a series of allegorical frescoes on the grandeur of royalty and the glory of the French king. This structure anchored the paintings within a framework of complex curling straps in high-relief stucco within which were imprisoned monumental figures, putti, hybrid monsters, garlands, swags and the king's emblem: the salamander. The ornament of Raphael and his followers had been small in scale, delicate, in low relief and classical. No precedent existed for the robust, twisted, bent, overlapping leather-like strapwork depicted at Fontainebleau. This transmutation of classical scrollwork into a richly hybrid type of ornament was Rosso's contribution to the contemporary Mannerist taste for the distorted, the twisted, the ambiguous and the strange.

Another significant contribution to the history of the grotesque in this period was the decorative tradition of Islam, which provided the inspiration for the stylized, interlaced complex patterns of foliage and abstract geometric shapes in an endlessly interlaced linear rhythm that were known in the West as Arabesques or Moresques after their Saracenic origins. Damascened and engraved metalwork produced in the Near East, and by Muslim craftsmen in Venice at the end of the 15th century, was decorated with sinuously inter-woven lines that created a strong bandwork design, with ogival intersections enclosing variegated polygonal shapes in a repeated framework. Although the delicate scale of Arabesque ornament is very different from the three-dimensional solidity of the style of Rosso Fiorentino, it was Rosso's assistant, Francesco Pellegrino (d 1552), who produced one of the first books of Arabesque designs, *La Fleur de la science de pourtraicture* (Paris, 1530), and many artists working at Fontainebleau used Arabesque ornament in their own work, including André Boyvin (c. 1525–98), Léonard Thiry and Antonio Fantuzzi. The impact of Fontainebleau was immense: a union of classical grotesques and northern strapwork, enriched by Arabesque influence, had been forged there, and subsequently the two types of ornament developed together.

After the death of Rosso in 1540, Primaticcio became the overseer of the works at Fontainebleau. From 1540 to 1570 he decorated the Galerie d'Ulysse (destr.) with grotesques that were light and elegant, less naturalistic than those of Raphael and his school, and that also incorporated a strapwork structure. He continued to use this decorative scheme at the château of Ancy-le-Franc in Burgundy (1546; *in situ*), where the ceiling of the Chambre de Diane echoed the designs from the Domus Aurea and the Villa Madama in Rome. It also included new details that were to become an important part of 17th-century French ornamental vocabulary: the pelmet shape, the temple structure and graceful depictions of the Four Elements. Primaticcio's work was a significant influence upon Jacques Androuet Du Cerceau, who published engraved designs for furniture, silver and textiles in *Livre de grotesques* (*Petites grotesques*, Paris, 1562; *Grandes arabesques*, Paris, 1582). Inspired by such Italian designers as Agostino Veneziano and Enea Vico, Du Cerceau's work was particularly important for the development of

furniture, providing a characteristically French alliance of classical form with voluminous carved imaginary motifs that was to influence the architect and designer Hugues Sambin.

During the second half of the 16th century the engraved designs of the Fontainebleau grotesque and strapwork decoration were disseminated throughout Europe. Such books as *Livre de la conqueste de la toison d'or* (1563), designed and drawn by Léonard Thiry and engraved by René Boyvin, or *Petit ornemens* (1560) by Etienne Delaune spread the fashion in the northern countries, and treatises proliferated to meet the demand of workshops and studios. *Veelderley veranderinghe van grotissen ende compatimenten* ('Grotesque ornaments and tomb designs'; Antwerp, 1556) by Cornelis Floris and *Grottesco in diverse manieren* (Antwerp, *c.* 1565) by Hans Vredeman de Vries were published in the Low Countries. In Germany some outstanding designs for metalwork were produced by Georg Wechter I in *30 Stuck zum Verzachnen fur die Goldschmied Verfertigt Geörg Wecher 15 Maller 79 Nürmberg* (Nuremberg, 1579). A more tortured element was introduced to the grotesque by Wendel Dietterlin in *Architectura und Ausstheilung der V. Seulen* (Stuttgart and Strasbourg, 1593). Although the grotesque motif was then being used mainly on furniture and silverware, it was still employed in interior decoration, for example in the library (destr.), designed by Friedrich Sustris, of the apartments of Hans Fugger in the Fugger Palace in Augsburg (1568–75).

During the second half of the 16th century and the beginning of the 17th, the grotesque was a contributory factor to the development of the hybrid reptilian forms of the AURICULAR STYLE, of which Adam van Vianen from Utrecht was the main exponent.

4. 1601–1752

In the 17th century, while Germany and the Low Countries were absorbed in the extravagant Fontainebleau style, France returned to a sense of classical restraint and discipline. In 1627 Simon Vouet returned from Rome, where he had studied antique remains as well as Renaissance works.

In 1644 he decorated the Cabinet des Bains (destr.) of Anne of Austria at the Palais-Royal in Paris with classical grotesques; the designs survive in *Livre de diverses grotesques peintes dans le cabinet des bains de la reine regente au palais royal* (Paris, 1647). The style was rather heavy, but harmonious, with landscapes and figures incorporated among the flat, ponderous acanthus scrollwork.

During the reign of Louis XIV (1643–1715) the whimsical grotesque had no part in the majestic court style that evolved under the direction of Charles Le Brun; the lighter spirit of classical ornament was, however, revived by the designer Jean Berain I. In 1671 he designed the painted stucco grotesques that decorate the Galerie d'Apollon at the Louvre. This light and airy style of decoration was developed simultaneously by several other ornamentalists: Claude Audran III, Claude Gillot and Antoine Watteau. Berain was among the first to use the interlaced bandwork and delicate tendrils reminiscent of the Muslim Arabesque in the frame surrounding a central design, usually a figure or group of figures standing under a fanciful architectural structure, with various animals, insects and hybrid creatures frolicking beneath swags, ribbons and trophies of all sorts. His work was an important influence on André-Charles Boulle, whose mirror (early 18th century; London, Wallace) for Charlotte de Saint-Simon, Princesse de Chimay, exhibits all these motifs together with lambrequins and Singerie. Textiles also employed the grotesque vocabulary: Audran's tapestry cartoons, the *Douze mois grotesques* (1699; published Paris, 1726), and Gillot's *Livre de portières*, published after his death (Paris, 1737), developed Berain's ornament further by softening the bandwork frame and introducing curves instead of angular lines. Bandwork was gradually reduced to the curving ribbons and tendrils important in the ROCOCO style, a particularly French version of grotesque ornament that spread to the whole of Europe. Designs by Juste-Aurèle Meissonnier and François de Cuvilliés I are triumphs of Rococo art, in which the Saracenic origins of the flowing, interlacing and interweaving bandwork are hardly recognizable.

5. After 1752

The publication of the excavations of Pompeii and Herculaneum in 1752 renewed awareness of the Classical grotesque. Artists again sought inspiration in Rome, where they looked not only at the Classical examples but also at the work of Raphael. Engravings of the Vatican Loggia had been published in the 16th and 17th centuries, but a new publication in 1772 by Giovanni Battista Volpato was followed in 1776 by a set of engravings of the Domus Aurea itself by Lodovico Miri. Ornamentalists and artists throughout Europe took up the style again. In France Jules-Hughes Rousseau (1743–1806) and his brother Jean-Simeon Rousseau de La Rottière (1747–after 1781) adapted it for the Petits Appartements of Marie-Antoinette at Versailles in 1783 and at Fontainebleau in 1786, achieving ensembles of great elegance and refinement. In order to become acceptable to the Age of Reason, the grotesque had shed its earlier fantastic and monstrous qualities, although in doing so it had lost much of its previous vitality.

Grotesque ornament was a component of the Etruscan style, which Robert Adam used for the decoration of the Etruscan Dressing-room (1775) at Osterley Park House, Middx (see fig. 27). Charles Percier and Pierre-François-Léonard Fontaine also created attenuated, graceful grotesque ornament interspersed with *trompe-l'oeil* cameo panels at the château of Malmaison in 1799. In these forms the style was gracious and elegant but deprived of its earlier robustness. In the 19th century grotesque ornament was often featured in such Renaissance Revival interiors as those at Chatsworth (1840s), Derbys, and Longleat, Wilts, by the Crace family of decorators.

The 20th-century ethos no longer favoured the elegant decorative qualities of the grotesque, the whimsical, fanciful motifs disciplined within a classical format. Yet there might be a distant reminiscence in the controlled designs of the fantastic and evocative curves and forms of Art Nouveau and Symbolist artists such as Aubrey Beardsley (see fig. 4) or Gustav Klimt (see col. pl. III), or in the Surrealist *frottages* of Max Ernst and the meandering line of Paul Klee.

Bibliography

Vitruvius: *De architectura* (*c.* 15 BC); Eng. trans. by M. H. Morgan as *The Ten Books on Architecture* (Cambridge, MA, 1914/R New York, 1960)

D. Guilmard: *Les Maîtres ornemanistes* (Paris, 1880)

P. Jessen: *Der Ornamentstich* (Berlin, 1920)

——: *Meister des Ornamentstiches* (Berlin, 1923)

J. Baltrusaitis: *Réveils et prodiges* (Paris, 1960)

P. Ward-Jackson: 'Some Main Streams and Tributaries in European Ornament, 1500–1750', *V&A Mus. Bull.*, 3 (1967), pp. 58–70, 90–103

N. Dacos: *La Découverte de la Domus Aurea et la formation des grotesques à la Renaissance* (London and Leiden, 1969)

C. Ossola: *Autunno del rinascimento* (Florence, 1971)

A. Chastel: *La Grotesque* (Paris, 1988)

M. Faietti and A. Nesselrath: 'Bizar pin che reverso di medaglia: Un Codex avec grotesques, monstres et ornements du jeune Amico Aspertini', *Rev. A.*, cvii (1995), pp. 44–88

P. Morel: *Les Grotesques: Les Figures de l'imaginaire dans la peinture italienne de la fin de la Renaissance* (Paris, 1997)

E. Miller: *16th-century Italian Ornament Prints in the Victoria and Albert Museum* (London, 1999)

MONIQUE RICCARDI-CUBITT

Gustavian style

Expression of 18th-century Swedish Neo-classicism during the reign of Gustav III (*reg* 1771–92). As a cultured man and an advocate of the European Enlightenment, the King's patronage of the visual arts was linked with patriotic ambition and an admiration for the French courtly life at Versailles. He spent part of 1770–71 in France, where he acquired a passion for the Neo-classical style. During his reign numerous palaces and country houses were built or refurbished in the Neo-classical style, either for himself or for members of his family and court. Early Gustavian interiors (*c.* 1770–85) were light and elegant interpretations of the Louis XVI style, with echoes of English, German and Dutch influences. Rooms were decorated with pilasters and columns; walls were applied with rich silk damasks or rectangular panels with painted designs framed in carved, gilded linear ornament and laurel festoons.

Damask, usually crimson, blue or green, was used to upholster benches, sofas and chairs. Other rooms were panelled in wood, painted light-grey, blue or pale-green; the dominant feature was a columnar faience-tiled stove, decorated with sprigged floral patterns. Klismos-style chairs upholstered in silk were very popular, as were oval-backed chairs with straight, fluted legs, and bateau-shaped sofas were common. Rooms were embellished with long, giltwood-framed mirrors, crystal chandeliers, gilt *torchères* and Classical-style vases and urns of Swedish porphyry. Wooden floors were laid with Swedish carpets inspired by those of Savonnerie.

Swedish painters, architects, cabinetmakers and carvers were encouraged by Gustav to train in France and Italy and to return to Stockholm to assist in the realization of the King's vision of a Swedish golden age. Two prominent Swedish architects who received important commissions were Jean Eric Rehn, whose work at the Royal Palace, Stockholm, and Drottningholm Palace on Lake Mälan introduced the Neo-classical style to Sweden, and C. F. Adelcrantz, who was responsible for designing the Royal Opera House (1775–82; destr. 1892), Stockholm, and the splendid Gustavian interiors at Sturehof (1778–81), outside Stockholm. The most important cabinetmaker of the period was Georg Haupt, who produced furniture inlaid with exotic woods for the royal family, including a mineral-cabinet (1773–4; Chantilly, Mus. Condé) presented by Gustav to Louis-Joseph, Prince de Condé (1736–1818). Notable contributors to the late Gustavian style (*c*. 1785–1810) were the French architect Louis-Jean Desprez and the designer Louis-Adrien Masreliez, both of whom worked on the interiors of the Pavilion at Haga Palace (*c*. 1790), which was constructed by the Swedish architect Olof Tempelman (1745–1816) after the Petit Trianon at Versailles. Masreliez covered the walls at Haga with Classical muses and grotesques derived from decoration at Pompeii, Herculaneum and the works of Raphael and Giulio Romano; it was the first decoration of this kind in Sweden. Late Gustavian furniture was rectilinear and austere, and there was a new accuracy in copying from antique models.

Secrétaires, commodes, cupboards and desks were decorated with figured veneers and gilded mounts, or were sparsely inlaid with different woods, as seen in the secrétaire (*c*. 1790; Stockholm, Nordiska Mus.) by Gustav Adolf Ditzinger (1760–1800).

In the fine arts the Gustavian style was mainly concentrated in the medium of sculpture, especially in the work of Johan Tobias Sergel. He was recalled to court from Italy in 1779 and was best known for such Classical figures in a flowing, Baroque manner as the marble *Faun* (1774; Stockholm, Nmus.). Among the many painters at court was Carl Gustaf Pilo, who had spent the early part of his career in Denmark. His most famous work was the *Coronation of Gustav III* (1783; Stockholm, Nmus.), executed in silvery, Rococo colours. Despite political problems, Gustav continued to make expansive building plans prior to his assassination in 1792. Neo-classicism continued in Sweden in the form of the later Empire and Biedermeier styles.

Bibliography

H. Groth and F. von der Schulenburg: *Neo-classicism in the North: Swedish Furniture and Interiors, 1770–1850* (London, 1990)

☐

Hague school

Group of Dutch artists, mainly living in The Hague between 1870 and 1900. The name was first coined in 1875 by the critic Jacob van Santen Kolff (1848–96). The Hague school painters drew their inspiration from the flat polder landscape and the everyday lives of peasants and fishermen around The Hague and the nearby port of Scheveningen.

The group covers two generations of painters, born roughly between 1820 and 1845. Their headquarters was the artists' society Pulchri Studio. In the mid-1850s some of the younger painters, including the three brothers Jacob, Matthijs and Willem Maris from The Hague, and the Haarlem-based Paul Joseph Constantin Gabriël and Anton Mauve, laid the foundation for a new landscape

art based on the close study of nature in the area around Oosterbeek, later styled the 'Dutch Barbizon'. Jozef Israëls, who was still living in Amsterdam at the time, established himself as the leading artist in the depiction of fishing scenes in the early 1860s.

In many ways the Hague school painters built on the achievements of the 17th-century Dutch masters, whose brilliant skies they emulated, but stylistically they were more influenced by the contemporary Barbizon school in France. Like their 17th-century ancestors, they mostly specialized in well-defined areas. Johannes Bosboom painted church interiors. Jozef Israëls and his close followers Adolphe Artz, Philip Sadée (1837–1904), Albert Neuhuys and Bernard Blommers all specialized in figure paintings and interiors showing the life of the fishing communities. Willem Roelofs started by painting Romantic wooded landscapes but then turned to painting cattle, as did his younger colleagues Anton Mauve and Willem Maris. H. W. Mesdag, originally a banker from Groningen and

39. Jacob Maris: *Vegetable Gardens near the Hague* (The Hague, Haag Gemeentemuseum)

a prominent collector of Barbizon painting, scored a surprising success at the Paris Salon of 1870 with *Breakers in the North Sea* and restricted himself to marine painting subsequently. As painters of land- and townscapes, Jacob Maris and Jan Hendrik Weissenbruch were the most versatile (see fig. 39). Matthijs Maris is generally included as a member of the school but his late work is closer to German Romantic illustrators and the Pre-Raphaelites than the rural art of the Hague school; he was an important influence on the Dutch Symbolists. The work of artists of the Hague school is distinguished from most contemporary European landscape and genre painting by an extreme preference for tonal painting, which earned them the nickname of the 'Grey school'. Their aim was to render atmospheric effects. Their work is Realist in style and, though not free from sentiment, generally succeeds in avoiding the anecdotal. The influence of the school, especially Jacob Maris, Mauve and Israëls, was enormous; they dominated the Dutch art world until the end of the 19th century. Some younger artists, such as Willem de Zwart and Willem Bastiaan Tholen, continued their intimate and restrained manner, while the 'Amsterdam Impressionists', such as Floris Arntzenius, George Breitner and Isaac Israëls, developed a more outgoing urban variant of the school in the 1880s and 1890s. Jan Toorop, Vincent van Gogh and Piet Mondrian were all dominated by the Hague school in their early work.

The Hague school was widely shown and collected abroad, particularly in the USA, Canada and Scotland. Some of the most important collectors were Scots by birth, including James Staats Forbes, Alexander Young, John Forbes White (1831–1904) and William Burrell. The main dealers for the Hague school were Goupil (The Hague, Paris), Elbert J. van Wisselingh (London), the French Gallery (London), Knoedler (New York) and Vose (Boston). Paintings and watercolours of the Hague school can be seen in abundance in Dutch museums, such as the Gemeentemuseum and Rijksmuseum Hendrik Willem Mesdag in The Hague, and the Rijksmuseum and Rijksmuseum Vincent van Gogh in Amsterdam.

Bibliography

J. de Gruyter: *De Haagse school*, 2 vols (Rotterdam, 1968–9)

The Hague School: Dutch Masters of the 19th Century (exh. cat., ed. R. de Leeuw; Paris, Grand Pal.; London, RA; The Hague, Gemeentemus.; 1983)

The Age of Van Gogh: Dutch Painting, 1880–1895 (exh. cat., ed. R. Bionda and C. Blotkamp; Glasgow, Burrell Col.; Amsterdam, Rijksmus. van Gogh; 1991)

RONALD DE LEEUW

Heidelberg school

Group of artists active in the late 19th century in Heidelberg, a suburb of Melbourne, who introduced *plein-air* Impressionism to Australia. The most important members were Tom Roberts, Frederick McCubbin, Arthur Streeton and Charles Conder.

Most of the group began their careers at the National Gallery of Victoria's School of Art in Melbourne; several later studied overseas. Roberts, Streeton and Conder painted in each other's company both at their various outer suburban *plein air* camps (Box Hill, mainly 1885–6; Mentone, Port Phillip Bay, 1887–8; the 'Eaglemont' estate at Heidelberg 14 km from Melbourne, 1888–90; and in Sydney) and in Melbourne where they often shared or occupied adjoining studios. McCubbin often worked with them. When apart they corresponded regularly, recalling their artistic camaraderie with great nostalgia. Davies and many lesser-known figures, such as Jane Sutherland, Clara Southern, John Mather (1848–1916), Tom Humphrey (1858–1922), Aby Altson (1866–1949), Charles Douglas Richardson (1853–1932) and Artur Loureiro (1853–1932), also painted the Yarra valley landscape around Heidelberg and Templestowe. They generally exhibited with the Australian Artists' Association from 1886 to 1888 (as opposed to the more conservative Victorian Academy of Arts) and the Victorian Artists' Society from 1889. Roberts initiated the deliberately controversial but ultimately most successful 9 *by 5 Impression Exhibition* (Aug 1889): seven artists presented 182 small oil sketches in the style of Whistler (mostly on cigar-box lids measuring 228×127 mm) and

called themselves 'impressionists' for the first time. Meanwhile they painted ambitious large-scale canvases intended for public galleries (then purchasing chiefly academic European art), for example Streeton's brilliant and broadly painted *Golden Summer, Eaglemont* (1889; Perth, W. J. Hughes priv. col.) or '*Fire's On*' (1891; Sydney, A.G. NSW), Roberts's heroic *Shearing the Rams* (1890; Melbourne, N.G. Victoria), Davies's crepuscules and McCubbin's poignant pioneering narratives. These monumental landscapes and naturalist figure subjects have become extremely popular 'national images'.

By the mid-1890s, however, the optimistic collective momentum of the Heidelberg school artists was on the wane. In 1890 Conder returned to Europe; Streeton (1890) and Roberts (1891) went to Sydney. The Heidelberg district remained a focus of artistic activity led by Walter Withers and Emanuel Phillips Fox, although in the 20th century the dynamic vision of the original artists became hackneyed in the hands of numerous conventional imitators.

The Heidelberg school was formed from the first important group of Australian artists who did not emigrate from Europe fully trained. They supplanted traditions established by such colonial precursors as John Glover, Abram-Louis Buvelot and Eugene von Guérard and transformed local landscape painting with new informality of composition, breadth of handling and an emphasis on characteristically Australian effects of light and colour. Although they were influenced by aspects of European Impressionism and Aestheticism, their consciously 'national' sentiments and subject-matter were encouraged by contemporary intellectuals and the local press. Roberts, McCubbin and Streeton were first grouped as 'the trio of the "Box Hill School" [with] the same feeling, a common thought, and a similar mannerism, while they hunt on the same Box Hill camping ground' (*Daily Telegraph*, Melbourne, 1 May 1888). The term 'Heidelberg School' was coined by a visiting American critic Sidney Dickinson (1851–1919) in 1891, describing Streeton and Withers 'for the purposes of distinction' as members of 'the "Heidelberg School", for their

work has been done chiefly in this attractive suburb, where, with others of like inclination, they have established a summer congregation for out-of-door painting'. William Moore used the term in 1934, and most writers since Bernard Smith (1945) have accepted it as a useful art-historical label.

Bibliography

F. J. Broomfield: 'Art and Artists in Victoria', *Centennial Mag.*, i (1889), pp. 882–9

S. Dickinson: 'Two Exhibitions of Paintings', *Australasian Critic* (1 July 1891), p. 240

W. Moore: *The Story of Australian Art: From the Earliest Known Art of the Continent to the Art of Today*, i (Sydney, 1934/R 1980), pp. 70–84

B. Smith: *Place, Taste and Tradition: A Survey of Australian Art since 1788* (Sydney, 1945, rev. 2/1979), pp. 78, 120–46

U. Hoff: 'Reflections on the Heidelberg School', *Meanjin*, x (1951), pp. 125–33

D. Thomas: 'Roberts, Conder and Streeton in Sydney', *A.G. NSW Q.*, ii/4 (1961), pp. 71–4

A. McCulloch: *The Golden Age of Australian Painting: Impressionism and the Heidelberg School* (Melbourne, 1969)

C. B. Christensen, ed.: *The Gallery on Eastern Hill: The Victorian Artists' Society Centenary* (Melbourne, 1970)

P. McCaughey and J. Manton: *Australian Painters of the Heidelberg School: The Jack Manton Collection* (Melbourne, 1979)

H. Topliss: *The Artists' Camps: Plein Air Painting in Melbourne 1885–1898* (exh. cat., Melbourne, Monash U., A.G., 1984)

L. Astbury: *City Bushmen: The Heidelberg School and the Rural Mythology* (Melbourne, 1985)

J. Clark and B. Whitelaw: *Golden Summers: Heidelberg and Beyond* (exh. cat., Melbourne, N.G. Victoria, 1985, rev. 1986)

W. Splatt and D. McLellan: *The Heidelberg School: The Golden Summer of Australian Painting* (Melbourne, 1986)

JANE CLARK

Hudson River school

American group of landscape painters active in the mid-19th century. It was a loosely organized group, based in New York City. The name is somewhat misleading, particularly in its implied geographical limitation; the Hudson River Valley, from New York to the Catskill Mountains and beyond, was the symbolic and actual centre of the school but was not the only area visited and painted by these artists. Neither was this a school in the strictest sense of the word, because it was not centred in a specific academy or studio of an individual artist nor based on consistently espoused principles. The term was in general use from the late 1870s but seems not to have been employed during the 1850s and 1860s, the most important years of the school's activities. It was initially used pejoratively by younger artists and critics who considered the earlier landscape painters hopelessly old-fashioned and insular in training and outlook. Nevertheless, the name gradually gained currency and is accepted by most historians.

Landscape paintings were created in modest numbers in America from the 18th century, but the early decades of the 19th century saw a great rise of interest in the genre. Several painters, notably Thomas Doughty, in Philadelphia, PA, and Alvan Fisher, in Boston, MA, were full-time landscape painters by 1820, but Thomas Cole was the acknowledged founder and key figure in the establishment of the Hudson River school (see col. pl. XVIII). In 1825 Cole made a sketching trip up the Hudson River, and the resulting paintings brought him immediate fame in New York, where they were seen by John Trumbull, William Dunlap and Asher B. Durand. Cole had a competent understanding of the European landscape tradition, especially the works of Salvator Rosa and Claude Lorrain, and based his interpretation of the American landscape on such 17th-century prototypes. Painting rugged mountain and wilderness scenes, such as *The Clove, Catskills* (c. 1827; New Britain, CT, Mus. Amer. A.), Cole gave the imprint of established art to American nature. At the same time, such writers as William Cullen Bryant (a friend and admirer of Cole) and James Fenimore Cooper were celebrating American scenery in prose and poetry, and this conjunction of artistic and literary interests provided an important impetus to the establishment of the school.

By the late 1820s Cole was the most celebrated artist in America, and he had begun to attract followers. His ambitions led him to investigate subjects other than pure landscape, such as the *The Subsiding of the Waters of the Deluge* (1829; Washington, DC, N. Mus. Amer. A.; see fig. 40), and also to journey to Europe in 1831–2 in search of new subject-matter. For the rest of his career, Cole divided his time between allegorical and moralizing pictures, such as the *Voyage of Life* (1839; Utica, NY, Munson–Williams–Proctor Inst.; version, 1841–2; Washington, DC, N.G.A.), and pure landscapes, such as the *Notch of the White Mountains* (1839; Washington, DC, N.G.A.), establishing a dual focus for the early years of the school.

By the early 1840s several artists, including Asher B. Durand, John F. Kensett, Jasper F. Cropsey and Frederic Edwin Church, had been inspired by Cole's example to take up landscape. These men regularly showed their works at the annual exhibitions of the National Academy of Design and the American Art-Union in New York, receiving praise from critics and attracting patronage from important New York businessmen and collectors, such as Philip Hone and Luman Reed.

An increasing number of artists began painting landscapes in the mid-1840s, and after Cole's death in 1848 the school burgeoned under the leadership of Durand, who became its principal spokesman and theorist. Durand's 'Letters on Landscape Painting', published in the New York art magazine *Crayon* in 1855, cogently expressed the aesthetics of the school. Addressed to an imaginary student, Durand's 'Letters' stressed the actual study of nature, the use of meticulous preparatory sketches made on the spot, and the execution of carefully conceived studio works that captured the majestic reality and special character of the American landscape.

Although Durand painted a few imaginary landscapes reminiscent of Cole, and Church and Cropsey often invested their compositions with some of Cole's high drama and intellectual content, the appeal of the allegorical mode gradually diminished in the early 1850s. Durand ultimately concentrated on pure landscape, devel-

40. Thomas Cole: *The Subsiding of the Waters of the Deluge*, 1829 (Washington, DC, National Museum of American Art)

oping two compositional types that became characteristic of the school: the expansive landscape vista, such as *Dover Plains, Dutchess County, New York* (1848; Washington, DC, N. Mus. Amer. A.), and the vertical forest interior, epitomized by *In the Woods* (1855; New York, Met.). These compositions were further developed by other painters, especially Kensett, who, in such paintings as *View on the Hudson* (1865; Baltimore, MD, Mus. A.), combined meticulously rendered foregrounds with expansive, light-filled vistas, achieving perhaps the purest, and most complete, expression of the school's aesthetic.

In the 1850s and 1860s the Hudson River school flourished, and its most important figures, Church, Cropsey, Kensett, Sanford Gifford, Albert Bierstadt, Thomas Moran and Worthington Whittredge, many of whom maintained painting rooms in the Tenth Street Studio Building in New York, created their finest works. These artists travelled widely, painting in remote regions of the northern United States, Canada, the Arctic, the American West and South America. Among others Bierstadt and Whittredge studied in Europe, occasionally painting European scenes once back in America. A number of painters, especially Kensett, Gifford and Martin Johnson Heade, were, by the 1860s, working in a manner

that gave light effects predominance, leading some modern historians to isolate their work within a stylistic phenomenon called LUMINISM. Although some artists that were considered Luminist painters, such as Fitz Hugh Lane, had little contact with the Hudson River school, most were part of it, suggesting that Luminism was simply one aspect of the school's approach to landscape.

The school began to wane after the Civil War (1861–5), and by the 1870s it was already considered old-fashioned. American tastes gradually shifted towards more internationally current artists in general and towards Barbizon-inspired painters, such as George Inness, in particular. Although some figures of the movement continued painting into the 20th century, the school's creative energy was largely exhausted by 1880. Interest in the school revived in the 1910s, and exhibitions in the 1930s and 1940s restored it to popular attention and historical importance. By the 1960s the school's place in the history of American art had been solidly established, and by 1980 virtually every major artist had been the subject of a monographic exhibition or published study.

Bibliography

The Hudson River School and the Early American Landscape Tradition (exh. cat., Chicago, A. Inst., 1945)

J. T. Flexner: That Wilder Image: The Paintings of America's Native School from Thomas Cole to Winslow Homer (Boston, 1962)

B. Novak: American Painting of the Nineteenth Century: Realism, Idealism, and the American Experience (New York, 1969)

Drawings of the Hudson River School (exh. cat. by J. Miller, New York, Brooklyn Mus., 1969)

J. K. Howat: The Hudson River and its Painters (New York, 1972/R 1978)

The Natural Paradise: Painting in America (exh. cat., ed. K. McShine; New York, MOMA, 1976)

B. Novak: Nature and Culture: American Landscape Painting, 1825–1875 (New York, 1980)

American Light: The Luminist Movement, 1850–1875 (exh. cat., ed. J. Wilmerding; Washington, DC, N.G.A., 1980)

Views and Visions: American Landscape before 1830 (exh. cat., ed. E. J. Nygren; Washington, DC, Corcoran Gal. A., 1986)

R. O. Rodriguez: 'Realism and Idealism in Hudson River School Painting', Mag. Ant., cxxxii (1987), pp. 1096–109

The Catskills: Painters, Writers, and Tourists in the Mountains, 1820–1895 (exh. cat. by K. Myers, Yonkers, NY, Hudson River Mus., 1987)

American Paradise: The World of the Hudson River School (exh. cat. by J. K. Howat, New York, Met., 1987); review by A. Wilton in Burl. Mag., cxxx (1988), pp. 378–9

M. W. Sullivan: The Hudson River School: An Annotated Bibliography (Metuchen, NJ, 1991)

A. E. Berman: 'Discovering Values in the Hudson River School', Archit. Dig., l (1993), p. 54

J. Driscoll: All that is Glorious around us: Paintings from the Hudson River School (Ithaca, 1997)

FRANKLIN KELLY

Impressionism

Term generally applied to a movement in art in France in the late 19th century. The movement gave rise to such ancillaries as American Impressionism. The primary use of the term Impressionist is for a group of French painters who worked between around 1860 and 1900, especially to describe their works of the later 1860s to mid-1880s. These artists include Frédéric Bazille, Paul Cézanne, Edgar Degas, Edouard Manet, Claude Monet, Berthe Morisot, Camille Pissarro, Auguste Renoir and Alfred Sisley, as well as Mary Cassatt, Gustave Caillebotte (who was also an important early collector), Eva Gonzalès, Armand Guillaumin and Stanislas Lépine. The movement was anti-academic in its formal aspects and involved the establishment of venues other than the official Salon for showing and selling paintings.

The term was first used to characterize the group in response to the first exhibition of independent artists in 1874. Louis Leroy and other hostile critics seized on the title of a painting by Monet, Impression, Sunrise (1873; Paris, Mus. Marmottan; see col. pl. XIX), as exemplifying the radically unfinished character of the works. The word 'impression' to describe the immediate effect of a perception was in use at the time by writers on both psychology and art. Jules-Antoine

Castagnary's review (1874) demonstrates that it was not always used in a negative way: 'They are *Impressionists* in the sense that they render not the landscape but the sensation produced by the landscape.' The name stuck, despite its lack of precision, and came to be used by the artists themselves.

Typical Impressionist paintings are landscapes or scenes of modern life, especially of bourgeois recreation. These non-narrative paintings demonstrate an attention to momentary effects of light, atmosphere or movement. The paintings are often small in scale and executed in a palette of pure, intense colours, with juxtaposed brushstrokes making up a field without conventional perspectival space or hierarchies of forms. Despite stylistic differences, the artists shared a concern for finding a technical means to express individual sensation.

The term is sometimes used to describe freely executed effects in works of other periods in which the artist has presented an impression of the visual appearance of a subject rather than a precise notation. It is also used by analogy in music and literature to describe works that evoke impressions in a subjective way.

1. Sources and emergence of the style

Impressionism grew out of traditions of landscape painting and Realism in France. The immediate predecessors of the Impressionists were Gustave Courbet and the Barbizon painters. The young

41. Edouard Manet: *Déjeuner sur l'herbe*, 1863 (Paris, Musée d'Orsay)

artists accepted Courbet's notion that the artist's own time and experience were the appropriate subject-matter for art. Courbet's undramatic renderings of scenes from ordinary life were an important example, as was his emphatic handling of paint and opposition to convention (see fig. 65). Manet's provocative subject-matter and broad brushstrokes with mere hints of modelling in such paintings as *Déjeuner sur l'herbe* (1863; Paris, Mus. d'Orsay; see fig. 41) owe much to Courbet. Directly, and through Manet's example, other artists were inspired by Courbet in the 1860s.

The Barbizon artists provided the Impressionists with a model of observed, specific, non-historical landscape with attention to times of day and seasons, often painted out of doors. Many of the Impressionists had direct contact with members of the older generation, whom they sometimes encountered in the 1860s painting in the forest of Fontainebleau. Théodore Rousseau's and Camille Corot's subjects of forest scenes, lanes, villages and fields (see fig. 9), Eugène Boudin's and Johan Barthold Jongkind's seascapes and Charles-François Daubigny's river scenes provided the initial inspiration for such paintings as Bazille's *Forest of Fontainebleau* (1865; Paris, Mus. d'Orsay), Sisley's *Village Street at Marlotte* (1866; Buffalo, NY, Albright–Knox A.G.) and Monet's views of the Normandy coast such as *Terrace at Sainte-Adresse* (1867; New York, Met.). However, the selfconsciously modern Impressionists did not choose to show the traces of historic France that sometimes appear in Barbizon works, and they avoided sublime natural effects such as sunsets and storms.

2. Chronology

The artists who would later be called the Impressionists began to emerge in the 1860s, when most of them were in their twenties. Despite later denials of its importance, most of the Impressionists had formal art training. Manet and Degas were students at the Ecole des Beaux-Arts, Paris, under Thomas Couture and Louis Lamothe (1822–69) respectively. Renoir also entered the Ecole des Beaux-Arts; he met Bazille, Monet and Sisley in the atelier of the academic artist Charles Gleyre and studied there until its closure in 1864. Some of the artists, including Cézanne, Guillaumin, Monet and Pissarro, also worked in 1860–61 at the Académie Suisse, Paris, where there was a model but no instruction. Despite the academic system's emphasis on the figure, the young artists discovered a common enthusiasm for landscape. Bazille, Monet, Sisley and Renoir went to Chailly-en-Bière to paint in the forest of Fontainebleau in 1864 and during the rest of the 1860s concentrated on painting *plein-air* landscapes and figures in landscape. Monet, dissatisfied with his attempt to work from sketches, submitted *Women in the Garden* (Paris, Mus. d'Orsay), a large canvas executed on the spot, to the Salon of 1867, where it was rejected. Renoir achieved some success with paintings of his mistress in outdoor settings such as *Lise with a Parasol* (1867; Essen, Mus. Flkwang). Bazille, who shared studios with Monet and Renoir, also did groups of figures out of doors. Moving away from their Barbizon antecedents, the artists also painted city views and landscapes that show the life of suburbs and seaside resorts. Rather than drawing on past art for their sources of inspiration, they looked to contemporary popular illustration and photographs but above all emphasized direct contact with nature.

Their palettes lightened, and they eliminated earth tones as they moved away from their Barbizon-inspired works of the early 1860s. Monet, Pissarro, Renoir and Sisley worked around Louveciennes in 1868 and 1869. Renoir and Monet painted together at the popular riverside resort called La Grenouillère in 1869 (respectively, Stockholm, Nmus.; London, N.G). In these canvases they began to use smaller, more fragmented brushstrokes and more intense colour in an attempt to suggest the visual appearance of light on rippled water, foliage and figures, without focusing on any detail of the scene.

Manet and Degas, whose families were members of the upper bourgeoisie, moved in different circles from those of Pissarro and the younger generation of Impressionists. Morisot, who met Manet in 1868, was also part of this social group and married Eugène Manet, the artist's

brother, in 1874. The figure paintings she exhibited in the late 1860s and early 1870s, such as *Mother and Sister of the Artist* (1869–70; Washington, DC, N.G.A.), show Manet's influence.

During the 1860s both Manet and Degas produced some history paintings, but in a non-academic style; for the most part, however, these artists devoted themselves to subjects they could readily observe. Degas concentrated on portraits of family and friends; because he did not work on commission, he was free to transform this standard genre through his interest in the characteristic gesture, the unexpected angle and the hidden light source. Like most of the artists, he became aware of the compositional possibilities suggested by Japanese prints with their daring cropping, non-Western perspective, simple outlines, lack of modelling and flat areas of colour (*see* JAPONISME). *Musicians of the Orchestra* (1868–9; Paris, Mus. d'Orsay; see fig. 42) integrates the portraits into a scene of modern urban life that includes a ballet on stage. Manet also painted contemporary entertainments such as Spanish dancers and people at the races; however, his most notorious works were those such as *Déjeuner sur l'herbe* and *Olympia* (1863; Paris, Mus. d'Orsay; see col. pl. XXXII), which flouted conventions of spatial construction and finish and, through their presentation of nudes in situations suggesting prostitution, pointed to ambiguities in Second Empire morality. In contrast to the emphasis on painting out of doors by the other Impressionists, these two urban artists worked extensively in the studio.

The Café Guerbois in Montmartre, Paris, provided a place for the artists to meet and to discuss their work. Manet, who was the centre of the group there, began to frequent the café around 1866. He was joined by such critics as Louis-Edmond Duranty, Théodore Duret, Armand Silvestre and Emile Zola, who wrote sympathetically about the new art; Bazille, Degas and Renoir went there regularly and, less frequently, Cézanne, Sisley, Monet and Pissarro, who were living outside Paris. Lively discussions on art provided a forum for the artists to clarify their ideas. They also met some collectors there, including Dr

42. Edgar Degas: *Musicians of the Orchestra*, 1868-9 (Paris, Musée d'Orsay)

Paul Gachet. The Café de la Nouvelle-Athènes replaced the Café Guerbois in the mid-1870s as the preferred gathering place.

During the 1860s most of the artists received some recognition at the Salon, where about half their submissions were admitted, and sold some works. However, many of them were struggling during this decade. The Franco-Prussian War (1870–71) was a major disruption and a turning-point, after which the artists (with the exception of Bazille, who was killed in 1870) settled into more stable circumstances. The Impressionists' subjects of the 1870s gave no hint of the destruction of the war. In celebrating the French countryside and the new face of Paris, they, like other citizens, seemed to be interested in putting the national humiliation behind them.

A number of the artists settled in places that provided them with consistent motifs, mostly within 50 km of Paris. Pissarro returned to Pontoise, where he had already painted in the late 1860s, and where he remained for the rest

of his life. He was joined there in 1872 by Cézanne, who abandoned the dark, turbulent form and content of much of his early work in favour of directly observed landscapes, such as *House of the Hanged Man* (1873; Paris, Mus. d'Orsay), painted with a varied touch according to Pissarro's teachings on colour. In his subsequent paintings done in the south of France, such as his views of L'Estaque from the later 1870s and early 1880s (e.g. Paris, Mus. d'Orsay; Chicago, IL, A. Inst.), Cézanne continued to work from nature but chose motifs that did not change quickly and began to use a constructive brushstroke. Between 1872 and 1877 Monet lived in Argenteuil, where Renoir, Sisley, Manet and Caillebotte also painted. About 20 minutes from Paris by train, the town was a centre for pleasure-boating on the Seine; more than any other place, it has become identified with Impressionism (e.g. Sisley's *Bridge at Argenteuil*, 1872; Memphis, TN, Brooks Mus. A.).

The paintings of the Impressionists, above all, show scenes of bourgeois recreation: people boating (Manet's *Boating*, 1874; New York, Met.), strolling along rivers, across bridges (Caillebotte's *Pont de l'Europe*, 1876; Geneva, Petit Pal.), through fields (Monet's *The Poppies*, 1873; Paris, Mus. d'Orsay) or on the new boulevards of Paris (Caillebotte's *Paris Street: Rainy Weather*, 1877; Chicago, IL, A. Inst.); attending the opera (Cassatt's *Lydia in a Loge*, 1879; Philadelphia, PA, Mus. A.), the café concert (Degas's *At the Café Concert 'Les Ambassadeurs'*, 1876–7; Lyon, Mus. B.-A.), the race-track and other forms of urban entertainment. They also depicted domestic interiors (Morisot's *The Cradle*, 1872; Paris, Mus. d'Orsay); the public park and the private middle-class garden (Renoir's *Monet Working in his Garden at Argenteuil*, 1873; Hartford, CT, Wadsworth Atheneum; and the rivers, roads and railway lines that made France accessible to travellers (Monet's *Arrival of the Normandy Train at Gare St-Lazare*, 1877; Chicago, IL, A. Inst.). Pissarro showed agricultural activities (e.g. *Harvest at Montfoucault*, 1876; Paris, Mus. d'Orsay), as did Sisley, though to a lesser extent. These subjects, which they shared with more fashionable genre

painters and popular illustrators, seemed neutral at the time, although Pissarro's cabbage patches were criticized as vulgar; it was the ways in which they were framed and executed that seemed provocative.

The style of these artists in the 1870s is considered 'classic Impressionism'. They became sophisticated in the manipulation of high-valued colours, in juxtaposed touches and flecks or soft, blended brushstrokes to convey the appearance of reflected light on water, as in Sisley's *Boat during the Flood at Port Marly* (1876; Paris, Orsay; see fig. 43), grass stroked by the wind (Renoir's *High Wind*, c. 1872; Cambridge, Fitzwilliam), complementary coloured shadows on frosty ground (Pissarro's *Hoar Frost*, 1873; Paris, Mus. d'Orsay), variations in atmosphere and the effect on the human form of reflections and incidental light (Renoir's *Ball at the Moulin de la Galette*, 1876; Paris, Mus. d'Orsay). The lack of concern for academic rules of composition that specified a hierarchy of forms and a clear placement of elements in space, as well as the sketchy quality of the works, suggested rapidity of execution and a direct response to an observed effect. Their technique signified spontaneity and originality, and, to some extent, this manner of execution became in itself a convention of the Impressionists, many of whom in fact worked deliberately.

Manet and Degas remained in Paris, continuing to lead the lives of sophisticated men about town. Degas concentrated increasingly on dancers at the Opéra, in rehearsal and performance, seen in a wide variety of postures from many angles and under different lighting. Like Manet, through his contact with the other artists he became more interested in painting outdoor scenes such as *Carriage at the Races* (c. 1872; Boston, MA, Mus. F.A.). His increasing use of pastels allowed him to work more freely with both line and colour. Manet also painted more outdoor scenes, such as *At Père Lathuille* (1879; Tournai, Mus. B.-A.), which still show a keen eye for the nuances of social phenomena. Like Degas, he also painted scenes in cafés and places of entertainment, culminating just before his death in *Bar at the Folies-Bergère* (1882; U. London, Courtauld Inst. Gals).

43. Alfred Sisley: *Boat during the Flood at Port Marly*, 1876 (Paris, Musée d'Orsay)

3. Impressionist exhibitions, dealers and patrons

The Impressionists had some important early patrons: Victor Chocquet, Caillebotte, Ernest Hoschedé, Jean-Baptiste Faure and Dr Gachet and in the later 1870s Eugène Murer (1845–1906) and Paul Gauguin. Some of the early critics, such as Duret, also bought paintings. A few dealers, such as Père Martin and later, and most significantly, Paul Durand-Ruel, sold some of their works. The artists' reputation and hopes for more widespread acceptance and sales, however, depended on their becoming known to the larger public through exhibitions.

At the first exhibition of the Salon des Refusés, established in 1863 by Napoleon III in response to the complaints about the number of rejections from the Salon, works by some of the artists later called Impressionists attracted attention. Although reviews of such works as Manet's *Déjeuner sur l'herbe* were mixed, some critics and members of the public realized that new directions were developing outside the academic mainstream.

The artists' first recognition as a group stemmed from their decision to exhibit outside the Salon. As early as 1867, when Courbet and Manet both held private exhibitions separate from the Exposition Universelle, they had considered showing together, and they continued to investigate various means of showing and selling art, for instance at auction. In 1874 thirty artists showed

in an exhibition of the Société Anonyme des Artistes Peintres, Sculpteurs, Graveurs, etc., which took place in the former studio of the photographer Nadar in Paris. These artists banded together to show their work without the sanction of the government and without a jury. The group included Cézanne, Degas, Monet, Morisot, Pissarro, Renoir and Sisley. While it also included Boudin, Guillaumin, Lépine and other artists whose styles had affinities with those of the Impressionists, the exhibition did not promote any stylistic unity and contained works by a number of artists who simply wished to exhibit as independents. Manet, determined to succeed by showing in the official Salon, never participated in the group exhibitions. Nevertheless, critics identified him as the father of the group, the more so when he sent *plein-air* paintings of Argenteuil and other works in a high-key palette to the Salon.

The exhibition attracted the attention of the press, both favourably and unfavourably, and gave the group a name. The term 'Impressionist', which some critics used derisively, was being used in a neutral way in 1876, and in 1877 the artists themselves used it for their exhibition. For later exhibitions, the artists adopted the term 'Indépendants', although the group exhibitions of 1874, 1876, 1877, 1879, 1880, 1881, 1882 and 1886 are commonly referred to as the eight Impressionist exhibitions.

The character of the these exhibitions varied. Disagreements about the nature of the group and the best strategy for presenting and selling work, as well as personal circumstances, led different artists to withdraw at different times. Pissarro was the only one of the core group who showed in all eight exhibitions. Degas's invitations to more conservative Realist artists such as Jean-François Raffaëlli angered his colleagues. At times Cézanne, Monet, Renoir and Sisley chose to send works to the Salon or to the Galerie Georges Petit, thereby forfeiting the right to show with the group. In the early 1880s some of these artists felt it was more advantageous to have solo shows at La Vie Moderne or at Durand-Ruel's gallery. New artists joined in: Caillebotte in 1876; Cassatt in 1879;

introduced by Degas; Gauguin and Raffaëlli in 1880; and in 1886 Odilon Redon, as well as Georges Seurat and Paul Signac, brought in by Pissarro, who had joined them in their Neo-Impressionist research. In the last exhibition, of 1886, only Degas, Guillaumin, Morisot and Pissarro remained of the original core group.

Dealers increasingly held individual or group exhibitions of artists whose works they represented. Paul Durand-Ruel, whom Monet and Pissarro had met in London in 1870, was the most important dealer for the Impressionists. He was their best single source of income, at times providing stipends in exchange for their works. Other dealers, such as Georges Petit and the Paris branch of Goupil, where Theo van Gogh worked, also exhibited works of many of the Impressionists during the 1880s. Ambroise Vollard gave Cézanne, whose work had hardly been seen since the group exhibition of 1877, his first solo exhibition in 1895.

4. The 'crisis' of Impressionism and later Impressionism

Around 1880 the artists, who were now entering middle age, went through a period of change, which has been referred to as the 'crisis' of Impressionism. It marked the end of the artists' close collaboration and the beginning of a time of individual re-evaluation. The artists had established their subjects and had achieved many of the formal goals implicit in their work of the 1860s and 1870s; they had evolved a complex set of techniques, allowing them to suggest the momentary quality of their perceptions. However, their expectations for the group in terms of support and success had not been fulfilled. They questioned whether the very form of their art might be the reason for the failure of their aspirations. Many of the artists felt dissatisfied with their spontaneous brushwork and casual compositions. Without approaching conventional standards of smooth finish and detailed rendering, the artists chose their motifs more carefully, worked longer on their paintings and considered different ways of arriving at a degree of finish that seemed aimed at making serious works.

Despite Renoir's success with portraits such as *Mme Charpentier and her Children* (1878; New York, Met.), he felt that he had to go back to the beginning again. Inspired by earlier art, especially Raphael's frescoes, he embarked on a study of drawing that led to many paintings in the 1880s of the nude, culminating in his *Bathers* of 1883–7 (Philadelphia, PA, Mus. A.). These were not distinctively modern, unlike Degas's contemporary women bathing in interiors. Later in his life, Renoir reintegrated these figure studies with a more Impressionist handling.

Degas continued to paint urban subjects, though in a more detached way. His dancers were less frequently shown in the context of performance, and, as in his studies of women bathing, he moved closer to his subjects and reduced their context to essentials. His work with monotypes and other prints, as well as with sculpture, revealed an interest in technical and formal experimentation.

Morisot, Cassatt and Pissarro painted figures extensively in the early 1880s in contrast to the subjects derived from a bourgeois woman's world, Pissarro concentrated on peasants. Such close-up scenes of peasant women as *Young Peasant Woman Drinking her Coffee* (1881; Chicago, IL, A. Inst.) show both a clarity of composition and an attempt to discipline what he considered the 'romantic' brushwork of Impressionism. The hatched brushstroke deriving from his work with Cézanne was later replaced by the more impersonal dot; seeking a scientific basis for his art in the mid-1880s, Pissarro turned away from the intuitive Impressionist approach to the colour theories and Pointillist technique of Seurat and the Neo-Impressionists. He always supported young artists, whom he encouraged to exhibit with the Impressionist group, and because of his radical politics he was sympathetic to the anarchist causes that some of them espoused.

Monet settled at Giverny in 1883, but he frequently left the familiar sites of the Ile de France and returned to the seacoast, no longer painting the populated resorts but choosing remote places seen from a viewpoint that gave them the strong, flattened shapes he admired in Japanese prints and a more evocative content. His many views of Etretat and Belle Ile in the mid-1880s show his interest in working in extended groups.

Cézanne, who spent most of his time in the south of France, became increasingly sensitive to the interlocking of shapes and the constructive function of brushstroke and colour in his many views of Mont Sainte-Victoire and paintings of bathers, culminating in his large *Bathers* (1900–06; Philadelphia, PA, Mus. A.). Although his formal inventions provided a point of departure for 20th-century artists, his goal of finding a means to realize his sensations remained an Impressionist one.

Sisley's style changed the least of any of the artists. Living in Moret, he continued to paint the same kinds of scene as in the 1870s, although with a shift in palette that was in line with a general change away from primary colours towards pinks, oranges, yellow-greens and other new colours in the 1880s. In the work of a number of the artists, these changes emphasized the subjective and expressive side that had always been a part of Impressionism and that was being explored in a different way in the works of the emerging Symbolist movement.

In the 1890s the Impressionists achieved recognition and, in a number of cases, financial success. Impressionism did not end or stand still while younger artists emerged, as the term POST-IMPRESSIONISM might imply. During their later years many of the Impressionists achieved notable innovations. Critics at the time noticed a trend towards a synthesis of form and expression and towards more decorative effects. Monet exhibited series—large groups of paintings of the same motif—that are in some ways the culmination of the idea of recording subtle shifts in perception (e.g. the series devoted to Rouen Cathedral, including *Rouen Cathedral: The Façade in Sunlight*, 1894; Williamstown, MA, Clark A. Inst.), but that are also a way of creating a more monumental form of Impressionism, especially in his *Waterlilies* (e.g. Paris, Mus. Orangerie), painted between 1897 and his death in 1926.

5. The influence of Impressionism

Because Impressionism combined new approaches to formal issues while remaining a naturalist art, it affected a variety of movements in the later 19th century. Although their works were controversial, the Impressionists were acknowledged as a force in the art of their time, and they contributed to an opening up of the art world. The term 'Impressionist' was used widely and imprecisely as a generic word for vanguard artists or to describe some artists who exhibited in the Salon. A lightened palette, looser brushwork and contemporary subject-matter became features of academic Realism. Impressionist colour, compositional innovations and subject-matter provided points of departure for experimental naturalist and Symbolist movements in the late 19th century and the early 20th in other European countries and North America as well as France. Impressionist techniques and approaches were disseminated through direct contact among artists, exhibitions and the adaptations of style and subject by more conservative painters.

Although they seldom took pupils, the original Impressionists influenced those artists with whom they painted as well as younger colleagues to whom they gave advice (and in Pissarro's case his sons, including Lucien). Degas influenced more conservative Realist artists, such as Raffaëlli and Jean-Louis Forain (e.g. *The Fisherman*, 1884; Southampton, C.A.G.), as well as Henri de Toulouse-Lautrec. Monet, who had painted with John Singer Sargent in the 1880s, offered advice in the 1890s to some of the young American artists who had formed a kind of colony at Giverny. Some of them, such as Theodore Robinson, became important American Impressionists. Pissarro advised Gauguin in the early 1880s and encouraged Vincent van Gogh later in the decade, while collaborating with the Neo-Impressionists. Renoir's later style appealed to such artists as Pierre Bonnard, Maurice Denis, Aristide Maillol and Picasso, who were reapproaching the nude or were interested in a new, classic expression.

Gauguin's initial adoption of Impressionist technique, colour and subject-matter and later incorporation of aspects of these into a personal style was characteristic of artists of the next generation who were inspired by Impressionist innovations in colour, composition or facture, while departing from the goal of recording sensations of nature. His paintings of the early 1880s were inspired by Pissarro's work; however, by the end of the decade, Gauguin had renounced a vision that 'neglected the mysterious centres of thought'. Seurat, Signac and their fellow Neo-Impressionists transformed the instinctive Impressionist division of colours and composition through their 'scientific' theories of colour and expression, while retaining the subject-matter of landscapes and urban entertainment (see col. pl. XXV).

For artists who felt that the Académie des Beaux-Arts and the Salon were no longer the sole arbiters of taste, the Impressionist paintings they saw exhibited provided a different course from academic teaching. Inspired by the Impressionist exhibitions, the Groupe des Artistes Indépendants, which had its first non-juried exhibition in 1884, provided a venue other than the Salon for younger artists. Many artists of the next generation went through an early Impressionist phase, and features of the style formed the basis for their further explorations. Arriving in Paris in 1886, van Gogh changed from his dark, early palette to one of pure, intense colours, adapting Impressionist subjects and brushwork to his expressive purposes (see fig. 60). Toulouse-Lautrec, Bonnard and Edouard Vuillard all went through Impressionist periods. Their work in the 1890s, though flattened, stylized in form and no longer naturalistic in colour, still drew on the imagery of modern life and urban entertainment and extended the Japanese-inspired compositional innovations of the older painters. Henri Matisse's early work was in an Impressionist vein, and he retained an interest in brilliant and contrasting colours.

A third means for the diffusion of Impressionism—and the most important for the pan-European movement—was the absorption of aspects of Impressionist *plein-air* subject-matter, colour and handling into mainstream academic painting. Discussions of 'Impressionism in the Salon' began

as early as 1877, referring to modern subjects shown in outdoor light with relatively loosely rendered backgrounds. Jules Bastien-Lepage was an important influence on artists interested in achieving 'Impressionist' light and colour in figure paintings with an appropriate degree of finish. Such works as his *Joan of Arc* (1880; New York, Met.) influenced artists in England, North America and Scandinavia, as well as in France. As a cultural centre for Europe, Paris attracted young artists who then carried Impressionist ideas back to their own countries. Some, such as the Norwegian Frits Thaulow, exhibited in France and were recognized as Impressionists.

American Impressionism was the most unified movement and the one closest in spirit to that of France. In the 1890s and early decades of the 20th century such American artists as Theodore Robinson, Julian Alden Weir, Childe Hassam and John H. Twachtman presented subjects in bright sunlight and used flecked brushwork and intense colour, but frequently retained a more

44. Childe Hassam: *The South Ledges, Appledore*, 1913 (Washington, DC, National Museum of American Art)

conservative approach to composition and the representation of figures than their French counterparts (see fig. 44).

British artists were influenced by the tonal paintings of James McNeill Whistler (see col. pl. I and fig. 83) and the modified academic Impressionism of such artists as Bastien-Lepage. Colour division derived from the Impressionists replaced Barbizon influence. Walter Sickert and Philip Wilson Steer were among those who admired Pissarro, Monet and Degas and evolved a treatment of landscape and figure subjects that drew on aspects of their work.

Later artists found Impressionism liberating in its insistence on the artist's sensibility rather than on academic rules as the determining factor in creating a picture. It provided an example for artists who wished to use colour and brushwork, expressively and who wished to find new ways of composing. Its limitation for later artists seemed to be its reliance on nature for inspiration. Gauguin had predicted that the Impressionists would be the 'officials' of tomorrow, and because of its naturalism, its immediacy and its spontaneous and easily imitated brushwork academic Impressionism became an accepted conservative style in the 20th century. Impressionism has steadily increased in popularity with the public and with buyers. Exhibitions of Impressionists' works draw huge crowds, and paintings sold at auction have continued to break records. Impressionism has often appealed to wealthy buyers who do not identify themselves as part of the Western European tradition: Americans around the turn of the century and, more recently, the Japanese.

6. Criticism and historiography.

Writing on individual Impressionists began in the 1860s when their paintings were noticed at the Salon or the Salon des Refusés. Zola was an early defender of Manet and, partly through his boyhood friendship with Cézanne, an early supporter of the other Impressionists. Later, however, his enthusiasm diminished because he felt that the artists had not lived up to their promise.

Early reviews of the Impressionist exhibitions were not overwhelmingly negative, although the negative ones have been frequently quoted. Negative reviewers commented on formal aspects such as the use of crude or violently palpitating colour (especially blues and violets), the exaggerated brushstroke and lack of finish in works that seemed little more than sketches, the negation of elementary rules of drawing and painting and the lack of accuracy. Some reviewers were uneasy about the notion that everything was equally worth painting, but there was little discussion of subjects. Positive critics, such as Duranty in *La Nouvelle Peinture* (1876), commented on the new manner of drawing and use of colour, unusual points of view and the way the artists addressed the psychology of the modern world. Others, such as Castagnary and Silvestre, emphasized the individual sensibility and sensation of the artists. They also remarked on the vividness and naturalism of effect, the direct, unfettered representation of reality and the study of colours in the subject rather than the subject itself, but did not discuss the techniques used to gain these effects.

Duret's pamphlet *Les Peintres impressionnistes* (1878) concentrated on the colourists and landscape painters, excluding Degas and Manet. The difference he pointed to between the artists who emphasized drawing and urban subjects and those who painted primarily in the country with a freer touch was acknowledged by the artists themselves and was a source of division in their exhibitions. Degas was praised for his draughtsmanship by such critics as Zola and Joris-Karl Huysmans, who had reservations about the other artists' lack of finish.

Some writers in the 1880s and 1890s put greater emphasis on the subjective aspects of Impressionism. Jules Laforgue commented on the Impressionist eye and its connection with consciousness. Camille Mauclair and Georges Lecomte compared the artists' effects to poetry and music and pointed to the decorative aspects of their later work.

Many of the early critics and biographers, such as Zola, Duret, Gustave Geffroy and Camille Mauclair, were literary friends of the artists and did not deal with specific aspects of their work. Julius Meier-Graefe, in the early 20th century, began to apply a more analytical approach. Later

writers dealt with documentation; Lionello Venturi published documents and produced catalogues raisonnés of Cézanne and Pissarro. Rewald's fundamental history, based on a systematic study of the available information, remains the point of departure for subsequent scholarship. Rewald's approach is empirical and assumes that the artists' subjects were essentially neutral and that their technique was necessitated by the goal of faithful recording. Later writers have stressed the conventionality of the artists' work and the long studio sessions that sometimes underlay their apparently spontaneous effects. Exhibitions in the late 20th century have attempted to set Impressionism in its social and artistic context, a trend also reflected by such writers as T. J. Clark (1984), whose work discusses iconography with subjects interpreted in terms of class ideology.

Bibliography

J.-A. Castagnary: 'Exposition du boulevard des Capucines: Les Impressionnistes', *Le Siècle* (29 April 1874); repr. in 1974 Paris exh. cat., pp. 264–5

L. Leroy: 'L'Exposition des impressionnistes', *Le Charivari* (25 April 1874), pp. 2–3; abridged Eng. trans. in Rewald, 1946, pp. 256, 258–61; repr. in 1974 Paris exh. cat.

A. Silvestre: 'Chronique des beaux-arts: L'Exposition des révoltés', *Opinion Nationale* (22 April 1874)

E. Duranty: *La Nouvelle Peinture: A propos du groupe d'artistes qui expose dans les galeries Durand-Ruel* (Paris, 1876); Eng. trans. in 1986 exh. cat., pp. 37–48

S. Mallarmé: 'The Impressionists and Edouard Manet', *A. Mthly Rev. & Phot. Port.*, i/9 (1876), pp. 117–22; repr. in 1986 exh. cat., pp. 28–34

T. Duret: *Les Peintres impressionnistes* (Paris, 1878; 2/1923); repr. in *Critique d'avant garde* (Paris, 1885)

J.-K. Huysmans: *L'Art moderne* (Paris, 1883)

G. Lecomte: *L'Art impressionniste d'après la collection privée de M. Durand-Ruel* (Paris, 1892)

G. Geffroy: *La Vie artistique*, iii: *L'Histoire de l'impressionnisme* (Paris, 1894)

P. Signac: *D'Eugène Delacroix au néo-impressionnisme* (Paris, 1899)

J. Laforgue: *Mélanges posthumes* (Paris, 1903)

C. Mauclair: *The French Impressionists* (London, 1903)

'E. Zola: critical writings', in *Salons*, ed. F. F. Hemmings and R. Niess (Geneva, 1979)

J. Meier-Graefe: *Entwicklungsgeschichte der modernen Kunst*, 3 vols (Stuttgart, 1904)

T. Duret: *Histoire des peintres impressionnistes* (Paris, 1906)

L. Venturi: *Les Archives de l'impressionnisme*, 2 vols (Paris, 1939) [contains lett. written by many of the artists to the dealer Durand-Ruel]

J. Rewald: *History of Impressionism* (New York, 1946, rev. 4/1973) [the standard hist. and basis for further stud.; extensive bibliog.]

——: *Post-Impressionism from van Gogh to Gauguin* (New York, 1956, rev. 3/1978)

J. Lethève: *Impressionnistes et symbolistes devant la presse* (Paris, 1959)

H. White and C. White: *Canvases and Careers: Institutional Change in the French Painting World* (New York, 1965)

L. Nochlin: *Impressionism and Post-Impressionism: Sources and Documents* (Englewood Cliffs, 1966)

M. Roskill: *Van Gogh, Gauguin and the Impressionist Circle* (New York, 1970)

J. Leymarie and M. Melot: *Les Gravures des impressionnistes: Oeuvre complet* (Paris, 1971)

K. Champa: *Studies in Early Impressionism* (New Haven, 1973)

B. White, ed.: *Impressionism in Perspective* (Englewood Cliffs, 1978)

S. Monneret: *L'Impressionnisme et son époque: Dictionnaire international*, 4 vols (Paris, 1978–81)

K. Varnedoe: 'The Artifice of Candor: Impressionism and Photography Reconsidered', *A. America*, lxviii (1980), pp. 66–78

J.-P. Bouillon: 'L'Impressionnisme', *Rev. A.* [Paris], 51 (1981), pp. 75–85

A. Callen: *Techniques of the Impressionists* (London, 1982)

T. J. Clark: *The Painting of Modern Life: Paris in the Art of Manet and his Followers* (Princeton, 1984)

R. Schiff: *Cézanne and the End of Impressionism* (Chicago, 1984)

J. Rewald: *Studies in Impressionism*, ed. I. Gordon and F. Weitzenhofer (New York, 1986)

B. Denvir, ed.: *The Impressionists at First Hand* (London, 1987)

R. Herbert: *Impressionism: Art, Leisure and Parisian Society* (London, 1988)

G. Pollock: 'Modernity and the Spaces of Femininity', *Visions and Difference* (London, 1988), pp. 50–78

A. Distel: *Les Collectionneurs des impressionnistes: Amateurs et marchands* (Dudingen, 1989)

Centenaire de l'impressionnisme (exh. cat. by A. Dayez and others, Paris, Grand Pal., 1974)

Impressionism: Its Masters, its Precursors and its Influence in Britain (exh. cat., ed. J. House; London, RA, 1974)

Japonisme: Japanese Influence on French Art, 1854–1910 (exh. cat. by G. Weisberg and others, Cleveland, OH, Mus. A., 1975)

The Crisis of Impressionism, 1878–1882 (exh. cat., ed. J. Isaacson; Ann Arbor, U. MI, Mus. A., 1980)

A Day in the Country: Impressionism and the French Landscape (exh. cat. by R. Brettell and others, Los Angeles, CA, Co. Mus. A., 1984)

The New Painting: Impressionism, 1874–1886 (exh. cat., ed. C. Moffett; San Francisco, CA, F.A. Museums, 1986)

Art in the Making: Impressionism (exh. cat., ed. D. Bomford and others; London, N.G., 1990)

Impressionism in Britain (exh. cat. by K. McConkey, London, Barbican A.G., 1995)

GRACE SEIBERLING

Intimisme

Term applied to paintings depicting everyday life in domestic interiors, usually referring to the work of Pierre Bonnard and Edouard Vuillard. It was first used in the 1890s, although the type of paintings to which it refers had been produced earlier by such artists as Johannes Vermeer and Jean-Siméon Chardin. The *intimiste* style is aptly characterized by André Gide's comment on Vuillard's four decorative panels, *Figures and Interiors* (1896; Paris, Petit Pal.), that the artist was 'speaking in a low tone, suitable to confidences' ('Promenade au Salon d'Automne', *Gaz. B.-A.*, xxxiv, 1905, p. 582). Bonnard and Vuillard were both members of the mystical brotherhood of the NABIS, but their commitment to the esoteric, symbolist side of the Nabi aesthetic was not as strong as their interest in the group's technical ideas on painting, and often their subject-matter was tranquil, bourgeois interiors. An example is Bonnard's *Le Déjeuner* (1899; Zurich, Stift. Samml. Bührle), in which the technique owes much to Impressionism, though, influenced by the theory of Paul Sérusier, the leader of the Nabis, more muted colours are employed. Their interest in decoration and pattern is evident, and the figures in their paintings often merge with the décor of their interiors, which in turn reflect the contemporary taste for rich patterned effects, as in Vuillard's *Mother and Sister of the Artist* (1893; New York, MOMA). Even when dealing with

exterior scenes, Bonnard and Vuillard often create a sense of domestic intimacy (e.g. Vuillard's *The Park*, 1894; New York, priv. col.; see Preston, p. 60). Vuillard's style remained predominantly *intimiste* throughout his career, whereas Bonnard's later paintings exhibit a more expansive approach with a use of brighter colours; nevertheless, some of the latter's late paintings (e.g. *Nu dans le bain*, 1936; Paris, Petit Pal.) still retain the *intimiste* quality of his earlier works.

Bibliography

A. Carnduff Ritchie: *Edouard Vuillard* (New York, 1954)

Bonnard and his Environment (exh. cat. by J. T. Soby and others, New York, MOMA, 1964)

J. Russell and others: *Bonnard* (London, 1984)

S. Preston: *Edouard Vuillard* (London, 1985)

J. Warnod: *Edouard Vuillard* (Näfels, 1989)

☐

Jacobean style

Term loosely used to describe British art and architecture produced during the reign (1603–25) of James I of England (James VI of Scotland). Portraiture dominated both miniature and easel painting in this period, during which the decorative and jewel-like manner of the Elizabethan era was carried to an extreme. John de Critz, Robert Peake, William Larkin and other court artists were much in demand for their iconic depictions of sitters, in which clothes, jewellery and heraldic insignia are minutely detailed. In the work of Daniel Mijtens I and Paul van Somer, there emerges a greater interest in the physical setting; this can be seen, for example, in Mijtens's use of a gallery and distant garden for the background to his pendant portraits of *Thomas Howard, 2nd Earl of Arundel* and *Alathea, Countess of Arundel* (both 1618; Arundel Castle, W. Sussex) and in van Somer's *Queen Anne at Oatlands* (1618; Windsor Castle, Berks, Royal Col.), whose background includes Inigo Jones's fashionable Serlian gate for Oatlands Palace, Surrey (destr.).

Jacobean architecture is most readily associated with the large brick-built prodigy houses of the English ruling class; they include Audley End

(c. 1603–16), Essex, Hatfield House (1607–12), Herts, and Blickling Hall (designed 1616–17), Norfolk. Extravagantly massed and silhouetted, early 17th-century country houses were frequently enlivened with arcades or loggias and ogee-capped towers; such features as balustrades and porches were often carved with Mannerist decorative motifs by Flemish or Flemish-trained masons, or by English masons working from pattern books. The Jacobean style thus contrasts strongly with the purer Renaissance classicism of Inigo Jones's Palladian buildings, commissioned by the court towards the end of James's reign. The so-called Jacobethan Revival houses of the Victorian period were modelled on the forms and detailing of Elizabethan as well as Jacobean architecture, for example Bear Wood (1865–74), Berks, by Robert Kerr, or Hewell Grange (1884–91), Hereford & Worcs, by G. F. Bodley and Thomas Garner.

Bibliography

J. Summerson: *Architecture in Britain, 1530–1830*, Pelican Hist. A. (Harmondsworth, 1953, rev. 7/1983)

E. K. Waterhouse: *Painting in Britain, 1530–1790*, Pelican Hist. A. (Harmondsworth, 1953, rev. 4/1978)

E. Mercer: *English Art, 1553–1625*, Oxford Hist. Eng. A. (Oxford, 1962)

M. Whinney: *Sculpture in Britain, 1530–1830*, Pelican Hist. A. (Harmondsworth, 1964, rev. 2/1988 by J. Physick)

ALICE T. FRIEDMAN

Japonisme

French term used to describe a range of European borrowings from Japanese art. It was coined in 1872 by the French critic, collector and printmaker Philippe Burty 'to designate a new field of study—artistic, historic and ethnographic', encompassing decorative objects with Japanese designs (similar to 18th-century Chinoiserie), paintings of scenes set in Japan, and Western paintings, prints and decorative arts influenced by Japanese aesthetics. Scholars in the 20th century have distinguished *japonaiserie*, the depiction of Japanese subjects or objects in a Western style, from Japonisme, the more profound influence of Japanese aesthetics on Western art.

1. Origins and diffusion

There has been wide debate over who was the first artist in the West to discover Japanese art and over the date of this discovery. According to Bénédite, Félix Bracquemond first came under the influence of Japanese art after seeing the first volume of Katsushika Hokusai's *Hokusai manga* ('Hokusai's ten thousand sketches', 1814) at the printshop of Auguste Delâtre in Paris in 1856. Adams argued that the American artist John La Farge was first: he began acquiring Japanese art in 1856 and had made decorative paintings reflecting its influence by 1859. Other authors conclude that since Japan began actively to export its wares only about 1859, Western artists could not have known Japanese art until the early 1860s.

Japanese works, however, were available in Europe before 1854, the year in which the American Commodore Matthew Calbraith Perry (1794–1858) opened Japan to trade with the West with the signing of the Kanagawa Treaty. Dutch merchants, in particular, in Japan were permitted limited trade through the island of Dejima and collected paintings, illustrated books, prints and *objets d'art*, which joined such public collections in Europe as the Etnografiska Museet, Stockholm, the Bibliothèque Nationale, Paris, the British Museum, London, and the Rijksmuseum voor Volkenkunde, Leiden.

Following Japan's opening to trade, access to Japanese wares as well as European public interest increased. Various artefacts were sold at public auctions and in Parisian curiosity shops, such as L'Empire Chinoise and Mme Desoye's store on the Rue de Rivoli, also known as la Porte Chinoise. In London, Farmer & Roger's Oriental Warehouse (later known as Liberty & Co.) opened in 1862. These shops sold both Chinese and Japanese art and were gathering-spots for artists, critics and collectors who found a new fashion in oriental art. In Britain James Abbott McNeill Whistler, D. G. Rossetti, W. M. Rossetti, John Everett Millais, Edward Burne-Jones, Sir Lawrence Alma-Tadema, Charles Keene, E. W. Godwin, William Morris, William Burges, Rutherford Alcock (1809–97), John Leighton (1822–1912), R. Norman Shaw and Christopher Dresser purchased Japanese objects at

Farmer & Roger's in the early 1860s or otherwise recorded their interest in the art and culture of Japan. In France in the 1860s the writers Charles Baudelaire, Edmond and Jules de Goncourt, Théophile Gautier, Emile Zola and Jules Husson Champfleury and the artists Jean-François Millet, Théodore Rousseau, James Tissot, Alfred (Emile-Léopold) Stevens, Edouard Manet, Edgar Degas and Claude Monet began collecting Japanese art (see col. pl. XX). About 1866 Burty, Zacharie Astruc, Henri Fantin-Latour, Jules Jacquemart, Alphonse Hirsch (1843–84), M. L. Solon and Bracquemond formed the secret Société du Jing-lar, a club devoted to the study and promotion of Japanese culture.

Major exhibitions also fuelled European enthusiasm for the decorative and pictorial arts of Japan: the International Exhibition in London (1862), the Musée Oriental (founded 1865) at the Union Centrale des Beaux-Arts (later the Musée des Arts Décoratifs) and the Exposition Universelle in Paris in 1867 were the most important early exhibitions. In the 1860s such institutions as the South Kensington Museum (later the Victoria & Albert Museum) and the British Museum in London, and the Bibliothèque Nationale and Union Centrale des Beaux-Arts in Paris, added Japanese art to their holdings. The Österreichisches Museum für Angewandte Kunst, Vienna, bought Japanese works from the displays at the Exposition Universelle of 1873. In the late 19th century such dealers as Kanezaburō Wakai, Tadamasa Hayashi (1851–1905) and Siegfried Bing also promoted Japanese art.

2. Painting and graphic arts

From the early 1860s Japonisme could be found in nearly all media across a variety of stylistic movements. In painting and the graphic arts it influenced the asymmetrical compositions of Degas and Henri Toulouse-Lautrec, the book illustrations of Walter Crane and the wood-engravings of Winslow Homer. The flatter modelling of Manet, Whistler, the Impressionists, Vincent van Gogh, Paul Gauguin and the Nabis had roots in Japanese sources, as did the pure colours and flat outlined forms preferred by many of these painters (see col.

pls I and XXXIX and figs 41 and 60). Japanese art also inspired similar decorative qualities in the work of the Eastern European artists Emil Orlik and Otto Eckmann. The calligraphic line of oriental ink painting influenced the Impressionist brushstroke, the drawings and prints of Pierre Bonnard and Edouard Vuillard, as well as graphic works by Manet, van Gogh and Toulouse-Lautrec in France and Aubrey Beardsley in England (see fig. 4). For the Pre-Raphaelites, the all-over patterning, the naive style of outlined forms and the subject of women in Japanese prints was as interesting as late medieval and early Italian painting (see fig. 85). In Italy the Macchiaioli group also studied and was inspired by the dramatic compositions and strong colours of Japanese prints. Such American artists as La Farge, Homer, Elihu Vedder, William Merritt Chase, John H. Twachtman and Maurice Prendergast were influenced by Japanese composition and design and often incorporated oriental motifs into their works. Later Helen Hyde (b 1868), Will Bradley, Louis John Rhead and Arthur W. Dow (1857–1922) adopted Japanese styles and effects in their graphic art.

The introduction of Japanese colour wood cuts to the West from the mid-19th century dramatically affected the history of printmaking. The woodcut revival of Auguste Lepère, Henri Rivière, Félix Vallotton, Ernst Hermann Walther (b 1858) and Eckmann was inspired by Japanese sources. Similarly, Japanese achievements in colour printing promoted the explosion in colour lithography and colour etching of the late 19th century.

3. Decorative arts

Japonisme in the decorative arts at first consisted primarily of imitations of Japanese models, with stylistic features paralleling Japonisme in painting; features such as asymmetrical compositions, pure bright colours combined in complementary colour schemes, and bold flat patterns and motifs. Many of these were copied directly from Japanese craftsmen's manuals and dyers' stencils. Japanese inspiration is evident in the products of the French manufacturers Christofle & Co. and

Haviland & Co. of Limoges, in the designs of Joseph Bouvier (1840–1901), Bracquemond, Jean Charles Cazin and Camille Moreau (1840–97), and in the cloisonné enamels of Alexis Falize (1811–98) and his son Lucien Falize (1839–97).

In the late 19th century the popularity of Japanese design continued; it is particularly evident in products of the Arts and Crafts movement and Art Nouveau, for example in the glasswork of Eugène Rousseau (1827–91), the ceramic decorations of Joseph-Théodore Deck (1823–91) and Emile Gallé, and the jewellery of René Lalique. In American and British decorative arts Japonisme appears in works produced by the Rookwood Pottery of Cincinnati, OH, which employed Japanese craftsmen, in the bold, patterned textile designs of A. H. Mackmurdo and Candace Wheeler, in the designs of Louis Comfort Tiffany's stained glass and in the naturalistic motives applied to silver manufactured by Tiffany & Co. of New York, as well as in the architecture of Frank Lloyd Wright.

4. Conclusion

Western artists sought inspiration in Japanese art for a variety of reasons. In the applied arts Japonisme arose from a widespread study of historic decoration, stemming from a desire to improve the quality of design in manufactured goods. The study of Japanese models also promoted a broader interest in principles of decorative design; during the late 19th century publications on decoration and the applied arts grew in number, and Japanese examples were frequently included.

In Britain, the allure of Japanese art coincided with a fascination for the decorative styles, pure colours and spiritual quality of medieval art and early Italian painting. In France, the critic Astruc, among others, advocated the model of Japanese originality as an antidote to the belaboured academic tradition. In the mid-19th century European artists had begun to draw inspiration from such non-traditional sources as caricatures, popular prints and, in France, brightly coloured *Epinal* woodcuts. Japanese *ukiyo-e* prints, which were often compared to these media, shared with them a graphic expressiveness, popular subject-matter, naive, archaizing style and original compositions.

It was the Japanese approach to form—expressive line, abstract graphic style, decorative colours and dramatic asymmetrical compositions—that most influenced Western artists. In 1905 the English critic C. J. Holmes wrote: 'Oriental art is almost wholly symbolic . . . the artist conveys to the educated spectator a sense of things beyond the mere matter of his picture—something which the most elaborate and complete representation would fail to convey' (Holmes, 1905, p. 5). As Holmes suggested, the study of Japanese art contributed to the birth of formalist aesthetics in the 20th century.

Bibliography

W. M. Rossetti: 'Japanese Woodcuts', *The Reader* (31 Oct 1863), pp. 501–3 (7 Nov 1863), pp. 537–40

E. Chesneau: 'Beaux-arts, l'art japonais', *Les Nations rivales dans l'art* (Paris, 1868), pp. 415–54

P. Burty: 'Japonisme', *Ren. Litt. & A.*, i (1872), pp. 25–6, 59–60, 83–4, 106–7, 122–3; ii (1873), pp. 3–5

—: 'Japonisme', *L'Art*, ii (1875), pp. 1–7, 330–42; v (1876), pp. 49–58, 278–82; vi (1876), pp. 150–55

E. Chesneau: 'Exposition Universelle, le Japon à Paris', *Gaz. B.-A.*, n.s., xviii (1878), pp. 385–97, 841–56

Le Blanc du Vernet: 'L'Art japonais', *L'Art*, xxi (1880), pp. 132–3, 250–55; xxii (1880), pp. 229–32; xxix (1882), pp. 249–53

L. Bénédite: 'Félix Bracquemond, l'animalier', *A. & Déc.*, xvii (1905), pp. 35–47

C. J. Holmes: 'The Uses of Japanese Art to Europe', *Burl. Mag.*, viii (1905), pp. 3–11

R. Graul: *Ostasiatische Kunst und ihr Einfluss auf Europa* (Leipzig, 1906)

E. Scheyer: 'Far Eastern Art and French Impressionism', *A.Q.*, vi (1943), pp. 116–43

C. Lancaster: *The Japanese Influence in America* (New York, 1963)

The Great Wave: The Influence of Japanese Woodcuts on French Prints (exh. cat., ed. C. F. Ives; New York, Met., 1974)

Japonisme: Japanese Influence on French Art, 1854–1910 (exh. cat., ed. G. Weisberg; Cleveland, OH, Mus. A., 1975)

C. Yamada: *Dialogue in Art: Japan and the West* (Tokyo and New York, 1976)

D. Bromfield: *The Art of Japan in later 19th Century*

Europe: Problems of Art Criticism and Theory (diss., U. Leeds, 1977)

Japonisme in Art: An International Symposium: Tokyo, 1979

Ukiyo-e Prints and the Impressionist Painters: Meeting of the East and the West (exh. cat., Tokyo, Sunshine Mus.; Osaka, Mun. Mus. A.; Fukuoka, A. Mus.; 1979)

K. Berger: Japonismus in der westlichen Malerei, 1860–1920 (Munich, 1980)

S. Wichmann: Japonisme: The Japanese Influence on Western Art in the Nineteenth and Twentieth Centuries (New York, 1981)

Japonismus und Art Nouveau: Europäische Graphik aus den Sammlungen des Museums für Kunst und Gewerbe Hamburg (exh. cat., Hamburg, Mus. Kst & Gew., 1981)

E. Evett: Critical Reception of Japanese Art in Late Nineteenth Century Europe (Ann Arbor, 1982)

D. Johnson: 'Japanese Prints in Europe before 1840', Burl. Mag., cxxiv (1982), pp. 341–8

P. Floyd: Japonisme in Context: Documentation, Criticism, Aesthetic Reactions (diss., Ann Arbor, U. MI, 1983)

H. Adams: 'John La Farge's Discovery of Japanese Art: A new Perspective on the Origins of Japonisme', A. Bull., lxvii (1985), pp. 449–85

P. Floyd: 'Documentary Evidence for the Availability of Japanese Imagery in Europe in 19th-century Public Collections', A. Bull., lxviii (1986), pp. 105–41

Le Japonisme (exh. cat., Paris, Grand Pal.; Tokyo, N. Mus. W.A.; 1988)

P. Floyd: Seeking the Floating World: The Japanese Spirit in Turn-of-the-Century French Art (Tokyo, 1989)

PHYLIS FLOYD

Joanine

Term used to designate the style of *talha* (carved and gilded wood) produced during the reign of John V (*reg* 1706–50) of Portugal. At that time a new type of retable evolved, differing in form and ornament from the National style of the 17th century. The typical Joanine retable is taller and narrower than those of the National style. Concentric arches were abandoned in favour of canopies and baldacchini of architectural form, combined with allegorical statues; these were taken from *Perspectiva pictorum et architectorum* (Rome, 1693–1700) by Andrea Pozzo.

The basis for the new stately style, one that is more dramatic and rhetorical, and for its decorative vocabulary, was Roman Baroque art and architecture, which were the fundamental inspiration of art at the court of John V. It can be said that the King, more than anyone else, was the true author of the courtly style that bears his name. Italian influence was diffused in Portugal through the import by John V of marble sculpture, as well as ecclesiastical goldsmiths' work from Rome; through the arrival in the country of foreign artists; and through the circulation there of engravings and illustrated books. The term Joanine, first used by Robert Smith (ii), has been employed subsequently to describe other art forms of the period, including painting (in particular portraiture), silver, furniture and glazed tiles, as well as interior decoration.

One of the earliest works in the Joanine style is the chancel (1721) of Nossa Senhora da Conceição, Loures, by Bento da Fonseca Azevedo (active c. 1721). Other important examples of *talha* in Lisbon include the interior of the church of Nossa Senhora da Pena (c. 1713–20), where the transition to the new style can be seen in the apse. One of the most lavish examples is the carved and gilded wood decoration (c. 1720) of the church of the royal monastery of Madre de Deus, Lisbon. In the second phase of the style, during the second quarter of the 18th century, wood was used to imitate other materials and in combination with marble. Solomonic columns, modelled on Bernini's baldacchino (1624–33) at St Peter's, Rome, were often used as supports. This is seen on the retable of the church of S Catarina or dos Paulistas (1727–30), Lisbon, by Santos Pacheco de Lima, where the new style appears in its most splendid form. In the apse three tiers of supporting gilt figures and decorative sculpture, by the same carver, are set against coloured marble.

The Joanine style spread to other parts of Portugal, to the Alentejo, where it is seen at S Madalena (1720), Olivença, and in the impressive Calvary Chapel in S Francisco, Evora. The University Library (1717–28) at Coimbra was presented to the University by John V and has one of the most sumptuous interiors in Portugal. It was a work of collaboration by many artists, under the direction of Gaspar Ferreira, and illustrates the

essentially decorative nature of the Joanine style. Three lofty, marbled arches with gilt brackets, garlands and targes lead to a portrait of John V, attributed to Giorgio Domenico Duprà, which is surrounded by curtains parted by putti, all simulated in polychromed wood. These scenographic effects are typical of the Joanine style.

There are fine examples of Joanine carving in northern Portugal, where the general lines of the style were continued but where local characteristics were introduced, such as elaborate chancel arches, pilasters alternating with figures and corbels, and retables designed in several tiers, resembling pyramidal thrones. The high altar of Oporto Cathedral was an important point of departure for the north. It was commissioned in Lisbon by the cathedral chapter from Santos Pacheco and ornamented (1727–30) with statues by Claudio de Laprada. This imposing retable served as the model for others, including that of the Misericórdia (1729), Mangualde; S Gonçalo (1734), Amarante; and the high altar (1731) of Viseu Cathedral, also designed by Santos Pacheco.

The combination of richly gilt surfaces, brilliant and luminous colours and Baroque forms all created a magnificent effect that is characteristic of the best Joanine art.

Bibliography

R. C. Smith: *A talha em Portugal* (Lisbon, 1962)
—: *The Art of Portugal, 1500–1800* (London, 1968)

JOSÉ FERNANDES PEREIRA

Leiden 'Fine' painters [*Leidse fijnschilders*]

Name given to a number of Dutch painters, active in Leiden c. 1630 to c. 1760. They are known for their small paintings, principally genre scenes, full of minute detail and executed in a polished style. The most famous and influential practitioners of this school were Gerrit Dou and his pupil Frans van Mieris the elder. Although the term was first used c. 1850, artists such as Dou, Frans van Mieris, Pieter van Slingeland (also a pupil of Dou), Frans's son Willem van Mieris and the latter's son Frans van Mieris the younger were

apparently already being praised for those same qualities in their own time. Other contemporary sources suggest that the tradition of Dou's art was continued by Frans the elder and van Slingeland, that the art of Frans, in turn, lived on through the work of his sons Jan and Willem, and that Willem was imitated by Frans the younger. It may thus be assumed that they were, to some extent at least, aware of the fact that they resembled each other in style and subject-matter. From the beginning they were admired for their 'neat' and 'elaborate' manner of painting, and the general reaction was one of wonder and amazement at the astonishing virtuosity and perfection of their small-scale paintings.

Already in his early paintings from the 1630s Dou applied himself continually to refining, with ever more detail, the manner of printing he learnt from the young Rembrandt, although from close up the brushstrokes can always be seen. That these paintings do not seem too meticulous is partly due to Dou's remarkably subtle use of chiaroscuro. Two of his most direct followers, Peter van Slingeland and Dominicus van Tol (after 1630–1676), were much less successful in this respect. Dou's most talented pupil, Frans van Mieris the elder, tried to conceal the effect of the brushstroke as much as possible. His highly polished paintings would probably seem rather stiff were it not for the lively handling of light. The same applies to the work of Arie de Vois. In van Mieris's later work, however, the enamel-like smoothness and the technical virtuosity became an end in themselves; his figures, too, became increasingly stylized. This tendency was continued in the work of his son Willem and that of his grandson Frans van Mieris the younger.

In the 1640s Dou began to develop what is known as the 'niche' format, which was to become virtually the hallmark of the Leiden 'Fine' painters (see fig. 45). The stone window, usually framing a maidservant or old woman, is an entirely artificial motif (in the 17th century Dutch houses did not have such windows). It emphasizes the sense of illusion, although it is never possible to speak of an actual *trompe l'oeil*. The style and themes developed between c. 1640 and 1675 by Dou and

45. Gerrit Dou: *Old Woman at the Window Watering Flowers*, 1660–65 (Vienna, Kunsthistorisches Museum)

van Mieris, were imitated, elaborated on and transformed by numerous painters for more than a century afterwards. With the third and fourth generations of Leiden 'Fine' painters, the colours are noticeably brighter, while the light is more even, and the figures are increasingly stereotyped, but essentially there were no stylistic or thematic innovations.

Dou, Frans van Mieris the elder and to a lesser degree van Slingeland and Willem van Mieris were among the most famous and best paid artists of their time, and their work was purchased not only by members of the Dutch bourgeoisie but also by foreign monarchs. In the course of the 19th century, however, appreciation of the Leiden 'Fine' painters dropped dramatically, reaching its lowest point at the beginning of the 20th century. It is only in the last few decades that their work has become acknowledged again as a highly important contribution to 17th-century Dutch genre painting.

Apart from the artists already mentioned, other Leiden artists commonly thought of as belonging to the group are Jacob van Spreeuwen (1609/10–after 1650), Johan Adriaensz van Staveren (1613/14–1669), Abraham de Pape (before 1621–1650), Adriaen van Gaesbeeck (1621–50), Johannes Cornelisz. van Swieten (?1635–61), Jacob Toorenvliet (1640–1719), Bartholomeus Maton (c. 1643–after 1682), Matthijs Naiveu, Abraham Snaphaen (1651–91), Karel de Moor, Jan van Mieris, Jacob van der Sluis (?1660–1732), Hieronymus van der Mij (1687–1761), Louis de Moni (1698–1771) and finally two rather weak artists, Pieter Cattel (1712–59) and Nicolaas Rijnenburg (1716–after 1776). Occasionally painters born or working in Leiden, such as Quiringh van Brekelenkam, Gabriel Metsu and Jan Steen, show the unmistakable influence of Dou and/or Frans van Mieris the elder. Outside Leiden the influence of the 'Fine' painters was also considerable on artists such as Jacob Ochtervelt, Godfried Schalcken, Eglon van der Neer, Caspar Netscher, Adriaen van der Werff, Arnold Boonen (1669–1729) and Philip van Dijk. Even in the 19th century there were artists, for example Machiel Versteegh (1756–1843) and George Gillis Haanen (1807–79), whose scenes hark back to works by Dou and his pupils.

Bibliography

S. van Leeuwen: *Korte besgrijving van het Lugdunum Batavorum nu Leyden* [A brief description of Lugdunum Batavorum, now Leyden] (Leiden, 1672), pp. 191–2

W. Martin: *Het leven en de werken van Gerrit Dou beschouwd in verband met het schildersleven van zijn tijd* [The life and works of Gerrit Dou in the context of contemporary painting] (Leiden, 1901; Eng. trans., abridged, London, 1902)

F. W. Robinson: 'Gerard Dou and his Circle of Influence', *Gabriel Metsu, 1629–1667: A Study of his Place in Dutch Genre Painting of the Golden Age* (New York, 1974), pp. 89–97

O. Naumann: *Frans van Mieris the Elder, 1635–1681*, 2 vols (Doornspijk, 1981)

Masters of Seventeenth-century Dutch Genre Painting (exh. cat., ed. P. Sutton; Philadelphia, PA, Mus. A.; Berlin, Gemäldegal.; London, RA; 1984), pp. xl–xliii

Leidse fijnschilders: Van Gerrit Dou tot Frans van Mieris de Jonge, 1630–1760 (exh. cat., ed. E. J. Sluijter; Leiden, Stedel. Mus. Lakenhal, 1988) [with an extensive bibliog.]

De Hollandse fijnschilders van Gerard Dou tot Adriaen van der Werff (exh. cat. by Peter Hecht, Amsterdam, Rijksmus., 1989)

E. J. Sluijter: *De lof der schilderkunst: Over schildenjen van Gerrit Dou (1613–1675) en een traktaat van Philips Angel uit 1642* (Hilversum, 1993)

ERIC J. SLUIJTER

Libre Esthétique

Belgian avant-garde exhibition society sponsoring art exhibitions, concerts and lectures, 1894–1914. A direct outgrowth of Les XX, it abandoned the earlier group's government by consensus and was administered solely by Octave Maus. Maus founded the Libre Esthétique in order to run the group more freely and avoid the problems of Les XX, which included argumentative artist-members and charges of exclusivity. Ostensibly dedicated to the struggle for new, evolving and progressive art from all countries, it focused on French and Belgian work continuing Les XX's practice of showing the decorative arts, which helped to make Belgium the European centre for such works in the 1890s. In its first decade, Symbolist and Impressionist artists, poets and musicians prevailed. Former Les XX members such as Constantin Meunier and Félicien Rops were included in shows and were frequently represented by many pieces. In its second decade, the exhibitions gradually lost their avant-garde edge, except that they introduced all the Fauve artists. During this period, Maus often chose a thematic approach for group shows, organizing exhibitions around subjects such as Impressionism (1903), landscape (1910) or the south of France (1913). He acted as curator, installer and packer for the exhibitions, assisted when necessary by Paul Dubois (ii), Gisbert Combaz (1869–1941) and Théo Van Rysselberghe, and he organized all the lectures. Eugène Ysaye (1858–1931) continued to take charge of the concerts that accompanied the exhibitions, as he had done for Les XX, but Maus contributed to the planning and at times even performed on the piano. The exhibitions were increasingly successful with the public; the State bought works from them, and the King and Queen always

visited. The lectures became less popular and were cancelled after 1906. Despite the loss of revolutionary focus, Maus planned to continue the exhibitions after the forced hiatus caused by World War I, but his death marked the end of the Libre Esthétique.

Bibliography

M. O. Maus: *Trente années de lutte pour l'art* (Brussels, 1926) [primary archival and anecdotal source written by wife of organizer]

J. Block: *Les XX and Belgian Avant-Gardism, 1868–1894* (Ann Arbor, 1984), pp. 74–8

JULIUS KAPLAN

Little Masters [Fr. *Petits maîtres*; Ger. *Kleinmeister*]

Term that refers in the broadest sense to northern European artists who made small-format prints (almost exclusively engravings) during the first half of the 16th century. As early as 1679 Joachim von Sandrart referred to the '*kleine Meister*', and John Evelyn's reference of 1662 to 'the Polite Masters' is probably a confusion with the French *Petits maîtres*. The term has most frequently been applied exclusively to three artists in the generation immediately following Albrecht Dürer in Nuremberg: Sebald Beham, his brother Barthel Beham and Georg Pencz. The phrase 'Nuremberg Little Masters' is often used to make this clarification, although only Pencz pursued his entire career in Nuremberg. In addition to their preference for a small engraving format, these three shared an association with Dürer (for whom Pencz probably worked) and the distinction of having been evicted from Nuremberg in January 1525 (at the culmination of the German Peasant Revolt) for their agnostic and anarchistic convictions. Because of their radical political and religious views, they were also known as the 'three godless painters'. When the term is used in a broader sense, Little Masters may include other engravers who favoured a minute format, such as Jakob Binck, Master I.B. and Heinrich Aldegrever in Germany and Allaert Claesz. and Dirk Vellert in the Low Countries.

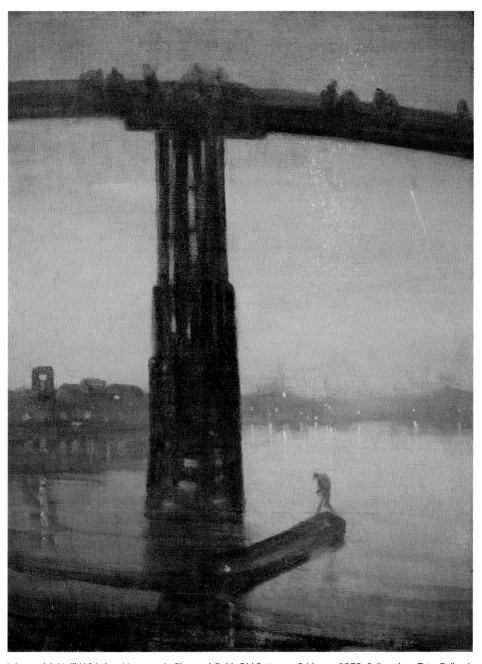

I. James McNeill Whistler: *Nocturne in Blue and Gold: Old Battersea Bridge*, c. 1872–5 (London, Tate Gallery)

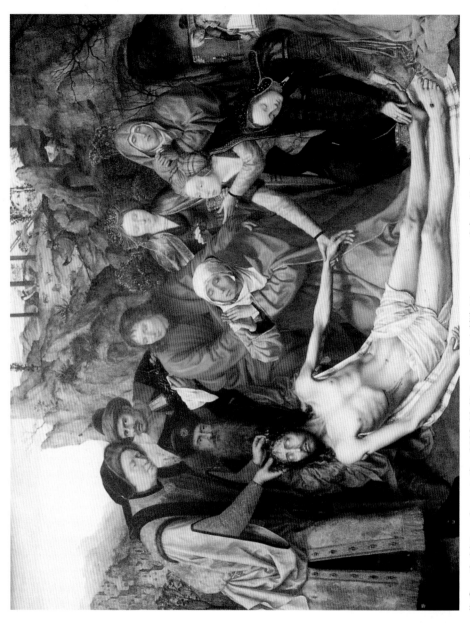

II. Quentin Metsys: *Lamentation*, 1508–11 (Antwerp, Koninklijk Museum voor Schone Kunsten)

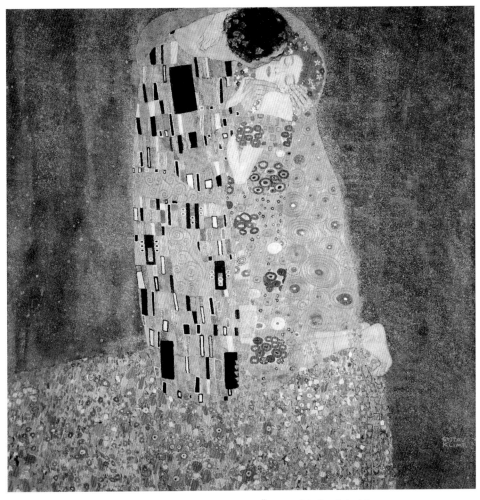

III. Gustav Klimt: *The Kiss*, 1907–8 (Vienna, Belvedere, Österreichische Galerie)

IV. William Morris: *Angeli Laudantes*, 1894 (London, Victoria and Albert Museum)

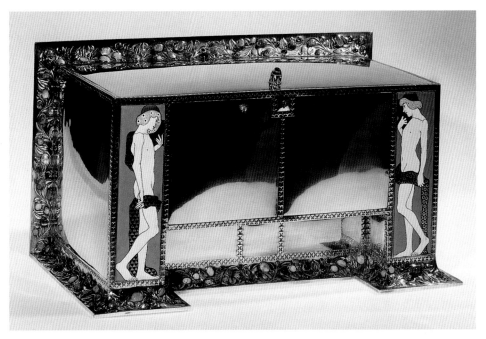

V. Kolo Moser: Decorative Coffer, 1905–6 (Vienna, Museum für Angewandte Kunst)

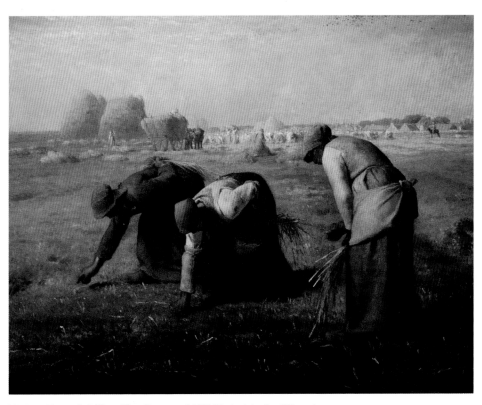

VI. Jean-François Millet: *The Gleaners*, 1857 (Paris, Musée d'Orsay)

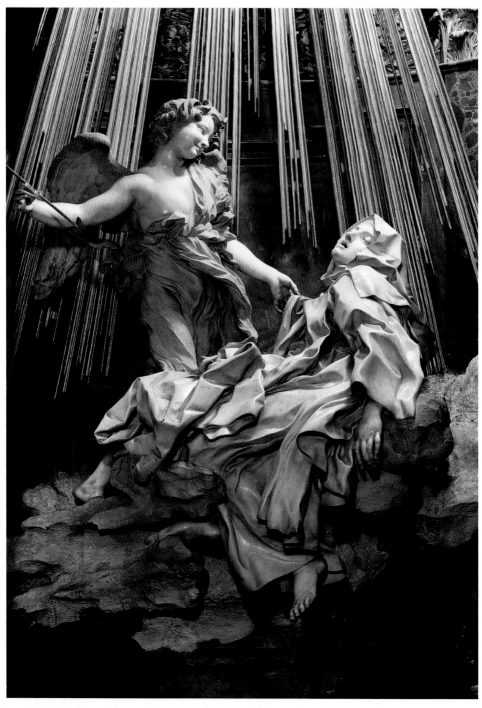

VII. Gianlorenzo Bernini: *Ecstasy of St Teresa*, 1645–52 (Rome, S Maria della Vittoria, Cornaro Chapel)

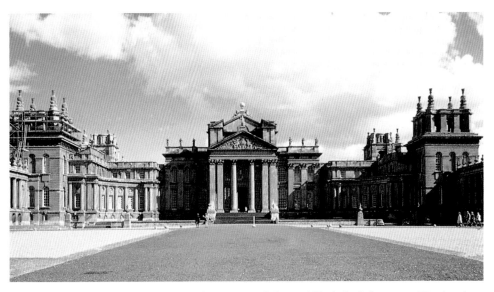

VIII. Sir John Vanbrugh and Nicholas Hawksmoor: North front of Blenheim Palace, near Woodstock, Oxon, 1705–c. 1725

IX. Michael Neder: *Scene in a Viennese Pub* (Vienna, Museen der Stadt Wien)

X. Albrecht Altdorfer: *Danube Landscape near Regensburg*, 1520–25 (Munich, Alte Pinakothek)

XI. Cornelis van Poelenburch: *Mercury and Battus* (Florence, Galleria degli Uffizi)

XII. James Hoban: White House, Washington, DC, 1792–1802

XIII. Francesco Primaticcio and Rosso Fiorentino: Galerie François I, 1532–9 (Fontainebleau, Musée National du Château de Fontainebleau)

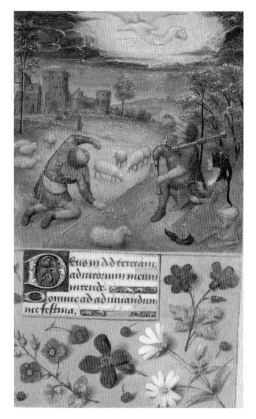

XIV. Annunciation to the Shepherds, Hours of the Virgin, Flemish, late 15th century, ms 6, *f* 41 (New York, Pierpont Morgan Library)

XV. John Chute, Richard Bentley, Robert Adam and James Essex: Strawberrry Hill, Twickenham, Middx.,1753–76

XVI. William Strickland: Second Bank of the United States, Philadelphia, PA, 1818–24

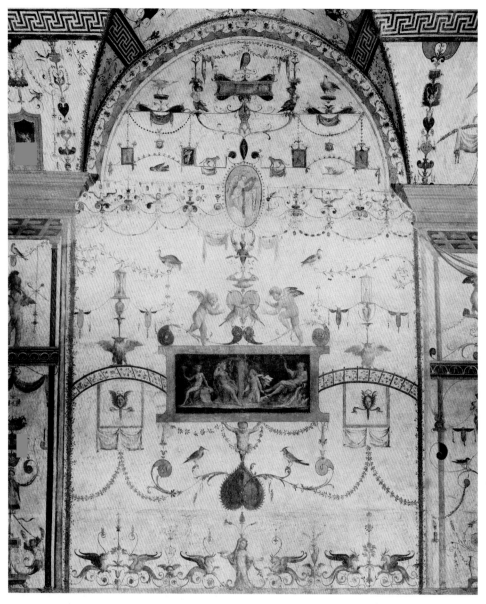

XVII. School of Raphael: Grotesque design with panel for the Vatican Loggia, 1518–19 (Rome, Vatican Palace)

XVIII. Thomas Cole: *The Pilgrim of the Cross at the End of his Journey*, *c.* 1846–8 (Washington, DC, National Museum of American Art)

XIX. Claude Monet: *Impression, Sunrise*, 1873 (Paris, Musée Marmottan)

XX. Edouard Manet: *Portrait of Emile Zola*, 1868 (Paris, Musée d'Orsay)

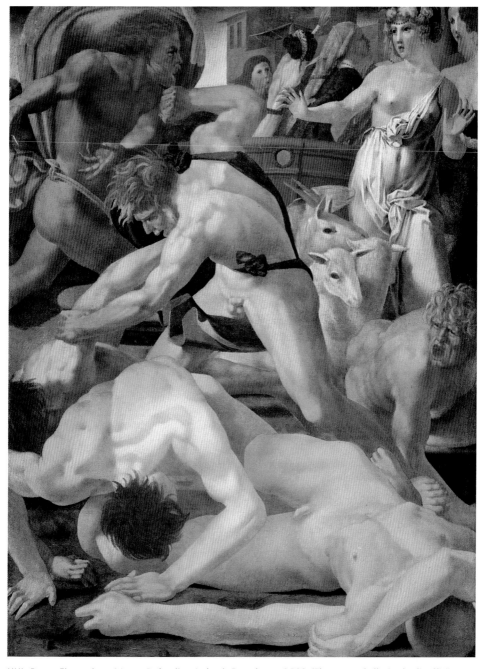

XXI. Rosso Fiorentino: *Moses Defending Jethro's Daughters*, 1523 (Florence, Galleria degli Uffizi)

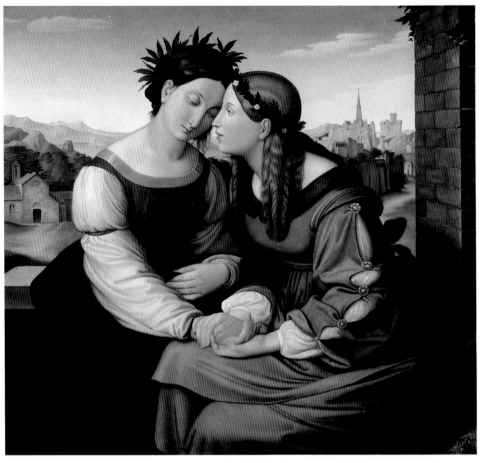

XXII. Friedrich Overbeck: *Germania and Italia*, 1811 and 1815–20 (Munich, Neue Pinakothek)

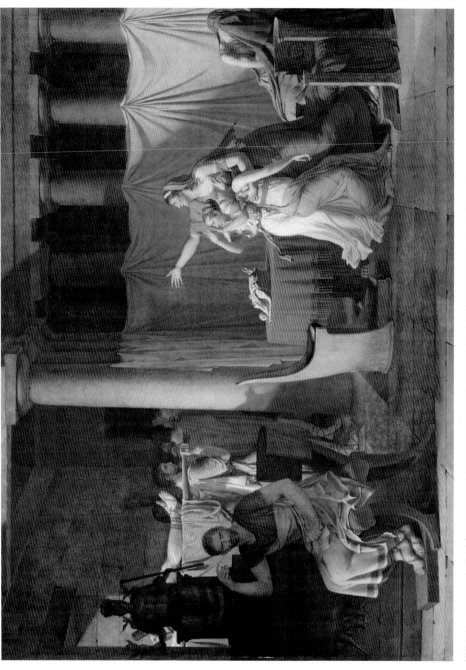

XXIII. Jacques-Louis David: *Lictors Bringing Brutus the Bodies of his Sons*, 1789 (Paris, Musée du Louvre)

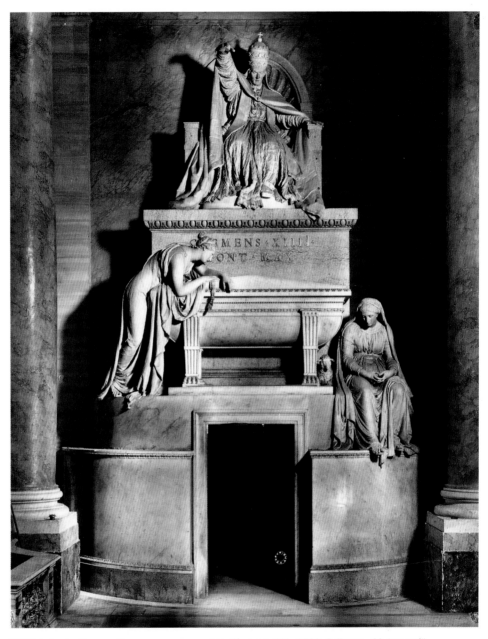

XXIV. Antonio Canova: Funerary monument to Clement XIV, 1783–7 (Rome, SS Apostoli)

XXV. Georges Seurat: *The Bathers at Asnières*, 1883 (London, National Gallery)

XXVI. Frederic Leighton: *Athlete Wrestling with a Python*, 1877 (London, Tate Gallery, on loan to Leighton House Art Gallery and Museum)

XXVII. William Kent, Richard Boyle, 3rd Earl of Burlington, and Thomas Coke: Holkham Hall, Norfolk, from 1734

XXVIII. John Frederick Lewis: *Life of the Harem, Cairo* (London, Victoria and Albert Museum)

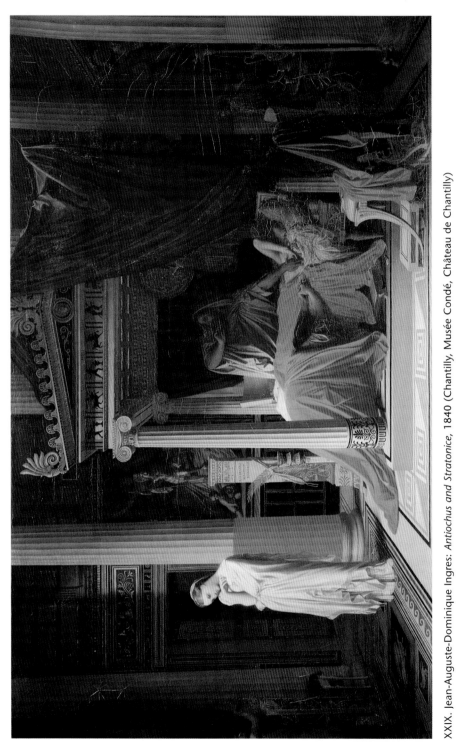

XXIX. Jean-Auguste-Dominique Ingres: *Antiochus and Stratonice*, 1840 (Chantilly, Musée Condé, Château de Chantilly)

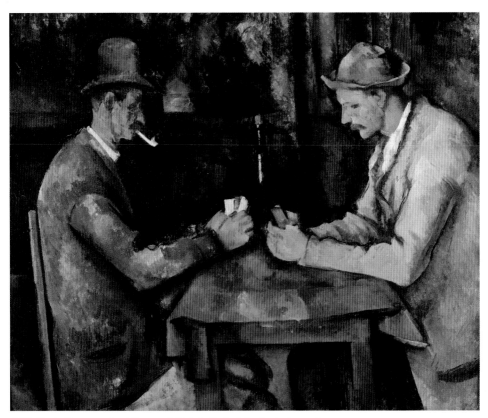

XXX. Paul Cézanne: *Card Players*, 1894–5 (Paris, Musée du Louvre)

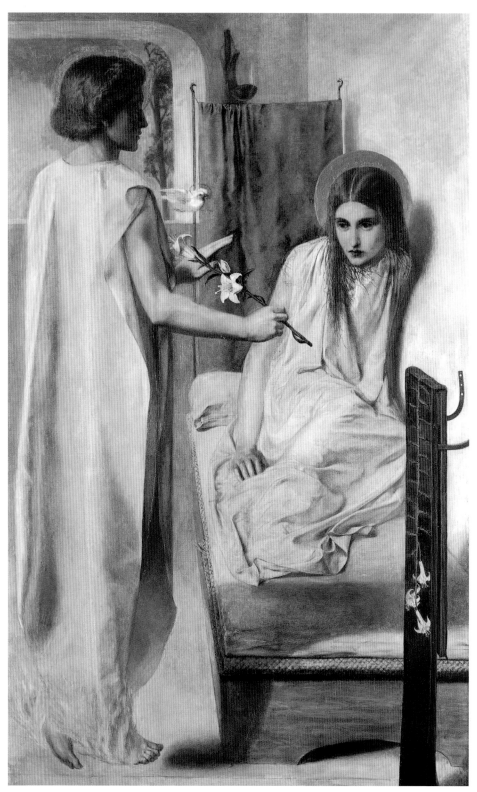

XXXI. Dante Gabriel Rossetti: *Ecce Ancilla Domini!*, 1849–50 (London, Tate Gallery)

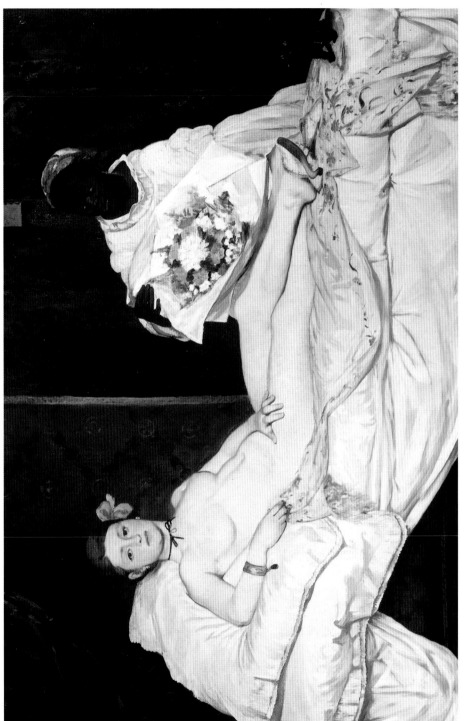

XXXII. Edouard Manet: *Olympia*, 1863 (Paris, Musée d'Orsay)

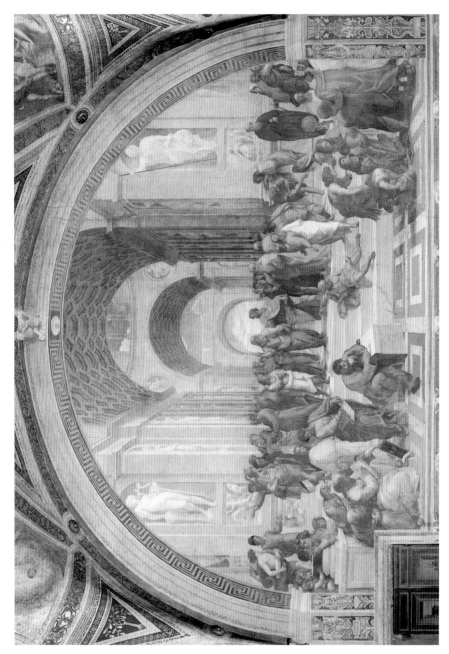

XXXIII. Raphael: *School of Athens*, c. 1510–12 (Rome, Vatican, Stanza della Segnatura)

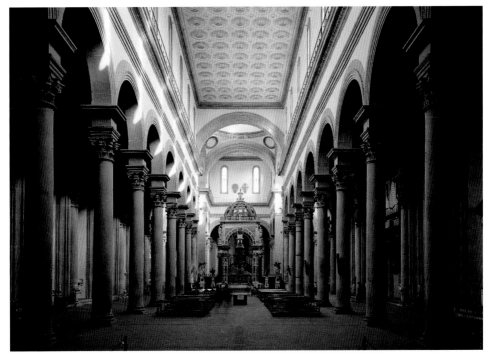

XXXIV. Filippo Brunelleschi: Interior of Santo Spirito, Florence, 1436–82

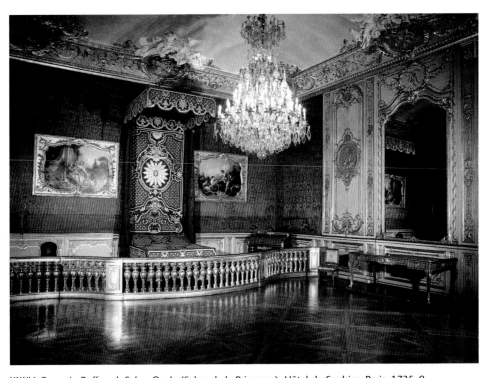

XXXV. Germain Boffrand: Salon Ovale (Salon de la Princesse), Hôtel de Soubise, Paris, 1735–9

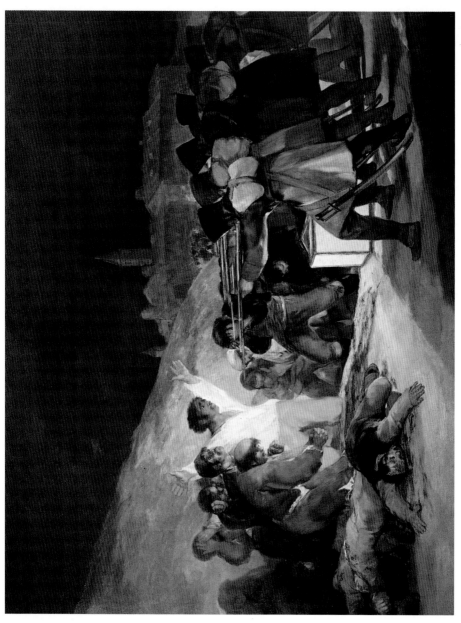

XXXVI. Francisco de Goya: *Third of May, 1808,* 1814 (Madrid, Museo del Prado)

XXXVII. J. M. W. Turner: *Rain, Steam and Speed: The Great Western Railway*, 1844 (London, National Gallery)

XXXVIII. Joseph Wright of Derby: *Vesuvius in Eruption, with a View over the Islands in the Bay of Naples* c. 1776–80 (London, Tate Gallery)

XXXIX. Paul Gauguin: *Vision After the Sermon: Jacob Wrestling with the Angel,* 1888 (Edinburgh, National Gallery of Scotland)

XL. Jean-Auguste-Dominique Ingres: *Paolo and Francesca*, 1819 (Angers, Musée des Beaux-Arts)

Although not generally considered to be a Little Master himself, Albrecht Altdorfer's small engravings (in part inspired by Italian niello engravings) strongly influenced the Little Masters. The rise in popularity of small engravings could be due to several factors: the custom of collecting them in folders and books, their applications in the decorative arts and a growing interest in miniature objects that was not to find its full expression until later in the century with the evolution of the *Kunstkammer*. The size of the Little Masters' engravings, excepting portraits and friezes, rarely exceeds that of Dürer's *Engraved Passion* series (about 117×75 mm). Their smallest works are about the size of a postage stamp.

The engravings by this group of artists encompass a wide range of Renaissance concerns, including allegory, antiquity, biblical themes, secular themes and decorative designs. Although their compositions often derive from Dürer and his contemporaries, such as the Italian Marcantonio Raimondi, the Little Masters were particularly inventive when dealing with the themes of sexuality, mortality and scenes of soldiers and peasants. The Nuremberg Little Masters fully explored these secular themes in their large woodcuts as well.

Barthel Beham may be singled out as the most gifted and inventive of the Little Masters. His first dated engravings, for example *Foot Soldier in front of a Tree* (1520; see Pauli, no. 50), done at the age of 18, display a considerable virtuosity and a preference for complex figural compositions. In 1547 Johann Neudörfer remarked that the Beham brothers and Pencz were famous for their paintings, drawings and prints and that their prints, including Sebald's entire graphic output, were still abundantly available (Neudörfer, p. 138). When Karel van Mander wrote his *Schilder-boeck* 57 years later, however, the artists had fallen into obscurity.

Bibliography

J. Neudörfer: *Des Johann Neudörfer Schreib- und Rechenmeisters zu Nürnberg Nachrichten von Künstlern und Werkleuten daselbst aus dem Jahre 1547*, ed. G. W. K. Lochner (Vienna, 1875)

W. B. Scott: *The Little Masters* (New York and London, 1879)

H. W. Singer: *Die Kleinmeister*, Künstler-Monographien, xcii (Bielefeld and Leipzig, 1908)

E. Waldmann: *Die Nürnberger Kleinmeister*, Meister der Graphik, v (Leipzig, 1910)

G. Pauli: *Barthel Beham: Ein kritisches Verzeichnis seiner Kupferstiche* (Strasburg, 1911)

H. Zschelletzschky: *Die 'drei gottlosen Maler' von Nürnberg, Sebald Beham, Barthel Beham, und Georg Pencz: Historische Grundlagen und ikonologische Probleme ihrer Graphik zu Reformations- und Bauernkriegszeit* (Leipzig, 1975)

G. Vogler: *Nürnberg, 1524/25: Studien zur Geschichte der reformatorischen und sozialen Bewegung in der Reichsstadt* (Berlin, 1982)

The World in Miniature: Engravings by the German Little Masters, 1500–1550 (exh. cat. by S. H. Goddard and others, Lawrence, U. KS, Spencer Mus. A., 1988)

K. Moxey and others: 'The Graphic Art of the Godless Painters of Nuremberg', *Register* [Lawrence, U. KS], viii/6 (1989)

STEPHEN H. GODDARD

Louis XIV style

Term applied to a style of architecture, interior décor and garden layout associated with the reign of Louis XIV of France (*reg* 1643–1715). Once he began his personal rule in 1661, the King took a passionate interest in the building and furnishing of the royal residences, notably Versailles, bringing together the most talented artists of the day to promote the power and magnificence of the monarchy. The style had its origins at Vaux-le-vicomte, the opulent late Baroque château created in the 1650s for Nicolas Fouquet, Surintendant des Finances, and the collaborative effort of the architect Louis Le Vau, the garden designer André Le Nôtre and Charles Le Brun, painter and designer. After Fouquet's disgrace and imprisonment in 1661, the three worked together to transform the King's hunting-lodge at Versailles into a statement of political absolutism.

The style is characterized by sumptuous materials, exquisite craftsmanship, a profusion of classical motifs and strict formality of organization. At Versailles, the layout of the gardens and the plan of the interior spaces were controlled by

symmetry and axial planning. The *grands apparte-ments* were arranged *en enfilade*, each opening on to the next with doors aligned to create lengthy vistas. Walls were covered with slabs of variegated marble divided by pilasters supporting bracketed cornices. Ceilings were painted with allegorical or mythological scenes celebrating the glory of the Sun King. Gilt stucco carved with trophies, helmets and Victories, and marble reliefs and classical busts on pedestals contributed a heavy, masculine element to the style. Pictorial tapestries were used extensively, sometimes hung above a marble dado. Plate-glass mirrors, sometimes lining the entire wall as in the Galerie des Glaces at Versailles, lightened the whole while reflecting the rich polychromy and varied texture of the interiors. In furniture the grand Italian Baroque style was allied with a more restrained French classical spirit. Cabinets, in ebony with panels of pietra dura and gilt bronze mounts, designed by Domenico Cucci and veneered with tortoiseshell and brass in the manner of André Charles Boulle, or with floral marquetry in the Dutch fashion of Pierre Gole, were grand showpieces. Solid silver furniture was produced at the Gobelins manufactory for the Galerie des Glaces but was melted down in 1689 to help pay for the King's wars. The taste for exotic imports from East Asia encouraged the use of lacquered or japanned panels on many forms of furniture. Blue-and-white porcelain, avidly collected since the beginning of the 17th century, was displayed on brackets, massed on top of cabinets or used to decorate entire rooms or Porcelain Cabinets. In all media, ornament included such classical motifs as scrolls and volutes, palmettes, grotesques, satyrs' masks and caryatids as well as bands of arabesque strapwork. A lighter note appeared *c.* 1710, reflecting the influence of the ornamentalists Jean Bérain, Claude Audran III and Pierre Le Pautre III. Such new elements as lambrequins, grotesques, putti, torches, arrows and quivers linked with ribbons, garlands and interlaced initials marked the emergence of the RÉGENCE STYLE.

Despite its magnificence, or perhaps because of it, the Louis XIV style proved highly adaptable as an art of political propaganda; it was widely emulated by other European monarchs and their colonial representatives (*see* WILLIAM AND MARY STYLE). Because of the strict control and high standards of the royal manufactories, France became pre-eminent in the arts of decoration and design during this period, and the products of French craftsmanship were widely sought after and exported. In the 20th century the term has lost the connotation of programmatic unity and is primarily used to describe the decorative arts.

Bibliography

E. Dacier: *Le Style Louis XIV* (Paris, 1939)

R. A. Weigert: *Le Style Louis XIV* (Paris, 1941)

L. Hautecoeur: *L'Architecture classique en France* (Paris, 1948)

P. Pradel: *L'Art au siècle de Louis XIV* (Paris, 1949)

Louis XIV: Faste et décors (exh. cat., Paris, Mus. A. Déc., 1961)

P. Verlet: 'Louis XIV', *Styles, meubles, décors du Moyen Age à nos jours*, ed. P. Verlet (Paris, 1972), pp. 223–39

J. Féray: *Architecture intérieure et décoration en France, des origines à 1875* (Paris, 1988)

M. Eleb-Vidal and A. Debarre Blanchard: *Architectures de la vie privée: Maisons et mentalités XIIe–XIXe siècle* (Brussels, 1989)

MONIQUE RICCARDI-CUBITT

Louis XV style

Term used primarily in France for a style of interior decoration and decorative arts between *c.* 1700 and 1750, which roughly corresponds to the period of the Régence (1715–23) and the first half of the reign of Louis XV (1723–74). The term is used to describe the style that developed from the RÉGENCE STYLE and the Rococo style in France (*see* ROCOCO, §II). The style was influenced by a more informal, intimate and comfortable way of life, reflecting the increasingly important role of women in social life. The production of decorative arts was encouraged by the influential patronage of the King's mistress, the Marquise de Pompadour, and her circle at court, and by the influence on design of the marchands-merciers. The style suited the interior decoration of *petits appartements* in the Hôtel particulier,

with *boiseries* carved in the sinuous Rococo style, as for example the interiors of the Hôtel de Soubise, or incorporating Chinoiserie and Singerie motifs or the *genre pittoresque* introduced by Juste-Aurèle Meissonnier and Nicolas Pineau, painted in light shades of colour or picked out in gilt or a contrasting colour. *Boiseries*, furniture, chimney-pieces, and light fittings were often designed as an ensemble, providing a harmonious elegance to the interior. The influence of women is reflected in the new forms of furniture that appeared at this time, for example the *marquise* (sofa), the *duchesse* (chaise-longue), the *bergère* (chair), and all manner of small, delicate *bonheurs-du-jour* (work-table), many fitted with porcelain plaques from the Sèvres porcelain factory or with elaborate mechanisms. An interest in contrasting colours and luxurious materials is reflected in the use of complex pictorial or geometric marquetry by the cabinetmaker Jean-François Oeben, the widespread use of elaborate *bronzes d'ameublement* and gilt-bronze mounts for furniture and the use of lacquer and japanning. Porcelain, notably from the factories of Vincennes and Sèvres, and faience from Marseille and Strasbourg reflected the influence of the Rococo, as did metalwork, tapestries and textiles. The Louis XV style waned in popularity from *c.* 1750, probably as a reaction against its frivolity and lightness, to be gradually replaced by the emerging Neo-classical style, which is known as the Transitional style (*see* LOUIS XVI STYLE).

Bibliography

F. Kimball: *The Creation of the Rococo* (Philadelphia, 1943, rev. New York, 1980)

C. Mauricheau-Beaupré: *L'Art au XVIIIe siècle en France*, 2 vols (Paris, 1946–7)

Louis XV et Rocaille (exh. cat., Paris, Mus. Orangerie, 1950)

E. Dacier: *L'Art au 18e siècle en France: Régence/Louis XV* (Paris, 1951)

P. Verlet: *Les Ebénistes français du XVIIIe siècle* (Paris, 1963)

——: *French Furniture and Interior Decoration of the 18th Century* (London, 1967)

P. Verlet, ed.: 'Louis XV', *Styles, meubles, décors du Moyen Age à nos jours* (Paris, 1972), pp. 222–39

MONIQUE RICCARDI-CUBITT

Louis XVI style

Term loosely referring to a decorative style in France that first emerged in the 1750s and was fully developed before Louis XVI succeeded to the throne in 1774. In 1754 the engraver Charles-Nicolas Cochin II appealed to craftsmen for a return to the restraint and discipline of the Antique, an appeal that reflected the larger philosophical and artistic movement of the Enlightenment. Between 1749 and 1751 Cochin undertook a tour of Italy in the company of Abel-François Poisson de Vandières (later the Marquis de Marigny and the future Directeur des Bâtiments du Roi), the architect Jacques-Germain Soufflot and the Abbé Le Blanc, which furthered the interest in the Antique. The discovery of Herculaneum (1738) and Pompeii (1748) was followed by numerous publications on antiquity, among them Cochin's own work, *Observations sur les antiquités de la ville d'Herculanum* (Paris, 1754) and *Recueil d'antiquités égyptiennes, étrusques, grecques, romaines et gauloises* (Paris, 1752–67) by the Comte de Caylus. These discoveries and subsequent publications stimulated a passion for the GOÛT GREC in France, the first, austere phase of NEO-CLASSICISM, for which such Classical motifs as the Anthemion, Palmette, Bucranium, Vitruvian scroll, Greek key and Guilloche were employed. Although it was the decoration and not the form of French furniture of this period that reflected the Antique, one new form that did emerge was the *athénienne*, a tripod form that could, for example, be used as a washstand, candelabrum or perfume burner.

This severe, pure style of decoration was superseded by the Transitional style, which moved away from the excesses of the Rococo style and heralded the Neo-classical style. *Rinceaux*, ribbon and floral motifs are used in a restrained, symmetrical manner, adding elegance and refinement to military trophies and Classical ornament. Geometrical forms and ornament—fluting, reeding, the lozenge, wreath and rosette—were generally used to great effect in furniture, porcelain and metalwork. The Transitional style also maintained certain elements typical of the Baroque, and there was a renewed interest in pietre dure and the

marquetry of André-Charles Boulle. Most specialist craftsmen adapted successfully to each different stylistic phase. By the 1770s the Transitional style had given way to the 'genre Arabesque' or 'goût étrusque' (*see* ARABESQUE STYLE and ETRUSCAN STYLE).

Bibliography

S. de Ricci: *Le Style Louis XVI: Meubles et décoration* (Paris, 1913)

P. Verlet: *Le Mobilier royal français* (Paris, 1945–55)

Mauricheau-Beaupré: *L'Art au XVIIIe siècle en France* (Paris, 1947)

P. Verlet: *Les Ebénistes français du XVIIIe siècle* (Paris, 1963)

M. Gallet: *Demeures parisiennes à l'époque de Louis XVI* (Paris, 1964)

G. Janneau: *L'Epoque Louis XVI* (Paris, 1964)

P. Verlet: *Louis XVI: Styles, meubles, décors* (Paris, 1972)

S. Eriksen: *Early Neo-classicism in France* (London, 1974)

MONIQUE RICCARDI-CUBITT

Luminism

Term coined *c.* 1950 by the art historian John I. H. Baur to define a style in 19th-century American painting characterized by the realistic rendering of light and atmosphere. It was never a unified movement but rather an attempt by several painters working in the USA to understand the mysteries of nature through a precise, detailed rendering of the landscape. Luminism flourished *c.* 1850–75 but examples are found both earlier and later. Its principal practitioners were Fitz Hugh Lane, Martin Johnson Heade, Alfred Thompson Bricher, David Johnson and Francis Augustus Silva (1835–86). Several artists of the HUDSON RIVER SCHOOL, among them Sanford Robinson Gifford, John F. Kensett and Albert Bierstadt, painted works that could be considered examples of Luminism, as did such Canadian painters as Lucius R. O'Brien (e.g. *Sunrise on the Saguenay*, 1880; Ottawa, N.G.).

The Luminists concentrated on nuances of light and atmosphere, an approach that may have been suggested by the new, dispassionate medium of photography. The work of slightly earlier 19th-century European artists, such as the German Caspar David Friedrich and the Dane Christen Købke, may also have been influential. Even earlier precedents for Luminist paintings are the works of such 17th-century Dutch masters as Jacob van Ruisdael. *Atmospheric Landscapes of North America*, a series of watercolours by George Harvey (1800–78) executed in the mid- and late

46. Alfred Thompson Bricher: *Castle Rock, Marblehead*, 1878 (Washington, DC, National Museum of American Art)

1830s, was perhaps the first purely Luminist manifestation in American art. Lane's work recalls the earlier paintings of Thomas Birch and especially those of Robert Salmon, an English marine painter active in Boston in the 1830s. However, a more direct influence came from the Transcendentalists, such as Ralph Waldo Emerson (1803–82), who saw nature as the ultimate expression of God's will. In a manner akin to pantheistic communion, Luminist painters strove for this sharpened sense of the awareness of nature's mysteries through concentrated meditation on the landscape.

Luminist paintings have several common characteristics. They show no picturesque details of landscape, have a great sense of interior depth and are usually sparsely composed and peopled with few or no figures, as in Bricher's *Castle Rock, Marblehead* (1878; Washington, DC, N. Mus. Amer. A.; see fig. 46) or Lane's *Owl's Head, Penobscot Bay, Maine* (1862; Boston, MA, Mus. F.A.. Their dimensions are broad and horizontal, though not encompassing the spectacular panoramic sweep typical of the work of Thomas Cole and Frederic Edwin Church. The main subjects are often sunlight or moonlight, which shines through a cloudless sky revealing crisply outlined forms. The mood tends to be one of magical and eerie stillness, enhanced by the inclusion of calm, glossy surfaces of water. Sometimes, however, impending storms were portrayed, as in Heade's *Thunderstorm over Narragansett Bay* (1868; Fort Worth, TX, Amon Carter Mus.). In Lane's *Western Shore with Norman's Woe* (1862; Gloucester, MA, Cape Ann Hist. Assoc.) a background haziness characteristically gives way to a pellucid foreground. Brushstrokes are generally invisible, and there is evidence of careful draughtsmanship. Lane, for example, painted his works in the studio using detailed pencil drawings, which he squared for transfer. The preferred locales were New England, New Jersey and Long Island. Among other regions, Heade favoured upstate New York (e.g. *Lake George*, 1862; Boston, MA, Mus. F.A) By the 1870s Luminist paintings began to be superseded by less detailed views rendered in the looser brushstrokes of the Impressionist technique.

Bibliography

J. I. H. Baur: 'Early Studies in Light and Air by American Painters', *Brooklyn Mus. Bull.*, ix/2 (1948), pp. 1–9
—: 'Trends in American Painting, 1815–1865', *M. and M. Karolik Collection of American Paintings, 1815 to 1865* (Cambridge, MA, 1949)
—: 'American Luminism, a Neglected Aspect of the Realist Movement in Nineteenth-century American Painting', *Persp. USA*, 9 (1954), pp. 90–98
Luminous Landscape: The American Study of Light, 1860–1875 (exh. cat. by G. Davidson, P. Hattis and T. Stebbins jr, Cambridge, MA, Fogg, 1966)
W. J. Naef and J. N. Wood: *Era of Exploration: The Rise of Landscape Photography in America* (New York, 1974)
The Natural Paradise: Painting in America, 1800–1950 (exh. cat., ed. K. McShine; New York, MOMA, 1976)
B. Novak: *Nature and Culture: American Landscape and Painting, 1825–1875* (New York, 1980)
American Light: The Luminist Movement, 1850–1875: Paintings, Drawings, Photographs (exh. cat., ed. J. Wilmerding; Washington, DC, N.G.A., 1980)
E. G. Garrett: *The British Sources of American Luminism* (diss., Cleveland, OH, Case W. Reserve U., 1982)

JOHN I. H. BAUR

Macchiaioli

Group of Italian artists based in Tuscany during the second half of the 19th century. The formation of the group between 1853 and 1860 coincided with the Paris Exposition Universelle and popular acceptance of the Barbizon school and of Camille Corot, who influenced them indirectly. In 1854 Serafino De Tivoli (1826–92) was one of a group of *plein-air* painters who called themselves the Scuola di Staggia. At about the same time Telemaco Signorini, Vincenzo Cabianca (1827–1902) and Odoardo Borrani (1834–1905) formed their own group, which was joined by Giovanni Fattori and Vito D'Ancona (1825–84) in 1855, Raffaello Sernesi (1838–66) and Silvestro Lega in 1859, and by Cristiano Banti (1824–1904) and Giuseppe Abbati (1836–68) in 1860. United by common artistic and political sentiments of opposition to the formal teaching of the Florentine Accademia di Belle Arti and support for Italian unification, these ten artists formed the first nucleus of the *Macchiaioli* group.

Isolated in their early years by the repressive political situation preceding Italian unification, the group kept up with wider European artistic trends through banned foreign periodicals and contact with artists who had been abroad. Domenico Morelli, Saverio Altamura (1826–97) and De Tivoli brought news from the Paris art world in 1855. Signorini and others met Edgar Degas in Florence in 1856. Giovanni Costa came to Florence in 1859 and for ten years was their friend and adviser. Marcellin Desboutin, French writer, poet, painter and antiquarian, was influential between 1857 and 1874. By 1861, when they were able to travel abroad, numerous artists, especially Signorini, began to make regular trips to Paris, London and Edinburgh.

While in Florence, the *Macchiaioli* frequented the Caffè Michelangiolo, which was favoured by artistic and political rebels until 1860. It was there that Signorini met Diego Martelli, whose moral and material support became vital to the group. His farm at Castiglioncello in the Tuscan Maremma was a gathering-place for the *Macchiaioli*, especially between 1861 and 1867, and many works were produced there (e.g. Odoardo Borrani, *Sea coast at Castiglioncello*, c. 1864–5; Florence, Pitti).

At first the *Macchiaioli* called themselves *Effettisti*, probably deriving the term from the French *effet*, used to describe the results of light and shade distribution in paintings and photographs. Their painting technique eschewed halftones; they claimed that 'effect' was achieved through the use of broad patches of colour, *macchie*, which moved abruptly from dark to light. *Macchia* translates as spot, blot or daub. In 1862 a Florentine critic dubbed them *Macchiaioli*, or spot-makers, ridiculing them as daubers who left their paintings unfinished; the name was then adopted by the group. Because the theories of the *Macchiaioli* were not written down until the 1870s and 1880s, its contemporary historians, Martelli, Signorini and Adriano Cecioni, may have shaped their descriptions of the early movement to conform with later experiences; thus Martelli saw Fattori's works as 'impressions' after becoming acquainted with Impressionism. According to

Martelli, the *macchia* was 'the theory of chiaroscuro and the relationship of one colour with another, whether they were found next to one another on the canvas on the same perspective plane or ... juxtaposed on the canvas but in different perspective planes'. Cecioni wrote: '*Il vero* [nature, as we see it] results from *macchie* of *colour* and of *chiaroscuro*, each one of which has its own value, which is measured by means of *relationship*. In every *macchia* this relationship has a double value: as light or dark, and as colour.' Cecioni also spoke of the use of a black mirror, or 'Claude glass', to help establish colour values and relationships. Such theories and research were inspired by two 19th-century concerns, the search to understand colour through science and the revival of interest in the Italian artistic past.

The word *macchia* had been part of the artistic vocabulary of the Italian Renaissance; it was used by Vasari in 1550 to describe the stage in a painting when the colours are blocked out in a flat, simplified scheme before the execution of the finished painting. Some scholars have accepted this traditional practice as the source of the *macchia* adopted by the *Macchiaioli* in their small, sketch-like paintings. Vasari also used the term in describing the loose finish in Titian's late manner. In 1660 Marco Boschini wrote a lengthy poetic description of the Venetian *macchia*, in which gesture, impasto, blurring of outline, colour reflections and the optical interplay of warm and cool colours were preferred to the smooth surfaces and hard outlines of Florentine painting. There are many points of similarity between Renaissance and 19th-century uses of the *macchia*, and in many ways the works of the *Macchiaioli* are part of a specifically Italian tradition of painting.

Nationalist sentiments were an important element of their ethos as a group; in their adoption of the local landscape as their main subject and in their identification with the ideals of Garibaldi and Mazzini, they were thoroughly bound up with the contemporary world. Their depiction of ordinary folk engaged in everyday activities in traditional Renaissance pictorial space was typically Realist (Silvestro Lega, *The Pergola*, 1868; Milan, Brera). They were not

Impressionists, and did not wish to be, in spite of Martelli's attempts to link them with contemporary French painting. While Impressionists and *Macchiaioli* both aimed for spontaneity and immediacy of effect, the Impressionists pursued effects of light and colour at the expense of form and depth, while *macchia* painting used light and colour to create form and pictorial space. Furthermore, the Impressionists used the 'scientific' colours of Isaac Newton, while the *Macchiaioli* palette, though bright, remained more traditionally Romantic.

Modern technology was not shunned, however; the use of photographs, documented by Signorini in 1874, can be detected in the group's more topographical views and in some figurative works that resemble photomontages, such as Signorini's *Leith* (1881; Florence, Pitti). The experiments of Fattori and Signorini with the colours and spatial organization of Japanese prints were noted at the time and have been documented (Gray Troyer, 1978). Some of the *macchia* paintings from as early as 1860 show a remarkable geometric reduction and abstract simplicity for their dating (Giuseppi Abbati, *Cloister, c.* 1861–2; Florence, Pitti).

Most *Macchiaioli* works have remained in Italian collections, and most of the literature on the group is in Italian. Scholars outside Italy have recently given the *Macchiaioli* a broader historical viewpoint and audience. A second generation of Italian *macchia* painters carried the technique into the 20th century.

Bibliography

T. Signorini: 'Cose d'arte', *Il Risorgimento* (June 1874); repr. in E. Somaré: *Signorini* (Milan, 1926), pp. 256–9

A. Cecioni: 'Vincenzo Cabianca', *Scritti e ricordi*, ed. G. Uzielli (Florence, 1905)

D. Martelli: 'Giuseppi Abbati', *Scritti e ricordi di Diego Martelli*, ed. A. Boschetto (Florence, 1952)

N. Broude: *The Macchiaioli: Academicism and Modernism in Nineteenth Century Italian Painting* (diss., New York, Columbia U., 1967)

—: 'The Macchiaioli: Effect and Expression in Nineteenth-century Florentine Painting', *A. Bull.*, lii (1970), pp. 11–21

—: 'The Macchiaioli as "Proto-Impressionists": Realism, Popular Science and the Re-shaping of *Macchia*: Romanticism, 1862–1886', *A. Bull.*, lii (1970), pp. 404–14

—: 'An Early Friend of Degas in Florence: A Newly Identified Portrait Drawing of Degas by Giovanni Fattori', *Burl. Mag.*, cxv (1973), pp. 726–35

I Macchiaioli (exh. cat. by D. Durbé and S. Pinto, Florence, Forte Belvedere, 1976)

N. Gray Troyer: *The Macchiaioli: Effects of Modern Color Theory, Photography and Japanese Prints on a Group of Italian Painters, 1855–1900* (diss., Evanston, IL, Northwestern U., 1978)

I Macchiaioli: Peintres en Toscane après 1850 (exh. cat. by D. Durbé, Paris, Grand Pal., 1978)

D. Durbé and G. Matteucci: *30 Macchiaioli inediti* (Rome, 1980)

N. Gray Troyer: 'Telemaco Signorini and Macchiaioli Giapponismo', *A. Bull.*, lxvi (1984), pp. 136–45

N. Broude: *The Macchiaioli: Italian Painters of the Nineteenth Century* (New Haven and London, 1987)

A. Boime: *The Art of the Macchia and the Risorgimento: Representing Culture and Nationalism in Nineteenth-century Italy* (Chicago, IL, 1993)

NANCY GRAY TROYER

Mälardal school

Term applied to several workshops of wall painters, active between *c.* 1400 and the 1460s in the provinces around the lake of Mälaren, Sweden, and in Finland, showing many common stylistic features. Several of the workshops display, to varying degrees, traces of the *Schöne Stil*, the German and Bohemian version of International Gothic, characterized by soft drapery folds and elegant curved figures. Another characteristic feature is a sometimes rather graceful vine ornamentation surrounding the figures. Many of the paintings, however, are of a provincial character. Among the more important painters of this school are the Master of Fogdö, who signed the paintings in Tensta Church, near Uppsala, in 1437; the Master of Ärentuna (*fl c.* 1435–40); and the master of the paintings in Litslena Church, which have been dated to *c.* 1470 but which show stylistic features from the early half of the century. Since most painters of this school are anonymous, very little is known about their origin, although it is likely that some of the painters were Swedish.

Stylistically, the Master of Ärentuna has much in common with Master Bertram in Hamburg and may have been German. His paintings are closely related to those in Vaksala and Färentuna, near Uppsala, and in the former Franciscan church in Arboga, Västmanland. The works in the sacristy in Kalanti, Finland, can also bĭe compared with those in Vaksala, while those in Litslena Church, near Uppsala, show stylistic similarities with a number of wall paintings in the area of Uppsala and in Södermanland, for example in Strängnäs Cathedral (1462–3). The artists of the Mälardal school certainly had common roots in Swedish 14th-century wall painting; while their work did show various different stylistic features, these overlapped and make it difficult to isolate an 'Ärentuna school' or a 'Strängnäs school'. The shared stylistic qualities are also, to a certain degree, more characteristic of the period than the region.

Bibliography

L. Wennervirta: *Suomen keskiaikainen kirkkomaalaus* [Medieval church painting in Finland] (Porvoo and Helsinki, 1937), pp. 232–4 [summary in Ger.]

B. G. Söderberg: *Svenska kyrkomålningar från medeltiden* [Swedish church paintings from the Middle Ages] (Stockholm, 1951), pls 78–81, 88–90, 109–11, 121–2, 133–5, 140

H. Cornell and S. Wallin: *Stockholmer Malerschulen des 15. Jahrhunderts* (Stockholm, 1961), pls 1–28, 37–50

A. Nilsén: *Program och funktion i senmedeltida kalkmåleri: Kyrkmålningar i Mälarlandskapen och Finland 1400–1534* [Programme and function in late medieval wall painting: church painting in the Mälaren region and Finland 1400–1534] (Stockholm, 1986), pp. 9–10, 517, 544

ANNA NILSÉN

Mannerism [It. *maniera*]

Name given to the stylistic phase in the art of Europe between the High Renaissance (*see* RENAISSANCE, §4) and the Baroque, covering the period from *c.* 1510–20 to 1600. It is also sometimes referred to as late Renaissance, and the move away from High Renaissance classicism is already evident in the late works of Leonardo da Vinci and Raphael, and in the art of Michelangelo from the middle of his creative career. Although 16th-century artists took the formal vocabulary of the High Renaissance as their point of departure, they used it in ways that were diametrically opposed to the harmonious ideal it originally served. There are thus good grounds for considering Mannerism as a valid and autonomous stylistic phase, a status first claimed for it by art historians of the early 20th century. The term is also applied to a style of painting and drawing practised by artists working in Antwerp slightly earlier, from *c.* 1500 to *c.* 1530 (*see* ANTWERP MANNERISM).

1. History of the term

The multitude of opposing tendencies in 16th-century art makes it difficult to categorize by a single term, a difficulty increased by the importance Mannerism placed on conflict and diversity. The word '*maniera*' was first applied to the visual arts in 1550 by Giorgio Vasari. He used the words '*maniera greca*' to describe the Byzantine style of medieval artists, which yielded to the naturalism of the early Renaissance, and he wrote of the '*maniera*' of Michelangelo, which deeply influenced later 16th-century art. This gave rise to the modern concept of Mannerism as a description for the style of the 16th century. Although in 18th- and 19th-century art theory Mannerism was regarded as marking a decline from the High Renaissance, in the early 20th century critics recognized its affinities with contemporary artistic movements, and Mannerist art was highly esteemed. At the same time its importance in leading to the Baroque was appreciated, as were those aspects that opposed the classical stability of the High Renaissance.

2. Historical context

Mannerist art can be understood only in the context of profound social, religious and scientific turmoil. The Reformation officially started when Martin Luther nailed up his theses in 1517; the Counter-Reformation opposition started from the time of the Council of Trent in 1545. The Protestant doctrine of justification by faith

challenged fundamental Catholic dogmas, and the Church of Rome could no longer exert its spiritual authority effortlessly, even in areas where the Counter-Reformation prevailed. The Sack of Rome in 1527 was interpreted as a retribution for moral decline and the glorification of luxury and sensuality. North of the Alps the structure of society was destabilized by the Peasants' Wars of 1524–5 in Germany. The discovery of the New World in the late 15th century and the early 16th must have had an equally momentous impact on the Christian West's concept of itself. The Old World could no longer see itself as the centre of the earth, but was revealed as a relatively small area within an immeasurable and largely still unexplored whole with incalculable potential. On top of this came Copernicus's recognition of the heliocentric planetary system (c. 1512). A completely new view of the world came into being. The varied forms of Mannerist art evolved against this background. The art of the 16th century as

a whole reflects deep doubts over the classical principles, normative proportions and lucid space of the High Renaissance. Mannerism may be described as the most wilful and perverse of stylistic periods.

3. Formal language

(i) Movement. For the first time in Western art the painting and sculpture of the 16th century made the optical suggestion of movement a central creative concern. In painting this mainly affected subjects that suggest the passage of time, such as the Assumption of the Virgin or scenes from the Life of Christ, such as the Deposition and the Entombment. Examples include the *Lamentation* by Pontormo (1525–8; Florence, S Felicità; see fig. 47), Tintoretto's *Bacchus and Ariadne* (c. 1575; Venice, Pal. Ducale) and, north of the Alps, Pieter Bruegel the elder's *Parable of the Blind* (1568; Naples, Capodimonte). In sculpture this interest in movement inspired the creation of single figures or groups of figures that can be viewed from all sides, rather than from a single point; just as the figure seems to be in perpetual movement, so the spectator is encouraged to keep moving around it. Giorgio Vasari coined the expression '*figura serpentinata*' (serpentine line) to describe this concept. The style was developed by Benvenuto Cellini in his *Perseus with the Head of Medusa* (1545–54; Florence, Loggia dei Lanzi) and subsequently by Giambologna in such works as *Mercury* (1580; Florence, Bargello) and the *Rape of a Sabine* (1582; Florence, Loggia dei Lanzi).

47. Pontormo: *Lamentation*, 1525–8 (Florence, S Felicità)

(ii) Spiritual intensity. Endeavours to depict the spiritual were equally characteristic of Mannerism, especially in the field of painting. Medieval artists set weightless figures against a spaceless gold ground to suggest the realm of the Divine; in the Renaissance an interest in naturalistic description and anatomy subordinated the depiction of the transcendental. In Renaissance art the 'miracle is a process like any other earthly event' (Frey). For example, in Raphael's *Disputa* the heavenly and earthly spheres are bound together by being represented with equal reality. Mannerism, however, developed new means of distinguishing between

the earthly and the divine, and in Mannerist art 'the world beyond intrudes into the world below' (Frey). The High Renaissance had paved the way for this process: Raphael, for instance, suggested the miraculous in the *Liberation of St Peter* (1514; Rome, Vatican, Stanza di Eliodoro) through the representation of light.

A new painterly concept was the necessary basis for representing the spiritual. In 15th-century painting line dominated over colour. Line fixes an object on a flat surface, making it appear tangible and real. Leonardo da Vinci countered this with a new emphasis on colour, as in the *Virgin and Child with St Anne* (c. 1515; Paris, Louvre). In his art line gave way to the subtle modulation of tone, and this concept deeply influenced 16th-century painting, especially in Venice and Emilia. Forms become less tangible and clearly defined, and while line primarily appeals to the intellect, colour speaks first and foremost to the emotions. Thus the conditions were set for the viewer to be overwhelmed by the miracle made visible in the picture.

This new potential was most fully realized in pictures of apparitions and visions. Titian's *Virgin and Child with SS Francis and Aloysius and the Donor Alvise Gozzi* (1520; Ancona, Pin. Com.), in which the Virgin miraculously appears to saints and to the donor, Alvise Gozzi, was of fundamental importance to the development of this theme. Many of Parmigianino's paintings, such as the *Vision of St Jerome* (commissioned 1526; London, N.G.) and the *Virgin and Child with SS Mary Magdalene, John the Baptist and the Prophet Zachariah* (c. 1530; Florence, Uffizi), were influenced by this work by Titian. Even the events described in the New Testament as taking place in this world were transposed into the divine realm, as in Titian's late version of the *Annunciation* (before 1566; Venice, S Salvatore) and Tintoretto's *Last Supper* (1592–4; Venice, S Giorgio Maggiore). Both the interest in movement and the representation of saintly visions and ecstasies were features developed by Baroque artists.

(iii) **Space.** Closely linked with giving visible expression to the spiritual was the endeavour to represent the infinite. In both architecture and painting the Renaissance had created space that was clearly defined on all sides. The viewer was provided with a definite frame and a fixed viewpoint. In the 16th century this situation was reversed. This development took place in stages. Initially the construction of pictorial space began to dominate over the animation of the surface. Here again the roots of the change can be found in the High Renaissance. Raphael's *School of Athens* (completed 1512; Rome, Vatican, Stanza della Segnatura; see col. pl. XXXIII) and the *Expulsion of Heliodorus* (1512–14; Vatican, Stanza di Eliodoro), in compositions based on the same principles, demonstrate the development from the primacy of surface to the primacy of space. In the second stage the space represented in pictures is seemingly extended into infinity: as in Francesco Salviati's fresco *Bathsheba Going to David* (1552–4; Rome, Palazzo Sacchetti), Tintoretto's *Rediscovery of the Body of St Mark* (before 1566; Milan, Brera) or Giambologna's relief of the *Rape of a Sabine* (1582; Florence, Loggia dei Lanzi). In the final stage, the side boundaries, too, are made transparent or even removed, as for example in Tintoretto's painting of the *Transportation of the Body of St Mark* (1562; Venice, Accad.) or Parmigianino's *Madonna of the Long Neck* (1534–40; Florence, Uffizi; see fig. 48). This last painting also epitomizes a further defiance of High Renaissance lucidity: the architectural features and figures are no longer rationally united. Data relating to proportion and perspective space are at variance with one another, as is also the case in Pontormo's earlier panels illustrating the *Story of Joseph* (1515–18; London, N.G.).

North of the Alps the impression of infinite space was conveyed by means different from those used in Italian painting, as northern artists were less skilled in the refinements of mathematical perspective. The world landscape (*Weltlandschaft*), seen from a bird's-eye viewpoint, was created in such works as Albrecht Altdorfer's *Battle of Alexander* (1529; Munich, Alte Pin.) and Joachim Patinir's *Charon Crossing the Styx* (c. 1510–20; Madrid, Prado).

48. Parmigianino: *Madonna of the Long Neck*, 1534–40 (Florence, Galleria degli Uffizi)

Developments in architecture were closely bound up with those in painting. The ideal of the centralized plan was abandoned in favour of the elongated axis. The administrative building of the grand duchy of Tuscany, the Uffizi, started in 1560 and designed by Vasari, was laid out according to this principle. The concept of a long gallery building, which was to be a constant component of grand houses and castles until the 19th century, became a favourite element in secular architecture. For example, Rosso Fiorentino created the Galerie François I at Fontainebleau in 1533–40 (5 m wide and 58 m long; see col. pl. XIII). In the 1580s Duke Vespasiano Gonzaga had the Palazzo del Giardino built at his residence in Sabbioneta, probably to designs by Vincenzo Scamozzi, on a narrow, seemingly unending axis. The blurring of fixed side

limits that can be observed in painting, however, also had parallels in architecture. Michelangelo in particular in his designs (1516) for the façade of S Lorenzo in Florence (not implemented), the New Sacristy (1519–33) at S Lorenzo and the vestibule of the Biblioteca Laurenziana (both from 1524) treated the wall in a way that defies the normative proportions and clarity of the High Renaissance. Not only is the wall more sculpturally modelled than ever before, but there is no clear surface to act as a point of reference for the projecting and receding architectural elements; where the wall and thus the spatial boundary lies is debatable. In addition, Michelangelo no longer made a precise distinction between the façade and the inner wall; in the vestibule of the Biblioteca Laurenziana and in the New Sacristy the observer is confronted with four inward-turning façades.

Another characteristic of Mannerist art with regard to treatment of space is the lifting of boundaries—or blurring of them—in a variety of ways. This applies especially to the boundary between the artistic space (in the work of art) and the real space. A distinction can be made between the passive and active removal of this aesthetic boundary: when it is lifted passively the artistic space appears to be a continuation of the real space, while when it is lifted actively elements or figures from the artistic space appear to step out into real space. Important preliminary stages of this process are again discernible c. 1500 (e.g. the altar wall of the Strozzi Chapel painted by Filippino Lippi at S Maria Novella, Florence). In 1516–17 Baldassare Peruzzi painted the Sala delle Prospettive in the Villa Farnesina in Rome, in which a painted architectural colonnade opens out over a view of Rome. In the Sala dei Cento Giorni (1546; Rome, Pal. Cancelleria) Vasari successfully achieved a disorientating play with the spatial boundaries, while with the Sala dei Cavalli (1525–35; Mantua, Palazzo del Te) Giulio Romano blurred the division between artistic and real space, and between architecture, painting and sculpture. With the frescoes (1561–2) in the Villa Barbaro at Maser, Paolo Veronese went farthest along this path. An important example of these trends north of the Alps is the painting in 1578–80

of the Narrentreppe and the Wartstube at Burg Trausnitz, outside Landshut, by Alessandro Scalzi.

(iv) The fusion of the arts. In all the examples given so far, it is clear that conditions specific to the individual art forms were removed. The possibility of replacing one art form with another—for example, sculpture and architecture with painting, or architecture with sculpture—is most powerfully rooted in the work of Michelangelo (the nude figures that appear to be painted sculptures in the ceiling of the Sistine Chapel in the Vatican, 1508–12). This trend developed fully in the next generation. When Correggio decorated the Camera de S Paolo at the monastery of S Paolo in Parma (c. 1519) not only did he make it impossible to see where the ceiling ended, but he also used painting to suggest the presence of sculpture and architectural elements. Veronese opened the boundaries between architecture, sculpture and painting farther than anyone else in his decorations at the Villa Barbaro at Maser.

Boundaries were overstepped in other respects too—here verging on the bizarre: for example, when buildings were created in the form of figural sculptures (c. 1580) in the garden at the Villa Orsini in Bomarzo Bomarzo, Sacro Bosco, or when sculpture sprang directly out of nature, as in the allegorical figure of the *Apennines* (1570–80) by Giambologna in the park at Pratolino, above Florence.

(v) Anti-classicism and subjective expression. 16th-century art rejected the classical principles of the High Renaissance. However, this alone does not make it Mannerist, as this further requires, among others, a predilection for the depiction of the abnormal and an emphasis on the subjective. Indeed, since the reassessment of Mannerism at the beginning of the 20th century, these latter aspects of 16th-century art have been much over-emphasized. In this context, the distortion of the human figure, often with the object of making it more expressive (a trend that is therefore allied with Expressionism), is of primary importance. Thus Rosso Fiorentino had no doubt studied Michelangelo, but he gave to his heroic figures seemingly arbitrary proportions and forms, summarizing and generalizing detail, as in *Moses Defending Jethro's Daughters* (1523; Florence, Uffizi; see col. pl. XXI) and the *Deposition* (1521; Volterra, Pin. Com.). In Florentine painting in particular figures were often elongated, while the heads remained relatively small, as in Pontormo's portrait of *Alessandro de' Medici* (c. 1525; Lucca, Mus. & Pin.), his *Visitation* (c. 1530; Carmignano, S Michele) and his frescoes (1523–5) in the Certosa del Galluzzo, near Florence. In North and Central Italy the same phenomena occurred, as in Parmigianino's *Madonna of the Long Neck* or Tintoretto's *Christ before Pilate* (1566–7; Venice, Scu. Grande di S Rocco). The work of El Greco is especially influenced by this anti-classical approach to the figure. The Milanese painter Giuseppe Arcimboldi came close to the style of Surrealism when he assembled human heads exclusively from realistically reproduced plant details (e.g. *Winter*, 1563; Vienna, Ksthist. Mus.) or placed figures in dreamlike contexts.

In general terms between 1400 and 1600 three stages of development in the representation of the human figure in art can be identified. In the early Renaissance the ideal was to show man as he appears naturally. There followed, in the High Renaissance, a desire to create ideally beautiful figures and to overcome the blemishes of nature. The ideal of Mannerism was to go beyond the natural reality and to distort figures in the interests of subjective expression.

In architecture classical forms are used in a fanciful and complex way that defies the rules of Classical architecture. Typical examples of this are the Palazzo del Te in Mantua, built c. 1525–35 by Giulio Romano, the courtyard face of which is structured *all'antica*, but with the masonry irregularly divided and with every third triglyph on the frieze threatening to slip out of place; the courtyard façade of the Palazzo Pitti in Florence, which adopts the Classical orders—Doric, Ionic and Corinthian—but where the actual load-bearing members, the columns, are given virtually no visual impact; or Palladio's Villa Rotonda (started in 1553), Vicenza, which externally embodies the idea of the centrally planned building to

perfection, while the central space within is so poorly lit that the visitor has the impression of being drawn outwards by the horizontal shafts of light coming from the four entrances. Thus the centripetal principle of the centrally planned building is reversed into its centrifugal opposite.

4. Iconography and theory

Mannerism is also distinguished by its intellectually complex iconography. Agnolo Bronzino's painting of the *Venus, Cupid, Folly and Time* (c. 1544–5; London, N.G.) is as typical in this respect as Benvenuto Cellini's salt cellar (Vienna, Ksthist. Mus; see fig. 29) with its heavy burden of mythological references, both works made for Francis I. Cellini himself said that he was well aware that he did not approach his work like many ignorant artists who, although they could produce things that were quite pleasing, were incapable of imbuing them with any meaning. Pieter Bruegel the elder drew much of his iconography from proverbs and folklore, attaining a similar intellectual sophistication.

The art theory of the Mannerist period was concerned with aesthetic problems rather than with the empirical problems of perspective, proportion and anatomy that had absorbed 15th-century writers. Venetian and Florentine theorists debated the primacy of *colore* and *disegno*; Paragone, a debate over whether painting or sculpture was the superior art form, raged; and in the late 16th century the question of the relationship between the creative idea (the 'concetto') and the model in nature was discussed by such theorists as Giovanni Paolo Lomazzo.

5. Spread and development

In the 1520s Mannerism was established as a style in Rome by the late work of Raphael and that of his followers, Giulio Romano and Perino del Vaga, and in Florence by the work of Pontormo and Rosso Fiorentino. After the Sack of Rome (1527), the style spread to other Italian centres (Giulio Romano worked in Mantua, Sanmicheli in Verona and Parmigianino in Parma) and Florentine art of the mid-16th century may be described as mature Mannerism, the principal exponents of which were Bronzino, Vasari, Salviati and Giambologna. The FONTAINEBLEAU SCHOOL was influential in the spread of Mannerism throughout Europe. The Italians Rosso, Cellini and Primaticcio were associated with it, and Rosso and Primaticcio, in the Galerie François I (1533–40), created a rich and intricate decorative style (see col. pl. XIII). The style was developed by Jean Goujon and Germain Pilon and, in the reign of Henry II, by such French artists as Jacques Androuet Du Cerceau the elder, who were influenced by developments in the Netherlands. In the Netherlands many artists who had visited Italy, among them Frans Floris and Marten de Vos, created a Mannerist style, and pattern-books such as those of Cornelis Floris, combining the Italian grotesque with scrolling and strapwork, had a decisive effect in the second half of the 16th century, especially on architectural decoration north of the Alps. A highly sophisticated Mannerism flourished at the Wittelsbach court of Albert V in Munich and the Habsburg court of Rudolf II in Prague.

In northern European art Mannerism continued well into the 17th century, but in Italy the Baroque style was established by c. 1600. The Mannerist interests in movement and expression were more prophetic of future developments than the static images of the High Renaissance. In many ways early Baroque art united these elements with High Renaissance clarity and naturalism.

Bibliography

EWA [with full bibliog. and list of sources]
G. Vasari: *Vite* (1550, rev. 2/1568); ed. G. Milanesi (1878–85)
G. P. Lomazzo: *Trattato dell'arte della pittura, scultura e architettura* (Milan, 1584)
——: *Idea del tempio della pittura* (Milan, 1590)
J. van Schlosser: *Die Kunstliteratur* (Vienna, 1924) [contains most sources]
H. Hofmann: *Hochrenaissance, Manierismus, Frühbarock: Die italienische Kunst des 16. Jahrhunderts* (Zurich and Leipzig, 1939)
R. Zürcher: *Stilprobleme der italienischen Baukunst des Cinquecento* (Basle, 1948)
De triomf van het Manierism (exh. cat., ed. M. van Luttervelt; Amsterdam, Rijksmus., 1955)
W. Friedländer: *Mannerism and Anti-Mannerism in Italian Painting* (New York, 1957)
E. Battisti: *Rinascimento e barocco* (Turin, 1960)

G. Briganti: *La maniera italiana* (Rome, 1961)

F. Württenberger: *Der Manierismus* (Vienna, 1962)

F. Baumgart: *Renaissance und Kunst des Manierismus* (Cologne, 1963)

J. Pope-Hennessy: *Italian High Renaissance and Baroque Sculpture*, 3 vols (London, 1963)

L. van Puyvelde: *Die Welt von Bosch und Breughel: Flämische Malerei im 16. Jahrhundert* (Munich, 1963)

D. Frey: *Manierismus als europäische Stilerscheinung: Studien zur Kunst des 16. und 17. Jahrhunderts* (Stuttgart, 1964)

A. Hauser: *Der Ursprung der modernen Kunst und Literatur: Die Entwicklung des Manierismus seit der Krise der Renaissance* (Munich, 1964); Eng. trans. as *Mannerism*, 2 vols (London, 1965)

J. Shearman: *Mannerism* (Harmondsworth, 1967)

G. Kauffmann: *Die Kunst des 16. Jahrhunderts* (Berlin, 1972)

H. Kozakiewiczowie and S. Kozakiewiczowie: *The Renaissance in Poland* (Warsaw, 1976)

M. Wundram: *Renaissance und Manierismus* (Stuttgart and Zurich, 1985)

MANFRED WUNDRAM

Mestizo [Sp.: 'mixed' or 'hybrid'] (Baroque)

Term first used by in its art-historical sense Angel Guido (1925) to describe the fusion of Baroque architecture with indigenous art forms in South America and especially the Altiplano or highlands of Bolivia and Peru from the mid-17th century to the late 18th. Mestizo is characterized by massive Baroque structure with finely dressed stone detailing in exuberant flat patterns reminiscent of embroidery or wood-carving. Motifs incorporating indigenous fruits and animals were used on portals, retables and decorative friezes; mythological characters play indigenous musical instruments; and Pre-Columbian decorative details help to fill every available space with dense ornamentation.

The most notable examples of the Mestizo style are to be found in the central Andes, at Arequipa in Peru and Potosí in Bolivia. In the region of Arequipa the use of a porous volcanic rock gave rise to a school of plane-surface carving that tended to stress chiaroscuro. The whole façade of the Jesuit church of La Compañía (1698) at Arequipa is carved in a foliated relief that invades the entablatures of the ground- and first-floor orders and fills the tympanum of the pediment. The same wealth of surface decoration, but in a finish more akin to wood-carving than embroidery, may be seen at the church of S Lorenzo (1728–44), Potosí. Spiral columns flanking the doorway are transformed in the upper portions of their shafts into caryatids with arms akimbo. The whole composition is substantially repeated on a smaller scale in an overdoor feature, where the columns are flanked by two mermaids playing the *charango*, a stringed instrument.

Efforts were made by the monastic orders in Latin America to eradicate pagan religions, but native workmanship was encouraged in church building since it was thought that the use of indigenous techniques and motifs would help spread Christianity. In addition to formal architecture, the Mestizo style also found expression in ephemeral structures such as triumphal arches, crosses, catafalques, street altars, reviewing platforms and other items that reinforced the importance of processional routes through towns. The Mestizo style eventually gave way before the rise of Neo-classicism and the control of the academies, although Mestizo portals and other features continued to appear in otherwise classicizing designs well into the 19th century, and artwork intimately related to Mestizo was still being recreated in indigenous and peasant communities at the end of the 20th century.

Bibliography

A. Guido: *Fusión hispanoindígena en la arquitectura colonial* (Rosario, 1925)

A. Neumeyer: 'The Indian Contribution to Architectural Decoration in Spanish Colonial America', *A. Bull.*, xxx (1948), pp. 104–21

H. E. Wethey: *Colonial Architecture and Sculpture in Peru* (Cambridge, MA, 1949)

P. Kelemen: *Baroque and Rococo in Latin America* (New York, 1951)

H. E. Wethey: 'Hispanic Colonial Architecture in Bolivia', *Gaz. B.-A.*, n. s., xxxix (1952), pp. 47–60

P. Kelemen: 'El barroco americano y la semántica de importación', *An. Inst. A. Amer. & Invest. Estét.*, xix (1966), pp. 39–44

S. Sitwell: *Southern Baroque Revisited* (London, 1967)

G. Gasparini: 'La arquitectura colonial como producto de la interacción de grupos', *Bol. Cent. Invest. Hist. & Estét. Caracas*, xii (1969), pp. 18–31

R. Gutiérrez: *Arquitectura colonial: Teoría y praxis* (Resistencia, 1979)

——: *Arquitectura y urbanismo en Iberoamérica* (Madrid, 1983)

T. Gisbert and J. de Mesa: *Arquitectura andina, 1530–1830* (La Paz, 1997)

RAMÓN GUTIÉRREZ

Moorish [Hindoo, Indo-Saracenic] style

Term used specifically in the 19th century to describe a Western style based on the architecture and decorative arts of the Muslim inhabitants (the Moors) of north-west Africa and (between 8th and 15th centuries) of southern Spain; it is often used imprecisely to include Arab and Indian influences. A similar revivalist style prevalent specifically in Spain around the same time is known as the MUDÉJAR REVIVAL. Although their rule in Spain finally ended in 1492, the Moors remained indispensably part of the European vision of the East. (*See also* ORIENTALISM.)

In the Renaissance *moreschi* were bandlike patterns allied to grotesques. The Swiss Johann Heinrich Müntz, who visited Spain in 1748 and drew unspecified Moorish buildings, designed a Moorish garden building (1750; London, RIBA) that may have formed the basis for the Alhambra (destr.), one of a series of exotic buildings designed by William Chambers after 1758 for the Royal Botanic Gardens at Kew, near London. Further early interest was shown by the painter William Hodges, who was in India between 1779 and 1784, in his *Travels in India* (1793), which incorporated much of a dissertation (prepared in 1787) on the prototypes of architecture, 'Hindoo, Moorish and Gothic'. He linked minarets with natural origins in pointed rocks. The style was acceptable to advocates of the Picturesque and was thus used at the Royal Pavilion in Brighton for the Indian Stables (1803–8) by William Porden and the exterior reconstruction of the Pavilion itself (1815–22) by John Nash, with onion domes and minarets.

While Romantic interest in an imaginary, dreamlike Orient, typified by Samuel Taylor Coleridge's poem *Kubla Khan* (1816), readily included the Moors, their history and particular contribution to Spanish and Western culture were reappraised after the Napoleonic Wars, as Spain and Morocco attracted writers, painters and travellers. The writers included Victor Hugo (his poem-cycle *Les Orientales* of 1829) and Washington Irving (*The Alhambra*, 1832). The artists included Eugène Delacroix (on a French diplomatic visit to Morocco in 1832), David Roberts (in Spain 1832–3) and John Frederick Lewis (in Spain 1832–4). The work of Roberts and Lewis was widely reproduced in popular publications. The best-known traveller was Richard Ford, whose *Handbook for Travellers in Spain and Readers at Home* (1845) reached nine editions by 1900. Literature about Spain tended to evoke the fantasy of the 14th-century courtyards and halls of the Alhambra, Granada, but encouraged an interest in Moorish gardens, particularly the Generalife, also in Granada (e.g. Frederic Leighton's oil painting of 1874, *Moorish Garden: A Dream of Granada*, Armidale, NSW, Teachers' Coll.).

At the same time detailed studies of Moorish art and architecture began to appear (e.g. James Cavanah Murphy's *Arabian Antiquities of Spain*, 1815). The colour-patterns of the Alhambra were recorded (1832–3) by Joseph-Philibert Girault de Prangey and later by Owen Jones, whose first-hand record, originally undertaken in 1834 with Jules Goury (1803–34) and continued in 1837, appeared in his monumental *Plans, Elevations and Sections of the Alhambra* (London, 1842–5). In his *Grammar of Ornament* (1856), Jones demonstrated his belief that the Moors were the authors of fundamental principles of pattern design and colour deployment. All his examples of 'Moresque' ornament came from the Alhambra, and he constructed an Alhambra Court (1854; destr. 1936) at the Sydenham Crystal Palace, London. As a result of his work, motifs derived from the Alhambra became a mainstay of manuals of ornament for over half a century.

The Moorish style proved a versatile resource. Ludwig von Zanth used it at the Villa Wilhelma

(1842–64) at Stuttgart for King William I of Württemberg (*reg* 1816). William Burges played freely with it in his wildly eclectic interior schemes for Cardiff Castle (from 1865), which included in the dining-room a Saracenic ceiling with an eight-pointed star. Most archaeologically correct was the Arab Hall (1877–9) at Leighton House, London, designed by George Aitchison (1825–1910) for Frederic Leighton, with a marble pool and walls decorated with 14th- and 15th-century Islamic tiles and screens and glass from Cairo and Damascus. The style spread widely, from the Palais du Trocadéro (destr. 1936), designed for the Exposition Universelle in Paris of 1878 by Owen Gabriel Davioud and Jules Bourdais (*b* 1835), to hotels in Florida, USA.

Hispano-Moresque ceramics were collected (e.g. by Alfred Ducane Godman in the 1860s, now London, BM; and Charles Lang Freer in the early 20th century, now Washington, DC, Freer), and they also influenced contemporary designs. For the mass market, Owen Jones designed tiles in Moorish style for the Minton ceramic factory, and Islamic style tin-glazed earthenwares were made in the factories of Ulysse Cantagalli (*d* 1901) in Florence and Zsolnay in Pécs (e.g. plate by Zsolnay of polychrome, painted earthenware, *c*. 1878; London, V&A). At the same time William De Morgan in England and Joseph-Théodore Deck in Paris were producing handmade, lustred 'art pottery' in Isnik, Hispano-Moresque, Byzantine and Persian designs (see fig. 49).

Towards the end of the 19th century the Moorish style reinforced its popular appeal. It was considered particularly suitable for halls and such masculine retreats as smoking and billiard rooms of which few English examples survive. The Moorish Smoking Room (*c*. 1880) from John D. Rockefeller's house in New York (now in New York, Brooklyn Mus.) has a cornice of 'Arab' arches, richly patterned walls, ebony woodwork and tasselled and fringed chairs. In London Carlo Bugatti created a distinctive bedroom (*c*. 1890; destr.) for the town house of Cyril Flower, Baron Battersea, a commission probably earned from the display of his work at the Italian Exhibition at Earls Court, London, in 1888. The style was also used by design

49. Joseph-Théodore Deck and Baron Jean-Charles Davillier: Alhambra Vase, 1862 (London, Victoria and Albert Museum)

firms such as Liberty & Co., London, and S. Bing, Paris.

Paradoxically, Moorish ideas were also used in synagogue design as part of a movement to emphasize Judaism's non-European origins. For the interior of the Dresden synagogue (1838–40; destr.), Gottfried Semper used 'Saracenic' forms deriving in part from a study of Islamic work in Sicily. The synagogue at Leipzig (1853–4) by Semper's pupil Otto Simonson (1829–after 1856) included the Moorish horseshoe arch, which was later used in synagogues in Cologne, Berlin and Vienna and in Russia. In the USA the Isaac M. Wise Temple (1863–5) in Cincinnati by James Keys Wilson combined the style with Gothic, in a manner widely imitated (e.g. the Temple Emanu-El, New York, 1866–8; destr. 1901; by Leopold Eidlitz).

Association with places of entertainment and relaxation led to the Moorish style becoming widely used for theatres, restaurants, piers and

bandstands. Examples in New York include the Central Park bandstand (begun 1859) by Owen Jones's pupil Jacob Wrey Mould, and the Casino Theatre (1880–82; destr. 1930) by Francis H. Kimball, with 'Alhambresque' capitals and horse-shoe arches. English examples include the Royal Panopticon of Science and Art (1854; interior reconstructed 1883; destr. 1936), Leicester Square, London, by Thomas Hayter Lewis (1818–89), an educational establishment that ironically became a music hall within two years; many theatres by Frank Matcham (e.g. the Empire Palace in Edinburgh, 1892; destr. 1911); and even cinemas (e.g. the Astoria [now the Academy], Brixton, London, 1929; by E. A. Stone, with an interior decorated to resemble the Generalife, Granada). The courtyard (1918–21) designed by Philip Tilden (1887–1956) at Port Lympne, Kent, was for a client, Sir Philip Sassoon, whose family was of Levantine origin. By the early 20th century, however, the distinctive historical associations and qualities of mood that had given the Moorish style its special resonance in the West became obscured, and the style was largely abandoned.

Bibliography

G. Sheldon: *Artistic Houses*, 2 vols (New York, 1882–4/*R* as one vol., 1971)

'Moorish Decoration', *Decorator & Furnisher*, v/4 (Jan 1885), p. 141

A. van de Put: *Hispano-Moresque Ware of the XV Century* (London, 1904)

A. Adburgham: *Liberty's: A Biography of a Shop* (London, 1975)

O. Grabar: *The Alhambra* (Cambridge, MA, 1978)

B. M. Walker: *Frank Matcham: Theatre Architect* (Belfast, 1980)

P. Dejean: *Carlo, Rembrandt, Ettore-Jean Bugatti* (New York, 1982)

M. Darby: *The Islamic Perspective: An Aspect of British Architecture and Design in the 19th Century* (London, 1983)

R. Head: *The Indian Style* (London, 1986)

G. Dumur: *Delacroix et le Maroc* (Paris, 1988)

J. Sweetman: *The Oriental Obsession: Islamic Inspiration in British and American Art and Architecture, 1500–1920* (Cambridge, 1988)

JOHN SWEETMAN, with assistance from A. R. GARDNER

Mudéjar revival

Term used to describe a style of architecture and the decorative arts employed by some artists in Spain and its colonies in the 19th century. It was based on the medieval work of Spanish *mudajjan*, an Arabic word denoting Muslims living under Christian rule (*see also* MUDÉJAR), and was particularly prevalent in such centres as Burgos, Seville and Toledo (e.g. Toledo Railway Station), which were rich in important examples of Islamic architecture. Nationalism during this period, however, led to the style being used in other cities throughout the Iberian peninsula and in the Spanish colonies (e.g. masonic temple, San Pedro Sula, Honduras). In other parts of Europe and the Western world a similar revival is usually called MOORISH STYLE.

☐

Nabis [Heb.: 'prophets']

Group of artists, predominantly French, active *c.* 1888–1900. Dedicated to pursuing the Synthetist example of Gauguin, the Nabis were a disaffected group of art students at the Académie Julian in Paris who formed themselves into a secret brotherhood in 1888–9. The movement's first adherents were Paul Sérusier, the group's founder, Maurice Denis, Pierre Bonnard, Paul Ranson and Henri-Gabriel Ibels. Returning to Paris from Pont-Aven in the autumn term of 1888, Sérusier revealed to his friends a new Synthetist use of colour and design exemplified in the *Bois d'Amour at Pont-Aven* (Paris, Mus. d'Orsay; see fig. 50), a boldly simplified landscape painted on a cigar-box lid under Gauguin's directions that later became known as *The Talisman*. Already drawn together by their common interest in idealist philosophy and in recent Symbolist developments in literature, they adopted their esoteric name from the Hebrew word for prophets—a private designation rather than a public label—at the suggestion of Henri Cazalis, a Hebrew scholar. The name aptly described the enthusiastic zeal with which they greeted and then disseminated the revolutionary teachings of Gauguin. Their youthful desire to shake off the taint of academicism—in their case

50. Paul Sérusier: *Bois d'Amour at Pont-Aven* ('*The Talisman*'), 1888 (Paris, Musée d'Orsay)

the quasi-photographic naturalism taught by their masters William-Adolphe Bouguereau and Jules Lefebvre—and revert to the pure decorative roots of art had loose, though possibly conscious, parallels with earlier artistic brotherhoods, notably the German Nazarenes and the English Pre-Raphaelites.

The original group was soon augmented by new recruits, Ker-Xavier Roussel and Edouard Vuillard, friends from the Ecole des Beaux-Arts, Paris, and in 1891-2 a number of foreign artists, including the Dutch Jan Verkade, Danish Mogens Ballin, Swiss Félix Vallotton and Hungarian József Rippl-Rónai. These in their turn introduced the sculptor Georges Lacombe and Aristide Maillol, whose Nabi experiments in a variety of media preceded his career as a sculptor. A few writers and musicians such as Charles Morice (1861–1919) and Pierre Hermant were affiliated to the Nabi group, and Gauguin, then in Tahiti, was made an honorary member. Although he never took any active

part in Nabi activities, he gave them his encouragement and appreciated their moral support.

Early meetings were held at a bistro, the L'Os à Moelle near the Académie Julian, and after 1890 monthly reunions took place in Ranson's studio at 25 Boulevard du Montparnasse, jokingly referred to as 'Le Temple'. Nicknames were adopted, and certain esoteric words were used, mainly by the more committed members of the group, Ranson, Sérusier and Verkade, as a means of setting themselves and their 'icônes' (pictures) apart from the uncomprehending 'pelichtim' (bourgeoisie).

Although at no stage can one identify a true group style, between 1890 and 1892, when Sérusier, Bonnard, Vuillard and Denis shared the use of a small studio in the Rue Pigalle, there was a common exploration of certain decorative stylistic features: simplified drawing, flat patches of colour and bold contours inspired by the work of Gauguin and Emile Bernard, as well as arabesques and other patterning devices inspired by Japanese prints. One finds such stylistic features combined in Denis's *Mme Ranson with a Cat* (1892; Saint-Germain-en-Laye, Mus. Dépt. Prieuré), which was painted on to a vertical panel suitable for a folding screen rather than on to a regular size of canvas. They frequently painted on unconventional supports, cardboard or even velvet and explored a wide spectrum of decorative work, ranging from posters, screens, wallpaper and lampshades to scenery painting or costume design for the Symbolist theatre. The Symbolist poet and dramatist Paul Fort (1872–1960) made use of their talents from 1891 to 1893 at his Théâtre d'Art, and from 1893 they were closely involved with the Théâtre de l'Oeuvre, managed by Denis's former schoolfriend the actor Aurélien Lugné-Poe. The *Revue blanche*, an anarchic and eclectic journal founded in 1891 by the brothers Thadée and Alexandre Natanson, did much to promote the Nabis: as well as sponsoring group printmaking ventures, the Natansons were responsible for offering Vuillard some of his earliest major decorative commissions. In 1895 Siegfried Bing commissioned stained-glass designs from Sérusier, Denis, Vuillard, Bonnard, Ibels, Roussel and Vallotton, which were made up

in Tiffany glass and exhibited at his Salon de l'Art Nouveau, while the art dealer Ambroise Vollard encouraged Denis, Bonnard, Vuillard and Roussel to experiment in the novel medium of colour lithography.

The first group exhibition, arranged by Denis, was held at the château of Saint-Germain-en-Laye in 1891; thereafter until 1896 group shows were held regularly in the gallery of the dealer Louis Le Barc de Boutteville, where the Nabis, identified as Symbolists, hung work alongside the Neo-Impressionists and independent figures such as Toulouse-Lautrec. During the 1890s the Nabis also exhibited, either together or separately, in Toulouse, Antwerp and Brussels. Denis's *Définition du Néo-traditionnisme* (*A. & Crit.*, May 1890), published as a defence of Gauguin and asserting the right of the painter to deform and simplify nature in the pursuit of decorative beauty, served as a loose stylistic credo; and in 1892 an important article by the critic Georges-Albert Aurier hailed the Nabis as inheritors of Gauguin's teaching and creators of a truly Symbolist art.

The lack of a clear programme or unified aesthetic aim left the way open for individual members to pursue their own independent paths, though the exact date at which the group disintegrated is unclear. Whereas Sérusier, who was essentially responsible for the group's existence, felt his initial vision of a unified brotherhood had been disappointed as early as 1892, and Nabi meetings after that date occurred less frequently, close collaboration over exhibitions and other projects continued until 1900; shows such as the Durand-Ruel group show of March 1899, which marked a decade of group activity, had a cohesive effect.

There were two main artistic divisions within the group: artists such as Sérusier, Denis and Ranson saw an essential connection between their Nabi ideas and their religious or theosophical beliefs and tended to draw their subjects from myth, religion or tradition; on the other hand, artists such as Vallotton, Vuillard and Bonnard, whose commitment to the esoteric, symbolist side of the Nabi aesthetic was weaker, drew their art more directly from nature and the modern world.

Whereas the former maintained their roles into the 20th century as disseminators of the Nabi aesthetic through teaching and religious painting, the two most successful members of the group, Bonnard and Vuillard, departed radically from their periods of Nabi experimentation and developed luminous and subjective styles that built on the Impressionists' use of colour (*see* INTIMISME). Yet even in their 20th-century portraits and fashionable paintings of and for bourgeois interiors, both artists retained something of the original emphasis on the flat, decorative purpose of painting that was the legacy of their Nabi beginnings.

Bibliography

G.-A. Aurier: 'Les Symbolistes', *Rev. Enc.*, xxxii (1892), pp. 474–86; also in *Oeuvres posthumes*, ed. R. de Gowmont (Paris, 1893)

A. Humbert: *Les Nabis et leur époque* (Geneva, 1954)

Bonnard, Vuillard et les Nabis (exh. cat., Paris, Mus. N. A. Mod., 1955)

C. Chassé: *Les Nabis et leur époque* (Paris, 1960; Eng. trans., London, 1969)

The Nabis and their Circle (exh. cat., Minneapolis, MN, Inst. A., 1962)

Die Nabis und ihre Freunde (exh. cat., Mannheim, Städt. Ksthalle, 1963–4)

Neo-Impressionists and Nabis in the Collection of Arthur G. Altschul (exh. cat., New Haven, CT, Yale U. A.G., 1965)

U. Perucchi-Petri: *Die Nabis und Japan: Das Frühwerk von Bonnard, Vuillard und Denis* (Munich, 1976)

G. Mauner: *The Nabis: Their History and their Art, 1888–1896* (New York, 1978)

Nabi Prints (exh. cat., New Brunswick, NJ, Rutgers U., Zimmerli A. Mus., 1988–9; Amsterdam, Rijksmus. van Gogh; 1989)

Les Nabis (exh. cat., Paris, Mus. d'Orsay; Zurich, Ksthaus; 1993)

BELINDA THOMSON

Nagybánya colony

Hungarian painters' colony, founded in 1896 in north-eastern Hungary. The idea of the colony was conceived in Simon Hollósy's painting academy in Munich, when János Thorma (1870–1937) and István Réti persuaded Hollósy to choose the small mining town of Nagybánya (now Baia Mare,

Romania) for his private summer school. Béla Iványi Grünwald and Károly Ferenczy also helped to found the colony. For Hollósy and his associates the small town soon became more than a convenient location for their summer workshop, and they eventually settled there. In the next six years Hollósy continued to attract Hungarian and foreign pupils from Munich to Nagybánya every summer. After his departure in 1902 the colony abolished tuition fees and continued to attract 50 to 70 students per year.

The Nagybánya colony was of great importance for the development of Hungarian art, and its establishment signalled the beginning of a new era. The colony had excellent teachers practising free-school methods and a surrounding landscape rich in motifs and colours similar to those found in Provence, France—a combination that greatly enhanced the artistic impact of Nagybánya. Critics referred to Nagybánya as the 'Hungarian Barbizon', although its members could have been influenced by French painting only indirectly via Munich. *Plein-air* painting may provide a link, but in Hungary the exodus also came from the desire of some painters to avoid the official celebrations in Budapest in 1896 of the 1000th anniversary of the taking of the land by Magyar tribes.

The colony's first exhibition was held in 1897. On display were paintings and illustrations to poems by József Kiss. Although initially greeted with ridicule by the critics, the Nagybánya representation of nature—so different from academic or salon painting—had within a few years influenced a significant number of Hungarian painters. The founder-members possessed different styles and thematic interests, although while working in Munich they were equally attracted to the refined naturalism of Jules Bastien-Lepage. Undoubtedly the strongest personality of the colony was Károly Ferenczy, whose particular method of achieving a unity of emotion and atmosphere between man and landscape became the artistic standard of the Nagybánya school.

The high ethical and qualitative standards of the founders ensured a great esteem for the colony in its own time and a long-lasting impact. Réti, the self-appointed chronicler of the colony,

distinguished three generations among its artists. The first comprised the founders and the artists who joined them, for example István Csók and Oszkár Glatz (1872–1958); the second included all the painter-pupils from 1902; and the third consisted of artists who arrived at the end of the 1910s. Of the second generation, Jenő Maticska (1885–1906), a talented painter who died young, showed the greatest promise. Réti applied the term 'loyal Nagybánya artist' to those second-generation painters who decided to settle in Nagybánya and who were prepared to uphold for a lifetime the ideals of style and landscape developed by Ferenczy. By around 1905, however, this ideal had changed into a rigid type of conservatism, peculiar to the Nagybánya colony, and the most accomplished painters of the second generation, in particular the 'neos' Béla Czóbel, Vilmos Perlrott Csaba and Sándor Ziffer (1880–1962) among others, turned against this ossified tradition. The works they exhibited in 1906 marked a new period in the history of Hungarian painting. They drew on German art, in particular on Expressionism, but they were most attracted to Parisian painters, such as Cézanne and Matisse. From 1907 even first-generation painters underwent a change in style, although they all showed some interest in Secessionist forms. Around 1910 Iványi Grünwald managed to attract some of the artists who left Nagybánya to his newly formed Kecskemét Colony.

From this period the remaining three founders, Ferenczy, Réti and Thorma, continued correcting students' work in the art school. It was mostly Thorma who fulfilled this role, however, as first Ferenczy, then Réti started teaching at the Academy of Fine Arts in Budapest. In the decade after 1910 the art school received increasingly younger painters, probably because of travelling difficulties brought about by World War I. After the Treaty of Versailles Nagybánya became part of Romania, and the school took both Hungarian and Romanian pupils, in some years up to 150. In 1927 the school was re-established under second-generation members as the School of Fine Arts (Szépművészeti Iskola). Although the colony's achievements in painting had been surpassed by

the time of the jubilee exhibition (1912), its ethical stance, based on the particular relationship between man and the landscape, continued in the work of the 'post-Nagybánya' school and the Szinyei Merse Society. Although the colony ceased to exist as such in the 1930s, its ideals persisted in art-school teaching methods in Hungary in the 1940s and 1950s.

Bibliography

Nagybányai jubiláris képkiállítás [Jubilee picture exhibition of the Nagybánya colony] (exh. cat., foreword I. Réti; Nagybánya, 1912) [first summary of the colony's history]

B. Szokolay: A nagybányai művésztelep [The Nagybánya artists' colony] (Cluj, 1926)

I. Genthon: 'A nagybányai iskola' [The Nagybánya school], Szépművészet (1944), pp. 1–8

N. Aradi: 'Nagybánya értékeléséhez' [Towards an assessment of the Nagybánya school], Művészettörténeti Tanulmányok (1954), pp. 423–34

I. Réti: A nagybányai művésztelep [The Nagybánya artists' colony] (Budapest, 1954) [incl. detailed inf. on the everyday life of the colony and list of pupils, 1896–1933]

NÓRA ARADI

National Romanticism

Term that suggests the merging of national boundaries and the indigenous 'ethnic essence' of a nation rather than a particular school or style. National Romanticism was a mid- and late 19th-century coalescence of two potent ideologies and was linked to the struggle for political legitimacy for a circumscribed geographic region. Its tenet was that the indigenous arts, history, music and folk traditions of a nation contributed to the spiritual and political survival of its people. It was manifest in the arts of those countries or regions of northern and central Europe, such as Scandinavia and Germany, that were once subject to foreign domination or had experienced recent unification. Thus, National Romanticism arose in response to a sense of intrusive internationalism that was perceived to weaken a sense of unity within a single geographic group. With its sources in German Romantic philosophy, this theoretical

movement was introduced in the mid-19th century to Denmark through the writings of Adam Oehlensläger (1779–1850), to Norway by Henrik Wergeland (1808–45), to Sweden by the German poet and philosopher Friedrich Leopold von Hardenberg (1772–1801) under his pseudonym Novalis and, somewhat later, to Iceland by Sigurður Guðmundsson (1833–74). The notions of Volksgeist propelling a nation's culture expounded by Johann Gottfried Herder and Johann Gottfried Fichte (1762–1814), and the theories of Hippolyte Taine linking race and milieu, were important underpinnings for the affirmation of National Romanticism: a nation's faith in a unified culture and in the uniqueness of its people.

The term 'National Romanticism' was later used in the 1880s and 1890s in Norway, Sweden and Finland to define the artistic and literary vanguard. In Sweden, the term Nyromantik (Neo-Romanticism), associated with a 'Swedish Renaissance', defined an anti-naturalist movement in the arts. The validity of national or regional legitimacy was asserted by identifying and exploiting subjects, materials and media that were perceived as unique to a nation. In the pictorial arts two basic strategies can be traced: the representation of landscape as a signifier of national essence and the 'high art' revival of native folk art. In landscape painting, the idea of an unspoilt wilderness served as a corrective to the ills of urbanization through its evocation of an eternal national spirit. The landscape paintings of the Swedish artists Karl Nordström, Richard Bergh, Nils Kreuger and Gustaf Fjaestad, the Norwegian Harald Oskar Sohlberg and the Finn Pekka Halonen (e.g. Wilderness, Karelian Landscape, 1899; Turku A. Mus.) suggested such mystical and redemptive readings. Artists represented nature as the source of collective identity by painting works with motifs chosen for their monumentality and topographic uniqueness, as in Sohlberg's Winter Night in Rondane (1914; Oslo, N.G.); for their political and historical resonance, as in Nordström's Varberg Fort (1893; Stockholm, Prins Eugens Waldemarsudde); or for their evocation of mysticism through localized meteorological or light effects, as in Fjaestad's Snow

(1900; Göteborg, Kstmus.). The scholarly rediscovery of the works of the Norwegian artist J. C. Dahl and the Germans Caspar David Friedrich and Philipp Otto Runge by the Norwegian art historian Andreas Aubert (1851–1913) supported this interpretation of landscape as primordial national soul.

Folk art was a crucial element in the definition of National Romantic movements throughout Europe and was perceived as an unbroken link with a pure native past. Decorative and utilitarian objects were collected from rural regions and used to inspire modern investigation. Those who produced these works were understood by urban intellectuals to be living legacies of a mythic past and the conservators of indigenous traditions. This veneration for folk culture led to the founding of such open-air architectural museums in northern Europe as the extensive Skansen complex (1891) in Stockholm. In Norway, the paintings of Erik Werenskiold (e.g. *Girls of Telemark*, 1883; Oslo, N.G.) and Gerhard Munthe (e.g. the *Horse of Death*, 1893; Oslo, N.G.) adapted medieval folk motifs, colour structures and rhythmical patterning, as did the tapestries of Munthe and Frida Hansen (1855–1935) (e.g. *Blue in White*, 1899; Oslo, Kstindustmus.), those of Fjaestad in Sweden (e.g. *Running Water*, 1906; Göteborg, Kstmus.) and the Friends of Finnish Handicrafts, founded in 1879 (e.g. Sigrid Wickström's embroidered sledge-cover, 1912; Helsinki, Mus. Applied A.). National Romantic scholarship, in the work of the Norwegian historian Peter Andreas Munch (1810–63), created a shift away from the historical study of aristocracy towards the consideration of daily life and the extraction of national characteristics among individual groups. An increased interest in national history, folk literature and folk language in mid-19th-century scholarship also introduced National Romanticism as a re-examination of native orthographies. The impulse to collect folk legends and incorporate their motifs into art came initially from such folklorists as the brothers Jakob Grimm (1785–1863) and Wilhelm Grimm (1786–1859) in Germany, Elias Lönnrot (1802–84) in Finland and Peter C. Asbjørnson (1812–85) and Jörgen Moe (1813–82) in Norway. In Finland Akseli

Gallen-Kallela and the sculptor Alpo Sailo (1877–1955) took the legends and ballads of the *Kalevala* as sources for much of their work, in keeping with National Romantic impulses (e.g. Gallen-Kallela's *Aino*, 1891; Helsinki, Athenaeum A. Mus.). Munthe, Werenskiold and Halfdan Egedius used *Snorre Sturlasons Kongesagaer* [Snorri Sturlason's sagas of the Norse kings] (Kristiania [now Oslo], 1896–9) as the basis for some of their illustrated work. Such musicians as Edvard Grieg (1843–1907) and Jean Sibelius (1865–1957) also incorporated folk melodies and rhythms into their compositions to communicate a sense of continuity with native traditions.

National Romantic architecture embodied a retrospective view of indigenous building forms. It was identified with folk forms and with wooden architecture rather than with such institutionalized or official architectural revivals as seen in the buildings of the *Dragestil* [Dragon-style] in Norway (c. 1840–1900), the artists' colony in Darmstadt (1899–1903) and Ragnar Östberg's City Hall (1913) in Stockholm. In Finland, National Romanticism described the national manifestation of *Jugendstil* and incorporated indigenous decorative motifs and wood construction. Gallen-Kallela's design for his studio, *Kalela*, in Ruovesi (1895), the Finnish Pavilion at the Exposition Universelle in Paris (1900) by Gesellius, lindgren, Saarinen and the church of St John (1902–7; now Tampere Cathedral) in Tampere by Lars Sonck are examples.

Bibliography

A. Bramsen: 'Rasen, Kulturen och Konsten', *Ord & Bild*, x (1901), pp. 354–73

C. Hayes: *Essays on Nationalism* (New York, 1926)

O. Falnes: *National Romanticism in Norway* (New York, 1933)

L. Østby: *Frå naturalisme til nyromantik: En studie i norsk malerkunst i tiden ca. 1885–1895* [From nationalism to neo-romanticism: a study in Norwegian painting from c. 1885–95] (Oslo, 1934)

E. M. Earle, ed.: *Nationalism and Internationalism: Essays Inscribed to Carleton Hayes* (New York, 1950)

C. Hayes: *Nationalism: A Religion* (New York, 1960)

S. Strömbom: *National-romantik och radikalism: Konstnärforbundets historia, 1891–1920* [National

Romanticism and radicalism: the history of the
Artists' League, 1891–1920] (Udevalla, 1965)

J. I. Kolehmainen: *Epic of the North: The Story of Finland's National Epic* (New York, 1973)

E. Gellner: *Nations and Nationalism* (Ithaca, NY, 1983)

F. Scott: *Sweden, The Nation's History* (Dexter, MI, 1983)

A. Ellenius: 'Aspekter på bildkonsten och den nationela romantiken vid sekelskiftet' [Aspects of painting and National Romanticism at the turn of the century], *Att vara svensk* [To be Swedish], Kungliga Vitterhets Historie och Antikvitets Akademien (Stockholm, 1984), pp. 65–72

The Mystic North: Symbolist Landscape Painting in Northern Europe and North America, 1890–1940 (exh. cat. by R. Nasgaard, Toronto, A.G. Ont.; Cincinnati, OH, A. Mus.; 1984)

PATRICIA G. BERMAN

Nazarenes

Group of artists working in Rome and later northern Europe from 1818 to the 1840s, several of whom, including Friedrich Overbeck, Franz Pforr and Peter Cornelius, had been part of the Lukasbrüder, a small fraternity of young artists originally based in Vienna. The terms 'Nazarene' and Lukasbrüder have often been used interchangeably. Strictly speaking, the Lukasbrüder were a formally organized group whose span of activity, in both Vienna and Rome, lasted from 1809 to 1818; the Nazarene group embraces the members of the Lukasbrüder and dozens of other artists who shared a leaning toward spiritually ponderous subjects, a commitment to crystalline linearity and local colour and a fascination with Renaissance art of the 15th and early 16th centuries, including the work of Dürer and Raphael. By *c.* 1817 the Lukasbrüder were beginning to be called *Die Nazarener*. The name was mockingly applied, probably first by Johann Christian Reinhart, because of the group's heavy concentration on biblical subjects (see fig. 51), the strict monastic life they lived at S Isidoro, a 16th-century Irish Franciscan monastery in Rome, and their costume of wide, trailing cloaks and long flowing hair. The term 'Nazarene' later came to be applied to younger artists, including Julius Schnorr von Carolsfeld, who were followers of the Lukasbrüder

and worked in Italy and northern Europe until *c.* 1850.

1. The Lukasbrüder, 1809–18

The founders of the Lukasbrüder were six young German, Swiss and Austrian students associated with the Akademie der Bildenden Künste in Vienna, who in July 1809 formed an artistic fraternity, the Lukasbund. Its original members were Overbeck, Pforr, Ludwig Vogel, Joseph Wintergerst, Joseph Sutter (1781–1866) and Franz Hottinger (1788–1828). Although originating in Vienna, in 1810 the group shifted the centre of its activity to Rome, where it expanded slowly until its dissolution in 1818. Its later members included Cornelius, Wilhelm Schadow, Johann Scheffer von Leonhardshoff and Philipp Veit. Rejecting Late Baroque classicism, the Lukasbrüder drew inspiration from early German and Italian Renaissance painting as well as from folk imagery, which they developed into an intense, linear style adequate to their naive, albeit impassioned, commitment to nature.

The original group of six held regular drawing sessions and discussion groups in Overbeck's lodgings in Vienna in 1808–9. They had been attracted to one another by their common commitment to artistic and spiritual sincerity as an antidote to facile eclecticism. Sceptical of academic models of mechanical competence, they looked to the earlier art displayed in the Imperial Picture Gallery, the Belvedere in Vienna, to the writings of Goethe, Schiller, Wilhelm Wackenroder, Ludwig Tieck and Friedrich von Schlegel, as well as to the example of Eberhard Wächter, as they evolved new expectations for artistic behaviour and production. It was their conviction that art must be 'characteristic', thereby reflecting the individuality of the artist and society rather than catering to the taste of a cosmopolitan aristocracy (see col. pl. XXII). The works of such early Renaissance masters as Masaccio and Fra Angelico were particularly admired by the Lukasbrüder for their emotional sincerity, their allegiance to observed nature and their reflection of a society that had been more spiritually integrated than was that of Napoleonic Europe.

51. Peter Cornelius: *The Last Judgement*, 1845 (Munich, Church of St Ludwig)

The closing of the Akademie early in 1809 forced the young artists to turn to one another for support, and, drawing on the inspiration of Enlightenment literary associations, they created their own *Bund* on 10 July of that year. When in October Wintergerst moved to Bavaria as the *Bund*'s 'first apostle', diplomas were created for each member. These carried the signatures and symbols of each member, as well as a stamp depicting St Luke at work, and they became the formal symbol of the group's spiritual solidarity. When the Akademie reopened in February 1810, financial constraints prevented the readmission of all but Sutter. As a result, Overbeck, Pforr, Vogel and Hottinger left for Italy in May, arriving in Rome on 3 July 1810. They entered the city's active community of artists from Germany, Austria, Switzerland and Scandinavia, establishing friendships with Bertel Thorvaldsen and Joseph Anton Koch. They also devoted themselves to the study of antique sites and the frescoes of Raphael and Michelangelo in the Vatican. In October 1810 Vogel

secured inexpensive lodgings in the monastery of S Isidoro a Copelecase, later Via degli Artisti, where they revived their life drawing sessions and discussions, and resumed work on the paintings that they had brought from Vienna. These were Pforr's *Entry of Rudolf von Habsburg into Basle in 1273* (1808–9/10; Frankfurt am Main, Städel. Kstinst.), Vogel's *Return of the Soldiers to Morgarten* (1809–15; untraced) and Overbeck's *Entry into Jerusalem* (1809–24; destr.).

From 1809 to 1812 significant changes occurred within the Lukasbund. Hottinger severed his ties with the group and left Rome in September 1811, while Wintergerst arrived in April 1811. Giovanni Colombo (*c.* 1784–1853) became a new member of the group in November 1810, as did Cornelius in February 1812. In June 1812 Pforr died, and in December Vogel and Colombo left for Switzerland and Austria respectively. The lease on S Isidoro also expired, and Overbeck, Cornelius and Wintergerst, the remaining members, dispersed and found separate lodgings elsewhere in Rome. Two paintings characteristic of these early years are Overbeck's portrait of *Franz Pforr* (1810; Berlin, Neue N.G.) and Pforr's *Sulamith and Maria* (1810; Schweinfurt, Samml. Schäfer). By the end of 1812 the first phase was over. The *Bund* had become far less cohesive, with Overbeck, Cornelius and Wintergerst working in Rome, Sutter and Colombo in Vienna and Vogel in Zurich.

The second Roman phase of the Lukasbund, from 1813 to 1816, was characterized by new, diverse initiates and by an increased interest in a heroic nationalism espoused by Cornelius. During these years, several members were converted to Catholicism, and there was an increased religiosity within their work as is evident in Overbeck's painting *Christ with Mary and Martha* (1815; Berlin, Tiergarten N.G.). Wintergerst departed for Ellwangen in February 1813. Shortly thereafter, Wilhelm Schadow was admitted to the group, along with the poet Zacharias Werner (1768–1823), who was the only member who was not an artist. Scheffer von Leonhardshoff was admitted in October 1815 and Johannes Veit (1790–1854) and Philipp Veit early in 1816. Finally, in July 1816 Sutter and Colombo arrived in Rome, ending their

years of relative isolation in Austria. In this second phase the Lukasbund also developed a circle of associates who were not actually members. Konrad Eberhard, Ridolfo Schadow, Ernst Platner (1773–1855) and Johannes Schaller (1777–1842) took part in the group's drawing sessions or the readings and discussions held on Saturday evenings as did Karl Leybold (1786–1844) and Johann Karl Eggers (1787–1863). None, though, was issued diplomas or formally admitted to the Lukasbund.

By 1816 the Lukasbund had lost most of its vitality. In May of that year Overbeck, Cornelius, Schadow and Philipp Veit began work on a major commission, the Casa Bartholdy frescoes (1816–19; Berlin, Alte N.G.) for one of the rooms in the Palazzo Zuccari (now the Biblioteca Hertziana), the home of Salomon Bartholdy, the Prussian consul general in Rome. Overbeck instigated the project, and the four artists each painted two frescoes illustrating the *Story of Joseph*. These works, which are set in landscapes and architectural frameworks reminiscent of the Italian Renaissance, constituted their first joint commission and brought them prominence as painters of monumental frescoes. Following the completion of this project Cornelius and Overbeck were commissioned by the Marchese Carlo Massimo to fresco three rooms of his Roman villa, work that continued after the dissolution of the Lukasbund and later involved other Nazarene artists also. The early optimism that followed the restoration (1814) of the monarchy in France, as well as the increased maturity of the Lukasbrüder, diminished the need for the group's supportive insularity. There is no formal record of their dissolution, but the reported admission of Ferdinand Olivier and Julius Schnorr von Carolsfeld in September 1817 could have had little real significance.

2. The Nazarenes and their influence, after 1818

By 1818 the Lukasbrüder no longer constituted a fraternity and had been effectively absorbed into what came to be known as the Nazarene movement, a larger and more loosely constituted group of artists, including Olivier, Schnorr von Carolsfeld, Ferenc Szoldatits and Johann Anton Ramboux. The Lukasbrüder's radical emphases on individual character, simplicity and sincerity were now subsumed in the Nazarenes' more monumental, revivalist style suitable to the celebration of traditional social or religious institutions or values throughout central and western Europe. Schnorr von Carolsfeld was a particularly active member of the Nazarenes in Rome. His painting *Angelica, Medoro and Orlando* (1821–7) for the Casa Massimo in Rome (*in situ*), exemplifies the group's interest in the revival of monumental art.

By the 1840s the art of the Nazarenes was beginning to be eclipsed by that of Realism, although their work was to have a strong influence on historical and religious painting in Europe well into the 1850s. Though frequently religious in orientation, it embraced themes from classical mythology, folk-tales, the landscape and contemporary literature, as it spread northward from Rome to Düsseldorf, Frankfurt am Main, Munich, Dresden and Vienna. Various artists took up teaching posts in Germany, thereby imparting their knowledge of Nazarene principles to a younger generation of German artists. Ingres, who was in Rome from 1806, was influenced by it, as were such British artists as William Dyce and A. W. N. Pugin. Ford Madox Brown also admired their work after his arrival in Rome in 1845.

Bibliography

H. Riegel: *Geschichte des Wiederauflebens der deutschen Kunst zu Ende des 18. und Angang des 19. Jahrhunderts* (Hannover, 1876)

Overbeck und sein Kreis (exh. cat., Lübeck, Mus. Behnhaus, 1926)

A. Neumeyer: 'Beiträge zur Kunst der Nazarener in Rom', *Repert. Kstwiss.*, l (1929), pp. 64–80

R. Benz and A. von Schneider: *Die Kunst der deutschen Romantik* (Munich, 1939)

J. C. Jensen: Über die Gründung des Lukasbundes', *Wagen* (1958), pp. 105–22

K. Andrews: *The Nazarenes: A Brotherhood of German Painters in Rome* (Oxford, 1964)

J. C. Jensen: 'I Nazareni: Das Wort, der Stil', *Klassizismus und Romantik in Deutschland: Gemälde und Zeichnungen aus der Sammlung Georg Schäfer, Schweinfurt* (exh. cat., ed. K. Kaiser; Nuremberg, Ger. Nmus., 1966), pp. 46–52

R. Bachleitner: *Die Nazarener* (Munich, 1976)

H. von Einem: *Deutsche Malerei des Klassizismus und der Romantik, 1760–1840* (Munich, 1978)

Die Nazarener (exh. cat. by H. Dorre and others, Frankfurt am Main, Städel Kstinst., 1978)

U. Krenzlin: 'Zu einigen Problemen nazarenischer Kunst: Goethe und die nazarenische Kunst', *Städel-Jb.*, n. s., vii (1979), pp. 231–50

W. Vaughan: *German Romantic Painting* (New Haven, 1980)

I Nazareni a Roma (exh. cat. by G. Piantoni and S. Susinno, Rome, G.N.A. Mod., 1981)

W. Geismeier: *Die Malerei der deutschen Romantik* (Dresden, 1984)

A. Schmidt: 'Hainbündler und Lukasbrüder: Eine vergleichende Studie', *Niederdt. Beitr. Kstgesch.*, xxiii (1984), pp. 163–74

B. Rittinger: 'Zur Entwicklung der nazarenischen Wandmalerei', *Wien. Jb. Kstgesch.*, xli (1988), 97–138

ROBERT E. MCVAUGH

Neo-classicism

Term coined in the 1880s to denote the last stage of the classical tradition in architecture, sculpture, painting and the decorative arts. Neo-classicism was the successor to Rococo in the second half of the 18th century and was itself superseded by various historicist styles in the first half of the 19th century. It formed an integral part of the Enlightenment in its radical questioning of received notions of human endeavour. It was also deeply involved with the emergence of new historical attitudes towards the past—non-Classical as well as Classical—that were stimulated by an unprecedented range of archaeological discoveries, extending from southern Italy and the eastern Mediterranean to Egypt and the Near East, during the second half of the 18th century. The new awareness of the plurality of historical styles prompted the search for consciously new and contemporary forms of expression. This concept of modernity set Neo-classicism apart from past revivals of antiquity, to which it was, nevertheless, closely related. Almost paradoxically, the quest for a timeless mode of expression (the 'true style', as it was then called) involved strongly divergent approaches towards design that were strikingly focused on the Greco-Roman debate. On the one hand, there was a commitment to a radical severity of expression, associated with the Platonic Ideal, as well as to such criteria as the functional and the primitive, which were particularly identified with early Greek art and architecture. On the other hand, there were highly innovative exercises in eclecticism, inspired by late Imperial Rome, as well as subsequent periods of stylistic experiment with Mannerism and the Italian Baroque.

However rationally dictated, these fresh interpretations of the Classical evoked powerful emotional responses to the past that require Neo-classicism to be understood within the broader movement of Romanticism, rather than as its opposite. Arguably, the most original phase of Neo-classicism anticipated the political revolution in France with which it is inevitably associated, providing visible expressions of ideology in buildings and images. By the early 19th century an increasing concern with archaeological fidelity, together with the daunting range of newly explored cultures and alternative styles (including the medieval, Gothic and Oriental), began to inhibit imaginative experiment and originality of vision within the Classical tradition for all but a few outstanding artists and designers. Moreover, what had originated as a style inspired, in part, by principles of republicanism was transformed under Napoleon I into a fashionable and international language of imperial opulence.

1. Archaeology and the rise of historicism

From the mid-18th century antiquity could no longer be regarded as finite, either in time or place. The remarkable burst of archaeological activity during the latter half of the 18th century served to encourage a growing awareness of historical change and of the almost limitless fund of inspiration offered by the diverse cultures that comprised antiquity. In this pluralistic revaluation of the past, aesthetics swiftly emerged as a necessary discipline to assess the relative values of art. The striking discoveries in Roman domestic life, gradually uncovered at Herculaneum (from 1738) and Pompeii (from 1748), were disseminated through

the plates of the official publication *Le antichità di Ercolano esposte* (1755–92). The full impact of these finds on the visual arts was slow to take effect, but literal transpositions from engravings of wall paintings can already be seen in such modish works as Joseph-Marie Vien's the *Cupid Seller*, exhibited at the 1763 Salon (Fontainebleau, Château; see fig. 57). Among the objects uncovered were bronze tripods, such as that found in the Temple of Isis, Pompeii, in the early 1760s; these spawned a type of furniture derived from what became known as the *Athénienne* (after the object's appearance in Vien's *Virtuous Athenian Girl*, 1763; Strasbourg, Mus. B.-A.).

Rome, which by the mid-century had become the main focus of the Grand Tour, brought together not only influential patrons and collectors (notably the *milordi inglesi*) but also the most progressive young artists and designers in Europe. The record of decisive encounters with the cultural palimpsest of Rome before 1800 constitutes a roll-call of such influential figures in the arts as Robert Adam, James Adam, Antonio Canova, Jacques-Louis David, John Flaxman, Jacques Gondoin, Joshua Reynolds, Charles Percier, Pierre-François-Léonard Fontaine, James Stuart and Bertel Thorvaldsen. In the city that Wilhelm Tischbein described as 'the true centre of the arts', a major reassessment of antiquity and the achievements of later flowerings of classicism, such as the Renaissance and the Baroque, began to inspire fresh visionary and poetic compositions, which replaced the traditional, laborious studies of antique exemplars. The distinction of the period between 'imitation' and 'copying'—that is, following the creative spirit rather than the letter of antiquity—was vividly demonstrated in the works and influence of Giovanni Battista Piranesi, in his lifelong crusade to improve contemporary design through a formidable output of engraved images. At the forefront of this shift from the interpretative towards the speculative and experimental was a significant group of students at the Académie de France in Rome during the 1740s and early 1750s. It included Charles-Michel-Ange Challe, Charles-Louis Clérisseau, Charles de Wailly, Pierre-Martin Dumont, Jean-Laurent Legeay, Louis-Joseph Le Lorrain, Ennemond-Alexandre Petitot and Marie-Joseph Peyre. Their innovative ideas, which derived from a radical reappraisal of antique forms and structures and were mainly developed in temporary festival structures, were subsequently to have a far-reaching influence after the artists had dispersed to work throughout Europe, as far as Russia.

Although Rome continued to be a centre for cultural interchange throughout the most productive phases of Neo-classicism, many challenging new discoveries were being made elsewhere in an increasing number and range of archaeological expeditions throughout the Mediterranean and the Near East. While recognition of the reforming potential of Greek antiquity can be traced back to Jean-Louis de Cordemoy earlier in the century, a fresh interest was awakened by the radical questioning of Roman design in favour of Greece in Marc-Antoine Laugier's *Essai sur l'architecture* (Paris, 1753). Like Rousseau's quest for fundamentals in human nature and social conduct, the cult of the Primitive, signified by the rustic 'Vitruvian hut' of rough-hewn trees that was illustrated in Laugier's frontispiece, emphasized the functional and almost ethical principles of truthful construction. Similar ideas were then being advocated independently in Venice through the Socratic teachings of Carlo Lodoli. Far more significant and persuasive, however, was the highly emotive advocacy of Greek art as a cultural phenomenon by Johann Joachim Winckelmann, initiated through his manifesto *Gedanken über die Nachahmung der griechischen Werke in der Malerei und Bildhauerkunst* (Dresden, 1755; Eng. trans., London, 1765), followed by his equally influential *Geschichte der Kunst des Alterthums* (Dresden, 1764). His poetic and highly persuasive writing, evoking the nobility of Hellenic life and achievements, was largely based on a deep knowledge of Classical authors and Roman copies of Greek original works of art. In lyrical passages of empathetic analysis, he created an awareness of Greek art and civilization on a par with Piranesi's potent imagery of Rome (*see also* GREEK REVIVAL, §2). Understandably, his ideas had a less immediate influence on architecture, which

features less in his writings than sculpture or painting. This is perhaps reflected in the brittle decorative pastiches of Greek temples that Carlo Marchionni added during the early 1760s to the villa (now Villa Torlonia) of Winckelmann's patron, Cardinal Alessandro Albani, in Rome. Within the main *salone* of the villa, Anton Raphael Mengs's acclaimed ceiling painting *Parnassus with Apollo and the Muses* (1760–61; *in situ*) provided a pictorial equivalent that owed far more to Raphael than to Greek antiquity, despite its featuring of a baseless Doric column and its relief-like composition. The first true Greek Revival building was, in fact, James Stuart's Doric temple (1758) in the park at Hagley Hall, Hereford & Worcs (*see* GREEK REVIVAL, §1). Also in 1758, Julien-David Le Roy's publication in Paris of the first reliable illustrations of the principal monuments in Athens, *Les Ruines des plus beaux monuments de la Grèce*, anticipated Stuart's and Nicholas Revett's more carefully considered *Antiquities of Athens* (3 vols, London, 1762–95). Following the 'discovery' (*c.* 1746) of the gaunt Doric temples at Paestum in southern Italy, a sequence of publications, which ironically culminated in sublime etchings (*Différentes vues . . . de Pesto*, 1778) by Piranesi, helped, by the end of the century, to transform the Greek Revival in architecture from an archaeological interest into an emotional understanding.

Predictably, the extravagant claims advanced for Greek architecture and design provoked a fierce polemical battle, led, on the Roman side, by Piranesi with his magisterial survey *Le antichità romane* (Rome, 1756), followed during the 1760s by his series of ambitious archaeological folios, with themes ranging from Rome's achievements in architectural composition and ornament to Roman engineering and urban planning. In certain of these works Piranesi championed the Etruscans as the sole mentors of Rome's creative genius; in fact, Etruscanology had already begun to develop as an important field of enquiry in its own right, with the establishment of the Accademia Etrusca at Cortona in 1726 and the Museo Etrusco Guarnacci at Volterra in 1727. Demonstrations of Roman achievement further

afield appeared in Robert Wood's folios on *The Ruins of Palmyra* (London, 1753) and *The Ruins of Baalbec* (London, 1757), as well as in Robert Adam's *Ruins of the Palace of the Emperor Diocletian at Spalatro in Dalmatia* (London, 1764). Other expeditions and books, such as James Dawkins's and Richard Chandler's *Ionian Antiquities* (London, 1769; additions 1797), were subsequently sponsored by the Society of Dilettanti, an extremely influential dining club of leading British patrons and *cognoscenti*.

2. The search for a contemporary style

Winckelmann's assertion in 1755 that 'there is only one way for the moderns to become great and, perhaps, unequalled: by imitating the Ancients' encapsulated Neo-classicism's concern with fostering contemporary art and values. During the 1750s the new theories and practice in art and design were impelled by a deliberate aim to replace what was seen as the frivolity and superficiality of the Rococo by an art with greater seriousness and moral commitment. In their different ways, theorists and teachers such as Winckelmann, Joshua Reynolds and Francesco Milizia emphasized the reforming power of antiquity, while Denis Diderot's regular critiques of the annual Salons in Paris praised the moral values of paintings by Jean-Baptiste Greuze at the expense of those by François Boucher. By the mid-1750s the Scottish artist Gavin Hamilton was pioneering in Rome a new type of history painting that featured morally uplifting themes from antiquity; this was perfected by Jacques-Louis David with such heroic exhibition pieces as *Andromache Mourning Hector* (exh. Salon 1783; Paris, Ecole N. Sup. B.-A., on dep. Paris, Louvre; see fig. 52), *Oath of the Horatii* (exh. Salon 1785; Paris, Louvre) and the *Lictors Bringing Brutus the Bodies of his Sons* (1789; Paris, Louvre;see col. pl. XXIII); these drew, thematically as well as formally, on authentic sources and came close to paralleling David's active involvement with Revolutionary politics. Likewise, the *Death of Marat* (1793; Brussels, Mus. A. Anc.; see fig. 36) provided a new kind of political icon in the manner of a secular Pietà, complementing David's designs for Revolutionary

festivals of Liberty and of the Supreme Being, which similarly exploited the heritage of Classical symbolism. During the same period, the semicircular plans and tiered seating of Greek theatres and Roman *curiae* were being adapted for political assemblies, passing later into building patterns for legislative halls, such as Benjamin Henry Latrobe's House of Representatives (1803–7; destr. 1812–15) for the US Capitol in Washington, DC.

Contemporary sculpture, following Winckelmann's precepts of 'noble simplicity and calm grandeur', likewise showed a new seriousness of purpose, as well as formal restraint. In the work of Canova, Neo-classicism's greatest sculptor, complex energies and powerful emotions were confined within relief-like compositions and governed by geometrical settings, as, for example, in works as varied as *Hercules and Lichas* (1795–1815; Rome, G.N.A. Mod.) and the funerary monument to *Clement XIV* (1783–7; Rome, SS Apostoli; see col. pl. XXIV). Among the most eloquent examples of the uses of funerary geometry is Canova's poignant tomb of *Maria Christina of Austria* (1798–1805; Vienna, Augustinerkirche), where a stark pyramid frames a dramatic tableau of personifications, including Death, Mourning, Piety and Beneficence. Likewise, Jean-Antoine Houdon, Joseph Nollekens and Johann Gottfried Schadow attempted in their portrait sculpture to reconcile the incidences of likeness and psychological character within the timeless properties of the Ideal, as derived from ancient prototypes. In Houdon's words, 'one of the finest attributes of the difficult art of sculpture is truthfully to preserve the form and render the image of men who have achieved glory or good for their country'. The same dilemma between the universal and the particular, recognized by Reynolds in his *Discourses on Art* (London, 1769–90), was one that he attempted to resolve in his portraits by the use of such Classical prototypes as the *Apollo Belvedere* (Rome, Vatican, Mus. Pio-Clementino) for *Commodore Keppel* (c. 1753–4; London, N. Mar. Mus.). The tension between the Ideal and the three-dimensional conventions of pictorial composition were, however, avoided in the stark simplicity of such line engravings as Flaxman's

illustrations to the Homeric epics (published 1793 and 1795) and Dante (published 1807), effectively demonstrating Winckelmann's 'noble simplicity' or, as William Blake put it in another context, 'the wiry line of rectitude'.

In the applied and decorative arts, theorists such as Charles-Nicolas Cochin *le fils* similarly advocated an emphasis on austerity and geometric restraint; their sharp reaction against the curvilinear and sensuous forms of such Rococo designers as Germain Boffrand and Juste-Aurèle Meissonnier was expressed in Cochin's celebrated article *Supplication aux orfèvres, ciseleurs, sculpteurs en bois pour les appartements et autres*, published in *Mercure de France* (Dec 1754). In France this was to launch a fashion for the so-called GOÛT GREC, as pioneered by Le Lorrain's furnished interiors (1756–8; now Chantilly, Mus. Condé) for the Parisian financier Ange-Laurent de La Live de Jully.

The new style was taken to a greater pitch of refinement by such outstanding *menuisiers* and

52. Jacques-Louis David: *Andromache Mourning Hector*, 1783 (Paris, Musée du Louvre)

ébénistes of the Louis XVI era as Georges Jacob (ii) and Jean-Henri Riesener, and its influence spread through the production of the copious plates of Jean-François de Neufforge's *Recueil élémentaire d'architecture* (10 vols, Paris, 1757–68 and 1772–80), in which the author claimed to imitate 'the masculine, simple, and majestic manner of the ancient architects of Greece and of the best modern architects'. These reactions to the *goût pompadour* also display a considerable element of revival of the arts of the Grand Siècle of Louis XIV, as found in Anges-Jacques Gabriel's masterpiece of geometric harmony and restraint, the Petit Trianon (1762–8) at Versailles.

In England the PALLADIANISM of the early 18th century, led by William Kent, Richard Boyle, 3rd Earl of Burlington and 4th Earl of Cork, and Thomas Coke, 1st Earl of Leicester, had anticipated continental Neo-classicism by several decades, in creating architecture and interiors from direct archaeological sources. Kent had been among the first designers in Europe to reintroduce the antique style of grotesque painting in such works as the Presence Chamber (1724) in Kensington Palace, London, inspired by Raphael's decorations in the Vatican loggias and the Villa Madama, Rome. However, a major new phase of experiments, involving radical and imaginative styles of design *all'antica*, took place between 1760 and 1780. These included James Stuart's Painted Room (from 1759) in Spencer House, London, the first convincingly Neo-classical interior with integrated furnishings in Europe. This scheme, combining Greek and Roman decorative and architectural sources within a framework of painted Raphael-esque grotesques, contained a suite of carved and gilt seat furniture. Particularly notable were four sofas incorporating winged lions and a pair of ormolu tripod candelabra–perfume burners supported by stands richly decorated in keeping with the surrounding walls. Equally remarkable was the first Pompeian interior, complete with classicizing Klismos chairs, in the gallery at Packington Hall, Warwicks (1785–8), designed by the Adams' assistant Joseph Bonomi in collaboration with the owner, Heneage Finch, 4th Earl of Aylesford. With its dominant colour scheme of deep reds and lustrous blacks, shared in common by the walls, ceilings, hangings and upholstery, this interior preceded by many years the main Pompeian Revival schemes on the Continent.

Under Neo-classicism, the search for a new or 'true style'—one that would be peculiar to the late 18th century and responsive to fresh social needs—took a variety of forms. In architectural design, eclectic solutions included Jacques-Germain Soufflot's Ste Geneviève (begun 1755; now the Panthéon), Paris, whose design combined Greek and Roman forms with Gothic principles of vaulting, while at the same time observing Laugier's advocacy of columnar functionalism. Piranesi's modest reconstructed church of S Maria del Priorato (1754–5; Rome) incorporates motifs drawn from Etruscan, late Imperial Roman and Mannerist sources in accordance with the bold philosophy of design advocated in his treatise *Parere su l'architettura* (Rome, 1765), which defended an extreme eclecticism. This broadly based system of composition found its most accomplished and original application in the architecture and furniture designs of Piranesi's associate Robert Adam. The consummate mastery with which Adam exploited an awkward series of given spaces and changes of level at Syon House (1760–69), London, is displayed in the Anteroom, where rich colours and textures are combined with Greek and Roman decorative sources to create an effect of patrician opulence. The highly self-conscious and consumer-led Adam Style (defended and illustrated in *The Works in Architecture of Robert and James Adam*, i–ii (London, 1773–9)), reached its most experimental form in a series of Etruscan rooms. In the most complete surviving example, the Etruscan Dressing-room (c. 1775–6; see fig. 27) at Osterley Park, London, the unifying system of ornament combined ingredients from Pompeian wall decoration with motifs and colours from antique vase paintings, then believed to be Etruscan.

Stylistic solutions involving extremes in geometric simplification and surface austerity were predictably limited to paper projects, such as Friedrich Gilly's design for a Schauspielhaus in Berlin (pen and ink with wash, c. 1798; ex-Tech.

Hochsch., Berlin, 1945); Etienne-Louis Boulleé's design for a gigantic spherical cenotaph to Isaac Newton (pen and ink with wash, 1784; Paris, Bib. N.); and Claude-Nicolas Ledoux's engravings of visionary designs for the Saline de Chaux at Arc-et-Senans, near Besançon, later published in his *L'Architecture considérée sous le rapport de l'art, des moeurs et de la législation* (vol. i, Paris, 1804). Works of a more practicable nature that were actually executed included such public buildings as Jacques Gondoin's anatomy lecture theatre (1780) at the Ecole de Chirurgie (now Faculté de Médecine), Paris, its interior displaying a remarkable fusion of the Pantheon in Rome and a Greek theatre.

Thomas Jefferson and Clérisseau had recourse to a celebrated Roman exemplar, the Maison Carrée, Nîmes for the basic form, albeit considerably enlarged, of the State Capitol (1785–99), Richmond, VA. Other striking solutions included Ledoux's ingenious series of toll-houses or *barrières* (1785–9) erected around Paris, and Leo von Klenze's Walhalla (1830–42) near Regensburg, which consisted of a peripteral Doric temple sited on the crest of a hill and containing busts of celebrated Germans. In all these works, classic restraint was to be seen as expressive of civic and national virtues.

3. Education and society

In the applied arts the new mass-production processes of the early years of the Industrial Revolution, often allied to the use of new synthetic materials, were swiftly adapted to the simplified forms and abstracted ornaments characteristic of astringent Neo-classical design. Britain came to fulfil a pioneering role with the foundation in 1754 of the Royal Society for the Encouragement of Arts, Manufactures and Commerce, the first organization established to promote industrial design. Its founder-members included the potter Josiah Wedgwood, who in his new factory, the Etruria works, opened in 1769 near Burslem, Staffs, exploited the vase forms, colours and decorative vocabulary of Pierre François Hugues d'Hancarville's *Collection of Etruscan, Greek and Roman Antiquities from the Cabinet of the Honble Wm Hamilton* (4 vols, Naples, 1766–76). Wedgwood's new materials, also inspired by the ancient world, were black basalts imitating Etruscan bronzes, and jasperware inspired by Roman cameo glass. A comparable entrepreneurial spirit was shown by Matthew Boulton, a fellow member of the Royal Society of Arts. At his Soho factory in Birmingham Boulton produced abstracted classicizing forms in a wide range of ornamental metalwork, from ormolu, Sheffield plate and silver to cast-iron architectural fittings. Both men also belonged to the Lunar Society, an influential discussion group of industrialists, scientists and avant-garde designers in the English Midlands, who met on evenings when they could travel by moonlight. This pioneering concern with the control of design and manufacture in industry bore fruit internationally early in the next century, through such outstanding architects as Schinkel, who in 1819 helped found the influential Technische Deputation in Prussia.

The role of the Royal Society of Arts highlights the central importance given to education in the theoretical and practical concerns of Neo-classicism. The very nature of the Enlightenment and the objective of Diderot's and d'Alembert's *Encyclopédie* (Paris, 1751–72) was to promote enquiry into the broadest range of activities; the arts were seen to have an important responsibility in spreading knowledge, as well as serving the interests of an ever-widening public. Consequently numerous art academies were established during the later 18th century to improve the intellectual training of artists and architects. Moreover, the subject-matter of art and the range of specialized building types extended accordingly to meet the needs of a wider social clientele. Accompanying this concern with education was the rise of professional organizations for artists and architects (often providing qualifications and diplomas) to enhance their social status, as exemplified in Reynolds's programme for the Royal Academy (established 1768) in London. Within this institution, the status of women artists was recognized with the inclusion of Angelica Kauffman and Mary Moser among the 40 founder-academicians, and the social significance of the institution was

signalled by the Academy's impressive head-quarters in Sir William Chambers's Somerset House (from 1776; moved to Burlington House by 1869), London.

In response to the didactic role of art as a moral and intellectual force in society, public museums and art galleries also began to be established, involving educationally motivated programmes of display and housed in some of the earliest custom-built structures. Such private galleries as the Uffizi in Florence and the Antiquarium at the Residenz in Munich had been in existence since the Renaissance, while cabinets of curiosities and *Kunstkammern* had been developed in the 17th century. In 1753 the British government founded the British Museum in London from the collection of Sir Hans Sloane, while in Paris the Musée Central des Arts in the Palais du Louvre was designated a public museum in 1792. In the last quarter of the 18th century, in the reigns of Clement XIV (*reg* 1769–75) and Pius VI (*reg* 1775–1800), the Vatican's unrivalled collection of antiquities was arranged within a sequence of sophisticated displays, and in the early 19th century several important new museums and galleries were constructed in Europe.

The attention paid to the developing social commitments of artists, architects and designers, as well as new areas of patronage and widening audiences, posed new problems over the definition of 'art'. Creating forms of universal significance with eternal validity related uneasily at times to the search for fresh modes of contemporary expression and demands for new subject-matter. This dilemma is vividly illustrated by such works as Benjamin West's *Death of General Wolfe*

53. Joseph Wright of Derby: *Experiment on a Bird in the Air Pump*, 1768 (London, National Gallery)

(1770; Ottawa, N.G.), where the event is controversially depicted in modern dress despite the use of historical formulae. Particularly challenging was Jean-Baptiste Pigalle's *Voltaire Nude* (1770–76; Paris, Inst. France), an uncompromising marble statue of the elderly writer reminiscent of the antique ('Borghese') *Dying Seneca* (Paris, Louvre). A revaluation of Nature and its associated phenomena, in which the emotions were seen to play an increasingly dominant role, is expressed in such paintings as Joseph Wright of Derby's *Experiment on a Bird in the Air Pump* (1768; London, N.G.; see fig. 53) portraying human reactions of excitement and apprehension to scientific enquiry. In George Stubbs's *Horse Devoured by a Lion* (exh. ?1763; London, Tate), the wild character of the enveloping landscape amplifies an epic subject, later to be a favourite theme of such 19th-century Romantic artists as Géricault.

4. Nature and classicism

The conception of landscape as Nature perfected by mankind's intervention, characteristic of art and landscape design in the previous 200 years, was now replaced by one in which sentiment and idealized forms demanded a deeper act of involvement by the spectator. This is reflected in works as diverse as the imaginary landscape paintings of Richard Wilson or Joseph Anton Koch and such portraits as Gainsborough's *Mrs Richard Brinsley Sheridan* (1785; Washington, DC, N.G.A.) or Wilhelm Tischbein's *Goethe in the Roman Campagna* (1787; Frankfurt am Main, Städel. Kstinst. & Städt. Gal.). Ideas first explored in the early 18th century by Alexander Pope and Kent attained new levels of significance in such poetic landscape gardens as Stourhead, Wilts, developed from 1743 by its owner, Henry Hoare the younger, and Ermenonville, near Senlis, created between 1766 and 1776 by Louis-René de Girardin and to be, appropriately, a temporary resting-place for Jean-Jacques Rousseau's remains in a tomb designed by the ruin painter Hubert Robert. In this type of garden a calculated sequence of symbolic structures—intact or ruined classical temples, rough-hewn grottoes and rustic structures—was carefully sited to arouse a variety of responses from the perambulating visitor (a person of Sensibilité), as characterized by Girardin's *Promenade ou itinéraire des jardins d'Ermenonville* (1788). Marie-Antoinette's severely classical dairy at Rambouillet, designed by Hubert Robert and constructed in 1785–8 by Jacques-Jean Thévenin (fl 1770–90), opens into a rocky grotto framing a marble statue of the nymph Amalthea and provided a setting for the Queen and her retinue to act out pastoral pursuits in harmony with Arcadian Nature.

Edmund Burke's essay *A Philosophical Enquiry into the Origin of our Ideas of the Sublime and the Beautiful* appeared in 1756 during the long evolution of literary-inspired gardening in Britain and marked a new critical stage in its analysis of the psychological roots of aesthetic perception (*see* SUBLIME, THE). This discussion culminated in the Picturesque debate of the 1790s led by Richard Payne Knight and Uvedale Price, which involved a conflict between the regular, geometric forms of the Classical ideal and the consciously asymmetrical, pictorial forms associated with the emerging GOTHIC REVIVAL. Architectural solutions to this dilemma, whereby buildings were carefully integrated with the surrounding landscape, included Knight's own house Downton Castle (1772–8), Hereford & Worcs, with its medieval castellar exterior and a classical dining rotunda among the principal rooms within. Robert Adam's exceptional sequence of Scottish castles of the 1780s and 1790s, such as Culzean Castle (1777–92), Strathclyde, and Seton Castle (1789–91), Lothian, while retaining an uncompromising classical symmetry and simplicity of volume, was effectively sited to bring out the full scenic potential through oblique views and dramatic settings. Similarly, the pioneering villa (c. 1802) in the Italianate style at Cronkhill, Salop, by John Nash involved a scenic composition that deployed classical forms in a skilfully asymmetrical plan.

By the early 19th century the newly awakened forces of the emotional and pictorial in art were beginning to undermine the dominance of certain aesthetic and cultural principles associated with the classical tradition over past centuries. Moreover, an increasing search for archaeological

truth served to impair imaginative processes and to weaken the character of the Neo-classical movement to a point where, according to Honour, it was 'drained of the force of conviction' and replaced by an international style of great decorative finesse and fashionable appeal.

5. The late phase

The adoption of Neo-classicism as an official style by the Jacobins of the French Revolution, accompanied by secular cults of Republican imagery, was succeeded during the Napoleonic age by the spread throughout Europe, by means of Bonapartist regimes, of a propagandist language of absolutism. Greek austerity was exchanged for the florid rhetoric of Imperial Roman art, extending from the creation of large urban-planning projects and public monuments down to schemes of interior decoration and furnishing (see DIRECTOIRE STYLE and CONSULATE STYLE). At its highest level, the applied arts of the First Empire (1804–15) involved such outstanding designers as Charles Percier and Pierre-François-Léonard Fontaine, whose *Recueil de décorations intérieures comprenant tout ce qui a rapport à l'ameublement* (Paris, 1801) served as a manifesto for this politically motivated classicism. Defining the official Napoleonic style, works ranged from the Arc de Triomphe du Carrousel (1806–7), Paris, with its polychromatic programme of imperial imagery, to interiors for the châteaux of Saint-Cloud and Malmaison and for the Palais des Tuileries in Paris, and such ceremonial settings as that depicted by David in the *Coronation of Napoleon in Notre-Dame* (1805–7; Paris, Louvre; version Versailles, Château). With the spread of the empire and its needs for an appropriate political image, the new classicism was developed by able practitioners: in Italy, for example, by such architects as Luigi Cagnola, Giovanni Antonio Selva and Giuseppe Valadier, and such designers as Antonio Basoli (1774–1843), Luigi Canonica and Pelagio Palagi. Meanwhile, the sculptural identity of Napoleon and his family was provided by Canova, who produced several monumental images between 1803 and 1809, including a bronze equestrian statue of the Emperor (later completed as *Charles III of Naples and Spain*, 1807–19;

Naples, Piazza Plebiscito), a colossal standing nude figure depicting *Napoleon as Mars the Pacifier* (marble, 1803–6; London, Apsley House; bronze replica, 1809; Milan, Brera) and *Paolina Borghese Bonaparte as Venus Victorious* (marble, 1804–8; Rome, Gal. Borghese), which is strangely reminiscent of Etruscan burial effigies while being the best-known, if unconventional, portrait of Napoleon's sister. Like the Roman Empire, its principal source of inspiration, the Napoleonic era converted for its use the decorative language of invaded cultures, notably that of ancient Egypt following the North African campaign in 1798. The resulting researches made by Vivant Denon, the future director of the Musée Napoléon (formerly the Musée Central des Arts), were published in the form of two influential source-books, *Voyage dans la basse et la haute Egypte pendant les campagnes du général Bonaparte* (2 vols, Paris, 1802) and *Description de l'Egypte* (24 vols, Paris, 1809–22), and often converted into designs for the imperial court. Examples of this new taste in the decorative arts are Martin-Guillaume Biennais's coin-cabinet (c. 1800–14; New York, Met.) based on the pylon at Qus (Apollinopolis Parva) in Upper Egypt and a lavish Egyptian service in Sèvres porcelain (1809–12; London, Apsley House; for further discussion see EGYPTIAN REVIVAL and EMPIRE STYLE).

In Britain the contemporary REGENCY STYLE, despite strong affinities in its formal language and decorative values to the French Empire style, was largely saved from a similar stereotyped character by the originality of a number of artists, architects and designers working within the classical tradition. Soane's exceptional and complex system of interlocking interiors for the Bank of England (1788–1833), London, with an ingenious use of toplighting and daring abstractions of classical structure and ornament, made it the most original public building of late Neo-classicism anywhere in Europe. Flaxman, apart from various funerary monuments (e.g. *Lord Nelson*, 1808–18; London, St Paul's Cathedral) and book illustrations to the Homeric epics and the works of Dante (see §2 above), was a highly versatile designer in the applied arts. In addition to his early work for

Wedgwood (e.g. the jasperware vase with the *Apotheosis of Homer*, 1786; London, BM), he served the royal goldsmiths Rundell, Bridge & Rundell. Thomas Hope, a discerning patron of such artists as Canova and Flaxman, exerted a considerable influence as a designer himself, transforming the interior of his own house (1799–1801; destr. 1850) in Duchess Street, London, and publishing the designs in his *Household Furniture and Interior Design* (London, 1807). Inspired by Piranesi and familiar with the contemporary work of Percier, Fontaine and Denon, he created a sequence of highly personal rooms, complete with furniture according to stylistic themes, and incorporating material from Greek, Roman, Egyptian, Indian and Turkish sources. In 1818–19 and 1823 he remodelled and extended his country house, The Deepdene (destr. 1967), Surrey, with skilful Picturesque planning, incorporating similar ideas.

In its most original and productive aspects, the period of late Neo-classicism covering the first quarter of the 19th century was a time of considerable achievements in urban design, involving a large number of major public buildings and civic works. Almost in contrast to the art of the Napoleonic age, the later GREEK REVIVAL—ideologically associated with both liberal and nationalist movements—became the preferred style for significant monuments. Outstanding among these were buildings and structures in Berlin by Carl Gotthard Langhans and Schinkel, in Edinburgh by Thomas Hamilton and William Henry Playfair, in Philadelphia by Benjamin Latrobe and Pierre-Charles L'Enfant and in St Petersburg by Thomas-Jean de Thomon (e.g. the Stock Exchange, 1805–10; now the Central Naval Museum) and Andreyan Zakharov (e.g. the Admiralty Building, 1806–12). The most significant innovations in planning as such, however, were in England, where between 1754 and 1775 John Wood I and John Wood II pioneered highly original and flexible housing patterns in Bath, Avon, in response to the natural contours of the site (e.g. the King's Circus, 1754–c. 1766, and the Royal Crescent, 1767–c. 1775). Many of these ideas were exploited in London from 1813 on a metropolitan scale by John Nash, with the active encouragement of the Prince Regent (later

George IV, *reg* 1820–30) in the innovative scheme for Regent's Park with its related royal processional route. Nash's ingenious blend of 'natural' landscape in the current Picturesque mode, placed within the heart of a monumental scheme of formal classical terraces and individual villas in the parkland, together with a satellite village and water-borne services by canal, was to provide key concepts for the Garden City movement 100 years later.

The fact that Nash's design for Regent's Park can be interpreted as either Neo-classical or Romantic (or even considered within the context of the hybrid term ROMANTIC CLASSICISM) indicates the degree of ambiguity of works of art and design within the classical tradition in the early 19th century. As Honour has pointed out (p. 186–7), early Romantic artists such as Anne-Louis Girodet had trained in David's studio and had emerged to develop a style that exploited rhapsodic and supernatural effects and themes found in contemporary nationalist literature in northern Europe (e.g. Girodet's *Ossian and the French Generals*, 1800–02; Malmaison, Château N.; see also fig. 76). Meanwhile, LES PRIMITIFS—artists who had taken the cult of Primitivism and simplicity to puritan extremes—left few works of any significance but disturbed the careful balance and ambiguity that had made the Neo-classical style so effective a force in its early development. Even the conventional polarity so often devised between Ingres, the ostensibly archetypal Neo-classicist, and Delacroix, the Romantic, appears more complex when the subject-matter and strong degree of sentiment are examined, even in Ingres's most classicizing works.

Like the social forces that condition their origins, maturation and development, stylistic movements have a lifespan that determines their relevance and effectiveness as well as, ultimately, their replacement by fresh intellectual climates. Neo-classicism, while still traced as an identifiable mode of classicism well into the 19th century in, for example, Alexander Thomson's churches in Glasgow or Thomas Couture's Salon paintings and James Pradier's sculptures in France, had ceased to be a commanding idea. In the 20th century it

reappeared, most significantly in architecture, as an influence on designers with strong classical sympathies as sharply contrasting as Mies van der Rohe and Albert Speer, and it has made a questionable 'come-back' in certain aspects of the Postmodern movement.

Bibliography

M.-A. Laugier: *Essai sur l'architecture* (Paris, 1753, rev. 1755/*R* 1972; Eng. trans., 1755)

D. Diderot: *Salons* (1759–81); ed. J. Adhémar and J. Seznec, 4 vols (Oxford, 1957–67, rev. 1983)

J. Reynolds: *Discourses on Art* (London, 1778); ed. R. R. Wark (San Marino, CA, 1959/*R* New Haven and London, 1975)

L. Eitner, ed.: *Neo-classicism and Romanticism, 1750–1850*, Sources & Doc. Hist. A., i (Englewood Cliffs, NJ, 1970)

G. B. Piranesi: *The Polemical Works*; ed. and trans. by J. Wilton-Ely (Farnborough, 1972) [contains *Della magnificenza ed architettura de' Romani* (Rome, 1761), *Parere su l'architettura* (Rome, 1765) and *Diverse maniere* (Rome, 1769) among other works]

J. Winckelmann: *Writings on Art*, ed. D. Irwin (London, 1972)

H. T. Parker: *The Cult of Antiquity and the French Revolutionaries* (Chicago, 1937)

N. Pevsner: *Academies of Art* (Cambridge, 1940)

M. Praz: *Gusto neoclassico* (Florence, 1940); Eng. trans. as *On Neo-classicism* (London, 1972)

F. D. Klingender: *Art and the Industrial Revolution* (London, 1947, rev. 1967)

D. Irwin: *English Neo-classical Art* (London, 1966)

R. Rosenblum: *Transformations in Late 18th-century Art* (Princeton, 1967)

H. Honour: *Neo-classicism*, Style & Civiliz. (Harmondsworth, 1968, rev. 1977)

P. Gay: *The Enlightenment, an Interpretation: The Science of Freedom* (New York, 1970)

J. M. Crook: *The Greek Revival* (London, 1972)

Age of Neo-classicism (exh. cat., ACGB, 1972)

J. Rykwert: *The First Moderns* (Cambridge, MA, 1980)

C. Justi: *Winckelmann und seine Zeitgenossen*, 3 vols (Leipzig, 1923)

J. Fleming: *Robert Adam and his Circle* (London, 1962, rev. 1978)

W. Herrmann: *Laugier and 18th-century French Theory* (London, 1962)

R. Rosenblum: *Jean-Auguste-Dominique Ingres* (London, 1967)

D. Watkin: *Thomas Hope (1769–1831) and the Neo-classical Idea* (London, 1968)

N. Goodison: *Ormolu: The Work of Matthew Boulton* (London, 1974)

G. Pavanello: *L'opera completa del Canova* (Milan, 1976)

J. Wilton-Ely: *The Mind and Art of Piranesi* (London, 1978)

D. Irwin: *John Flaxman (1755–1826): Sculptor, Illustrator, Designer* (London, 1979)

A. Brookner: *Jacques-Louis David* (London, 1980)

M. Snodin, ed.: *Karl Friedrich Schinkel: A Universal Man* (London, 1991)

A. Potts: *Flesh and the Ideal: Winckelmann and the Origins of Art History* (London, 1994)

T. F. Hamlin: *Greek Revival Architecture in America* (New York, 1944)

J. Summerson: *Architecture in Britain, 1530–1830*, Pelican Hist. A. (Harmondsworth, 1953, rev. 7/1983)

H. R. Hitchcock: *Architecture: Nineteenth and Twentieth Centuries*, Pelican Hist. A. (Harmondsworth, 1958, rev. 1977)

J. Harris: 'Le Geay, Piranesi and International Neo-classicism in Rome, 1740–1750', *Essays in the History of Art Presented to Rudolf Wittkower* (London, 1967), pp. 189–996

D. Wiebenson: *Sources of Greek Revival Architecture* (London, 1969)

K. Woodbridge: *Landscape and Antiquity: Aspects of English Culture at Stourhead, 1718–1835* (Oxford, 1970)

N. Pevsner: *A History of Building Types* (London, 1976)

A. Braham: *The Architecture of the French Enlightenment* (London, 1980)

R. Middleton and D. Watkin: *Neo-classical and 19th-century Architecture* (London, 1980)

D. Watkin and T. Mellinghoff: *German Architects and the Classical Ideal, 1740–1840* (London, 1987)

D. Stillman: *English Neo-classical Architecture*, 2 vols (London, 1988)

J. Wilton-Ely: *Piranesi as Architect and Designer* (New Haven, 1993)

W. Friedlaender: *From David to Delacroix* (Cambridge, MA, 1950)

E. K. Waterhouse: *Painting in Britain, 1530–1790*, Pelican Hist. A. (Harmondsworth, 1953)

F. Novotny: *Painting and Sculpture in Europe, 1780–1880*, Pelican Hist. A. (Harmondsworth, 1960)

M. Whinney: *Sculpture in Britain, 1530–1830*, Pelican Hist. A. (Harmondsworth, 1964)

M. Levey: *Painting and Sculpture in France, 1700–89*, Pelican Hist. A. (Harmondsworth, 1992)

F. J. B. Watson: *Louis XVI Furniture* (London, 1960)

E. Harris: *The Furniture of Robert Adam* (London, 1963)

M. Gallet: *Demeures parisiennes: L'Epoque de Louis XVI* (Paris, 1964)

S. Eriksen: *Early French Neo-classicism* (London, 1974)

A. González-Palacios: *Il tempio del gusto: Le arti decorative in Italia fra classicismi e barocco: Roma e il regno delle due Sicilie*, 2 vols (Milan, 1984)

J. Wilton-Ely: 'Pompeian and Etruscan Tastes in the Neo-classical Country House Interior', *Conference Proceedings. The Fashioning and Functioning of the British Country House: Washington, 1985*, pp 51–73

A. González-Palacios: *Il granducato di Toscana e gli stati settentrionali*, 2 vols (Milan, 1986)

G. Worsley: 'Antique Assumptions', *Country Life*, clxxxvi (6 Aug 1992), pp. 48–50

JOHN WILTON-ELY

Néo-Grec

Term used for a manifestation of the Neo-classical style initiated in the decorative arts of France during the Second Empire (1852–71) of Napoleon III and his wife, the Empress Eugénie. Based on the standard repertory of Greco-Roman ornament, it combined elements from the Adam, Louis XVI and Egyptian styles with a range of motifs inspired by discoveries at Pompeii, where excavations had begun in 1848; it can be identified by the frequent use of Classical heads and figures, masks, winged griffins, sea-serpents, urns, medallions, arabesques, lotus buds and borders of anthemion, guilloche and Greek fret pattern. Néo-Grec was eclectic, abstracted, polychromatic and sometimes bizarre; it enjoyed popularity as one of the many revival styles of the second half of the 19th century.

In Paris, the Néo-Grec style was best exemplified in the famous 'Maison Pompéienne' (1856–8; destr. 1891) designed for Prince Napoléon Bonaparte by Alfred Nicolas Normand; the style of this colourfully decorated house was derived from the 'third style' of Pompeii c. 82–79 BC, as may be seen in Normand's design for the atrium (pencil, ink, watercolour and gouache, Paris, 1860; Paris, Mus. A. Déc.). Some of the painted room decorations were the work of Jean-Léon Gérôme. In furniture, the Empress Eugénie's passion for the 18th century resulted in a vogue for the styles of Louis XV and Louis XVI, recreated either in direct imitation or in the more fanciful Néo-Grec manner;

the latter pieces were often painted, ebonized and gilded, with shallow carving or incised decoration and crossed or tripod, hocked and hoofed legs. Rooms of this period were crowded with seating of all kinds, upholstered in button-tufted velvet, damask or corded silk with fringes, tassels and bobbles, a treatment echoed in the window curtains; this style is depicted in a plate (London, V&A) from *Le Magasin de Meubles* (Paris, 1865–7) illustrating Néo-Grec window treatment. Tripod stands, often dangling chains with pendant balls, and classical figures of bronze supporting candelabra were favoured items.

In the USA, Néo-Grec coincided with an interest in Egyptian artefacts, which sometimes led to an exotic fusion of themes, as in the painted and gilded beech-wood stool (c. 1865; New York, Met.) designed by Alexandre Roux (fl 1837–81). More typical was the solid, rectilinear parlour furniture manufactured by such companies as M. & H. Schrenkeisen and George Hunzinger (fl 1861–80), both of New York, where the heightened chair crests were carved with such Néo-Grec devices as scrolled volutes, foliate forms, palmettes and roundels, topped by enlarged acroteria and miniature pediments (e.g. parlour suite no. 95 from the M. & H. Schrenkeisen catalogue, New York, 1879; Winterthur, DE, Mus. & Gdns. Lib.). This fashionable furniture was frequently categorized with the American Eastlake style, which also featured angular forms and incised decoration.

The ceramics, silver and glass produced at this time commonly exhibited ancient Greek pottery forms; the shapes included the amphora and the kylix (a shallow, footed bowl). Both silver and glass manufacturers preferred slender, elegant vessels engraved or applied with Classical designs and frequently resting on tripod bases with hoofed feet, an example being a vase of wheel-engraved glass set in cast bronze feet (Toronto, Royal Ont. Mus.), made in the 1870s, possibly in France. The many diverse objects that are now accepted as Néo-Grec are appreciated as a lively, disciplined embellishment of Classical traditions.

A group of painters in Paris, active from the mid-1840s and led by Gérôme, were dubbed the Néo-Grecs, for their popular renderings of

antiquity. They lived and worked together in a house on the Rue de Fleurus, which their friend and champion, the writer Théophile Gautier, called 'little Athens'. Besides Gérôme, the original members included Jean-Louis Hamon and Henri-Pierre Picou (1824–95). The group painted intimate scenes, drawn from Classical literature, of everyday life in Greece of the 5th century BC. Their nude or gauzily draped maidens and youths in short tunics were depicted with photographic realism and an underlying homoeroticism, typified by Gérôme's well-known painting *The Cockfight* (oil, 1846; Paris, Louvre). Although highly fashionable for a while, the Néo-Grec painters' work attracted criticism for its preciousness and pseudo-intellectualism.

Bibliography

C. H. Stranahan: *A History of French Painting* (London, 1889), pp. 329–35
K. L. Ames: 'Sitting in (Néo-Grec) Style', *19th C.* [New York], ii (1976), pp. 51–8
G. M. Ackerman: *The Life and Work of Jean-Léon Gérôme* (London, 1986) [with cat. rais.]

□

Neo-Impressionism

Term applied to an avant-garde, European art movement that flourished from 1886 to 1906. The term Neo-Impressionism was coined by the art critic Félix Fénéon in a review, 'Les Impressionistes' (in *La Vogue*; Paris, 1886), of the eighth and last Impressionist exhibition. Camille Pissarro had convinced his Impressionist colleagues to allow paintings by himself, his son Lucien Pissaro, Paul Signac and Georges Seurat to be shown together in a single room, asserting a shared vision and inviting comparison. Fénéon considered Albert Dubois to be one of the 'new Impressionists'; the group soon included Charles Angrand, Louis Hayet, Henri Edmond Cross, Léo Gausson, Hippolyte Petitjean and Maximilien Luce.

Fénéon paid homage with the term Neo-Impressionism to the group's rebellious precursors, Monet, Auguste Renoir and Alfred Sisley, while distinguishing the new group's innovations.

Impressionism, for Fénéon, was synonymous with instinct and spontaneity, whereas Neo-Impressionism was based on reflection and permanence. Although the Impressionists obeyed rules of colour contrast, they did so pragmatically and not according to the codified, scientific principles that were adopted by the Neo-Impressionists, who believed that painting could be based on rules that would make it possible to replicate the luminosity of nature on canvas. These rules would enable the artist to perfect his individual vision but were not intended to be used as a formula. The techniques associated with Neo-Impressionism were initiated by Seurat and were distinguished by the application of discrete units of paint, combined according to various theories of colour (see col. pl. XXV). This gave rise to the terms Pointillism, which refers to the application of dots of paint, and Divisionism, which involves the separation of colour through individual strokes of pigment (*see* DIVISIONISM).

1. Origins and theoretical background

In the mid-1880s Seurat had become interested in several newly published studies of light and colour, including the experiments of the American physicist Ogden Rood, discussed in *Students' Text-book of Colour: or, Modern Chromatics, with Applications to Art and Industry* (New York, 1881), as well as the colour discs of James Maxwell and the theories of Heinrich-Wilhelm Dove. Seurat adopted Rood's belief that 'optical mixture' was preferable to the 'palette mixture' employed by Delacroix and the Impressionists. The goal of optical mixture was luminosity, which was aided by the adoption of separate dots of colour. These small dots also permitted the artists to paint on dry areas of canvas, in contrast to the Impressionists, who painted wet strokes upon wet to capture changing conditions of light and atmosphere. Neo-Impressionists made use of the laws of simultaneous and successive contrast gleaned from Michel-Eugène Chevreul's *De la loi du contraste simultané des couleurs et ses applications* (Paris, 1839), in which he explained that simultaneous contrast occurs when two complementaries are juxtaposed to create an effect of

great intensity and vibrancy; successive contrast is the appearance around a passage of one colour of a halo of its complement.

This interest in colour extended to the borders around the canvases. At first, Seurat favoured white frames, believing that gold competed with the orange hues in his paintings. After a brief period of experimentation with dots applied directly to the frame, he settled on adding a dotted inner border of complementary colours on the canvas, between the image and the white frame.

As well as a desire to replicate natural light and colour, the Neo-Impressionists sought scientific mastery of composition. Seurat was particularly influenced by Charles Henry's *L'Esthétique scientifique* (Paris, 1855), an exploration of physiological responses to line and colour. According to Henry, upward lines and warm colours produced a 'dynamogenous' or uplifting effect, and downward lines and cold colours an 'inhibitory' one. Seurat's *The Parade* (1887–8; New York, Met.) is composed on a balance of such diagonal lines arranged according to the golden section, a ratio recommended by Henry for determining the placement of horizontals and verticals in a composition. However, the work of Seurat and his circle attempted more than the sum of the scientific systems derived from Chevreul, Rood and Henry. Like the contemporary Symbolist writers, the Neo-Impressionists wished to evoke a mood and to go beyond the mere appearance of nature to an underlying structure and meaning. At regular gatherings at Signac's studio Cross and Dubois met the Symbolist writers Gustave Kahn, Fénéon and Henri de Régnier. These writers saw in Seurat's work a search for a timeless monumentality that evoked the art of Ancient Egypt and Greece.

Both the Neo-Impressionists and Symbolists were acquainted with anarchist beliefs, including the writings of the Russian aristocrat Prince Pyotr Kropotkin, whose *Paroles d'un Révolté* (Paris, 1885) popularized the socialist views of William Morris. Kropotkin's emphasis upon the importance of art in everyday life, his belief that art should be in the service of revolution and his support for the individuality of the artist were all attractive to the group. Although they contributed illustrations and subscribed to, and at times financially supported, anarchist publications such as Jean Grave's *La Révolte* and *Les Temps nouveaux*, the Neo-Impressionists were not militant anarchists. They held that their radicalism lay in the very nature of their innovative art, which would help bring about the downfall of the status quo and all that was conservative; the style itself was helping to create a new society. Moreover, a painting's content could contribute to this end: factories, peasants, and industrial suburbs were depicted to show the meanness of daily life.

2. Diffusion of Neo-Impressionism in Europe

Seurat's entries for the Impressionist exhibition of 1886, most notably the *Grande Jatte*, led to an invitation to show in Brussels at the avant-garde exhibition society, Les XX, with Camille Pissarro in February 1887. Octave Maus, secretary of the group, welcomed the opportunity to show the controversial painting in Brussels and in an article, 'Les Vingtistes Parisiens' (in *Art moderne*, 1886), proclaimed Seurat 'the Messiah of a new art'. Seurat attended the opening in Brussels accompanied by Signac. In 1888 French Neo-Impressionism was represented at Les XX with 12 paintings by Signac and 13 by Dubois. The presence of these works in Brussels created a new group of Belgian Neo-Impressionists within Les XX. In summer 1887 Alfred William Finch had become the first Belgian to adopt Neo-Impressionist techniques, and by 1889 he was joined by fellow Vingtistes Anna Boch, Henry Van de Velde, Théo Van Rysselberghe and Jan Toorop. In 1890 Georges Lemmen adopted the style, creating some of his most successful portraits, such as *Julie* (1891; Chicago, IL, A. Inst.), and marine paintings in the Neo-Impressionist manner. Seurat exhibited at Les XX in 1889 and 1891; in 1892 the Vingtistes sponsored a memorial exhibition in his honour.

The Belgians came close to dominating the movement by 1892. Neo-Impressionism was introduced to the Netherlands by the exhibition by Les XX held at The Hague in 1892, in which Van de Velde and Toorop played major roles. Dutch artists who adopted Neo-Impressionism included Joseph

Aarts, Hendricus Peter Bremmer and Jan Vijlbrief (1868–95). Neo-Impressionism had little influence outside France, Belgium and the Netherlands. The German artists, Paul Baum (1859–1932) and Christian Rohlfs, experimented with divided colour; and the Italians Angelo Morbelli and Plinio Nomellini were also briefly attracted to the technique of Divisionism, but there was no real sympathy for the French style.

3. The decline of Neo-Impressionism and the 'second phase' of influence

Major shows of Neo-Impressionist works continued to be held in Paris, including an exhibition in early 1893 at the Hôtel Brébant and four shows during 1893 and 1894 at the Galerie Rue Laffitte. However, Neo-Impressionism suffered a severe blow with Seurat's death in 1891. In 1890 Dubois had died, and Angrand had become disenchanted with the Neo-Impressionist technique. Lucien Pissarro and Camille Pissarro also grew weary of what they came to think of as a tedious formula. After several seasons, the Vingtistes abandoned the style: Toorop rejected Neo-Impressionism for Symbolism, Van de Velde turned first to the decorative arts and then to architecture, and after 1895 Lemmen became increasingly involved in the decorative arts and the creation of *intimiste* paintings.

In 1896 Neo-Impressionism experienced a revival created by Paul Signac, whose book, *D'Eugène Delacroix au Néo-Impressionnisme* (Paris, 1899), which first appeared as a series of articles in the *Revue Blanche*, attracted a new generation of converts. Attracted by this book and by the bold, later work of Signac and Cross, younger artists of the Fauve group, including Henri Matisse and André Derain, were drawn to Neo-Impressionist colour theories, as, for example, in Matisse's *Luxe, Calme et Volupté* (1904–5; Paris, Pompidou). Robert Delaunay, Jean Metzinger and Gino Severini all experimented with Pointillism as a means to produce dynamic and vibrant colour.

Bibliography

P. Signac: *D'Eugène Delacroix au Néo-Impressionnisme* (Paris, 1899); ed. F. Cachin (Paris, 1964)
J. Rewald: *Post-Impressionism: From van Gogh to Gauguin* (New York, 1956, rev. 1978)
W. I. Homer: *Seurat and the Science of Painting* (Cambridge, MA, 1964/R 1978)
Neo-Impressionism (exh. cat. by R. L. Herbert, New York, Guggenheim, 1968)
J. U. Halperin: *Félix Fénéon: Oeuvres plus que complètes*, 2 vols (Geneva, 1970)
J. Sutter: *The Neo-Impressionists* (London, 1970)
Post-Impressionism: Cross Currents in European Painting (exh. cat., London, RA, 1979)
The Aura of Neo-Impressionism: The W. J. Holliday Collection (exh. cat. by E. Lee, Indianapolis, Mus. A., 1983)
R. Thompson: *Seurat* (Oxford, 1985)
Exposition du Pointillisme (exh. cat., Tokyo, N. Mus. W.A., 1985)
Georges Seurat, 1859–1891 (exh. cat. by R. L. Herbert, New York, Met., 1991)

JANE BLOCK

Newlyn school

English group of c. 20 figural landscape painters who formed an artists' colony from the early 1880s at the coastal town of Newlyn, Cornwall (nr Penzance). Its size varied yearly, but the most permanent and accomplished artists were Stanhope Forbes, Frank Bramley, Thomas Cooper Gotch, Walter Langley, Alexander Chevallier Tayler (1857–1926), Fred Hall (1860–1948), Norman Garstin and Elizabeth Stanhope Forbes, a Canadian, who was one of two women and the only committed foreigner. Continental training, especially in Paris, had exposed these artists to the work of such French naturalist painters as Jules Bastien-Lepage, Edgar Degas and Edouard Manet. While in France many had experimented with the naturalist principles of painting rural subjects *en plein air*, notably in Normandy and Brittany. Settling in England, they found that Newlyn suited their needs to continue painting in this manner.

The Newlyners continued the English Pre-Raphaelite and French naturalist traditions of using local, non-professional models and seemingly recognizable sites. They reinterpreted familiar subjects of rural activities and the cycle of life. Their painted Newlyn seemed healthy and unchanging, an interpretation Victorians still wanted

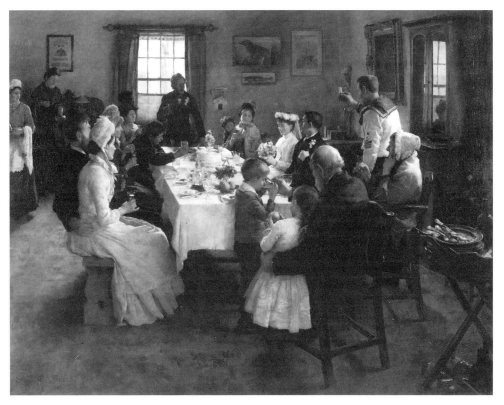

54. Stanhope Forbes: *Health of the Bride*, 1889 (London, Tate Gallery)

in art. Characteristic qualities of Newlyn paintings are a subdued palette, grey atmosphere, a concern with natural and/or artificial light effects and French brushwork; the square brush technique became a hallmark of the Newlyn school.

The colony's strongest and most acclaimed period was between 1885 and 1895. In 1886 Forbes, Gotch and Henry Scott Tuke were founder-members of the New English Art Club, set up to provide exhibition opportunities for non-members of the Royal Academy of London. Nevertheless, the Academy did hang Newlyn works regularly in favourable positions; these paintings helped to revitalize the Academy shows and to break down England's nationalistic isolation from Continental artistic ideas. The consideration of the Chantrey Bequest trustees of Forbes's *A Fish Sale on a Cornish Beach* (1885; Plymouth, City Mus. & A.G.)

and the purchase of Bramley's *A Hopeless Dawn* (1888; London, Tate) for the nation, and Henry Tate's acquisition of Forbes's *The Health of the Bride* (1889; London, Tate; see fig. 54), contributed to these artists being elected ARAs. These successes also focused attention on the entire colony and the general goals that united them.

The original colony gradually broke up in the mid-1890s as critical attention revealed group and individual weaknesses. References to a 20th-century Newlyn school refer either to the art school established by the Forbeses in 1899 (closed 1938) or to subsequent painters who studied, worked or settled in the area. Among them were Dame Laura Knight, Dod Proctor (1892–1972) and Lamorna Birch (1869–1955). This second generation, however, lacked the shared background and aims of the earlier group.

Bibliography

A. Meynell: 'Newlyn', *A. J.* [London] (1889), pp. 97–102, 137–42

Artists of the Newlyn School, 1880–1900 (exh. cat. by C. Fox and F. Greenacre, Newlyn, A. G., 1979)

B. Cogger Rezelman: *The Newlyn Artists and their Place in Late-Victorian Art* (diss., Bloomington, IN U., 1984)

Painting in Newlyn, 1880–1930 (exh. cat. by C. Fox and F. Greenacre, Newlyn, Orion Gals, 1985)

BETSY COGGER REZELMAN

New Sculpture

Movement in British sculpture *c.* 1877–*c.* 1920. The term was first used in 1894 by the writer Edmund Gosse, in an essay of that title in the *Art Journal*, to denote developments in late 19th-century British sculpture. Gosse's label was retrospective, as the movement's ancestry can be traced back to the mid-Victorian sculptors John Henry Foley and Alfred Stevens. The New Sculpture cannot be defined by a particular style, iconography or ideological manifesto, and no sculptors grouped together to propound or promote it; Janson has defined it as 'anything different from what had been thought possible in the 1870s'. However, in spite of the scope for individualism, the protagonists of the New Sculpture recognized each other's achievements and consciously attempted to revive the quality of British sculpture. Their success in transforming it from the conservative Neo-classical blandness of such artists as William Theed and John Bell to a multi-media symbolist decorative fantasy underlines the movement's revolutionary nature.

The New Sculpture originated within the artistic establishment; Frederic Leighton is traditionally regarded as having begun it with *Athlete Wrestling with a Python* (exh. London, RA, 1877; see col. pl. XXVI). That Leighton was known as a painter, not a sculptor, accentuated the surprise and thus the impact of the work. Both its physical energy and its naturalistic, detailed modelling distinguished it from the more generalized finish of such works as Bell's *Eagleslayer* (*c.* 1844; versions, Wentworth Woodhouse, S. Yorks; London, Bethnal Green Mus.). Leighton's assiduous promotion of sculptural education, practice and patronage during his period as President of the Royal Academy (1878–96) was acknowledged by the two major figures of the New Sculpture, Hamo Thornycroft and Alfred Gilbert, who made Leighton a bronze statuette of *Icarus* (1884; Cardiff, N. Mus.).

Another formative influence was exercised by European émigré sculptors and art educators. Among them was Joseph Edgar Boehm, who had both Alfred Gilbert and Alfred Drury as assistants. Equally significant was Jules Dalou, who, during his London sojourn (1871–80), taught at the National Art Training School, South Kensington, and the South London Training School, Lambeth, shifting the sculptural emphasis from carving in marble to modelling in terracotta and casting in bronze. His pupils included Drury, Harry Bates and Frederick Pomeroy. Influential teachers of British birth included John Sparkes and William S. Frith (1850–1924), both based at Lambeth, while Leighton helped to establish the Sculpture School at the Royal Academy in 1881. Many sculpture students moved on from the technical emphasis of Lambeth and South Kensington to the Academy; this blurring of the traditional distinctions between sculpture and the decorative arts was consistent with the principles of the Arts and Crafts Movement. Most of the New Sculptors also spent prolonged periods studying and working abroad, in Paris rather than Rome. Gilbert worked in Paris for Pierre-Jules Cavelier, Drury for Dalou and George Frampton for Antonin Mercié. Continental exposure was a matrix for innovation and removed British sculpture from its traditional insularity.

The New Sculpture contained two distinct substyles, which may respectively be termed realist and symbolist. The realist manner, showing what Gosse called 'a reverent observation of nature', is evident in the work of Thornycroft, who was the leading New Sculptor until the mid-1880s. His sculpture consolidated Leighton's achievement; works such as *Artemis and her Hound* (plaster, 1880; Macclesfield Town Hall), *Putting the Stone* (1880; London, Leighton House A.G. & Mus.) and especially *The Mower* (1884) markedly departed

from what Gosse dubbed 'Canovesque daintiness' and showed realism and originality both in their handling and in their abstract themes. Their stylistic origins were also unusual; the sources of *The Mower* range from Donatello to Fred Walker but exclude traditionally dominant Greco-Roman sculpture. Thornycroft's *Major-General Charles George Gordon* (1886–8; London, Victoria Embankment; version, 1888–9; Melbourne, Gordon Square) was the first major New Sculpture public monument. Both *The Mower* and *Gordon* are imbued with meditative qualities, thus showing that the realist and symbolist sub-styles were not mutually exclusive.

In the mid-1880s the initiative was captured by Gilbert's more symbolist and fantastical style. He expanded on Thornycroft's iconographic innovation with the *Enchanted Chair* (1886; destr. 1901) and, most famously, with the *Eros* figure surmounting his memorial to *Anthony Ashley Cooper, 7th Earl of Shaftesbury* (aluminium and bronze, 1885–93; London, Piccadilly Circus). Inspired by G. F. Watts and Edward Burne-Jones, Symbolist themes of Fate, Love, Life and Death replaced traditional mythology. In Gilbert's most ambitious work, the tomb of *Prince Albert Victor, Duke of Clarence* (1893–1928; Windsor Castle, Berks, Albert Memorial Chapel), the *St George* statuette is inspired by the idealized armour of Burne-Jones's painting of *King Cophetua and the Beggar Maid* (1884; London, Tate). The richness of that work and of the *Briar Rose* series (1870–90; Buscot Park, Oxon, NT) influenced the introduction of colour into sculpture. Gilbert led the way with the memorial to *Henry Fawcett* (1887; London, Westminster Abbey) and was followed by Frampton in the bronze, ivory and opal bust of *Lamia* (1899–1900; London, RA) and by Gilbert Bayes in his enamelled bronze statuette of *Sigurd* (1910; London, Tate; see fig. 55). By 1900 such artists had transcended the boundaries between sculpture, metalwork and jewellery.

In the hands of the New Sculptors, architectural decoration changed from a minor art of masons and carvers to a major focus of sculptural creativity. The stone reliefs by Thornycroft and subsidiary carvings by Bates (1888–93) for the

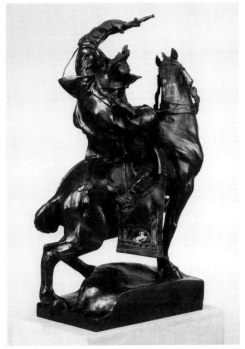

55. Gilbert Bayes: *Sigurd*, 1910 (London, Tate Gallery)

Institute of Chartered Accountants in London, developed in cooperation with the architect John Belcher, were the most prominent example. Other examples include Frampton's stone frieze and bronze statuettes (1898–1901) for Lloyd's Register of Shipping, Fenchurch Street, London, and Drury's stone groups (1904–5) for the War Office (now Ministry of Defence), Whitehall, London.

The New Sculpture left few areas untouched. The revival of the cast bronze medal, initiated by Alphonse Legros, might be termed the New Sculpture in miniature. Bayes and Albert Toft (1862–1949) were employed to design ceramic decorations and figurines for the Doulton ceramic factory, and Gosse promoted the mass production of bronze statuette versions of such works as Leighton's *Athlete* and Thornycroft's *Gordon*. The intention was to democratize sculpture by making it affordable to the middle-class public. Of the many New Sculpture public monuments, one of

the best known is the Victoria Memorial (1901–24; London, The Mall) by Thomas Brock (in collaboration with the architect Aston Webb), whose quotations from Stevens, Dalou and Gilbert have been criticized as plagiarisms. The whole memorial has been denounced as pretentious; yet arguably its eclecticism is intelligent and effective, and the monument excels in imperialistic panache.

According to Beattie, by 1905 the decline of the New Sculpture had set in. The premature deaths of Bates and Edward Onslow Ford, together with Gilbert's semi-exile in Belgium (1901–26), were crippling blows, and, with the upsurge of Beaux-Arts classicism, architects were taking less interest in sculptural decoration. However, recent reappraisal of the Romantic tradition in British art has suggested more equivocal conclusions. The careers of the sculptor–metalworkers William Reynolds-Stephens and Bayes continued to thrive; Bayes's work, such as the *Lure of the Pipes of Pan* (artificial stone, 1932; Birmingham, Mus. & A.G.), came to approach Art Deco in style, although remaining New Sculptural in theme. William Goscombe John's memorial to the *Engine Room Heroes* of the *Titanic* (1916; Liverpool, Pierhead) and Frampton's memorial to *Edith Cavell* (1916–20; London, St Martin's Place) may lack the vitality of the New Sculpture in its turn-of-the-century heyday, but they introduced a monumental simplicity to public statuary. The achievement of the New Sculpture was, in Spielmann's words, to give 'a new direction to the aims and ambitions of the artist'; in raising the British school to a new level, it smoothed the path for the next major era of innovation introduced by Jacob Epstein and Eric Gill.

Bibliography

E. Gosse: 'The New Sculpture', *A. J.* [London] (1894), pp. 138–42, 199–203, 277–82, 306–11

M. H. Spielmann: *British Sculpture and Sculptors of To-day* (London, 1901)

British Sculpture, 1850–1914 (exh. cat., London, F.A. Soc., 1968)

D. Farr: *English Art, 1870–1940* (Oxford, 1978)

Victorian High Renaissance (exh. cat., Minneapolis, MN, Inst. A.; Manchester, C.A.G.; New York, Brooklyn Mus.; 1978–9)

British Sculpture in the Twentieth Century (exh. cat., ed. S. Nairne and N. Serota; London, Whitechapel A.G., 1981)

E. Manning: *Marble and Bronze: The Art and Life of Hamo Thornycroft* (London, 1982)

B. Read: *Victorian Sculpture* (New Haven and London, 1982)

S. Beattie: *The New Sculpture* (New Haven and London, 1983)

R. Dorment: *Alfred Gilbert* (New Haven and London, 1985)

H. W. Janson: *Nineteenth-century Sculpture* (London and New York, 1985), pp. 240–49

M. Stocker: 'Edmund Gosse on Sculpture', *U. Leeds Rev.*, xxviii (1985–6), pp. 283–310

Alfred Gilbert: Sculptor and Goldsmith (exh. cat., ed. R. Dorment; London, RA, 1986)

The Last Romantics: The Romantic Tradition in British Art, Burne-Jones to Stanley Spencer (exh. cat., London, Barbican A.G., 1989)

Pre-Raphaelite Sculpture: Nature and Tradition in British Sculpture, 1848–1914 (exh. cat., London, Matthiesen F.A., 1991; Birmingham, Mus. & A.G., 1992)

Reverie, Myth, Sensuality: Sculpture in Britain, 1880–1910 (exh. cat., Stoke-on-Trent, City Mus. & A.G.; Bradford, A. Gals & Museums; 1992–3)

MARK STOCKER

Norman Revival

Architectural style, predominantly used for castles and churches built in Britain in the 18th and 19th centuries, which was based on English Romanesque. The Norman Revival is usually treated as a minor strand of the Gothic Revival—part of that interest in medieval styles of building that ran parallel with, but counter to, classical architecture; yet the earliest buildings in a round-arched medieval style pre-date by a decade accepted pioneers of the Gothic Revival, such as Clearwell Castle (*c.* 1728), Glos. Later, between 1820 and 1850, the use of Norman forms and details seriously rivalled Gothic ones in civil, domestic and ecclesiastical architecture, a phase that has its continental parallel in the German *Rundbogenstil*. The Norman Revival was a more self-conscious movement than the Gothic Revival, for while the use of Gothic forms had never quite died

out in Britain, the round-arched medievalism of the Norman style had been extinct as a building tradition since *c.* 1200. Nevertheless, in the 17th century a development in design from the crude round-arched classicism of the Jacobean period to a rough imitation of the round-arched Norman style was relatively easier to make than a complete change of style to the pointed arches of Gothic would have been. This proximity can be illustrated by Inigo Jones's decision, when designing his classical shell for the Norman nave of old St Paul's Cathedral (1633–42), London: he decided to retain the original pattern of fenestration and merely superimposed a classical skin of rusticated masonry. Hugh May carried out extensive rebuilding of Windsor Castle (1675–84) for Charles II, removing most of the original pointed Gothic windows and replacing them with long round-headed openings; this further enhanced its 'Castle Air' (Vanbrugh's vivid phrase of 1707 for his own remodelling of Kimbolton Castle, Cambs), and this was almost certainly intended by May as an evocation of Windsor's Norman beginnings. Vanbrugh designed his own house, Vanbrugh Castle (*c.* 1718), at Blackheath, near London, in a playful round-arched castle style, although none of its detail was accurately Norman. Antiquarian scholarship then and for much of the 18th century was confused over the dates and even the sequence of Anglo-Saxon, Norman and Gothic work, but a series of buildings with battlements and round-arched detail—Shirburn Castle (*c.* 1716–25), Oxon, Enmore Castle (*c.* 1751), Somerset, and Robert Adam (i)'s Culzean Castle (1777–92), Strathclyde—suggest that 18th-century architects associated the Norman style with aristocratic power and were consciously evoking this in a simplified Norman Revival.

This was certainly the aim of Charles Howard, 11th Duke of Norfolk, in his reshaping of Arundel Castle, W. Sussex, between 1791 and 1815. By that time illustrated books such as John Carter's *The Ancient Architecture of England* (1795–1814) were making authentic Norman detail available for masons to copy. An attempt by John Nash (i) to devise a small, villa-type Norman house (*c.* 1801–3) at Killymoon Castle, Co. Tyrone, was

not influential and thereafter Norman Revival forms tended to be reserved for romantic houses on the grandest scale, usually in the Celtic north and west where their feudal profile seemed historically appropriate. Thomas Hopper built Penrhyn Castle (*c.* 1822–37), Gwynedd, for G. H. Dawkins Pennant, a slate magnate, and this, the aesthetic masterpiece of the movement, proving that the neo-Norman style needed to be handled with a bold eclectic freedom to be successful, mixed Jacobean, Venetian and 14th-century Gothic detail within a rugged Norman framework. Hopper also designed an oak wardrobe for the castle (*c.* 1835; London, V&A) in the same vein. Glenstal Castle, Co. Limerick, begun in 1838 by William Bardwell, works to the same formula on a more modest scale, but by that date the British had turned from the neo-Norman as a domestic style and instead used it on occasion to give a grim appearance to new penal institutions such as Walton Gaol (1848–55), Liverpool. With 19th-century churches the Norman Revival made a more hesitant start. Its essential qualities are spatial, not linear; thinned into a watery compromise, as it was in a number of churches built in the late 1830s in London's East End, it acquired unfortunate associations with poverty-stricken congregations and cheap construction. Benjamin Ferrey set out to demonstrate the structural potential of the Norman Revival, but the vault of his new church, at East Grafton (1842–4), Wilts, collapsed in 1842, killing a clergyman who had come to inspect it. A revival of the sumptuous decorative detail of Romanesque churches such as Kilpeck (*c.* 1134), Hereford & Worcs, might have endeared the style to the Victorians; some interesting churches were built in that style, such as Llanymynech (1845), on the Powys and Shropshire border, by Thomas Penson (*c.* 1790–1859), but the neo-Norman style never attracted the kind of champion it needed—an apologist such as Ruskin, or a dedicated architect of A. W. N. Pugin's rank.

Bibliography

T. Mowl: *The Norman Revival in British Architecture, 1790–1870* (diss., U. Oxford, 1981)

T. Cocke: 'Rediscovery of the Romanesque', *English Romanesque Art, 1066–1200* (exh. cat., ed. G. Zarnecki; London, Hayward Gal., 1984), pp. 360–91

J. Marsden: ' "Far from Elegant, yet Exceedingly Curious": Neo-Norman Furnishings at Penrhyn Castle', *Apollo*, cxxxvii/374 (April 1993), pp. 263–70

TIM MOWL

Old English style

Term first coined by the architects Richard Norman Shaw and William Eden Nesfield to describe a style of domestic architecture that was practised widely in England from the second half of the 19th century and that made use of traditional English forms and materials. The style owes its origin to an appreciation of the picturesque qualities of the English landscape and its rural houses and cottages and was first used in ornamental garden buildings such as Queen Charlotte's timber-framed and thatched cottage of *c.* 1772 in the Royal Botanic Gardens at Kew, London. The style came into prominence for houses in the 1860s only as a result of architects moving away from the formality of the Gothic Revival. An influential exponent was George Devey, whose estate cottages at Penshurst, Kent (1850), brought to general notice the use of vernacular techniques such as timber-framing and tile-hanging. Shaw and Nesfield visited the Weald of Kent and Sussex and soon incorporated traditional elements into their houses. Early examples include Nesfield's cottages at Hampton in Arden, W. Midlands (1868), and Shaw's Leyswood (1868–9; mostly destr.), Groombridge, E. Sussex, which the architects specifically described as 'Old English' (see Eastlake, pp. 206, 312), and also J. L. Pearson's Roundwyck House (1868–70), Kirdford, W. Sussex. Thereafter, the style inspired the best work of Ernest Newton, notably in Chislehurst, London, many of Sir Edwin Lutyens's earlier houses in west Surrey, as well as, more generally, the houses of new garden suburbs and the pioneering cottage estates of several local authorities at the start of the 20th century. The style has persisted under the name 'Vernacular Revival'.

Bibliography

C. L. Eastlake: *A History of the Gothic Revival* (London, 1872), pp. 340–44

A. Saint: *Richard Norman Shaw* (New Haven, 1976), pp. 24–53

A. P. Quiney: *John Loughborough Pearson* (New Haven, 1979), pp. 87–96

J. Allibone: *George Devey, Architect, 1820–1886* (Cambridge, 1991)

ANTHONY QUINEY

Orientalism

Art-historical term applied to a category of subject-matter referring to the depiction of the Near East by Western artists, particularly in the 19th century.

1. Introduction

Images of the life, history and topography of Turkey, Syria, Iraq, Iran, the Arabian Peninsula, Jordan, Israel, Lebanon, Egypt, Libya, Tunisia, Algeria, Morocco and sometimes modern Greece, the Crimea, Albania and the Sudan constitute the field of Orientalism. Although almost any biblical subject in Western art would rank as an Orientalist image by this definition, most such works dating before the 19th century fail to present any specifically Near Eastern details or atmosphere and are not Orientalist. Artists need not have journeyed to the Near East to be labelled Orientalist, but their works must have some suggestion of topographic or ethnographic accuracy.

Orientalism was essentially a 19th-century phenomenon, a facet of Romanticism. However, before Napoleon invaded Egypt in 1798, Gentile Bellini painted Ottoman subjects, Veronese represented some figures in Turkish costume, Rembrandt portrayed men in vaguely Orientalist garments and, most important for later developments, Rococo artists, including Jean-Baptiste Le Prince and Carle Vanloo, painted opulent fantasies of harems and sultans. Jean-Etienne Liotard and Jean-Baptiste van Mour (1671–1737) lived in Turkey in the 18th century and provided a seemingly more authentic glimpse of the East. Yet it was only in the 19th century, when Europe became more

involved politically in the Near East, and when means of travel improved, that Western artists began visiting the region in great numbers and paid closer attention to its distinctive features. In the 19th century Orientalism became a standard subject in which artists throughout Europe specialized.

Orientalism is notable in 19th-century architecture and decorative art but is most significant in painting, the graphic arts and photography. In sculpture only one major specialist arose: Charles-Henri-Joseph Cordier. His busts of North African people in the 1850s introduced polychromy and semi-precious stones to sculpture in order to portray the opulence and patterning that were central to Western conceptions of a luxurious East.

The most important publication in the early development of Orientalism was the French government's *Description de l'Egypte* (Paris, 1809–22), the 24 volumes of which illustrate the monuments, people, flora, fauna and geography of Egypt. This project, initiated by Napoleon during his Egyptian campaign, provided information not only for the settings and costumes of paintings but also for EGYPTIAN REVIVAL architecture, tombs and decoration. The Egyptian motifs that ornament Empire furniture, for example, stem from Napoleon's invasion; subsequent military events in the Near East, such as the Greek War of Independence, the conquest of Algeria, the Crimean War and the suppression of the Mahdi in the Sudan, also fostered Orientalist works.

Antoine-Jean Gros executed the earliest grand history paintings that reflect an increased knowledge of the Near East. The French government provided him with detailed descriptions of commissioned subjects, and his *Battle of Aboukir* (1806; Versailles, Château) includes not only Islamic architecture and dress but also a strong impression of Eastern sunlight and terrain. Gros's paintings glorify Napoleon (e.g. *Bonaparte Visiting the Victims of the Plague at Jaffa*; Paris, Louvre), and there is a political current in much Orientalist art. French depictions of Algeria in the 1830s by Horace Vernet and Eugène Delacroix, even when they do not depict battles, are testaments of imperial possession. Exhibition reviews and imperialist

publications indicate that images of nomads and harems, Romantic ruins of the ancient world, exotic marriage customs and primitive means of transport could all be pointedly interpreted as pictures of backwardness, decay and barbarism. The underlying assumption of much Orientalism is that colonialism was justified as a civilizing and modernizing force. Paintings such as *Massacre of the Janissaries* (1827; Rochefort, Mus. Mun.) by Charles-Emile de Champmartin (1797–1883) and Henri Regnault's *Execution without Judgement under the Moorish Kings of Granada* (1870; Paris, Mus. d'Orsay) more obviously speak of Near Eastern violence and misgovernment and imply the superiority of Western society. Not all Orientalist works, however, are primarily imperialist tracts, and many artists deplored Westernization.

2. Subject-matter

(i) Secular history painting. Gros was followed by Vernet as the painter of French imperial power, and the *Capture of Abd-el-Kader's Train by the Duc d'Aumale* (1845; Versailles, Château) typifies the exaggerated movement, histrionics and dazzling light of Orientalist battle scenes. Paintings of Near Eastern history, both ancient and modern, display more violence and disorder than Western subjects, and this is particularly true of the works of Delacroix. The *Massacres at Chios* (1824) and the *Death of Sardanapalus* (1827; both Paris, Louvre) reflect not merely Romantic gusto for some un-Classical place beyond the restraints of Western culture, but also a conception of the Near East as wild and cruel. Delacroix's viewpoint was communicated to his friends and followers, including Jules-Robert Auguste (1789–1850; he travelled to the East before Delacroix), Richard Parkes Bonington, Théodore Chassériau and Adolf Schreyer (1828–99). The association of the Near East with turbulence and cruelty was ubiquitous, beyond the influence of one artist, and is found in such works of disparate style and date as Anne-Louis Girodet's *Revolt at Cairo* (1810; Versailles, Château) and Hans Makart's *Death of Cleopatra* (1875; Kassel, Schloss Wilhelmshöhe). Near Eastern history paintings by English artists are rarer and

more subdued. David Wilkie's *Tartar Messenger Narrating the News of the Victory of St Jean d'Acre* (1840; Sir James Hunter Blair priv. col., see K. Bendiner: 'Wilkie in Turkey', *A. Bull.*, lxiii/2, 1981, p. 260), like the later works of Jean-Léon Gérôme, merges history painting with charming genre, and the lithographs of William Simpson (1823–99) published in his *Seat of War in the East* (London, 1856) present many quiet and domestic illustrations of the Crimean War.

(ii) **Religious works.** Orientalist biblical pictures outnumber secular history paintings from the second half of the 19th century. The Near East was considered a land unchanged since ancient times, and Horace Vernet was the first artist to make use of Near Eastern costume, landscape and ethnic types in scriptural images. Alexandre-Gabriel Decamps also produced some examples, but this new field was taken up in the 1840s and 1850s most enthusiastically by English artists. They saw the presentation of biblical history in accurate Near Eastern garb and setting as Protestant, documentary and non-idolatrous. Wilkie travelled to Egypt and Palestine to produce such images and even thought of painting a *Last Supper* with Christ and the Apostles seated on the floor, Arab fashion. Wilkie died before carrying out his task, but William Holman Hunt followed in the 1850s and produced the *Finding of the Saviour in the Temple* (1860; Birmingham, Mus. & A.G.), which set the new standard for Orientalized scriptural imagery. The biblical paintings of Ford Madox Brown, Simeon Solomon, Edward John Poynter and Vasily Vereshchagin reflect Hunt's accomplishment, as do the illustrations in Protestant Bibles produced subsequently in Britain and America. The most influential Orientalized Bible was produced by James Tissot; his Old and New Testament illustrations were exhibited widely at the end of the 19th century and were published in lavish editions (e.g. Tours, 1896–7). They present Holy Writ in dramatic Near Eastern contexts and were the starting-point for the biblical epics of Hollywood.

Representations of faith and prayer constitute a different form of Orientalist religious art. The subjects are contemporary and the characters anonymous. Arabs and Turks are shown performing their devotions in the mosque and the desert and travelling to Mecca. Jewish services, Orthodox festivals and Roman Catholic worshippers in the Holy Land were also depicted. Although some works, such as Hunt's *Miracle of the Sacred Fire in the Church of the Sepulchre, Jerusalem* (1893–9; Cambridge, MA, Fogg) and Delacroix's *Fanatics of Tangiers* (1838; Minneapolis, MN, Inst. A.) portray religious mayhem, most of these genre paintings, whether by Gérôme, Léon Belly, John Frederick Lewis, Frederick Goodall, Frederic Leighton, Gustav Bauernfeind (1848–99), Ludwig Deutsch (1855–1935) or Rodolphe Ernst (*b* 1854), are uncritical, non-sectarian tributes to those in the modern age who could still believe.

(iii) **Harems and slave and street markets.** Genre painting was the most prevalent form of Orientalism in the 19th century, and harem scenes were particularly numerous. Despite greater accuracy in detail, the 18th-century libertine vision of Oriental domestic life persisted, and Western beauties continued to appear as odalisques. Male painters almost never saw a genuine harem, and their aim was to create an erotic ideal, not a sociological document. Jean-Auguste-Dominique Ingres's nude odalisques, languid and sensual, were most influential. His imagery of voluptuous luxury, privacy and lethargy was echoed in works by Gérôme, Jean Lecomte de Noüy and Edouard Debat-Ponsan. The placement of the nude in a context neither classical nor allegorical heightened the figure's sexuality, and seraglio pictures, justified as ethnography, were among the most erotic public displays of the nude in the 19th century. As a personal troupe of pleasure givers, the harem automatically possessed erotic meaning, even in more decorously dressed images such as Delacroix's *Women of Algiers in their Apartment* (1834; Paris, Louvre; see fig. 56). This opulently robed seraglio tradition was carried on by Théodore Chassériau, Benjamin Constant and Auguste Renoir in France, and Lewis produced a minutely detailed version in England (see col. pl. XXVIII). The Orientalist harem chamber, closed-off, stuffed with patterned finery and dedicated to quiet pleasure, stimulated the

construction of sumptuous Islamic lounges in residences throughout Europe and America, most notably the Arab Hall (1877–9) designed by George Aitchison for Leighton House in London. Furthermore, the narcotic and decorative settings of Aesthetic paintings by Albert Moore, Lawrence Alma-Tadema and others reflect the same inspiration but are no longer tied to Muslim societies.

Slave market scenes, by Gérôme, Charles Gleyre and Regnault, are essentially outdoor harems and are equally erotic. Occasionally some negative portrayals were executed by William Allan and others during the Greek War of Independence and by David Roberts in his images of black slave traffic in his book *Egypt and Nubia* (London, 1846–9). Also related to harem imagery are Near Eastern market scenes, with a similarly complex array of colourful patterns and stuffs of many nations, which exhibit a 19th-century perception of Eastern street life as a marvellous jumble. Mariano Fortuny y Marsal, Gérôme, William James Müller, Lewis, Frank Brangwyn and Leopold Carl Müller (1834–92) produced these views of splendid disorder.

(iv) Bedouins and soldiers. In contrast to harems and city markets are pictures of Spartan bedouin life. Eugène Fromentin, Delacroix, Eugène-Alexandre Girardet, Adolf Schreyer, Lewis, Frederick Goodall and Gustavo Simoni (*b* 1846) depicted bedouin men as noble herdsmen, hunters and warriors, and their women as gentle mothers. Western travellers often had themselves portrayed as these tough

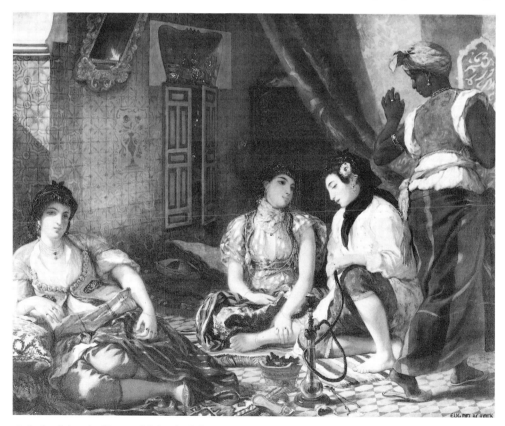

56. Eugène Delacroix: *Women of Algiers in their Apartment*, 1834 (Paris, Musée du Louvre)

desert Arabs. Another aspect of this cowboy-like vision of the Near East is exemplified by the pictures of soldiers and seraglio guards by Gérôme, Decamps, Arthur Melville and Lecomte de Noüy, but here a strong note of cruelty and savage violence is usually present.

(v) Landscape and architecture. From the publication of the *Description de l'Egypte* until the mid-19th century, the Orientalist landscape generally exhibited a scientific objectivity, documenting famous ancient and medieval sites in Turkey, Egypt and Palestine, although Prosper Marilhat, Adrien Dauzats and later Edward Lear and Frederic Edwin Church employed Picturesque compositional devices. In desert landscapes, treeless and vast, however, standard formulae were impossible, and even architectural draughtsmen such as Roberts created startlingly open landscapes. Later painters played upon the emptiness of the East and produced such vistas of death as Gustave Guillaumet's *The Sahara* (1867) and Fromentin's *Land of Thirst* (c. 1869; both Paris, Mus. d'Orsay). A Romantic taste for ruins as symbols of degeneration and mortality was also widespread. Roberts's *The Holy Land, Syria, Idumea & Arabia* (London, 1842–5) and *Egypt and Nubia* remained the standard guides to Eastern archaeological and religious sites throughout the 19th century and were imitated in the photographs of Maxime Du Camp, Francis Frith and Francis Bedford. Roberts's scenes of Palestine became acceptable Protestant icons, and his views of Islamic buildings inspired Victorian architects. Like many others, he saw Muslim architecture as the source of Gothic. Théodor Frère (1814–88) and Alberto Pasini (1826–99) continued this precise delineation of monuments into the 1880s, but in the later 19th century more evocative landscapes appeared. Luc Olivier Merson, Elihu Vedder, Lucien Lévy-Dhurmer and other Symbolists imagined a dream-like East, filled with ancient mystery.

3. Conclusion

The increased authenticity of accessories and settings in 19th-century Orientalism did not prevent artists from indulging in fantasies of luxury, eroticism, violence or ancient history. Separate Eastern cultures were often mixed or generalized, and any evidence of modernity or rationality was usually ignored. Orientalism ultimately shored up Western myths more than it revealed Eastern realities, and in the 20th century only the stylistic approaches changed. Henri Matisse, Max Slevogt, Paul Klee, Vasily Kandinsky, August Macke, Oskar Kokoschka and Bart van der Leck merely reiterated the Orientalist subjects, themes and sentiments that had been established in the 19th century.

Bibliography

J. Alazard: *L'Orient et la peinture française au XIXe siècle* (Paris, 1930)

P. Jullian: *The Orientalists: European Painters of Eastern Scenes* (Oxford, 1977)

M. Verrier: *The Orientalists* (New York, 1979)

P. Hughes: *Eighteenth-century France and the East* (London, 1981)

Orientalism: The Near East in French Painting, 1800–1880 (exh. cat. by D. A. Rosenthal, U. Rochester, Mem. A.G., 1982)

L. Nochlin: 'The Imaginary Orient', *A. America*, lxxi/5 (1983), pp. 118–31, 186, 189, 191

L. Thornton: *Les Orientalistes: Peintres voyageurs, 1828–1908* (Paris, 1983)

The Orientalists: Delacroix to Matisse (exh. cat. by M. A. Stevens, London, RA, 1984)

La Sculpture française au XIXe siècle (exh. cat., Paris, Grand Pal., 1986)

KENNETH BENDINER

Ormonde school

(*fl* 16th century–second half of the 17th). Workshop of Irish sculptors. It received many commissions from the Butler family, Earls and later Dukes of Ormonde, which ruled Kilkenny. The school executed a number of tombs with effigies of Butler knights in St Canice's Cathedral, Kilkenny, and in Gowran, Kilkenny. Particularly noteworthy are the effigies of ladies in their long pleated robes, such as that of *Margaret FitzGerald* (Kilkenny, St Canice). The figures of apostles and representations of the *Crucifixion* on the sides of

the tomb chests are in the Gothic manner and more naturalistic than the tombs of the O'Tunney school. However, in the Ormonde school productions there is a repetitive provincial use of common European stereotypes.

Bibliography

John Hunt: *Irish Medieval Figure Sculpture, 1200–1600* (Dublin and London, 1974)

JOHN TURPIN

Palladianism

Term used to describe an architectural style, dominant in the mid-18th century, in which architects adapted the designs of Andrea Palladio to contemporary conditions. Palladio was selected because he was thought to be the most reliable guide to and transmitter of the eternal values of Classical architecture. Although the style was prevalent in Europe and North America, it was predominantly a British phenomenon, and it is on Palladianism in the British Isles that this article concentrates. Characteristic examples include Colen Campbell's Stourhead (*c.* 1720–24), Wilts; Richard Boyle, 3rd Earl of Burlington's town house for General Wade (1723; destr. 1935) in London; and Holkham Hall (from 1734; see col. pl. XXVII). Increased attention to Palladio was reinforced by growing discontent with the extravagance of early 18th-century Baroque.

1. Origins

Among Italian Renaissance treatises Palladio's *I quattro libri dell'architettura* (1570) had many advantages as a mediator of ideas on the theory and practice of architecture: its brief and well-ordered text covered the principal aspects of civil architecture; its numerous plates gave adequate practical detail, including the design and ornament of the five orders, a range of Palladio's own designs of secular buildings for both town and country and an abundance of Classical Roman models from which alternative decorative ideas could be obtained. Copies of the *Quattro libri* were to be found in English libraries by the end of the 16th century, and manuscript translations of it

into English preceded by several decades the appearance of the whole book in print. In 1663 an English version of a French digest of the first book (P. Le Muet: *Manière de bien bastir pour toutes sortes de personnes*, Paris, 1623), covering the orders, appeared as *The First Book of Architecture by Andrea Palladio* by Godfrey Richards, intended principally to answer the needs of artisans rather than to express any general style of building. Although an immensely popular manual—eight editions were printed before 1700—it did not initiate a crusade for architectural reform; motivation for this came later.

The reaction against Baroque architecture that eventually gave rise to the Palladian movement had one root in Rome in the 1630s, where a group of artists and writers criticized the lack of rule in contemporary Roman architecture by reference to the careful study of antique monuments. Their ideas were particularly influential in France, on, for example, the painter Nicolas Poussin and the writer Roland Fréart de Chambray. Fréart's *Parallèle de l'architecture antique et de la moderne* (1650) analysed modern architecture by examining the authorities on the orders and judging them against each other and against approved antique models. With clear and effective plates he proclaimed the supremacy of the three Greek orders, Doric, Ionic and Corinthian, and ruled out experimentation with others. In these comparisons his preferred model was usually Palladio, whose *Quattro libri* he translated into French (1650). The *Parallèle* was rapidly translated into English (1664) by the scholar John Evelyn as part of a deliberate attempt to improve the quality of British architecture; it was reprinted four times in the next eighty years, while Fréart's translation of the *Quattro libri* formed the basis of the first full English version in 1715. French classical architecture of the late 17th century was not dominated by the influence of Palladio, but its contrast to the excesses of Baroque architecture provided the model for Campbell's attacks on 'capricious ornaments' and 'the Heaps of Materials without Strength and Solids without their true bearing' in his introduction to *Vitruvius Britannicus* (1715–25).

During the 17th century British architects and writers profited from first-hand study of Palladio. Sir Henry Wotton, author of the influential digest of Renaissance architectural ideas, the *Elements of Architecture* (1624), was Ambassador to Venice and owned drawings by Palladio. Palladio's buildings formed the major object of study during the principal Italian journey of Inigo Jones (1613–14). The new sophistication that this study gave to Jones's mature style initiated the assimilation of Palladio's ideas into Britain and became a crucial point of reference for Palladian architects of the 18th century. The most telling evidence of this assimilation in the late 17th century is the use of quadrant colonnades connecting house and offices popularized at Buckingham House (*c.* 1702), London, by either William Winde or William Talman, although perhaps as early as the 1670s James Smith was making drawings based on Palladio's Villa Capra (Rotonda; *c.* 1549–53) and his palaces in Vicenza; these drawings passed to Colen Campbell.

The influence of Palladio rose to prominence in Britain amid reactions against Baroque extravagance during the period in which Castle Howard (1700–12), N. Yorks, and Blenheim Palace (1705–16), Oxon (see col. pl. VIII), were built (both by John Vanbrugh) and Wren's St Paul's Cathedral, London, was completed (*c.* 1715). Mordant criticism of the latter had been expressed by Anthony Ashley Cooper, 3rd Earl of Shaftesbury, in his 'Letter Concerning Design' of 1712, but this stance was not the preserve of a small literary coterie: for example, the young architect John James emphasized in a letter that 'the Beauties of Architecture may consist with the greatest plainness of structure', and looked back to the example of Inigo Jones. Neither Shaftesbury nor James was explicitly Palladian. Their advocacy of consciously Classical restraint was also contemporary with the building of the Peckwater Quadrangle (1707–14; by Henry Aldrich), Christ Church, Oxford, the sober elevations of which recall the façade of Lindsey House (*c.* 1640), London, then attributed to Jones, or Palladio's own palace façades. Aldrich, an influential Oxford teacher, was the author of an unfinished manual on architecture. These factors do not suggest that a Palladian revival was developing by *c.* 1710, but that several challenges to the prevailing orthodoxy were already apparent. The publication of books extolling the qualities of Jones and Palladio gave direction to these inchoate aspirations.

2. Establishment

The first of these books was *Vitruvius Britannicus* (1715–25). Published as three volumes, each containing 100 large and accurately engraved plates, it was the work of a group of London booksellers, aimed at an established market for country-house engravings. Its contents were, however, decisively shaped by Colen Campbell, whose own designs were included, and some of which were closely based on a wide range of original designs by Palladio. Campbell also provided an incisively outspoken introduction, in which he criticized the licentiousness of the Italian Baroque and looked back to the classical 'simplicity' of Palladio, hailed as the greatest architect of the Renaissance and a rival of 'the Ancients'. In his opinion the only equal to Palladio was Jones, who had brought Palladio's ideas to Britain and whose achievements proved what British architects were capable of. The recovery of Classical propriety was thus associated with the self-assertion of a nation that, having triumphed in war, no longer needed to look to other countries for artistic leadership.

The publication in 1715–16 of a complete English translation of Palladio's *Quattro libri*, by James Leoni, was a milestone. This was even more lavish than *Vitruvius Britannicus*, fully illustrating all Palladio's designs, although some of these had been altered by Leoni to suit his own extravagant ideas. Neither this nor his subsequent architectural career suggests that Leoni shared Campbell's desire for a radical reform of British architecture. What both shared was their attempts to bring themselves to public notice by publishing grand books: Campbell was much more successful. Both books were aimed at a large and wealthy book-buying public. The court, so influential in the dissemination of artistic culture in the 17th century, took little part in the adoption of Palladianism, for George I (*reg* 1714–27) had

neither interest nor money to lead. Palladianism therefore developed within the requirements of the land-owning aristocracy, who, after 1720, exercised political power with increasing security. Thus the revival was insignificant in terms of church- or palace-building, for which there was no call, and created few urban hôtels on the French model. Instead the dominant forms were the country house, the focus of aristocratic social and political patronage in the countryside, and the much smaller private house in or near the capital. The latter was built either for high society gatherings, whose members were partly dependent on connections with Parliament, such as Pembroke House (1724; destr. 1913; Colen Campbell) or Richmond House (c. 1730; destr. 1791; Richard Boyle), both Whitehall; or else for pleasure in the suburbs near Chiswick or Twickenham, for attendance at court in the summer. The term 'villa' was often applied to such houses, and its connotation was as much Palladian as Classical. Within its restrictions of size the small house or villa form was capable of a vast range of alterations of function, situation and design, so that it could exist as a country house, for example at Rokeby (1729), Durham, by Sir Thomas Robinson, as well as a town house on the outskirts of London or Edinburgh. A third form of building that was significantly influenced by aristocratic needs and Palladian ideas was the urban terrace. The expansion of London involved the speculative development of several aristocratic estates, most notably that of Lord Burlington, off Piccadilly. Here ideas and standards of the élite came directly to influence the artisan builders who were to transform the face of Georgian towns. Slight but significant changes in the standard three- or five-bay street elevation indicate the reception of a stricter classicism: the change of window heads from segmental to horizontal; greater stress on the first rather than the ground-floor; and the adoption of pedimented doorcases. Such superficial changes show no grasp of the Renaissance aesthetics expressed by Palladio, and the formulae of 'improved' taste were quickly satirized by Alexander Pope in his *Epistle to Lord Burlington* (1731).

Lord Burlington's patronage was decisive for the growing impact of Palladianism. Initially he had employed Campbell to redesign his house in Piccadilly, but, following his second journey to Italy to study architecture and to collect drawings (particularly those of Palladio), he became increasingly confident as an architect in his own right. By 1721, with the additional purchase of those Palladian drawings that had belonged to Jones, Burlington had the basis for a profound study of Palladio, one that eclipsed Campbell's enthusiastic but unfocused purism. The result was Chiswick House (1725–9), Middx. Based on Palladio's Villa Capra (Rotonda), near Vicenza, it surpassed Campbell's imitation of the same building at Mereworth (1723), Kent, and it incorporated in its octagonal dome ideas from Vincenzo Scamozzi's Rocca Pisani (c. 1575), near Lonigo, and from other unexecuted Palladian designs; the ground-plan draws upon the sequence of contrasting room shapes of Palladio's Palazzo Thiene (1542), Vicenza. Chiswick, more a theoretical essay than practical living-quarters, was built in the garden of Burlington's suburban villa to house his canonical collection of drawings and to exemplify his taste. It was accompanied by the publication of two books, Kent's *Designs of Inigo Jones* (1727) and *Fabbriche antiche* (1731), in which Burlington presented Palladio's reconstructions of ancient Roman baths.

Burlington's social position, his much-visited villa and his influential books greatly enhanced the reputation of Palladianism by the late 1720s. His influence was also powerful after 1726 in ensuring the appointment at the Royal Office of Works of architects and craftsmen sympathetic to the new style. His friend William Kent became Master Carpenter, his draughtsman Henry Flitcroft became Clerk of Works at five royal palaces, while a fellow amateur and political ally, Thomas Worsley (1710–78), became Surveyor General. Subsequent appointments institutionalized Palladianism and provided the base that secured but could also enervate architects of the second generation of Palladians, such as Stephen Wright (d 1780), Isaac Ware and John Vardy.

3. Development

As Palladianism developed, it revealed greater eclecticism and variety than its reputation for homogeneous orthodoxy might suggest. Campbell was not clear about which aspects of Palladio he wished to emphasize: his preparatory drawings for *Vitruvius Britannicus* show that he altered both Palladian originals and drawings he assumed to be Jones's in order to suit his preconceived ideas, while his executed buildings retain characteristics of contemporary Baroque decoration. Lord Burlington's temperament and resources enabled him to discipline this uncertainty while developing a widened vocabulary of decorative motifs, not all of which were strictly Palladian in origin. These included the segmental 'thermal' window and the Serliana set within a relieving arch. Fortunate in the abundance of good building materials, English architects could avoid the stucco of many of Palladio's elevations, and, increasingly, wide expanses of ashlar emphasized the decoration of windows. The corner tower, which at Houghton Hall (1722–35), Norfolk, Campbell derived from the disguised Tudor turrets by Jones at Wilton (1636), Wilts, was rendered Italianate, if not particularly Palladian, at Holkham, Norfolk, and was so frequently copied, for example at Croome (1751–2), Worcs, by Robert Adam and at Kimberley (1755–7), Norfolk, by John Sanderson, as to become a Palladian cliché.

If the authoritative influence of Lord Burlington tended to establish simple repeatable formulae, the impact of William Kent was quite opposite. Trained for many years in Rome and with only slight first-hand knowledge of Palladio, he produced a response to the elaborate ornament and rich surface of 16th-century Roman architects, particularly Giulio Romano, that recalled the greater range and eclecticism of Inigo Jones, which was itself only sparingly exploited by the Palladians. Kent showed an insouciant attitude to academic architecture, and his powerfully sculptural handling of wall surface bears as little relation to the reticent plainness of his contemporaries, as it does to the dramatic angularity of Vanbrugh or Nicholas Hawksmoor. The west front of the Horse Guards (1750–59), London, built by John Vardy to Kent's designs, shows the combination of a formulaic Palladian design with the imaginative richness of surface that typifies Kent's contrast with his Palladian friends. Stephen Wright's University Library (1754–8), Cambridge, proves that he was not alone.

With interior design, a single recognizably Palladian approach is even harder to distinguish. This was due partly to architects not always exercising tight control over interior decoration; in Campbell's case he had little clear idea of what he wanted, whereas Kent's distinctively Roman style was established earlier and proved more pervasive. Palladio had left few examples of designs for chimney-pieces and doors; in turning to the legacy of Jones, the Palladians developed the variety of early 17th-century French sources that Jones had used. Enriched with coloured marbles and carvings, the copies are grander and the fireplace more distinct than in the prototypes. Apart from swags and masks, carved ornament was usually architectural and held within rectangular panels, but this did not restrain the exuberance of decorative plasterwork found in many grand interiors.

Palladian ideas provided clearer guidance for the layouts of house-plans. Following Italian examples, increased emphasis was placed on the *piano nobile*, with servants' quarters either in the rusticated basement or in offices attached to the house by quadrant colonnades. Burlington was the first to use a sequence of variously shaped rooms, at Chiswick and then at Holkham. In other architects' hands this was combined with the three-sided bow window to provide the decisive loosening up of the conventionally flat elevation. Palladio had advocated that interrelated proportions be used for the dimensions of rooms and for the relationship of individual rooms to each other. A similar system underlies some of Campbell's designs, but in general, harmonic proportions were restricted to the use of the cube or double cube for principal rooms, as Jones had done at Wilton.

The application of such overtly Classical motifs as a temple front added to a country house was part of a pervasive Classical culture. Monuments depicted dukes in Roman dress, and much English

poetry adopted the models of Horatian verse. Robert Castell recreated in detail Pliny the younger's villa at Laurentum, and at least two translations of Vitruvius were projected. For many, the authoritative pragmatism of Palladio obscured the Classical culture that he and his humanist patrons strove to recreate.

The spread of Palladianism beyond the group whose Classical education made its purpose coherent led to increasingly superficial use of decorative motifs. This was, however, the result of social and economic pressures and does not negate the serious attempts of the more scholarly Palladians to recover the simplicity (based on order, proportion and restraint) of Classical antiquity.

During the 1740s and 1750s the strictness of early Palladianism was eroded, particularly by the advent of Rococo decoration in interiors. Even Ware, who published *Designs of Inigo Jones* (1731) and whose translation of Palladio (1738) became definitive, had to accept it in his house (1748–9) for Philip Dormer Stanhope, 4th Earl of Chesterfield, London. The most significant development of, rather than reaction to, Palladianism can be seen in the work of Sir William Chambers, whose Neo-classical training in Rome and Paris was tempered by a conservative restraint, epitomized by such buildings as Duddingston House (1762), Edinburgh, a suave restatement of the early Palladian villa type of Baldersby (1720–28), N. Yorks, by Colen Campbell.

4. Diffusion

Palladianism in Britain spread quickly from being the interest of an aristocratic élite and their architects to becoming the common style of the English-speaking world. This change was largely due to the simultaneous development of architectural pattern books, and Palladianism was the first architectural style to be disseminated so widely by such books. By the 1730s several architects and publishers provided cheap, illustrated manuals for artisans. *Practical Architecture* (1724) by William Halfpenny was one of many that provided practical help in the design of the orders and the attendant problem of fitting accurately proportioned orders into an existing design, while patterns for whole houses and garden buildings were published by Robert Morris and Daniel Garrett (d 1753). Compendiums of all necessary information, including builders' prices, are exemplified by Salmon's *Palladio Londinensis* (1734), of which nine editions were published by 1774, and by which it was said 'a carpenter can convert himself . . . into a builder'. Palladian designs did not monopolize the new market; Batty Langley, some of whose polemics were deliberately anti-Palladian, provided by far the largest variety of patterns of all sorts, while perhaps the widest-known books of all were the *Book of Architecture* (1728) and *Rules for Drawing the Several Parts of Architecture* (1732) by James Gibbs, who was never a strict Palladian. Production of books fluctuated with the economic fortunes of the building industry, but their nation-wide influence spread a uniformity of design, a lasting result of which is the regularity of the Georgian street, whether in London or Bath, Dublin or Edinburgh. Also during this period the first attempts to write the history of English architecture were made by people heavily influenced by a Palladian version of the development of Classical architecture; the result was that the final legacy of Palladianism was to dictate the terms in which that architecture should be understood.

Beyond England, the spread of Palladian ideas depended as much on the strength of the native architectural tradition as on the popularity Palladianism may have gained from pattern books. Although James Smith's drawings reveal a precocious, independent approach to Palladio in Scotland, 18th-century architecture there did not capitulate to English taste. William Adam borrowed from English illustrated sources, but such works as Arniston House (1726–32), Lothian, show a fondness for richer surfaces than English taste directed, although the few independent works of his eldest son, John Adam, do show a more direct response to it. Ireland had no previous Palladian experience, and its classical tradition in architecture was weak and uncertain. The brief career of Edward Lovett Pearce (1726–33) initiated the reception of Palladio, whose work he had studied at first hand. This is reflected in the severe villa

at Bellamont (*c.* 1726), Co. Cavan, while some of its heavy details reveal his training under his kinsman, Vanbrugh. Certain Palladian details, particularly thermal windows and Serlianas placed on plain rectangular forms, which themselves owe more to Gibbs, are often found in the work of Richard Castle and Nathaniel Clements (1705–77), most impressively at Castle's Russborough (1742–55), Co. Wicklow. The scholarly copy of Burlington's execution of a Palladian design for General Wade at Provost's House (1769), Trinity College, Dublin, is as exceptional in its accuracy as it is typical for its late date.

Early evidence of Palladian influence in the American colonies can be found in Peter Harrison's Redwood Library (1749) at Newport, RI. This combines a precise copy of a garden building by Kent, which had been published by Ware, with a version of the garden front of Chiswick. Harrison's own book collection proved his English dependence and included 29 architectural books ranging from Fréart's *Parallèle* to the manuals of Halfpenny. In 1775, the year of Harrison's death, the first architectural book in North America was published at Philadelphia, Abraham Swan's *British Architect*, which had been published in England in 1745, but sources remained scarce. Only Thomas Jefferson's collection made any bid for completeness, and it, like his own magisterial contribution to architecture, had propagandist intent. Jefferson's architecture was the result of European travel, reading and his own incisive scientific thought. When he created Palladian designs, as he did most obviously in his submission of a rotunda design for the President's House competition in 1792, he did so by deliberate choice and with knowledge of current French Neo-classical design. For Jefferson, Palladio remained the best guide to 'the models of antiquity'.

In the 18th century European approaches to Palladio were diverse. In France where he had long been honoured but not imitated, A.-J. Gabriel's Petit Trianon (1762–4) at the château of Versailles shows a direct debt to him in the subtle differentiation of the Palladian tripartite villa façades. This may be more the result of Gabriel's independent studies than of any English influence through pattern books. Elsewhere, Palladian influence came from outside. In Prussia, Frederick II (*reg* 1740–86) was influenced by Francesco Algarotti's Palladian enthusiasm and Burlingtonian designs, one of which was erected at Potsdam (1755; destr. 1957). An analogous mixture of sources lay behind the design of Giacomo Quarenghi's pavilion (1781–9; destr. 1945) in the English garden at Peterhof for Catherine II of Russia. Even in the Veneto, where patriotism and precocious Neo-classicism stimulated increased interest in Palladio, encouragement from English residents and Grand Tourists was significant. The most important memorials to this were books, particularly Tommaso Temanza's biography of Palladio (1762) and Bertotti Scamozzi's complete survey of his works (1776–83). The process may be seen as complete when Consul Joseph Smith published the *Trattato* of Teofilo Gallaccini in 1767, a late product of the Roman classicist circle that had influenced Fréart.

Bibliography

A. Palladio: *I quattro libri dell'architettura* (Venice, 1570/*R* New York, 1965, 3/1601/*R* Newcastle upon Tyne, 1971; Eng. trans. by I. Ware, London, 1738)

V. Scamozzi: *L'idea della architettura universale*, 2 vols (Venice, 1615/*R* Ridgewood, NJ, 1964)

R. Fréart de Chambray: *Parallèle de l'architecture antique et de la moderne* (Paris, 1650; Eng. trans., London, 1664, rev. 2/1707)

A. Ashley Cooper, Earl of Shaftesbury: 'Letter Concerning the Art or Science of Design', *Characteristics of Men, Manners, Opinions and Times*, iii (London, 1712, 5/1732)

C. Campbell: *Vitruvius Britannicus*, 3 vols (London, 1715–25)

W. Halfpenny: *Practical Architecture* (London, [1724] 8/1751)

W. Kent: *Designs of Inigo Jones with Some Additional Designs*, 2 vols (London, 1727)

R. Castell: *The Villas of the Ancients Illustrated* (London, 1728)

J. Gibbs: *A Book of Architecture Containing Designs of Buildings and Ornaments* (London, 1728, 2/1739)

R. Boyle, Earl of Burlington: *Fabbriche antiche* (London, [1731]); rev. and enlarged by C. Cameron as *The Baths of the Romans Explained and Illustrated* (1772)

A. Pope: *Epistle to Lord Burlington: Of the Use of Riches* (London, 1731)

I. Ware: *Designs of Inigo Jones and Others* (London, [c. 1731])

J. Gibbs: *Rules for Drawing the Several Parts of Architecture* (London, 1732/*R* Farnborough, 1968, 2/1738, 3/1753)

J. Ralph: *A Critical Review of the Public Buildings of London and Westminster* (London, 1734)

W. Salmon: *Palladio Londinensis, or the London Art of Building* (London, 1734)

[B. Langley]: 'New Critical Review of Public Buildings', *Grub Street J.* (11 July 1734–6 March 1735) [a series of weekly reviews]

—: *Ancient Masonry*, 2 vols (London, 1736)

—: *Builder's Compleat Chest-book* (London, 1738)

F. Muttoni: *Architettura di Andrea Palladio*, 10 vols (Venice, 1740–48)

J. Vardy: *Designs of Inigo Jones and William Kent* (London, 1744)

D. Garrett: *Designs and Estimates, of Farmhouses &c.* (London, 1747)

R. Morris: *Rural Architecture* (London, 1750)

I. Ware: *Complete Body of Architecture* (London, 1756)

J. Gwynn: *London and Westminster Improved* (London, 1757)

R. Morris: *Select Architecture* (London, 1757)

T. Gallaccini: *Trattato sopra gli errori degli architetti* (Venice, 1767)

O. Bertotti Scamozzi: *Le fabbriche e i disegni di Andrea Palladio* (Vicenza, 1776–83)

H. Walpole: *Anecdotes of Painting in England*, iv (Strawberry Hill, 1780)

F. Algarotti: *Opere* (Venice, 1791–4), viii and xv

W. Adam: *Vitruvius Scoticus* (London, [1812])

G. Quarenghi: *Fabbriche e disegni* (Milan, 1821)

Colvin

F. Kimball: *Thomas Jefferson, Architect* (Boston, 1916)

J. Summerson: *Georgian London* (London, 1945)

C. Bridenbaugh: *Peter Harrison: First American Architect* (Chapel Hill, NC, 1949)

C. Hussey: *English Country Houses, Early Georgian* (London, 1955)

J. Fleming: *Robert Adam and his Circle in Edinburgh and Rome* (London, 1962)

F. Haskell: *Patrons and Painters* (London, 1963)

J. Harris: *The Palladian Revival* (New Haven, 1994)

<div align="right">T. P. CONNOR</div>

Picturesque

Descriptive term that was formulated into an aesthetic category in late 18th-century Britain, with particular application to landscape scenery, landscape painting and garden and park design. The leading characteristics of picturesque landscape are irregularity, roughness and variety, and the more wild areas of the British Isles, which it was then thought best exhibited such characteristics, were frequently visited and minutely examined by those tourists who followed the cult of the Picturesque.

1. Origins

In its earliest and primary usage 'picturesque' denoted 'as in or like a picture'. The Italian term *pittoresco* was current by 1654 when G. A. Costa applied it to architecture in *Per la facciata del duomo di Milano*; since the word is not included in Filippo Baldinucci's *Vocabulario toscano dell'arte del designo* (1681), we may suppose, as did Uvedale Price, that it derived from usage in northern Italy by Venetian painters. There is an analogous Dutch usage (*schilderachtig*) somewhat earlier in 1618, and an identical German one used by Joachim von Sandrart I in *Teutsche Akademie der Edlen Bau-, Bild- und Mahlerey-Kunste* (1675–9) concerning Rembrandt van Rijn (though only 'malerisch' appears in German dictionaries, without the connotations of picturesque). Although the Académie Française did not admit 'pittoresque' until 1732, the term was in English usage by the late 17th century. Indeed, Stendhal considered the concept originated in English, and it is the British elaboration of an aesthetic of the Picturesque by the early years of the 19th century that gave the term its widest currency and popularity.

By 1800 the term was largely applied to landscape, although even its most famous promoter, William Gilpin, told Joshua Reynolds in 1791 that since it meant 'such objects, as are proper subjects for painting', it could apply as well to a Raphael cartoon or 'a flower piece' (Gilpin, 1792). Its earliest English usage was equally broad: in *Painting Illustrated* (1685) William Aglionby observed generally of free, vigorous and natural execution in painting that 'the Italians call [this] A la pittoresk'. The word could indicate the content and format of history or

allegorical painting in the grand manner: when Alexander Pope invoked 'picturesque', which he took to be a French term, in the commentary to his translation (1715–20) of the Homeric epic the *Iliad* (X, note to line 677), the contexts suggest that he had in mind some picture where a central human action, in this case based upon Homer, takes place in an appropriate setting. Gilpin considered that 'History-painting . . . is certainly the grandest production' among the visual arts, and Horace Walpole also often appealed to this kind of painting in his written descriptions of scenes in landscape parks (e.g. 'Journals of Visits to Country Seats', *Walpole Soc.*, xvi, 1928).

This early usage of picturesque to signal parallels between garden architecture and history painting has generally eluded modern commentators. But it goes some way to explain Pope's and others' invocation of the term and of painted landscapes when discussing garden design, since gardens were settings in which responsive visitors, statues, inscriptions, architecture and natural forms all contributed to the meaning of that 'picture'. Further, this sense of a garden or landscape scene as localizing some incident, however residual, or some association, however faint, which words were needed to enunciate, remained a substantial part of the practice if not the theory of picturesque taste, linking formal values with historical, poetic or sentimental themes. Thus picturesque may be seen as having intimate connections with earlier traditions of *ut pictura poesis*; hence Lancelot 'Capability' Brown's offer to Richard Saunderson, 4th Earl of Scarborough, in 1774 to manage the grounds at Sandbeck and Roche Abbey, S. Yorks, 'With Poet's feeling and with Painter's Eye' (see D. Stroud, *Capability Brown*, London, 1950, rev. 1974/*R* 1984, p. 139).

2. 18th-century aesthetic

Brown's ideal landscape forms, although they had developed out of some of the broad concerns of the early 'picturesque', were rejected as too bland and insipid by the group of connoisseurs—Gilpin, Price and Richard Payne Knight—who erected the theoretical apparatus of the Picturesque and focused it upon landscape in the last decades of the 18th century. This trio codified what had become various ways of giving scenery culturally and aesthetically respectable forms and meanings. Poets such as John Dyer (1700–58) and James Thomson had written of scenery in pictorial terms; artists had similarly and more directly begun to 'improve' the indigenous natural beauties of the British Isles by portraying them in the styles of foreign painters. As Joseph Addison had written as early as 1712, 'we find the Works of Nature still more pleasant, the more they resemble those of Art' (*The Spectator*, 414, 25 June 1712).

All three commentators also wanted to augment Edmund Burke's famous distinction, made in his *Philosophical Inquiry*, between THE SUBLIME and the Beautiful, to accommodate the Picturesque as a third category; although Price wished to divorce the Picturesque completely from the other terms, in practice it effectively drew nourishment from both. In Gilpin's *Essay upon Prints* he defined the Picturesque as 'that peculiar kind of beauty, which is agreeable in a picture'. It was, however, a Beauty that essentially partook of some Sublime, as is indicated by his contrasting images in *Three Essays* of 'non-picturesque' smooth mountain slopes and rough, irregular and shadowy picturesque formations, and by the role that ruins, with their Sublime potential, played in the picturesque experience. Gilpin's first recorded use of the term picturesque was in front of some simulated ruins in the gardens at Stowe, Bucks, although in picturesque practice it was the irregular shapes of ruins or their encouragement of verbal recollections or sentimental associations that mattered most. The picturesque preference for low points-of-view also tended to overwhelm the artist with his subject-matter in ways that recalled Burke's definition of Sublime experiences. The modern commentator, Robert Smithson, is therefore right to see the Picturesque as in fact a synthesis of the Beautiful and the Sublime, although its first theorists had too much at stake to acknowledge this amalgamation.

Gilpin's *Observations Relative Chiefly to Picturesque Beauty* is a series of descriptions of tours mostly taken through parts of Britain where the picturesque potential was strong—Wales, the Lake District, Scotland. In the tours he was especially concerned to grade scenery, as when he found the northern end of Lake Windermere in the Lake District 'rather amusing than picturesque' or the Firth of Forth in Scotland 'exceedingly grand and amusing [but] not indeed picturesque'. Such careful discriminations now seem rather absurd, yet they encouraged many tourists to adjudicate landscape for themselves, as did Gilpin's championing of the great variety of picturesque beauties to be found in Britain. Gilpin also formulated what became very influential rules for the selection, composition and handling of landscape in drawings. These formulae for studying and recording nature had the double appeal both of the scientific and the emotional. Rough, irregular subjects and pencil-work were above all recommended; figures, except as staffage, were played down—thus distancing the Picturesque from earlier appeals to history painting. Cultivated countryside was also dismissed as unpicturesque, while ruined cottages and vagrants, notwithstanding the ethical implications of their cult, were esteemed. This reactionary, anti-utilitarian element in picturesque taste was especially strong in Uvedale Price.

Gilpin and Knight gave to the picturesque cult its more sustained and philosophical commentary, and in so doing they effectively rejected Neoclassical art's appeal to ideal forms, now thought insipid, in favour of energetic, local and characterful subjects or handling. They transferred the emphasis of picturesque taste from some artistic processing of nature to an intensified, direct experience of it. Price's *Essay on the Picturesque* championed an observation of nature according to principles of intricacy, variety of form and disposition, roughness, variation of texture and of light and shade and irregularity; although these principles were clearly derived from the study of Dutch and Venetian paintings, Price nevertheless wanted to divorce the Picturesque from 'a mere reference to the art of painting'. Knight's poem,

The Landscape, dedicated to Price, echoed the latter's ideas and was published with an influential pair of etchings by Benjamin Thomas Pouncy (d 1799) after Thomas Hearne, showing a bald, dull parkland in the Brownian mode contrasted with the same scene graphically made picturesque. His more substantial contribution in the *Analytical Inquiry into the Principles of Taste* was to link the picturesque aesthetic to current ideas of psychology, the perception of the exterior world coloured by other experiences including that of painting. This associationist emphasis drew upon a century of empirical epistemology as well as upon a poetic tradition of rehearsing the meanings and sentiments connected with topographical sites.

Independently of Price and Knight, Archibald Alison, in *Essays on the Nature and Principle of Taste* (1790), also highlighted the role of association in the perception of scenery, in a work that was to have a lasting effect on Romanticism. Indeed, there was hardly a collection of essays from this period that did not address the question of picturesque taste, especially in relation to landscape and landscape garden design.

3. Legacy

Theoretical nuances, however, did not always impress the many amateur artists and picturesque tourists who made and sustained the cult. They were more concerned with discovering authorized (or, if more adventurous, even new) 'stations' from which the best picturesque views were to be 'taken' (technical jargon to denote both viewing and taking down in visual or verbal memoranda). They were also concerned with manipulating their basic equipment—notably the Claude glass, a tinted mirror that controlled and framed a suitable portion of scenery, or a series of variously coloured glasses through which to view landscape directly—and with compositional or associational aspects, such as deciding which painter (Claude Lorrain, Gaspard Dughet, Salvator Rosa) would best do justice to the scene or from which poet to borrow the best literary tag to label it. If Hussey and Hipple have amply treated the largely theoretical aspects of the Picturesque,

these more practical aspects of the amateur at large in the countryside have been surveyed by Andrews with detailed references to many published and MS tours.

The presses were full of works that exploited the Picturesque, including the picturesque possibilities of foreign parts; the picturesque taste spread to North America, despite a scenery sometimes too overwhelming for its nuances, and Claude glasses were on sale as late as 1883 in Philadelphia. In American landscape architecture, too, picturesque criteria continued to be cited, notably by Andrew Jackson Downing ('an idea of beauty strongly and irregularly expressed') in *A Treatise on the Theory and Practice of Landscape Gardening* (1841).

If once the Picturesque had yielded a fresh, even creative approach to landscape it rapidly became routine and mechanical. So in the early 19th century some writers and artists, such as William Wordsworth, Samuel Taylor Coleridge, John Constable, and J. M. W. Turner, struggled to reject or reformulate picturesque theory and practice. These renovations gave fresh life to the idea, which continued to function into the late 20th century as a useful currency in both tourism and visual taste, despite the scorn poured upon its mechanical insipidity by writers as different as Jane Austen and John Ruskin; the latter thought it the vaguest of expressions, yet sought to revitalize its significance in *Modern Painters* (1843–60).

In the 20th century Marshall McLuhan traced picturesque habits and structures from Tennyson's iconic poetry to modern Symbolism, and Martin Price also discussed its central role in the 18th-century watershed of modernism; others directed attention to the centrality of picturesque structuring in the novel from Sir Walter Scott to Thomas Hardy. While modern art has resisted the lure of the pictorial and such artists as Richard Serra resent being associated with or labelled 'picturesque', Yve-Alain Bois, drawing largely on Robert Smithson, has usefully demonstrated the continuing life and sharpness of the term. With the advent of moving photography (i.e. film), new possibilities of picturesque intricacy (a key term

for Price) have emerged, and something of the old and awkward contradiction between static pictures and the movement of the picturesque spectator through landscape space has been bypassed. Tired as the term can be, 'picturesque' effectively identifies a particular vision that attempts to access and inhabit landscape.

Bibliography

E. Burke: *A Philosophical Inquiry into the Origin of our Ideas of the Sublime and the Beautiful* (London, 1757); ed. J. T. Boulton (London, 1958)

W. Gilpin: *Essay upon Prints* (London, 1768)

—: *Observations Relative Chiefly to Picturesque Beauty*, 8 vols (London, 1782–1809)

—: *Three Essays, to Which is Added a Poem on Landscape Painting* (London, 1792)

R. P. Knight: *The Landscape: A Didactic Poem* (London, 1794)

U. Price: *An Essay on the Picturesque as Compared with the Sublime and the Beautiful*, 2 vols (London, 1794–8, rev. in 3 vols 3/1810) [3rd edn has further essays on garden design and architecture]

R. P. Knight: *An Analytical Inquiry into the Principles of Taste* (London, 1805)

E. W. Manwaring: *Italian Landscape in 18th-century England* (London, 1925)

C. Hussey: *The Picturesque: Studies in a Point of View* (London, 1927) [includes appendix on 'the most eminently picturesque English painters']

W. D. Templeman: *The Life and Works of William Gilpin* (Urbana, 1939)

H. M. McLuhan: 'Tennyson and Picturesque Poetry', *Ess. Crit.*, i (1951), pp. 262–82; repr. in *Critical Essays on the Poetry of Tennyson*, ed. J. Killham (London, 1960), pp. 67–85

W. J. Hipple jr: *The Beautiful, the Sublime, and the Picturesque in 18th-century British Aesthetic Theory* (Carbondale, 1957) [with full bibliog. and many references to MSS]

C. P. Barbier: *William Gilpin: His Drawings, Teaching and Theory of the Picturesque* (Oxford, 1963)

M. Price: 'The Picturesque Moment', *From Sensibility to Romanticism*, ed. F. W. Hilles and H. Bloom (New York, 1965), pp. 259–92

D. J. Warner: 'The Landscape Mirror and Glass', *Antiques*, cv (1974), pp. 158–9

K. Woodbridge: 'Irregular, Rococo or Picturesque', *Apollo*, cviii (1978), pp. 356–8

N. Holt, ed.: *The Writings of Robert Smithson* (New York, 1979)

J. D. Hunt: 'Picturesque Mirrors and the Ruins of the Past', *A. Hist.*, iv (1981), pp. 254–70

D. Watkin: *The English Vision: The Picturesque in Architecture, Landscape and Garden Design* (London, 1982)

Y.-A. Bois: 'A Picturesque Stroll around Clara-Clara', *October*, xxix (1984), pp. 32–62

J. D. Hunt: 'Ut pictura poesis, ut pictura hortus, and the Picturesque', *Word & Image*, i (1985), pp. 87–107; rev. in *Gardens and the Picturesque* (Cambridge, MA, 1992)

A. M. Ross: *The Imprint of the Picturesque on Nineteenth-century British Fiction* (Waterloo, Ont., 1986)

M. Andrews: *The Search for the Picturesque* (Aldershot, 1989) [provides lists of various Picturesque tours made in England, Wales and Scotland]

JOHN DIXON HUNT

Pintura de la luz [Sp.: 'painting of light']

Type of painting practised in Spain in the late 19th century and early 20th and concerned primarily with the use of light, especially in the depiction of landscape. Its exponents included Aureliano Beruete, Francisco Domingo y Marqués, Mariano Fortuny y Marsal, Francisco Iturrino, Ramón Martí Alsina, Joaquim Mir, Antonio Muñoz Degrain, Ignacio Pinazo, Darío de Regoyos, Augustín Riancho, Eduardo Rosales Martínez and Joaquín Sorolla y Bastida, though they never formed a school. The artists were influenced by a wide range of sources, including the work of the Barbizon school, the *plein-air* method of Corot, French Impressionism, the painting of the Italian *Macchiaioli* and Post-Impressionism, as well as by the Spanish tradition of painting. Somewhat artificially and in a similar manner to the French Impressionists, the painters were subsequently grouped together, more for the differences that separated them from other contemporary painters than for any relationships among them. Common to the work of these various artists, however, is the use of light as the basic element, although the treatment varies from painter to painter, and also a preference for landscape.

The attitude of these artists is well summed up by Pinazo's statement (1896): 'For the true artist, then, there is nothing but light. Even form, which could be considered the most material element, is capable of being expressed only with colour; form is inconceivable without colour and colour without light'.

Bibliography

J. A. Gaya Nuño: 'Difficultés de l'impressionisme espagnol', *Cah. Bordeaux* (1959), pp. 29–32

El impresionismo en España (exh. cat. by J. A. Gaya Nuño, Madrid, Salas Exp. Dir. Gen. B.A., 1974)

M. C. Pena López: *El paisaje español del siglo XIX: Del naturalismo al impresionsimo* (Madrid, 1982)

Pintores de la luz (exh. cat., Madrid, Banco de Bilbao, 1983)

ANDRÉS UBEDA DE LOS COBOS

Plateresque style [Sp. *plateresco*, from *platero*, 'silversmith']

Term used to describe the elaborately decorated Late Gothic and early Renaissance architecture of 16th-century Spain. Its characteristically florid decoration employs motifs derived from Gothic, Italian Renaissance and Islamic sources and tends to mask the structure it adorns. The term is also applied, more generally, to the decorative arts of the same period. The comparison between sculpture and architectural decoration and gold- or silverwork in terms of style and skill was commonplace in Spanish literature in the 16th and 17th centuries, including art criticism (from Cristóbal de Villalón in 1539 to Lope de Vega). Contemporary authors did not distinguish between architectural decoration and embroidery or filigree work; there is no reference to specific decorative motifs, only to general forms of handicraft. The term was apparently first used in an anonymous drawing (*c.* 1580) for the decoration of a frieze in the chapter house of Seville Cathedral. The term *targatas platerescas* ('plateresque tablets') appears to describe a decorative motif coming from international Mannerist repertories, used by architectural and sculptural decorators or silversmiths, and bears no relation to the

decoration typical of early 16th-century Spanish architecture—the candelabra and grotesques—to which it later referred almost exclusively.

The term Plateresque was linked to the Italian style of decoration by Diego Ortiz de Zúñiga (1677), who described the town hall and the Royal Chapel of the cathedral in Seville as 'all covered with excellently drawn foliage and fanciful decorations that the artisans call Plateresque'. Ortiz de Zúñiga criticized such fantasies for violating the rules of ancient Roman architecture; thereafter the term is used to describe the highly decorative works of architecture of the first half of the 16th century.

Although the term was also employed during the 18th century to describe any capricious and irrational type of decoration freely applied to architecture, the critic Antonio Ponz used Plateresque style to refer specifically to the middle phase of 16th-century Spanish architecture, between the Gothic style and the revival of Greco-Roman architecture. In 1804 J. A. Ceán Bermúdez continued this line of thought, locating Plateresque architecture between Gothic and Greco-Roman. The style, he claimed, marked 'the commencement of the restoration of the Greco-Roman style, poor in its organization, prodigal in its ornaments and lacking elegance as a whole'. It retained Gothic decoration with a characteristic use of foliage and figures, because both patrons and artisans were used to the 'superfluity and trifling nature of Gothic ornament'. According to Ceán Bermúdez, this type of architecture began with Enrique Egas, Alonso de Covarrubias, Diego de Siloé, Felipe Vigarny, Juan de Badajoz the younger and Diego de Riaño. From the early 19th century the basic characteristics attributed to the Plateresque style remained constant, with few variations. José Caveda (1849) described it as a mixed style, combining Gothic, Muslim and Classical elements, and praised its distinctive national character.

In the 20th century architectural historians attempted a wide range of definitions, with Bevan (1939) making the pertinent suggestion that Plateresque is 'not so much a type of ornament as a taste for ornament'. Marías (1983–6), reviewing 16th-century literature on art and departing from Bury (1976), sought to relinquish criteria based on decoration in his attempt to characterize the architecture of the period using architectural terms; thus, he distinguished between buildings that are Gothic in technique, structure and volumetry to which Plateresque decoration had been added, and buildings where, beneath a similar type of ornamentation, there exist structures, styles, wall arrangements and a volumetry that were derived from ancient or Italian Renaissance architecture. As contrasted with Plateresque Gothic architecture, it is therefore possible to speak of an ornamented Renaissance style, as opposed to the Estilo desornamentado or stripped style of the second half of the 16th century.

Spanish architecture between 1490 and 1570 can be divided into several currents. The first is marked by the survival and evolution of a Gothic style that rejects any kind of decorative innovation, represented by such schemes as those for the cathedrals of Salamanca and Segovia, designed in the second and third decades of the 16th century and still under construction in the early 17th century. The second current is characterized by a surviving Gothic style that retains the profuse decoration of the Flamboyant style, incorporating ornament from France and Italy and using the orders as mere elements of decoration. Only Corinthian or composite pilasters are used, with no interest in correct morphology or proportion, their shafts covered in reliefs; unorthodox baluster columns are also featured, and entablatures are converted into a series of strips decorated with grotesques. Here the compositions will admit new motifs, which are included in Gothic structures, especially doorways and windows, with the orders lacking any architectural value or impact. This current of Gothic survival, with added Plateresque decoration, features in Diego de Sagredo's treatise of 1526, *Medidas del romano*; it contains precepts by Vitruvius and Leon Battista Alberti, applied to a superficial, decorative concept of the Classical orders, but advocates the use of correct morphology and proportions for the columns and places particular stress on the possibility of their being decorated. Such architects as Lorenzo Vázquez de Segovia, Enrique Egas, Diego de Riaño, Juan de

Alava and Francisco de Colonia designed in this style, and such buildings as the Hospital de Santa Cruz in Toledo, with its façade by Antón Egas, Enrique Egas and Alonso de Covarrubias, the Universidad de Salamanca or the Portada de la Pellejería in Burgos Cathedral are among the earliest examples.

The third current—represented by Diego de Siloé, Pedro Machuca, Alonso de Covarrubias and Luis de Vega, among others, together with their schemes built from about 1520—was marked by a more accurate use of the orders, compositions influenced by ancient architecture and styles emanating from Italy, although ornamentation was not abandoned when the character of the buildings required it. Ornamentation was suppressed, especially after Sebastiano Serlio's books were published in Spanish in 1552, easing the transition towards the stripped style of the last decades of the 16th century.

Bibliography

D de Sagredo: *Medidas del romano* (Toledo, 1526, 4/1549, rev. Murcia, 1986)

C. de Villalón: *Ingeniosa comparación entre lo antiguo y lo presente* (Valladolid, 1539, rev. Madrid, 2/1898)

D. Ortiz de Zúñiga: *Anales eclesiásticos y civiles de la ciudad de Sevilla* (Madrid, 1677)

A. Ponz: *Viaje de España*, 18 vols (Madrid, 1772–94, rev. 1947)

J. A. Ceán Bermúdez: *Descripción artística de la catedral de Sevilla* (Seville, 1804/R 1981)

J. Caveda: *Ensayo histórico sobre los diversos géneros de arquitectura empleados en España desde la dominación romana hasta nuestros días* (Madrid, 1849)

J. de Contreras: *Historia del arte hispánico*, i (Barcelona and Buenos Aires, 1945)

B. Bevan: *History of Spanish Architecture* (New York and London, 1939)

J. Camón: *La arquitectura plateresca*, 2 vols (Madrid, 1945)

G. Kubler: *Mexican Architecture of the Sixteenth Century* (New Haven, 1948, rev. 1972; Sp. trans., Mexico City, 1983)

M. Toussaint: *Arte colonial en México* (Mexico City, 1948; Eng. trans., Austin, 1964)

F. Chueca Goitia: *Arquitectura del siglo XVI*, A. Hisp., xi (Madrid, 1953)

E. E. Rosenthal: 'The Image of Roman Architecture in Renaissance Spain', *Gaz. B.-A.*, 6th ser., lii (1958), pp. 329–46

J. Camón Aznar: *La arquitectura y la orfebrería españolas del siglo XVI*, Summa A., xvii (Madrid, 1959, 3/1970)

G. Kubler and M. Soria: *Art and Architecture in Spain and Portugal and their American Dominions*, Pelican Hist. A. (Harmondsworth, 1959)

S. Sebastián: 'La decoración llamada plateresca en el mundo hispánico', *Bol. Cent. Invest. Hist. & Estét. U. Caracas*, vi (1966), pp. 42–85

J. B. Bury: 'The Stylistic Term "Plateresque"', *J. Warb. & Court. Inst.*, xxxix (1976), pp. 199–230

A. Cloulas: 'Origines et évolution du terme "platersco": A propos d'un article de J. B. Bury', *Mél. Casa Velázquez*, xvi (1980), pp. 151–61

S. Sebastián: *Arquitectura: El renacimiento* (Madrid, 1980), iii of *Historia del arte hispánico*

R. Gutiérrez: *Arquitectura y urbanismo en Iberoamérica* (Madrid, 1983)

F. Marías: *La arquitectura del renacimiento en Toledo (1541–1631)*, 4 vols (Toledo and Madrid, 1983–6)

S. Sebastián López, J. de Mesa Figueroa and T. Gisbert de Mesa: *Arte iberoamericano desde la Colonización a la Independencia* (Madrid, 1985)

F. Marías: *El largo siglo XVI: Los usos artísticos del renacimiento español* (Madrid, 1989)

V. Nieto and others: *Arquitectura del renacimiento en España, 1488–1599* (Madrid, 1989)

V. Fraser: *The Architecture of Conquest: Building in the Viceroyalty of Peru, 1535–1635* (Cambridge, 1990)

M. Sartor: *Arquitectura y urbanismo en Nueva España: Siglo XVI* (Mexico City, 1992)

J. Early: *The Colonial Architecture of Mexico* (Albuquerque, 1994)

R. J. Mullen: *Architecture and its Sculpture in Viceregal Mexico* (Austin, 1997)

FERNANDO MARÍAS

Poblano

Term used to describe an exuberant architectural and sculptural style that developed in and around the city of Puebla, Mexico, in the 18th century. It is characterized by Baroque elements used in combination with ornate stucco, geometrically patterned red brickwork and polychrome glazed tiles (Sp. *azulejos*), which were produced by flourishing local industries. The style developed in parallel with the growth of the city itself. As Puebla

became wealthier and more important in the 17th century, increasing numbers of workshops were set up by ceramicists, many of them from Spain; Spanish artistic trends became more important, and these workshops came to exert a great deal of influence on the development of art in the city and surrounding villages. At the same time the growing wealth of the city financed the construction of religious and secular buildings that reveal their patrons' and owners' desire for luxury and display. Heavily ornamented mansions, as well as convents and churches designed in opulent styles reflecting the donations of affluent local merchants, farmers and factory owners, all contributed to the evolution of an architecture rich in colour and imagination.

An important contributory factor to the development of the Poblano style was the Spanish taste for coloured ceramics and plasterwork, and for the type of brick often used in those parts of Spain dominated by Islamic influences. The use of glazed tiles and plaster arabesques, first seen in the 17th century in the interior vaults of such churches in Puebla as La Concordia and S Inés, continued in the dome of the church of S Cristóbal and reached a peak in the Rosario Chapel of S Domingo, which was decorated between 1650 and 1690 with gilt and polychrome Baroque plasterwork featuring plant, animal and figural motifs. The Renaissance scrolls in the interior of the Rosario Chapel were remodelled in the Baroque style, while the painted saints and polychrome statues, designed within a framework of complex symbolism exalting the Virgin, are surrounded by a welter of stucco and plaster Moresque tracery, as well as by a profusion of glazed tiles.

During the 18th century, however, the fashion for polychrome brickwork, geometric shapes and glazed tiles, often set in panels with images of saints, spread to the exterior of houses and churches in Puebla, reflecting the economic strength of the city; and this combination of materials, used together with stucco, created the Poblano style that came to characterize the city. Bricks and tiles were employed to form intricate geometric patterns or panels in harmonious, decorative compositions; friezes were executed in plaster, while the balcony supports, door- and window-frames and the cresting of houses and churches were made from a strikingly white mix of lime and sand; decoration was created according to the caprice of sculptor and architect, who gave free rein to their imaginations and combined elements in new ways but always retaining a sense of harmony and the framework of the Baroque. Outstanding examples of religious buildings in Puebla with towers, domes or façades designed in the Poblano style include S José (1595; altered 1628); the Carmelite church (18th century), Guadalupe; and the churches of S Marcos, S Francisco (1667) and S Catalina. The so-called Casa del Alfeñique (c. 1790; now Puebla, Mus. Reg. & Cer.) is a masterpiece of secular Poblano architecture, as are the Casa del Canónigo Peláez and the Casa de los Muñecos.

It was natural that the influence of such an attractive style of architecture should extend to the surrounding area, as can be seen, for example, in Atlixco and at the Santuario de Ocotlán in Tlaxcala; in the camarín (small chapel behind and above the high altar) of the latter the religious ecstasy of the sculptor overflowed into fantasy. Also notable is the façade of the little church of S María Tonantzintla (c. 1700), outstanding above all for the interior of the nave and the dome, the Poblano decoration of which exceeds the Rosario Chapel in richness and polychromy, if not in quality. The masterpiece of glazed-tile work in the Poblano style, however, is the 18th-century church in the village of S Francisco Acatepec, where the Baroque façade is completely encased in multicoloured polychrome tiles. The influence of the style declined with the advent of new architectural ideas introduced with European Neo-classicism at the end of the 18th century.

A comparable tendency to develop a distinctive Hispano-American form of Baroque may be seen in the Mestizo style of the highland provinces of Peru and Bolivia.

Bibliography

D. Angulo Iñiguez, E. Marco Dorta and M. J. Buschiazzo: *Historia del arte hispano-americano*, ii (Barcelona, 1948)

P. Kelemen: *Baroque and Rococo in Latin America* (New York, 1951)

S. Sebastián López, José de Mesa Figueroa and T. Gisbert de Mesa: *Arte iberoamericano desde la colonización a la independencia*, Summa A., xxviii and xxix (Madrid, 1981 and 1985)

L. Velázquez Thierry: *El azulejo y su aplicación en la arquitectura poblana* (Puebla, 1992)

CONSTANTINO REYES-VALERIO

Pointillism

Technique of employing a point, or small dot, of colour to create the maximum colour intensity in a Neo-Impressionist canvas. While NEO-IMPRESSION-ISM suggests both the style created by Georges Seurat and the ensuing movement that flourished between 1886 and 1906, Pointillism denotes only the technique. Seurat favoured the term 'chromo-luminarism', which conveys his dual interest in intensifying the effect of colour and light. Seurat's chief disciple, Paul Signac, in his book *D'Eugène Delacroix au Néo-Impressionnisme* (Paris, 1899), offered an alternative term to Pointil-lism or chromo-luminarism: DIVISIONISM. Division-ism refers to the separation of colour into individual strokes of pigment, in accord with colour theories, rather than to the points them-selves.

JANE BLOCK

Pombaline style

Portuguese architectural style that developed in the 18th century and that was named after Sebastião José de Carvalho e Melo, 1st Marquês de Pombal. Following the earthquake of 1 November 1755 that completely destroyed Lisbon, Carvalho e Melo, the future Marquês de Pombal, undertook a total reorganization of the Kingdom of Joseph. Plans for the city's reconstruction were drawn up, approved and carried out under the supervision of the chief engineer Manuel da Maia and the mil-itary engineers Eugénio dos Santos and Carlos Mardel. The aim was to rebuild the city on its tra-ditional location on the banks of the Tagus and to alter its urban plan, which, apart from the

sumptuous late 16th-century royal-palace area, dated back to the Middle Ages. The Baroque addi-tions of the early 18th century had done little to improve the overall scheme.

The layout was radically changed so as to consist of a grid plan of streets, parallel and per-pendicular to each other, covering the lower part of the city between the two old squares, which were altered for the purpose. The royal palace having been destroyed, the square in which it had stood, looking on to the river, became Praça do Comércio as a sign of the new social values result-ing from the rise of the bourgeoisie. The Rossio too was replanned with the new Inquisition palace on top. This was the northern limit of the city, beyond which was to be a public walk, again cre-ating a new accessibility between the various parts of the city.

The replanning of Lisbon was one of the most important urban projects in Europe and the Americas in the mid-18th century. It was carried out according to the philosophical and aesthetic principles of the Enlightenment, which were accepted by Pombal. Thus the architectural pro-jects were to be entirely subordinate to the logical uniformity of the plan. In this way, to the plans of Maia, Santos and Mardel were added drawings of a series of façades conceived on a hierarchical basis, according to the importance of the streets for which they were intended. The resulting monotony, criticized by foreign visitors at the time, that originated from this principle was also due to economic reasons and the urgent nature of the work. A standard system was conceived, apply-ing to both the interiors and the exteriors. Only the two city squares were exempted from this severe plan, in favour of more splendid schemes. In the Rossio the three façades designed by Mardel possess a rhythmical variety, with double roofs and windows in the German manner. The Praça do Comércio, which housed the government departments, was built on arcades. The wings, which are at right angles to the river, end in towers, harking back to the old royal palace. The central wing has a triumphal arch in the middle, the opening of which is in line with an equestrian statue of *King Joseph* (inaugurated 1775); on the

statue's pedestal is a medallion of Pombal. In contrast, the churches that were built have an independence of style, in the Roman manner, simplifying the Baroque richness of the architecture of the reign of John V.

The Pombaline style of architecture is also evident in Oporto and in the Reinaldo Manuel dos Santos's Vila Real de Santo António (1773–4) in the Algarve and constitutes an early form of Neo-classicism that lasted until the mid-19th century.

Bibliography

J.-A. França: *Une Ville des lumières, la Lisbonne de Pombal* (Paris, 1967)

G. Byrne: 'Ricostruire nella città: La Lisbonna di Pombal', *Lotus Int.*, 51 (1987), pp. 6–24

JOSÉ-AUGUSTO FRANÇA

Pompeian Revival

Term used to describe a variety of attempts in Europe, dating from the second half of the 18th century, to emulate antique Roman interior decoration based on the latest archaeological findings. The dramatic uncovering of the Roman cities of Herculaneum from 1738 and Pompeii from 1748—buried by an eruption of Mt Vesuvius in AD 79—inspired a series of experiments in the design of interiors and furnishings as well as in other areas of the decorative arts. Undoubtedly the most creative phases of the Pompeian Revival occurred during the second half of the 18th century. At that time limited archaeological evidence was finely balanced with imaginative experiment in works by a succession of architects and designers. Owing to the quantity of pictorial wall decorations recovered in the Vesuvian excavations, the revival also exercised a certain influence on easel painting and, to a far lesser degree, on sculpture. However, the phenomenon remained largely confined to interior schemes, losing impetus as the 19th century advanced and eventually becoming one of the many alternative styles of decoration in the historicist repertory.

1. Early excavations and beginnings

From the Early Renaissance European artists were stimulated by descriptions of antique painting, as well as encaustic techniques, by such authors as Pliny the elder. The discovery around 1500 of surviving painted interiors from Nero's Domus Aurea in Rome prompted the first essays in reviving schemes of antique decoration. These culminated during the High Renaissance in the Vatican *loggie* and the Villa Madama schemes of Raphael and his followers (see col. pl. XVII and fig. 38). The resulting GROTESQUE mode of decoration entered the European ornamental vocabulary through such Mannerist designers as Giulio Romano and the artists of the Fontainebleau school (see col. pl. XIII). It was first effectively introduced in England by William Kent during the 1720s. The grotesque became inextricably bound up with all early systems of interior decoration inspired by excavations at Herculaneum and Pompeii.

The impact of these excavations was extremely slow to take effect, since opportunities for recording finds were jealously restricted by Charles VII of the Two Sicilies (later Charles III of Spain), who established a museum at Portici in 1734. (Of its exhibits the majority was transferred to Naples in 1779.) Apart from random illustrations in early accounts, the principal paintings brought to light in the 1740s and early 1750s were published only from 1757 in the first volume of the official *Le antichità di Ercolano esposte*, issued by the Accademia Ercolanese di Archeologia founded in 1755. Even then the fragmentary nature of the frescoes depicted was due to the severe physical constraints of Herculaneum's underground site and the crude methods of recovery, and they provided little idea of entire room schemes or their functions.

Among the first attempts in Europe to re-create an interior in the antique taste following these discoveries was James Stuart's Painted Room (from c. 1759) in Spencer House, London. This involved a mixture of grotesque ornament, painted panels after Herculaneum compositions and motifs from a wide range of antique sources, including Greek ones. The surviving room was originally enhanced by a remarkable suite of furniture, certain pieces

of which have since been transferred to the Spencer country seat (Althorp House, Northants), including tripod candelabra-perfume burners, as well as an impressive set of four gilt-wood sofas with winged-lion ends emulating the monumental forms of Classical design in the applied arts.

In conscious rivalry with Stuart, the Adam brothers were swift to exploit various modes of painted interiors at Kedleston Hall, Derbys, Syon House, London, and Audley End, Essex, during the 1760s. A fresh challenge to them was presented by James Wyatt, who, in 1771, produced an exquisitely devised system of painted decoration, with furnishings to match, in the Cupola Room of Heaton Hall, Lancs. Wyatt also pioneered the novel ETRUSCAN STYLE in a fishing temple at Fawley Court, Bucks, using ornaments, figures and colours derived from ancient vase paintings. However, by the mid-1770s the Adam brothers had perfected a mature language of antique decoration in a series of at least eight Etruscan style interiors, epitomized by the Dressing Room (c. 1775–6) at Osterley Park House, London (see fig. 27). The walls, decorated with a system of trellis construction inspired by Herculaneum (suggested by an etched design by Giovanni Battista Piranesi), blended with the vase motifs of Wedgwood, were skilfully coordinated with chairs, a pole-screen, ceiling and carpet to achieve a near-perfect unity of expression.

2. Wedgwood ceramics and paintings in oils

The fictive plaques featured in the Adam brothers' schemes reflected the forms produced by Josiah Wedgwood during the 1770s in his black basalt ware. In the 1773 catalogue Wedgwood advertised 'Herculaneum dancing nymphs' and 'other beautiful figures modelled in Italy found in Herculaneum'. These motifs, along with the painted centaurs, also recovered from the so-called 'Villa of Cicero', were produced in jasper, terracotta and biscuit and were available in the form of wall sconces, free-standing figures and small medallions that could be used to ornament furniture.

Apart from providing accurate details of costume or furniture, the impact of frescoes published in the Antichità on contemporary painting was, by comparison, relatively modest. For example, between 1758 and 1759 Anton Raphael Mengs carried out a pastiche of a Herculaneum fresco, *Jupiter and Ganymede* (Rome, Pal. Barberini), to deceive his friend Johann Joachim Winckelmann, and was to base at least two of his oil compositions of the 1760s—*Augustus and Cleopatra* (Vienna, Czerninsche Gemäldegal.) and *Perseus and Andromeda* (St Petersburg, Hermitage)—after the engraved plates. Joseph-Marie Vien converted a particularly unprepossessing fresco, depicted in the third volume of the *Antichità* (1762), into a particularly modish composition, the *Cupid Seller* (Fontainebleau, Château; see fig. 57), exhibited at the Salon of 1763 ('comme tout cela sent la manière antique', commented Diderot) and originally part of the collection of Mme du Barry at the château of Louveciennes. Another of his works, the *Virtuous Athenian* (exh. Salon 1763; Strasbourg, Mus. B.-A.), features an antique altar that was to inspire *ébénistes* with the idea of the ubiquitous *athénienne* tripod form in Neo-classical furniture.

3. The late 18th century

The Etruscan style, continued into the 1780s by Adam, Wyatt and their imitators, found its parallel in France in painted interiors in the grotesque manner; these were introduced into the Louis XVI style by Charles-Louis Clérisseau, who designed salons in two houses for Laurent Grimod de la Reynière in Paris in 1773–4 and 1779–81. By now, however, important new perspectives on the decorative achievements of Roman antiquity were being revealed as the focus of excavations shifted from Herculaneum to the newly identified Pompeii, known as Civita when first located in the 1740s. The more accessible nature of the site and the relatively greater ease in removing volcanic ash, as opposed to the solidified lava of Herculaneum, allowed large portions of houses to be explored *in situ*. These activities encouraged a fresh interest in documenting painted interiors elsewhere, as well as in reconstructing total schemes from available evidence. Publications characteristic of the new attitude were Charles Cameron's *The Baths of the Romans* (1772) and

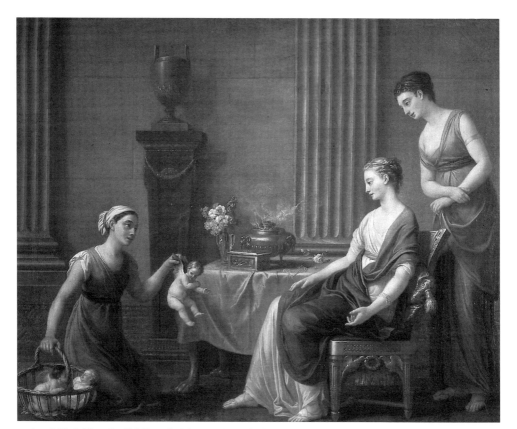

57. Joseph-Marie Vien: *Cupid Seller*, exh. Salon 1763 (Fontainebleau, Musée National du Château de Fontainebleau)

M. Ponce's *Description des bains de Titus* (Paris, 1786).

By the later 1770s the Society of Antiquaries of London was receiving accounts from Sir William Hamilton of total painted schemes at Pompeii; he occasionally supplied coloured sketches to amplify these descriptions (reproduced in line engravings by the Society in volume four of their transactions, *Archaeologia*, in 1786). The impact of these fresh sources is impressively demonstrated at Packington Hall, Warwicks, where Heneage Finch, 4th Earl of Aylesford and a fellow of the Society of Antiquaries, converted a room originally intended for sculpture into a fully fledged Pompeian Gallery between 1785 and 1788. Aided by the architect Joseph Bonomi, and a team of craftsmen and decorative painters led by John Francis Rigaud, Finch devised an extremely striking interior, following the spirit rather than the letter of third-style Roman wall compositions, for which he was particularly indebted to Ponce's folio. He also used historic methods of encaustic painting (later described in a detailed memoir by Rigaud's son) to execute a colour scheme involving strong reds combined with black and gold, extended to the curtains as well as to the upholstery of a set of highly original Klismos chairs. As a result, it can be claimed that the Packington gallery was the earliest Pompeian Revival interior in Europe, anticipating by over half a century the more archaeological reconstructions in France and Germany.

In Italy, meanwhile, the positive influence of the excavations continued to be extremely limited. In 1782, when Charles III had reluctantly left Naples to govern Spain, his son Ferdinand IV presented him with the Herculaneum Service—some 88 pieces of Capodimonte porcelain decorated with the discoveries of the previous 40 years. Another such service, presented by Ferdinand to George III, is in the British Royal Collection. Decorators in ceramic design at Sèvres and Vienna also extracted motifs from the *Antichità* to apply to cups, plates and vases.

4. The 19th century and later

By the 19th century, excavations were given fresh impetus by Joachim Murat during the French occupation of Italy. The Empire taste for the sumptuous and the heavily ornate drew fresh inspiration from Pompeii, as reflected in the designs of Charles Percier and P.-F.-L. Fontaine in their *Recueil de décorations intérieures* (1801). Two decades earlier, the Scottish architect Charles Cameron, working in the 1780s for Catherine II, Empress of Russia, at Tsarskoye Selo, had already anticipated this heavy opulence. His researches on the Baths of Titus in Rome were given practical expression in the often startling combination of semi-precious materials including agate, lapis and other exotic substances.

While a number of remarkable bronze objects, such as the tripods from the Temple of Isis and from the House of Julia Felix, Pompeii, had been uncovered and published in the *Antichità* during the 1760s, hitherto they had made little impact on contemporary furniture design. However, not only did Napoleonic taste favour the direct imitation of antique furniture types (as seen in David's *Mme Récamier*, 1800; Paris, Louvre; see fig. 58), but classical details were being applied more extensively than ever. Examples of this were the interiors at Malmaison, Compiègne and the Hôtel Beauharnais, Paris, as devised by Percier and executed by such *ébénistes* as François-Honoré-Georges Jacob-Desmalter (1770–1841). Pompeian motifs, typified by the dancing figures from the Villa of Cicero, were to be found in a wide variety of roles, ranging from the bronze ornaments

applied to Empress Josephine's jewel cabinet (Fontainebleau, Château), attributed to Pierre-Paul Prud'hon, to those painted by Louis Lafitte (1770–1828) on the dining-room doors (1799) at Malmaison, and from Gobelins and Beauvais tapestries to items of Sèvres porcelain.

British designers of the Regency era valued the potentially rich tonality of Pompeian schemes. In 1828 the Classical scholar and topographer Sir William Gell had painted his sitting-room in Rome 'in all the bright staring colours I could get, a sort of thing between Etruscan and Pompeian', while the London interiors of the arbiter Thomas Hope had similarly vivid colour schemes to set off furniture that he had based on antique prototypes or composed from a range of pictorial sources. It was in Germany and later in France, however, that some of the most ambitious Pompeian interiors were created during the first half of the 19th century. In 1825–6 Karl Friedrich Schinkel designed a Pompeian tea salon for Friedrich William IV in the Schloss Charlottenburg, Berlin. A surviving projected design of 1830 for Palais Redern, Berlin, shows the rich Pompeian red extended by Schinkel from the walls to the upholstery of a continuous ottoman running along the wall of an apsidal-formed room. As the century advanced, the heavy hand of archaeological exactitude increased its effect. This is particularly evident in the elaborate Pompeianum at Aschaffenburg produced by Friedrich von Gärtner for Ludwig I between 1841 and 1846 in imitation of the House of Castor and Pollux at Pompeii. In France, where the imagination of such an artist as Ingres could exploit a Pompeian interior with chilling power, as in his *Antiochus and Stratonice* (1840; Chantilly, Mus. Condé; see col. pl. XXIX), the now lost interior of Prince Napoléon's Parisian house, created by Alfred Normand between 1854 and 1859 (recorded in a Gustave Boulanger salon piece of 1861, the *Rehearsal of 'Le Joueur de flûte' and 'La Femme de Diomède'*; Versailles, Château), appears somewhat lifeless and sterile.

In Victorian England, despite a wave of literary enthusiasm following Bulwer Lytton's celebrated novel, *The Last Days of Pompeii* (1834), the revival was of far less significance. Inspired by Queen

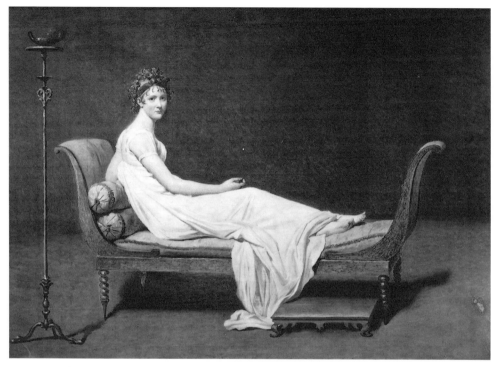

58. Jacques-Louis David: *Mme Récamier*, 1800 (Paris, Musée du Louvre)

Victoria's visit to Pompeii in 1838, Prince Albert commissioned a room in the taste from Agostino Aglio for a garden pavilion (1843–5; destr.) at Buckingham Palace, London. Similarly limited in interpretation, if more extensive in scale, was the Roman Room at Ickworth, Suffolk, designed by J. D. Crace in 1879; this was closely derived from authentic decorations discovered at the Villa Negroni in Rome.

With the reorganization of Italy under Victor Emmanuel during the late 1860s, a new phase of systematic excavations was introduced at Pompeii under Giuseppe Fiorelli; this continued into modern times. While major discoveries in the 20th century, such as the Villa of the Mysteries, have encouraged no further revivals, apart from the sets of Hollywood epics and the celluloid fantasies of Federico Fellini, in the 1960s there was the unexpected phenomenon in California of the scholarly recreation of the Villa of the Papyrii,

Herculaneum (first documented by excavations in the early 1750s), in John Paul Getty's lavish museum (opened 1974) at Malibu, designed by the Los Angeles firm of Langdon & Wilson.

Bibliography

N. M. Venuti: *Descrizione delle prime scoperte dell'antica città d'Ercolano ritrovata vicino a Portici* (Rome, 1748); Eng. trans. as *A Description of the Discovery of the Ancient City of Heraclea* (London, 1750)

Le antichità di Ercolano esposte, Accademia Ercolanese di Archeologia, 8 vols (Naples, 1757–92)

C. Cameron: *The Baths of the Romans Explained and Illustrated* (London, 1772)

T. Martyn and J. Lettice: *Antiquities of Herculaneum* (London, 1773)

C. Percier and P.-F.-L. Fontaine: *Recueil de décorations intérieures* (Paris, 1801)

W. Gell and J. P. Gandy: *Pompeiana: The Topography, Edifices and Ornaments of Pompeii*, 2 vols (London, 1817–19)

R. Rosenblum: *Transformations in Late 18th-century Art* (Princeton, 1967)

M. Praz: *On Neoclassicism* (London, 1969)

M. Binney: 'Packington Hall, Warwickshire, III', *Country Life*, cxlviii (23 July 1970), pp. 226–9

E. Croft-Murray: *Decorative Painting in England*, ii (London, 1970), pp. 47–59

P. Werner: *Pompei und die Wanddekoration der Goethezeit* (Munich, 1970)

N. Dacros: *La Découverte de la Domus Aurea et la formation des grotesques à la Renaissance* (Leiden, 1971)

D. Fitzgerald: 'A Gallery after the Antique', *Connoisseur*, clxxxi (1972), pp. 2–13

R. Trevelyan: *The Shadow of Vesuvius: Pompeii, A.D. 79* (London, 1976)

Pompeii, A.D. 79 (exh. cat., ed. J. Ward-Perkins and A. Claridge; London, RA, 1977)

Pompeii as Source and Inspiration (exh. cat., ed. S. Panitz; Ann Arbor, U. MI, Mus. A., 1977)

D. Watkin: *Athenian Stuart: Pioneer of the Greek Revival* (London, 1982)

J. Wilton-Ely: 'Pompeian and Etruscan Tastes in the Neo-classical Country House Interior', *The Fashioning and Functioning of the British Country House*, ed. G. Jackson-Stops and others (Washington, DC, 1989), pp. 51–73

JOHN WILTON-ELY

Pont-Aven

French village on the Aven river in Brittany, 260 km west of Paris and 7 km north of the Bay of Biscay. Before the 20th century its protected tidal harbour made it a busy commercial port for the transport of flour, firewood and fish. Though it attracted artists from the 1860s onwards, it is most famous for the colony of artists that gathered there around Paul Gauguin in the late 1880s and early 1890s. According to Emile Bernard, the first artist to paint in Pont-Aven was the Dutchman Herman van den Anker (1832–83). His Salon paintings in the 1860s faithfully depict the costumes and customs of Breton peasants, whose clothes point precisely to Pont-Aven as their village of origin. In 1864 the American artist Robert Wylie (1839–77) settled in the village and, except for brief trips to Paris, remained there until his death. By 1866 a small group of American artists had

moved to Pont-Aven in the summer in search of picturesque Breton subjects. They were primarily former students of the Pennsylvania Academy of Fine Arts in Philadelphia who had spent the previous academic year painting in Paris. In 1876 there were at least 11 American artists in the village as well as several Frenchmen and van den Anker.

During the heyday of naturalism art connoisseurs in Paris were fascinated by Breton themes. Not only did Brittany offer rural scenes and regional costumes, but it also provided glimpses into a cultural past that was governed less by French culture than by a fascinating amalgam of Celtic, Druidic and medieval Christian folklore. Breton, the primary language spoken in Brittany until the 20th century, was unintelligible to French speakers, yet the province was French and an artist seeking exotic rural subjects could therefore be assured of some familiar French customs and comforts after his two-day carriage trip from Paris to Pont-Aven.

By the time Paul Gauguin arrived in Pont-Aven in July 1886, catering to artists had become a town business. Two hotels housed and fed most of the artists and local people willingly rented rooms and served as models. Special 'folk festivals' were arranged for the artists and the local paper proudly announced their Salon successes. Besides augmenting local incomes, the artists also brought the village fame. Other summer colonies for artists flourished simultaneously in other Breton villages such as nearby Concarneau and Dournanez, but from the 1860s until the turn of the century Pont-Aven's was always more international. Gauguin was painting in an Impressionist style when he arrived in Pont-Aven in 1886. Like his teacher, Camille Pissarro, he was interested in rustic subjects and the effect of light falling on trees and figures out of doors. Following the current trend of naturalism, Gauguin also studied Breton costumes and customs, trying in his paintings, drawings and ceramics to suggest the character and environment of his subjects.

Most of the artists in Pont-Aven during Gauguin's time in the village (1886, 1888–91 and

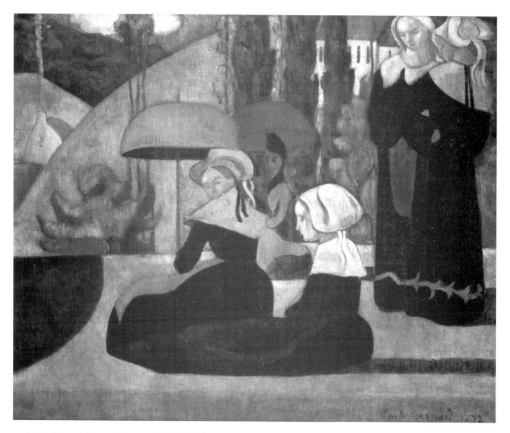

59. Emile Bernard: *Breton Women with Umbrellas*, 1892 (Paris, Musée d'Orsay)

1894) clung to more accepted academic traditions than he did. Sombre colours, attention to effects of light and careful detailing of costume and setting characterize most of the works, whether by French or foreign artists. The industrial and modern side of Pont-Aven was usually ignored: there are, for example, few paintings of flour mills, the busy harbour or the hotels. The artists preferred the more timeless and pastoral scenes of women going about their daily chores, festivals, children in traditional costumes or farmers and fishermen. Gauguin shared this selective approach to subject-matter (see fig. 61).

In early 1888 Gauguin returned to Pont-Aven and established himself once again at the Pension Gloanec, the smaller and simpler of the two hotels on the village's main square. Emile Bernard, 20 years his junior, arrived at the end of the summer, working in a style he called CLOISONNISM, using flat areas of colour outlined in dark blue. His formal ideas sparked a short period of intense collaboration with Gauguin, during which Cloisonnism developed quickly into what became known as SYNTHETISM. Bernard and Gauguin urged artists to incorporate three features into their work: nature, the artist's interpretation of his subject and abstract concepts of line, colour and form, resulting in paintings such as Gauguin's *Vision after the Sermon: Jacob Wrestling with the Angel* (1888; Edinburgh, N.G.; see col. pl. XXIX) and Bernard's *Breton Women with Umbrellas* (1892; Paris, Orsay; see fig. 59).

While Bernard soon went in other stylistic directions, Gauguin spent long periods in Pont-Aven and the nearby coastal village of Le Pouldu until his departure for Tahiti in 1891. In his Breton paintings of this period Gauguin's palette became progressively richer and his compositions more abstract.

Although a school never existed around Gauguin, both in Pont-Aven and Le Pouldu he attracted a fluctuating band of artists of many nationalities who were impressed with his ideas. Other artists, such as Paul Sérusier, moved back and forth between Brittany and Paris. After Gauguin left for Tahiti in 1891, his influence continued to affect the artistic development of such artists as Jacob Meyer de Haan and Jan Verkade (Dutch), Mogens Ballin (Danish), Wladyslaw Slewinski (Polish), Roderic O'Conor (Irish), Robert Bevan (English) and the Frenchmen Armand Seguin, Charles Filiger, Henry Moret (1856–1913), Henri-Ernest Ponthier de Chamaillard (1865–1930), Maxime Maufra, Gustave Loiseau and Emile Jourdan (1860–1931). This influence was further sustained by Gauguin's final visit to the village in 1894.

Some of Gauguin's followers, such as Jourdan, remained loyal to Pont-Aven throughout their careers; others came to the village in the summers of the 1890s. By the turn of the century, however, their numbers had dwindled as more artists sought wilder, more sparsely populated areas of Brittany. Nevertheless, Pont-Aven's reputation was so well established that artists continued to visit during the summer months. Paul Emile Colin (1867–1949) and Ernest Correlleau (1892–1936), for example, painted there early in the 20th century, as did Pierre Eugène Clairin (1897–1980) and Fernard Dauchot (1898–1982) just after World War II. With its scores of galleries, artists' studios, international art school and fine museum, the village continued to attract artists into the 1990s.

Bibliography

C. Chassé: *Gauguin et le groupe de Pont-Aven* (Paris, 1927)
Gauguin and the Pont-Aven Group (exh. cat., ed. D. Sutton; ACGB, 1966)
W. Jaworska: *Gauguin et l'école de Pont-Aven* (Paris and Neuchâtel, 1971; Eng. trans., London, 1972)
B. Quéinec: *Pont-Aven, 1800–1914* (Pont-Aven, 1983)
C. Boyle-Turner and S. Josefowitz: *The Prints of the Pont-Aven School: Gauguin and his Circle in Brittany* (Washington, DC, 1986)
D. Delouche, ed.: *Pont-Aven et ses peintres à propos d'un centenaire*, Arts de l'Ouest (Rennes, 1986)
1886–1986: Cent ans, Gauguin à Pont-Aven (exh. cat., ed. C. Puget; Pont-Aven, Mus. Pont-Aven, 1986)
C.-G. Le Paul and J. Le Paul: *Gauguin and the Impressionists at Pont-Aven* (New York, 1987)
Gauguin and the School of Pont-Aven (exh. cat by R. Pickvance, Sydney, A.G., NSW, 1994)
Le Cercle de Gauguin en Bretagne, 1894 (exh. cat., ed. C. Puget and C. Boyle-Turner; Pont-Aven, Mus. Pont-Aven, 1994)

CAROLINE BOYLE-TURNER

Post-Impressionism

Term applied to the reaction against IMPRESSIONISM led by Paul Cézanne, Paul Gauguin, Vincent van Gogh and Georges Seurat. It can be roughly dated from 1886, the year of the last Impressionist exhibition, to c. 1905, when Fauvism appeared and the first moves towards Cubism were made. While it was predominantly a French movement, there were related developments in other countries, which often occurred somewhat later. Post-Impressionism can be loosely defined as a rejection of the Impressionists' concern for the naturalistic depiction of light and colour in favour of an emphasis on abstract qualities or symbolic content. It therefore includes NEO-IMPRESSIONISM, SYMBOLISM, CLOISONNISM, SYNTHETISM and the later work of some Impressionists. The term was coined in 1910 by the English critic and painter Roger Fry for an exhibition of late 19th-century French painting, drawing and sculpture that he organized at the Grafton Galleries in London.

1. History and application of the term

After considering more substantive terms such as 'expressionism', Fry settled on 'Post-Impressionism' for the title of the exhibition at the Grafton Galleries in 1910–11, as this did no more than point out that the Post-Impressionists came after the Impressionists. From the beginning

he admitted that the label was not descriptive of a single style. The catalogue preface, written by Fry with Desmond MacCarthy, secretary to the gallery, but not signed by either, begins (1910–11 exh. cat., p. 7): The pictures collected together in the present exhibition are the work of a group of artists who cannot be defined by any single term. The term 'Synthetists', which has been applied to them by learned criticism, does indeed express a shared quality underlying their diversity; and it is the critical business of this introduction to expand the meaning of that word, which sounds too much like the hiss of an angry gander to be a happy appellation. For Fry and MacCarthy the only common denominator between the Post-Impressionist painters was their rejection of Impressionism (1910–11 exh. cat., p. 7): In no school does individual temperament count for more. In fact, it is the boast of those who believe in this school, that its methods enable the individuality of the artist to find completer self-expression in his work than is possible to those who have committed themselves to representing objects more literally ... the Post-Impressionists consider the Impressionists too naturalistic.

The full title of the exhibition was *Manet and the Post-Impressionists*, although Manet was represented by fewer works (nine) than the painters of the next generation. There were, for example, forty-six works by Gauguin, twenty-five by van Gogh and twenty-one by Cézanne. Other artists whose work was shown included Seurat (two works), Paul Sérusier (five), Maurice Denis (five), Félix Vallotton (four) and Odilon Redon (three). The Fauves were represented by Albert Marquet (five), Henri Manguin (four), Maurice de Vlaminck (eight) and André Derain (three). The two paintings by Matisse and the three by Picasso were supplemented by numerous drawings and sculptures by both. Fry felt that Manet had begun the rejection of the Impressionists' realistic goals and that Cézanne was Manet's heir. Gauguin and van Gogh concurred in their rejection of nature in favour of expressing emotion in their works. According to Fry, Cézanne most distinctly marked the transition away from naturalism. He 'aimed

first at a design which would produce the coherent, architectural effect of the masterpieces of primitive art' (1910–11 exh. cat., p. 10). Cézanne's goal was to move away from the 'complexity of the appearance of things to the geometrical simplicity which design demands' (1910–11 exh. cat., p. 10) (see col. pl. XXX). Fry viewed Gauguin as more of a theorist than a painter, claiming that his interest was 'the fundamental laws of abstract form' and 'the power which abstract form and colour can exercise over the imagination of the spectator' (1910–11 exh. cat., p. 11). Van Gogh was singled out for his Romantic temperament. Fry's initial definition of Post-Impressionism excluded Neo-Impressionism, even though he included two works by Seurat in the exhibition. Of the generation following Gauguin, Cézanne and van Gogh, only Matisse was mentioned in the catalogue preface. He was praised for the fact that his 'search for an abstract harmony of line, for rhythm, has been carried to lengths which often deprive the figure of all appearance of nature' (1910–11 exh. cat., p. 11).

In 1912 Fry organized a second Post-Impressionist exhibition at the Grafton Galleries. While he had concentrated the first solely on French artists, in the second he admitted that the movement had existed in England and Russia as well. He therefore included works by such English artists as Duncan Grant, Vanessa Bell, Stanley Spencer and Wyndham Lewis and by such Russian artists as Natal'ya Goncharova and Mikhail Larionov. He disparaged the Post-Impressionist painting in European countries outside France, England and Russia, writing: 'Post-Impressionist schools are flourishing, one might say raging in Switzerland, Austro-Hungary and most of Germany. But so far as I have discovered, they have not added any positive element to the general stock of ideas.' His introduction to the 'French Group' concentrated on Cézanne and ignored both van Gogh and Gauguin. There were, however, more works by Matisse and the Fauves than before. The development of Cubism was also highlighted by a large number of works by Picasso.

The one area of late 19th-century French art

that Fry left unexplored was Symbolism. Of its pioneers, Gustave Moreau (see fig. 81) and Pierre Puvis de Chavannes developed their style and aesthetic before Impressionism, while Odilon Redon (whose work was included in the 1910–11 exhibition) developed his contemporaneously with Impressionism. Symbolism exerted its most powerful influence on the artists of the generations immediately following the Impressionists. By its contribution to the redirection of art from the external to the internal world and by its rejection of the superficiality of Impressionism, Symbolism is characteristically Post-Impressionist. Though imprecise, the term 'Post-Impressionism' remains widely used: John Rewald used it as the title for his encyclopedic work, *Post Impressionism: From Van Gogh to Gauguin*, first published in 1956, although he limited his attention to French artists. The exhibition entitled *Post-Impressionism: Cross-Currents in European Painting*, held at the Royal Academy, London, in 1979–80, attempted to broaden the term to include works by a variety of such European artists as Carlo Carrà, Lovis Corinth, James Ensor, Erich Heckel, Fernand Hodler, Fernand Khnopff, Ernst Ludwig Kirchner, Edvard Munch, Emil Nolde, Giovanni Segantini, James McNeill Whistler and many others.

2. Development in France and elsewhere

Influenced by the Symbolist movement in literature, the French Post-Impressionists ignored the minutiae of natural scenes in favour of the more intangible areas of aesthetics or symbolic content. Deeper meanings, as well as the personal feelings of the artist, became valid subjects. Cézanne used colour to explore the spatial relationships between objects in nature, while at the same time studying the underlying forms of nature itself. His work shows one of the earliest reactions against Impressionism, as in *Zola's House at Médan* (c. 1880; Glasgow, Burrell Col.), where he used carefully brushed, diagonal paint strokes to lend structure to the composition. Van Gogh, on the other hand, allowed his brushstrokes and colour to express his almost pantheistic fascination with the energy that animates natural forms as well as individual people, as in *Starry Night* (1889; New

York, Met.) and *Roses and Anemones* (1890; Paris, Orsay; see fig. 60). Gauguin preferred to use colour and line in order to suggest the spiritual as well as physical environments of the places he painted, especially Brittany and Tahiti, as in *Peasant Women in a Breton Landscape* (1894; Paris, Orsay; see fig. 61) and *Nevermore* (1897; U. London, Courtauld Inst. Gals). Seurat, the chief theorist and practitioner of Neo-Impressionism, produced harmonious, static paintings by adopting a meticulous, scientific approach to colour and composition, as in *The Bathers at Asnières* (1883; London, N.G.; see col. pl. XXV).

In the work of all these artists, the abstract concerns of harmony and the two-dimensional arrangement of forms took precedence over naturalism. Many French artists were soon influenced by these innovations, particularly by those of Gauguin and Seurat. A group of painters, including Paul Sérusier, Emile Bernard and others, gathered around Gauguin at Pont-Aven in Brittany, while Seurat's divisionist technique was taken up by such artists as Henri Edmond Cross, Maximilien Luce and Paul Signac. Some of the original Impressionist artists, including Renoir, themselves moved away from their earlier aesthetic in an attempt to introduce a greater structure to their work, as shown in Renoir's painting *La Roche-Guyon* (c. 1885; Aberdeen, A.G.), executed in meticulous brushstrokes like those used by Cézanne. Monet, on the other hand, loosened his compositions and colour schemes in order to become more subjective in his interpretation of nature.

In France the political and cultural anarchy of the 1880s and 1890s encouraged artists to reject the stylistic norms of the past. In other European countries different aesthetics and political environments spawned varying responses to this artistic freedom. In Germany the lack of a strong Impressionist tradition, as well as of any single artistic centre, diluted the impact of Post-Impressionism. The Norwegian Edvard Munch caused a stir in Berlin in 1892 with such starkly expressionistic works as *Sick Child* (1885–6; Oslo, N.G.) and created a following in avant-garde circles. The predominant artistic style among avant-garde painters nonetheless remained

Naturalism, as in the works of such painters as Hans Reinhard von Marées and Lovis Corinth. A few painters, such as the Swiss artists Arnold Böcklin and Ferdinand Hodler, who worked mainly in Germany, moved from Naturalism to Symbolism, as shown by Hodler's *Eurhythmy* (1895; Berne, Kstmus.). The critic Julius Meier-Graefe was largely responsible for bringing the works of van Gogh, Gauguin and the other French Post-Impressionists to the attention of the German public. Visits between France and Germany by such artists as Paula Modersohn-Becker, Alexei Jawlenski, Maurice Denis, Jan Verkade and Paul Sérusier further helped to establish an awareness of Post-Impressionist work in the next generation of German painters, the Expressionists.

In 1883, when Octave Maus and 20 disgruntled artists established Les XX in Belgium, they opened their annual exhibition to French Post-Impressionist artists. Redon, Seurat, Signac, Gauguin, Bernard, Denis and van Gogh were among those represented in exhibitions between 1886 and 1893. These close contacts between French and Belgian artists quickly led such painters as Théo Van Rysselberghe, James Ensor and Fernand Khnopff to adopt French ideas: Neo-Impressionism and Symbolism dominated avant-garde Belgian artists from the 1890s until the beginning of the 20th century (see fig. 82. The British were less interested in the politics of the French Post-Impressionists but were more open to the intellectual approach to art offered by Cézanne. Impressionism, filtered through the more naturalistic work of Jules Bastien-Lepage, remained the predominant style in Britain until the 1890s. Fascination with the work of Whistler in London led some artists, including Walter Richard Sickert and George Moore, to an interest in the work of Degas. Moreover, the large number of British art students in Paris helped to transmit Post-Impressionist ideas back to London, as did the fact that such artists as Roderic O'Conor and Robert Bevan spent time in Pont-Aven, absorbing the ideas of Gauguin and his circle. However, the greatest influence of Post-Impressionism came in the first two decades of the 20th century in the work of such artists as Grant and Bell and certain

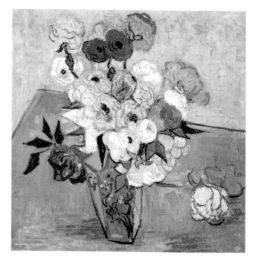

60. Vincent van Gogh: *Roses and Anemones*, 1890 (Paris, Musée d'Orsay)

members of the Camden Town Group, especially in the wake of Fry's two exhibitions.

The anarchist or socialist beliefs of many French Neo-Impressionists particularly attracted Dutch and Italian artists to their political as well as artistic causes. In the Netherlands the Impressionist landscape and light of the Hague school set the standard for most Dutch artists in the late 19th century. However, Jan Toorop's exposure to Neo-Impressionist and Symbolist ideas, when he studied in Brussels (1882–5) and became a founder-member of Les XX, led to his efforts to introduce these new art forms to his native country, as did Johan Thorn Prikker soon afterwards. The proximity of Brussels led many Dutch artists to visit the annual exhibitions of Les XX, so furthering awareness of French Post-Impressionism. These new ideas, however, were often subordinated to the Dutch passion for order and carefully defined spaces, as seen in the early works of Piet Mondrian. In Italy the divisionist techniques of the Neo-Impressionists were influential on the work of many artists in the early years of the 20th century, most notably on the work of those artists who later became Futurists, such as Giacomo Balla, Umberto Boccioni, Carlo Carrà and

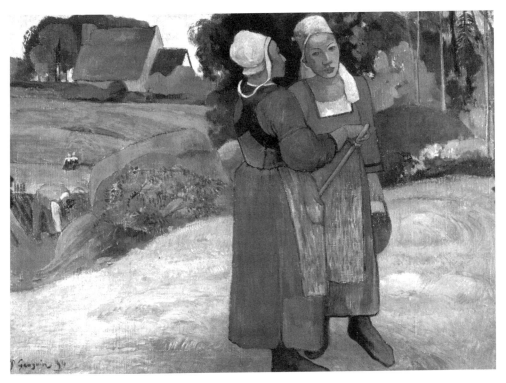

61. Paul Gauguin: *Peasant Women in a Breton Landscape*, 1894 (Paris, Musée d'Orsay)

Gino Severini. In Scandinavia, Russia and North America, Impressionism and Naturalism continued to dominate the art world until well after 1900. In these areas, as in other countries, Post-Impressionism was never considered a 'movement' in art. The French Post-Impressionists nevertheless later influenced many artists who were trying in various ways to move beyond the realistic concerns of the Impressionists. Thus the synthetism of Gauguin, the geometry of Cézanne, the expressionism of van Gogh and the divisionism of Seurat found followers throughout the world.

Bibliography

Manet and the Post-Impressionists (exh. cat. by R. Fry and D. MacCarthy, London, Grafton Gals, 1910–11)

The Second Post-Impressionist Exhibition (exh. cat. by R. Fry, London, Grafton Gals, 1912)

J. Rewald: *Post-Impressionism: From Van Gogh to Gauguin* (New York, 1956, rev. 3/1978)

F. Elgar: *The Post-Impressionists* (Oxford, 1977)

Post-Impressionism: Cross-currents in European Painting (exh. cat., ed. J. House and M. A. Stevens; London, RA, 1979–80)

B. Thomson: *The Post-Impressionists* (Oxford and New York, 1983, rev. 2/1990)

J. Rewald: *Studies in Post-Impressionism* (London, 1986)

CAROLINE BOYLE-TURNER

Poussinisme

Term used to describe one of the two groups of artists and connoisseurs in 17th-century France who were in opposition over the so-called Querelle du coloris, which was debated primarily from 1672 to 1678 (*see also* RUBÉNISME). The Poussinistes took the work of the mature period of Nicolas Poussin as their model (see fig. 62), together with that of Raphael (see col. pl. XXXIII) and the example of Classical sculpture, and concentrated on certain

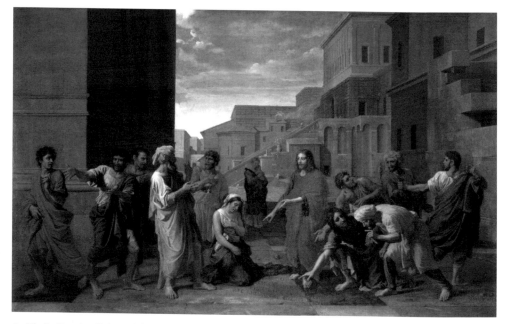

62. Nicolas Poussin: *Christ and the Adultress* (Paris, Musée du Louvre)

principles: the importance of the idea as expressed through *dessein* (Old Fr.: both the intellectual and manual aspects of drawing); decorum, the historical reconstruction of the subject; and the expression of the 'passions' of the soul (reactions to a given event). One of the first consequences of this trend of thought was the establishment of a hierarchy of genres, in which historical subjects (see fig. 69) were considered to be of most importance, followed by portraits, landscapes and still-lifes. Thus, Louis XIV's requirements for the decoration of his palaces were perfectly accommodated by these categories.

The principal supporters of Poussinisme were Charles Le brun and his pupils François Verdier and René-Antoine Houasse, as well as Philippe de Champaigne and his nephew Jean-Baptiste de Champaigne, Sébastien Bourdon, Noël Coypel and Antoine Bouzonnet-Stella (1637–82). As far as form was concerned, Poussin's most faithful follower was undoubtedly Nicolas Colombel. About the time of Poussin's death, the doctrine of

Poussinisme developed in Paris at the Académie Royale de Peinture et de Sculpture under the direction of Le Brun and with the help of one of the Académie's lecturers, André Félibien. Jean-Baptiste Colbert had considered giving Poussin the post of Director of the Académie de France in Rome, but in 1666 it was given to Charles Errard the younger. In 1667 the first *conférences* (lectures) read at the Académie Royale were published from Félibien's transcriptions. At the same time, Félibien was writing *Entretiens sur les vies et les ouvrages des plus excellens peintres anciens et modernes* (10 vols, Paris, 1666–88), the culmination of which was his discussion of the life of Poussin (taking up the whole of the 8th *Entretien*, published in 1685). In 1671 the dispute was raised during the course of one of the *conférences* given by Philippe de Champaigne; an objection by Gabriel Blanchard was taken up and enlarged upon by Roger de Piles.

The precedent already set in the Renaissance period by the Roman and Florentine schools, which emphasized *disegno* as opposed to the Venetian

school, which preferred *colore*—that is, the distinction between Raphael or Michelangelo on the one hand and Titian on the other—suggests a certain similarity of context: in 17th-century France, as had been done in 15th- and 16th-century Italy, artists were attempting to lay claim to a degree of social standing and were highlighting the intellectual aspect of their activity, particularly the phase of the conception of a work of art known as the *disegno/dessein*. The artistic independence that Poussin symbolized around 1660 led to his being taken as an example in France, particularly by those teaching at the Académie, without necessarily taking into account the deeper meaning of his art. In this respect, the doctrine of Poussinisme succeeded in solidly establishing the social status of painters and sculptors (and, generally speaking, of all of the arts involving drawing and line), as well as that of the Académie until the time of the French Revolution. Even Antoine Coypel, a Rubéniste, did not dispute its influence at the Académie when he became Director in 1714.

Bibliography

J. Thuillier: 'Pour un "Corpus Pussinianum"', *Colloque Poussin: Paris, 1958*, ii, pp. 151–4, 167–76
——: 'Doctrines et querelles artistiques en France au XVIIe siècle: Quelques textes oubliés ou inédits', *Archvs A. Fr., xxiii (1968)*, pp. 125–217

<div align="right">SYLVAIN KERSPERN</div>

Pre-Raphaelitism

Style originated by the Pre-Raphaelite Brotherhood (PRB), a group of English artists active between 1848 and 1853. Initially characterized by intense colour, tight handling and predominantly medieval subject-matter, during the later 19th century the style became broader and more muted in colour through the work of the Brotherhood's followers.

1. The Pre-Raphaelite Brotherhood

The group was founded in September 1848 by its three principal members, all students at the Royal Academy in London, William Holman Hunt, John Everett Millais and Dante Gabriel Rossetti; they soon brought in their friends James Collinson, F. G. Stephens and Thomas Woolner and Dante Gabriel's brother, William Michael Rossetti. These seven were motivated more by the impatient idealism of youth than by any clear programme; they aimed to restore to British art the freshness and conviction that they found in early Italian painting before the era of Raphael, hence their title 'Pre-Raphaelite' (a term of abuse, since at that time the early Italians were generally regarded as primitive).

The first paintings bearing the secret initials 'PRB' were exhibited in 1849: Rossetti's *Girlhood of Mary Virgin* (1848–9; London, Tate), Hunt's *Rienzi* (1848–9; priv. col., see 1984 exh. cat., p. 67) and Millais's *Isabella* (1849). In 1850 the Brotherhood published a journal, *The Germ*, which ran for four issues. That year the meaning of the initials was revealed, and the PRB paintings shown at the Royal Academy, in particular Millais's *Christ in the Carpenter's Shop* (1849–50; London, Tate; see fig. 63), were savagely criticized for alleged crudity of design and Romish tendencies. In 1851 John Ruskin sprang to the defence of the movement; other early supporters included the collectors Thomas Combe, B. G. Windus, Thomas Plint and subsequently Thomas Fairbairn. In 1852 the PRB exhibits were better received, but whatever coherence the Brotherhood had possessed was disappearing as the artists went their separate ways. Collinson had resigned in May 1850 and W. H. Deverell was proposed for membership instead, though never elected. Rossetti ceased to exhibit in public after 1852, and in July of that year Woolner emigrated to Australia. Millais became an ARA in 1853 and gradually abandoned the laborious techniques associated with Pre-Raphaelitism. In 1854 Hunt left for Palestine. He remained dedicated to the intensity of the Pre-Raphaelite vision, but sought to describe it on a larger scale and in a broader technique. However, by the mid-1850s others had taken up the new style, including John Brett, Arthur Hughes, J. W. Inchbold, William Bell Scott (e.g. *Iron and Coal*, 1861), Thomas Seddon and Henry Wallis; and in Liverpool, where Pre-Raphaelite paintings had been favoured at the Liverpool Academy, a local

63. John Everett Millais: *Christ in the Carpenter's Shop*, 1849–50 (London, Tate Gallery)

school emerged, including W. L. Windus and William Davis.

The early work of the PRB was anticipated by a slightly older associate, Ford Madox Brown, who adopted clear modelling and bright colour in the mid-1840s in such works as the *Seeds and Fruits of English Poetry* (1845–51; Oxford, Ashmolean). In the first few years of the Brotherhood, the leading painters worked closely together, sharing a developing visual language. The work of 1848–50 was deliberately angular, with simple, almost shadowless, modelling and stark clarity of gesture based on their study of engravings after early Italian murals, and original early Netherlandish paintings in the National Gallery, London. In the early 1850s the style became more naturalistic, employing brilliant colours painted on a wet, white ground with a painstakingly minute touch, giving a dazzling effect of sharp all-over focus.

The Pre-Raphaelites made a particularly innovative contribution to landscape painting, working out of doors to capture precise light effects with glowing colour, and delighting in such subjects as tangles of ivy and carpets of flowers and grasses, depicted with botanical accuracy (e.g. Millais's *Ferdinand Lured by Ariel*, 1849–50; priv. col., see 1984 exh. cat., p. 75). In their religious subjects the artists sought to create new images to replace the traditional iconographic types, reviving the language of symbolism and typology, as in Rossetti's *Ecce Ancilla Domini!* (1849–50; London, Tate; see col. pl. XXXI). Their historical and literary subjects breathed vivid new life into an outworn mode and often reflected the artists' passionate interest in their literary heroes, particularly Keats and Shakespeare (e.g. Millais's *Ophelia*, 1851–2; London, Tate; see also figs 1 and 85). They also painted topical modern-life subjects, often with a social or moral dimension and highly charged with emotion (e.g. Hunt's *Awakening Conscience*, 1853–4; London, Tate). Throughout this apparent diversity, there ran a consistent seriousness of purpose, a desire to see things with fresh eyes and an intensity of expression, which was their greatest contribution to British art, one that was a perpetual challenge to academic good manners.

2. The second generation

The second phase of the Pre-Raphaelite movement began in the late 1850s when a new circle of younger artists formed around Rossetti. William Morris and Edward Burne-Jones had discovered the work of the PRB while Oxford undergraduates and met Rossetti in 1856. He asked them to take part in his technically disastrous scheme to paint an Arthurian fresco cycle at the Oxford Union, with Arthur Hughes, Val Prinsep, J. R. Spencer Stanhope and J. H. Pollen (1820–1902). Other members of the circle were Madox Brown, Frederick Sandys, Simeon Solomon and G. P. Boyce. The fanciful medievalism of the late 1850s was gradually superseded by a broader, more decorative style, muted in colour and owing much to Italian Renaissance and Mannerist sources, and appealing to such patrons of later Pre-Raphaelitism as F. R. Leyland and William Graham. Many of the artists made imaginative, forceful black-and-white drawings for wood-engravings in what became known as the 'Sixties style' of illustration. Pre-Raphaelitism also became increasingly concerned with the decorative arts with the foundation in 1861 of Morris, Marshall, Faulkner & Co. (later Morris & Co.), which involved the artists in wallpaper, textile, furniture, stained glass and book design (see col. pl. IV). Through the poetry of Rossetti and Morris, the movement also made an important contribution to English literature.

In the fine arts, as Rossetti's work became more repetitive, Burne-Jones emerged as the leader of late Pre-Raphaelitism. His imaginative range and depth was never matched by his followers, who included Walter Crane, Evelyn De Morgan, T. M. Rooke (1842–1942) and J. M. Strudwick (1849–1937). The opening of the Grosvenor Gallery in 1877 provided an alternative forum to the Academy for late Pre-Raphaelitism, which, though allied to Whistler's pure Aestheticism in its concern with design and pattern, frequently used symbolism and myth and never abandoned content. Its cultivation of poetic suggestiveness and mysterious otherworldly beauty was quite the reverse of the factually descriptive, brightly coloured, hard-edged style of the early 1850s.

3. Influence and historiography

By the 1890s superficial imitations of the later Pre-Raphaelite style by artists such as J. W. Waterhouse and Frank Dicksee were common at the Royal Academy. The early Pre-Raphaelite style was reinterpreted by a group of painters mostly associated with the Birmingham School of Art and the Tempera Society, among them Joseph Southall (1861–1944), Henry Payne (1868–1940), Charles Gere (1869–1957) and John Byam Shaw. Art Nouveau book illustrators such as Aubrey Beardsley were indebted to the work of Burne-Jones (see fig. 4). There are also echoes of Pre-Raphaelitism later in the work of Paul Nash, Stanley Spencer, Maxwell Armfield (1881–1972), Thomas Monnington (1902–76) and the Brotherhood of Ruralists (whose membership included Peter Blake).

In America Pre-Raphaelite paintings were shown in 1857 in New York, Boston and Philadelphia, and Ruskin's ideas were promoted by W. J. Stillman through his magazine, *The Crayon* (1855–61), and by T. C. Farrer (1839–91). The *New Path* (1863–5), published initially by the Society for the Advancement of Truth in Art, subsequently promoted a similar message. Pre-Raphaelite influence was limited to the Ruskinian landscapes and botanical studies of the 1860s and 1870s by a small group of artists led by Farrer and including William Trost Richards, Charles Moore (1840–1930) and J. W. Hill. In Europe the Pre-Raphaelites were more widely influential. Pictures by Hunt and Millais shown at the Exposition Universelle of 1855 in Paris impressed Delacroix; Brown and Crane were invited to show in Brussels with Les XX in the 1880s and 1890s, and Burne-Jones exhibited in Paris, Munich, Dresden and Vienna. The Pre-Raphaelite influence on European Symbolism is seen in the work of Gustave Moreau (see fig. 81), Pierre Puvis de Chavannes, the painters of the Salons de la Rose + Croix, Hans von Marées, Ferdinand Khnopff (see fig. 82) and Jan Tooroop. Even more widespread in Britain, Europe and America was the influence of Morris & Co., forerunner of a host of guilds and societies of artist-craftsmen, which made up the Arts and Crafts movement and, through such organizations as the Vienna Secession and the Bauhaus, deci-

sively affected the course of 20th-century architecture and design.

In the late Victorian and Edwardian era the Pre-Raphaelites were at the height of their fame: their work was widely shown, and memoirs and monographs of the chief figures of the movement were published. After World War I their work fell from favour, and the flame was kept alive only by a few enthusiasts such as Evelyn Waugh, who published books on Rossetti and on the Pre-Raphaelites in the 1920s, and by the families of the artists who supported the centenary exhibitions of Burne-Jones at the Tate Gallery (1933) and Morris at the Victoria and Albert Museum (1934) in the face of public indifference. In 1948 the centenary of the PRB was marked by several exhibitions, and Ironside and Gere published the first serious modern book on the subject. Nevertheless, Pre-Raphaelite paintings were still regarded as eccentric or literary until the 1960s, when interest was revived by a few dealers, by Fredeman's bibliographical work and above all by Mary Bennett's series of exhibitions on Brown, Millais and Hunt, which was the basis for the work of younger scholars culminating in the 1984 Tate Gallery exhibition.

Bibliography

The Germ, 4 issues (1850); rev. in book form as *The Germ: Thoughts toward Nature in Poetry, Literature and Art* (Oxford, 1979)

W. M. Rossetti, ed.: *Ruskin: Rossetti: Preraphaelitism: Papers, 1854 to 1862* (London, 1899)

——: *Preraphaelite Diaries and Letters* (London, 1900)

W. H. Hunt: *Pre-Raphaelitism and the Pre-Raphaelite Brotherhood*, 2 vols (London, 1905, rev. 2/1913)

R. Ironside and J. Gere: *Pre-Raphaelite Painters* (London, 1948)

W. E. Fredeman: *Pre-Raphaelitism: A Bibliocritical Study* (Cambridge, MA, 1965)

J. D. Hunt: *The Pre-Raphaelite Imagination, 1848–1900* (London, 1968)

T. Hilton: *The Pre-Raphaelites* (London, 1970)

A. Staley: *The Pre-Raphaelite Landscape* (Oxford, 1973)

J. Christian: *The Pre-Raphaelites in Oxford* (Oxford, 1974)

Pre-Raphaelite Paintings, Manchester, C.A.G. cat. (Manchester, 1974)

W. E. Fredeman, ed.: *The Pre-Raphaelite Journal* (Oxford, 1975)

A. I. Grieve: *1. 'Found' 2. The Pre-Raphaelite Modern-life Subject* (1976), ii of *The Art of Dante Gabriel Rossetti* (Hingham, Norfolk, and Norwich, 1973–8)

The Pre-Raphaelite Review (1977–80); cont. as *Journal of Pre-Raphaelite Studies* (1980–87) and *Journal of Pre-Raphaelite and Aesthetic Studies* (1987–)

J. Treuherz: *Pre-Raphaelite Paintings from the Manchester City Art Gallery* (Manchester, 1980)

L. Parris, ed.: *Pre-Raphaelite Papers* (London, 1984)

The Pre-Raphaelites (exh. cat., ed. L. Parris; London, Tate, 1984)

The New Path: Ruskin and the American Pre-Raphaelites (exh. cat. by L. S. Ferber and W. H. Gerdts, New York, Brooklyn Mus., 1985)

M. Bennett: *Artists of the Pre-Raphaelite Circle: The First Generation: Catalogue of Works in the Walker Art Gallery, Lady Lever Art Gallery and Sudley Art Gallery* (London, 1988)

The Last Romantics (exh. cat., ed. J. Christian; London, Barbican, A.G., 1989)

B. Read and J. Barnes, eds: *Pre-Raphaelite Sculpture: Nature and Imagination in British Sculpture* (London, 1992)

Pre-Raphaelite Drawings in the British Museum (exh. cat. by J. A. Gere, London, BM, 1994)

JULIAN TREUHERZ

Pre-Rembrandtists

Term given to a group of history painters active in Amsterdam in the early 17th century. Though considered the forerunners of Rembrandt, some of them actually worked at the same time as the famous artist. Their most important representatives were Pieter Lastman (Rembrandt's teacher), Claes Moeyaert, the brothers Jan Pynas and Jacob Pynas, Jan Tengnagel and François Venant (1591/2–1636). Their significance was first recognized in the 1930s, but scholars have only recently agreed that this group exerted an immense influence on Rembrandt and his pupils. Their works show a homogeneous and distinctive style, although each member of the group developed a personal style by which he could be distinguished from the rest. Lastman and Moeyaert were the most productive; fewer paintings and drawings by Jan and Jacob Pynas have survived, and still fewer by Tengnagel and Venant. All are mentioned in a panegyric of 1618 on Amsterdam by Theodoor

Rodenburgh, but their importance and influence on history painting in the 17th century were very varied. Although Moeyaert was the first to secure a place in the cultural life of Amsterdam, from the standpoint of art history, Lastman was by far the most significant Pre-Rembrandtist.

The works of the Pre-Rembrandtists resemble each other superficially in both subject-matter and technique. The early work of all of them is distinguished by the influence of Venetian and Roman painting and, above all, by that of Elsheimer; in some cases these influences continued to operate into the artist's middle or even late period. With the exception of Moeyaert, who executed some portraits, the Pre-Rembrandtists painted almost exclusively histories. In the work of Lastman, biblical themes predominated, particularly those from the Old Testament. He especially favoured conversation scenes, meetings between people or scenes of miracles. He was followed in this choice of subjects by Moeyaert, the Pynas brothers and Venant. Tengnagel was fond of mythological scenes and also painted scenes from ancient history as well as biblical themes. Many of these subjects had previously been treated only in graphic arts, and it was Lastman who was the first to transfer them to the higher category of painting. His composition and narrative style also influenced his colleagues. He employed a rich language of gesture and had a liking for iconographic precision and an ornamental treatment of motifs and landscape. In their efforts to emulate Lastman, Moeyaert and Jacob Pynas produced overloaded compositions, whereas Jan Pynas limited his compositions to the main figures. Venant inclined towards calm compositions, in contrast to Tengnagel, who exaggerated Lastman's gestures to theatrical heights, so that his figures sometimes seem to be dancing. Lastman's influence extended far beyond Rembrandt to the Rembrandt school. That a famous but artistically second-rate artist such as Lastman should exert an influence over three generations is an unusual phenomenon in European art.

Bibliography

The Pre-Rembrandtists (exh. cat., ed. A. Tümpel; Sacramento, CA, Crocker A. Mus., 1974)

A. Tümpel: 'Claes Cornelisz. Moeyaert', *Oud-Holland*, lxxxviii (1974), pp. 1–163, 245–90

ASTRID TÜMPEL

Primitifs [Barbus; Méditateurs; Penseurs], Les

Group of French artists formed in 1797. From the studio of Jacques-Louis David, they were united in their quest for ideal beauty and rejected all but the simplest styles in art. Membership of the group fluctuated during its brief existence. Formed in reaction to David's painting, The *Intervention of the Sabine Women* (completed 1799; Paris, Louvre), it was no longer a coherent entity after 1803. The spiritual leader of the group was Pierre-Maurice Quay (c. 1779–1802/4); other leading figures were Jean-Pierre Franque, his brother Joseph-Boniface Franque (1774–1833) and wife Lucile Messageot (1780–1802), Jean Broc and Antoine-Hilaire-Henri Périé (1780–1833). Prominent sympathizers included Paul Duqueylar (1771–1845), Jacques-Nicolas Paillot de Montabert and the Italian sculptor Lorenzo Bartolini; the writers Jean-Antoine 'Auguste' Gleizes (1773–1843) and Charles Nodier (1780–1844) were also closely involved.

In keeping with the contemporary enthusiasm for antiquity, David was seeking in the *Sabine Women* to achieve a Greek purity by avoiding excessive anatomical realism and illusionistic devices. However, this did not go far enough to satisfy Les Primitifs, who declared the painting to be lacking in simplicity, grandeur and primitiveness, further denouncing their master as 'Vanloo, Pompadour, Rococo'. Quay, known within the group as 'Agamemnon', was a charismatic figure. Influenced, it may be assumed, by the works of Johann Joachim Winckelmann and Jean-Jacques Rousseau and by the ideas of the French Revolution, he attempted to reform the corrupt state of contemporary art by returning to fundamentals. He believed that the artist should seek inspiration only in the most archaic vases and sculptures, and he viewed all art executed after the age of Pheidias as mannered, false and theatrical. Les Primitifs wanted to purge art: they considered academic technique mere facility and

denounced the use of colour and chiaroscuro for effect as ignoble. Clarity of design was prized above all else, and models were found in early Greek works (already popularized by John Flaxman) and Italian 15th-century artists such as Perugino. From 1801, having left David's circle, the sect withdrew to a disused convent in the isolated Parisian suburb of Chaillot, where they took part in esoteric rituals, wore ancient Greek dress and practised vegetarianism.

The work of Les Primitifs is difficult to assess as little was produced at the time of their association. No surviving work has been certainly attributed to Quay although Delécluze described him preparing his palette before a huge drawn-in picture of *Patroclus Returning Briseis to Agamemnon*. The first of the group's few pictures to feature in an official exhibition were Broc's *School of Apelles* (1800; Paris, Louvre) and Duqueylar's *Ossian Chanting his Poems* (Aix-en-Provence, Mus. Granet), both shown at the Salon of 1800. Their relatively strong colours imply that these two artists at least were aiming more for clarity of composition than for linearity.

A number of their fellow students, and perhaps David himself, were influenced by the ideas of Les Primitifs. François Gérard's *Psyche Receiving Cupid's First Kiss* (1798; Paris, Louvre; see fig. 64) with its simplified range of colours, large nude figures and lack of shadow is an example, as is Ingres's *Venus Wounded by Diomedes* (*c.* 1804–6; Basle, Kstmus.), with its frieze-like arrangement of figures, archaic handling of space and use of gilding. There are similarities between Les Primitifs and the Lukasbrüder: both groups rejected an increasingly rationalist world and the equation of art with the naturalistic recording of visual experience. In setting themselves apart from society, Les Primitifs were precursors of the alienated 19th-century artist, while their devotion to the archaic and unconventional in art found an early 20th-century parallel in the primitivism of Picasso and the Modernist avant-garde.

64. François Gérard: *Psyche Receiving Cupid's First Kiss*, 1798 (Paris, Musée du Louvre)

W. Friedländer: 'Eine Sekte der "Primitiven" um 1800 in Frankreich und die Wandlung des Klassizismus bei Ingres', *Kst & Kstler*, xxviii (1930), pp. 281–6, 320–26

J. H. Rubin: 'New Documents on the Méditateurs: Baron Gérard, Mantegna and French Romanticism circa 1800', *Burl. Mag.*, cxvii (1975), pp. 785–90

R. Rosenblum: *The International Style of 1800: A Study in Linear Abstraction* (New York and London, 1976), pp. 135–84

G. Levitine: *The Dawn of Bohemianism: The 'Barbu' Rebellion and Primitivism in Neo-classical France* (University Park, PA, and London, 1978)

PAUL SPENCER-LONGHURST

Bibliography

E.-J. Delécluze: *Louis David: Son école et son temps, souvenirs* (Paris, 1855/R Paris, 1983)

Purismo

Italian movement, *c.* 1820–60. The coinage was originally applied to an 18th-century literary movement aimed at the preservation of linguistic purity through the study and imitation of the great 14th-century Italian writers. The term was first applied in the visual arts in 1833 by Antonio

Bianchini. Bianchini characterized the attitude of artists who rejected Neo-classicism and advocated a return to the spiritual values, expressivity and 'primitive' idiom of Italian 14th- and 15th-century painters, particularly Giotto, Fra Angelico and the early Raphael.

Bianchini was the pupil of the Roman painter Tommaso Minardi, and the epithet applied to his master's established practice and teaching, which in its turn had been inspired by the German Nazarenes. Paintings such as the *Apparition of the Virgin* (1825; Rome, S Andrea al Quirinale) mark out Minardi as the leading Roman practitioner of Purismo. In 1842–3 Bianchini codified the principles of the movement in *Del purismo nelle arti*, a manifesto co-signed by Minardi, Friedrich Overbeck and Pietro Tenerani. The Puristi favoured religious and mystic subjects conveyed in a precise and strongly linear style. The movement had a different tenor in Florence, where 15th-century naturalism and colouring were combined with a rigorous approach to drawing derived from Ingres. Here the main exponents were the sculptor Lorenzo Bartolini, a friend of Ingres, and the painter Luigi Mussini, who had met Minardi and the Nazarenes in Rome between 1840 and 1844. In 1844 Mussini opened a school (1844–8) with Franz Adolph von Stürler (1802–81), a pupil of Ingres, and he was later employed at the Accademia di Belle Arti in Siena; his expounding of Purismo was highly influential. Mussini's most important painting, *Sacred Music* (1841; Florence, Pitti), was praised by the Paduan academician Pietro Selvatico who disseminated Purismo in Venice through his book *Del purismo* (Venice, 1851). Purismo's reliance on an indigenous artistic tradition for inspiration was in tune with the contemporary ideals of the struggle for Italian national unity.

Bibliography

L. Mussini: *Scritti d'arte* (Florence, 1880)
I. Faldi: 'Il purismo e Tommaso Minardi', *Commentari*, i (1950), pp. 238–46
P. Barocchi: *Testimonianze e polemiche figurative in Italia: L'ottocento dal bello ideale al preraffaellismo* (Florence, 1972)

EFREM GISELLA CALINGAERT

Queen Anne Revival [Free Classic style]

Architectural style popular from the 1870s until the early 20th century in England and the USA. Developing in reaction to the dogma of Gothic Revival, the style borrowed freely from the domestic architecture of the late 17th century and Queen Anne periods in England and the Netherlands. The style is characterized by asymmetrical plans, use of red brick and a combination of medieval and Classical motifs, such as oriel windows and Flemish gables together with pilasters and broken pediments. It was allied to progressive social attitudes and a desire to make good design available to all. The decorative arts were of great importance to the style, and domestic fittings contributed substantially to the desired aesthetic effect. In England the style ended in the hands of speculative builders and in the USA it merged into the Shingle style and the vernacular.

1. Origins and development in England

William Morris's Red House (1858), Bexleyheath, London, designed by Philip Webb, started a creative free adaptation of the domestic architecture of the reign of Queen Anne, which in turn had been influenced by 17th-century Dutch architecture. W. E. Nesfield's Lodge (1866) at Kew Gardens, Richmond, London, best exemplifies the early Queen Anne Revival, built of red brick with white casement windows. It retains much of the symmetry of Dutch models such as Kew Palace, built in 1632 for a merchant of Dutch descent and situated near by, also within Kew Gardens. The tall, decorated chimney stack, low walls and steep roof give the Lodge a vertical appearance. The style soon became asymmetrical, more agitated and vertical in fenestration as well as in silhouette.

Queen Anne Revival became associated with progress and enlightenment by being used in educational projects. The Elementary Education Act of 1870 resulted in the construction of thousands of new schools, known as Board Schools, and Queen Anne Revival was widely adopted for them. The schools were characterized by Flemish gables, ribbed chimney stacks and large windows and were sometimes decorated by pilaster strips or panels of brick or terracotta. The style was

flexibly interpreted, often using cramped sites. Board School architects included J. J. Stevenson, who also used Queen Anne Revival for his domestic commissions, E. R. Robson, who was responsible for the Bonner Street School (1875), Hackney, London, and Basil Champneys, who designed the Eel Brook Common School (1872), Harwood Road, Fulham, London. Champneys also designed the Butler Museum (1884–6) for the public school Harrow; it has a double-ridged roof ending in Flemish gables that contain oriel windows and, at one corner, an open-arcaded staircase. Also in Queen Anne Revival style are Champneys's buildings for Newnham College (1878–94), Cambridge, one of the earliest university colleges for women. The college buildings, with their bay and oriel windows, elaborate gables and broken pediments, were informally laid out. Newnham is one of the masterpieces of the fully evolved Queen Anne Revival, with buildings of great charm and lightness.

The style was also used for office and public buildings. New Zealand Chambers (1871–3; destr. World War II), Leadenhall Street, London, was designed by R. Norman Shaw and modelled on Sparrowe's House, a 17th-century house in Ipswich, Suffolk. Shaw adapted the oriel windows with their central arched lights and the ornate pargetting of his model for his controversial and influential office building. New Scotland Yard (1887–90; extension designed 1898–9, built 1906), the former headquarters of the Metropolitan Police (now Norman Shaw North and Norman Shaw South Buildings), provided a lively alternative to Gothic Revival. New Scotland Yard was built with granite below red brick with bands of Portland stone.

The greatest contribution of Queen Anne Revival was to domestic architecture. The style was established with commissions such as Nesfield's Kinmel Park (1868), Clwyd, and two houses by Shaw, Cragside (1868–82), Rothbury, Northumb., and Lowther Lodge (1871, now the Royal Geographical Society), Kensington Gore, London. The style was popularized in London by Philip Webb at 1 Palace Green (1867–70), Kensington, and Shaw's own house at 6 Ellerdale Road (1874),

Hampstead. As the Cadogan estate in the fashionable London West End was developed in the late 1870s, Queen Anne Revival was adopted, notably in Cadogan Square and Pont Street, showing that the style was by then accepted among the wealthier classes. Other examples in London include J. J. Stevenson's use of it at 8 Palace Gate (1873–5) and that of George & Peto at 39 Harrington Gardens (1882), built for W. S. Gilbert.

Queen Anne Revival continued to be associated with progressive attitudes, in art as in education, and a number of fashionable artists' studios were built in the style in Chelsea, in Tite Street and on Chelsea Embankment. E. W. Godwin designed several of these houses, including 35 Tite Street (1877–8) for James McNeill Whistler and 44 Tite Street (1878) for Frank Miles (1852–91). From 1878 Bedford Park was laid out in west London as the first garden suburb. Houses there were designed by Shaw, with Godwin, Maurice B. Adams and E. J. May (1854–1941) also contributing. An irregular street pattern was used, preserving existing trees, with streets containing a mixture of house designs. Brick was used, with tile hanging and some rough-cast rendering. The models developed at Bedford Park were emulated for decades in suburban housing design. By 1899 the style was merging into the Arts and Crafts style with C. F. A. Voysey's house Greyfriars, near Puttenham, Surrey, built for Julian Sturgis, excellently situated under the brow of the hill, the Hog's Back (*see also* ARTS AND CRAFTS MOVEMENT).

Interiors of Queen Anne Revival houses centred on handsome staircase halls, richly panelled in oak, with inglenook fireplaces, carved screen and window seats. Tiles were lavishly used for mantels and floors and stained glass helped to create an artistic interior. By 1860 industrial production of shaped brick, encaustic tiles and sculpted and moulded terracotta was under way. Moreover, a generation of carvers and artisans had been trained at the Thames Bank workshops during the construction of the Houses of Parliament. Artists, sculptors and architects had studied industrial art at the South Kensington schools since the Great Exhibition of 1851. A number of books published in the 1870s and 1880s depicted contemporary

designs for furniture, stained glass, textiles and wallpapers, making the designs of Queen Anne Revival known to the newly affluent middle class.

2. Development in the USA

In the USA different visual forms evolved for Queen Anne Revival architecture. In 1873 the Scottish designer Daniel Cottier (1838–91) opened a shop in New York selling imported building materials and furniture. A series of articles by Clarence Cook published in *Scribner's Magazine* between 1875 and 1877 (repr. in 1878 as *The House Beautiful*) publicized the movement widely. The depression of the mid-1870s meant that little construction was taking place but opportunity abounded in Boston, MA, following the great fire of 1872 and the filling in of the Back Bay. In Boston and Newport, RI, moreover, architects and clients had knowledge of recent British work from their travels and from imported books, photographs and periodicals.

Already by 1870 John Hubbard Sturgis, an American architect trained in England and half-brother to Voysey's client Julian Sturgis, had designed a building for the new Museum of Fine Arts, Boston. Ornamented with English terracotta like its model, the South Kensington museums in London, Sturgis's museum initiated an educational programme in art and the decorative arts. Robert Swain Peabody's brick and terracotta Hemenway Gymnasium (1878; destr.) at Harvard College, Cambridge, MA, was followed in Back Bay by William Ralph Emerson's Boston Art Club (1882), and many mansions and public buildings, most notably Sturgis's palatial Frederick L. Ames House (1882), 306 Dartmouth Street, Boston .

In the USA, as in England, Queen Anne Revival was used most creatively in domestic architecture. The early 18th century had been the first monumental building period in the English colonies, and traditional American styles of this period were now revived together with English styles. The Bostonian architect Robert Peabody first linked Colonial Revival with Queen Anne Revival in his article 'A Talk about Queen Anne' (1877). Peabody found a romantic inspiration in the wooden architecture of Colonial New England, combining in his

John Denny House (1877) in Milton, MA, an 18th-century gambrel roof and Palladian window with an irregular Queen Anne Revival plan.

Queen Anne Revival houses in Boston and Newport constructed in the early 1870s by Sturgis, Richard Morris Hunt and others had broad verandahs and wooden clapboards with stickwork above a masonry ground floor instead of the tile hanging and half-timbering of their English models. Interiors were notable for their free, organic planning, with an emphasis on architectural furniture, and often with an imposing staircase hall.

In 1874 H. H. Richardson used shingles to clad his Queen Anne Revival house in Newport for William Watts Sherman. This house and the Newport Casino (1878–9) by McKim, Mead & White started the SHINGLE STYLE of the 1880s. Wooden shingles or weatherboards were used for the upper storeys, rather than timberwork, tile and pargetting, while the ground floor and foundation were of brick or glacial boulders. The Shingle style immediately became popular and absorbed elements of Queen Anne Revival. In Newport, Peabody's house Breakers (1878) for Pierre Lorillard faithfully translated into wood the gables and swags common in Queen Anne Revival in London; but his Kragsyde (1882, destr.) at Manchester-by-the-Sea, MA, evoking Shaw's Cragside in Northumberland, brings together the various elements of domestic American architecture of the period. Picturesquely sited on a rocky crag, it has an irregular, organic plan, with an entrance arch placed to one side, and the main portion of the hall reached by a flight of stairs. Many elements are drawn from the English Queen Anne Revival, but its upper walls are clad in smooth shingles in a purely American development of the style.

Queen Anne Revival co-existed and merged freely with COLONIAL REVIVAL and the Shingle style in the 1880s. Urban mansions of brick and stone were built in the style in Boston, Minneapolis, Chicago and New York, documented in Daly's *L'Architecture américaine* (1887) and George Sheldon's *Artistic Houses* (1882) and *Artistic Country Seats* (1882, 1883). After first-hand experience in England, Wilson Eyre produced early designs for houses in Philadelphia in the 1880s that were

particularly creative. With completion of the Union Pacific Railroad in 1878, and through pattern-books by such firms as Paliser & Paliser of New York (1886), Queen Anne Revival swiftly influenced the American vernacular and continued in a debased form, unprotected by theory or rules. Examples of the style, executed in standard millwork, often with patterned shinglework and bulbous turned posts in a Jacobean style, extended from Boston to San Francisco by 1897, and the style spread to other parts of the English-speaking world.

Although Queen Anne Revival was discussed in both professional and popular periodicals in England and the USA at the time, it plunged from favour in the first half of the 20th century and was derided for its lack of rules and excessive reliance on ornament. From the 1950s, however, growing recognition of its quality and the importance of its legacy led to further research.

Queen Anne Revival flourished during a hopeful and progressive period at the end of the 19th century. Liberated from the doctrinaire rigidity of earlier 19th-century styles, it provided educated and artistic people with many delightful buildings with attractive interiors.

Bibliography

B. Talbert: *Gothic Forms* (London, 1876)
R. S. Peabody: 'A Talk about Queen Anne', *Amer. Architect & Bldg News*, ii (1877), pp. 133–4
C. Cook: *The House Beautiful* (New York, 1878)
M. J. Lamb: *Homes of America* (New York, 1878)
J. J. Stevenson: *House Architecture* (London, 1880)
R. W. Edis: *Decoration and Furnishing of Townhouses* (London, 1881)
M. E. Hawes: *Beautiful Houses* (London, 1882)
G. W. Sheldon: *Artistic Houses* (New York, 1882)
M. B. Adams: *Artists' Houses* (London, 1883)
M. Schuyler: 'Recent Architecture in New York', *Harper's Mag.* (Sept 1883); repr. as 'Concerning Queen Anne', in *American Architecture and Other Writings*, ed. W. H. Jordy and Ralph Coe (Cambridge, MA, 1961), pp. 453–68
A. Daly & fils: *L'Architecture américaine* (Paris, 1886)
G. W. Sheldon: *Artistic Country Seats*, 2 vols (New York, 1886–7/R 1979)
J. Moyr Smith: *Ornamental Interiors* (London, 1888)
V. J. Scully, jr: *The Shingle Style: Architectural Theory and Design from Richardson to the Origins of Wright* (New Haven, 1955); rev. as *The Shingle Style and the Stick Style (New Haven, 1971)*
H. R. Hitchcock: *Architecture: Nineteenth and Twentieth Centuries*, Pelican Hist. A. (Harmondsworth, 1958, rev. 1977)
B. Bunting: *Houses of Boston's Back Bay* (Cambridge, MA, 1967)
T. A. Greeves: 'London's First Garden Suburb', *Country Life*, cxlii (7 Dec 1967), pp. 1524–9
—: 'The Making of a Community', *Country Life*, cxlii (14 Dec 1967), pp. 1600–02
M. H. Floyd: 'A Terra Cotta Cornerstone for Copley Square: Museum of Fine Arts, Boston by Sturgis and Brigham, 1870–1876', *J. Soc. Archit. Historians*, xxxii (1973), pp. 83–103
W. A. Holden: 'The Peabody Touch: Robert Swain Peabody of Peabody & Stearns of Boston', *J. Soc. Archit. Historians*, xxxii (1973), pp. 114–31
Marble Halls: Drawings and Models of Victorian Secular Buildings (exh. cat. ed. J. Physick and M. Darby; London, V&A, 1973)
North Kensington, xxxvii of *Survey of London*, ed. F. H. W. Shepherd (London, 1973)
T. A. Greeves: *Bedford Park: The First Garden Suburb* (London, 1975)
A. Lewis and K. Morgan: *American Victorian Architecture* (New York, 1975)
A. Saint: *Richard Norman Shaw* (London and New Haven, 1976)
Museums Area of Kensington and Westminster, xxxviii of *Survey of London*, ed. F. H. W. Shepherd (London, 1976)
M. Girouard: *Sweetness and Light: The 'Queen Anne' Movement, 1860–1900* (Oxford, 1977)
R. Longstreth: *On the Edge of the World* (New York, 1983)

MARGARET HENDERSON FLOYD

Realism

Movement in mid- to late 19th-century art, in which an attempt was made to create objective representations of the external world based on the impartial observation of contemporary life. Realism was consciously democratic, including in its subject-matter and audience activities and social classes previously considered unworthy of representation in high art. The most coherent development of Realism was in French painting, where it centred on the work of Gustave Courbet, who used the word *réalisme* as the title for a man-

ifesto that accompanied an exhibition of his works in 1855. Though its influence extended into the 20th century its later manifestations are usually labelled as Social realism.

1. History, theory and critical reaction

There is much confusion about the Realist movement, firstly because it takes its name from what is already an ingredient of almost any art, and secondly because its various aspects are sometimes contradictory. In some cases the term is used interchangeably with Naturalism. During the 19th century there was a growing current of opposition to idealized painting in the Grand Manner in favour of truth to 'reality'. Drawing on antique and Renaissance art and taught by the official academies, the Grand Manner emphasized humanistic themes and classical forms. Following the French Revolution the expansion of the audience for art was accompanied by a decline in the authority of classicism. Modern historical subjects had already entered art in the late 18th century in the work of such artists as Jacques-Louis David in France and Benjamin West in Britain, though the influence of the Grand Manner remained. Official patronage under Napoleon enhanced this trend in early 19th-century French art, as shown by the works of Antoine-Jean Gros, for example. These developments contributed to the blurring of distinctions between history painting and genre painting, and between high and low art. Increasing middle-class patronage encouraged landscape, genre, portrait and still-life painting rather than the depiction of historical subjects. Many Romantic artists and writers, though emphasizing the imaginative aspect of art by choosing literary and exotic themes, saw modernity and naturalism as dual means to establish an art for their times.

In its opposition to academic art and its demand for a modern style Realism continued the aims of the Romantics. By rejecting externally imposed art forms, Realism became a measure of the artist's sincerity, and its exponents aimed for both impartiality and truth to their own vision. While truth to the self had earlier been a crucial Romantic concept and had led to an emphasis on subjective vision, the Realists incorporated the concept into a simplistic theory of perception. They assumed that reality could be perceived without distortion or idealization, such that truth to the perception of the individual became compatible with objectivity and also central to the Realist condemnation of the Grand Manner. Indeed, as Realist art claimed to be a true mirror of reality, it asserted its independence from any traditions as these were engrained with aesthetic 'distortions'. The Realists also believed that naive perception was shared by all, and the movement was therefore often associated with democracy, individual rights and anti-authoritarianism.

The roots of the Realist aesthetic can be traced back at least to the 1830s. In his review of the Salon of 1833 the critic Gabriel Laviron (1806–49) called for an accessible, popular art that was based on visible reality alone, without making use of allegory or literary allusion. One of the first writers to use the term 'Realism' itself in the context of art was Gustave Planche. In his review of the Salon of 1836 he cautiously supported Realism as a means of artistic regeneration but felt that it was not, on its own, art (*Etudes sur l'école française*, Paris, 1855, ii, pp. 48–9). In the 1840s and into the 1850s the term was used pejoratively to attack the emergent movement. In 1852 the critic Ernest Chesneau wrote: 'Realism has been more contemptuous than it should be of any poetic interpretation of reality' (*Salon de 1852*).

Courbet's 'Manifesto of Realism', entitled *Le Réalisme*, which he published for his exhibition in the purpose-built Pavillon du Réalisme in Paris in 1855, emphasizes the dual concepts of objective representation and personal independence, as did the flurry of theoretical writings in the wake of his exhibition. In his manifesto Courbet claimed that the name 'Realism' had been thrust upon him. Critical hostility to the movement remained, and Charles Perrier, for example, wrote: 'The Realist's argument is that nature is enough' (*L'Artiste*, 14 Oct 1855). Charles Baudelaire echoed such views when in his review of the Salon of 1859 in the *Revue française* he wrote that Realists, whom he called 'positivists', want to represent 'things as they are, or as they would be,

supposing that I [the perceiving subject] did not exist'. That is, he added, 'The Universe without man'—a harsh and sterile art, unilluminated by imagination. His attitude was in keeping with his hostility towards photography, which for some years had provided a standard by which realistic representation could be judged. Courbet reinforced the basis for this critical opinion by proclaiming in a letter to the *Courrier du dimanche* (25 Dec 1861) that 'painting is an essentially *concrete* art and can only consist of the representation of *real and existing* things. It is a completely physical language.' He opposed the painting of ideas in favour of an essentially non-symbolic focus on things in themselves. For him Realism was 'the negation of the Ideal'.

Realist theories emerged primarily as a defense against criticism and frequently emphasized the movement's individualism and pursuit of truth. In an article in *L'Artiste* in 1855, Fernand Desnoyers wrote: 'The word "realist" has simply been used to distinguish the sincere and clairvoyant artist from the one who . . . continues to see through tinted glasses'. In one issue of his short-lived journal *Le Réalisme* (15 Nov 1856) Louis-Edmond Duranty claimed: 'Realism is the reasonable protest of sincerity and hard work against charlatanism and laziness . . . in order to awaken people's minds to a love of truth'. To speak of Realism as a school was for him a contradiction, because '[Realism] signifies the frank and complete expression of individuality; it is an attack upon convention, imitation, any kind of school'. Even Jules-Antoine Castagnary, while advocating Naturalism (his word for a more politically neutral Realism than Courbet's), recognized in his review of the Salon of 1857 in *Le Présent* that 'visual art can be neither a copy nor even a partial reproduction of nature, but, rather, an eminently subjective product'.

2. Development in France

After the artistic changes of the late 18th century and the early 19th, by the 1840s an early, 'Romantic' Realism had emerged in the writings of Honoré de Balzac (e.g. *Les Paysans*, 1844), George Sand (e.g. *La Mare au diable*, 1846) and Champfleury (e.g. *Les*

Oies de Noël, 1853) and in paintings by Philippe-Auguste Jeanron, Armand Leleux, Adolphe Leleux, François Bonvin, Théodule Ribot and Jean-François Millet, all of whom were active until at least the 1860s. Romantic Realism extolled the simplicity of rural life and domestic tasks in styles often recalling 17th-century Dutch painting (Jeanron and both Leleux), Spanish art of the same period (Ribot) or Chardin (Bonvin). The critic Théophile Thoré, a great admirer of Dutch art (and the rediscoverer of Vermeer), praised such Realism as 'an art for man' because it focused on the daily experience of common people. Millet was the most original painter of this generation (see col. pl. VI). Called the 'Rustic Michelangelo', he evoked Renaissance monumentality more than the genre painting tradition, as in *Going to Work* (1851–3; Cincinnati, OH, A. Mus.), and aimed at the heroization of an ideal (and lost) rural condition. Falling into the same category and contributing also to the development of Realism were such Barbizon landscape painters as Corot, Constant Troyon and Théodore Rousseau, the last named drawing on John Constable as well as Dutch art. Often working on the spot, they became less and less concerned with distinctions between sketch and finished picture, thus leading the way for Impressionism. Their relatively rough handling of paint was both a reminder of spontaneous acts of direct observation and an evocation of rustic irregularities in unimproved nature.

The expansion from the 1830s of illustrated journals and graphic arts, the latter best exemplified by the lithographs of Honoré Daumier, significantly contributed to the more general involvement of art with everyday life and social themes. Even academic artists treated modern social subjects on occasion, as in William Bouguereau's *Destitute Family* (1865; Birmingham, Mus. & A.G.), though, as in this case, the carefully planned compositions and manipulatively sentimental subjects invariably distinguished their work from the more detached style of Realism. The Revolution of 1848 spawned representations of soldiers and barricades with political overtones (e.g. Ernest Meissonier's *Barricade of the Rue de la Mortellerie*, 1848; Paris, Mus.

d'Orsay), though military subjects had been part of the Romantic repertory since the days of Napoleon. Despite the objections to it made by such critics as Baudelaire, photography had a great effect in bringing artists' conceptions of the pictorial transposition of reality closer to optical principles and in making them more conscious of the usefulness of detail and fragment. Anxious to distinguish their creativity from its mechanical processes, however, few painters imitated photographic effects fully until Impressionism.

The nostalgic motivations of early or Romantic Realists distinguish their efforts from those of Gustave Courbet. His demythified, unidyllic and demographically specific images of the countryside highlighted rather than glossed over politically sensitive issues. In his book *Le Réalisme* (1857) Courbet's friend and apologist Champfleury dated the beginning of Realism to 1848, alluding both to the Revolution and to the year he first saw Courbet's work. Courbet's first controversial painting was *The Stonebreakers* (1849; ex-Dresden, Gemäldegal. Neue Meister; untraced). This was the first work to show the dehumanizing hardship and boredom of manual labour in the countryside. Far from the timeless pastoral harmony of conventional landscape, the barren, dusty roadside in *The Stonebreakers* is reduced to a relative minimum, and attention concentrates on the shabbily dressed workers. The two expressionless figures with their faces obscured exhibit no engagement or satisfaction in their work that might mask its infinite repetitiveness. Courbet's stark, unaffected honesty of style and content—like photographic naturalism, but used consciously as an antidote to traditional artistic and social values—was correctly understood as inappropriate to the idealizing traditions of Salon painting. Many contemporaries criticized the workers' ugliness and unwashed appearance. However, the political theorist Pierre-Joseph Proudhon sensed the picture's connection to contemporary socio-economic conditions, calling it an 'irony addressed to our industrial civilization'.

Another ingredient of Courbet's painting that distinguishes it from earlier versions of Realism is

its roots in popular imagery. Courbet saw Champfleury frequently at the Brasserie Andler in Paris, a Realist haunt of the late 1840s, and was undoubtedly influenced by the writer's deep interest in folk art and popular prints. This interest accords perfectly with Courbet's sympathies for working people. Unlike most painters of rural or working-class subjects who continued to employ a sophisticated pictorial vocabulary, Courbet imitated the simple, sometimes apparently awkward compositions of popular woodcuts or of the Le Nain brothers, whom Champfleury had recently rediscovered and extolled for their realism. Even though Courbet's early work shows the lessons he had learnt from Old Masters as diverse as Titian, Rembrandt and the Spaniards of the 17th century, after 1848 he emulated the apparent heavy-handedness of the provincial artisan. The controversy surrounding his art seemed to focus on his unglorified subject-matter and his workmanlike style, both of which gave rise to ignoble and unidealized forms. On a deeper level, it revealed the public's political and social resistance to opening art to the democratic forces for which those forms were a visual language. Courbet subtitled the *Burial at Ornans* (1849–50; Paris, Mus. d'Orsay; see fig. 65) as a *tableau historique*, thus claiming historical significance for the death of a common man. Its huge dimensions (3.15×6.88 m) reinforced this claim, since life-size painting was traditionally reserved for history subjects. By academic standards the *Burial* had none of the sophisticated compositional devices and smooth finish associated with high art. Its matter-of-factness seemed to deny obvious humanistic meanings in favour of plain presence. The inclusion of the citizens of Ornans in the halls of art—traditionally the realm of the rich and powerful—was tantamount to a political challenge.

Courbet consciously contrived these political consequences. Influenced by Proudhon's *Système des contradictions sociales* (1846) and *Philosophie du progrès* (1853), in his autobiographical painting the *Painter's Studio: A Real Allegory Determining a Phase of Seven Years of my Artistic Life* (1854–5) he associated Realism with both personal and universal liberation. Realism was a matter of

65. Gustave Courbet: *Burial at Ornans*, 1849–50 (Paris, Musée d'Orsay)

truth to oneself as well as to the social reality of one's time. Courbet claimed that he had depicted all of society in the work, thus seizing for himself a central and leadership position. He showed himself painting a landscape from his home region, thus suggesting both the subjective and objective elements of Realism. In other words, Realist honesty had ramifications beyond the realm of art; its authentic vision was the key to transcending social contradictions.

For later generations, Courbet's avant-garde association of Realism with liberal social concern contradicted its aesthetic of neutrality. Castagnary drew attention to the long-standing tradition of the more neutral concept of naturalism so that artists might follow Courbet's commitment to contemporary reality without proclaiming its radical political doctrine. Such artists as Henri Fantin-Latour (e.g. *A Studio of the Batignolles Quarter*, 1870; Paris, Mus. d'Orsay), Carolus-Duran and James Tissot adopted this course in much of their work of the 1860s, as did the Impressionists in many early paintings. Frédéric Bazille and Gustave Caillebotte (e.g. *Planing the Floor*, 1875; Paris, Mus. d'Orsay) developed the lighter palette of Impressionism, while retaining the solidity of Courbet's style.

In the 1860s Edouard Manet also shifted the realm of radical artistic activity towards the pictorial rather than the political sphere. Such images of modern life as *Olympia* (1863; Paris, Mus. d'Orsay; see col. pl. XXXII) were shocking more on grounds of decorum and technique than as signs of a threatening political position. While accepting the Realist commitment to modern subjects, Manet constantly cast those subjects in terms that created a dialogue with the art of the past. His paintings of the 1860s often evoke Dutch or Spanish precedents without co-opting their picturesque nostalgia. On the contrary, his bright colours, bold flattened forms and broad brushstrokes asserted his very contemporary presence as a brash and self-confident appropriator of artistic tradition for a new aesthetic. Zola defended Manet's paintings both as 'sincere' expressions of 'temperament' and as 'analytic', a word he also used to describe the natural vision of a scientific age. He asserted that one should seek 'neither story nor sentiment', but only 'a literal translation'. Manet treated his figures in the manner of a still-life. More than through subject-matter, however, he expressed his modernity by the adoption of an artistic process centred on seeing rather than on literary imagination or traditional skills.

His ostensible neutrality toward his subjects and his style derived from Spanish art and Japanese prints (e.g. portrait of *Emile Zola*, 1868; Paris, Mus. d'Orsay; see col. pl. XX) were perceived as expressions of that modernity. Even though Manet's art was tied to his society and its rituals, he was less self-consciously absorbed with them than with the expression of his artistic persona through the artifices of representation: brushstroke, colour and pattern. Going well beyond the Realist preoccupation with ordinary people and social subjects, he moved towards the Impressionists' luminous aestheticization of the modern urban world and its focus on private leisure. His is a bourgeois Realism that confirms rather than challenges social values while founding a new vehicle—a direct, personal and informal style—for their expression.

While French sculptors sometimes submitted to the aesthetic of impartial observation (e.g. François Rude and Auguste Préault), their contribution to Realism was slight until the late 19th century. In his sculpture *Little Fourteen-year-old Dancer* (1880–81; bronze version, London, Tate) Edgar Degas extended the detached aesthetic of his paintings into three dimensions, enhancing the presence of the figure by the addition of a real tulle tutu and satin hair ribbon (the original clay and wax version included a horse hair wig as well). Closer to the socially engaged form of Realism is the unfinished monument to *Workers* by Jules Dalou, which he worked on in the late 1880s and 1890s (plaster and clay maquettes; Paris, Petit Pal.).

3. Development elsewhere

In parts of the world less dominated by institutional support for the Grand Manner, the distinction between Realism and the realist tradition is even harder to measure than in France. The popularity of genre painting (e.g. Biedermeier painting; Victorian narrative in England) made the French Realist spirit of revolt of little interest, but Courbet's solid forms and directness did have an appeal in some countries. Germany was the main area of Courbet's influence, since he had travelled there and had patrons there. Hans Thoma, Wilhelm Leibl (e.g. *Women in a Village Church*,

1878–81; Hamburg, Ksthalle), Wilhelm Trübner and the young Max Liebermann were attracted by the dark earthiness of his figures and by his direct and powerful handling. Adolph Menzel developed independently in Berlin, though he met Courbet in Paris in 1855 and in the 1860s. He was most famous among contemporaries for his history paintings, but he also produced such direct, unidealized works as *Funeral of the Martyrs of the Berlin Revolution* (1848; Berlin, Alte. N.G.) as well as treating more intimate, domestic subjects.

Throughout Europe Realism contributed in a more general sense to serious representations of rural or working-class life and social conditions. In Italy the MACCHIAIOLI sometimes represented field workers in landscapes that seem half-way between those of the Barbizon painters and those of the Impressionists. Daumier's images of the poor, such as the *Third Class Carriage* (c. 1856; New York, Met.) had such counterparts in Britain as Walter Howell Deverell's the *Irish Beggars* (c. 1850; Johannesburg, A.G.). Ford Madox Brown's programmatic *Work* (1852–65; Manchester, C.A.G.) exhibits a moralizing attitude conveyed through allegory and narrative rather than through direct pictorial confrontation. He adopted the scrupulous truth to observation associated with the Pre-Raphaelites, whose work, though unaffected by French Realism, parallels its spirit of protest against convention and sometimes shares its social concern. Certain paintings by John Everett Millais and William Holman Hunt (e.g. the *Awakening Conscience*, 1853; London, Tate) have a starkness and dryness that would indicate a naive vision were it not for their literary or religious subjects and their insistence on symbolism. It is in their landscapes that the Pre-Raphaelites came closest to the ideals of Realism.

In the Netherlands artists of the Hague school painted landscape and genre works in a Realist style, which influenced the early works of Vincent van Gogh. Such darkly coloured paintings by van Gogh as *The Loom* (1884; Otterlo, Rijksmus. Kröller-Müller) concentrate on the life of peasants and workers, though by the late 1880s his palette and subject-matter had moved beyond this. In Belgium, Constantin Meunier turned after 1878 to

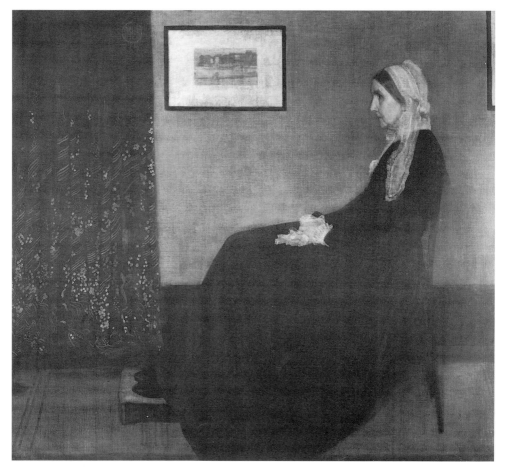

66. James McNeill Whistler: *Arrangement in Grey and Black, No I: Portrait of the Artist's Mother*, 1871 (Paris, Musée d'Orsay)

images of industry and its workers in both paintings and sculptures, as in the painting the *Mining Girl* (1887; Brussels, Mus. Meunier). From the late 1880s he worked on the monument to *Labour*, an unfinished sculptural project for which he produced a number of such studies as the bronze relief *Mining* (1901; Brussels, Mus. Meunier). In Russia a powerful and epic version of Realism was practised by Il'ya Repin (e.g. *Religious Procession in the Kursk District*, c. 1880; Moscow, Tret'yakov Gal.), though like many late 19th-century depictions of common people it is conservative in style.

In the USA Realism engaged such major painters of the second half of the 19th century as Winslow Homer, Thomas Eakins (e.g. the *Gross Clinic*, 1875; Philadelphia, PA, Thomas Jefferson U., Medic. Col.) and John Singer Sargent, all of whom used their European experience to import fashionable influence to the USA. The American expatriate James McNeill Whistler moved to Paris in 1855, where he met and was influenced by Courbet. In *Arrangement in Grey and Black, No. 1: Portrait of the Artist's Mother* (1871; Paris, Mus. d'Orsay; see fig. 66) he created a refined balance between

Realism and his emerging Aestheticism in a way that fits perfectly within the transition from Courbet to Manet.

Bibliography

Champfleury: *Le Réalisme* (Paris, 1857)

E. Bouvier: *La Bataille réaliste* (Paris, 1913)

B. Weinberg: *French Realism: The Critical Reaction, 1830–1870* (New York, 1937)

L. Nochlin, ed.: *Realism and Tradition in Art, 1848–1900* (Englewood Cliffs, 1966)

L. Nochlin: *Realism* (New York and London, 1971)

The Realist Tradition: French Painting and Drawing, 1830–1900 (exh. cat., ed. G. P. Weisberg; Cleveland, OH, Mus. A.; New York, Brooklyn Mus.; St Louis, MO, A. Mus.; Glasgow, A.G. & Mus.; 1980–81)

G. Needham: *19th-century Realist Art* (New York, 1988)

K. Herding: *Courbet: To Venture Independence* (New Haven, 1991)

J. H. Rubin: *Gustave Courbet: Realist and Visionary* (London, 1995)

J. H. RUBIN

Reduktionsgotik [Ger.: 'reduced Gothic']

Term used to describe German churches of the High Gothic period erected by the mendicant orders using a deliberate austerity of style. The aim was to provide assembly halls where the faithful could crowd round the preacher. Such churches were often built with flat ceilings instead of vaulting, or with large areas of unadorned walls. Examples include the Franciscan church of St Mariä Empfängnis (1244–60; destr. 1942–3; rebuilt 1958) at Cologne, the Dominican church (now St Blasius; begun 13th century) at Regensburg, and the Franciscan church of St Martin (begun 1262; rest. 1953) at Freiburg im Breisgau. □

Régence style

Decorative style in furniture and interior decoration associated with Philippe II, Duc d'Orléans, Regent for the young Louis XV of France from 1715 to 1723. Generally considered to be the first phase of the Rococo style in France (*see* ROCOCO, §II), the style appeared *c.* 1710 and lasted until *c.* 1730 when it was superseded by the *genre pittoresque*.

Enlivened by the GROTESQUE and ARABESQUE ornament employed by Jean Bérain i, the Régence style added a lighter, more whimsical element to the solemn LOUIS XIV STYLE. Ribbons, garlands and putti replaced formal classical motifs, and the playful and intimate *fête galante* of Antoine Watteau replaced allegorical rhetoric and classical grandeur (see fig. 72). This more informal and intimate style was better suited to the interior decoration of *petits appartements* than to grand reception rooms. Wall coverings of imposing slabs of marble were replaced by carved *boiseries* of increasingly sinuous, though still symmetrical, contours. Such new furniture forms as the commode took on more serpentine forms, with parquetry decoration in such exotic woods as tulip wood and kingwood; other new furniture types such as the *bureau plat* and the *duchesse brisée* (a form of chaise longue) evolved to fit the more intimate, curvilinear proportions of the rooms. Seat furniture moved into the centre of the room, and the back of the fauteuil took on a curved outline; straight back chairs, however, remained against the walls. There was an increasing emphasis on comfort and informality; seat furniture had thick cushions and upholstery, and cane-work became fashionable *c.* 1720.

The Régence style is epitomized in the work of the artists employed by Philippe II: the furniture of Charles Cressent (e.g. commode, *c.* 1730; Waddesdon Manor, Bucks, NT); the Salon d'Angle (1719–20) at the Palais-Royal (destr.), Paris, designed by Gilles-Marie Oppenord, chief architect and designer during the Regency; the interior of the Hôtel de Soubise (*in situ*) by Germain Boffrand (see col. pl. XXXV); and in particular the Galerie Dorée (1718), designed by François-Antoine Vassé (1681–1736) at the Hôtel de la Vrillière (1713–19; subsequently the Hôtel de Toulouse, now the Banque de France), restored by Robert de Cotte. Though primarily a French phenomenon, the Régence style influenced the early work of such Huguenot silversmiths working in England as Paul de Lamerie.

Bibliography

D. Guilmard: *Les Maîtres ornementistes* (Paris, 1880/81)

C. Mauricheau-Beaupré: *L'Art au XVIIIe siècle en France* (Paris, 1947)

E. Dacier: *L'Art au XVIIIe siècle en France, Régence/Louis XV* (Paris, 1951)

P. Verlet: *Les Ebénistes du XVIIIe siècle* (Paris, 1963)

——: *French Furniture and Interior Decoration of the 18th Century* (London, 1967)

——: 'La Régence', *Styles, meubles et décors du moyen âge à nos jours*, ed. P. Verlet, i (Paris, 1972), pp. 171–83

J. Feray: *Architecture intérieure et décoration en France: Des origines à 1875* (Paris, 1988)

M. Eleb-Vidal and A. Debarre Blanchard: *Architectures de la vie privée: Maisons et mentalités XIIe–XIXe siècle* (Brussels, 1989)

J. Whitehead: *The French Interior in the Eighteenth Century* (London, 1992)

MONIQUE RICCARDI-CUBITT

Regency style

Style of decorative arts and architecture produced in England during the rule of George, Prince of Wales, as Prince Regent from 1811 until his accession as George IV in 1820, although it is also generally applied to the period from the 1790s until the death of George IV in 1830. Predominantly a style of interior decoration, it began as an enrichment of the late GEORGIAN STYLE, as typified by the work of Henry Holland for the Prince Regent at Carlton House (after 1783; destr. 1827–8) and the Royal Pavilion (1787), Brighton; for the brewer Samuel Whitbread (1758–1815) at Southill (1796–1800), Beds; and for Francis Russell, 5th Duke of Bedford, at Woburn Abbey (1787–1802; partially destr. 1954), Beds. Furniture for such interiors was designed by Holland and made in England by such émigré craftsmen as François Hervé (*fl* 1780–90) or in France by such craftsmen as Georges Jacob. Similar styles were published in later editions of both Hepplewhite's *Cabinetmaker and Upholsterer's Guide* (1788, rev. 2/1789, 3/1794) and Sheraton's *Cabinetmaker and Upholsterer's Drawing Book* (1791–3, rev. 2/1794, 3/1802). Around the turn of the 18th century, however, the sabre leg replaced the straight or cabriole leg and such lighter toned, more figured woods as satinwood, rosewood and zebra-wood super-seded mahogany. Versions of the Greek klismos-chair and other Greco-Roman forms became popular, as illustrated in C. H. Tatham's *Etchings of Ancient Ornamental Architecture* (1799).

The short-lived Peace of Amiens of 1802 allowed British travellers to experience French styles at first hand; these were simplified by such cabinet-makers as George Smith and George Bullock, who specialized in richly decorated classical furniture, often incorporating metal inlays in the form of Greek-key frets, anthemions, palmettes and guil-loches. These details are larger in scale and bolder than in the earlier Neo-classical and Adam styles. French influence was also evident in variants of the Etruscan and Empire styles in such features as monopodia and caryatid legs, for example furniture by Thomas Chippendale for Stourhead (1806), Wilts (*in situ*). Thomas Hope, in his *Household Furniture and Interior Decoration* (1807), also introduced such Indian and Egyptian motifs as the lotus leaf and hieroglyphics, the latter originally inspired by Napoleon's Egyptian campaign and adapted from the work of Charles Percier and Pierre François Léonard Fontaine in Paris. A boulle-work revival was also current in the work of such makers as Thomas Parker (*fl* 1808–29) and Louis Le Gaigneur (*fl* 1815–20).

In general, the architectural setting for such furniture became increasingly restrained in style, although there were a number of notable exceptions. The Indian style exterior of Sezincote, Glos, and the Royal Pavilion (remodelled *c.* 1801) at Brighton, for example, display the full efflorescence of extreme Orientalism. There were also a few manifestations of the Gothick taste in architecture, notably at Abbotsford (1812–32), near Melrose, for Sir Walter Scott. Most Gothick extravagances, however, appear in such interiors as the Gothick Library (1807–10) at Stowe, Bucks, by John Soane, whose normal architectural style was a restrained, attenuated classicism. The palatial stucco terraces by John Nash in London are the most obvious examples of the coarser late Regency style. His interiors for George IV at Buckingham Palace (1825–30), London, make up in scale for

what they lack in subtlety. The King also employed Jeffry Wyatt (later Wyatville) to Gothicize the royal apartments at Windsor Castle, Berks (1824–40), creating interiors suitable for the monarch of the most powerful nation in the world after the Battle of Waterloo.

George IV was also an important client for silver in the new, rich style produced by such silversmiths as Paul Storr and Rundell, Bridge & Rundell, who employed John Flaxman as a designer. Ceramics became more flamboyant, with the use of colourful patterns based on Imari prototypes, as well as highly ornate classical motifs, particularly on ware by Spode and Worcester. In glass, forms became heavier and more elaborate, with much use of complex facet cutting. The late Regency style tended towards more naturalistic patterns, especially on furniture, in the form of gilt vine- and water-leaf ornament, as seen in such pattern books as *The Practical Cabinetmaker, Upholsterer and Complete Decorator* (1826) by Peter Nicolson (1765–1844) and Michael Angelo Nicolson (c. 1796–1844). This style evolved into the naturalism prevalent from the 1830s.

Bibliography

M. Jourdain: *Regency Furniture, 1795–1820* (London, 1948)

E. T. Joy: *English Furniture, 1800–1851* (London, 1977)

C. Wainwright: *The Romantic Interior* (New Haven and London, 1989)

Carlton House: The Past Glories of George IV's Palace (exh. cat. by G. De Bellaigue, London, Queen's Gal., 1991)

S. Parissien: *Regency Style* (London, 1992)

<div align="right">BRUCE TATTERSALL</div>

Renaissance [Fr.: 'rebirth']

Term generally used for periods that hark back to the culture of Classical antiquity. Though it has applications elsewhere, it is most often used to refer to that era in Europe, beginning approximately in the 14th century, in which a new style in painting, sculpture and architecture was forged in succession to that of Gothic and in which, in a broader cultural sense, the transition from the Middle Ages to the modern age was made. This period culminated in the High Renaissance, a brief phenomenon confined essentially to Italy in about the first two decades of the 16th century and supremely embodied in some of the work of that time by Leonardo da Vinci, Michelangelo and Raphael. Following this came that phase of the late Renaissance called MANNERISM.

1. Application and history of the term

As early as the beginning of the Christian era, Augustan artists drew on the Greek art of the 5th and 4th centuries BC. Later, a Carolingian *renovatio* or renaissance is seen as having occurred in the early Middle Ages. In the architecture of Tuscany there was a 'proto-Renaissance' in the 11th and 12th centuries represented by the Florentine church of S Miniato al Monte, in which Classical orders and tranquil rhythms anticipate the Florentine Renaissance, and the Baptistery of S Giovanni, probably remodelled in the 11th century. In the same period architecture and sculpture inspired by antiquity were being created in Provence, for example the abbey church of St Gilles, and St Trophîme in Arles. The 13th century culminated in the classicizing art created in the Hohenstaufen imperial workshops of Emperor Frederick II, who collected antique sculpture and erected buildings and statues in imitation of antiquity, for example the Capua Gate (1234–40). Works influenced by antiquity were created north of the Alps too, especially in the field of sculpture: the *Visitation* on the façade of Reims Cathedral; the *Rider* (c. mid-13th century) in Bamberg Cathedral; and the founders' statues in the west chancel of Naumburg Cathedral are notable examples.

The term Renaissance in its narrower sense developed under the influence of 19th-century French art theory and was originally applied to the period 1400–1600. In this context it refers to the actual rebirth of art by its drawing on the spirit of antiquity, a one-sided concept that is still widely prevalent. However, this use of the word has older and wider roots: as early as 1550 Giorgio Vasari spoke of the 'rinascità' of art from the 14th century, meaning the re-emergence of 'good art' after the medieval period (i.e. of art modelled on nature again for the first time since antiquity). The intention was not that art should copy nature,

however, rather that it should give visible expression to its perfect idealized form, and here lies the connection with antiquity. It is impossible to speak of the Renaissance comprising a rediscovery of the repertory of form used in antiquity, because in Italian medieval art the antique tradition had never been broken. For example, the figures derived from antique sources on Nicola Pisano's pulpit in the Baptistery at Pisa (c. 1257–64) are more faithful than any ever achieved in the Renaissance. The return to antique sources was not in itself the moving force behind the Renaissance, rather it was the other way round: the endeavour to comprehend all the phenomena of reality in this world reopened artists' eyes to the works of antiquity. Writing in the 18th century the French encyclopedist Denis Diderot put it thus: it is necessary to study antiquity in order to recognize reality.

The Renaissance refers not only to a stylistic period succeeding that of the Gothic but also to the crucial turning-point between the Middle Ages and the modern age. We can talk in general terms of a change from the medieval theocentric (God-centred) image of the world to an anthropocentric (man-centred) concept of the world. This change, the most radical since the end of the antique period, impinged on every area of life.

2. Early Renaissance, c. 1300–1450

The transition from the Late Gothic to the Renaissance is extremely varied. In Italian art c. 1300 the works of Giotto and his contemporaries already indicate a first surge of interest in the phenomena of the temporal world, for example Giotto's frescoes (c. 1305–10) in the Arena Chapel in Padua or the cycle of scenes from the Life of St Francis (c. 1290) by unknown masters in the Upper Church of S Francesco at Assisi. Vasari correctly saw this as a first stage in the 'rinascità'. In the fresco by Ambrogio Lorenzetti, the Effects of Good Government (1338–9; Siena, Pal. Pub.), buildings and landscape attain a realism unrivalled until the second quarter of the 15th century. North of the Alps the art associated with Emperor Charles IV's court in Prague, with its strong emphasis on the body and on space, and the tendency to portray strongly characterized individuals (e.g. the portrait busts, from 1372, in the triforium of the choir of Prague Cathedral), can also be seen as part of the prologue to the Renaissance.

The mendicant orders played an important role in the emergence of the Renaissance. Their call for personal devotion and direct imitation of the life and sufferings of Christ resulted in a higher value being placed on the individual. Devotional pictures, such as Pietàs, began to appear from c. 1300, and independent panel paintings emerged a little earlier. In literature, especially in Italy, there was a new interest, in the 14th century, in Classical writers. The poetry of Francesco Petrarch and his knowledge of Classical literature are associated with the early development of Humanism, which took place, especially in Florence, towards the end of the 14th century.

The starting and focal-point of early Renaissance art was republican Florence, where the precedence of sculpture in displaying new and different forms is significant. By its very three-dimensionality sculpture comes closest to reality, and in a period of the 'discovery of the world and of man' (Burckhardt) it is logical that sculpture should be especially prominent. In early 15th-century Florence Nanni di Banco and Donatello created the modern concept of the statue, in which the drapery is no longer expressive, the emphasis falling instead on the form of the human body, with the drapery serving to articulate its structure. The Classical device of contrapposto was recreated in such works as Nanni di Banco's St Philip (c. 1410) and Four Crowned Saints (c. 1416) and Donatello's St Mark (between 1411 and 1413; all Florence, Orsanmichele) and St George (c. 1414; Florence, Bargello; see fig. 67) and remained influential in the history of the statue until the late 19th century.

In relief sculpture Lorenzo Ghiberti developed a concept that remained valid for centuries. He took Andrea Pisano's approach to relief as his starting-point for the north doors of the Baptistery in Florence, but as he worked on the project (1403–24) he developed a sense of tension between fore-ground figures, projecting ever more prominently,

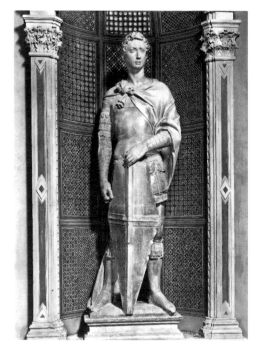

67. Donatello: *St George*, c. 1414 (Florence, Museo Nazionale del Bargello)

and the receding background, achieved by differentiated gradations in the depth of the relief. This led to the 'pictorial' opening up of the background in the Baptistery's *Gates of Paradise* (1426–52), the last set to be completed. Donatello created a less influential form of shallow relief, the *rilievo schiacciato* (It.: 'flattened-out relief'), of which the earliest example is the marble relief showing *St George and the Dragon* (1417; Florence, Bargello), formerly on the lintel beneath the statue of *St George* at Orsanmichele.

A towering figure laid the foundations for Renaissance architecture: Filippo Brunelleschi. From 1420 he was in charge of vaulting the dome of Florence Cathedral, primarily a brilliant piece of engineering. In the same period he built the loggia of the Ospedale degli Innocenti and the Old Sacristy at S Lorenzo (both from 1419), and evolved designs for S Lorenzo (from c. 1421) and Santo Spirito (from 1436; see col. pl. XXXIV).

What is crucial about his buildings is less the adoption of individual antique-inspired forms, already anticipated in the Romanesque buildings of the Tuscan proto-Renaissance, than the human-inspired measure of the whole and its parts. The column is employed as the architectural component most closely related to the human body; each individual element is placed in a carefully calculated, immediately perceptible relationship with the element adjoining it and the building as a whole. Brunelleschi thus achieved a harmony of proportion intended to be attuned to man, rather than soaring beyond him as in the Gothic cathedral.

The work of Masaccio, whose figural style was influenced equally by contemporary sculpture and Giotto's painting, forms the prelude to early Renaissance painting. His fresco of the *Trinity* at S Maria Novella in Florence (c. 1425; see fig. 68) demonstrates new artistic objectives, for the first time since antiquity creating a three-dimensional space on a flat surface by use of the newly discovered science of mathematical perspective. His painted figures are life-size and the eye level of the viewer is at the same height as the eye level from which the perspective is constructed, so that the donors appear to be kneeling in front of the painted architecture. Thus, the space in the picture and the space occupied by the viewer merge into one.

This fresco is at the root of all subsequent illusionistic painting until the start of the Baroque period. Masaccio, working with the older artist Masolino, created his masterpiece in the frescoes of scenes from the *Life of St Peter* in the Brancacci Chapel (started c. 1424; Florence, S Maria del Carmine), in which he proved himself to be the true heir of Giotto. With his skill in composition, the power of his figural modelling, the freedom of his grouping, the new possibilities of conveying space and the first attempts to reproduce atmospheric effects, he left behind him an artistic legacy, the development of which absorbed the following generations. Foremost among these later painters were Paolo Uccello, who in his frescoed equestrian monument to *Sir John Hawkwood* (1436) in Florence Cathedral and fresco (after 1440)

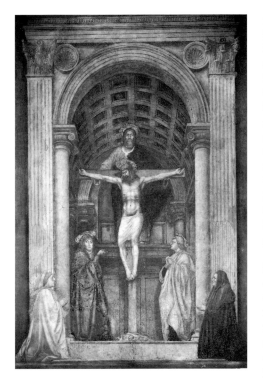

68. Masaccio: *Trinity*, c. 1425 (Florence, S Maria Novella)

of the *Flood* in the Chiostro Verde of S Maria Novella, Florence, refined the science of perspective; Andrea del Castagno, whose frescoed equestrian monument to *Niccolò da Tolentino* (1456; Florence Cathedral), *Last Supper* (1447; Florence, S Apollonia) and cycle of *Famous Men and Women* (Florence, Uffizi) attempted to convey the painted figure as a polychrome sculpture; Domenico Veneziano, whose *St Lucy* altarpiece (mid-1440s; Florence, Uffizi) revealed a new response to reproducing sunlight; and finally, in pride of place, Fra Angelico, who can be regarded as Masaccio's heir with such works as the frescoes (1439–47) in the monastery of S Marco, Florence, and those (1448–9) in the chapel of Nicholas V, Vatican, Rome.

The widespread notion that there was no Renaissance north of the Alps before *c.* 1500, with Albrecht Dürer's journeys to Italy (1494–5 and

1505–7) seen as decisive milestones, cannot be sustained, and it is unsatisfactory to consider the art immediately before this date as Late Gothic. North of the Alps there is the same passion as in Florence for depicting the body and representing space and the reciprocal relationship between the two. This is evident first of all in sculpture, in the work of Claus Sluter at the Charterhouse of Champmol, near Dijon, *c.* 1400 and in Hans Multscher's sculptures in Ulm, *c.* 1430. From the 1430s it is especially apparent in painting, for example in the Ghent Altarpiece by Hubert van Eyck and Jan van Eyck (*c.* 1423–32; Ghent, St Bavo), the paintings of Robert Campin and Rogier van der Weyden; Lukas Moser's altar in Tiefenbronn parish church (completed 1432); and in Konrad Witz's paintings.

The extent to which 15th-century art, overriding different regional artistic traditions, was determined by the same cultural shifts is illustrated by a new genre of painting that came into being independently north and south of the Alps: the portrait in its modern sense as a reproduction of the unique, unmistakable, individual appearance. This phenomenon again reflects the anthropocentric basis of the Renaissance. Nonetheless, differences in the early Renaissance north and south of the Alps should not be overlooked: first of all, the artistic perception of reality in the north was still completely intuitive, whereas Italian perspective and theories of proportion are an attempt to discover how appearances conformed to rules. Secondly, the north was initially concerned with the accurate rendering of detail, with the whole being the sum of precisely observed parts, while in the south a concept of the whole determined the arrangement and form of the detail. It is in this, rather than in individual borrowed forms, that the real relationship of the Italian Renaissance with antiquity lies.

The difference between north and south is particularly evident in the portrait. In northern Europe, especially in the southern Netherlands, artists developed the three-quarter view in which the profile and full face merge, so conveying a greater measure of individuality; until the third quarter of the 15th century the south on the other hand preferred the severe profile, influenced by

the portrait medallions of such artists as Pisanello. In the north the sitter looks out of the painting, creating a relationship with the spectator; in the south the portrait remains self-contained, and the sitter makes no contact with the viewer. The three-quarter view shows the sitter in space (as, for example, in Jan van Eyck's *Portrait of a Man*, inscribed *Tymotheos*, 1432; London, N.G.), while the profile ties him to the flat surface.

In the north the emphasis fell on a painterly treatment of surface and texture, in the south line dominated. The transformation of the picture of the donor on altarpieces is part of the same reappraisal of the individual. In medieval art, which graded figures in size according to importance, donors are shown in very small proportions, yet in the Renaissance they were painted on the same scale as the sacred figures.

However, the new emphasis on the visible world did not affect every artistic region equally, either south or north of the Alps. Initially the early Renaissance in Italy emanated only from Florence, while north of the Alps it was mainly the rich trading cities in the southern Netherlands and south-west Germany, where middle-class patrons were to be found, who welcomed the new creative possibilities. Where feudal and church patrons were predominant, on the other hand (for instance Venice and Milan), the Late Gothic tradition persisted well into the 15th century. Consequently, the early Renaissance can be described as the first great cultural achievement of the middle classes. They created their own forms of expression, while the church and the nobility, backed by tradition, at first rejected the new realism.

3. Renaissance, 1450–c. 1500

In the second half of the 15th century, three major developments took place. First, Tuscan artists spread the early Renaissance into Central and North Italy. Donatello's activity in Padua between 1443 and 1453, where he created the high altar in S Antonio (1446–50) and the equestrian statue of *Gattamelata* (1447–53) in the Piazza del Santo, had a decisive impact on painting, particularly on Andrea Mantegna. The latter in turn became

a master of realistic figure depiction and virtuoso perspective construction, as displayed in the S Zeno Altarpiece (1456–9; Verona, S Zeno) and in the Camera Picta or Camera degli Sposi in the Palazzo Ducale at Mantua (1465–74). Mantegna profoundly influenced Venetian painting, especially that of his brother-in-law Giovanni Bellini. The humanist and architect Leon Battista Alberti developed his style by studying antique Roman buildings, already anticipating the High Renaissance, and added a classically inspired Renaissance façade to S Maria Novella in Florence (c. 1458–70). He brought a Renaissance style to Upper Italy with his masterpiece, S Andrea in Mantua (begun 1472). In the early 1480s Tuscan and Umbrian painters decorated the walls of the Sistine Chapel at the Vatican with the first large Renaissance fresco cycle in Rome; those collaborating on it included Sandro Botticelli, Domenico Ghirlandaio, Pietro Perugino and Luca Signorelli.

A lively exchange between north and south got under way, with Italy initially being the more receptive. Rogier van der Weyden is said to have visited Rome in 1450, and the display of Hugo van der Goes's Portinari Altarpiece (c. 1473–9; Florence, Uffizi) in Florence in 1483 was a milestone. Nevertheless, it was, above all, Antonello da Messina, through his study of works from the Netherlands at the court in Naples, who united Italian achievements with the painterly qualities of the southern Netherlands (as in, for example, his *St Jerome in his Study*, c. 1460–65; London, N.G.). His visit to Venice in 1475–6 and the influence of Mantegna were of fundamental importance to Venetian painting, particularly to that of Giovanni Bellini.

Over wide areas north and south of the Alps from c. 1450 there was a reversion to Late Gothic forms, such as the elongated figures, the predominance of vibrantly lively lines over sculptural modelling and the inclusion of decorative detail. This shift started in Italian painting with Benozzo Gozzoli's decoration (1459–63) of the chapel in the Palazzo Medici, Florence. In the following period Sandro Botticelli and Filippino Lippi were outstanding representatives of this courtly, refined trend. In the north, works by Dieric Bouts

the elder, for example his altarpiece of the *Last Supper* (Leuven, St Peter), and Hugo van der Goes are typical of these renewed Gothic tendencies. There was a comparable phenomenon in sculpture: south of the Alps in the works of Andrea Verrocchio, Desiderio da Settignano and Antonio Pollaiuolo, for example, and in the north in those of Veit Stoss I and Michael Pacher. How close the image in the north and south can be is illustrated by comparing the figures in Veit Stoss's altar to Our Lady (1477–89; Kraków, St Mary) with Verrocchio's *Christ and St Thomas* (1466–83; Florence, Orsanmichele). Even so, new creative possibilities did emerge amid this return to Gothic forms. Especially in the field of sculpture the idea of a single, fixed viewpoint gave way to multiple viewpoints, again concurrently in the north and the south. Verrocchio's bronze equestrian statue of *Bartolomeo Colleoni* (1483–94; Venice, Campo SS Giovanni e Paolo) is at the same stage of development as *St George* and *St Florian* in Michael Pacher's high altar in St Wolfgang im Salzkammergut (1471–81) or Erasmus Grasser's *Moorish Dancer* (1480; Munich, Stadtmus.).

Only a brief outline of the reasons for this change in style can be given here. Obviously the rich middle classes were increasingly striving to emulate a courtly way of life, as exemplified by the Medici family. In contrast to the early 15th century, it was problems of assimilation rather than demarcation that were at issue. At the same time, especially north of the Alps, a change in the form of individual piety may have played an important role.

Not everything that was happening in Italian art during the 15th century can be classified as a return to Late Gothic forms. Venetian painting, with Giovanni Bellini as its leading figure, moved towards the High Renaissance uninterrupted, with harmoniously balanced composition and an equilibrium between colour and line. These qualities can be seen in the S Giobbe Altarpiece of *c.* 1480 (Venice, Accad; see fig. 69) and in the S Zaccaria Altarpiece (1505; Venice, S Zaccaria). Another innovative artist *c.* 1500 was Piero della Francesca, with his emphasis on a clear outline and the integration of three-dimensional representation into

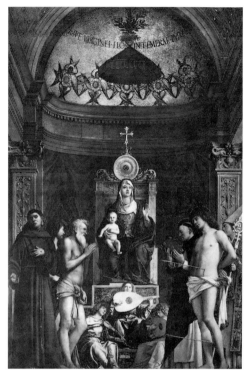

69. Giovanni Bellini: S Giobbe Altarpiece, *c.* 1480 (Venice, Galleria dell'Accademia)

the conditions imposed by the two-dimensional surface.

4. High Renaissance.

All the artistic trends of the 15th century culminated around 1500 in the short-lived High Renaissance whichHeinrich Wölfflin, in *Klassische Kunst* (introduction, 1898), described as the Classic Art of the modern age. It is as hard to give precise time limits to the period as it is to give a comprehensive definition of it. It is generally accepted that artists of the High Renaissance developed more monumental forms and created unified and harmonious compositions that reject the decorative details of 15th-century art.

In terms of the geography of art, there were important shifts in the period from *c.* 1490 to *c.* 1510. Florence lost its cultural ascendancy owing to the fall of the Medici in 1494 and the

subsequent influence of the Dominican monk Girolamo Savonarola. After Savonarola was executed in 1498, Florence alternately fell into the hands of rival forces before the Medici returned to power in 1512. Those two decades were the climax of the High Renaissance, but Florence lacked influential patrons. The papacy with its restored power, on the other hand, attracted leading artists to Rome. In 1506 Pope Julius II appointed Donato Bramante architect for the new St Peter's, in 1505 he commissioned Michelangelo to build his tomb, and in 1508 he appointed Raphael to provide paintings for his private rooms, the Stanze. Rome once again became the centre of the Christian West. At the same time Venice—which retained a powerful and wealthy feudal aristocracy who became enthusiastic patrons of art, particularly of painting—developed as a second important centre whose influence spread throughout 16th-century Europe.

At the start of the 16th century an intense dialogue began between the art of the Italian Renaissance and that of northern Europe, which surpassed earlier isolated, albeit significant, exchanges, and with northern Europe now the main recipient. After c. 1500 most important German and Netherlandish painters spent some years as apprentices in Italy as part of their training, and a wider knowledge of Italian art was spread through woodcuts and engravings.

(i) Architecture. In architecture Rome acted as a catalyst, enabling architects to mature their talents through a study of Classical antiquity. The centrally planned building, contained within itself and developed symmetrically round a centre, was preferred. Donato Bramante's Tempietto in the courtyard of the monastery of S Pietro in Montorio, which is not only a pure centrally planned building but a completely unified structure, is comparable to sculpture with perfectly harmonious proportions. The additive composition of earlier centrally planned buildings, such as Giuliano da Sangallo's Madonna delle Carceri (1485–91) in Prato, was here discarded in favour of a more unified structure. Bramante intended to enclose the building within a circular colonnade, which would

have emphasized its centrality and related it to its surroundings. The new St Peter's was also laid out as a pure centrally planned building, possibly a symbolic reference to its position as the centre of Christendom. In keeping with the size of the project, Bramante designed a richly organized structure, the many spatial compartments of which were brought together in the ground-plan as a square. The extent to which the inspiration of antiquity was at work is indicated by Bramante's proud declaration that in his design for St Peter's he wanted to put the Pantheon on top of Constantine's basilica (the Lateran Basilica). Bramante's scheme, still at its initial stages on his death in 1514, was modified by his successors, who included Raphael, Baldassare Peruzzi and Antonio da Sangallo the younger, and transformed by Michelangelo from 1547 when the sculptor shifted it in a more sculptural direction and incorporated more detail.

Only a few of the great architectural projects of the early 16th century were implemented. The extent to which variants on the idea of the centrally planned building occupied artists' imaginations can be recognized particularly from painted background buildings and design drawings, especially those of Leonardo da Vinci. Of the large church projects that were realized, S Maria della Consolazione in Todi, conceived under Bramante's influence, is the purest incarnation of the spirit of the High Renaissance: no longer is the building assembled from independent cubes, instead the central structure and the transepts blend into one another, with the half-cylinders and half-domes of the transepts serving as a preparation for the circular form and hemisphere of the dominant central dome.

(ii) Sculpture. The complexity and detail of the work of the preceding generation gave way to a new, unified concept of the statue. There were of course preliminary stages, such as the Virgin Enthroned and St Sebastian by Benedetto da Maiano (both Florence, Misericordia, left unfinished on the sculptor's death in 1497). They form part of the foundations of the work of Michelangelo, the most important sculptor of the High Renaissance, who

also contributed decisively towards bringing this brief stylistic period to an end. A series of monumental commissions given to Michelangelo, which included Julius II's tomb (a commission awarded in 1505, then constantly reduced in scale), the cycle of 12 larger-than-lifesize statues for the choir of Florence Cathedral, started in 1506 (only *St Matthew* was executed; Florence, Accad.), the sculptural programme for the façade of S Lorenzo in Florence, which never got beyond the design stage (1516), and the enrichment (from 1524) of the New Sacristy in S Lorenzo, Florence, were on an unprecedented scale and made new demands. Antiquity now played a crucial role as a source of inspiration. The importance of Roman ruins to architecture was paralleled in sculpture by the many antique works that were being excavated in Rome and that came to form the foundations of the Vatican collections. In 1506 the *Laokoon* (Rome, Vatican, Mus. Pio-Clementino) was found, supposedly in the presence of Michelangelo. In 1515 Pope Leo X appointed Raphael overseer of the antique buildings of Rome.

(iii) Painting and graphic art

(a) Italy. Around 1500 Italian painting is notable for its wide range of varied possibilities, some contradictory and some complementing one another. Lively lines could be used as a means of heightening expression, as in the art of Botticelli, but the line could also be exaggerated to virtuosic brilliance, with no inhibitions about effect, as by Filippino Lippi. At the same time the Umbrian school (led by Pietro Perugino) and Venetian painters (particularly Giovanni Bellini) cultivated the modelling of figures and objects by means of light and colour. Alongside the ability of Mantegna and Melozzo da Forlì to achieve powerful illusionistic effects was Piero della Francesca's doctrine of the constitutive importance of the surface. Artists such as Luca Signorelli developed a detailed realism, barely imaginable in the early 15th century, and associated with mastery in conveying the human body in extremes of movement. There are also examples of large-scale and imposing, multi-figured compositions, such as Domenico Ghirlandaio's frescoes of the *Life of the Virgin* and

Life of St John the Baptist (1486–90) in the choir of S Maria Novella, Florence. The subject-matter of the early 15th century had been expanded by a wide range of mythological, secular themes.

Against all probability and expectation, elements that had to some extent appeared irreconcilable came together in a synthesis *c.* 1500, beginning with Leonardo da Vinci's *Last Supper* (see fig. 70) for the refectory of S Maria delle Grazie in Milan in 1496–7. The viewer is initially overwhelmed by apparently being able to identify with the painted figures but is in fact held at a distance by the various perspective systems governing real and artistic space, the ideal nature of the composition, which has been thought through to the last detail, and the monumental scale of the figures. In Leonardo's panel paintings his compositional skill is combined with a revolutionary approach to painterly qualities. Increasingly line was replaced by the modulation of colour, and the transitions between figures and landscapes became fluid. Space came to be conveyed not primarily by the use of mathematical perspective, but by lightening the colour and gradually softening the outlines. Leonardo, the perfect embodiment of the ideal of an artist able to work in every artistic sphere and at the same time possessing universal knowledge, did not receive the recognition and understanding that were his due in either Florence or Rome. His move to North Italy, justified in worldly terms by a large number of prestigious commissions from Ludovico Sforza, Duke of Milan, was ultimately sanctioned by an internal logic: close to Venice, he was able both to develop and to spread his influence. The Venetian approach to colour, created by Giorgione and the young Titian, is inconceivable without knowledge of Leonardo.

Next to Leonardo, Raphael most perfectly represents the ideals of the High Renaissance. Born in Urbino, he was exposed to the works and theories of Leon Battista Alberti and Piero della Francesca while still very young. His feeling for the painterly treatment of contours and his gift for depicting landscape were developed in Umbria in Perugino's studio. During the years he spent in Florence his drawing became more precise, he

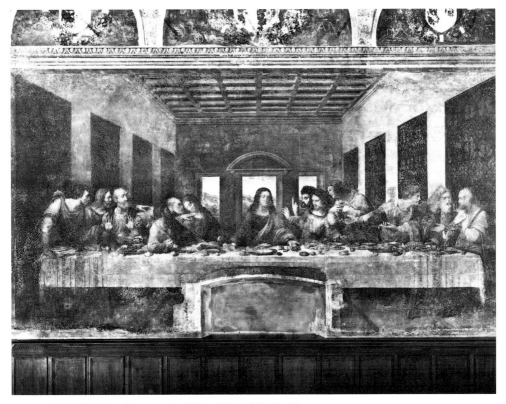

70. Leonardo da Vinci: *Last Supper*, 1496–7 (Milan, S Maria delle Grazie)

acquired an understanding of how to convey the human body in movement, and at the same time the works of Fra Bartolomeo provided him with a model for the large-scale organization of monumental compositions, which he then perfected on Roman soil in his own frescoes under the influence of antique monuments. As with Leonardo's *Last Supper*, the *Disputà* and the *School of Athens* (see col. pl. XXXIII), both in the Stanze at the Vatican, do not at first sight reveal the artistic intelligence with which the tension between the painted space and the flat surface is resolved, or how the unpromising, badly lit wall surfaces, asymmetrically interrupted by doors, are seemingly transformed into virtually 'ideal' formats; or how the unforced and apparently casual figure groupings are in fact thought out down to the smallest detail and are extensively prepared in a long series of studies; or, finally, how the complicated iconographical programmes are made readily comprehensible.

(b) Germany. The High Renaissance is essentially a phenomenon of Italian art. North of the Alps the antique tradition, the inspiration of all 'classical art', was absent. The great exception is the work of Albrecht Dürer. In northern Europe an interest in the ideals of Italian art, at present inexplicable in terms of the history of either art or civilization, culminated in the work of Dürer. In the 15th century the greatest northern achievements had taken place in the Netherlands, but in the 16th century Germany became the dominant artistic centre. Initially Dürer used line as his prime means

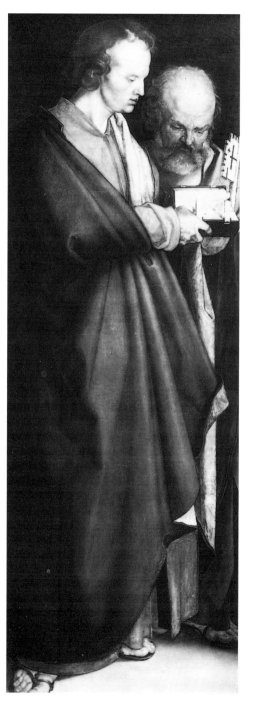

of expression, and accordingly in his early work woodcut and engraving are at the centre of his creative output. His decisive encounter with Italian art took place in the course of his two journeys to Italy in 1494–5 and 1505–7. From the Venetians, above all Giovanni Bellini, he learnt to use colour to soften outlines and recognized the need for a theory of art going beyond the purely intuitive description of objects. Presumably he also went to Rome during his second stay in Italy and was able to see the monuments of antiquity for himself. The *Virgin of the Rose Garlands* (1506; Prague, N.G.) painted in Venice for the Fondaco dei Tedeschi, the Landauer Altarpiece (Vienna, Ksthist. Mus.)—a counterpart to Raphael's *Disputà*—and the *Four Apostles* (1526; Munich, Alte Pin.; see fig. 71) superbly demonstrate a blending of the German and Italian feeling for form.

Dürer's great German contemporaries cannot be categorized as High Renaissance artists. Matthias Grünewald has even been described as the 'master of anti-classical painting' (A. M. Vogt). He emphasized the expressive power of colour. His Isenheim Altar (begun *c.* 1512; Colmar, Mus. Unterlinden) is the most important contribution to the history of colour ever made throughout the course of German art. Further research is still needed to establish the extent of any connection between it and Leonardo's new colour theories and the work of Giorgione. The painters of the Danube school, especially Lucas Cranach the elder as a young man, Albrecht Altdorfer and Wolfgang Huber, also took colour as their starting point (see col. pl. X).

(iv) **The move towards Mannerism.** The High Renaissance period could only last a short time. The integration of the real into the ideal, of the utmost fullness of life into something strictly composed, of the spontaneous into the intellectual, of the extremely individualistic into the typical, of the perfect, illusionistic representation of space into a flat surface and of the secular into the sacred

71. Albrecht Dürer: *SS John and Peter*, left wing of the altarpiece of the *Four Apostles*, 1526 (Munich, Alte Pinakothek)

could not be surpassed. It was in fact the very people who had participated in the High Renaissance who introduced new developments: Michelangelo when he painted the ceiling of the Sistine chapel in the Vatican (1508–12) by the passionate sweep of movement in his figures and the blurring of the boundaries between painting and sculpture; Raphael in the later Stanze in the Vatican and his final panel paintings (e.g. *Transfiguration*, 1517–19; Rome, Pin. Vaticana) by his emphasis on spatial depth at the expense of surface, on colour at the expense of line, on the contrasts of light and shade at the expense of an even spread of light, and on the free equilibrium of forces at the expense of a balance achieved by near symmetry; and finally Leonardo by the *sfumato* of his late works causing figures and objects to retreat as it were behind a veil. They opened the way to the late Renaissance phase now generally referred to as Mannerism.

Bibliography

L. B. Alberti: *Della pittura* (Florence, 1435); ed. L. Mallé (Florence, 1950)

P. della Francesca: *De prospectiva pingendi* (MS.; before 1482); ed. G. Nicco Fasola, 2 vols (Florence, 1942/*R* 1984)

L. B. Alberti: *De re aedificatoria libri X* (Florence, 1485); ed. G. Orlandi (Milan, 1966)

G. Vasari: *Vite* (1550; rev. 2/1568); ed. G. Milanesi (1878–85)

J. Burckhardt: *Die Kultur der Renaissance in Italien* (Basle, 1860)

J. Huizinga: *Herfsttij der Middeleeuwen: . . .* (Haarlem, 1919); Eng. trans. as *The Waning of the Middle Ages: A Study of the Forms of Life, Thought and Art in France and the Netherlands in the 14th and 15th Centuries* (London, 1924/*R* 1980)

D. Frey: *Gotik und Renaissance als Grundlagen der modernen Weltanschauung* (Augsburg, 1929)

A. Warburg: *Gesammelte Schriften*, ed. G. Bing, 2 vols (Leipzig and Berlin, 1932/*R* Nedeln, 1969)

M. Wackernagel: *Der Lebensraum des Künstlers in der florentinischen Renaissance: Aufgaben und Auftraggeber, Werkstatt und Kunstmarkt* (Leipzig, 1938; Eng. trans., Princeton, 1981)

E. Panofsky: *Studies in Iconology: Humanist Themes in the Art of the Renaissance* (New York, 1939/ *R* 1962)

F. Antal: *Florentine Painting and its Social Background* (London, 1943)

A. Chastel and R. Klein: *L'Age de l'humanisme* (Paris, 1963)

H. Bauer: *Kunst und Utopie: Studien über das Kunst- und Staatsdenken in der Renaissance* (Berlin, 1965)

J. Burckhardt: *Der Cicerone: Eine Anleitung zum Genuss der Kunstwerke Italiens* (Basle, 1855)

H. Wölfflin: *Renaissance und Barock* (Munich, 1888; Eng. trans., London, 1964)

—: *Die klassische Kunst: Eine Einführung in die italienische Renaissance* (Munich, 1899; Eng. trans., Oxford, 1953)

M. Dvořák: *Geschichte der italienischen Kunst im Zeitalter der Renaissance*, 2 vols (Munich, 1927–9)

H. Wölfflin: *Italien und das deutsche Formgefühl* (Munich, 1931)

W. Pinder: *Die deutsche Kunst der Dürer-Zeit* (Leipzig, 1940)

E. Panofsky: *Renaissance and Renascences in Western Art*, 2 vols (Stockholm, 1960)

The Renaissance and Mannerism: Studies in Western Art. Acts of the 20th International Congress of the History of Art: Princeton, 1963

A. Chastel: *Italienische Renaissance: Die grossen Kunstzentren* (Munich, 1965)

—: *Italienische Renaissance: Die Ausdrucksformen der Künste* (Munich, 1966)

E. H. Gombrich: *Norm and Form: Studies in the Art of the Renaissance* (London, 1966)

A. Chastel: *Der Mythos der Renaissance, 1420–1520* (Geneva, 1969)

M. Wundram: *Frührenaissance* (Baden-Baden, 1970)

F. W. Fischer and J. J. Timmers: *Spätgotik: Zwischen Mystik und Reformation* (Baden-Baden, 1971)

J. Bialostocki: *Spätmittelalter und Beginn der Neuzeit* (Berlin, 1972)

P. Burke: *Tradition and Innovation in Renaissance Italy* (London, 1972)

F. Seibt, ed.: *Renaissance in Böhmen* (Munich, 1985)

J. Burckhardt and W. Lübke: *Geschichte der Renaissance in Italien* (Stuttgart, 1878, 3/1891)

C. von Stegmann and H. von Geymüller: *Die Architektur der Renaissance in Toscana*, 11 vols (Munich, 1885–1909)

H. Willich and P. Zucker: *Die Baukunst der Renaissance in Italien*, 2 vols (Potsdam, 1914–29)

A. Haupt: *Baukunst der Renaissance in Frankreich und Deutschland* (Berlin and Neubabelsberg, 1923)

R. Wittkower: *Architectural Principles in the Age of Humanism* (London, 1952)

P. Murray: *The Architecture of the Italian Renaissance* (London, 1969/*R* 1981)

H. A. Milton and V. M. Lampugnani, eds: *The Renaissance from Brunelleschi to Michelangelo: The Representation of Architecture* (London, 1994)

W. Pinder: *Die deutsche Plastik vom Mittelalter bis zum Ende der Renaissance*, 2 vols (Potsdam, 1914–29)

J. Pope-Hennessy: *Italian Renaissance Sculpture* (London, 1958)

T. Müller: *Sculpture in the Netherlands, Germany, France and Spain*, Pelican Hist. A. (Harmondsworth, 1966)

C. Seymour jr: *Sculpture in Italy, 1400–1500*, Pelican Hist. A. (Harmondsworth, 1966)

K. Escher: *Die Malerei des 14.–16. Jahrhunderts in Mittel- und Unteritalien* (Potsdam, 1922)

R. van Marle: *Italian Schools* (1923–38)

M. Friedländer: *Die altniederländische Malerei* (The Hague, 1924)

E. van der Bercken: *Malerei der Früh- und Hochrenaissance in Oberitalien* (Potsdam, 1927)

A. Stange: *Deutsche Malerei der Gotik*, 11 vols (Munich, 1934–61)

G. Ring: *A Century of French Painting, 1400 to 1500* (London, 1949)

L. Venturi: *La Peinture italienne*, 3 vols (Geneva, 1950–)

E. Panofsky: *Early Netherlandish Painting: Its Origins and Character*, 2 vols (Cambridge, MA, 1953)

J. White: *Birth and Rebirth of Pictorial Space* (London, 1957, rev. 1975)

S. Freedberg: *Painting of the High Renaissance in Rome and Florence*, 2 vols (Cambridge, MA, 1961)

R. Salvini: *Pittura italiana II: Quattrocento* (Munich, 1962)

MANFRED WUNDRAM

Renaissance Revival

Term in use from the mid-19th century to describe a style of architecture and the decorative arts that flourished in the West from the early 19th century to early 20th. It was based on the arts of the Renaissance, initially of Italy (15th–16th centuries), and later on its regional manifestations (16th–17th centuries), principally of France and Germany.

1. Architecture.

The first impetus for the revival came from France, with the publication of Jean-Nicolas-Louis Durand's *Précis de leçons d'architecture* (1802–5) and Auguste-Henri Grandjean de Montigny's *L'Architecture de la Toscane* (Paris, 1806–19), both of which cited examples from the Italian Renaissance. Early French buildings in a Roman Renaissance palazzo style include those in the Rue de Rivoli (begun 1802) by Charles Percier and Pierre-François-Léonard Fontaine, and the Ministère des Relations Extérieures (begun 1810; destr. 1871) in Paris by Jacques-Charles Bonnard (1765–1818). In Germany, where the Renaissance Revival was exclusively taken from Italian models until the mid-19th century, Leo von Klenze designed for the Leuchtenbergpalais (1818–21), Munich, and other palaces in styles that also recalled Roman models, particularly the Palazzo Farnese, but his example was slow to be followed. In England the style was taken up particularly by architects of London clubs, notably Charles Barry in his Travellers Club (1829–32) and the adjacent Reform Club (1837–41), both Pall Mall. The increasingly rich treatment of the revival is exemplified by Félix Duban's façade (begun 1833), in 16th-century Italian style, for the Ecole des Beaux-Arts, Paris. A decade later the style had crossed the Atlantic, an early example being John Notman's Athenaeum Club (1845), Philadelphia, based on Barry's work; it was also being advocated by Arthur delavan Gilman.

By the middle of the 19th century a more diverse range of Italian sources was being used. Gottfried Semper's Hoftheaters in Dresden (the first 1838–41; destr.; the second 1865–71; destr. 1945, reconstructed) were examples of the stylistic transition from the elegance of the cinquecento to the richness of the seicento; other examples of this later style include the Heinrichshof (1861), Vienna, by Theophilus Hansen; the Ungarische Akademie der Wissenschaften (1862–4; now the Magyar Tudományos Akadémia), Budapest, by Friedrich August Stüler; the Foreign and India Offices (1868), London, by George Gilbert Scott I; and the Palazzo della Cassa di Risparmio (1868–76), Bologna, by Giuseppe Mengoni.

One of the first examples of a national Renaissance Revival was the reconstruction (1836–48; destr. 1871) in a 16th-century French style of the

Hôtel de Ville, Paris, by Jean-Baptiste-Cicéron Lesueur and Etienne-Hippolyte Godde. This development was widely imitated, and French-style buildings include the Schwerin Schloss (begun 1842) by Georg Adolph Demmler; the Great Western Hotel (1851), London, by Philip Hardwick; the Amstel Hotel (1864–7), Amsterdam, by Cornelis Outshoorn; the Palais Kronenberg (1866–70; destr.), Warsaw, by Friedrich Hitzig; and the State, War and Navy Building (1871–86; now Old Executive Building; see fig. 25), Washington, DC, by Alfred B. Mullet. By the 1870s, however, this French aspect of the Renaissance Revival was becoming indistinguishable from the SECOND EMPIRE STYLE.

The German Renaissance Revival began to establish itself in the 1870s, the earliest examples being Julius Raschdorff's entrance hall (begun 1866) for the Rathaus, Cologne, and the Schackgalerie (1872–4), Munich, by Lorenz Gedon (1843–83). The full development of the style is represented by the work of Kayser & von Grossheim, particularly their Deutscher Buchhändlerhaus (1886–8), Leipzig. The last phase of the style is exemplified by the Rathaus (1899–1905), also in Leipzig, by Hugo Licht. In England architects borrowed freely from both French and German Renaissance Revivals, as well as developing their own peculiarly English style, the QUEEN ANNE REVIVAL, derived from a combination of elements drawn from 17th- and early 18th-century models.

Bibliography

P. L. Moreau: *Histoire générale de l'art au XIXe siècle* (Paris, c. 1910), pp. 1–33, 299–303, 333–8, 365–9, 394–5, 404–05

L. Patetta: *L'architettura dell'eclettismo* (Milan, 1975)

K. Milde: *Neorenaissance in der deutschen Architektur des 19. Jahrhunderts* (Dresden, 1981)

C. Mignot: *L'Architecture au XIXe siècle* (Fribourg, 1983)

M. Major: *Geschichte der Architektur*, iii (Berlin, 1984)

D. Maddex: *Master Builders* (Washington, DC, 1985)

R. Middleton and D. Watkin: *Neoclassical and Nineteenth Century Architecture* (London, 1987)

G. Ulrich Grossman and P. Krutisch, eds.: *Renaissance der Renaissance: ein bürgerlicher Kunststil im 19.*

Jahrhundert-Nachtrag, Schriften des Wesserrenaissance-Museums Schloss Brake bei Lemgo, viii (1995)

JULIUS FEKETE

2. Decorative arts

The revival of Renaissance forms paralleled that in architecture, following first Italian, then regional models. Furniture in the Renaissance style was usually of a rather eclectic nature combining elements, usually carved or inlaid, based on north Italian furniture of c. 1500 and sometimes on the later models of Mannerist architecture. The François Ier and later French styles were also often quarried for ideas. Cheaper articles of furniture relied on numerous brackets and shelves, small, usually broken pediments and machine-made carving for effect. More expensive pieces (e.g. rosewood cabinet inlaid with engraved ivory designed by Stephen Webb, made by Collinson & Lock, c. 1890; London, V&A) were often beautifully made, but they still bore evidence of deriving from a combination of period sources. A brass four-poster bed exhibited by R. W. Winfield at the Great Exhibition (1851), London, was an assemblage of motifs, bearing no resemblance to any known Renaissance bed. In France the style was considered particularly appropriate for dining-rooms, and in consequence was largely confined to upright chairs, tables and cabinet furniture (e.g. ebony cabinet with gilt-bronze ornaments, c. 1865, made for the house of Thérèse-Esther-Pauline-Blanche Païva in the Champs Elysées; now Paris, Mus. A. Déc.). It was also popular for smoking-rooms and men's studies. In Germany the style was popularized by Jacob von Falke, who declared in his book *Die Kunst im Hause* (1871) that it could not be improved upon for interior decoration. Following an American edition of the book in 1878, the Renaissance Revival became the preferred style of rich Americans. The most palatial examples were inside the 'cottages' built by Richard Morris Hunt at Newport, RI, in the 1880s and 1890s. However, the style had already achieved popularity among a lower social class, and, since the 1870s, there had

been mass production of what was loosely called 'French Renaissance' furniture, principally by firms in Grand Rapids, MI, which continued until the end of the century. The favourite material was walnut. A particularly gross Renaissance Revival bedroom suite (now Grand Rapids, MI, Pub. Mus.) was exhibited by Berkey & Gay at the Centennial International Exposition (1876) in Philadelphia. This ponderous suite features pediments, strapwork, columns, brackets, decorative veneer panels and a variety of virtually unclassifiable but vaguely 16th-century-derived ornament.

Renaissance Revival jewellery became increasingly popular after *c.* 1840, when the fashion was set by such Parisian jewellers as François-Désiré Froment-Meurice (1802–55), who in 1844 was offering 'François I' and 'Medici' brooches. At the same time another Parisian jeweller, Marchand, was reviving strapwork designs for medallions, brooches and chased bracelets. Vienna became known as a source for mass-produced Renaissance Revival jewellery (by such firms as J. Bacher & Sons and Herman Ratzersdorfer), and in London, members of the Giuliano family, particularly Carlo Giuliano (1831–95) after 1875, were active in adapting Renaissance designs to current demands. The fashion continued into the late 19th century, one particularly fine, late example being the 'Diane' Bracelet (1883; Paris, Mus. A. Déc.), in gold, enamels and diamonds, made by Alphonse Fouquet (1828–1911) after a model by Albert-Ernest Carrier-Belleuse, with enamels by Paul Grandhomme. Jewellers also produced objects of vertu in Renaissance style, such as a table centrepiece (1844; Paris, Mus. A. Déc.), made by Jean-Baptiste Klagmann (1810–67), comprising three dishes of glass and gilt-bronze set with precious stones, and a covered cup (*c.* 1860; Paris, Chaumet Mus.) by Morel & Cie, made of rock crystal, gold and enamel.

Ceramics in Renaissance Revival style were also widely manufactured. Wares in the manner of the 16th-century French potter Bernard Palissy were particularly popular in France. Maiolica wares were also widely imitated at factories in France, Italy and England, where Minton in particular copied the Saint-Porchaire ware.

Bibliography

J. von Falke: *Die Kunst im Hause* (Vienna, 1871; Eng. trans., Boston, CT, 1878)

H. Hayward, ed.: *World Furniture* (London, 1965), pp. 216–17, 241–3, 250–53

R. J. Charleston, ed.: *World Ceramics* (London, 1968), pp. 288–9

P. Thornton: *Authentic Decor: The Domestic Interior, 1620–1920* (London, 1984)

CHARLES WHEELTON HIND

Rococo

A decorative style of the early to mid-18th century, primarily influencing the ornamental arts in Europe, especially in France, southern Germany and Austria. The character of its formal idiom is marked by asymmetry and naturalism, displaying in particular a fascination with shell-like and watery forms. Further information on the Rococo can be found in this dictionary within the survey articles on the relevant countries.

I. INTRODUCTION

The nature and limits of the Rococo have been the subject of controversy for over a century, and the debate shows little sign of resolution. As recently as 1966, entries in two major reference works, the *Penguin Dictionary of Architecture* and the *Enciclopedia universale dell'arte* (*EWA*), were in complete contradiction, one altogether denying its status as a style, the other claiming that it 'is not a mere ornamental style, but a style capable of suffusing all spheres of art'. The term Rococo seems to have been first used in the closing years of the 18th century, although it was not acknowledged by the Académie Française until the 1842 supplement to its dictionary, which defines it as the type of ornament that characterized the reign of Louis XV and the beginning of that of Louis XVI. The term was originally derogatory, probably derived from the term Rocaille, on the model of the Italian *barocco*. Rocaille, which had originally referred to the shell-work employed in garden grottoes, began from 1736 to be

used to designate a specific mode of decoration. Critical analysis of the Rococo style was inaugurated by Gottfried Semper; he isolated its essence as organic and, in an attempt to relate the genesis of the style to the invention of porcelain in Europe, he identified it as a *Stoffstil*. In 1873 von Zahn pointed out the fallacy of this theory but likewise sought the origins of the plastic character of Rococo ornament in the nature of a material, this time stucco. Jessen (1894) again concentrated on naturalism, while Schmarsow in 1897 characterized the antithesis between Baroque and Rococo forms as plastic versus painterly; however, he almost entirely neglected the Rococo's French origins. Brinckmann (1919) used in his analysis of the Rococo the same concepts of space and plasticity that he had applied to the Baroque and later (1940) conceived the Rococo as an organic development of the Baroque. In 1922 Rose similarly analysed the Rococo only in terms of the late Baroque, while in the same year Giedion replaced the notion of the Rococo with his concept of late Baroque classicism, as opposed to the romantic classicism of the later 18th century.

A more pragmatic trend began to emerge in opposition to this highly theoretical scholarship. It had originated in the Goncourt brothers' *L'Art du XVIIIe siècle*, which uncovered many new sources and pioneered a fresh appreciation of Rococo decoration in purely aesthetic terms. The culmination of a series of early 20th-century monographs by such French scholars as H. Clouzot and P. de Nolhac was the classic study by the American scholar Fiske Kimball, *The Creation of the Rococo* (1943), which was the first to successfully delimit the style to its proper fields of influence—essentially the decorative arts—and to identify the protagonists in the story of its development in France. He argued, vehemently and convincingly, against the supposition that it was the final phase of the Italian Baroque or that it had arisen in reaction to it. In 1966 Nikolaus Pevsner denied that the Rococo was a style at all, on the grounds that true stylistic transformations corresponded only to what he conceived of as great watersheds in Western thought. In the same

year, however, Hans Sedlmayr and Hermann Bauer (*EWA*) asserted that the term Rococo was by no means restricted to ornament but encompassed all the arts in Europe in the first half of the 18th century. They consequently included under the heading Rococo such diverse and clearly unrelated phenomena as *scene vedute in angolo*, an Italian Baroque stage-device invented by Ferdinando Galli-Bibiena in 1703, and Denis Diderot and Jean d'Alembert's *Encyclopédie*. Anthony Blunt made admirable progress towards a workable definition of the Rococo in the paper he read to the British Academy in 1972, *Some Uses and Misuses of the Terms Baroque and Rococo . . .* . He followed Kimball in arguing persuasively that the application of the term should be restricted to groups of works that had certain fundamental formal qualities in common.

II. FRANCE

1. Beginnings of the Rococo, to 1715

In the last decade of the 17th century there was a stylistic shift in the court art of Louis XIV (*reg* 1643–1715). The death of Jean-Baptiste Colbert in 1683 and the waning of Charles Le Brun's influence brought to an end the stylistic hegemony of the rich Italian Baroque interiors of Pietro da Cortona, first introduced to Paris by Giovanni Francesco Romanelli in his work of 1644 for Cardinal Jules Mazarin. Despite the depleted state of the French royal treasury, the remodelling of rooms at Versailles continued, although now on a smaller scale and using more informal materials, such as *boiserie* and mirror glass, rather than the precious metals and marble that had characterized the Grands Appartements. An early experiment in single-storey apartment planning—a theme that was to be particularly important in the first half of the 18th century—was the Trianon de Porcelaine (1670; destr. 1687), built at Versailles after the model of the Imperial Palace of Beijing, as recorded in Jan Nieuhoff's *L'Ambassade de la compagnie orientale des provinces unies* (Paris, 1665). As Tadgell maintained (see Blunt, 1978), it would be misguided to talk about 'Rococo planning',

but the almost universal replacement of rooms arranged *en enfilade* by the apartment with its suite of small, comfortable rooms must have been congenial to the adoption of the Rococo, a style ideally suited for the intimate interior. The extent to which Chinese art might have influenced the development of the Rococo has not yet been fully elucidated. One particular enigma is the inspiration for André Le Nôtre's Bosquet des Sources in the grounds of the Trianon de Porcelaine, a small enclosed garden riddled with irregular streams and rivulets, thus demonstrating an interest in asymmetry and 'naturalism' several decades before the Rococo proper.

The office of Premier Architecte du Roi was revived for Jules Hardouin Mansart in 1683, and in his studio the new generation of designers enjoyed much greater individual freedom than had hitherto been allowed. From a careful analysis of personal styles Kimball showed that, although all decorative schemes bear Mansart's signature, specific motifs and innovations can be identified in the work of particular designers in his team; the two most important were Pierre Lassurance I and Pierre Le Pautre. There exist numerous designs by Lassurance from the period 1684–99: one of the earliest of these (1685) was a project for the Petite Galerie at Versailles to be revetted in mirror glass, with small consoles placed against the glass to support a myriad of miniature vases. This failed to be executed, but designs by Lassurance were realized in the left wing of the Trianon de Marbre and in the Salon Ovale in the main château. In contrast to the rigid geometry of these, the rooms that were commissioned from him for the young Duchesse de Bourgogne, her chamber at the Trianon and the Appartement d'Été at the Ménagerie (1698–9), were panelled in *boiserie* of unprecedented liveliness, with tall, arched mirrors and circular panels in place of a dado.

The use of these tall, arched mirrors over chimney-pieces was rapidly adopted in royal residences, for example by Jean Berain I in the Cabinet du Dauphin at the château of Meudon (destr.) in 1699, and in the remodelling of the Grand Salon at the château of Marly (partly destr.) in the same year. Here the chimney-pieces were designed by Le Pautre; and in contrast to Lassurance's geometric framework, the decorative elements, which previously were restricted to mouldings and friezes, now extended across the surface of the woodwork. Most notably, the acute angles of the panels over the mirrors were truncated by C-scrolls ending in a flourish of acanthus, a device adapted from the painted arabesques of Berain. In 1700 several such chimney-pieces were installed at Versailles in private apartments, and in 1701 the long-overdue remodelling of the Appartement du Roi was undertaken: two rooms in the south-west corner of the Cour de Marbre were combined to create the Salon de l'Oeil de Boeuf, thus providing a suitable antechamber to the central salon of the Petit Château, which now became the Chambre du Roi. Le Pautre was responsible for the extant drawings in both cases. In the Salon de l'Oeil de Boeuf a deep coving, scored with a fine network of gold lines, formed the background for a frieze of gambolling infants; here youthfulness was triumphant. In the last years of Louis XIV's reign, the new style was adopted in numerous interiors that betray Le Pautre's involvement, ranging from Parisian hôtels particuliers, such as the Hôtel de Pontchartrain (interiors 1703), to ecclesiastical architecture, most notably the chapel at Versailles (1706–10), throughout which the stone piers and vaults are carved as though in *boiserie* with arabesques and asymmetrical *trophées d'église*.

2. Régence style, 1715–c. 1730

On the death of Louis XIV in 1715, Philippe II, Duc d'Orléans, was appointed regent for the five-year-old Louis XV. Although the regency lasted only until 1723, the characteristic phase of Rococo decoration identified as the RÉGENCE STYLE continued until the end of the decade. Gilles-Marie Oppenord, Premier Architecte of the Duc d'Orléans, was given the lead in architecture with the remodelling of the Palais-Royal, Paris, the seat of the regency. Here he terminated the gallery with a magnificent oval hemicycle, at the centre of which a huge mirror rose from the mantel to the entablature. This was crowned by figures of Victory

holding a shell cartouche, from which folds of Baroque drapery cascaded over the mirror. On either side, fluttering ribbons and acanthus leaves scrolled outwards from monumental military obelisks that were carved in relief on the panels.

In 1718 a similarly bold scheme was prepared for the gallery of the Hôtel de La Vrillière (now the Banque de France), Paris, by François-Antoine Vassé (1681–1736), who became the chief designer at the Bâtiments du Roi on Le Pautre's death in 1716. Vassé's first scheme exactly paralleled Oppenord's, except that the military trophies were not confined to obelisks but ran freely the length of the wall, appearing to deform the panels on which they were carved. Instead of framing the opening of the fireplace with a stable ellipse, as Oppenord had done, Vassé adopted a boldly curvaceous design, in which two rippling S-curves met to form the outline of a bow. When executed, the designs were fractionally tamer, but the entablature was interrupted above the chimney-piece by a ship's prow thrusting out of the wall-mass. In both these works, the new freedom of ornament introduced by Le Pautre was coupled with a newly displayed plasticity. When Oppenord worked on a smaller scale, as at the Hôtel d'Assy of 1719, the carved ornament regained its characteristic linearity and playful lightness and lost almost all trace of rectangular geometry.

Further developments in interior decoration were made by the favourite architect of the house of Condé, Jean Aubert, who was employed on the rebuilding (1718–22) of the Grand Château at Chantilly. In the Chambre de Monsieur le Prince and the Salon de Musique (1722), he extended gold filigree across the expanses of white panelling in a manner that had by then become conventional; in adventurous contrast, however, spidery scrollwork frothed out on to the ceilings above the cornice at the corners and mid-points of the walls.

A rare parallel in the field of contemporary pictorial art can be noted in the late masterpieces of Antoine Watteau. His first *fête galante*, *Pilgrimage to the Isle of Cythera* (Paris, Louvre; see fig. 72), was accepted by the Académie Royale in 1717. He had previously worked for Claude Gillot and Claude Audran III, both masters of the Arabesque style; and it was in the medium of this purely decorative work that Watteau developed his charming pastoral scenes. He was also one of the earliest to exploit the asymmetries inherent in Chinese art, in his designs for painted panels (1720) in the Cabinet du Roi at the Château de La Muette, which are known only from the series of engravings *Figures chinoises et tartares*.

3. Genre pittoresque or rocaille, after c. 1730

Before 1730 there had been little development from the essential innovations of Le Pautre, and decorative motifs remained on the whole well behaved and conventional, although in the 1720s Thomas Germain had begun to incorporate vegetable motifs, for example cauliflowers, into his silverwork. Now a new unruliness set in, the responsibility for which has been variously attributed to Juste-Aurèle Meissonnier and Nicolas Pineau. Trained as a goldsmith, in 1726 Meissonnier was appointed Dessinateur de la Chambre et du Cabinet du Roi, a post formerly held by Berain. At this date he had already begun to experiment with the asymmetry or *contraste* that was to transform the decorative arts of 18th-century Europe. In his design for a monstrance (1727) for the Carmelites of Poitiers, the Glory is borne aloft by vigorously spiralling clouds, from which ears of wheat, bunches of grapes and cherubs sprout asymmetrically. In the following year he designed a candlestick of such convoluted form that it required three separate engravings (figs 10–12) in the *Oeuvre de Juste-Aurèle Meissonnier*, posthumously published by Gabriel Huquier (1742–51), to convey its form. Although Meissonnier was anxious to obtain architectural commissions—he seems to have volunteered his extraordinary design for the façade of St Sulpice, Paris, in 1726, while Oppenord was still the architect—he was responsible for only a single building, a house (1733) for Léon de Brethous in Bayonne, and a handful of interiors, such as the cabinet (1734) for Count Franciszek Bieliński in Dresden and the apartment (after 1736) for the Baronne de Bézenval in Paris.

Pineau, having returned from Russia, worked in Paris in association with the architect Jean-

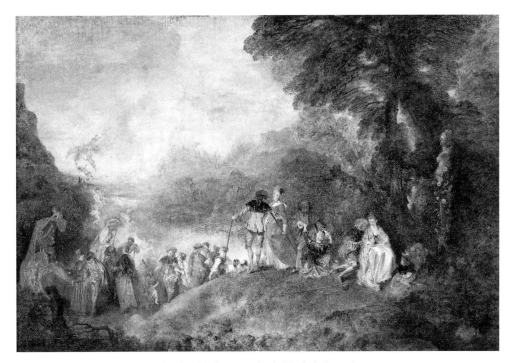

72. Antoine Watteau: *Pilgrimage to the Isle of Cythera*, 1717 (Paris, Musée du Louvre)

Baptiste Le Roux, being responsible for important interiors at the Hôtel de Rouillé (*c.* 1732), Hôtel de Villars (1731–3), Hôtel de Roquelaure (1733) and Hôtel Mazarin (1736). While Meissonnier had invested his work with a robust plasticity, giving fluidity not only to the ornament but also to the wall-mass, Pineau confined his creative energy to the feathery network of gilt filigree that became ever more playful. He stopped short of the flagrant asymmetries in individual panels introduced by Meissonnier, but it was this *contraste* that was to be vital to the spate of ornamental engravings that appeared in the 1730s. These had been foreshadowed, in theme if not in form, by the *Desseins à plusieurs usages* (*c.* 1716) of Bernard Toro, which include a series of grotesque cartouches that harked back to the etchings of Stefano della Bella. In Meissonnier's own *Livre des légumes* (1733) and *Livre d'ornemens* (1734), the fantasy is not restricted to cartouches but applied to a wide range of objects, from silverwork to fountains, producing the most extreme and characteristic expression of the Rococo, known as *genre pittoresque* or rocaille. Similar suites of engravings were produced by Jacques de Lajoüe, in his *Recueil nouveau de différens cartouches* (1734) and *Livre nouveau de douze morceaux de fantaisie* (1736); by Jean Mondon (*fl c.* 1736–45) in *Premier livre de forme rocquaille et cartel* (1736) and *Ornemens chinois* (1736); by François de Cuvilliés I in *Livres de cartouches* (1738); and even by François Boucher. It was through the medium of these and similar prints issued in Augsburg and Nuremberg that Rococo ornament was rapidly diffused throughout Europe, creating an international style in the decorative arts.

In addition to *boiserie* and metalwork, crafts that were immediately influenced by such prints were furniture and porcelain—minor arts that rose to a new pre-eminence. The demand for furniture decorated in the manner of André-Charles

Boulle with inlaid woods, usually in patterns of scrolling bandwork and arabesques, was such that in 1723 the Parisian guild of *ébénistes* had been founded. In the work of the great designers Charles Cressent and Jacques Caffiéri, the lines of chairs and commodes became extravagantly curvaceous. Although porcelain—now made in Europe—did not play an important role in the actual development of the style, its reflective glazes, small scale and easily moulded forms ensured its rapid adoption for the manufacture of Rococo ornaments.

By the late 1730s the Rococo reached its apogee in France: it was universally accepted and underwent no further development. The most important works of this late period were those undertaken at the late age of 69 by Germain Boffrand. For most of his career he had produced buildings of a restrained classicism, but the corner pavilion (1735–9) he added to the Hôtel de Soubise , Paris, housed two oval salons with immensely rich and animated interiors. In the Salon Ovale (Salon de la Princesse) (see col. pl. XXXV), the rhythmic succession of arched mirrors, doors and windows was united by Charles-Joseph Natoire's series of painted panels in the spandrels and by the undulating coving, which both supported putti and, at intervals, extended tentacles of filigree to the central rosette.

It is not surprising that after several decades of popularity, so extreme a style should provoke a critical reaction. As early as 1731 Voltaire voiced criticism in his *Temple du goût*; and in 1737 Jacques-François Blondel railed in *De la distribution des maisons de plaisance et de la décoration des édifices en général* (1737–8) against the 'ridiculous jumble of shells, dragons, reeds, palm-trees and plants' in contemporary interiors. The Abbé Jean-Bernard Le Blanc published in 1747 a letter to the Comte de Caylus criticizing the loss of 'noble simplicité' in French decorative arts. In 1749 he read two papers on the same theme to the Académie Royale and continued his attack in a review of the Salon of 1753. In the next two years there appeared in the *Mercure de France* two famous articles by Charles-Nicolas Cochin *le fils* ridiculing the current taste; the first was entitled 'Supplication aux orfèvres', while the second ironically purported to be by a group of Rococo architects. Although it was to be another decade before the *Goût grec* provided an alternative style for interior decoration, it was there, in the circle of the Marquis de Marigny, that the first stirrings of the reaction to the Rococo in France were felt, foreshadowing the return to classicism in the later part of the century.

Bibliography
EWA

E. de Goncourt and J. de Goncourt: *L'Art du XVIIIe siècle*, 12 vols (1859–75)

G. Semper: *Der Stil in den technischen und tektonischen Künsten: Oder praktische Ästhetik*, 2 vols (Frankfurt am Main and Munich, 1860–63)

A. von Zahn: *Barock, Rokoko und Zopf*, viii of *Vorlagen für Ornamentmalerei: Motive aller Stylarten von der Antike bis zur neuesten Zeit* (Leipzig, 1873)

P. Jessen: *Das Ornament des Rococo und seine Vorstufen* (Leipzig, 1894)

A. Schmarsow: *Barock und Rokoko: Über des Malerische in der Architektur* (Leipzig, 1897)

A. E. Brinckmann: *Baukunst des 17. und 18. Jahrhunderts in den romanischen Ländern* (Berlin, 1919)

S. Giedion: *Spätbarocker und romantischer Klassizismus* (Munich, 1922)

H. Rose: *Spätbarock* (Munich, 1922)

A. E. Brinckmann: *Die Kunst des Rokoko* (Berlin, 1940)

F. Kimball: *The Creation of the Rococo* (New York, 1943/R 1980); Fr. trans. and rev. as *Le Style Louis XV: Origine et évolution du rococo* (Paris, 1949)

L. Hautecoeur: *Histoire de l'architecture classique en France*, 7 vols (1943–57)

P. Verlet: *Les Meubles du XVIIIe siècle*, 2 vols (Paris, 1955)

N. Pevsner: *Penguin Dictionary of Architects* (Harmondsworth, 1966)

P. Minguet: *Esthétique du rococo* (Paris, 1967)

F. Wolf: *Cuvilliés: Der Architekt und Dekorschöpfer* (Munich, 1967)

A. Blunt: *Some Uses and Misuses of the Terms Baroque and Rococo as Applied to Architecture* (London, 1972)

W. Graf Kalnein and M. Levey: *Art and Architecture of the Eighteenth Century in France*, Pelican Hist. A. (Harmondsworth, 1972)

A. Blunt, ed.: *Baroque and Rococo: Architecture and Decoration* (London and New York, 1978/R 1982)

A. Laing: 'French Ornamental Engravings and the Diffusion of the Rococo', *Le stampe e la diffusione delle immagini e degli stili*, ed. H. Zerner (Bologna, 1983)

M. Gallet, ed.: *Germain Boffrand, 1667–1754* (Paris, 1986)

RICHARD JOHN

III. GERMANY, AUSTRIA AND EASTERN EUROPE

Through artists' travels, the trade in works of art and the publication of ornamental pattern sheets and theoretical treatises, Rococo art rapidly spread throughout the countries of Central and Eastern Europe. In the German-speaking regions in particular, not only were the forms and motifs of the Rococo absorbed, but a symbiosis achieved between architecture and decoration, in which stucco, sculpture and painting (overdoors, wall paintings and ceiling paintings), as well as panelling, furniture, porcelain, table-silver etc all played a part. In south Germany the Rococo was also applied to church building. Its outstanding characteristics were the primacy of ornament and its application to architecture and painting, and the high value granted to the lower architectural orders, such as pilaster strips, pediments and volutes. In the sphere of iconography, formerly rarely depicted deities such as Pan and the nymphs, and stories of the saints interpreted in psychological terms, came to the fore. Another characteristic was a predilection for chinoiserie. A common feature of the art of the period was its playful exploitation of illusion. Rococo was, however, only one of a number of the artistic trends of the 18th century, and between 1730 and 1770, as it confronted the inheritance of the late Baroque and the emerging claims of Neo-classicism, local and regional variants emerged.

1. Holy Roman Empire

(i) Palaces Palace building was characterized by a profound anomaly. In the years following the War of the Spanish Succession (1701–14), the imperial and princely rulers increasingly felt a need to display their power; palace architecture was in general modelled on Versailles (e.g. Ludwigsburg, Pommersfelden, Schleissheim, Würzburg and Brühl). Interior decoration, on the other hand, followed contemporary French examples. Thus not only was a tradition of absolutist ceremonial perpetuated that even in France, after the death in 1715 of Louis XIV, had become obsolete but also an art originally developed for decorating the comparatively small and intimate private rooms of the Parisian hôtel particulier was made to serve the grandiose demands of palace architecture.

In Franconia this trend is exemplified by the rebuilding and decoration of the Prince-Bishop's Residenz in Würzburg. The building, commissioned in 1719 from Balthasar Neumann by the Schönborn family, was distinguished by a new type of staircase (1737) at the centre of the *corps de logis*; this endowed the route from the vestibule to the banqueting hall of the Residenz with the opportunity for sumptuous court ceremonial. It was a manifestation of an architecture of power that Neumann's patrons had already attempted in the staircase (1712–18) of Schloss Weissenstein at Pommersfelden by Johann Lukas von Hildebrandt and Johann Dientzenhofer. A similar ambition is evident in Neumann's staircase in the Prince-Bishop's Residenz at Bruchsal (from 1728). In the staircase of the Residenz at Würzburg, the original plan (before the decision to commission Giambattista Tiepolo's ceiling paintings) had been for stucco decorations with Rococo motifs. The design (c. 1743; Berlin, Kstbib.) shows how a contemporary decorative system could be freely applied to late-Baroque architectural forms without disrupting the original conception. The decorations were skilfully designed to make the staircase appear more spacious.

In Bavaria, the death in 1726 of Elector Maximilian II Emanuel put an end to the large, ambitious palace building projects at Schleissheim and Nymphenburg. His successors, Charles Albert (*reg* 1726–45) and Maximilian III Joseph, undertook the lavish interior decoration of the Residenz in Munich, including the Treasury and the Reiche Zimmer (1730–37) and the Residenztheater (1750–53). These important new Rococo creations were chiefly the work of François de Cuvilliés, whose work here and elsewhere, as for

example his decoration of Schloss Brühl (1728–40) and his designs (c. 1743–9) for Schloss Wilhelmsthal near Kassel, were hugely influential.

In Prussia, the Goldene Galerie (1742–7) in Schloss Charlottenburg, Berlin, is considered to be one of the most magnificent creations of Rococo interior decoration of the reign of Frederick the Great. In it, gilt motifs, partly representational and changing from field to field, but symmetrical at the centre, are arranged on a green scagliola background. Although the design is clearly based on French models, it differs from them in its greater lightness, delicacy and freedom in the play of forms, although with a specifically Prussian element of formal rigour and spareness. It was probably mainly the work of Georg Wenceslaus von Knobelsdorff, the King's most important architect.

In Austria, the long period during which the hereditary Habsburg estates were also the seat of the Emperor was characterized by the decoration of the new state rooms in Schönbrunn Palace in Vienna, following the accession of 1740 of Maria-Theresa, Queen of Hungary and Bohemia and later Empress of Austria. The decorative work was directed (1745–9) by the court architect Nikolaus Pacassi; although it did not change the existing structure of the palace rooms, it testified to an artistic tendency to diverge from the ideas of Austrian Baroque triumphal architecture. The new element in the decoration was the multiplicity of chinoiserie motifs, integrated within the decorative framework and demonstrating the adaptability of rocaille. As chinoiserie was a personal preference of the Empress, it emphasizes the private character of the rooms, which include two Chinese cabinets, the Blauer Chinesischer Salon, the Millionenzimmer (c. 1750–60) and the Vieux-Laque-Zimmer (1770).

In Bohemia, the influence of the Rococo can be seen in the preference for smaller types of building, such as the villa and the chapel, and in a heightened interest in interior decoration (e.g. Anselmo Martino Lurago's chapel (1742) at Horin castle near Melnik). In Český Krumlov, Josef Lederer, a painter from Augsburg, was commissioned by the Schwarzenberg family to execute in

the Oberburg illusionistic wall paintings (1748) with scenes from the *commedia dell'arte*. In conjunction with adjacent wall mirrors, they involved the spectator in a playful confusion of appearance and reality.

(ii) **Maisons de plaisance and gardens.** From about 1730 the design and decoration of hunting-lodges, pleasure-houses and garden-houses in parks became a special task for court architects. These buildings were based on French models and were intended to create an atmosphere of carefree seclusion, yet still within the rigid, absolutist court structure. The Amalienburg, probably the most important maison de plaisance in Bavaria, was built (1734–9) in the park of Schloss Nymphenburg, Munich, to designs by Cuvilliés in collaboration with Johann Baptist Zimmermann. The ground-plan of the single-storey building, with the convex and concave outline of its central room and symmetrical suites of rooms on either side, is a variation on the châteaux of Vaux-le-Vicomte and Marly. The rooms flanking the rotunda of the Spiegelsaal are arranged *en enfilade*. Sharp corners were avoided and were replaced by rounded profiles. The exterior of the building is carried out in restrained architectural relief. The interior decoration, especially in the Spiegelsaal, is modelled on such Parisian hôtels particuliers as Boffrand's Hôtel de Soubise (*see* §II, 3 above), but the pictorial effect is heightened by a freer use of stuccoed ornamentation. The architectural substructure disappears under the prolific and luxuriant mouldings of gods, nymphs and putti. The alternation of many mirrors and windows draws the onlooker into an unreal world, oscillating between interior and exterior.

Such pavilions were sometimes promoted to become rulers' principal residences, an important example being Schloss Sanssouci in Potsdam, which was designed (1745–7) by Knobelsdorff from sketches by Frederick the Great. The architecture of Sanssouci embodies the transition from the late Baroque, public in character and intended to impress, to the private and intimate nature of more modern decoration. While the entrance side is dominated by the colonnade of the *cour d'hon-*

73. Music-room of Schloss Sanssouci, Potsdam, by Georg Wenceslaus von Knobelsdorff, *c.* 1750

neur, on the garden side, a projecting oval room with a cupola accentuates the centre of the shallow, single-storey structure, built in the style of a country house. Between the large windows are pilasters decorated with Bacchanalian herms, the work of Friedrich Christian Glume (1714–52); these enhance the carefree mood suggested by the palace's name, a mood further expressed by the interior decoration in the transition from the vestibule to the central room and the adjoining rooms, which include a library, music-room and flower-room (see fig. 73); this decoration is distinguished by a dissolution of the Classical orders and a playful use of ornamental motifs. Other examples of the Rococo maison de plaisance are Schloss Falkenlust in Brühl (1729–34), Schloss Benrath in Düsseldorf (1755–69) and Schloss Solitude in Stuttgart (1763–7).

Garden design was initially based on Italian and French models (e.g. at Nymphenburg, Schleissheim and the Belvedere in Vienna). Around 1750 small Rococo gardens began to appear (e.g. Veitshöchheim, Bayreuth) that were distinguished by enclosed spaces, delicate details and carefully placed, small buildings.

(iii) Churches. Church building in the region of the Holy Roman Empire was mainly influenced by Italian architectural traditions. However, in southern Germany the type of the Bavarian Rococo church came into being, a development of regional church architecture and the local tradition of stuccowork; it was thus a synthesis of architecture and the decorative arts, combining traditions of popular piety with the concept of the *theatrum sacrum*. The work of the brothers Egid Quirin Asam and Cosmas Damian Asam, such as the Benedictine church of St Georg and St Martin (1716–18) in Weltenburg or St Johann Nepomuk (1733–46) in Munich, was still influenced by the Roman tradition of church architecture. However, the churches built by the architect Dominikus Zimmermann and his brother, the painter and stuccoist Johann Baptist Zimmermann, both of whom trained at the abbey of Wessobrunn, were mature examples of the Rococo church. In the pilgrimage church (1728–33) at Steinhausen and the pilgrimage church (1745–57) at Die Wies, near Steingaden, the ornamental forms are used as a constituent element of the architecture (see fig. 74); the upper arcades in the intrados of the choir vaulting are replaced by rocaille cartouches. Thus the transition between the columns of the nave and its ceiling gives the appearance of being realized in terms of ornament rather than of structure. The role of mediating between architecture and ceiling painting is taken over by the stucco ornament, which passes from the spectator's real space into the artificial pictorial space.

Similar arrangements may be found in other churches, where the ceiling paintings frequently combine history painting with visions of eternity. The edges of the frescoes become terrestrial theatres, in which legendary, historical or contemporary events are enacted, while the centres of the paintings continue to be dominated by the saints and conceptions of heaven. Examples of such deployment of stuccowork include that by Johann

Georg Bergmüller in the former Augustine collegiate church at Diessen (1736); the work of Gottfried Bernhard Göz in the pilgrimage church (c. 1749) at Neubirnau on which he collaborated with Joseph Anton Feuchtmayer (see §(iv) below); and that by Martin Knoller at the Benedictine abbey church (1770–75) at Neresheim.

Johann Michael Fischer's church of St Michael at Berg am Laim (consecrated 1751; frescoes by Johann Baptist Zimmermann, sculpture by Johann Baptist Straub) in Munich and his Benedictine abbey church (1759–67; frescoes by Matthäus Günther, stucco by Franz Xaver Feichtmayer) at Rott am Inn represent later developments of this church type; they are characterized, however, by a lack of integration between architecture and decoration. The same is true of the Franconian pilgrimage church at Vierzehnheiligen (designed 1743 by Balthasar Neumann; building directed from 1745 by Johann Jakob Michael Küchel; consecrated 1772), where the impression of a curved spatial configuration is created through the intersection of different parts of the vaulting of the centralized hall on an oval ground-plan. The main origins of this style are to be found in the complex structure of walls and vaulting in the work of Christoph Dientzenhofer in Bohemia, such as the palace church (1699–1713) at Smiřice; and also in the influence of Guarino Guarini's church architecture, such as the chapel of SS Sindone in S Lorenzo, Turin. In Vierzehnheiligen, this spatial impression is heightened by Küchel's altar of the *Fourteen Saints* (Nothelferaltar), built up of rocaille forms in the central space of the church. However, the ceiling painting by Giuseppe Appiani does not promote cohesion between the architecture and the rest of the decoration.

(iv) Sculpture and procelain figures. Secular Rococo sculpture was generally surpassed in scope and importance by religious sculpture, both wood and stucco, for church decoration, especially in the Catholic south of the Empire. Paul Egell, court sculptor to Charles Philip, Elector Palatine, endowed the animated Baroque figures of his teacher Balthasar Permoser with an expressive delicacy of manner, seeking to combine sculpture

74. Interior of the pilgrimage church at Die Wies, Steingaden, by Dominikus Zimmermann and Johann Baptist Zimmermann, 1745-57

with ornamentation, as in the carved-wood high altar (1739–41; fragments, Berlin, Bodemus.) of St Sebastian in Mannheim. The works of Johann Baptist Straub in Bavaria are characterized by an interplay of figural sculpture with a restrained ornamental frame and display a close integration of architecture, stucco and painting, for example his six altars and pulpit (1756–62) in the Benedictine monastery church at Ettal. In Swabia, Joseph Anton Feuchtmayer and Johann Joseph Christian, both trained in the stucco tradition of the abbey of Wessobrunn, achieved prominence in their work in the Benedictine monastery church of the Holy Trinity (c. 1755–68), Ottobeuren. The pilgrimage church at Neubirnau on which Feuchtmayer collaborated with Göz also contains characteristic examples of his sculptural work. Ignaz Günther, Straub's most important pupil, created elongated figure types, which, with their capriciously swirling body movements and outspread contours, expressed a heightened

spiritual quality (e.g. the *Guardian Angel* group 1763; Munich, Bürgersaal). In Günther's *Annunciation* group (wood, 1763–4) in the monastery church at Weyarn the distinctions between decorative art, religious sculpture and stage scenery are blurred.

In decorating palaces and churches, sculptors used stone, wood or plaster, often elaborately painted to resemble expensive materials, such as gold, silver or marble. The use of such surrogates was not, however, simply intended to deceive the eye; rather, the use of art media had itself become the subject-matter of art. The garden sculptures produced by Ferdinand Tietz in 1765 for the park at Schloss Veitshöchheim are a revealing example, being made of sandstone lacquered white to resemble porcelain. They express the playful Rococo concept of reality, which inhabits the interstices between art, artifice and nature.

In Schloss Mirabell in Salzburg, Georg Raphael Donner's putti on the banisters of a staircase (c. 1726) already express a leading characteristic of Rococo in their nonchalant playfulness and the ambivalent quality of the ornament and of putti, the symbol of eternal youth. The same characteristics appeared subsequently in porcelain figures, which fulfilled the demand for small-scale decorative sculptures for a domestic setting. The most important porcelain factory was founded in 1710 in Meissen, with Johann Joachim Kändler as its leading modeller; it was followed by factories in Höchst (1746), Fürstenberg (1747), Frankenthal (1755), Ludwigsburg (1758) and Nymphenburg (1761). The subject-matter of the figures was often drawn from mythology, the pastoral and the *commedia dell'arte*; in structure they often resembled the ornaments of interior decoration, rocaille being an integral element of the scenery. Examples are the *Toilet of Venus* (c. 1760; Munich, Residenz) by Johann Wilhelm Lanz (fl 1748–61) at Frankenthal and the *Sleeper Roused* (c. 1760; Munich, Bayer. Nmus.), the creation of Franz Anton Bustelli at Nymphenburg. While this treatment called into question the realism of the porcelain figure, it charmed the viewer with its wit and inventiveness.

2. Poland and Russia

In the kingdom of Poland, initially linked to Saxony but subsequently partitioned between Austria, Prussia and Russia, a Rococo influence in the arts can be observed from about 1750, despite the political destabilization. The artistic developments that arose independently of each other included church buildings in Wilno (now Vilnius) and its region, built between c. 1730 and 1780 by largely unknown architects; they include the former Basilians church (1756–64) in Berezwecz, near Vilnius. As well as Warsaw and Kraków, Lwów (now L'viv) was an important centre of Rococo sculpture in Poland; the major sculptors included Jan Obrocki (fl 1769–80), Maciej Polejowski (fl 1766–76) and Antoni Osiński (d c. 1765).

In Russia, under the Empress Elizabeth, Rococo idiom and motifs gained some influence. The leading architect of the period, Bartolomeo Francesco Rastrelli, largely confined himself to the late-Baroque idiom and the use of the Classical orders. He occasionally used Rococo decoration on the exteriors and interiors of buildings, but did not always achieve an organic unity between architecture and decoration (e.g. Winter Palace, St Petersburg, 1745–68; Tsarskoye Selo (now Pushkin, Palace–Museum), 1749–56). In the park of Tsarskoye Selo, Rastrelli built small pavilions (destr.).

Bibliography

Z. Hornung: *Antoni Osinskz* (Warsaw, 1937)

T. Rensing: *Johann Conrad Schlaun: Leben und Werk des westfälischen Barockbaumeisters* (Munich, 1954)

B. Rupprecht: *Die bayerische Rokoko-Kirche* (Kallmünz, 1959)

H. Bauer: *Rocaille: Zur Herkunft und zum Wesen eines Ornament-Motivs* (Berlin, 1962)

H. G. Franz: *Bauten und Baumeister der Barockzeit in Böhmen: Entstehung und Ausstrahlung der böhmischen Barockbaukunst* (Leipzig, 1962)

W. Hentschel: *Die sächsische Baukunst des 18. Jahrhunderts in Polen*, 2 vols (Berlin, 1967)

C. Norberg-Schulz: *Late Baroque and Rococo Architecture* (New York, 1974)

V. Loers: *Rokokoplastik und Dekorationssystem* (Munich, 1976)

E. Cyran: *Preussisches Rokoko* (Berlin, 1979)

H. Bauer: *Rokokomalerei: Sechs Studien* (Mittenwald, 1980)

A. von Buttlar: *Der Landschaftsgarten* (Munich, 1980, rev. Cologne, 1989)

T. Eggeling: *Studien zum friderizianischen Rokoko: Georg Wenzeslaus von Knobelsdorff als Entwerfer von Innendekorationen* (Berlin, 1980)

B. Rupprecht: *Die Brüder Ansam: Sinn und Sinnlichkeit im bayerischen Barock* (Regensburg, 1980, rev. 1985)

M. Jarry: *Chinoiserie: Chinese Influence on European Decorative Art, 17th and 18th Centuries* (New York and London, 1981)

G. Beard: *Stucco and Decorative Plasterwork in Europe* (London, 1983)

G. Brucher: *Barockarchitektur in Österreich* (Cologne, 1983)

K. Harries: *The Bavarian Rococo Church: Between Faith and Aestheticism* (New Haven and London, 1983)

H.-J. Kadatz and G. Murza: *Georg Wenzeslaus von Knobelsdorff: Baumeister Friedrichs II* (Munich, 1983)

H. Reuther: *Balthasar Neumann: Der mainfränkische Barockbaumeister*, 2 vols (Munich, 1983)

U. Schiessl: *Techniken der Fassmalerei in Barock und Rokoko* (Worms, 1983)

L. Tavernier: 'Apropos Illusion: Jean Baptist Dubos' Einführung eines Begriffs in die französische Kunstkritik', *Pantheon*, xlii (1984), pp. 158–60

H. Bauer and A. Bauer: *Johann Baptist and Dominikus Zimmerman: Entstehung und Vollendung des bayerischen Rokoko* (Regensburg, 1985)

K. Kalinowski, ed.: *Studien zur europäischen Barock- und Rokokoskulptur* (Poznań, 1985)

Bayerische Rokokoplastik: Vom Entwurf zur Ausführung (exh. cat., Munich, Bayer. Nmus., 1985)

W. Braunfels: *François Cuvilliés: Der Baumeister der galanten Architektur des Rokoko* (Munich, 1986)

W. Buhl, ed.: *Franken im Rokoko* (Munich, 1986)

H. Körner, C. Peres, R. Steiner and L. Tavernier, eds: *Empfindung und Reflexion: Ein Problem des 18. Jahrhunderts* (Hildesheim, Zurich and New York, 1986)

P. Volk: *Entwurf und Ausführung in der europäischen Barockplastik* (Munich, 1986)

D. von Frank: *Die 'maison de plaisance': Ihre Entwicklung in Frankreich und Rezeption in Deutschland* (Munich, 1989)

H. Bauer and H. Sedlmayr: *Rokoko: Struktur und Wesen einer europäischen Epoche* (Cologne, 1991)

G. Brucher, ed.: *Die Kunst des Barock in Osterreich* (Salzburg, 1994)

LUDWIG TAVERNIER

IV. ENGLAND

The concerted effort of Richard Boyle, 3rd Earl of Burlington and 4th Earl of Cork, and his circle to promote Palladianism in England began in 1719 and continued until the mid-century. Because of their efforts to stifle the influence of French decorative art, there are no examples in England of wholly Rococo buildings; the single exception might have been Cornelius Johnson's ambitious but unexecuted design (1754) for a British Museum. A few English interiors can be classed as Rococo, but the process of acclimatization resulted in a local variant. The English never understood the inherent contradiction between the simple box-shaped Palladian room and the free-flowing stucco forms of the Rococo: hence the pattern-book ornament that English plasterers applied to interiors always seems half-detached from its ground. In the 1720s a group of Ticinese stuccoists working for James Gibbs came close to rocaille forms in their rich but heavy plasterwork; but in examples such as the saloon (1725) at Ditchley Park, Oxon, the emphasis is on the tectonic, and no architectural boundaries are transgressed. It was not until the 1750s that stuccowork acquired the necessary lightness and delicacy. Good examples are the work of John Jenkins and William Brown at Powderham Castle (c. 1755), Devon, and of Joseph Rose the elder (c. 1723–80) in the drawing-room (c. 1758) at Heath Hall, N. Yorks. In the latter, scrolling foliage skips lightly from impost to impost in the bay window. These provincial essays by native plasterers must have been derived from *genre pittoresque* pattern books and often betrayed their origins in the veneer-like manner of their application. Isaac Ware attacked these practices, deploring ceilings 'straggled over with unmeaning Cs and Os and tangled semicircles', although he himself in 1748–9 produced at Chesterfield House (destr. 1934), London, good imitations of French decorations, based on plates by Pineau.

The English manufacturing arts and crafts displayed a more sophisticated domestication of Rococo. The earliest example of the 'modern French' taste is in the silver of Paul de Lamerie

(from 1731), in the Régence style, deriving details from Germain. However, the *genre pittoresque* was soon imported into England by the French engraver Hubert Gravelot. By the end of the 1730s plagiarized engravings of ornament by Meissonnier, Mondon and Lajoüe were being published in London by George Bickham, and soon both metalwork and wood-carving partook of the necessary *contraste*. Matthias Lock, who designed and executed stunning examples of Rococo woodcarving, such as pier-glasses and tables, was the first to publish a native pattern book for carvers, his *Six Sconces* (1744). English furniture-making was subsequently transformed by Thomas Chippendale, who tamed the French Rococo, making the forms more refined. Gravelot was one of the artists associated with the St Martin's Lane Academy founded in 1735 by William Hogarth. Although Hogarth did not specifically intend his *Analysis of Beauty* (1753) to be a manifesto for the Rococo, his conviction that beauty and grace could only be found in the serpentine line was the closest anyone came in Europe to offering a theoretical justification for the style. At precisely the same moment that asymmetry was being attacked in France, Hogarth asserted: 'Such shell-like winding forms, mixt with foliage twisting about them are made use of in all ornaments; a kind of composition calculated merely to please the eye. Divest these of their serpentine twinings and they immediately lose all grace.'

Porcelain manufacture and silk-weaving were also heavily influenced by continental Rococo. Although the secret of manufacturing hard-paste porcelain did not reach England until 1768, soft-paste porcelain was being made at Chelsea by 1745. During the next decade, the introduction of rocaille shell-like forms can be observed in the wares of the Lawrence Street factory. The leading English silk-designer of the second quarter of the 18th century, Anna Maria Garthwaite (1690–1763), incorporated naturalistic, asymmetrical flowers in her designs from 1742, and in the following year started using C-scrolls reversed on each other. Late in life, she recommended that the silk-designer 'ought to follow the principles Mr Hogarth gives in his *Analysis*, observing the Line of Beauty',

demonstrating that even the minor arts had acquired a new self-importance through the influence of the Rococo.

V. ITALY

Rome was almost completely oblivious to the Rococo; Baroque remained the norm, until superseded by the Neo-classicism of Johann Joachim Winckelmann. However, elsewhere in Italy, certain pockets of influence were to be found. Benedetto Innocente Alfieri, who succeeded Filippo Juvarra as architect to Victor-Amadeus II, Duke of Savoy, adopted the style for a series of small rooms for the Palazzo Reale, Turin, and for the Palazzina di Stupinigi near by. He was also responsible for the extraordinary horseshoe plan (1757–64) of S Giovanni Battista in Carignano. In Venice, the appeal of the courtly elegance of the Rococo was much greater. It featured not only in interior decoration, such as the exquisite rooms on the mezzanine of the Palazzo Foscarini, but also in furniture and mirrors, for example in the work of Andrea Brustolon. Even the young Giovanni Battista Piranesi produced designs for gondolas that are profusions of rocaille ornament. Pictorial parallels can be noted in the capricci of Giambattista Tiepolo, but despite the lightness of the colours of his frescoes, their heroism places them firmly within the tradition of the Baroque. In the south, there was little direct influence from France and, strictly speaking, there were no examples of pure Rococo buildings; yet Domenico Antonio Vaccaro produced such flights of fantasy as the dome (1730s) of S Maria delle Grazie in Calvizzano, near Naples, where structural lines are dissolved in swathes of fluffy white stucco, which compares well with the work of the Zimmermann brothers (*see* §III, 1 above). Vaccaro's remarkable application of rocaille forms to marble carving resulted in altar rails without recognizable architectural elements, sprouting leaves from otherwise polished surfaces. Such altars became highly popular in Neapolitan churches and chapels, an example being the altar (*c*. 1760) in the Certosa di S Martino by Vaccaro's pupil Giuseppe Sanmartino.

Bibliography

P. Thornton: *Baroque and Rococo Silks* (London, 1965)
Rococo: Art and Design in Hogarth's England (exh. cat., ed. M. Snodin and E. Moncrieff; London, V&A, 1984)
C. Hind, ed.: *Rococo in England: A Symposium* (London, 1986)

RICHARD JOHN

Rococo Revival

A renewed interest among artists, writers and collectors between *c.* 1820 and 1870 in Europe, predominantly in France, and in America in the Rococo style in painting, the decorative arts, architecture and sculpture. The revival of the Rococo served diverse social needs. As capitalism and middle-class democracy triumphed decisively in politics and the economy, the affluent and well-born put increasing value on aristocratic culture of the previous century: its arts, manners and costumes. Championing the Rococo was a way of contesting what was seen as an oppressive and stern bourgeois morality. To praise Antoine Watteau was to proclaim oneself for pleasure and the freedom of the imagination.

Among the earliest artists in the 19th century to appreciate and emulate 18th-century art were Jules-Robert Auguste (1789–1830), R. P. Bonington, Eugène Delacroix and Paul Huet. For these young artists the Rococo was a celebration of sensual and sexual pleasure and a product of a free and poetic imagination. Looking particularly at the work of Watteau, they sought to reproduce the Rococo capacity for lyrical grace, its sophisticated understanding of colour and its open, vibrant paint surfaces in their work. These qualities can be seen in such re-creations of 18th-century scenes as Eugène Lami's *Festival at the Château of Versailles on the Occasion of the Marriage of the Dauphin in 1745* (1861; London, V&A) and in depictions of literary subjects, for example Charles Robert Leslie's scenes from Molière's *Le Bourgeois Gentilhomme* (1841; London, V&A), which features Rococo costume and interior decoration.

In addition to many Rococo-inspired creations of 18th-century life, later Romantic artists created graceful images of contemporary, fashionable life that were meant to recall comparable 18th-century images. This is particularly evident in the works of the Devéria brothers, Camille Roqueplan, Thomas Couture and Alfred Stevens (ii), and Franz Xaver Winterhalter's success as a portrait painter rests on his images that evoke 18th-century elegance (e.g. the *Empress Eugénie among her Ladies-in-waiting*, 1855; Compiègne, Château). Such work also distinguished both its patrons and producers (often self-styled dandies) as men of refined sensibility and aristocratic feeling.

In England the taste for the Rococo Revival was fuelled by the arrival of French works of art dispersed after the Revolution and purchased by such collectors as George IV. The style was popularized by the architect Benjamin Dean Wyatt, who in 1833 chose Rococo mouldings for the gallery of Apsley House, London. In 1863 a flamboyant Rococo style was used by Charles Garnier for the interior of the Paris Opéra, the staircase of which is ornamented with decorative bronze torchères by Albert-Ernest Carrier-Belleuse.

The Empress Eugénie, wife of Napoleon III, was a leading patron of the Rococo Revival style, commissioning, among other pieces, a Rococo secretaire (1855; Compiègne, Château) from Alphonse Giroux. She favoured such sculptors as Jean-Baptiste Carpeaux, who designed a bronze monument to *Watteau*, installed in Valenciennes in 1884. Notable collections of Rococo works formed in the 19th century include those of Baron Vivant-Denon and Louis La Caze, who donated many of the best French Rococo pictures in the Louvre.

In the 19th century the history of the Rococo style was traced in such works as Théophile Gautier's *Histoire du romantisme* (Paris, 1874) and the Goncourt brothers' *L'Art du XVIIIe siècle* in three volumes (Paris, 1881–4). The taste for the Rococo made its earliest appearance in literature in Honoré Balzac's *Cousin Pons* (Paris, 1847), the hero of which, a poor musician, amasses a collection of 18th-century porcelain and paintings by searching second-hand stores. He typifies those seeking to acquire social recognition through possessing items of a refined and aristocratic

distinction. Indeed, through the means of mass production, by the 1840s the petite bourgeoisie could create an inexpensive Rococo-style interior. In England such firms as Minton & Co. produced imitation Sèvres porcelain with mid-18th-century style decoration (e.g. wine-glass cooler, 1853; London, V&A).

Bibliography

S. O. Simches: *Le Romantisme et le goût esthétique du XVIIIe siècle* (Paris, 1964)
C. Duncan: *The Pursuit of Pleasure: The Rococo Revival in French Romantic Art* (New York and London, 1976)
S. Jervis: *High Victorian Design* (Woodbridge, 1983), pp. 37–57

☐

Romanesque Revival

Style of architecture used chiefly in western Europe and North America from the 1820s until the end of the 19th century. In Europe it was related to the RUNDBOGENSTIL and the BYZANTINE REVIVAL, and in England it was an extension of the NORMAN REVIVAL. It derived ultimately from Romanesque church architecture of the 11th and 12th centuries. Its principal characteristics were the semicircular arch and the barrel or groin vault. In Bavaria, for example, Leo von Klenze based the Allerheiligen-Hofkirche (1826–37; destr. 1944; rebuilt from 1986) in Munich on the Romanesque Palatine Chapel (begun 1131) in Palermo, Sicily. It was an architecture of stone and brick, sometimes laid in different colours for contrast. Ornament was generally spare, in geometric or foliate patterns and confined to arches, tympana or the ribs of vaulting. The increased use of the style from the 1860s formed part of the general move away from international classicism and the Gothic Revival and towards eclecticism in architecture. The style was, however, most commonly used first for churches and ultimately for prisons.

In France the Romanesque Revival formed part of a renewed interest in 'primitive' Romanesque and Byzantine forms. Architects who used the style include Claude Naissant (1801–79; Notre Dame de la Gare, Ivry, 1855), Victor Baltard (St Augustin, Paris, 1860–67), Gustave Guérin (Chapelle des Lazaristes, Tours, 1861), Théodore Ballu (St Ambroise, Paris, 1863–9) and Paul Abadie (Sacré-Coeur, Paris, begun 1874). Best known is Emile Vaudremer's church of St Pierre de Montrouge (1864–70), Paris, which is a skilful blend of a Tuscan basilica plan with Sicilian and north Italian Romanesque and Early Christian Syrian elements. Vaudremer's individual approach probably influenced H. H. Richardson during his stay in Paris (1860–65). Richardson returned to the USA with a passion for Romanesque architecture, which developed into a fundamental influence on his work. The two most powerful examples of his American Romanesque Revival style are the Trinity Church (1872–7), Boston, and the Allegheny County Court-house and Jail (1884–8), Pittsburgh. In his imposing Marshall Field Wholesale Store (1885–7; destr. 1930), Chicago, Richardson demonstrated the Romanesque adapted to a 'modern' multi-storey building. Another American architect who developed his own version of the Romanesque Revival was Alfred B. Mullett (e.g. the Sun Building, 1885–6, Washington, DC).

Bibliography

H. R. Hitchcock: *Architecture: Nineteenth and Twentieth Centuries*, Pelican Hist. A. (Harmondsworth, 1958, 3/1968)
C. Mignot: *Architecture of the Nineteenth Century in Europe* (New York, 1984)
Romantik und Restauration: Architektur in Bayern zur Zeit Ludwigs I., 1825–1848 (exh. cat., ed. W. Nerdinger; Munich, Stadtmus., 1987)

☐

Romanism

Term used in reference to north and south Netherlandish painters who travelled to Rome in the 16th century and came under the influence of the Italian artists of the period. The greatest impression was made by Michelangelo (particularly his work in the Sistine Chapel), Raphael (frescoes in the Vatican Stanze and Logge; see

col. pl. XXXIII) and Raphael's students, particularly Giulio Romano, Polidoro da Caravaggio and Perino del Vaga. In addition, the surviving Classical monuments and artefacts in Rome also exerted a strong influence on the work of Netherlandish artists. Somewhat later in the 16th century, other Italian centres also exercised a strong attraction for these northern artists. In Venice, Domenico Tintoretto's style was the most frequently imitated; in Florence, the popular artists in this respect were Rosso Fiorentino, Vasari and the various sculptors then active; in Emilia, Parmigianino and his followers were also highly influential.

Through their assimilation of Italian formal language, the Romanists definitively established a Renaissance style in the Netherlands which continued until the early 17th century. Romanism found expression, above all, in religious or mythological figure pieces, in which the undraped, anatomically correct depiction of the human body, preferably in a complicated pose, was a central element. Although this expressive, sometimes even eccentric style now seems somewhat forced and artificial, the challenge it represented in the 16th century was chiefly an intellectual one—an attempt to master the most difficult and artistic of subjects by means of a kind of wrestling-match with form. Furthermore, the complexity of the compositions and an increased interest in new and intricate themes often revealed the Romanist's knowledge of humanism.

Jan Gossart was one of the first Netherlandish artists to study Classical sculpture in Rome in 1508/9; after his return to the northern Netherlands, he specialized in mythological scenes (see fig. 75). Michiel Coxcie was in Rome from 1529 to c. 1538 and worked there in a completely Italianized style, comparable to that of Raphael. Pieter Coecke van Aelst was probably in Italy before 1527. Although Bernard van Orley probably never actually travelled to Italy, he can still be counted among the Romanists, because he assimilated an Italianate style from Italian prints and Raphael's cartoons for the papal tapestries, which were woven in Brussels from 1516 onwards. Jan van Scorel worked in Rome in 1522/3 and was particularly influenced by Michelangelo and Raphael.

75. Jan Gossart: *Metamorphism of the Hermaphrodite* (Rotterdam, Museum Boymans—van Beunigen)

Following van Scorel's example, in 1532 Maarten van Heemskerck travelled to Rome, where he produced paintings and, more importantly, drawings after Classical sculpture. After his return to the north, his altarpieces, mythological scenes and hundreds of prints disseminated a strongly Italianizing style, distinguished by particular emphasis on the anatomy of the naked human body. The most important contribution of the Liège artist Lambert Lombard, who travelled to Rome in 1537, were his theories about classicism. During the 1540s Frans Floris worked for some years in Rome and was influenced by Michelangelo and Giulio Romano. He was the most important representative of Romanism in Antwerp and introduced the new style with the help of his numerous students and followers (including Crispin van den Broeck, Frans Pourbus, Lambert van Noort, Anthonie Blocklandt and Marten de Vos).

This later generation of artists showed a greater feeling for proportion and used a simpler formal vocabulary. Dirck Barendsz. from Amsterdam

visited Rome in 1555 but was more obviously influenced by the art of Venice, where he worked until 1562. Adriaen de Weerdt from Brussels was in Italy *c.* 1560 (probably Rome and Venice), where he assimilated the style of Parmigianino, as perpetuated by the latter's students, such as Andrea Schiavone. De Weerdt's fellow citizen Jan Speeckaert produced frescoes in Rome in the 1560s and 1570s. He, in turn, influenced northern painters such as Hans von Aachen and Bartholomäus Spranger. The latter worked in Rome at about the same time; he subsequently further developed his elegantly stylized figures in the mythological scenes that he produced for the courts of Maximilian II in Vienna and Rudolf II in Prague. Spranger, in his turn, exerted a fundamental influence on Dutch artists in Haarlem *c.* 1600 (e.g. Hendrick Goltzius, who drew much Classical sculpture in Rome in 1591, Cornelis Cornelisz. van Haarlem and Karel van Mander. However, the art of this generation, characterized by its elegant figures, is usually classified with the Mannerists.

The term 'Romanism' is now less often used. This is mainly because a more profound study of the work of individual artists has led to more attention being given to their specific characteristics, while the diversity of their responses to Italian art has come to be more fully appreciated.

Bibliography

G. J. Hoogewerff: *Nederlandsche schilders in Italie in de 16de eeuw: De geschiedenis van het Romanism* (Utrecht, 1912)

M. J. Friedländer: *Die niederländischen Romanisten* (Leipzig, 1922)

M. Dvořák: 'Über die geschichtlichen Voraussetzungen des niederländischen Romanismus', *Kstgesch. Geistesgesch.* (1924), pp. 203–15

C. M. A. A. Lindeman: *Oorsprong, ontwikkeling en betekenis van het romanisme in de Nederlandsche schilderkunst* [The origins, development and importance of Romanism in Netherlandish painting] (Utrecht, 1928)

G. J. Hoogewerff: *Vlaamsche kunst en Italiaanse Renaissance* (Mechelen, 1935)

N. Dacos: 'Les Peintres romanistes: Histoire du terme, perspectives de recherche et l'exemple de Lambert

van Noort', *Bull. Inst. Hist. Belge Rome*, i (1980), pp. 161–86

Fiamminghi a Roma, 1508–1608 (exh. cat., Brussels; Rome; 1995)

ILJA M. VELDMAN

Romantic Classicism [Ger. *Romantischer Klassizismus*]

Term indicating the merging of romantic sentiment with subject-matter drawn from Greek and Roman antiquity in the fine arts and architecture of Western Europe and the USA. It was first used in German in 1922 by Sigfried Giedion and in English in 1944 by Fiske Kimball (see bibliography). Romantic Classicism was neither a coherent movement nor a style but rather an attitude among individuals at work within the realm of Neo-classical art occurring over a period of about 100 years from around the mid-18th century. Examples of Romantic Classicism were for the most part a conscious attempt to humanize the cooler aspects of Neo-classicism, while retaining its sense of striving for a universal ideal. Early manifestations of this trend are found in the Picturesque movement that first developed in English landscape design during the first half of the 18th century. Geometric layout and formal parterres were ousted in favour of Virgilian landscapes of hills, lakes and trees, punctuated for purposes of romantic contemplation by Greek- and Roman-style temples (e.g. Praeneste, 1739, an arched portico at Rousham, Oxon, designed by William Kent and based on a Roman temple at Palestrina, Italy).

In the fine arts the Romantic Classicists established a middle course (known in France as *le juste milieu*) between Romanticism and what they viewed as the dry, disengaged conventions of current academic painting based on ancient themes, as typified by the work of Anton Raphael Mengs. Kenneth Clark in *The Romantic Rebellion* (1973) wrote that in artists of the first rank the apparently opposed philosophies of Romanticism and Classicism overlap, citing as an example the Graeco-Roman subject-matter of the arch Neo-classical painter Jacques-Louis David (e.g.

76. Anne-Louis Girodet: *Sleep of Endymion*, 1791 (Paris, Musée du Louvre)

the *Lictors Bringing Brutus the Bodies of his Sons*, 1789; Paris, Louvre; see col. pl. XXIII). Clark pointed out that the feelings submerged beneath the heroic stance of David's principal figures, the theatricality of gesture and the artist's obvious pleasure in depicting beautiful women all signify a veiled Romanticism. In Scandinavia Asmus Jakob Carstens, whose work influenced German Romanticism, sought a synthesis of Romantic Classicist doctrine in his combination of Michelangelesque figures with Nordic legend (e.g. *Night with her Children, Sleep and Death*; Weimar, Schlossmus.). Other artists working in the Romantic Classical manner include Anne-Louis Girodet, who studied under David (e.g. *Sleep of Endymion*, 1791; Paris, Louvre; see fig. 76), Tommaso Minardi and Hans Reinhard von Marées (e.g. *Diana Resting*, 1863; Munich, Neue Pin.).

By the 1770s Neo-classicism in architecture and the decorative arts was reflected in the increased employment of pure Greek rather than Roman forms, as seen in the more severe appearance of what is regarded in France as the Louis XVI style rather than the Louis XV style. Claude-Nicolas Ledoux, whose work began in the Louis XVI style but by the late 1780s had achieved a hitherto unknown level of monumentality, and Etienne-Louis Boullée, who designed much but built little, were the first great masters of Romantic Classical design. Their strong influence on Karl Friedrich Schinkel was a lasting legacy, as his patriotic pride found expression in the monumental buildings he erected in Berlin (e.g. the Schauspielhaus, 1818–21; and the Altes Museum, 1823–30). His furniture designs too were less direct imitation and more an imaginative simplification of the Greek and

Roman repertory, executed with a concern for traditional German values of comfort and solidity. Related works of Romantic Classical architecture abound throughout Britain, Europe and the New World. In Britain its greatest exponents were John Soane and John Nash, while the form was brought by such architects as Benjamin Henry Latrobe to the USA, where it became the most prestigious mode for prominent public buildings (e.g. University of Virginia, 1823–7, Charlottesville, VA, designed by Thomas Jefferson). The importance of the best Romantic Classicist work was in its carefully controlled appeal to both the intellect and the emotions.

Bibliography

S. Giedion: *Spätbarocker und romantischer Klassizismus* (Munich, 1922)

F. Kimball: 'Romantic Classicism in Architecture', *Gaz. B.-A.*, xxv (1944), pp. 95–112

M. Brion: *Art of the Romantic Era: Romanticism, Classicism, Realism* (London, 1966)

L. Eitner: *Neoclassicism and Romanticism, 1750–1850: Sources and Documents* (Englewood Cliffs, NJ, 1970)

K. Clark: *The Romantic Rebellion: Romantic versus Classic Art* (New York, 1973)

□

Romanticism

Dominant cultural tendency in the Western world in the late 18th and early 19th centuries. It caused a re-evaluation of the nature of art and the role of the artist in society. Significantly, from the 1790s it was a self-proclaimed movement, the first such, and so initiated a tradition that has remained in Western culture since. Romanticism was rejected or ignored by most of the major artists later seen as associated with it, but it nevertheless identified several key tendencies of the period. Though hard to define precisely, it essentially involves: 1) placing emotion and intuition before (or at least on an equal footing with) reason; 2) a belief that there are crucial areas of experience neglected by the rational mind; and 3) a belief in the general importance of the individual, the personal and the subjective. In fact it embodies a critique of that faith in progress and rationality that had characterized the main trend of Western thought and action since the Renaissance. This resulted in an opposition to the dominant contemporary values and social structures. Romanticism started as a literary movement but soon came to include the visual arts, particularly painting, the most notable exponents being Blake, Delacroix, Friedrich, Géricault, Goya, Philipp Otto Runge and Turner. To a lesser extent it also affected the graphic arts, sculpture and architecture. By the 1840s it was being superseded by Realism, though many of its ideas persisted throughout the 19th century and into the 20th.

1. The movement

Romanticism emerged as a movement in literary circles in the 1790s but soon spread to the other arts, including the visual arts. The first definition of 'romantic poetry' was given in 1798 by the German critic Friedrich Schlegel in the magazine *Athenaeum*, which he ran with his brother August Wilhelm Schlegel. It appeared in the first issue and hailed Romantic poetry as 'progressive, universal poetry' that is 'always becoming, never completed', a characteristically heady and imprecise definition. The word itself was drawn from the medieval literary form, the 'romance'. What Schlegel did in effect was to turn the irrational and fantastic qualities of these tales into positive values and to assert that they represented the essential features of the modern (i.e. post-classical) tradition. Following Schlegel's pronouncement, the term gradually gained ground in Germany over the next decade and was then exported elsewhere. It reached England and France primarily through the French author Mme de Staël, whose *De l'Allemagne* (written in 1810, but published in London in 1813) was an apologia for contemporary German culture. By 1820 it had currency throughout Europe and North America as the term for a contemporary cultural movement.

Probably the best way to understand Romanticism is as a reaction to the rationalist ideals of the 18th-century Enlightenment. The belief in the perfectability of man on logical principles that

this movement had promoted received a severe blow from the events of the late 18th century. The programme of political and social reform supported by the *philosophes* of the Enlightenment most dramatically culminated in the outbreak of the French Revolution in 1789. In its aftermath there was first a period of horrific terror in France itself and then a period of European-wide war that ended only in 1815. Such turmoil seemed to many contemporaries to undermine the idea that society could be improved simply by removing old, corrupt conventions. Equally important were the changes taking place in commerce. The rapid economic development in the period, the Industrial Revolution, was interpreted by many as a sign of man's weak control over his own destiny even when subject to rational planning. On all sides, therefore, political, social and economic changes seemed to emphasize the helplessness of the individual when confronted by fate.

Stimulated by such experiences, Romanticism can be seen as a reaction to an earlier confidence in the power of reason. Like most reactions, it took a multiplicity of forms. Some favoured retreat, clutching at past traditions and evoking the 'good old days' of the Middle Ages. Others turned to worlds beyond the reach of civilization, to the contemplation of the 'primitive' in the natural world. This tendency underpinned the great outburst of 'nature' poetry of the period, and in the visual arts it led to a re-evaluation of the natural world. It encouraged a taste for more informal landscape gardens, for the depiction of rural and primitive life and, perhaps most significantly of all, for more ambitious and challenging forms of landscape painting. It is no exaggeration to say that Romanticism was responsible for one of the greatest moments in Western landscape painting, evident particularly in the work of such artists as Constable, Friedrich and Turner. For many, spiritualism or mysticism was the means of opposing the rationalism of the previous age. This can be seen in the prophetic works of Blake and in the more fantastic aspects of Goya's art. It is symptomatic of the oppositional nature of Romanticism that it had no clear political message, apart from that of criticizing the status quo. Some of

those associated with the movement espoused an extreme political conservatism, as was eventually the case with Friedrich Schlegel. Others (such as Blake) supported heady forms of radicalism. Though it is hard to find a common denominator in all these reactions, it can perhaps be seen in the widespread endeavour to discover something beyond immediate experience, whether distanced by time (in the past or the future) or by space (in the cultures of distant lands).

2. Aesthetics

The Romantic Movement depended on the changes in the concept of art and aesthetic experience that had taken place in the preceding decades. In the late 18th century aesthetic experience began to be seen as something independent of practical or moral restrictions, a view pioneered by Alexander Gottlieb Baumgarten in his *Aesthetica* (1750–58) and endorsed by Kant in his *Kritik der Urteilskraft* (1790). For the generation of the 1790s such autonomy encouraged an idealized view of art as a realm that could inform and ennoble mankind by virtue of its very independence of necessity. This view, implicit in Kant, was popularized by the German writer Friedrich Schiller in his *Über die ästhetische Erziehung des Menschen–in einer Reihe von Briefen* (1795). Later it led the English poet Percy Bysshe Shelley to claim that poets were the 'unacknowledged legislators of the world'. These theories underpinned the idea of the autonomy of aesthetic feeling and the heroic role of the artist. New categories of experience were also developed, greatly expanding the range of the aesthetic. To the traditional concept of beauty was added a radical new understanding of THE SUBLIME. This concept had, of course, been available since Classical antiquity, but it now took on a new meaning. From being a rather mystical image of 'supreme beauty', it became a dynamic and powerful force. The greatest encouragement for this change of meaning came from Edmund Burke's *A Philosophical Enquiry into the Origin of our Ideas of the Sublime and Beautiful* (1756). This presents the Sublime as an overpowering experience based on fear, an interpretation widely criticized by those such as Kant and Blake, who saw it as

divinely inspired. Nevertheless, the notion stimulated an interest in the overpowering—whether fear-driven or spiritual—which thus became an accepted part of aesthetic experience.

The new understanding of the Sublime was essential both to the taste for horrific subjects (evidenced, for example, in the dramatic violence of paintings by Fuseli such as *Thor Battering the Midgard Serpent* (1790; London, RA) and the general taste for such disaster scenes as shipwrecks, as in the work of Turner, and to the idea of the struggling, heroic artist. Another important aesthetic development was the concept of the Picturesque, which first became current in late 18th-century Britain. Unlike the Sublime, which was literary in origin, the Picturesque was largely a visual movement. Based on the idea of travel, it promoted an interest in the quaint, the Old World and the irregular. Perhaps most importantly it encouraged associationism, the notion that aesthetic experiences could evoke ideas and sensations while remaining autonomous. Thus the contemplation of nature, of ruins and of the past could inspire heady poetic experiences, as well as more tangible cultural feelings such as nationalism. For, while Romanticism began as a movement concerned with personal experience and enrichment, it ended in most cases with the reinforcement of traditional culture and nationalism.

3. Manifestations in art

(i) General. As Romanticism is so readily identified with themes and attitudes it is often believed to have no characteristic visual form. Unlike Neo-classical art, there is no clearly definable 'style' in Romantic art, which seems rather to take almost any form. It is most usually associated with a broad painterly manner, as in the work of Delacroix and other French Romantic history painters. However, there are also Romantic paintings that show a precise and meticulous style, as in the landscapes of Friedrich (e.g. *Chalk Cliffs at Rügen*, 1818; Winterthur, Samml. Oskar Reinhart). In architecture Romanticism is often associated with the Gothic Revival, but it can also be seen in reworkings of other styles, including the classical. Despite

this variety, Romanticism does characterize an attitude to form, just as it does to themes and subjects. This is evident in the tendency to extremes, whether of painterliness or of detail. This is bound up with a concern to evoke sensuous experience, spiritual transformation or both.

Perhaps the most significant visual interest among the Romantics was that of colour. This was explored both for its optical effects and for its symbolic associations. Many artists associated with the movement (e.g. Delacroix and Turner) were interested in colour theory, and Runge wrote a book on the subject, *Die Farbenkugel* (Hamburg, 1810). This interest in colour and association led most Romantic theorists (e.g. August Wilhelm Schlegel) to see painting as the quintessential Romantic visual art. Schlegel in fact argued that sculpture, with its emphasis on form, was essentially classical but that painting, with its emphasis on colour and illusion, was essentially Romantic. Though Schlegel's division was not accepted by all, sculpture was far less affected by the Romantic Movement than painting. Indeed, Romanticism in the visual arts centres largely on painting and the graphic arts. Romantic ideas also strongly influenced architecture, where the tendency towards association led to the forging of a new attitude to style, whereby different styles stood for different values. Indeed the Romantic Movement caused the baffling historicism that led to the revival of virtually every historical style before the end of the 19th century. As in sculpture, however, the classical style was pre-eminent throughout the Romantic period, the only exception occurring in Britain, where the Gothic Revival was strongly favoured.

(ii) Painting. As in the other arts, Romanticism emerged in painting as a means of opposing the academic and the classical. This opposition was made all the more intense in the late 18th century because it occurred at the time of a vigorous revival of classical principles and the academic hierarchy that supported them. In the traditional hierarchy history painting was pre-eminent and, although accounting for only a tiny fraction of the paintings of this period, its prestige was such that

major developments tended to crystallize around it. In the late 18th century Neo-classical principles triumphed in this genre, particularly in France, where David emerged as the leading painter (see col. pl. XXIII and figs 52 and 58). At the same time there were challenges, and in general there were two main alternatives: the treatment of exotic (and usually medieval) historical themes or of modern-life subjects. Both types encouraged a colourful, painterly treatment that contrasted with the severity of the classical mode. In France the medievalizing tendency can be seen in work by Jean-Simon Berthélemy and François-Guillaume Menageot from the 1780s. In England the medieval and the fantastic can be seen in the work of John Hamilton Mortimer and Fuseli and among those artists who also pioneered a rigorous classicism, such as James Barry and Benjamin West. English history painting was strongly influenced by the literary revival of medieval and national themes. One of the principle focuses for history painters in this period was the Shakespeare Gallery in London, which opened in 1789 and for which John Boydell commissioned a series of history paintings on Shakespearian themes. More important in international terms was Benjamin West's innovative and heroic treatment of contemporary historical subjects in modern dress, notably in his *Death of General Wolfe* (1770; Ottawa, N.G.). This tendency was later developed in France, notably by David, Gros and Géricault.

Of all these, Fuseli is the most firmly related to a pre-Romantic ideology. Swiss by birth, he settled in England after wandering in Germany and studying art in Rome. He started his career as a literary figure and was closely related to the German *Sturm und Drang* movement, which took the English nature poets as its model and emphasized the elemental and self-expression. His most famous work, *The Nightmare* (1781; Detroit, MI, Inst. A.), combines violence, eroticism and fear of the unknown. Though an adherent of expression, Fuseli was a rationalist and was sceptical of religious and visionary experience. In this sense he fell short of the Romantic sensibility, and it is perhaps significant that his paintings show almost no interest in colour. He was, however, a great

stimulus to a slightly younger generation who adopted the Romantic concept of the artist as prophet and visionary. From the 1780s Blake produced publications that combined his own poetry with Gothic-inspired illustrations. He was an absolute defender of the importance of vision and once exclaimed: 'Talent thinks, genius sees'. His pictures, with their striking imagery and unconventional technique, exemplify his dedication to originality and imagination (see fig. 77). In his painting and poetry he elaborated a complex personal mythology, and this highlights the importance of myth to the Romantics, who saw it as a kind of primitive narrative encapsulating experience not accessible to the rational mind.

Blake was far from being the only artist of the period to create his own mythology. In Germany the somewhat younger Runge elaborated a heady nature mythology around his uncompleted cycle the *Times of Day* (1803–10; e.g. *Morning*, 1808; Hamburg, Ksthalle), in which he sought to convey an ecstatic vision of the universe 'when everything harmonizes in one chord'. Another creator of a form of personal mythology was Goya, who in 1799 produced the *Caprichos*, a series of etchings in which bizarre nocturnal creatures emerge from the sleep of reason. Each of these 'visionary' artists produced a highly individualistic art, yet they are united by their belief in the importance of personal vision and in their critique of the rational. They also believed in the didactic and political role of art. In their different ways, their apocalyptic art forms are reactions to the political uncertainties of the period of the French Revolution and its aftermath. Goya's position was the most paradoxical, because as well as being a private visionary he was also the court painter to Charles IV and then Ferdinand VII. But his public works maintain an ambiguity and seem always to have a private side. His most moving painting, the *Third of May, 1808* (1814; Madrid, Prado; see col. pl. XXXVI), shows Spanish insurgents being executed by the French during their invasion of the country. Yet what is most clear in these martyrs is not their heroism but their fear of death: Goya cut through the rhetoric to express the personal emotion.

77. William Blake: *Pity*, c. 1795 (London, Tate Gallery)

Unlike Blake and Goya, Runge was in contact with a programmatic Romantic movement. He lived in Dresden while the circle of 'Dresden Romantics' around Friedrich von Schlegel was active and he was particularly close for a time with one member of that group, the poet and novelist Ludwig Tieck. Yet Tieck effectively abandoned Runge, whose ideas and work developed beyond the sphere of the Dresden Romantics. A more programmatic relation between painting and literary Romanticism came with the medievalist movement, the interest in depicting medieval subjects in a style recalling the Middle Ages. Admiration for the Gothic had been growing since the mid-18th century and was widespread among Romantic sympathizers. Blake, for example, once declared 'Grecian art is mathematical form, Gothic art living form'. This medieval revival was already having an impact on subject-matter in the 1780s, but it was not until 1800 that it took a definitive form. To a certain extent it was fundamentally linked with programmatic Romanticism, for the very choice of the word 'romantic' referred back to medieval literary romances. More importantly, it was supported by the reaction against the excesses of the French Revolution (and, by implication, of classically inspired rationalism). This occurred in France as much as anywhere. Originally it was a protest movement, fanned by such defences of tradition as François-René Chateaubriand's *Le Génie du Christianisme ou beautés de la religion chrétienne* (1802). It then received a kind of official promotion when Napoleon, with great prescience, re-established Christianity in France and took the title of Emperor. Napoleon's court (and in particular his

wife Josephine Bonaparte) favoured a chivalric medievalism that came to be known as the Troubadour style, and many French history painters of the day, such as Anne-Louis Girodet and Pierre-Paul Prud'hon, exploited this mood. Most intriguing of all was the use made of it by Ingres, who, though later seen as the bastion of classicism, was one of the most subtle interpreters of the Gothic at this time, as shown by the tender portrait of *Mlle Rivière* (1806; Paris, Louvre). Equally striking in the Napoleonic period was the promotion of a vivid, painterly style for heroic modern subjects. David himself made attempts in this direction, particularly with his record of the *Coronation of Napoleon in Notre-Dame* (1805–7; Paris, Louvre). But it was Antoine-Jean Gros who mastered this style with his celebrations of Napoleon's exploits, most notably that of *Bonaparte Visiting the Victims of the Plague at Jaffa* (1804; Paris, Louvre).

Such works seem to be Romantic in all but name. However, the leading artists of this period were strongly opposed to Romanticism later and were also defenders rather than critics of the status quo. The promotion of medievalism as a protest against the contemporary situation took place elsewhere, largely in Germany and in England. It was most overt in central Europe, where, in particular, a group of students at the Akademie der Bildenden Künste in Vienna formed the Lukasbrüder in 1809, in emulation of a medieval guild. The Nazarenes (as they later became known after their leaders, Friedrich Overbeck, Franz Pforr and others, moved to Rome in 1810) saw art essentially in terms of morality and placed sincerity of vision above technical accomplishment. In this sense their artistic ideals accord with those of such German literary Romantics as Tieck and Wilhelm Heinrich Wackenroder, whom they admired, even though their art has little of the pictorial sensuousness normally associated with Romanticism. They were also representative of the movement in the way that they banded together to make their protest. They were not quite the first 'breakaway' group to be formed (that honour can probably be given to the Primitifs, a group of students active in David's studio *c.* 1800), but they were the first to make their protest successful. They thus established a pattern that has become one of the stereotypes of the modern art world, that of the avant-garde outburst that settles down to become the new orthodoxy. The Nazarenes' pious medievalism eventually brought them international fame. In the reactionary climate of post-Napoleonic Europe their traditionalism had a strong appeal, particularly in the authoritarian regimes of central Europe. Despite this, 'protest' medievalism remained a strong current in 19th century art, particularly in Britain where it stimulated both the Pre-Raphaelite movement in painting and the decorative arts and the Gothic Revival in architecture.

The emergence of a fully fledged genre of Romantic history painting occurred in France following the fall of Napoleon. This might be seen as a result of the restoration of the Bourbon monarchy, since Troubadour painting was vigorously promoted by the new regime, as shown in pro-Bourbon historical subjects by Gros and François Gérard (e.g. Gérard's *Entry of Henry IV into Paris*, exh. Salon 1817; Versailles, Château). In fact the new history painting was largely motivated by disillusion and a spirit of opposition, as is clear from the career of Géricault, arguably the greatest painter of the first half of the 19th century. He began his career celebrating the heroism of Napoleonic France in such dramatic modern-life works as the *Charging Chasseur* (1812; Paris, Louvre); after the confusion of the Restoration (and many personal disappointments), he painted the monumentally anti-heroic work the *Raft of the Medusa* (exh. Salon 1819; Paris, Louvre; see fig. 78), which combines all the uplifting visual qualities of the best history painting with a theme of utter despair. Géricault died young in 1824: both the tragedy of his death and still more the vistas opened up by his art left a vivid challenge to other French artists. The growing discussion of Romanticism in literary circles at the time, as embodied in the philosophy of Victor Cousin and the writing of Stendhal and Victor Hugo, also provided a new and convenient rallying-point for their protest. By far the most intelligent

78. Théodore Géricault: *Raft of the Medusa*, exh. Salon 1819 (Paris, Musée du Louvre)

and skilled of this younger generation was Delacroix. In later years he was disdainful of the term Romantic, but in the early 1820s he seemed happy enough to accept it. His major Salon paintings of the 1820s, notably the *Massacres of Chios* (1824; Paris, Louvre) and the *Death of Sardanapalus* (1827; Paris, Louvre), combine the subversiveness of Géricault, though usually subtly mediated, with a more dedicated exploration of colour as the means of conveying sensation.

A large number of other artists emerged at this time who combined sensationalism with the portrayal of exotic, modern or medievalizing themes, notably Horace Vernet, Eugène Devéria, Alexandre-Gabriel Decamps and Léopold Robert. The new interest in sensationalism led to an unprecedented attention to English art, including the naturalism of Constable. A number of English and Anglo-French artists profited from this concern, the most remarkable being Richard Parkes Bonington, a brilliant watercolourist who did much to establish a new form of informal historical painting that appealed to the Romantic interest in the anti-heroic. With the July Revolution of 1830 Romantic history painting came of age in France and received much official support under the government of Louis-Philippe. It is characteristic of Delacroix that he should have benefited from this new mood by gaining a prodigious number of state commissions for murals (most notably those for the library of the Palais du Luxembourg in Paris; *in situ*) while distancing himself increasingly from programmatic Romanticism. Nevertheless, the reflective pessimism of his later work and his deepening exploration of colour effects show him to have been working within the spirit of the movement at a profounder level. Other history painters of the Romantic generation showed little capacity for development, and the field of fashionable history painting was soon given over to such academic artists as Paul

Delaroche, Théodore Chassériau and Thomas Couture, who attempted to achieve a *juste-milieu* by creating a rapprochement between Romantic and classical and/or Realist tendencies.

The impact of French Romantic history painting spread throughout Europe from the late 1820s. At that time the two dominant historical schools were acknowledged to be those of Paris and of the Nazarene-inspired history painting of Germany, as represented in particular by the work of Peter Cornelius (see fig. 51). In Belgium the tendency was more towards the French school, notably in the work of Gustaf Wappers and Antoine Wiertz. In England William Etty's work showed the strong influence of French artists, while such later artists as Daniel Maclise and William Dyce looked more towards the Germans. In Italy the Roman-based Purismo Movement (whose leading figure was Tommaso Minardi) showed the impact of the Nazarenes, while in the north Francesco Hayez painted in a more individual mode that had strong affinities with elements of the work of Ingres and Delacroix. In Germany itself the Düsseldorf school constituted a middle road between Nazarene and Parisian history painting (particularly in the work of Karl Friedrich Lessing). A similar combination can be seen in the art of eastern Europe, as in the history painting of Karl Bryullov and Sergey Ivanov. History painting also began to gain ground in the USA: Washington Allston was strongly influenced by English art, while the work of such later painters as Emanuel Gottlieb Leutze reveals the impact of the Düsseldorf school.

Parallel with the development of individualism, medievalism and modernity in history painting came the challenge of other genres for a status similar to that of history. The strongest came from genre painting, as the growing power of the bourgeoisie throughout Europe at this time did much to stimulate its popularity. To some extent this had been initiated by the genre scenes of the French painter Jean-Baptiste Greuze. The sentimental attitude to the simple, moral life articulated in his works created a taste that was exploited by such other painters of the rural and domestic as George Morland in England. In the early 19th century the Scottish painter David Wilkie achieved an immense success in London with his Dutch-inspired portrayals of domestic life. In France the depiction of simple domestic virtue was carried on by Louis-Léopold Boilly. In Germany it developed a sentimental direction, particularly in the post-Napoleonic Biedermeier style, when Moritz von Schwind, Ludwig Richter and Carl Spitzweg treated the theme with varying degrees of fantasy and humour.

Another figurative genre that took on new dimensions at this time was portraiture. The Romantic interest in individualism and temperament had its effect at both the fashionable and the more private level. At the former it led to a new kind of suave society portrait, which was mastered most effectively by the English painter Thomas Lawrence, who became the most sought-after portrait painter in Europe. At a deeper level it led to the profoundly paradoxical portraits of Goya (such as the group portrait of the *Family of Charles IV*, 1800; Madrid, Prado), which seem both to celebrate social status and undermine individual character, and to moving explorations of aberrant personality, most notably in Géricault's portraits of the insane (e.g. *Gambling Mania*, 1823; Paris, Louvre). The interest in passion and temperament also stimulated a new interest in the portrayal of animals. Following the tradition established by George Stubbs, the English showed a marked proficiency in this genre, as exemplified by James Ward and Edwin Henry Landseer in particular. Indeed, the only form of portrayal of the natural world that does not seem to have gained a new dimension in the Romantic era is still-life, but perhaps it is because this genre shows nature curtailed and organized rather than organic and living.

The perception of nature as a living entity certainly underpinned one of the most remarkable and original developments in the Romantic era, namely the re-evaluation of landscape painting. The change was both external and internal. Externally it led to the claim that the subject of landscape was as important as that of history painting. This is a view that was supported by the development of 'nature' poetry in the 18th century, with its refocusing on nature as the

source of spiritual inspiration. The writings of the Swiss-French philosopher Jean-Jacques Rousseau were also significant because of their insistence that man and society were at their best in the natural state. A new enthusiasm for landscape—in particular the representation of wild and evocative scenery—was prevalent throughout Europe at this time. Probably the most famous landscape painter of this period was Joseph Vernet, who both reintroduced works of idyllic calm based on the work of the 17th-century landscape painter Claude and innovatively painted scenes of wild storms that drew their inspiration from the current interest in the Sublime. Wild landscape scenery became a vogue in England too, promoted by Philippe Jacques de Loutherbourg and by Gainsborough in some of his later work. This led to a re-evaluation of the wilder parts of the British Isles, such as the Lake District and north Wales. On the Continent the high mountain scenery of the Alps began to be appreciated in a new light, as shown in the work of the Swiss landscape painter Caspar Wolf. The new taste for travel in search of the Picturesque (generated by the writings of William Gilpin, Richard Payne Knight and Uvedale Price) also led to a wider interest in topography. The growing concern with direct observation is symptomatic of this interest and led, among other things, to the promotion of the *plein-air* oil sketch and to the development of water-colour painting. The British proved to be particularly adept at the latter, and many of the greatest landscape painters of the period, including Thomas Girtin and John Sell Cotman, practised largely or exclusively in this medium.

It was the generation who came to maturity around 1800 who took Romantic landscape painting to its height. This occurred for the most part in Britain. In general there seem to have been two major tendencies, one to explore the dramatic and fantastic, the other to become immersed in the minutiae and in a sense of the local and particular. Trained as a watercolour painter, Turner aimed to master all forms of landscape, but he was at his best in extremes, in dramatic scenes of disasters (such as his early *Shipwreck*, 1805; London, Tate) and in quiet moments of intense lyricism.

He penetratingly explored the effects of nature as shown in *Rain, Steam and Speed: The Great Western Railway* (1844; London, N.G.; see col. pl. XXXVII), in which he also ironically included a hare running ahead of the train, so suggesting the limitations of technology. He was equally concerned with modes of representation and in his later works achieved transcendent visions of colour effects. Other painters, notably John Martin and Francis Danby, emulated his dramatic tendencies, but none could equal his late, near abstract work. The other major landscape painter of the period, Constable, aimed at depicting local scenery on a grand scale. Like the poet William Wordsworth, he was deeply attached to the scenes of his childhood. His *Hay Wain* (1821; London, N.G.) has subsequently become a symbol of idyllic English rural life, but he himself became increasingly depressed by the collapse of the rural society of his childhood, and his later works are stormy and pessimistic. As well as these depictions of tranquil rural life, there was a more visionary interpretation of the countryside, represented most strongly in the work of Samuel Palmer, a follower of Blake. This attitude is, however, more evident in Germany, where there was a greater interest in the expression of religious and philosophical ideas through landscape. Runge represents this tendency at its most extreme, but it was Friedrich who most successfully combined such concerns with actual experiences of nature.

Up to 1820 these developments took place largely in England and northern Europe. After that, there was a growing tendency in France to view landscape more seriously. To some extent this was part of the response to English art of the period, and such painters as Paul Huet largely based their style on that of the English. Others, such as Georges Michel, looked to the great Dutch landscape painters of the 17th century. There was also a reassessment of an indigenous tradition: Pierre Henri de Valenciennes had done much to promote *plein-air* painting, as well as the prestige of the genre in general. The most important beneficiary of this was Corot, who studied in Rome (1825–8) and developed a quiet, meditative form of naturalism that is positively Franciscan in its

pantheism. The search for a wild 'national' naturalism (so much a keynote of Romanticism in every country) was answered largely by the Barbizon painters, who from *c.* 1830 began to settle in the village of that name in the forest of Fontainebleau. Although most of this group are more closely associated with Realism, its leading figure, Théodore Rousseau, was still deeply affected by the Romantic quest for the spiritual in nature (see fig. 9). A similar combination of naturalistic and spiritual interests can be found in the numerous other groups of landscape painters who proliferated around Europe after 1820. Pride of place must be given to the artists of the Danish school, in particular Christen Købke. In Germany there were major centres in Dresden, where the Norwegian J. C. Dahl reigned supreme, in Düsseldorf and in Berlin. In the last named place Karl Blechen gave a new dimension to Romantic landscape painting through his exploration of ironic effect. Romantic landscape painting was also one of the most successful visual exports to the New World. In the USA there was a distinguished tradition of practitioners, including Thomas Cole, who developed the fantastic along the line of Turner and Martin (see col. pl. XVIII and fig. 40), and such other members of the Hudson River school as Asher B. Durand, who were involved in a more direct celebration of American nature.

(iii) **Graphic arts.** In many ways Romanticism in the graphic arts can be seen as an extension of that in painting: many of the major Romantic painters, such as Blake, Goya, Géricault and Delacroix, also practised the graphic arts. There were also some individual developments, however. During the Romantic period there was a constant introduction of new techniques, such as aquatint, lithography and steel engraving. These can be seen as side-products of the Industrial Revolution, because they made use of new technology as well as catering for a new mass audience. This proliferation tended to emphasize the distinction between 'creative' painting and the use of graphic arts for reproduction. Reproductive engraving developed as an industry, both for the reproduction of works of art and for the illustration of books and peri-

odicals. By the 1840s there was already a form of journalism that depended on mass illustration, as witnessed by the emergence of the *Illustrated London News* in 1842.

However, vigorous and inventive graphic art also developed. Perhaps the most notable innovation associated with Romanticism is the emergence of political caricature. The exploration of fantasy prevalent in the late 18th century encouraged the underlying association of exaggerated portraiture with allegory. The practice first emerged in Britain, where James Gillray was the principal master. The political cartoon later became a major form in French graphic art, most notably in the work of Honoré Daumier. In France in particular etching was also developed as a creative medium, for example in the fantastic work of Louis Boulanger and the urban views of Charles Meryon. Revivalism also had its impact on the graphic arts, encouraging interest in the striking graphic modes of the 16th century; perhaps the most successful use of these was made by the German artist Alfred Rethel.

(iv) **Sculpture.** Partly because Romantic theorists thought that sculpture was quintessentially classical and concerned primarily with form, Romanticism had relatively little impact on sculpture until around 1830. Before this Romantic themes were sometimes explored by sculptors, and there were even tendencies towards sensuality that can be associated with the movement. Thus the leading Neo-classical sculptor of the period, Antonio Canova, certainly has more than a classical eroticism in his work, and such sculptors as Joseph Chinard, Antonio Bosio and Antoine-Denis Chaudet, who were associated with the Napoleonic court, also exploited this mode, but this can hardly be seen as more than a tendency. In the next generation the leading Neo-classical sculptor, the Dane Bertel Thorvaldsen, also had dramatic moments, perhaps most strongly in his *Lion of Lucerne* (modelled 1819; executed in the cliff at Lucerne by Lucas Ahorn, 1819–21), a monument that shows a lion emerging from a rock. Funereal and memorial monuments can generally be associated with Romanticism, but this is perhaps

79. David d'Angers: *Niccolò Paganini*, 1830–33 (Angers, Galerie David d'Angers)

because of the inevitable pathos of their subject. Certainly a number of the memorial monuments of the English sculptors John Flaxman and Francis Chantrey can be seen in this light.

It was in France in the 1820s, in the context of the development of an overt Romantic Movement, that sculpture with a more direct relationship to Romanticism emerged. The most prominent sculptor associated with it was Pierre-Jean David D'Angers, who made spirited, temperament-filled studies of the great men of his age (see fig. 79). Other major practitioners were Auguste Préault, Jehan du Seigneur and François Rude. All these sculptors attempted emotive subjects, but they were also linked to Romanticism by their move away from the smooth surfaces of classical sculpture to rougher and more individualistic effects— a formal equivalent to the impassioned brushwork of Delacroix. This is perhaps most clear in the *ani-malier* sculpture of Antoine-Louis Barye, whose scenes of animal violence (e.g. *Lion Attacking a Serpent*, bronze, 1832; Paris, Louvre) fit both for-

mally and in terms of subject-matter with the concepts of Romanticism.

Outside France, and to some extent inspired by developments there, Romantic styles of sculpture gained ground in the 1830s. Most countries had their national representatives, such as Ludwig von Schwanthaler in Germany. Of these the most successful was probably the Italian Carlo Marochetti, who gained an international reputation for his swashbuckling representations of heroic historical figures (e.g. *Duke Emanuel-Philibert of Savoy*, bronze, 1833–7; Turin, Piazza San Carlo). Perhaps because of the public nature of the medium, there was relatively little development of the more private and reflective sides of Romanticism in sculpture. However, in this context it is worth mentioning the marvellous modelled caricatures (e.g. *Ratapoil*, plaster, c. 1851; Buffalo, NY, Albright–Knox A.G.) that Daumier made for his own use and the gentler mood evident in the work of the English sculptor Alexander Monro (1825–71), who was inspired by the Pre-Raphaelites.

(v) **Architecture and planning**. Romanticism in architecture, planning and design represents the most directly social aspects of the movement. In general, Romantic ideas first began to affect these areas through élitist groups who wished to distance themselves in one way or another from contemporary society. In the later period this sense of distancing remained but took on the character of a moral distancing, a means by which the values of the modern world could be censured.

Landscape gardening is arguably the area in which Romantic ideas first became manifest. Throughout the 18th century there was a growing vogue in England for laying out gardens in an informal manner, which contrasted with the formalism of French and Italian gardens. First pioneered by William Kent, the habit was expanded by Lancelot 'Capability' Brown and later by Humphry Repton. Encouraged by the Picturesque movement, by the end of the 18th century an extreme wildness was fashionable, such as can be seen in the woods around Fonthill Abbey, Wilts, the house built by the eccentric William Beckford.

This move towards informality and the fantastic also became popular on the Continent.

While principally a manifestation of the cult of nature, this tendency was accompanied by a taste for the fantastic in architecture, either as follies within a park setting or as rural retreats to live in. Often this was part of the revival of medieval styles, which appealed because of their chivalric associations. Horace William Walpole's Gothick house at Strawberry Hill, Twickenham, constructed from 1748 onwards, was the most important of these (see col. pl. XV). As with the taste for natural gardens, this tendency was also found on the Continent, particularly among reclusive aristocrats, as shown by the Désert de Retz (1774–94) near Marly in France, laid out by François-Nicolas-Henry Racine, Baron de Moinville (1734–97), assisted by François Barbier (fl 1764–75), and the Löwenburg (1793–8) in Kassel, Germany, by Heinrich Christoph Jussow.

In the last decades of the 18th century architectural idealism took on a more social dimension, particularly in France, where Claude-Nicolas Ledoux and Etienne-Louis Boullée designed idealist architectural structures that were, for the most part, not executed. Based on a geometricized classicism, their architecture can be seen as Romantic principally in its scale and ambition. The style they promoted, often known as Romantic Classicism, had affinities elsewhere in Europe, where it led to the actual realization of buildings. In England it can be seen in the work of John Soane and John Nash. In Germany it affected the work of such leading classicists of the day as Friedrich Gilly, Karl Friedrich Schinkel and Leo von Klenze.

The growing nationalistic mood of the early 19th century encouraged grandiose redevelopments of major capital cities. Napoleon set the pace with his remodelling of Paris (largely through the agency of the architects Charles Percier and Pierre-François-Léonard Fontaine), and in England his activities were emulated by the Prince Regent (later George IV), who commissioned Nash to redesign the West End of London. In Berlin similar schemes were supervised by Schinkel. The dominant style for these was classical, but medievalism gained ground because of its nationalistic and religious associations. The concept of style as symbolic (something that Ledoux had paved the way for when he talked of *architecture parlante*) took on a new power. It can be seen in the Gothic war memorials constructed after the Napoleonic Wars, particularly in Prussia. To some extent this linked in with the chivalric Gothic Revival of the 18th century (as can be seen, for example, in James Wyatt's remodelling of Windsor Castle, Berks, c. 1824–37). The movement gained a new moral dimension in the 1830s. This was the period in which A. W. N. Pugin pioneered a thorough-going Gothic Revival on the grounds that it would be a means of resurrecting the spiritual values of the Middle Ages. Pugin was mainly concerned with religious architecture (and was a major force in the reintroduction of Gothic for church buildings), but the revival was also secular, as can be seen by the decision to build the New Palace of Westminster in the Gothic style for reasons of national association. The Gothic Revival became so powerful in England that it was virtually the national style in the period c. 1845–75. Elsewhere the revival of styles was broader. In Germany the *Rundbogenstil* was favoured, largely because of national associations with the Romanesque.

This stylistic revivalism was accompanied by a growing knowledge of historical styles from archaeological and antiquarian research. As well as encouraging the use of more scholarly and detailed revivalism, this also promoted the fantasy that the spirit of past ages could in some sense actually be reconstructed. This element took on a growing importance at a time when such architectural theorists as John Ruskin were emphasizing the need for architecture to take a moral stand against contemporary values. The fantasy of a medieval 'golden age' also affected attitudes to design. This was the area in which the impact of the Industrial Revolution had been most direct, leading to the mass-production of goods and the need to separate the process of design from the process of production. One of the outcomes of this was a reactionary move to preserve traditional craft practices, something that was promoted by

Ruskin and which formed the mainstay of the Arts and Crafts Movement.

4. The legacy

Strictly speaking, the Arts and Crafts Movement lies outside the period of Romanticism. However, this emphasizes the fact that Romanticism was effective far beyond the time when it constituted a dominant cultural movement. In the 1840s Romanticism seemed to be giving way to a new movement, Realism. However, the latent subjectivity involved in the latter—and the cult of personality indulged in by the leading figures associated with it (notably Courbet)—suggests that many attitudes pioneered by Romanticism had persisted. Since the late 19th century there have been several artistic movements that have reaffirmed Romantic ideas in one way or another: the Aesthetic Movement, Symbolism, Expressionism, Surrealism and (from the 1930s to the early 1950s) Neo-Romanticism. Post-modernism seems to be emulating the Romantic Movement's concern for stylistic revival and association aesthetics. These continuous re-emergences seem to emphasize the extent to which Romanticism stood not just for a movement but also for a set of principles.

Bibliography

F. D. Klingender: *Art and the Industrial Revolution* (London, 1947, 2/1968)

R. Williams: *Culture and Society, 1780–1950* (London, 1958, rev. 1987)

F. Novotny: *Painting and Sculpture in Europe, 1780–1880*, Pelican Hist. A. (Harmondsworth, 1960, 2/1971)

W. Hofmann: *The Earthly Paradise: Art in the Nineteenth Century* (London, 1961)

A. Hauser: *Rococo, Classicism and Romanticism*, iii of *The Social History of Art* (London, 1962)

E. J. Hobsbawm: *The Age of Revolution: Europe, 1789–1848* (London, 1962, rev. 1978)

P. Deane: *The First Industrial Revolution* (Cambridge, 1965)

E. Gilmore Holt, ed.: *From the Classicists to the Impressionists: A Documentary History of Art and Architecture in the Nineteenth Century* (New York, 1965)

L. Eitner: *Neoclassicism and Romanticism*, 2 vols (Englewood Cliffs, 1970)

K. Clark: *The Romantic Rebellion* (London, 1973)

R. Brinkman, ed.: *Romantik in Deutschland* (Stuttgart, 1978)

W. Vaughan: *Romantic Art* (London, 1978)

H. Honour: *Romanticism* (London, 1979)

M. Butler: *Romantics, Rebels and Revolutionaries* (Cambridge, 1982)

D. G. Charlton, ed.: *The French Romantics* (Cambridge, 1984)

H. W. Janson and R. Rosenblum: *Art of the Nineteenth Century* (London, 1984)

A. Boime: *Art in an Age of Revolution, 1750–1800*, A Social History of Modern Art, i (Chicago and London, 1987)

W. Friedlaender: *David to Delacroix* (Cambridge, MA, 1952)

T. S. R. Boase: *English Art, 1800–1870*, Oxford Hist. Eng. A. (Oxford, 1959)

J. Lindsay: *Death of the Hero: French Painting from David to Delacroix* (London, 1960)

K. Andrews: *The Nazarenes* (Oxford, 1964)

B. Novak: *American Painting of the Nineteenth Century* (New York, 1969)

A. Boime: *The Academy and French Painting in the Nineteenth Century* (New York, 1971)

French Painting, 1774–1830: The Age of Revolution (exh. cat. by P. Rosenberg, R. Rosenblum and A. Schnapper; Detroit, MI, Inst. A.; New York, Met.; 1975)

C. Duncan: *The Pursuit of Pleasure: The Rococo Revival in French Romantic Art* (New York, 1976)

J. Wilmerding: *American Art*, Pelican Hist. A. (Harmondsworth, 1976)

Die Nazarener (exh. cat., ed. K. Gallwitz; Frankfurt am Main, Städel. Kstinst., 1977)

H. von Einem: *Deutsche Malerei des Klassizismus und der Romantik* (Munich, 1978)

W. Vaughan: *German Romantic Painting* (New Haven and London, 1980)

M. Monteverdi, ed.: *Storia della pittura italiana dell'ottocento* (Busto Arsizio, 2/1984)

K. Clark: *The Gothic Revival* (London, 1928, 3/1962)

H. Russell Hitchcock: *Architecture: Nineteenth and Twentieth Centuries*, Pelican Hist. A. (Harmondsworth, 1958, 4/1977)

M. Whinney: *English Sculpture, 1720–1830* (London, 1971)

J. M. Crook: *The Greek Revival* (London, 1972)

G. Germann: *Gothic Revival* (London, 1972)

J. Cooper: *Nineteenth-century Romantic Bronzes* (Boston, 1975)

J. Dixon Hunt and P. Willis, eds: *The Genius of the Place: The English Landscape Garden, 1620–1820* (New York, 1975)

H. W. Janson: *Nineteenth Century Sculpture* (New York, 1987)

M. H. Abrams: *The Mirror and the Lamp: Romantic Theory and the Critical Tradition* (New York, 1953)

L. Eitner: 'The Open Window and the Storm-tossed Boat: An Essay in the Iconography of Romanticism', *A. Bull.*, xxxvii (1955), pp. 281–90

W. J. Hipple: *The Beautiful, the Sublime and the Picturesque in Eighteenth-century British Aesthetic Theory* (Carbondale, 1957)

B. Smith: *European Vision and the South Pacific* (Oxford, 1960, rev. New Haven and London, 2/1985)

M. Z. Schroder: *Icarus: The Image of the Artist in French Romanticism* (Cambridge, MA, 1961)

S. H. Monk: *The Sublime* (Ann Arbor, 1962)

M. Hope Nicolson: *Mountain Gloom and Mountain Glory: The Development of the Aesthetics of the Infinite* (New York, 1963)

R. Rosenblum: *Transformations in Late Eighteenth-century Art* (Princeton, 1967)

K. Kroeber: *Romantic Landscape Vision: Constable and Wordsworth* (Madison, 1975)

R. Rosenblum: *Modern Painting and the Northern Romantic Tradition* (New York and London, 1975)

G. Levitine: *The Dawn of Bohemianism: The 'Barbu' Rebellion and Primitivism in Neoclassical France* (University Park and London, 1978)

WILLIAM VAUGHAN

Rubénisme

Term used to describe the school followed by one of the two groups of artists and connoisseurs in 17th-century France involved in the so-called *Querelle du coloris*, which was debated primarily from 1672 to 1678 (*see also* POUSSINISME). While Charles Le Brun and his followers took Classical antiquity for their example, those who supported Rubénisme, including Roger de Piles, Gabriel Blanchard, Charles de La fosse, Jean Jouvenet, Antoine Coypel and nicolas de Largillierre, preferred the paintings of Peter Paul Rubens and the 16th-century Venetians. In contrast to the intellectual vision of the Poussinistes, the Rubénistes emphasized the suggestion of reality made possible by colour, which provided the *tout-ensemble* reconstruction of nature. For them, the goal of painting was the effect of *trompe l'oeil*, which created a more sensual *délectation* in the viewer. Visual persuasion was achieved by the study of atmospheric light and the union of colours in the construction of space, creating chiaroscuro.

In 1671, during a lecture at the Académie Royale de Peinture et de Sculpture in Paris, in which Philippe de Champaigne criticized Titian's work on the basis of Poussin's thinking, Gabriel Blanchard sprang to Titian's defence with great vehemence. An argument broke out that apparently was resolved by Le Brun's judgement in favour of preserving the point of view of the Académie. However, in 1673 de Piles, a collector and connoisseur who was also a painter and a friend of the painter and writer Charles-Alphonse Du Fresnoy, published *Dialogue sur le coloris*, a pamphlet supporting Blanchard's ideas. Afterwards he grouped together several like-minded people who held up Rubens as the finest example to emulate. The debate drew to a close without any apparent solution, but de Piles and his supporters finally achieved recognition after Jean-Baptiste Colbert died in 1683, and Le Brun was succeeded in 1690 as Premier Peintre du Roi by Pierre Mignard I, an artist who favoured Rubénisme. De Piles was elected to the Académie as Conseiller Honoraire in 1699.

As in the case of Poussinisme, material circumstances should be taken into consideration: the type of painting encouraged by the doctrine of the Académie (that of Italian art generally and the Bolognese masters in particular) was becoming increasingly rare on the art market, whereas the work of Flemish artists was more readily available. *Le Cabinet de Monseigneur le Duc de Richelieu* (1676), a text written by de Piles, concerned the collection of Rubens's works built up so quickly by Armand-Jean du Plessis, Duc de Richelieu. The position taken by Mignard revealed a more partisan spirit; his attitude was one of opposition to Le Brun and was linked to the taste of the Orléans family in whose service he was employed, although this had little or no discernible effect on his own work. However circumstantial this opposition between the two artists may appear to have been, it nevertheless preserved French art from the more mannered aspects of Poussin's work as seen in the paintings of Nicolas Colombel, a faithful follower. It was also proof of the self-confidence enjoyed by 17th-century French artists and of the tolerance that was char-

acteristic of the Académie at that time, in which ideas were accepted, even when opposed to its principles. Although Poussin was chosen and cited as an example for young artists, the fact that the victory of the Rubénistes did not culminate in the elimination of their adversaries demonstrated that it was possible to choose quite different examples and adapt them to French taste. At the same time, these developments established another kind of artistic freedom quite different from that sought by the Académie through social standing: the freedom of caprice.

Bibliography

B. Teyssèdre: *Roger de Piles et les débats sur le coloris au siècle de Louis XIV* (Paris, 1965)

<div style="text-align:right">SYLVAIN KERSPERN</div>

Rundbogenstil [Ger.: 'round arch style']

Term used to describe an architectural style that began and flourished in Germany in the second quarter of the 19th century, with parallels, mostly later, in other northern European countries and the USA, and which survived much longer as a utilitarian style. Based on the structural unit of the round arch, or *Rundbogen*, it has frequently been confused with Romanesque Revival architecture. The *Rundbogenstil*, however, was not a historical revival; instead, it was among the first architectural movements to insist that form be derived not from history but according to abstract notions of utility and objectivity. By placing issues of planning and construction above those of formal composition and ornament, the *Rundbogenstil* was an important forerunner to 20th-century architecture, bringing Germany for the first time to a position of international prominence in architectural theory.

The *Rundbogenstil* arose out of the debate over the meaning of Classical Greek and Roman architecture that preoccupied German architects in the first decades of the 19th century. Germany had maintained a strong vernacular architectural tradition, and architects educated in the building trades, for example David Gilly and Friedrich

Weinbrenner, brought a characteristically deep interest in construction to their investigation of the architecture of Classical antiquity. In particular the workshop of the Neo-classicist Weinbrenner was the source of the most important future practitioners of the *Rundbogenstil*, including Heinrich Hübsch, Friedrich von Gärtner, Alexis de Chateauneuf and August Andreae (1804–46). These young architects reacted against the wearisome debates over the correct proportions of the Classical orders, and they were influenced by the notions of architecture as rational construction then being promulgated in France by Jean-Nicholas-Louis Durand.

The theory of the *Rundbogenstil* was first codified by Hübsch. Studying philosophy and mathematics at the University of Heidelberg before turning to architecture, he brought to the stylistic debate a speculative and empirical approach. As the first important German architect to travel to Greece and Constantinople (1817–20), he began to rethink the meaning of Classical architecture. He came to deny the generally accepted notion that the forms of the Greek temple originated in a timber predecessor, and in his *Über griechische Architektur* (1822) he stressed instead the perfect correspondence between antique architectural forms and the nature of stone construction. He further amplified this idea that architecture should express an organic structural system in his vastly influential *In welchem Style sollen wir bauen?* (1828), the manifesto on which the *Rundbogenstil* depended.

For Hübsch architectural style was the function of climate, building materials and the construction system. He rejected Roman architecture for its 'deceitful' mixture of lintels and arches but also ruled out Greek architecture as a model for Germany, with its harsher climate and different available materials. Instead he looked for inspiration to the Romanesque style, the round, sandstone arch of which was as structurally true and appropriate to the climate and character of Germany as the massive marble lintel was for Greece. In this he was supported by the contemporary understanding of architectural history—which interpreted Romanesque architecture as

Byzantine or 'neo-Greek' architecture—and he could praise the Romanesque abbey church at Maria Laach, Rheinland, as a German Parthenon. While he valued the structural consistency of Romanesque architecture, however, Hübsch advocated following its principles rather than copying its forms. His book was saturated with hostility towards the archaeological copyism of his Neoclassicist teachers, and he pleaded eloquently for a style that could be appreciated without archaeological instruction: ornament, in particular, should not be copied from historical examples but should be left to the free fantasy of the artist. As Hübsch recommended, *Rundbogenstil* buildings typically derived their ornament from a free mixture of sources, particularly Byzantine, Romanesque and Classical.

During the 1830s the *Rundbogenstil* supplanted Neo-classical forms in most of Germany, dominating religious, civic and domestic architecture. *Rundbogenstil* buildings were distinguished by freedom in exterior composition, based on an often bald interpretation of the programme and construction. They were frequently rather utilitarian in character, forming extended horizontal blocks without projecting frontis-pieces or porticos, such as Hübsch's own Technische Hochschule (1833–6; altered), Kaiserstrasse, Karlsruhe, which is now part of the university. Other buildings showed a great freedom from historical precedent and an interest in structural display, such as Hübsch's Trinkhalle (1837–40) in Baden-Baden and his theatre (1851–3; destr. 1944) in Karlsruhe, both of which boldly placed segmental arches upon colonnades.

The *Rundbogenstil* enjoyed rich regional diversity. In northern Germany it assumed a distinctive form, based in large measure on local brick construction, which encouraged a vigorous articulation of pilaster-strips, corbel friezes and blind arcades. Often polychromatic and more emphatically medieval in character than its southern German counterpart, this northern *Rundbogenstil* was developed in Hamburg and Hannover by Alexis de Chateauneuf and August Andreae respectively. An important example in Hamburg, where the style came close to the Renaissance Revival, was the Johanneum (1836–9), an educational complex built by Carl Ludwig Wimmel, a pupil of Weinbrenner, and Franz Forsmann (1795–1878). Perhaps the most idiosyncratic *Rundbogenstil* buildings were the splendidly colourful and imaginative churches built near Koblenz by Johann Claudius von Lassaulx in the 1830s and 1840s, distinguished by the most exacting standards of vaulting technology. These include St Servatius (1833–40), Güls, on the Mosel River, and the church at Vallendar (1837–41), on the Rhine. In later years Hübsch was not as theoretically important, and other cities succeeded Karlsruhe as centres of the *Rundbogenstil*, particularly Munich. This was the legacy of a major building programme there and also of the city's influential academy of architecture. Munich became a showplace of the *Rundbogenstil*, renowned for Gärtner's buildings on the Ludwigstrasse, including the Ludwigskirche (1829–44), the Staatsbibliothek (1832–3) and the Salinengebäude (1838–43). These Bavarian buildings were typically monochromatic blocks with heavy entablatures and cornices, massed like the Florentine palazzi and suggesting the ties of southern Germany to Italy.

By the start of the 1840s the *Rundbogenstil* was firmly ensconced in Germany's schools of architecture, typically forming a quasi-official part of the curriculum. Berlin alone was something of an exception to the general enthusiasm for the style, largely because of the legacy of the eclectic Karl Friedrich Schinkel, and there the *Rundbogenstil* was practised concurrently with a range of other styles. Within a few years, however, the style came under theoretical attack. Gottfried Semper's vast *Rundbogenstil* project for the Nikolaikirche in Hamburg won the competition held in 1845, but it was later rejected in favour of the Gothic Revival design (tower extant) of George Gilbert I Scott. From then the Gothic Revival and Renaissance Revival both chipped away at the dominance of the *Rundbogenstil*, which was seen to lack the strong symbolic associations of those styles; generally suitable for all functions, it was specifically well suited for none. By the end of the 1860s it had been relegated to a utilitarian style, used for factories or barracks. The *Rundbogenstil* corresponded generally

to the ROMANESQUE REVIVAL in France, Britain (usually known as the NORMAN REVIVAL) and the USA.

Bibliography

H. Hübsch: *In welchem Style sollen wir bauen?* (Karlsruhe, 1828/R 1984) [postscript by W. Schirmer]

K. Möllinger: *Elemente des Rundbogenstiles* (Munich, 2/1848)

A. Mann: *Die Neu-romanik: Eine rheinische Komponente im Historicismus des 19. Jahrhunderts* (Cologne, 1966)

N. Pevsner: *Some Architectural Writers of the 19th Century* (Oxford, 1972), pp. 62–7

K. Döhmer: *In welchem Style sollen wir bauen?* (Munich, 1976)

H.-R. Hitchcock: *Architecture: Nineteenth and Twentieth Centuries*, Pelican Hist. A. (Harmondsworth, 1977), pp. 55–7

MICHAEL J. LEWIS

St John's Wood Clique

English group of artists. In the 1860s a group of young, ambitious artists living in the St John's Wood area of London formed a loose association, known as the St John's Wood Clique to distinguish it from another artistic group, THE CLIQUE. The members were Philip Hermogenes Calderon, J. E. Hodgson (1831–95), G. D. Leslie (1835–1921), Henry Stacy Marks, Val Prinsep, G. A. Storey (1834–1919), Fred Walker, William Frederick Yeames and D. W. Wynfield (1837–87). With the exception of Prinsep and Walker, who were 'honorary' members, all resided in St John's Wood. The St John's Wood Clique met every Saturday in a member's home to hold informal sketching classes based on a chosen theme; members then criticized each other's work. The largely social nature of the group led them to combine artistic endeavour with such frivolity as singing and reciting mock sermons. At one point they decorated Hodgson's house in Hill Road with frescoes. Literary men such as George Du Maurier were also invited to join their parties.

Unlike the Pre-Raphaelite Brotherhood, the St John's Wood Clique had no set rules or credo. These diverse artists were united to some extent by an interest in historical subject-matter, made palatable by its domestic flavour, or what the contemporary critic Tom Taylor called 'the home life of past times'. Yeames's *And When Did you Last See your Father?* (exh. RA 1878; Liverpool, Walker A.G.) epitomizes this type of historical genre painting. In the summer of 1867 Yeames and Calderon rented Hever Castle, Kent, where they were joined by other members of the St John's Wood Clique, who used the castle in a number of their historical paintings. Most members of the group became Royal Academicians, and commercial success heralded the dissolution of their bond. The early deaths of Wynfield and Walker broke up the group, and by the 1890s many of the artists had moved out of St John's Wood.

Bibliography

T. Taylor: 'English Painters of the Present Day', *Portfolio* [London], i (1870), pp. 97–102, 177–82 [on Calderon and Leslie]; ii (1871), pp. 17–21, 81–7 [on Hodgson, Storey, Yeames and Wynfield]

M. H. S. Smith: *Art and Anecdote: Recollections of William Frederick Yeames, RA* (London, 1927)

B. Hillier: 'The St John's Wood Clique', *Apollo*, lxxix (1964), pp. 490–95

SHEARER WEST

Salon de la Rose + Croix

Six exhibitions (1892–7) in Paris, organized by Joséphin Péladan and his followers. They were a major focal point of the occultist and Catholic tendencies in French Symbolist art, growing out of the Ordre de la Rose + Croix du Temple et du Graal ou de la Rose + Croix Catholique, founded by Péladan to promote the esoteric within Catholicism and to conquer materialism within modern society. The Salons de la Rose + Croix were conceived and presented by Péladan as *gestes esthétiques*, a synthesis of the visual arts, literature and music in the spirit of Richard Wagner, whom Péladan venerated, and echoing the *Chansons de geste* of medieval literature.

In 1891 Péladan published a grandiloquent manifesto in *Le Figaro* (2 Sept 1891) and a brochure proclaiming the rules that would govern Rosicrucian exhibitions. Their dogmatism no doubt

alienated potential allies: Péladan failed to recruit such major figures as Pierre Puvis de Chavannes, Gustave Moreau and Odilon Redon. Many artists of real stature did, however, seize the opportunity to exhibit at the first Salon, opened in March 1892 in Paul Durand-Ruel's gallery: Emile Bernard, Charles Filiger, Fernand Khnopff, Ferdinand Hodler, Carlos Schwabe, Jan Toorop and Félix Vallotton were among the 69 participants. Péladan's genius for publicity triumphed at the first Salon. The press and public were fascinated by the exhibition and by the bizarre and colourful events that accompanied it. Erik Satie, briefly the official Rosicrucian composer, provided occasional music for performances of Péladan's play *Le Fils des étoiles*, a 'pastorale kaldéenne en trois actes'. The exhibition was presented as a sumptuous sanctuary of art, graced by the music of Giovanni Pierluigi da Palestrina and Wagner. The presence of progressive artists quickly led to a crisis. Péladan's primary aide, Comte Antoine de La Rochefoucauld (1862–1960), himself an exhibitor at the first Salon, strongly supported the presence of innovative artists, but respect for tradition was uppermost in Péladan's values. La Rochefoucauld was obliged to leave the Order, thereby creating a financial crisis, since he had to a large extent funded the first Salon. Comte Léonce de Larmandie (*b* 1851), remembered as the author of a dynamic but at times inaccurate history of the Salons de la Rose + Croix, became Péladan's chief lieutenant.

None of the remaining five Salons equalled the first in originality or impact. The second (March–April 1893) was beset by financial and practical difficulties, although a prestigious venue was obtained: the central dome of the vast Palais du Champ de Mars. Publicity was again to the fore, especially surrounding performances of Péladan's play *Babylone*, a 'tragédie wagnérienne en quatr'actes'. Wagner and Ludwig van Beethoven were among the featured composers. The range of exhibitors narrowed: Bernard, Filiger, Hodler, Schwabe, Toorop and La Rochefoucauld were absent and did not reappear in subsequent years. Emile-Antoine Bourdelle was given a large section, but this, his second appearance with the

Rosicrucians, was his last. Péladan's rules, forbidding subject-matter ranging from modern life to humour, began to have some influence on these artists, and some, including Maurice Chabas, Jean Delville, Alphonse Osbert, Armand Point and Alexandre Séon, were seen as typically Rosicrucian. Such Belgian painters as Khnopff became prominent, and Delville even organized a Rosicrucian group in Brussels in 1894.

The third and fourth Salons (1894, 1895) were much slighter, and financial constraints proved crippling. In both years Péladan hired the Galerie des Artistes Contemporains, a small gallery in the Rue de la Paix. In 1894 Péladan's plays had to be banished to a neighbouring theatre for lack of space. In 1895 there was not even an exhibition poster or proper catalogue, and only about one hundred works were on show.

The fifth Salon, in 1896, benefited from the wide publicity surrounding Péladan's wedding to a niece of Léonce de Larmandie in January of that year. This prestigious social event returned the Rosicrucians to public favour, enabling Péladan to move the Salon to the larger Galerie des Arts Réunis, in the Avenue de l'Opéra, which even offered the novelty of electric lighting. This success was arguably more social than artistic, however, and this period has been seen as the lowest point of the Salons de la Rose + Croix, despite the presence of Chabas, Osbert, Point and Séon.

The sixth and last Salon (1897) was a more general success. The Rosicrucians were invited to use one of the most famous venues in Paris, the Galerie Georges Petit. Among newcomers was a group of pupils of Gustave Moreau that included Georges Rouault. It was on this successful note that Péladan decided to terminate the venture; he never revealed in full the motives behind his decision, but his personal ambitions had clearly changed since 1892.

About 230 artists exhibited in the six Salons de la Rose + Croix. Few were of the first rank, and the Salons suffered critical neglect until Lethève's rehabilitating article of 1960. Their reputation is often shrouded in anecdotes of *fin-de-siècle* eccentricity, which distort a fair assessment of their

contribution to the Symbolist rejection of mimetic realism.

Bibliography

L. de Larmandie: *L'Entr'acte idéal: Histoire de la Rose + Croix* (Paris, 1903)

E. Bertholet: *La Pensée et les secrets du Sâr Péladan*, 4 vols (Lausanne, 1952–8) [see esp. vol. iii]

J. Lethève: 'Les Salons de la Rose + Croix', *Gaz. B.-A.*, n.s. 6, lvi (1960), pp. 363–74

Les Salons de la Rose + Croix (exh. cat. by R. Pincus-Witten, London, Piccadilly Gal., 1968)

R. Pincus-Witten: *Occult Symbolism in France: Joséphin Péladan and the Salons de la Rose + Croix* (New York, 1976)

R. Edighoffer: *Les Rose-Croix* (Paris, 1982)

RICHARD HOBBS

Sarmatism

Term used to describe an ideology and a way of life of Polish nobles in the 17th century and the early 18th. Although it is not an art-historical term, it has been used to describe artistic phenomena connected with the patronage of Polish nobles of the period. Like the historians of other European countries, the Polish historians of the 16th century sought to dignify the origins of their nation by placing them in antiquity. The fabled valiant Sarmatians were believed to have been the ancestors of the Poles and to have lived north of the Black Sea in the time of the Roman Empire; later driven west and northwards by other peoples, they were thought to have conquered the Polish territory and reduced its original population to serfdom, themselves forming the nobility of the new nation. The name Sarmatia was already applied to Poland in the 16th century, and its people referred to as Sarmatians. The Polish–Sarmatian nation of the nobility developed a specific outlook and civilization that had its culmination in the late 17th century; to a great extent it adopted elements from the general culture of Catholic Europe. Politically, the exponents of Sarmatism promoted the idea of a republic of nobles with an elected king as first among equals, and strongly opposed absolutist tendencies, then popular in Europe. Consequently, its features included conservatism, traditionalism, xenophobia, religious zeal and, finally, a deep conviction that the Polish political and social system was the best possible and that the mission of the Polish nation was to defend the Christian (especially Roman Catholic) world against the Eastern Orthodox, Protestant and Islamic peoples.

Artistically, the term Sarmatism is applied, not specifically to architecture, sculpture or painting, but to the general cultural life of the nobility. Owing to continuous contact with the Turks, there was strong Oriental influence on everyday life, especially on the costume of the nobility, who wore long robes of Persian origin made of precious silk, broad silk waist sashes and fur caps. The sashes were originally imported from Persia, but in the early 18th century they began to be manufactured in Poland. Weapons, horse harnesses and saddles were heavily decorated with jewels. These fashions harmonized well with Western Baroque taste, but they did not appear in monumental art, which was usually sponsored by ecclesiastical patrons or the wealthiest aristocrats, who followed mostly Italian (and, from the late 17th century, also French) models. On the other hand, features of Sarmatism appear in 17th- and 18th-century portraits of Polish nobles in decorative costume. The painters of these typical portraits concentrated on details of dress or weapons at the expense of problems of space, light or expression. There is a specific branch of Sarmatian portraiture in funerary portraits in hexagonal shape devised to fit the backs of coffins. Further, the temporary structures and decorations erected in churches or in the street for funerals (*pompes funèbres*) or official entrances sometimes display a profusion of decorative detail and inscriptions reflecting Sarmatian attitudes. Some scholars use the concept of 'enlightened Sarmatism' (Karpowicz) to describe tendencies pre-dating the Enlightenment and manifested by most educated and cultivated aristocratic patrons of the late 17th century. They commonly pursued claims to distinguished lineage in antiquity and introduced Classical forms and iconography into architecture and the figurative arts.

Bibliography

T. Mańkowski: *Genealogia sarmatyzmu* [Genealogy of Sarmatism] (Warsaw, 1946)

T. Dobrowolski: *Polskie malarstwo portretowe: Ze studiów nad sztuk{ao} sarmatyzmu* [Polish portrait painting: from studies on Sarmatian art] (Kraków, 1948)

T. Mańkowski: *Orient w polskiej kulturze artystycznej* [The Orient in Polish artistic culture] (Wrocław, 1959)

T. Ulewicz: 'Il problema del sarmatismo nella cultura e nella letteratura polacca', *Ric. Slav.*, viii (1960)

M. G{eo}barowicz: *Szkice z historii sztuki XVII wieku* [Sketches in the history of art of the 17th century] (Toruń, 1966)

S. Cynarski: 'The Shape of Sarmatian Ideology in Poland', *Acta Pol. Hist.*, xix (1968)

M. Karpowicz: *Sztuka oświeconego sarmatyzmu* [The art of enlightened Sarmatism] (Warsaw, 1970)

L. I. Tananayeva: *Sarmatskiy portret* [The Sarmatian portrait] (Moscow, 1979)

J. Tazbir: 'Le sarmatisme et le baroque européen', *La République nobiliaire et le monde* (Wrocław, 1986), pp. 7–27

<div align="right">JAN BIAŁOSTOCKI</div>

Scapigliati, Gli

Italian literary and artistic movement active in Milan between *c.* 1860 and *c.* 1870. Its name was taken from the novel *Scapigliatura* (1862) by Cletto Arrighi (pseudonym of Carlo Righetti), which used the term *scapigliato* to describe young people of a restless, independent spirit, though not, in the novel, artists, and the word gained currency in literary and artistic circles. The artists associated with the movement included Tranquillo Cremona, Daniele Ranzoni and Giuseppe Grandi. The term *scapigliatura* has been extended to describe a painting technique of longer duration than the 1860s, from such forerunners as Giovanni Carnevali and Federico Faruffini to younger artists frequenting the same milieu centred round the Milanese taverns, such as Filippo Carcano, Eugenio Gignous and Luigi Conconi: it has also been applied to the sculpture of Paolo Troubetskoy and Medardo Rosso. Gli Scapigliati aimed both in their art and in their general behaviour to defy the complacent conformity of the rising bourgeois class, to whom they preferred the intellectual élite. Their painting was characterized by an atmospheric fusion of figure and background, emphasized by softened contours, open brushwork, impasto and interwoven colours. The musicality of the colours exemplified their philosophy of the fusion of the arts. This was promoted by the novelist and critic Giuseppe Rovani (1818–74) and was influenced by contemporary French literature. The Romanticism of their early history paintings persisted in their interpretation of contemporary life, landscape and their favoured genre of portraits, mostly of nobility or literary figures. Their work created a prelude to the decadent Symbolism of the 1890s. Gli Scapigliati also produced lampoons and satirical sketches. Although such key figures in the movement as Faruffini, Cremona and Ranzoni died prematurely, most of the surviving artists continued to work in the *scapigliatura* manner, which influenced such divisionist painters as Giovanni Segantini and Gaetano Previati.

Bibliography

E. Gara and F. Piazzi, eds: *Serata all'osteria della Scapigliatura* (Milan, 1946)

S. Pagani: *La pittura lombarda della Scapigliatura* (Milan, 1955)

Mostra della Scapigliatura: Pittura, scultura, letteratura, musica, architettura (exh. cat., ed. A. M. Brizio and D. Isella; Milan, Pal. Permanente, 1966)

G. Ottani: 'Arte e artisti al tempo della "scapigliatura"', *Alm. Fam. Meneghina* (1974), pp. 57–94

<div align="right">PAUL NICHOLLS</div>

Schildersbent [Bent]

Society of Dutch and Flemish painters in Rome, which flourished from *c.* 1620 to 1720. The Schildersbent (Dut.: 'painters' clique') was notorious for its bacchic rituals and opposition to the Roman Accademia di S Luca. Its members called themselves *Bentvueghels* ('birds of a feather'). The organization was primarily social, providing a meeting-place for friends and, when needed, financial support for fellow countrymen. The Bent was, however, polemical in its opposition to academic procedures and advocated artistic principles

contrary to those promoted by the official painters' organizations.

Hoogewerff (1923 and 1952) tried to establish 1623 as the year of the Schildersbent's founding, basing his argument on the fact that a drawing in a series representing the group's original members (Rotterdam, Mus. Boymans–van Beuningen) includes the portrait of Franciscus Veroli (or Viruly), who died on 14 March 1623. However, the Bent may have been formed as early as 1620 (Bodart, 1970), since Wybrand de Geest, who returned to the Netherlands before 1621, possessed a nickname similar to those always bestowed on new members at Bent induction ceremonies. Among the group's originators identified in the Rotterdam drawings are the Dutchmen Cornelis van Poelenburch, Bartholomeus Breenbergh, Dirck van Baburen and Paulus Bor, as well as the Flemings Cornelis Schut and Simon Ardé (d 1638). The Bent later welcomed some non-Netherlandish artists such as Valentin de Boulogne, Joachim von Sandrart and Daniel Seiter (c. 1649–1705), but the preponderance of the membership was always Dutch and Flemish. Jan Asselijn, Pieter and Jan Frans van Bloemen, Andries and Jan Both, Karel Dujardin, Samuel van Hoogstraten, Pieter van Laer, Pieter Mulier (d 1670), Lodewijk Primo (1606–67), Jan-Baptist Weenix and Dominicus van Wijnen (b 1661) were among the group's notable initiates. A catalogue of Bentvueghels compiled by Hoogewerff (1952) contains well over 200 entries.

During the 1630s, the Bentvueghels engaged in a protracted struggle against the Roman Accademia di S Luca over fiscal matters. Since its founding in 1577, the Accademia had received voluntary offerings from artists in Rome, including the Netherlanders, on the feast day of St Luke (18 October). After the founding of the Bent, however, the northerners gradually abstained from almsgiving. Seeing its prerogatives threatened, the Accademia obtained a brief (11 July 1633) from Urban VIII instituting an obligatory tax on all artists. The northerners refused to pay, claiming exemption on the basis of privileges granted them by Paul III and Sixtus V, and were subsequently sued by the Accademia on 25 August 1635. After discussions between representatives of the disputing parties, the Accademia was finally defeated in a meeting attended by 42 northerners and 32 Italians on 14 November 1636.

The Bentvueghels were notorious for their 'Baptisms', bacchic initiation rituals for new members. Aspects of these events were recorded in drawings, prints and paintings, as well as in written accounts by Bent members. The ceremonies customarily began with the staging of witty tableaux vivants in which group members played the roles of Bacchus and other mythological and allegorical figures. Against this background, the initiate would be presented to a mock priest (the Veldpaap: 'field pope'), crowned with a laurel wreath, and assigned a pseudonym by which he was thereafter addressed. The entire company would then partake of a drunken feast that could last for 24 hours. Finally, the group would march to the church of S Costanza, then popularly known as the Temple of Bacchus, where the Bentvueghels prayed before a porphyry sarcophagus (now Rome, Vatican), which they took to be Bacchus's tomb. The artists commemorated their visits to the mausoleum by scratching their signatures on to the walls of niches flanking the recess where the sarcophagus once stood. Many of these inscriptions are still visible. The ceremonies were banned by a decree of Pope Clement XI in 1720, the year that the group was disbanded.

Although the Bentvueghels did not advance a comprehensive theory of art, detailed representations of their activities by van Wijnen and others suggest that the group may have viewed itself as an anti-academy opposed to orthodox methods of teaching and practice. A drawing of Bentvuegels drinking and drawing in a tavern (Berlin, Kupferstichkab., 5239) has been interpreted as an allegory asserting that the Schildersbent held inspiration, rather than reasoned learning, to stimulate artistic production (Levine, 1987). The induction ritual may have been intended in part to deride pedagogical activities associated with conventional academies of art (Levine, 1990).

Bibliography

J. von Sandrart: *Teutsche Academie* (1675–9); ed. A. R. Peltzer (1925), pp. 27–8

G. B. Passeri: *Vite* (1679); ed. J. Hess (1934), p. 73

C. de Bruyn: *Reizen van Cornelis de Bruyn door de vermaardste deelen van Klein Asia* (Delft, 1698), pp. 5–6

C. van Rijssen: *Gedigten, verdeeld in snel, punt- en mengel-digten als mede eenige bend-vaarzen en liederen* (Amsterdam, 1704–8), ii, pp. 135–46

A. Houbraken: *De groote schouburgh* (1718–21); ed. P. T. A. Swillens (1943–53), ii, pp. 271–84; iii, pp. 78–81, 361–5

J. van Gool: *De nieuwe schouburg* (1750–51), i, pp. 104–13

G. J. Hoogewerff: 'Bentvogels te Rome en hun feesten', *Meded. Ned. Hist. Inst. Rome*, iii (1923), pp. 223–48

——: 'De nederlandsche kunstenaars te Rome in de XVIIe eeuw en hun conflict met de academie van St Lucas', *Acad. Anlct.: Kl. Lett.*, lxii (1926), pp. 117–48

——: *De Bentvueghels* (The Hague, 1952)

D. Bodart: *Les Peintres des Pays-Bas méridionaux et de la principauté de Liège à Rome au XVIIème siècle* (Brussels, 1970), i, pp. 98–112

H. van de Schoor: 'Bentvueghel Signatures in Santa Costanza in Rome', *Meded. Ned. Inst. Rome*, n. s. 3, xxxviii (1976), pp. 77–86

T. Kren: '*Chi non vuol Baccho*: Roeland van Laer's Burlesque Painting about Dutch Artists in Rome', *Simiolus*, xi (1981), pp. 63–80

J. W. Salomonson: 'Dominicus van Wijnen: Ein interessanter "Einzelgänger" unter den niederländischen Malern des späten 17. Jahrhunderts', *Niederdt. Beitr. Kstgesch.*, xxiv (1985), pp. 140–41

D. A. Levine: 'Pieter van Laer's *Artists' Tavern*: An Ironic Commentary on Art', *Holländische Genremalerei im 17. Jahrhundert: Symposium Berlin 1984*, ed. H. Bock and T. W. Gaehtgens, *Jb. Preuss. Kultbes.*, iv (Berlin, 1987), pp. 169–91

——: 'The Bentvueghels: *Bande Académique*', *IL60*, ed. M. Lavin (New York, 1990)

DAVID A. LEVINE

Scottish Baronial

Scottish architectural style derived from the forms and detailing of the late 16th- and early 17th-century Tower House. A spirit of romantic nationalism helped to make it the leading architectural style in mid-19th-century Scotland, when it was used widely for both domestic and public buildings. The indigenous castellar style of the tower house, with its tall austere walls, asymmetrically grouped and crowned with a skyline of corbelled battlements, crow-stepped gables, bartizans and turrets could, despite the detail it derived from French and Flemish models, be uniquely identified with Scottish national culture in much the same manner as the Elizabethan manor house served for England. In both cases a revived transitional style proved suitably symbolic in character and sufficiently flexible and uncodified in composition to meet the changing cultural and social demands of the 19th century.

Intimations of a revived Scottish idiom were first confined to the building type that was chosen as its precedent: Robert Adam deliberately used distinctly Scottish details and forms (e.g. gables, turrets, corbelling) for his castle style, notably at Culzean (1777–92), Strathclyde. Such compositions, set in the kind of wild, picturesque and sometimes sublime landscapes depicted in 18th-century pen and wash caprices were, however, still Neo-classical in their rigorous symmetry. Less evidently Scottish, the castellated Gothic mansions of Robert Lugar (?1773–1855), James Gillespie Graham and William Atkinson were, on the other hand, more relaxed in layout, their spreading, asymmetrical designs as much indicative of changing domestic needs as of prevalent aesthetic attitudes. In addition to these tentative invocations there was a revival of national consciousness through contemporary literature, particularly that of Walter Scott. The home that he created at Abbotsford (1816–24), Borders, something of a cross between an English manor house and a cut-down castle, embodied this same myth-making paradox; one of the earliest translations from the language of fortified building into the quieter dialect of rural living, Abbotsford nevertheless failed to exert any immediate influence on architectural development. The domestic architecture of William Burn (1789–1870), built during the second quarter of the 19th century, was far more influential. Having gathered a corpus of Scottish features during his work on earlier tower houses, he introduced it into his designs

for a succession of large country-house projects, for example Tyninghame (1829–30), Lothian. Elizabethan and Jacobean elements were to linger in Burn's work, but an increasingly Scottish character nevertheless emerged: asymmetrical groupings of turreted and gabled masses enlivened by eaves-dormers, crow-steps and bartizans. At Milton Lockhart (1829–36), Strathclyde, this was coupled with the most picturesque landscape, described by Scott as 'the prettiest place in all Scotland'.

Burn's influence was especially significant, first through the executed work of his young partner David Bryce, and secondly through publication of *The Baronial and Ecclesiastical Antiquities of Scotland* (1845–52), which Burn helped commission from the English architect Robert Billings (1813–74). In the 1840s Bryce had already begun to develop what was to become a huge country-house practice, for example at Seacliffe (1841), Borders, providing an aristocratic and mercantile clientele with the mock material evidence of its Scottish heritage; but it was only after Billings had published the genuine evidence that the historic lineaments of the emergent Baronial style became widely accessible, and its revival took off. Just as Burn had been the master of planning problems entailed by the social complexities of Victorian country-house life, Bryce was the master of allusion and association, and at Craigends (1857; destr. 1967), Strathclyde, Ballikinrain (1868), Central, and elsewhere, he adduced the forms and motifs of the past to the needs and aspirations of his own age. Using the material in Billings's *Antiquities*, the Baronial revival figured prominently in the Scottish architectural scene, with more and more architects becoming active in a style that had broadened its scope from the castellar house to a range of building types, most of which could claim little or no historical precedent.

One measure of the acceptance of this style can be seen in the royal patronage of William Smith (1817–91), who remodelled Balmoral (1853–6), Grampian. Another was the decision to build the Wallace Monument (1861–9), near Stirling, to John Thomas Rochead's craggy Scottish profile, a design acknowledged as peculiarly fitting for commemorating the country's late 13th-century national hero. The issue of stylistic decorum, however, was by now being argued on a much wider front: Scottish education, religion, administration and litigation (in all of which marked differences from English practice prevailed) merited their own national architectural expression. A strictly Baronial derivation of form was not always to be found. Schools and university buildings exploited a spectrum of forms from castle to cloth hall, David Bryce's Fettes College (1864–70), Edinburgh, being the supreme example. Some churches had crow-stepped gables and keep-like towers, although a more Scottish if less Baronial distinction was a crown spire, as at Buckie (c. 1880), Grampian, Peebles (1885–7), Borders, and Paisley (1893–4), Strathclyde. Town halls at Rutherglen (1861–2), Strathclyde, Aberdeen (1868–74), Grampian, Dunfermline (1875–9), Fife, and elsewhere were given bartizaned or turreted steeples. Most Scottish of all were the sheriff courts, for example at Dumfries (1863–6), Dumfries & Galloway, Greenock (1864–7), Strathclyde, and Selkirk (1868–70), Borders, which, ruggedly rusticated and battlemented, recalled the baronial jurisdiction of feudal times. There were also banks, barracks, hospitals, railway stations, even whole streets of 'fortified' housing decorated by these national characteristics. Understandably, perhaps, Edinburgh was fascinated by the revival. Peddie & Kinnear's Cockburn Street, the rehabilitation of the Old Town by David Cousin (1809–78) and John Lessels (1809?–83) and David Bryce's more upmarket Warrender Estate, all of which were begun in the 1860s, are splendid examples of Baronial townscape. No style proved more adaptable to new needs.

Architects across Scotland sought to supply this demand for a national style. Many had been apprenticed to David Bryce or had subscribed to Billings's *Antiquities*. James Matthews (1820–98) in Aberdeen, Andrew Heiton (1823–94) in Perth, James Rochead (1814–78), John Burnet (1814–1900) and Robert Baldie (d c. 1890) in Glasgow, and in Edinburgh, Thomas Brown (c. 1781–1850) and James Maitland Wardrop (1824–82), David Cousin,

John Lessels, David Rhind, Peddie and Kinnear and, of course, David Bryce all made outstanding contributions to the development of the style, while with Rowand Anderson came a later, more Renaissance-orientated interpretation of Scottish historicism.

By the last decade of the 19th century, one Edinburgh partnership, that of David MacGibbon (1832–1902) and Thomas Ross (1839–1930), had added a second text to the revival's canon with *The Castellated and Domestic Architecture of Scotland* (1887–92). The very title of the work indicated a change of emphasis: by now the revival was both castellar and vernacular in derivation. In the east of Scotland Robert Lorimer elaborated an Arts and Crafts fusion of the two. It was, however, Charles Rennie Mackintosh in the west who achieved their radical transmutation.

Bibliography

R. W. Billings: *The Baronial and Ecclesiastical Antiquities of Scotland*, 4 vols (Edinburgh, 1845–52)

D. MacGibbon and T. Ross: *The Castellated and Domestic Architecture of Scotland from the Twelfth to the Eighteenth Century*, 5 vols (Edinburgh, 1887–92)

V. Fiddes and A. Rowan: *Mr David Bryce, 1803–1876* (Edinburgh, 1976)

F. A. Walker: 'National Romanticism and the Architecture of the City', *Perspectives of the Scottish City*, ed. G. Gordon (Aberdeen, 1985), pp. 125–59

FRANK ARNEIL WALKER

Scuola di Posillipo

Italian school of landscape painters working from *c.* 1820 to 1850 and named after Posillipo, a hill-top village near Naples. The principal artists were

80. Giacinto Gigante: *Coast at Amalfi with a Stormy Sea*, *c.* 1850 (Naples, Museo e Gallerie Nazionali di Capodimonte)

Giacinto Gigante, Achille Vianelli and Antonio Sminck van Pitloo, its founder. The members reacted against the academicism prevalent in the work of such late 18th-century Neapolitan landscape painters as Philipp Hackert and concentrated on *plein-air* painting. Pitloo came to Naples in 1814 to teach at the Accademia Tecnica del Paesaggio. Despite his academic background, in 1820 he established an informal studio at Posillipo, where young artists, many of whom were earning their living as *vedutisti*, could learn from his more spontaneous approach, where he used a lighter palette and painted *en plein air*, as in *Three Temples at Paestum* (c. 1820; Naples, Capodimonte). This manner of painting represented a complete break with such grandiose approaches to the landscape as Hackert's *Hunting Scene* (1783; Naples, Capodimonte). An important external influence on Pitloo was the intermittent presence in Naples of Turner between 1819 and 1829.

In 1825 Gigante, the most innovative painter of the group, joined Pitloo's studio. In his watercolours he used pure patches of colour to create form, as in *Houses at Gaeta* (1831; Rome, G.N.A. Mod.) and *Pompeii* (1862; Naples, Mus. N. S Martino). His oils (e.g. the *Coast at Amalfi with a Stormy Sea*, c. 1850; Naples, Capodimonte; see fig. 80) are more derivative of Pitloo's work, yet Gigante's larger paintings in this medium influenced the work of other artists in the group, including Vianelli, Consalvo Carelli (1818–1900), Gabriele Smargiassi (1798–1882) and Teodoro Duclere (1816–69). Gigante's unromanticized depictions of nature were an influence on Filippo Palizzi, who was concerned both with a precise delineation of nature (e.g. *Plant Study*, c. 1840; Rome, G.N.A. Mod.) and, in his later work, with the transient effects of light and colour on form. His brother Nicola Palizzi was also influenced by the practices of the Scuola. Together, Gigante and Filippo Palizzi created a school of naturalistic painting that provided the technique for the younger Domenico Morelli. By the mid-1850s, Morelli's pragmatic approach to nature was superseded by a greater concern for spiritual values and by a move away from pure landscape painting. In the second half of the century the movement

towards Naturalism became known by the more general term of VERISMO.

Bibliography

P. Pfister: *La Scuola di Posillipo* (Rome, 1925)
R. Causa: *La Scuola di Posillipo*, Mensili d'arte (Milan, 1967)
V. Bindi: *La Scuola di Posillipo*, Turin, Pin. Civ. Giulianova cat. (Turin, 1983)

□

Scuola di Resina [Repubblica di Portici]

Italian group of painters, based in Naples. The group established their studios in the former royal palace of Portici immediately after the unification of Italy in 1861, with the aim of creating an anti-academic renewal in painting in opposition to the style and influence of Domenico Morelli. The group's founder was Marco De Gregorio (1829–76), and he was soon joined by Federico Rossano (1835–1912) and, from 1864, by Giuseppe De Nittis. The identity of other members of the school is uncertain, but they probably included Michele Tedesco (1834–1917), Antonino Leto (1884–1913), whom De Gregorio met during Garibaldi's campaigns, and Raffaele Belliazzi (1835–1917). The work of the painters Francesco Lojacono (1841–1915), Edoardo Dalbono and Federico Cortese (*b* 1829) also reveals affinities with the Resina school.

The starting-point for the painters of the Resina school was the detailed and analytic painting style formulated by Filippo Palizzi. However, the presence of the Tuscan painter Adriano Cecioni in Naples from 1863 to 1867 was vitally important in helping them develop on Palizzi's rigorous approach to reality. Cecioni supplied the Neapolitans with a theoretical basis for their work and acted as a link with the achievements of the Florentine MACCHIAIOLI painters. In seeking a closer relationship with the Macchiaioli, the painters of the Resina school adopted a painting technique that consisted of abrupt transitions from lights to darks, the elimination of half-tones and the enhancement by contrast of light values, thereby attempting to shed the influence of Morelli. The contemporary presence in southern Italy of the anarchist Mikhail Bakunin may have influenced their choice of subject-matter—coarse yet dignified

peasants, bleak and muddy landscapes and the streets of poor villages. Their achievement can be seen in such works as De Gregorio's *The Hoer* (1873; Naples, Capodimonte) and *Street in Resina* (1873; priv. col., see 1963 exh. cat., pl. cxvii), or De Nittis's *Crossing of the Apennines* (1864; Naples, Capodimonte).

In 1867 Cecioni returned to Florence, while De Nittis settled in Paris. In *c.* 1870 Rossano also moved to France to study further Corot's painting, overtones of which he had seen in Palizzi's work. He began to paint landscapes in silvery tones and diffused colours, for example in various paintings of the forest of Fontainebleau (see 1963 exh. cat., pl. cxi). The Resina school began to decline from this period. Only De Gregorio, who had been the group's dominant artistic personality, continued to affirm the values of the Resina school.

Bibliography

G. De Nittis: *Notes et souvenirs* (Paris, 1895)

A. Cecioni: *Scritti e ricordi* (Florence, 1905)

DBI

Antonino Leto (exh. cat., ed. N. Sofia; Venice, Espos. Int. A., 1924)

F. Girosi: *La Repubblica di Portici* (Bergamo, 1931)

Giuseppe De Nittis e i pittori della 'Scuola di Resina' (exh. cat., ed. L. Autiello and others; Naples, Padiglione Pompeiano, 1963)

R. Fossataro: *Federico Rossano* (Milan, 1964)

Arte e socialità in Italia dal realismo al simbolismo, 1865–1915 (exh. cat., ed. R. Bossaglia; Milan, Pal. Permanente, 1979), pp. 52, 109–19

MARIANTONIETTA PICONE PETRUSA

Scuola di Rivara

Italian group of painters founded in the early 1860s by Carlo Pittara (1836–90). It was a loose association with a common interest in *plein-air* landscape painting, confined to the area of Canavese in Piedmont and based on direct observation from nature, with forceful colouring, tonal luminosity and characteristic bright patches of sunlight on grass. It was named after the villa of Pittara's brother-in-law, Carlo Ogliani, which was a lively centre of hospitality for visiting artists. These included Ernesto Bertea (1836–1904), Alberto Issel (1848–1926), Vittorio Avondo (1836–1910), Federico Pastoris (1837–84) and Ernesto Rayper (1840–73), who had previously frequented the Macchiaioli in Florence. However, their approach to nature was less closely associated with contemporary nationalist ideals, being more influenced by medievalist Romanticism; certain members of the group had historical interests, for example Alfredo D'Andrade and Pastoris in archaeology, and Bertea and Avondo in art history. Some paintings, especially Rayper's (e.g. *September at Rivara*, 1872; Genoa, Costantino Nitti priv. col.), also reflected the presence of Antonio Fontanesi, who took up summer residence at Volpiano *c.* 1870. Others associated with Rivara included Adolfo Dalbesio (1862–1914), Eugenio Gignous, Giuseppe Monticelli (1841–79), Antenore Soldi (1844–77), Giulio Viotti (1845–78) and the caricaturist and writer Casimiro Teja (1830–97). During the summer they dedicated their activity in the Canavese to sketching trips and mountain excursions, sharing a common approach rather than a common style of painting. By 1870 the viridescence of their direct observation of nature aroused criticism, which, together with their reputation for vivacious behaviour, served to give them a group identity. However, after the death of Rayper, and with D'Andrade's dedication to architectural restoration and Pittara's increasing attachment to Paris, the encounters of artists at Rivara declined.

Bibliography

Scuola di Rivara (exh. cat., ed. M. Bernardi; Turin, Salone La Stampa, 1942)

A. Dragone and J. Dragone Conti: *I paesisti piemontesi dell'ottocento* (Milan, 1947), pp. 127–44

L. Mallé: *La pittura dell'ottocento piemontese* (Turin, 1976), pp. 67–77

La Scuola Grigia a Carcare (exh. cat., ed. G. Bruno and L. Perissinotti; Carcare, Bib. Com., 1989), pp. 19–22

PAUL NICHOLLS

Scuola di Staggia

Term applied informally in 1873 by Telemaco Signorini (see Signorini) to describe a new

approach to teaching and to landscape painting that was adopted by the brothers Károly Markó the younger and András Markó and imparted to a group of Italian landscape painters sketching *en plein air* in the 1850s and 1860s. Their work is characterized by a tendency to depict identifiable, usually picturesque, locales in the Tuscan campagna, while focusing on specific peculiarities and everyday aspects. The name 'Staggia' is derived from a village in the hilly region near Siena, where Károly Markó first painted in 1853 and was then joined in about 1854–5 by other painters from Florence. The group consisted of the two brothers, who were the sons and assistants of Károly Markó the elder, who from about 1846 ran the only school for landscape painters in Florence; his pupils Serafino De Tivoli (1826–92) and Lorenzo Gelati (1824–93); the painter Carlo Ademollo, known for his patriotic subject-matter; and two artists from Naples: Alessandro La Volpe (1820–93), a landscape painter, and Saverio Altamura (1826–97), a painter of historical subjects set in luminous landscapes. As with András Markó's *Landscape under a Storm* (*c.* 1855; Florence, Pitti), scenes were romanticized in the manner of the much-admired Alexandre Calame and rendered in a finely 'finished' conventional mode that appealed to public taste. However, the only pictorial evidence of the group's painting activities at Staggia is five entries in the catalogues of the Esposizione della Società Promotrice di Belle Arti, held in Florence in 1854 (*Castle of Staggia* and *Motif Taken in Staggia*; see 1854 cat.) and 1855 (*Motif near Staggia*, *Village from Life at Staggia* and *Study from Life near Staggia*; see 1855 cat.), which refer to motifs by Károly Markó the younger, De Tivoli and Gelati. From 1856 De Tivoli and Altamura became strongly influenced by the Barbizon school, while Staggia remained a favourite subject for Károly Markó the younger until at least 1863. He and some of his followers, including Emilio Donnini (*fl* 1855–61) and Curio Nuti, continued to paint views of Elba and the Tuscan campagna and coast in a romanticized manner (e.g. Donnini's *Beach at Rio*, 1861; Florence, Pitti). The school is significant for having been one of the earliest instances in Tuscany of a

group of artists painting together from nature, a fact that greatly influenced the practices of the MACCHIAIOLI. Moreover, it stimulated an exchange of ideas between artists of the Neapolitan school and their Tuscan colleagues, which was a significant step in the development of landscape painting in Italy in the second half of the 19th century.

Bibliography

Catalogo delle opere ammesse nelle sale della Società Promotrice delle Belle Arti in Firenze per la Solenne espozisione, x (1854), nos. 10, 38; xi (1855), nos 16, 29, 33

T. Signorini: 'Ernesto Rayper', *G. Artistico*, i/14 (1873), pp. 108–9

O. Roux: 'Carlo Ademollo', *Infanzia e giovinezza di illustri italiani contemporanei*, ii (Florence, 1909), pp. 155–60 [contemp. doc. listing most members of Scuola di Staggia]

Contributo a Borrani (exh. cat., ed. D. Durbe; Florence, Pal. Strozzi, 1981)

E. Spalletti: *Gli anni del Caffè Michelangelo* (Florence, 1985)

EFREM GISELLA CALINGAERT

Scuola Labronica

Group of 18 Italian artists, all born in or around Livorno. It was officially founded in 1920, though its members had met regularly at the Caffè Bardi, in the centre of Livorno, since 1908. It continued until about 1950. The members were Adriano Baracchini Caputi (1886–1968), Benvenuto Benevenuti (1881–1959), Mario Borgiotti (1906–77), Eugenio Carraresi (1893–1973), Mario Cocchi (1898–1957), Carlo Domenici (1898–1981), Cafiero Filipelli (1889–1973), Raffaello Gambogi (1874–1943), Lando Landozzi (1887–1959), Giovanni Lomi (1889–1969), Giovanni March (1894–1974), Manlio Martinelli (1884–1974), Corrado Michelozzi (1883–1965), Renato Natali (1883–1979), Gastone Razzaguta (1890–1950), Renuccio Renucci (1880–1947), Gino Romiti (1881–1967) and Giovanni Zannacchini (1884–1939). Giovanni Fattori, whom most of them knew as a friend and teacher, was the single most important influence, and Romiti, in particular, remained true to his example. These artists were also strongly influenced by the

Divisionist movement in Italy, led by Vittore Grubicy de Dragon, and several of them exhibited in Paris in 1907 at the Salon des Peintres Division-nistes Italiens, the Divisionist exhibition held at Cours la Reine. Having published a newsletter, *Niente da dazio?* (1909–13), the group held its first show at the Palace Hotel, Livorno, in August 1920 with a manifesto loosely describing its aims as nurturing local young artists. There was no uni-fying style; they were all figurative painters who were inspired by their local scenery and whose aim was to depict the everyday life of their city. Naturalism was combined with a sense of moder-nity, particularly in Romiti's paintings, such as the *Livorno Shipyard* (c. 1930; Florence, priv. col., see Donzelli, p. 158), which are bolder in colour and form than those of the other artists. Their clientele was local and nearly all of their oils and graphics are now in private collections. Some are, however, in the collection of the Bottega d'Arte, Livorno, which was run by Gustavo Mors, who pro-moted their work as well as that of the Macchiaioli. Razzaguta, the group's secretary from 1920 to 1950, recorded its activities in *Virtù degli artisti labronici* (Livorno, 1943).

Bibliography

F. Donzelli: *Pittori livornesi: La scuola labronica del novecento, 1900–1950* (Livorno, 1979)

☐

Second Empire style

Term applied to the art produced in France during the reign of Napoleon III, first as Prince President of the Second Republic (1848–52) and then as Emperor during the Second Empire (1852–70), but also used more narrowly to define a specific archi-tectural style that emerged in other European countries and the USA during the 1860s. This style became popular in the 1870s and 1880s for all types of secular building, from city halls and man-sions to country cottages. Modelled after the New Louvre in Paris (1853–69, by Louis-Tullius-Joachim Visconti and Hector-Martin Lefuel) and typified by the Grosvenor Hotel, London (1860–62, by James Thomas Knowles), and the State, War and Navy

Building in Washington, DC (1871–86, by Alfred B. Mullet; see fig. 25), it is characterized by mansarded pavilions, pedimented dormers and French Renaissance detailing.

The first meaning, which originated in the 19th-century convention of identifying an artistic period by its political context, is culturally spe-cific yet stylistically vague, since the Second Empire style relates a wide diversity of artistic cur-rents to the epoch's common social conditions. The materialistic reign of Napoleon III confirmed the bourgeoisie's dominance in French culture, undertook the country's economic industrializa-tion and physical modernization, fostered exten-sive technological innovation, centralized and institutionalized most professions and aggres-sively patronized the arts in both the public and private realms. These trends all took root during the reign of Louis-Philippe and the July Monarchy (1830–48) yet were embraced as determinant facts by the Second Empire society. Selfconscious and unsure of its legitimacy, the bourgeois Second Empire, seeking to reconcile its sense of historical continuity with its progressive belief in the present, became the focus of the 19th century's generally Romantic crisis of modernism.

The Romantic revolution of the 1820s to 1840s had countered the Neo-classical certainties of uni-versally valid principles of art with a historicist belief in the evolutionary and cultural nature of art: style, subject-matter and execution became matters of choice as each artist sought to repre-sent the progress of history in the image of his times. By the 1850s, Romanticism had matured from a revolutionary into an established move-ment. The older generation of leading artists imparted a Romantic sensibility to the epoch, including the painters Paul Delaroche, Jean-Auguste-Dominique Ingres (see col. pl. XXIX) and Eugène Delacroix (see fig. 56); the sculptors François Rude, Pierre-Jean David d'Angers and Antoine-Louis Barye; and the architects Félix Duban, Henri Labrouste, Louis Duc, Léon Vaudoyer and Victor Baltard. Conservative as much as radical artists of the next generation, including the painters Jean-Léon Gérôme and Edouard Manet (see col. pls XX and XXXII and fig. 41), the

sculptors Pierre-Jules Cavelier and Jean-Baptiste Carpeaux, and the architects Charles Garnier and Eugène-Emmanuel Viollet-le-Duc, shared this Romantic inheritance and struggled with the same problem of recovering some artistic order from their century's fragmentation of principle.

The State's artistic institutions responded by balancing conservative and radical extremes against a bourgeois *juste milieu*. The Académie des Beaux-Arts, nominally the conservative bastion of French classicism, lost its Neo-classical coherence of doctrine and membership: the canons of classicism and the Antique were succeeded by historicism and astylistic criteria of technical and compositional skill; radicals who were elected members included artists as disparate as Delacroix (1857) and Labrouste (1867). History painting, traditionally the highest form of academic art, devolved from Jacques-Louis David's Neo-classical idealism (see col. pl. XXIII) to a Romantic fascination with anecdotal detail and local colour that confused history painting with genre painting in the work of such artists as Gérôme and Ernest Meissonier. Attacks on the annual Salons for their exclusive exhibition of academically approved art prompted the State in 1863 to sanction a Salon des Refusés for works rejected by the official Salon. The need for such alternatives, however, was obviated by continuing if erratic changes to the juries and selection standards of the official Salons. In 1864 no submissions were rejected from the Salon, although works judged 'weak' were exhibited in separate galleries and excluded from the awards competition. In 1865 the Salon jury admitted and (initially) displayed in a prominent place Manet's *Olympia* (1863; Paris, Mus. d'Orsay; see col. pl. XXXII): critics and the public were as scandalized by the jury's action as by Manet's transformation of the classical nude into a modern courtesan.

The 1863 reform of the Ecole des Beaux-Arts and of the Académie de France in Rome was equally ambiguous in its outcome. Answering Viollet-le-Duc's call for reform, the Surintendant des Beaux-Arts, the Comte de Nieuwerkerke, wrested control of these institutions from the Académie des Beaux-Arts by restructuring the Prix de Rome competitions, the administration of the

Académie in Rome and the professorships, curriculum, requirements and ateliers of the Ecole. The students, however, preferred what had become a liberal system of education that valued professional competence over doctrinal coherence, and they sided with the Académie in protesting against the reforms. Viollet-le-Duc resigned his professorial chair at the Ecole in 1864, and most of the reforms were subsequently ignored, loosened or annulled.

The stylistic diversity of the Second Empire reflected the modernist dialectic between progress and tradition. Second Empire art pitted the progressive alternatives of Courbet's realism (see fig. 65), the paintings of modern life by Manet and Degas (see fig. 42) and the nascent movement of Impressionism against the conservative historicism of academic artists. Italian art from the Renaissance to the Baroque influenced such painters as Paul Baudry and William Bouguereau and such sculptors as Albert-Ernest Carrier-Belleuse and Paul Dubois. Others turned to sources as varied as Greco-Roman art (the sculptors Jacques-Léonard Maillet and Gabriel-Jules Thomas), 17th-century Dutch (Meissonier) or 18th-century Rococo works (the painter Alexandre Cabanel). Second Empire architecture, embracing every theoretical camp, includes Duc's 'Greek' Vestibule d'Harlay at the Palais de Justice (1852–68), Alfred Nicolas Normand's 'Roman' Maison Pompéienne (designed 1855; destr. 1891) in Paris, Viollet-le-Duc's 'Gothic' restoration of the château of Pierrefonds (1857–70), Visconti's and Lefuel's 'Renaissance' New Louvre and Garnier's 'Baroque' Paris Opéra (1861–75). Vaudoyer's Marseille Cathedral (1852–93), condensing the history of Western architecture from late antiquity to the Renaissance, typifies the Second Empire's historicism.

Such stylistic labels, however, misrepresent historicism. Viollet-le-Duc, for example, was no more interested in creating a Gothic Revival style than was Garnier in creating a Baroque Revival style. History acted instead as a repository of precedents from which each artist selected ideas that justified his present aesthetic programme. Viollet-le-Duc extracted from the Gothic

a set of structurally rational principles to generate a modern architecture, just as Garnier extracted from the Baroque a theatricality of space and form to express his conception of the Opéra as a stage for Second Empire society. Academic painters and sculptors were equally interpretative in their use of history. Many, in their attempt to adapt past precedents to present conditions, appropriated aspects of Courbet's realism; indeed such sculptors as Carpeaux and such painters as Gustave Boulanger effectively turned realism into another academic idiom. Nor were radical artists free from historical influence. Manet—like his teacher Thomas Couture—confused his critics by integrating an academic sense of composition with a broad execution that combined a modernizing flatness with debts to Velázquez and Goya, and executed works that recast traditional subjects of history painting in a contemporary guise.

The Second Empire also brought recognition to decorative artists whose work would previously have been considered marginal, such as the ornamental sculptor Henri-Marie-Alfred Jacquemart (1824–96), the metalworkers Ferdinand Barbedienne and Charles Christofle (1805–83), the cabinetmaker Alfred Beurdeley and even the couturier Charles Frederick Worth (1825–95). Such photographers as Nadar or the Bisson frères questioned the conventional means of image-making, while some women, such as the sculptor Marcello (Duchessa da Castiglione Colonna), challenged the professional hegemony of male artists. Traditional distinctions between the fine arts were confused by a revival of the Renaissance and Baroque practice of artistic collaboration. Two major imperial commissions, the New Louvre and the Paris Opéra, reveal the consequences of this collaboration, since both make works of painting and, even more, of sculpture inseparable elements of the architectural composition. Yet Garnier's Opéra—decorated by 15 painters and 75 sculptors, whose works range from the realism of Boulanger's paintings for the Foyer de la Danse and Carpeaux's façade group, The Dance (1869), to the Renaissance inspiration of Baudry's Grand Foyer paintings (1866–74) and the academic classicism of Jean-Baptiste-Claude-Eugène Guillaume's façade group

Instrumental Music (1865–9)—indicates that decorative coherence did not depend on stylistic uniformity.

Second Empire art also answered to an increasingly industrialized society, applying new factory techniques to the creation of art objects. The Union Centrale des Beaux-Arts Appliqués à l'Industrie (founded 1864) campaigned for the alliance of fine art with industrial design. Iron, combining structural efficiency with relative economy compared to stone, gained widespread acceptance in architecture. Silversmiths embraced silverplating, and sculptors experimented with electroforming, in part because these economical and technically precise alternatives to solid silver- or bronze-casting duplicated the appearance of traditionally crafted objects. Photography—caught between claims to scientific precision and artistic interpretation—epitomizes the epoch's ambiguous marriage of art and science.

Napoleon III, the State's titular client, was best positioned to promote a Second Empire style. France became an unrivalled patron that commissioned and purchased works of art in all media; through his Préfet de la Seine, Baron Georges-Eugène Haussmann, the Emperor spent some 2500 million francs on the rebuilding of Paris alone. He supported the immense Expositions Universelles of 1855 and 1867, along with the annual Salons (exhibited works increased from 1757 in 1852 to 5434 in 1870), and he permitted the 1863 Salon des Refusés and educational reforms. Yet the Emperor cared little about art, and his largely political interventions were meant to demonstrate his liberalism by encouraging the arts across the broadest possible spectrum. Empress Eugénie (1826–1920) had pretensions to taste, championed her favourite architect, Viollet-le-Duc, and the court painter, Franz Xaver Winterhalter, and was an avid interior decorator, praised for her comfortable mixture of Louis XVI, Empire and contemporary furniture at the château of Compiègne. Her influence, however, was as limited as that of Princess Mathilde Bonaparte, who acted privately as an astute collector of painting.

The unity of Second Empire art lies not in a style but in a state of mind that sought a consistent way

of responding to a suddenly complex world. Replacing any rectitude of style with a recognition of the ambiguities of life, the Second Empire artist conflated art with experience in works that made the spectator a participant in the artist's image of his world.

Bibliography

C. Baudelaire: *Curiosités esthétiques: L'Art romantique*, 2 vols (Paris, 1868–9/*R* 1962)

C. Daly, ed.: *Funérailles de Félix Duban* (Paris, 1871)

L. Hautecoeur: *Histoire de l'architecture classique en France*, vii (Paris, 1957)

The Second Empire: Art in France under Napoleon III (exh. cat., Philadelphia, PA, Mus. A.; Paris, Grand Pal.; 1978–9)

T. J. Clark: *The Painting of Modern Life: Paris in the Art of Manet and his Followers* (Princeton, 1984)

C. Rosen and H. Zerner: *Romanticism and Realism: The Mythology of Nineteenth-century Art* (New York, 1984)

R. Rosenblum and H. W. Janson: *Nineteenth-century Art* (New York, 1984)

P. Mainardi: *Art and Politics of the Second Empire: The Universal Expositions of 1855 and 1867* (New Haven and London, 1987)

D. Van Zanten: *Designing Paris: The Architecture of Duban, Labrouste, Duc, and Vaudoyer* (Cambridge, MA and London, 1987)

C. Mead: *Charles Garnier's Paris Opéra: Architectural Empathy and the Renaissance of French Classicism* (New York, Cambridge, MA and London, 1991)

D. Van Zanten: *Building Paris: Architectural Institutions and the Transformation of the French Capital, 1830–1870* (Cambridge, MA, 1994)

CHRISTOPHER MEAD

Shingle style

Late 19th-century architectural style in the USA. The style, identified by V. J. Scully in 1952, originated in New England *c.* 1880 and became popular across the whole of the USA by the beginning of the next decade. Broadly, it was a return to traditionalism and discipline after the licence of the High Victorian architecture of the 1860s and 1870s. More precisely, it was a reaction against the American Queen Anne Revival: it avoided the more extreme picturesque effects and varied wall surfaces and textures of Queen Anne in favour of the uniform wall covering of shingles that give the style its name. This use of shingles was also felt to make the style American, which the Queen Anne Revival, originating in England, could never really be; it was, as H.-R. Hitchcock wrote, 'to its protagonists already a sort of Colonial Revival'.

In Shingle-style houses the walls were perceived as thin, light membranes shaped by the space they enclosed, an effect heightened by segmental bays or round turrets swelling out from the body of the house. Sometimes the shingled walls seem all the thinner and lighter for being contrasted with a basement of rubble masonry or fieldstone. Roofs were usually of gentle pitch with broad gables; in two-storey houses the roofs often continued down and out to ground-floor level in a manner reminiscent of the lean-to of 17th-century New England 'saltbox' houses. The gambrel roof was more common than the hipped. The tall, panelled brick chimneys that were a feature of the Queen Anne Revival were used by William Ralph Emerson for the Charles J. Morrill Cottage (now Redwoods), Bar Harbor, ME, in the first completely shingled house (1879), but generally chimneys were less obtrusive, conforming to the prevailing horizontality of the style.

The plan of the Shingle-style house was characterized by freedom and openness. Typically, the nucleus was a living-hall complete with fireplace, a feature inherited from the English Queen Anne houses of R. Norman Shaw. The main stairs often rose from the living-hall, around which were disposed other ground-floor reception rooms. These rooms were often entered through wide openings with sliding doors, so that the whole area could be made into a single, if subdivided, space. Verandahs or piazzas, instead of being attachments as they were in earlier 19th-century styles, were integral parts of the plan.

A comparison of the Isaac Bell jr House (1881–3), Newport, RI, and the Mrs. M. F. Stoughton House (completed 1883), Cambridge, MA, by H. H. Richardson, reveals a variety typical of the Shingle style. Although they share almost all of the style's general characteristics, they are vastly different in spirit and overall effect. The Bell House, although

quite compact, is picturesque in its massing: round-ended shingles add to the texture of the walls, and posts imitating bamboo (there are other oriental features in the interior) support the verandah roof. Everything is delicate and decorative in the Stanford White manner. The Stoughton House, in contrast, has long, level roof lines and is clad in uniform rectangular shingles. In its simplicity of form and lack of ornament, it is entirely characteristic of Richardson.

Among the other architects who did notable work in the style were Robert Swain Peabody, John G. Sterns (1843–1917), Arthur Little and John Calvin Stevens in New England, Hugo Lamb (1848–1903), Charles A. Rich (1855–1943) and Bruce Price in New York, Wilson Eyre in Pennsylvania, and John Wellborn Root and Joseph Lyman Silsbee in Chicago. In California, A. Page Brown (1859–96), Ernest Coxhead and Willis Jefferson Polk worked in the style in the 1890s. Although it was primarily a domestic style, it was employed for at least two outstanding churches: the Lake View Presbyterian Church (1887), Chicago, by Root, and St John's Episcopal Church (1891), Monterey, CA, by Coxhead. Owing to the influence of Scully's book of 1955, which established the currency of the term, the style acquired a following among Post-modern architects.

Bibliography

A. F. Downing and V. J. Scully jr: *The Architectural Heritage of Newport, Rhode Island, 1640–1915* (Cambridge, MA, 1952, rev. New York, 2/1967)

V. J. Scully jr: *The Shingle Style: Architectural Theory and Design from Richardson to the Origins of Wright* (New Haven, 1955); rev. as *The Shingle Style and the Stick Style* (New Haven, 1971)

H.-R. Hitchcock: *Architecture: Nineteenth and Twentieth Centuries*, Pelican Hist. A. (Harmondsworth, 1958, rev. 4/1977)

V. J. Scully jr: *The Shingle Style Today: Or, The Historian's Revenge* (New York, 1974)

S. B. Woodbridge, ed.: *Bay Area Houses* (New York, 1976)

MARCUS WHIFFEN

Skagen

Danish fishing community located on the northernmost tip of Jutland and site of an artists' colony.

In 1833 Martinus Rørbye first painted epic views of the land and sea around Skagen such as *Beach Scene in Skagen* (1834; Skagen, Skagens Mus.), setting a precedent for Danish marine painters. The painter and poet Holger Drachmann (1846–1908) and Karl Madsen (1855–1938), later a pre-eminent art historian and Director of the Dansk Kunstmuseum, visited the town in 1871, initiating an artists' community that would develop into one of the most important summer artists' colonies in late 19th-century Scandinavia. Carl Locher (1851–1915), Viggo Johansen and the Norwegian Christian Skredsvig followed in the mid-1870s. Michael Ancher first visited Skagen in 1874 and in 1880 married the painter Anna Ancher [née Brøndum], who was born there. The Hotel Brøndum, which was run by Anna's family, became the centre of the artists' colony. At Skagen Michael Ancher painted such works as *Lifeboat Going through the Sand Dunes* (1883; Copenhagen, Stat. Mus. Kst.), and Anna Archer rendered genre scenes, among them *Sewing School in Skagen* (c. 1910; Copenhagen, Ny Carlsberg Glyp.). In 1879 the Norwegians Frits Thaulow and Christian Krohg came to Skagen from Paris and Berlin respectively. After arriving in 1882, P. S. Krøyer painted *At the Grocer's Shop when the Fishermen Are Ashore* (Copenhagen, Hirschsprungske Saml.) and *Artists' Luncheon in Skagen* (1883; Skagen, Skagens Mus.), the latter forming the centrepiece of the Hotel Brøndum's collection of paintings. In the 1880s Krøyer and the Anchers were the central figures in the community that included, among others, Drachmann, Madsen, Jens Ferdinand Willumsen, the Swedish painter Oscar Björck and the Norwegian painter Eilif Petersssen. Besides painters, the Danish critic Georg Brandes (1842–1927), the Norwegian writer Hans Jæger (1854–1910) and the collectors Alfred Bramsen (1851–1932) and Heinrich Hirschsprung visited the colony. While differing in style, the artists who worked in Skagen from the 1870s to 1890s were the pioneers of Danish naturalism and Neo-Romanticism. They shared a commitment to *plein-air* painting and a desire to portray the local population in an unanecdotal manner. In 1908 the Skagens Museum, which contains the collection from the Hotel Brøndum,

was founded. Between 1911 and 1928 its quarters were in Krøyer's house; in 1928 a new museum, designed by the architect Ulrik Plesner (1861–1933), was opened to the public.

Bibliography

A. Schwartz: *Skagen før og nu* [Skagen then and now], 2 vols (Copenhagen, 1912–13, rev. 1981)

K. Madsen: *Skagens maleri og Skagens Museum* (Copenhagen, 1929)

I. Rockswold Platou: *The Art Colony at Skagen: Its Contribution to Scandinavian Art* (diss., Minneapolis, U. MN, 1968)

H. Usselmann: *Complexité et importance des contacts des peintres nordiques avec l'impressionnisme* (diss., Göteborgs U., 1979) [with Eng. summary]

Les Peintres de Skagen, 1870–1920 (exh. cat. by K. Voss, Paris, Maison Danemark, 1980)

K. Voss, ed.: *Skagens Museum illustreret katalog* (Skagen, 1981) [essays in Ger., Fr. and Eng.]

PATRICIA G. BERMAN

Slav Revival

Architectural movement adopted by the Slav peoples from the mid-18th century to the early 20th. It developed in response to rising ambitions for national identity and was reflected principally in the revival of characteristic national, regional or local styles of architecture. These tended to reflect the historical and political conditions of particular areas, and the Slav Revival did not produce a recognizably distinct overall style. Accordingly it can be considered in terms of the major national divisions: Russia, Ukraine, Serbia, Bulgaria and Poland.

1. Russia

In Russia the first symptoms of a revival of a distinctively national architecture emerged within the framework of the European Baroque in the mid-18th century. On the initiative of the Empress Elizabeth (*reg* 1741–62), the traditional five-domed cathedral church form was revived in St Petersburg, for example in the naval cathedral of St Nicholas (1753–62; by Savva Chevakinsky). In the late 19th century, estate churches, mansions and park pavilions began to be built in Gothic forms. Although such forms had never existed in the medieval kingdom of Rus, they became a symbol of the revival of the country's own national tradition and were accompanied by the use of a number of details from Russian medieval architecture. The beginning of a genuinely wide movement for the revival of Old Russian architecture came with the spread of the 'Byzantine' style from the late 1820s to the 1850s. The use of this term was intended to reflect the distinctive roots of Russian national culture, its affiliation to a great tradition and its distinctness from Western Europe, but it was not literally descriptive of the actual buildings to which the term was applied. These were in fact modelled on the ancient monuments of Russian rather than Byzantine architecture. Encouraged by Nicholas I (*reg* 1825–55) the 'Byzantine' style developed predominantly in religious architecture. Notable examples included the church of Christ the Redeemer (1832–80; destr. 1934), Moscow, by Konstantin Ton, and the Desyatinnaya Church, Kiev, by Vasily Stasov. The domestic architecture of this period was decisively influenced by different housing types designed for villages in the 1830s and 1840s, based on a standardized interpretation of the 'Byzantine' style.

In the late 19th century the 'Byzantine' style was succeeded by the 'Russian' style. As well as maintaining absolute dominance in religious architecture, the latter also became widespread in secular building in cities, for example much of the centre of Moscow, and on country estates, in holiday villages and industrial settlements. A reinvigorated vernacular tradition led to the covering of large areas of towns and suburbs in timber buildings, a unique phenomenon. The architects who initiated this development included Viktor Gartman, Ivan Ropet, Ivan S. Bogomolov (1841–86), Fyodor Kharlamov (1835–89) and Dmitry N. Chichagov (1835–94) (*see also* ABRAMTSEVO). At the beginning of the 20th century a further tendency, the 'neo-Russian' style, emerged as part of the broader Art Nouveau movement. Like the earlier manifestations of the Slav Revival, it took various forms but was particularly represented in church architecture following the religious freedom

declared during the revolution of 1905. Leading exponents included Fyodor Shekhtel', A. A. Ostrogradsky, Aleksey Shchusev, Vladimir Pokrovsky and Stepan S. Krichinsky (1874–1923). In 1906–17 there was a short but extremely intense period of building of Old Believer churches in the 'neo-Russian' style, notably by Il'ya Bondarenko.

Bibliography

Ye. A. Borisova: *Russkaya arkhitektura vtoroy poloviny XIX veka* [Russian architecture in the second half of the 19th century] (Moscow, 1979)

A. V. Pozdnukhov: 'Ob avtorstve rannikh psevdogotich-eskikh sooruzheniy' [On the authorship of early pseudo-Gothic buildings], *Istoriya i teoriya arkhitek-tury i gradostroitel'stva: Mezhvuzovskiy tematecheskiy sbornik trudov* [History and theory of architecture and urban planning: collection of academic studies], ii (Leningrad, 1980), pp. 160–68

Ye. I. Kirichenko: *Russkaya arkhitektura 1830–1920-kh godov* [Russian architecture from the 1830s to 1920s] (Moscow, 1982)

2. Ukraine

In Ukraine the quest for a national style of architecture reflected the peculiarities of the cultural and historical development of the country's main regions: Eastern Ukraine, which was part of the Russian Empire, North Bukovina, which was linked by a common cultural heritage to South Bukovina, composed of Moldova and Wallachia, and Western Ukraine, which as East Galicia formed part of the Polish territories of the Austro-Hungarian Empire. In the mid- and late 19th century, Ukrainian vernacular architecture began to influence certain civil engineering projects in Eastern Ukraine, although examples are exceedingly rare (e.g. house of G. P. Galagan, 1854–6, Lebedyanitsy, Eastern Ukraine, by Ye. I. Chervinsky. It was only in the early 20th century that the 'neo-Ukrainian' style, so called by analogy to the 'neo-Russian' style, became widespread in areas rich in ancient cultural traditions, such as around Poltava, Chernihiv and Kiev. The principal centre of its development was Kharkiv, where such architects as S. I. Vasyl'kovs'ky, Vasyl Krychevsky (1872–1952), S. P. Tymoshenko and Konstantin N.

Zhukov (1873–1940) were active. Here the distinctive type of the Ukrainian Orthodox church, which emerged in the mid-17th century and continued into the 18th, was the dominant model for revival.

In North Bukovina a local type of medieval and vernacular architecture inspired a number of projects, notably the Palace of the Metropolitan of Bukovina (1864–73; now University building), Chernivtsi, by Iozef Glavka (1831–1908). In Western Ukraine, revival architecture was centred on Lwów (now L'viv), where Ukrainian and Polish architects worked in creative harmony from distinct traditions. The 'Hutsul' style of Western Ukraine developed on the basis of the vernacular art of the Carpathian Mountain region; its architects included Ivan Levinsky (1851–1919), O. Lupshinsky, Tadyeush Obminsky (1847–1932) and P. Levinsky. The 'Zakopane' style developed in the Polish parts of the range (*see* §4 below).

Bibliography

M. P. Tsapenko: 'Z istoriï shukan' natsional'noho stylyu v arkhitekturi Ukraïny' [History of the quest for a national style in Ukrainian architecture], *Pytanniya istoriï arkhitektury ta budivel'noï tekhniky Ukraïny* (Kiev, 1959), pp. 285–302

L'vivs'ka setsesiya: Arkhitektura dekorativno prikladne mistetstvo [The L'viv Secession: architecture and fine and applied art] (exh. cat. by Yu. O. Biryul'ov, L'viv, 1986)

V. Ye. Yasiyevich: *Arkhitektura Ukrainy na rubezhe XIX–XX vekov* [Ukrainian architecture at the turn of the century] (Kiev, 1988)

3. Serbia and Bulgaria

For the Serbs and Bulgarians, because of the peculiarities of their national history, the immediate source for the revival of a national style was provided by Byzantine architecture. The fact that Serbia was liberated from the Turks earlier than Bulgaria meant that the quest for a Serbian national style had a longer history. From 1850 to 1890 the revivalist style began to be used in religious buildings by architects such as Theophilus Hansen, Svetozar Ivačković (1844–1924) and Jovan Ilkić (1857–1917). Secular buildings in the

Serbian style appeared from the end of the 19th century, for example works by J. Ilkić and J. Partoš. Elements of medieval architecture, especially decorative details from Moravian churches, were also incorporated in these in the spirit of the Vienna Secession, notably by Branko Tanazević (1876–1948), V. Popović, P. Bajalović, D. Maslać, I. Novaković and P. Popović, and from the beginning of the 20th century Serbian architects drew on the forms of vernacular dwellings.

The earliest experiments in the revival of 'Old Bulgarian' architecture were undertaken immediately after the liberation from the Turks (1877), with designs by the Russian architects V. F. Maas and Ivan Bogomolov. The 1880s and 1890s were a time of intense Europeanization, during which European features took root in Bulgarian architecture. From the end of the 1890s, under the initial influence of the Russian Aleksandr Pomerantsev's design for the St Alexander Nevsky Memorial Church (1904–12), Sofia, a revival of the distinct 'Old Bulgarian' style was practised by Bulgarian architects. An interpretation of traditional Bulgarian variants of Byzantine architecture occurred simultaneously in religious and secular architecture and retained vitality until the mid-20th century. A notable example is the Mausoleum (1907), Pleven, by P. Koychev. Other architects to work in this style included Petko Momchilov (1864–1923), Yordan Milanov (1867–1932), Naum Torbov (1880–1952) and Anton Torn'ov (1868–1942).

Bibliography

M. P. Tsapenko: *Arkhitektura Bolgarii* [The architecture of Bulgaria] (Moscow, 1958)

Kratkaya istoriya bolgarskoy arkhitektury [A brief history of Bulgarian architecture] (Sofia, 1969)

Z. Skalamera: 'Obnova "srpskogo stila" u arkhitekturi' [Revival of the 'Serbian style' in architecture], *Zborn. Likovne Umĕtnosti*, v (1969), pp. 191–235

M. Koyeva: 'Traditsiya i novi momenti v blgarskata arkhitektura sled Osvobozhdeniyeto' [Tradition and new factors in Bulgarian architecture after liberation], *Iz istoriyata na blgarskoto izobrazitelno izkusstva*, i (Sofia, 1976), pp. 106–62

Ye. I. Kirichenko: 'Yugoslaviya: Arkhitektura', *Genezis i razvitiye sotsialisticheskogo iskusstva v stranakh*

Tsentral'noy i Vostochnoy Yevropy [The origins and development of socialist art in the countries of Central and Eastern Europe] (Moscow, 1978), pp. 545–57

4. Poland

From the mid-19th century, churches were built in Poland that re-created the distinctive Romanesque and Gothic religious architecture of the Vistula–Baltic region, for example by Józef pius Dziekoński and J. Huss. From the 1880s the heritage of northern brick Gothic was revived for religious buildings, and also for secular ones, particularly by Dziekoński in Warsaw, and Teodor Marian Talowski in Lwów (now L'viv). The first efforts to create a national style also date from the 1880s, when Stanisław Witkiewicz (1851–1915) developed an idiom based on the vernacular art of the Zakopane district of the Carpathian Mountains. The 'Zakopane' style was particularly represented in health resort architecture, and also in interior and furniture design originating from Warsaw. Witkiewicz's ideas were developed most notably in Kraków by Stanisław Wyspiański. In the early 20th century there were increasing efforts to create a national style, from the architecture both of the Polish Renaissance, for example by Stefan Szyller (1857–1933), and of the 'mansion house' style developed by Józef Czajkowski and Romuald Gutt from the architecture of aristocratic estates. The latter inspired the architects who designed new types of houses for garden cities, which were the focus of an exhibition of architecture and interiors in a garden setting (1912) in Kraków, and persisted until the 1920s, for example in a housing estate design (1925) by T. Bursze and M. Krupa. The work of Jan Witkiewicz-koszczyc combined the 'Zakopane' and 'mansion house' styles. Religious architecture continued to draw steadfastly on the Romanesque and Gothic tradition until the 1930s, for example in the work of Oskar Sosnowski (1880–1939).

Bibliography

A. Olszewski: 'Przegląd koncepcji stylu narodowego w teorji architektury polskiej przełomu XIX i XX wieku' [A survey of the concept of national style in Polish

architecture at the turn of the century], *Sztuka & Kryt.*, iii–iv (1956), pp. 280–372

—: *Nowa forma w architekturze polskiej, 1900–1925* [New form in Polish architecture, 1900–1925] (Wrocław, Warsaw and Kraków, 1962)

I. Guml': 'Vozrozhdeniye remesla v pol'skom iskusstve' [The revival of crafts in Polish art], *Khudozhestvennyye protsessy v pol'skom i russkom iskusstve XIX–nachala XX veka* [Artistic processes in Polish and Russian fine arts, 19th century to early 20th] (Moscow, 1977), pp. 136–49

J. A. Mrozek: 'Historyzm narodowy lat dwudziestych jako wyraz myśli' [National historicism in the 1920s as an expression of Romantic thought], *Sztuka XIX wieku w Polsce* [Art of the 19th century in Poland] (Warsaw, 1979), pp. 145–64

<div align="right">E. I. KIRICHENKO</div>

Société Libre des Beaux-Arts

Belgian avant-garde exhibition society, *c.* 1868–*c.* 1876. Heir to the earlier tradition of art clubs and free studios in Belgium, such as the Académie de Saint-Luc (*c.* 1846–63) and Jean-François Portaels's free studio in Brussels (*c.* 1858), it provided an alternative exhibition site to the official Salon. The original organizing committee of 16 members is shown in a group portrait of 1874–5 by Edmond Lambrich (1830–87; Brussels, Mus. Ixelles). It included Louis Artan de Saint-Martin (1837–90) and Charles De Groux, both members of Saint-Luc; Alfred Jacques Verwée, Félicien Rops, Louis Dubois and Constantin Meunier, all of whom remained active in avant-garde organizations throughout the century. Their manifesto, published on 31 January 1869, proposed the Realist goal of 'free and individual interpretation of nature', as well as the more avant-garde concepts of 'struggle, change, freedom, progress, originality and toler-ance'. The manifesto's author, the Society's secre-tary Camille Van Camp (1834–91), edited their bi-monthly review, *Art libre*, which voiced a desire for openness and change in the face of conserva-tive dogmatism: 22 issues were published between December 1871 and December 1872. The society held four exhibitions (December 1868, March, May and August 1872) that showed their admira-tion for the work of Courbet and the Barbizon artists. In 1868 Courbet, Corot, Charles-François Daubigny, Théodore Rousseau and Jean-François Millet were asked to join, setting an example of internationalism that would be followed later, most notably by Les XX. They were strongly supported by the critics Camille Lemonnier (1844–1913), who urged them to 'be of their own time', and Théo Hannon (1851–1916), who saw their work as sincere and direct, rebelling against artificial formulae. Official critics were very hostile to them at first; gradually this hostility diminished until by 1875 the official Salon found Realism acceptable, thus coopting the group's aims and contributing to its demise. The Society provided a model for subsequent avant-garde art groups in Belgium.

Bibliography

O. Roelandts: 'Etude sur la Société Libre des Beaux-Arts de Bruxelles', *Mém. Acad. Royale Belgique: Cl. B.-A.*, iv (1935), pp. 5–116

S. Speth-Holterhoff: *Camille Van Camp* (Brussels, 1952)

M. J. Chartrain-Hebbelinck: 'Quelques Maîtres de la "Société Libre des Beaux-Arts" dans les Archives de l'Art contemporain', *Mus. Royaux B.-A. Belgique: Bull.*, v 13, nn. 1–2 (1964), pp. 11–26

S. M. Canning: *A History and Critical Review of the Salons of 'Les Vingt', 1884–1893* (diss., Philadelphia, U. PA, 1980), pp. 17–19

P. Roberts-Jones: 'Belgium as a Crossroads', *Belgian Art, 1880–1914* (exh. cat., New York, Brooklyn Mus., 1980), pp. 9–13

J. Block: *Les XX and Belgian Avant-Gardism, 1868–1894* (Ann Arbor, 1984), pp. 1–4, 12, 16, 40 [complete list of the founding members]

<div align="right">JULIUS KAPLAN</div>

Stick style

Architectural term coined in 1949 by Vincent J. Scully jr to describe a style of mid-19th century American timber-frame domestic architecture. Scully posited a common theoretical link: the desire to express structure with an externally visible wooden frame. 'This new aesthetic sensi-tivity to the expression of light wood structure', wrote Scully in 1953, 'in a sense stripped the skin off the Greek Revival and brought the frame to

light as the skeleton of a new and organically wooden style.' While acknowledging European sources, Scully concluded that the Stick style was, like the other style he identified, the Shingle style, essentially American. He cited as noteworthy examples A. J. Downing's board-and-batten cottage designs of the 1840s and 1850s, Richard Morris Hunt's J. N. A. Griswold House (1861–3), Newport, RI, and Dudley Newton's Cram House (1875-6), Middletown, RI. Despite its wide acceptance, a few critics have questioned the validity of Scully's term. Rarely is there a direct correlation between external woodwork and actual structure; Hunt's Griswold House drawings bear this out; and there is little evidence that American designers sought structural expression. Their goals had more to do with the Picturesque, historicism, eclecticism and a wish to follow the latest fashion from abroad. These houses recall a variety of wooden building types, from the half-timbered Late Gothic domestic architecture of England, France and Germany to the Swiss chalet and Scandinavian, Tyrolean and Slavic vernacular building. They reflect the contemporary European taste for houses that invoked these traditions.

Bibliography

V. J. Scully jr: *The Cottage Style: An Organic Development in Later 19th-century Wooden Domestic Architecture in the Eastern United States* (diss., New Haven, CT, Yale U., 1949)
——: 'Romantic Rationalism and the Expression of Structure in Wood: Downing, Wheeler, Gardner and the "Stick Style"', *A. Bull.*, xxxv (1953), pp. 121–42
——: *The Shingle Style and the Stick Style* (New Haven, 1955, rev. 1971)
——: *The Shingle Style Today: Or the Historian's Revenge* (New York, 1974), pp. 6–19
S. B. Landau: 'Richard Morris Hunt, the Continental Picturesque and the Stick Style', *J. Soc. Archit. Hist.*, xlii (1983), pp. 272–89

<div align="right">DAVID CHASE</div>

Sublime, the

Aesthetic concept, originating in Classical Greece, that was the subject of considerable philosophical debate in 18th-century Europe and that re-emerged in the late 20th century as a central factor in the study of aesthetics. The literary treatise *On the Sublime* (1st century AD), traditionally ascribed to Longinus, was a major influence on 18th-century writers on taste. In essence, Longinus defined the Sublime as differing from beauty and evoking more intense emotions by vastness, a quality that inspires awe. Whereas beauty may be found in the small, the smooth, the light and the everyday, the Sublime is vast, irregular, obscure and superhuman. The term entered 18th-century discourse by way of literary theory and criticism, such as *Grounds of Criticism in Poetry* (1704) by John Dennis (1657–1734), and Joseph Addison's *Spectator* essays, *The Pleasures of the Imagination* (1711). It soon came to be applied to visual art by, among others, Jonathan Richardson sr in *An Essay on the Whole Art of Criticism as it Relates to Painting etc* (1719), in which he remarked that terror is a suitable subject for painters as 'by consideration of our own safety it gives us pleasing ideas'. This concept, common to writers on the Sublime, was most fully expounded by Edmund Burke in *A Philosophical Enquiry into the Origin of our Ideas of the Sublime and the Beautiful* (1756). Burke distinguished between the Sublime and the Beautiful by identifying man's leading passions as self-preservation and love of society. Self-preservation gave rise to delight, as a result of a diminution of pain or terror, while beauty was the source of 'positive and independent' pleasure. Thus delight might arise from the contemplation of a terrifying situation—natural, artistic or intellectual—that could not actually harm the spectator, except in the imagination; the resulting imagery produced an emotion more intense than that offered by beauty—'the strongest emotion which the mind is capable of feeling'. Burke was thus rejecting established theories that affirmed that beauty was the result of proportion, utility or perfection.

Burke almost certainly influenced the German philosopher Immanuel Kant, who first wrote on the subject in *Observations on the Feeling of the Beautiful and the Sublime* (1764) and elaborated his views in further writings, culminating in the *Critique of Judgement* (1790). Kant differentiated

between coarse feelings, directed towards the satisfaction of appetites, and the finer feelings required to appreciate both the Beautiful and the Sublime, which evoked enjoyment, but with horror. He further divided the Sublime into three categories, the terrifying, the noble and the splendid, epitomized respectively by great depths, great heights and great buildings. While largely agreeing with Burke's definition of the aesthetic qualities of the Sublime as vastness, terror and obscurity, Kant rejected the idea that sublimity is inherent in the specific properties of objects and substituted the importance of the individual's subjective capacity for feeling; the Sublime was thus not a universal property but an individual response. Kant furthermore linked the Sublime to morality, Sublime behaviour being the adoption and application of universal affection, a code of behaviour that depended on principles, rather than emotions. The physical properties, whether actually or imaginatively perceived, that were generally accorded to the Sublime by 18th-century writers, were vastness, obscurity and irregularity, all of which could evoke a degree of terror. Collectors in search of the Sublime found it in the banditti paintings of Salvator Rosa. It became fashionable to travel to wild and rugged places, such as the Alps, Snowdonia and the Lake District. The poet and essayist William Shenstone (1714–63) was among the first gardeners to put Burke's theories into practice at Leasowes, his small estate near Halesowen. Richard Payne Knight, in *The Landscape: A Didactic Poem* (1794), and Uvedale Price, in his *Essay on the Picturesque* (1794), both advocated greater irregularity and wildness in landscape gardening (*see also* PICTURESQUE). In architecture the Sublime was sought in the irregular GOTHICK style epitomized by Fonthill Abbey, which William Beckford designed in collaboration with the architect James Wyatt. Beckford also attempted Sublime effects in his Orientalist Gothick novel *Vathek* (1786), following a fashion set by Horace Walpole with *The Castle of Otranto* (1764), which owes much to contemporary theories of the Sublime.

Among the 18th-century artists who sought to express the Sublime in their works were James Barry, Henry Fuseli and John Hamilton Mortimer, who frequently chose to interpret subjects from Homer, Shakespeare and Milton, writers on vast and epic themes, and from *Fingal* (1762) and other poems that James Macpherson (1736–96) passed off as the work of the ancient Scottish bard Ossian. Painters of landscapes recorded natural phenomena: from the mid-1770s Joseph Wright of Derby produced many pictures of *Vesuvius in Eruption* (e.g. London, Tate; see col. pl. XXXVIII), while Richard Wilson painted the *Falls of Niagara* (1774) and Philippe de Loutherbourg invented the Eidophusikon, a miniature theatre with sound and lighting effects illustrating the sublimity of nature. Theories of the Sublime ceased to be widely discussed in the 19th century, but it remained a potent force in the paintings of J. M. W. Turner, John Martin, Francis Danby and James Ward, whose *Goredale Scar* finely exemplifies the genre. On the Continent the Sublime is a recognizable element in the work of Delacroix, Géricault and Friedrich. In the USA the painters of the Hudson River school sought to express in terms of the Sublime the overwhelming magnificence of American scenery (see col. pl. XVIII and fig. 40).

In the second half of the 20th century the Sublime again became a pivotal aspect of aesthetic studies; its stress on the importance of the imagination offered a way out of narrow aesthetic parameters. Kant's theories, in particular, have been adapted to a number of different critical disciplines, including Post-Structuralism (in the writings of Jacques Derrida and Jacques Lacan), psychoanalytical theory, Marxism and also Postmodernism, as expressed in influential articles by Jean-François Lyotard. Artists of the 20th century have sought to reinterpret the Sublime in terms of their own age; thus to Barnett Newman it became a term for the graphic expression of the horror of the Holocaust and the tragedy of the human condition.

Bibliography

S. H. Monk: *The Sublime: A Study of Critical Theories in Eighteenth-century England* (New York, 1935, rev. 1960)

Edmund Burke: *A Philosophical Enquiry into the Origin of our Ideas of the Sublime and the Beautiful*, ed. J. T. Boulton (London, 1958)

Turner and the Sublime (exh. cat. by A. Wilton, Toronto, A.G.; New Haven, CT, Yale Cent. Brit. A.; London, BM; 1980–81)

J. Lyotard: 'The Sublime and the Avant-garde', *Artforum*, xxii/4 (1984), pp. 36–43

P. Crowther: *The Kantian Sublime: From Morality to Art* (Oxford, 1989)

T. Eagleton: *The Ideology of the Aesthetic* (London, 1990)

DAVID RODGERS

Symbolism

European cultural movement that was at its peak in the last two decades of the 19th century, profoundly affecting the visual arts and inextricably bound up with music and literature.

1. Introduction

Symbolism was first identified as a literary movement by Jean Moréas (1856–1910) in the Symbolist manifesto ('Le Symbolisme', *Le Figaro*, 18 Sept 1886). Symbolism in the visual arts was further defined by Albert Aurier as the 'painting of ideas' ('Les Symbolistes', *Rev. Enc.*, 1 April 1892). Its complex aesthetic was a mix of Platonic-inspired philosophy, mystical and occult doctrines, psychology, linguistics, science, political theory and such aesthetic issues as the relationship between abstraction and representation. While many Symbolists reacted against the materialism of 19th-century science and its implications (positivist philosophy, social Darwinism, artistic Realism), others sought to reconcile modern science with spiritual traditions. Ideas based on the rise of scientific psychology with its emphasis on individual freedom and the great interest in the occult, together with such practices as hypnosis, opened up a realm of psychic experience, which promised access to important realms of knowledge. Symbolism stressed feeling and evocation over definition and fact and emphasized the power of suggestion. Stéphane Mallarmé wrote in 1891, 'To *name* an object is to suppress three-fourths of the enjoyment of the poem that comes from the delight of divining little by little; to *suggest* it, there is the dream' (J. Huret: 'Enquête sur l'évolution littéraire', *Le Figaro*, 1891). It was felt that empirical science left no room for the spirit; however, psychological theory and occult doctrines explained perception and cognition as symbolic processes and indicated a spiritual path to understanding. These spiritual insights were obtained via intuition, fantasy, imagination and such subjective and irrational experiences as dreams, visions, hypnotism and alchemy. The realm of the irrational was approached through a variety of means, including drugs and such popular synthetic religious and spiritualist movements as theosophy and anthroposophy and the esoteric ideas of Eliphas Lévi (1810–75). Baudelaire's lines from his poem *Correspondance* (*Les Fleurs du mal*, 1857) illustrate the belief in the connection between nature and the soul: 'Nature is a temple of living pillars/where often words emerge, confused and dim;/and man goes through this forest, with/familiar eyes of symbols always watching him.' All these notions were rooted in Romanticism and were revived later in Surrealism.

For most people, the clearest access to Symbolist ideas was through Joris-Karl Huysmans's novel *À rebours* (1886). Des Esseintes, the disillusioned hero, withdraws into a private world where he celebrates all that is artificial and unnatural and surrounds himself with evocative works by Gustave Moreau and Odilon Redon. While the novel was highly dramatized and exaggerated, it was highly influential in forming the popular idea of Symbolism.

2. Symbolism in the visual arts

Symbolist critics in France saw both Impressionism and Neo-Impressionism as Symbolist. By the mid-1880s the original Impressionist aim of truth to visual experience had shifted: the artists had developed their technique to a point where the pictures appeared to be approximations of reality, rather than objective views of reality itself. Most Impressionist and Post-Impressionist paintings from this period emphasize texture and surface. The consequent denial of space and thus

the denial of the illusion of reality in this style of painting is a major component of Symbolism in the visual arts; Impressionist as well as Neo-Impressionist pictures appear more suggestive than descriptive. Another basic feature of Symbolist art is an interest in spiritualism and in the Platonic notion that an ideal world lies beyond the world of appearances; important Neo-Impressionist notions of the relationship between style and meaning were based on the spiritualist ideas of Charles Henry.

Gustave Moreau, Puvis de Chavannes, Edward Burne-Jones and Arnold Böcklin were important precursors for the artists who thought of themselves as Symbolists. Sharing an attraction to the Romantic subjects of the early 19th century and a concomitant lack of interest in Realist, Naturalist or Impressionist goals, the earlier generation were equally concerned with spirituality and revelation evoked via myth, religion and literature (e.g. Moreau's *The Apparition*, 1876; Paris, Louvre; see fig. 81). Dedicated to an ideal level of expression, the ambition of which was to match that of the Old Masters, they were all independent individualists, who focused on their ideal, undistracted by the art that was going on around them. These concerns attracted a younger group with whom they came to co-exist.

France took the lead in the development of Symbolism, and Paul Gauguin played a seminal role. By 1885 his writings (H. Chipp: *Theories of Modern Design*, Berkeley, 1975, p. 58) reflected Symbolist interests. He believed that the emotional response to nature is more important than the intellectual; that lines, colours and even numbers communicate meaning; that intuition is crucial to artistic creation; and that one should communicate ideas and feelings derived from nature by means of the simplest forms, after dreaming in front of the subject. However, he was not able to translate these ideas into images until summer 1888, when he worked with Emile Bernard at Pont-Aven in Brittany, where he produced such works as *Vision after the Sermon: Jacob Wrestling with the Angel* (1888; Edinburgh, N.G.; see col. pl. XXXIX). At Pont-Aven he developed a new style, Synthetism, in which clear outlines

81. Gustave Moreau: *The Apparition*, 1876 (Paris, Musée du Louvre)

define areas of pure colour arranged in flat planes. His work expresses the Symbolist belief in art as a form of language, together with the corollary that the most primitive form of language operates on a symbolic level. These notions, combined with envy of the natural spirituality of the uneducated and 'native' peoples and their distance from modern, decadent civilization, led Gauguin to try to re-create elemental forms of communication and the power of primitive artistic achievements. He wrote that artists should paint 'the mysterious centres of thought' (1880) and explained his approach to Symbolism in 1901 when he said, 'Puvis would call a painting *Purity*, and to explain it he would paint a young virgin holding a lily in her hand Gauguin, for the title *Purity*, would paint a landscape with limpid waters.'

Symbolism rejects traditional iconography and replaces it with subjects that express ideas beyond

the literal objects depicted. The notion of the expressive potential of simplified forms and pure colour provided the freedom and directness that young, academically trained students were looking for, and it became one of the two stylistic options in Symbolism. Paul Sérusier relayed this message from Gauguin's teaching to students at the Académie Julian in Paris, including Paul Ranson, Maurice Denis, Edouard Vuillard and Pierre Bonnard; in 1888–9, this group became the NABIS. Their name, Hebrew for prophets, claimed clairvoyant status for the group and for the occult, religious, anarchist, genre and landscape subjects members explored in the new style.

Even the most commonplace scene by Vuillard or Bonnard could be Symbolist when considered in the context of statements by the Belgian writer, Maurice Maeterlinck (1862–1949); in an article in *Le Figaro* (2 April 1894), he described the artist as: Seated in an armchair, listening simply to all the eternal laws which reign throughout his house, interpreting without understanding, all that there is in the silence of doors and windows and in the little voice of light, submitting to the presence of his soul and of his destiny . . . a good painter will show a house lost in the country, an open door at the end of a corridor, a face or hands at rest, and these simple pictures will have a power of adding something to our awareness of life.

Other artists followed the trend established by Gauguin, perhaps none so successfully as Edvard Munch, who charged his oeuvre with such strong personal meaning that his style and content became a source for Expressionism. A much more traditional stylistic approach, with strong occult associations, was housed in the Salons de la Rose + Croix in Paris organized by Joséphin Péladan. From 1892 to 1897 his salon welcomed work that subscribed to the illusionistic style of Renaissance art and was spiritual in subject; he specifically rejected anything that might have associations with Realism, such as portraits, landscapes or genre scenes, preferring 'Catholic Ideal and Mysticism . . . Legend, Myth, Allegory, the Dream, the Paraphrase of great poetry'. He was very influential; such artists as Carlos Schwabe, Fernand Khnopff, Ferdinand Hodler and Jean Delville

participated in his salons, and his example was followed by the similar Salon d'Art Idéaliste in Brussels. Nonetheless, such critics as Félix Fénéon responded negatively: 'Three pears spread on a tablecloth by Paul Cézanne are moving and sometimes mystical and all the Wagnerian Valhalla is as lacking in interest as the Chamber of Deputies if painted by them' (Halperin, 1970). The problem is that for a Symbolist work to be successful it has to be evocative and emotionally resonant; some artists relied on narrative or specific imagery to evoke a mood, while others relied more on style. Since each person is unique, what one person considers a masterpiece of evocation will strike another as silly or kitsch. That is why a definition of Symbolism remains so elusive. Since Symbolism has no comprehensive definition, recent literature is inclusive and defines the movement very broadly.

3. Characteristics of Symbolism

Despite these problems of definition, there were certain interests all Symbolists shared. Music was highly admired for its evocative potential and abstract language; Richard Wagner was especially esteemed by Symbolists for his desire to unite all the arts into a single synaesthetic experience. Synaesthesia uses all the senses to create a universal harmony, giving unity to the variety of nature. Whether artists chose to use form, subject or both as their major aesthetic focus, their purpose was to render visible the invisible and to communicate the inexpressible. Whatever they touched was manipulated to create a psychological impact, to express ecstasy, ambiguity, mystification, revelation—all that is subjective, irrational, variable and subject to interpretation. They used a number of similar themes, including sleep and dreams, silence, stillness, meditation and a range of feelings about women from worship to hate (e.g. Khnopff's *Caresses*, 1896; Brussels, Mus. A. Mod.; see fig. 82). Symbolist fascination with and fear of sensual passion co-existed; often expressed by the image of the femme fatale, the resolution of this conflict also appears in the figure of the androgyne, a symbol for the resolution of opposites into a harmonious unity. At the artist's whim, flowers,

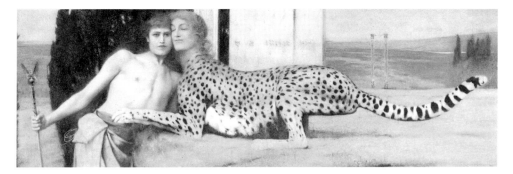

82. Fernand Khnopff: *Caresses*, 1896 (Brussels, Musée d'Art Moderne)

animals (often composite ones like the sphinx) and landscape take on all sorts of meaning. Since these meanings are always personal, standard methods of exegesis are not satisfactory. Whereas precursors of Symbolism sometimes used traditional symbols, emblems and allegory, true Symbolism when it used images did not mean them to signify what they represented; they were signs of a deeper or higher level of consciousness. Symbolism was much more open-ended than the movements from which it drew inspiration. For example, Moreau's paintings were primarily didactic and sympathetic to exegesis, whereas Gauguin's were personal and were intended to be suggestive of meaning; even the titles of such works as *Where Do We Come From? Who Are We? Where Are We Going?* (1897; Boston, MA, Mus. F.A.) were designed to evoke rather than to describe. Similarly, such stylistic developments as Abstraction were not created for their own sake; rather, they were meant to suggest new and mysterious meanings. Periodicals spread the word, communication was rapid, and the groups were international in their outlook. That is why it is possible to point to artists who were working in a similar way all over Europe and in the USA. However, Paris always remained the heart of the movement.

Another common feature linking many Symbolists was their sympathy for socialism and especially anarchism. Artists and social critics shared a sense of disillusion with the world as it was and stressed the importance of individuality. Symbolism's suspicion of the scientific culture of the 19th century, with its belief in progress, occurred at the same time that bourgeois political culture was under attack, and there was a groundswell of interest in social and political problems. Just as the Symbolists were suspicious of the notion of objective reality, so the anarchists were completely opposed to contemporary forms of government. Both artists and politicians reacted to a period that was in the process of great change and flux. The Symbolist response to this climate can be seen in the creation of an art of enigmatic meanings requiring interpretation on a level beyond the literal. Like the anarchist solution of tearing everything down in order to let each individual operate independently, the Symbolist artists argued for highly individual creation and interpretation of works of art. Simultaneously, a distrust of surface reality appeared in the new field of psychiatry, with its claim that conscious thought and action are the result of unconscious forces accessible only through the indirect techniques of psychotherapy. Part of the Symbolist/ anarchist attitude was hatred of the bourgeoisie, yet most of the participants in both movements were members of it, and the artists depended on it to support their activities through allowances or patronage, creating objects for the market economies of the day. Despite lip-service to the contrary, Symbolists were products of middle-class culture.

Symbolism played an important role in the development of modern art; the famous definition of painting formulated by Maurice Denis ('a flat

surface covered with colours assembled in a certain order') is a formula for Abstraction. Symbolism's stylistic strategy of de-emphasizing reality by means of simplifications, lack of clarity or exaggeration was utilized by 20th-century artists. Such modern artists as Kandinsky, Mondrian and František Kupka, who shared the spiritualist and occult interest in their most fashionable forms of theosophy and anthroposophy, were led to non-objective styles as the best way to depict the spiritual, as opposed to the real.

Bibliography

A. G. Lehmann: *The Symbolist Aesthetic in France, 1885–1895* (Oxford, 1950, rev. 1968)

H. B. Chipp: 'Symbolism and Other Subjectivist Tendencies', *Theories of Modern Art* (Berkeley, 1968), pp. 48–123

J. U. Halperin, ed.: *Félix Fénéon: Oeuvres plus que complètes* (Geneva, 1970), p. 211

J. A. Argüelles: *Charles Henry and the Formation of a Psychophysical Aesthetic* (Chicago, 1972)

C. McIntosh: *Eliphas Lévi and the French Occult Revival* (London, 1972)

A. Mackintosh: *Symbolism and Art Nouveau* (London, 1975)

R. L. Delevoy: *Symbolists and Symbolism* (Geneva, 1978)

F. E. Burhan: *Visions and Visionaries: Nineteenth-century Psychological Theory, the Occult Sciences and the Formation of a Symbolist Aesthetic in France* (diss., Princeton U., NJ, 1979)

J. U. Halperin: *Félix Fénéon and the Language of Art Criticism* (Ann Arbor, 1980)

R. Shiff: *Cézanne and the End of Impressionism* (Chicago, 1984)

S. Hirsh, ed.: 'Symbolist Art and Literature', *A. J.* [New York], xlv/2 (1985) [entire issue]

J. Bergman-Carton: 'The Medium is the Medium: Jules Bois, Spiritualism and the Esoteric Interests of the Nabis', *A. Mag.*, lxi/4 (1986), pp. 24–9

P. T. Mathews: *Aurier's Symbolist Art Criticism and Theory* (Ann Arbor, 1986)

L. D. Henderson: 'Mysticism and Occultism', *A. J.* [New York], xlvi/1 (1987) [entire issue]

M. Marlais: 'In 1891: Observations on the Nature of Symbolist Art Criticism', *A. Mag.*, lxi/5 (1987), pp. 88–93

P. L. Mathieu: *The Symbolist Generation, 1870–1910* (New York, 1990) [summary bibliog. to 1989]

JULIUS KAPLAN

Synthetism

Style of painting that developed out of CLOISONNISM and formed a current within SYMBOLISM. It was practised by Paul Gauguin and his circle in the late 1880s and early 1890s. The term derives from the French verb *synthétiser* (to synthesize) and is based on the idea that art should be a synthesis of three features: the outward appearance of natural forms, the artist's feelings about his subject and purely aesthetic considerations of line, colour and form. The term was coined in 1889 when Gauguin and Emile Schuffenecker organized an exhibition entitled *L'Exposition de peintures du groupe impressioniste et synthétiste* in the Café Volpini at the Exposition Universelle in Paris. The confusing title acknowledged the artists' roots in Impressionism, with its adherence to natural forms and the depiction of light, while at the same time highlighting their more recent attempts to abandon nature as the focal point of art. Although realistic, tangible subjects served as their starting-point, the artists distorted these images in order to express more clearly certain moods or interpretations. In 1890 Maurice Denis summarized the goals of Synthetism: 'It is well to remember that a picture before being a battle horse, a nude woman, or some anecdote, is essentially a flat surface covered with colours assembled in a certain order.' However, Denis preferred the label 'Symbolism' for the new style.

The term Synthetism appeared again when Gauguin parodied it in an inscription on a ceramic piece: 'Vive la sintaize!' In *A Nightmare* (1889; Paris, Louvre), a caricatural drawing of Schuffenecker, Emile Bernard and himself, Gauguin drew himself pointing mockingly to the inscription 'Synthétisme'. While Gauguin may have accepted this label, he distanced himself from any group or title. In an article for *Mercure de France* in 1891 the critic Albert Aurier treated the term more seriously by including it as one of his criteria for a successful work of art. According to him, art must be simultaneously ideological, symbolistic, subjective, decorative and 'synthetic, because it presents these forms, these signs, in such a way that they can be generally understood' (Aurier, p. 162). Aurier's definition of Synthetism

suggests that the term should be used to describe certain formal aspects of painting in contrast with Symbolism, in which ideas are expressed. Characteristics of Synthetist art, as practised by Gauguin, Emile Bernard, Paul Sérusier, the Nabis and other members of the Pont-Aven circle of artists, include the use of a limited range of colours with little or no modulation, the repetition of colours across the canvas to establish a harmonious rhythm, and a strong definition of forms, either by outlining (Cloisonnism) or juxtaposition, so as to create an overall, linear rhythm (see figs 19 and 59). The emphasis on the flat arrangement of lines and colours leads to the suppression of pictorial depth. In landscape subjects this often results in a dual representation of distance and two-dimensional patterns. This curious ambiguity adds interest in such landscapes as Gauguin's *Blue Trees* (1888; Copenhagen, Ordrupgaardsaml.), in which colours and shapes are distorted and exaggerated in order to emphasize harmonies and rhythms.

Gauguin and Bernard established the Synthetist working method during their collaboration in Pont-Aven in the autumn of 1888: the artist should contemplate his subject in nature, making only sketches, or simply committing the scene to memory. Later, in the studio, his mind would filter out the elements and details unnecessary to the translation of his own feelings about the subject. By limiting the number of lines and colours, as well as any concern with space and modelling, the artist could concentrate on suggesting intangible sentiments uncluttered by realistic details. As Denis's statement quoted above suggests, painting pure feeling in a non-representational manner was not a consideration. However, the insistence on the importance of abstract formal concerns over naturalistic ones opened the way for the next generation of artists to abandon tangible reality as a subject-matter altogether.

Bibliography

M. Denis: 'Définition du néo-traditionnisme', *A. & Crit.* (23 and 30 Aug 1890); also in *Théories (1890–1910): Du Symbolisme et de Gauguin vers un nouvel ordre*, eds L. Rouart and J. Watelin (Paris, 1912), pp. 1–13

A. Aurier: 'Le Symbolisme en peinture: Paul Gauguin', *Mercure France*, ii (1891), pp. 155–65

CAROLINE BOYLE-TURNER

Tierp school

Term applied to a group of Swedish wall-painters, working mainly in the eastern parts of Uppland from *c*. 1460 to 1500. The group attracted followers both in Uppland and the northern parts of Sweden, who were active until *c*. 1520 and who have often been included in the Tierp school. However, since they also learnt from such figures as Albert the painter, and differed from the original group in several ways, they should not be regarded as part of the Tierp school. The term should be reserved for the earlier group, which appeared in the 1460s and received its name from the best-preserved cycle of paintings, in Tierp Church (*c*. 1470). It is not known who was the leader of the group or workshop, although several painters belonging to it are known by name. A strong candidate for this role is no doubt Andreas Erici, whose signature has been found in several churches (at Alunda, Skuttunge and Österlövsta). Erici is also the first of a number of painters mentioned in an inscription in Alunda and is the only one given a second name, which might indicate that he was above the others in rank. To judge from the names, these artists were of Swedish origin. Several of them had learnt from the painter Johannes Ivan and were probably employed by him at Alunda, where they had to finish the paintings when Ivan died in 1465. The Tierp school inherited several stylistic features from Ivan, such as his way of reserving the walls for the holy stories and covering the vaults and ribs with foliate decoration, especially a chain-like motif consisting of stylized leaves in a row dividing each section of a cross-vault into two. The vaults also contain paintings of saints. The foliate vault ornamentation of the Tierp school has a characteristic seaweed-like appearance, and seems to grow along the ribs of the vaults. The painters also adopted the style of broken drapery-folds, and often depicted elongated Gothic figures. The backgrounds are filled with decorative motifs, including a stencilled

flying bird, especially typical of the school. Except for the prophets, there are no references to the Old Testament in the paintings—a fundamental difference from the work of the contemporary artist Albert the painter, who worked in the same province. It has been suggested that the painter Peter Henriksson (*fl* Finland, *c.* 1470–90) came from the Tierp school. Although this is possible, there are differences, both stylistic and iconographic, between his work and that of the Tierp school. The problem of his origins has not yet been sufficiently investigated.

Bibliography

L. Wennervirta: *Suomen keskiaikainen kirkkomaalaus* [Medieval church painting in Finland] (Porvoo and Helsinki, 1937), pp. 223–48 [summary in Ger.]

H. Cornell and S. Wallin: *Die Malerschule von Tierp* (Stockholm, 1965)

A. Nilsén: *Program och funktion i senmedeltida kalkmåleri: Kyrkmålningar i Mälarlandskapen och Finland, 1400–1534* [Programme and function in late medieval wall painting: church painting in the Mälaren region and Finland, 1400–1534] (Stockholm, 1986)

ANNA NILSÉN

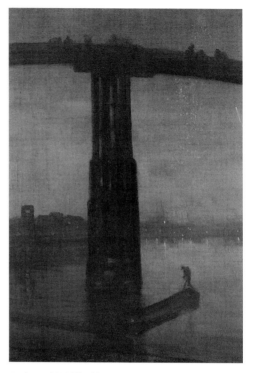

83. James McNeill Whistler: *Nocturne in Blue and Silver: Cremorne Lights*, 1871 (London, Tate Gallery)

Tonalism

Style of American painting that appeared between *c.* 1880 and 1920. Though not clearly defined, its main exponents were George Inness, James McNeill Whistler, Thomas Wilmer Dewing, Dwight W. Tryon, Alexander Helwig Wyant and such artists of the Photo-Secession as Edward J. Steichen. The term was used by Isham in 1905 and by Brinton in an essay in a catalogue for an exhibition of American painters held in Berlin in 1910. Brinton named the now virtually forgotten artists J. Francis Murphy, Bruce Crane (1857–1937), Ben Foster (1852–1926) and Henry Ward Ranger (1858–1916) as exponents of the style and as leaders of contemporary art in the USA. The style is characterized by soft, diffused light, muted tones and hazily outlined objects, all of which imbue the works with a strong sense of mood. The term was applied especially to landscape painting in which nature is presented as serene or mysterious, never disquieting or dramatic.

Tonalism grew up alongside American Impressionism yet is distinguished from that (and from French Impressionism) by its restrained palette and strongly subjective aesthetic. Somewhat in the tradition of George Fuller and of the earlier HUDSON RIVER SCHOOL in America, the Tonalists approached nature in a contemplative, Romantic manner, the intention being to capture not so much the appearance of a landscape as its mood as perceived by the artist. This idealistic attitude linked Tonalism to the contemporary Symbolist aesthetic (*see* SYMBOLISM), particularly evident in such paintings as Steichen's *Across the Salt Marshes, Huntington* (*c.* 1905, Toledo, OH, Mus. A.). The outlines of the trees are scarcely visible in the dim, misty atmosphere, lending the scene a strong sense of mystery. Whistler's earlier

Nocturnes, which date from the 1870s onwards, have similar qualities, as shown by *Nocturne in Blue and Silver: Cremorne Lights* (1871; London, Tate; see fig. 83). Closer to Impressionism in its lighting and in the brushwork, though still characteristic of Tonalism, is Tryon's *Morning in May* (1911; Oshkosh, WI, Paine A. Cent.) depicting a serene area of tree-lined landscape. Occasionally the Tonalist style was applied to figure and interior subjects, as in Dewing's *The Spinet* (1902; Washington, DC, Smithsonian Inst., Archvs Amer. A.), in which the prominent soft brown hues fuse the foreground with the background, blending the central figure into her surroundings.

Bibliography

S. Isham: *The History of American Painting* (New York, 1905)
C. Brinton: 'Die Entwicklung der amerikanischen Malerei', *Ausstellung amerikanischer Kunst* (exh. cat., ed. K. Francke; Berlin, Akad. Kst., 1910), pp. 9–42
E. P. Richardson: *Painting in America from 1502 to the Present* (New York, 1956, rev. 1969), pp. 304–7, 368
The Color of Mood: American Tonalism, 1880–1910 (exh. cat. by W. Corn, San Francisco, CA, de Young Mem. Mus., 1972)
R. J. Boyle: *American Impressionism* (Boston, 1974), pp. 76–8
The Paintings of Edward Steichen (exh. cat. by M. Steichen Calderone and A. C. De Pietro, Huntington, NY, Heckscher Mus., 1985)
A. J. Ellis: 'American Tonalism and Rookwood Pottery', *Substance of Style: Perspectives on the American Arts and Crafts Movement*, ed. B. Denker (Hanover, NH, 1996), pp. 301–15
American Tonalism: Paintings, Drawings, Prints and Photographs (exh. cat. by K. Avery, New York, Met., 1997)

Troubadour style

A branch of history painting that flourished in the late 18th century and early 19th, primarily in France. Born out of the historical and aesthetic interests of the 18th century, the Troubadour style in France preceded Romanticism, with which it shared its devotion to the past and its most famous exponents: Ingres, Bonington and Delacroix. It adapted the 18th-century fashion for Neo-classical pastiche and prefigured the historicism of 19th-century art in its taste for scenes and characters drawn from the art and history of the Middle Ages. The style was at first confined to the fine arts and appeared in the Paris Salon from c. 1800. Later it merged into Romanticism and influenced the decorative artists of the Restoration (1814–30). It was distinct from the Cathedral style, which was manifested primarily in the decorative arts, and from the Gothic Revival, which followed it.

The term 'troubadour' was first applied by the last contemporaries of Romanticism (e.g. Privat d'Anglemont in 1880) to the art of the previous generation. The style arose out of the vogue for medieval literature that was encouraged around 1780 by Louis-Elizabeth de la Vergne, the Comte de Tressan, and his imitators. To illustrate their works, Clément-Pierre Marillier (e.g. *Amadis de Gaule*, 1787) and Jean-Michel Moreau (e.g. *Figures de l'histoire de France*, 1779–85) invented pretty scenes of chivalry, which already combined all the clichés of the Troubadour style: sentimental anecdote, elegant costume and references to earlier art.

The revival of genuine medieval practice in gardening and pageants and the portrayal of French history presented distinct alternatives to earlier antiquarian models. C. Collé's *La Partie de chasse d'Henri IV* (Paris, 1766) and M.-J. Chénier's *Charles IX* (Paris, 1790), incontestably the two most successful illustrated books on 'historic' theatre, make apparent the universality of old costume in the Spanish style, such dress being common to the *fête galante* and to the heroes of the 18th-century French dramatist Pierre Augustin Caron de Beaumarchais. The accuracy of medieval costumes became general under the Empire (Jean Simon Berthélemy, *Costumes de l'Opéra*, 1804; Paris, Bib.-Mus. Opéra), particularly in the case of Moreau (*Costumes du XIIIe siècle*; Rouen, Mus. B.-A.). The statues of great men (e.g. *Jean de La Fontaine*; Paris, Louvre) and the cartoons of the *Tapestry of the History of France* commissioned by Louis XVI for the Louvre brought early popularity to the heroes of Troubadour iconography, chief among whom was Henry IV.

On the eve of the Revolution, activity in the art dealing world and the tastes of art lovers encouraged a retrospective vein, which Jean-Baptiste Mallet and Nicolas-Antoine Taunay, among others, were to exploit for 40 years. The Revolution interrupted these activities, but revolutionary vandalism, notably at Saint-Denis Abbey, hastened the growing awareness of an artistic heritage that needed to be preserved. It was from Alexandre Lenoir's Musée des Monuments Français and from their studios in the Convent of the Capucines that the first Troubadour painters drew their inspiration. The Louvre, whose collections were swollen with the booty of the French wars, became a fabulous museum of masterpieces, which widened Troubadour influences to include the masters of the Renaissance and, to a lesser extent, early Italian painting. Troubadour painting also grew out of a continuing northern tradition; this developed through Watteau's parodies of Rubens, the *Conversations espagnoles* of Carle Vanloo and the 'fantasy' portraits of Jean-Honoré Fragonard and culminated in pastiches of Dutch and Flemish genre scenes by Jean-Louis Demarne, Mallet and Taunay.

The relationship of Troubadour artists with the past was tinged with ambiguity, for they sought to evoke it as much by the application of medieval artistic techniques (e.g. precision of line) as by the events and customs they depicted, for instance in Pierre Révoil's oil *The Tournament* (1812; Lyon, Mus. B.-A.). But Troubadour paintings were not limited, as has often been supposed, to small-format works on copper or on wood demanding a very refined technique, such as Ingres's *Paolo and Francesca* (1819; Angers, Mus. B.-A.; see col. pl. XL). Such works as François-Marius Granet's *Blanche of Castille Freeing Prisoners* (1801; Paris, Petit Pal.) and Fleury Richard's *Valentine of Milan* (1802; St Petersburg, Hermitage) were planned as large-format works. There were also ambitious compositions which ostensibly represented historic monuments or sites but which were primarily imaginative re-creations animated by characters who might have inhabited them, such as in the *History of Saint-Denis* (1813; Paris, sacristy of St Denis), with scenes by, among others, Etienne-

Barthélemy Garnier, Gros and Pierre Guérin. In the same way the Troubadour style was introduced into heroic landscape painting by Alexandre Millin Du Perreux (1764–1843), Hippolyte Lecomte, Taunay and Auguste, Comte de Forbin, who drew the subjects of their paintings from old chronicles. After 1820 François-Alexandre Pernot (1793–1865) specialized in painting 'historiated' monuments.

Equally equivocal is the feminine strain to Troubadour art. It derives in part from the work of such women artists as Pauline Auzou, Hortense Haudebourt-Lescot, Sophie Lemire (*b* 1785), Henriette Lorimier (*fl* 1800–14) and Eugénie Servières (*b* 1786) and their famous clients, who included the Empress Josephine (an important patron of Troubadour art) and Caroline, Duchesse de Berry. But Troubadour art more often involved male artists idealizing women in their search for heroines from the past to give their contemporaries some respite from the masculine subject-matter of ancient and modern wars. Such themes included women as the inspiration of creativity (e.g. Louis Ducis's *Arts under the Sway of Love*; Limoges, Mus. Mun.); the mother of heroes (e.g. Jean-Antoine Laurent's *Du Guesclin as a Child*; lithograph by Pierre Laurent, 1739–1809); the unflinching warrior (e.g. Révoil's *Captivity of Joan of Arc*; Rouen, Mus. B.-A.; see fig. 84); the troubled lover (e.g. Paul Delaroche's *Filippo Lippi and Lucrezia Buti*; Dijon, Mus. B.-A.); and the tearful queen (e.g. *Death Sentence of Mary Stuart*; Arenenberg Schloss, nr Steckborn, by Jean-Baptiste Vermay (*d* 1833)). As artists often drew their inspiration from historical novels and fictionalized biographies intended for the female public, so women were more often depicted.

The Troubadour iconography was as varied as the historical and literary curiosities of the century in which the illustrated book reached its zenith. Printmakers perhaps gave the most perfect expression to the Troubadour style. Alfred and Tony Johannot produced engravings for the complete works of Sir Walter Scott (1826), Eugène Lami for the *Histoire des ducs de Bourgogne* (1838) by Baron Brugière de Barante and the *Histoire et*

84. Pierre Révoil: *Captivity of Joan of Arc* (Rouen, Musée des Beaux-Arts)

chronique du petit Jehan de Saintre (1830) by Antoine de Lasalle.

The Troubadour style, almost the exclusive speciality of Marie-Philippe Coupin de la Couperie (1773–1851), Laurent, Révoil and Richard, affected most Romantic artists at least briefly, particularly the sculptors of historic figures (Edmé-Etienne-François Gois (1765–1836), Félicie de Fauveau, Marie-Christine-Caroline d'Orléans, James Pradier and Mme de Sermezy (1767–1850)). Among these painters the result was very uneven: the works of Antoine Ansiaux (1764–1840), Pierre-Nolasque Bergeret, Merry-Joseph Blondel and Pierre-Auguste Vafflard were often laborious on the large scale that was so well suited to Delaroche (e.g. *Death of Queen Elizabeth*; exh. Paris Salon 1827), to Eugène Devéria (e.g. *Birth of Henry IV*; exh. Paris Salon 1827) and to Alexandre-Evariste Fragonard (e.g. *Francis I and Bayard*, 1819; all Paris, Louvre). The range and essence of the Troubadour style might best be summed up by contrasting the work of Ingres and Delacroix in this manner: the highly elaborate technique of the former in the *Death of Leonardo da Vinci* (1818; Paris, Petit Pal.) against the freer technique of the latter in his *Self-portrait at Ravenswood* (1821; Paris, Louvre), which probably echoes that of *Henry III and the Ambassadors* (1828; London, Wallace) by his friend Richard Parkes Bonington. Themes taken from the lives of the great artists gave rise to some undeniable masterpieces, for example Fragonard's *Raphael and the Model of the Virgin and Child* (Grasse, Mus. A. & Hist. Provence), in which the Troubadour painters expressed a genuine poetic

meditation on the art of their predecessors. Later in the 19th century the painters of the Lyon school such as Claudius Jacquand, Révoil and Richard exploited the historical vein in a systematic but less interesting manner. The Rococo revival exemplified by the work of such artists as Diaz de la Peña brought a more subtle revival of the Troubadour spirit.

Bibliography

H. Jacoubet: *Le Comte de Tressan et les origines du genre troubadour* (Paris, 1923)

R. Lanson: *Le Goût du moyen âge en France au XVIIIe siècle* (Paris, 1926)

H. Jacoubet: *Le Genre troubadour et les origines du romantisme* (Paris, 1929)

Le Style troubadour (exh. cat., Bourg-en-Bresse, Mus. Ain, 1971)

R. Strong: *'And When Did you Last See your Father?': The Victorian Painter and British History* (London, 1978)

M.-C. Chaudonneret: *La Peinture troubadour, deux artistes lyonnais: Pierre Révoil (1776–1852): Fleury Richard (1777–1852)* (Paris, 1980)

Raphaël et l'art français (exh. cat., ed. J. P. Cuzin; Paris, Grand Pal., 1983)

F. Pupil: *Le Style troubadour ou la nostalgie du bon vieux temps* (Nancy, 1985)

M. Pointon: ' "Vous êtes roi dans votre domaine": Bonington as a Painter of Troubadour Subjects', *Burl. Mag.*, cxxviii (1986), pp. 10–17

FRANÇOIS PUPIL

Turquerie

French term used to describe artefacts made in Turkey, or in France by Turkish craftsmen, and by derivation the influence on French design of elements from the Byzantine Empire, the Saljuq Islamic period and the Ottoman Empire. Specific motifs, borrowed from the original Turkish carpets, included arabesques or stylized flowers and vegetal scrolls and decorative animal forms—also included within the generic term 'grotesques'—from the Renaissance onwards. From the Middle Ages inventories and accounts record objects *façon de Turquie* imported from the East through the Crusades or the Silk route. In the accounts (1316) of Geoffroi de Fleuri, treasurer to King Philippe V of France, '11 cloths of Turkey' were noted, and in 1471 the inventory of the château of Angers records a wooden spoon and a cushion 'à la façon de Turquie'. In the 16th century Turkish textiles were highly prized, and Turkish craftsmen were employed in Paris to embroider cloth for ladies' dresses: in 1603 Louise de Vaudemont owned 'a piece of blue satin from Turkey'. These fabrics were often listed alongside carpets: in 1653 Cardinal Mazarin's inventory records 'a coverlet from Turkey' together with some 20 carpets among which was a 'carpet made of wool, from Turkey, with a red ground and flowers *à la turque* in different colours'. In the 17th century *tapis de Turquie* was a generic term to describe all carpets from Persia, Egypt and Asia Minor as well as French carpets made in Turkish or Eastern designs. Such carpets were very valuable and were displayed on tables and buffets, as well as on the ground. In the 17th century, under the influence of André Le Nôtre, gardens were designed to imitate East Asian carpets, with flowerbeds known as *parterres de broderie* or *parterres de Turquerie* in which boxwood was cut in arabesque patterns, for example at the châteaux of Vaux-le-Vicomte and Versailles. In the 18th century there was a limited vogue for *cabinets turcs*, for example that of the Comte d'Artois at Versailles (1780s; three surviving panels, Paris, Mus. A. Déc.), for which François Rémond made a gilt-bronze clock with figures of sultans (1780; Paris, Louvre). Queen Marie-Antoinette commissioned a canapé sofa, footstools and a carpet for her *boudoir turc* (see exh. cat.), and a pair of console tables (*c.* 1780) from a *cabinet turc*, showing turbaned negroes and medallions of Turkish heads, are now in the Frick Collection, New York. Apart from the *cabinets turcs*, in the 18th century Turquerie refers more widely to a certain ORIENTALISM in fashion, literature, paintings, prints and decorative motifs for such objects as fans. The fashion for Turkish smoking rooms and other Turkish elements in the revival style of the 19th century is a direct product of the Orientalist aspect of Romanticism, the love of the Orient that had started in the 17th century with the creation of the East India Companies

(1660 in France) and culminated in the 19th century in the poetry of Victor Hugo (e.g. *The Orientals*, 1829) and the harem scenes of J. A. D. Ingres (e.g. *Turkish Bath*, 1863; Paris, Louvre).

Bibliography

H. Havard: *Dictionnaire de l'ameublement et de la décoration* (Paris, 1887)

Exposition de la Turquerie au XVIIIe siècle (exh. cat., Paris, Mus. A. Déc., 1911)

E. de Ganay: *Les Jardins de France et leur décor* (Paris, 1949)

MONIQUE RICCARDI-CUBITT

Utrecht Caravaggisti

Group of painters from Utrecht who travelled to Rome at the beginning of the 17th century and were profoundly influenced by the work of Caravaggio. On their return to the northern Netherlands, they developed these new artistic ideas into a style known as Utrecht Caravaggism. This trend had a short-lived but intense development that lasted from 1620 to 1630. The first generation and initiators were Hendrick ter Brugghen, Gerrit van Honthorst and Dirck van Baburen, who introduced Caravaggism into Utrecht painting *c.* 1620 with immediate success. Such older painters as Abraham Bloemaert, Paulus Moreelse and even the Mannerist Joachim Wtewael were affected.

The Utrecht Caravaggisti painted predominantly history scenes and genre pieces. These are life-size paintings with economical and powerful compositions; the impact of the scene is heightened by contrasting areas of light and dark, and a small number of figures who are abruptly cropped so that they seem to be portrayed in close-up.

Utrecht Caravaggism marked a break with the artificiality and fantasy of Mannerism. The Caravaggisti strove for realism. Through a life-size and lifelike presentation of figures, they stripped away the then customary elevation and detachment in painting's themes. This is most noticeable in religious subjects, where saints are often shown as ordinary types. Ter Brugghen and van Baburen were the most daring and expressive of the Utrecht

Caravaggisti, both in choice of subject and spontaneity of technique. Other Caravaggisti, such as van Honthorst, Jan van Bijlert and Hendrick Bloemaert, had a more restrained style. Several themes were introduced into Dutch painting or revived by the Utrecht Caravaggisti, for example St Sebastian, the Calling of St Matthew or Heraclitus and Democritus. The genre scenes show a preference for half-length figure pieces with shepherds and shepherdesses, procuresses or merry companies.

Utrecht Caravaggism came to an end after the deaths of van Baburen and ter Brugghen in 1624 and 1629 respectively; van Honthorst had by then already turned more towards international Classicism, followed by, among others, Abraham Bloemaert and van Bijlert. Although Caravaggism ceased to predominate in Utrecht thereafter, painters continued to work in the style, as is evident in the paintings of Paulus Bor, Gerard van Kuijll (1604–73), Lumen Portengen (1608–49), Johan Baeck (*d* 1654/5) and Jan Gerritsz. van Bronchorst. Even in the 1650s such Utrecht painters as Johan de Veer (*c.* 1610–62) and Johannes Jansz. van Bronchorst were inspired by it.

Utrecht Caravaggism had an important influence on Dutch painting. Frans Hals, Jan Lievens and Rembrandt, among others, adopted various features of the style. Other painters in Amsterdam, Haarlem and Delft were also influenced; the early work of Johannes Vermeer, from the 1650s, was inspired by Utrecht Caravaggism. The style was thus more than a merely local phenomenon; it laid the groundwork for later developments of the 17th century.

Bibliography

A. von Schneider: *Caravaggio und die Niederländer* (Marburg, 1933/*R* Amsterdam, 1967)

Caravaggio en de Nederlanden (exh. cat., Utrecht, Cent. Mus.; Antwerp, Kon. Mus. S. Kst.; 1952)

Nieuw Licht op de Gouden Eeuw: Hendrick ter Brugghen en tijdgenoten (exh. cat., ed. A. Blankert and L. J. Slatkes; Utrecht, Cent. Mus.; Brunswick, Herzog Anton Ulrich-Mus.; 1986–7)

Hendrick ter Brugghen und die Nachfolger Caravaggios in Holland: Braunschweig, 1987

PAUL HUYS JANSSEN

Verismo

Movement in Italy, primarily in Naples and Tuscany, from *c.* 1850 to 1900 that developed as a response to naturalism and realism in French art and literature. The principal visual artists were Antonio Mancini, Francesco paolo Michetti and Vincenzo Gemito. In the early part of the century, which was dominated by Neo-classical idealism, an interest in the representation of the real world was confined to landscape painting (e.g. *Scuola di Posillipo*) and portrait painting, as practised by Andrea Appiani. One of the first Italian painters to observe nature systematically in a similar way to realist artists in France was Filippo Palizzi. In his work *Vineyard with Priest* (Rome, G. N. A. Mod.), every detail is minutely depicted. Another form of realism is to be seen in the work of Domenico Morelli who, while breaking classical canons and working in tones and values rather than in contours, maintained the importance of imagination over observation. Thus in the *Christian Martyrs* (1855; Naples, Capodimonte) naturalistic light and colour enhance a religious theme. However, the MACCHIAIOLI, based in Tuscany, were the first group of Italian painters to show an overriding interest in the effects of natural light on form and to concentrate on contemporary subjects, whether political events, as in Michele Cammarano's battle scenes of the Risorgimento, or intimate interiors, as with the paintings of Adriano Cecioni and Odoardo Borrani (1834–1905). One of its members, Giovanni Fattori, wrote in 1903 that Verismo should be a means to 'show posterity our ways' (Maltese, p. 22). Towards the end of the century, particularly in Naples, the desire to capture the essence of contemporary life and to portray the world as it appeared became the dominant movement in both literature and art. A new awareness of popular culture, regional characteristics and local dialects was created by such authors as Giovanni Verga (1840–1922). Among the most prominent painters in this manner was Mancini who, while being close to Morelli stylistically, portrayed ordinary Neapolitans (e.g. *Street Urchin*, 1868; The Hague, Rijksmus. Mesdag) with a new and profound empathy. Equally, Michetti and Gioacchino Toma portrayed the poor with

great fidelity. Although the most successful painter of the group, Michetti's flamboyant colour and painterly effects helped to divert the original intentions of Verismo towards sentimentality and overdramatization. In sculpture, Gemito was the most innovative and successful exponent of Verismo. His sculptures are the antithesis of Neo-classical works: each surface is depicted, every flicker of light and shade is suggested, and the poses are taken from ordinary attitudes emphasizing the three-dimensionality of form rather than the noble outline (e.g. *Little Fisherboy*). This approach was taken to its ultimate conclusion with Medardo Rosso's portrait heads, where form virtually dissolves.

Bibliography

Comanducci

F. Bellonzi: *Verismo e tradizione in Antonio Mancini*, Atti della Accademia Nazionale di San Luca, vi/3 (Rome, 1963)

C. Maltese: *Realismo e verismo nella pittura italiana* (Milan, 1967)

Victorian style

Term used to describe the fine and decorative art and architecture produced within the British Empire during the reign of Queen Victoria (1837–1901). It is sometimes applied to contemporary work elsewhere. The period is conventionally divided into early Victorian (1837–*c.* 1850, but often taken to have begun in 1831, after the end of the Regency period), high Victorian (*c.* 1850–*c.* 1870) and late Victorian (*c.* 1870–1901).

Although the GOTHIC REVIVAL, the predominant style of the early and high Victorian periods, has come to be identified as the Victorian style, during this time of rapid social change and aesthetic uncertainty—when works of art were created, reproduced, criticized and collected and buildings designed and erected, in unprecedented quantity—no one style was ever universally accepted; indeed, much late Victorian work, notably that produced by the AESTHETIC MOVEMENT and the ARTS AND CRAFTS MOVEMENT, is actively 'anti-Victorian' in spirit and

form, for example the severely geometrical tableware designed by Christopher Dresser for Elkington & Co.

When faced with a challenge, Victorian designers showed themselves capable of achieving superb clarity, as exemplified by the Crystal Palace (destr.) designed by Joseph Paxton for the Great Exhibition of 1851 in London and the New Palace of Westminster designed and partially carried out (1835–60) by Charles Barry. Frequently, however, they felt circumscribed by historical precedent and the difficulties of answering to a committee, which resulted in a confused compromise and the indifferent application of poorly mass-produced details copied from such pattern-books as *Grammar of Ornament* (1856) by Owen Jones. No such timidity marked the Victorians' wholesale restoration of earlier buildings. Ponderousness (combined with fine workmanship) characterizes the furniture produced specifically for public exhibition, while the pieces created by William Morris and his followers represent a reaction to exaggerated ornamentation.

The seriousness with which A. W. N. Pugin reinterpreted Gothic contrasts with the triviality of much Victorian genre painting. Portrait photographers and the Pre-Raphaelite painters (*see* PRE-RAPHAELITISM) sought a new realism. The work of this group of artists is now held by many to epitomize Victorian style (see fig. 85). They sought liberation from their immediate artistic past in the use of pure colour; such architects as William Butterfield and William Burges explored the possibilities of polychromy, as did the sculptor John Gibson with the *Tinted Venus* (1851–6; Liverpool, Walker A.G.). Victorian architecture, as well as painting and sculpture, was most widely appreciated in monochrome engraving, which the illustrators of the 1860s raised to new expressive heights, as in *The Graphic*.

The central hall of Wallington Hall, Northumb. (NT), brings together many of the features that typify the Victorian style. In 1853–4 the architect John Dobson roofed over an open courtyard to create a more welcoming domestic interior. The first-floor balustrade was copied from an illustration to Ruskin's *The Stones of Venice* (1851–3). William Bell Scott was commissioned to paint

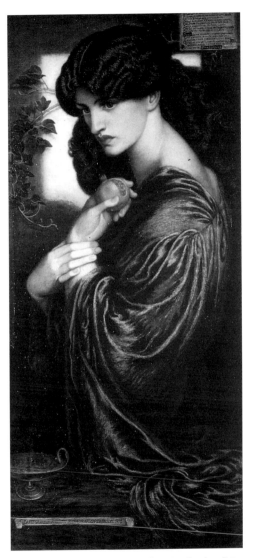

85. Dante Gabriel Rossetti: *Proserpine*, 1874 (London, Tate Gallery)

eight scenes celebrating the history of Northumberland (*Building the Roman Wall*) and local heroism (*Grace Darling Rescuing the Men of Forfarshire*) and industry (*Iron and Coal on Tyneside in the 19th Century*). The artist took great trouble to include authentic detail and underlined the narrative with dramatic gesture

and texts placed above. Ruskin helped to paint the elaborate flowers and foliage on the pilasters, exhibiting the truth to nature that he professed in his writings. The sculpture is ideal (*Mother and Child*, marble, 1856–7, by Thomas Woolner, symbolizing Civilization), literary (plaster maquette for *Paolo and Francesca*, exh. 1851, by Alexander Monro, the subject taken from Dante's *Inferno*) and commemorative (profile medallions of Tennyson and Robert Browning by Munro); all these works are *in situ*. The furniture, like many Victorian pieces intended for everyday use, was based on 18th-century prototypes.

For much of the 20th century the Victorian style—antipathetic to the Modern Movement—was out of favour. The foundation of the Victorian Society in London in 1958 marked growing scholarly interest shown by Nikolaus Pevsner and others in the diverse achievements of the period.

Bibliography

J. Steegman: *Consort of Taste* (London, 1950); rev. as *Victorian Taste* (Cambridge, 1970)

Vict. Stud. (1957–) [with annual bibliog.]

J. Gloag: *Victorian Taste* (London, 1962/R 1972)

N. Pevsner: *Victorian and After* (1968), ii of *Studies in Art, Architecture and Design* (London, 1968)

M. Girouard: *The Victorian Country House* (Oxford, 1971, rev. 1979)

Victorian and Edwardian Decorative Art: The Handley-Read Collection (exh. cat., ed. S. Jervis; London, RA, 1972)

P. Conrad: *The Victorian Treasure-house* (London, 1973)

H. J. Dyos and M. Wolff, eds: *The Victorian City*, 2 vols (London, 1973)

R. Dixon and S. Muthesius: *Victorian Architecture* (London, 1978)

Great Victorian Pictures (exh. cat. by R. Treble, London, RA, 1978)

B. Read: *Victorian Sculpture* (London, 1982)

S. Jervis: *High Victorian Design* (Woodbridge, 1983)

OLIVER GARNETT

XX, Les [Vingt, Les; Fr.: 'The Twenty']

Belgian exhibition society. It was founded on 28 October 1883 in Brussels and held annual shows there between 1884 and 1893. The group was formed by 11 artists dissatisfied with the conservative policies of the organization L'Essor: Frantz Charlet (*b* 1862), Paul Dubois (ii), James Ensor, Alfred William Finch, Charles Goethals (?1853–85), Fernand Khnopff, Darío de Regoyos, Théo Van Rysselberghe, Willy Schlobach (*b* 1864), Guillaume Van Strydonck (1861–1937) and Rodolphe Wytsman (1860–1927). They invited an additional nine members—Achille Chainaye (1862–1915), Jean Delvin (*b* 1853), Jef Lambeaux, Périclès Pantazis, Frans Simons (1855–1919), Gustave Vanaise (1854–1902), Piet Verhaert (1852–1908), Théodore Verstraete (1850–1907) and Guillaume Vogels—thereby fixing their number at 20. In contrast to L'Essor, Les XX had neither a president nor governing committee but was run by its secretary, Octave Maus, who organized the exhibitions. Maus, in turn, secured the aid of his friend, fellow lawyer and co-founder of the Belgian periodical *L'Art moderne* (1881–1914), Edmond Picard (1836–1924). Through Picard, *L'Art moderne* provided Les XX with a strong theoretical defence against hostile critics and members of the public attending the Salon. Maus and Picard identified the Academy and the Salon system as their principal foes and symbols of the status quo. With his inflammatory rhetoric, Picard intentionally created enemies both within and outside Les XX. His attacks on established tradition drew the hostility of critics, and the resulting hostile press frightened some members of the society. By 1887 conservative artists Lambeaux, Verhaert, Verstraete, Simons, Delvin and Vanaise had fled from Les XX, some under direct pressure from Maus and Picard. Les XX replaced them with members more sympathetic to its cause: Anna Boch (1848–1926), Guillaume Charlier, Henry De Groux, Georges Lemmen, George Minne, Robert Picard (*b* 1870), Auguste Rodin, Félicien Rops, Paul Signac, Jan Toorop, Henry Van de Velde and Isidore Verheyden. Over its ten-year history Les XX actually included 32 members.

From the outset, Les XX brought an international dimension to its exhibitions by inviting non-Belgians to exhibit. With the help of Van Rysselberghe and the writer and critic Emile

Verhaeren, Maus sought out important emerging artists from Europe and the USA: Whistler, Sargent, Odilon Redon, Cézanne, Monet, Renoir, Toulouse-Lautrec, Seurat, Signac, Rodin and Walter Crane were among those invited. In all, 126 *invités* showed at Les XX's exhibitions, an eclectic group that reflected various styles including Realism, Impressionism, Neo-Impressionism, Symbolism, Art Nouveau and, in the final years, the growing interest in the decorative arts. A healthy interaction between original members and those invited to exhibit often resulted in close ties between avant-garde circles in Brussels, London and Paris. The repeated participation of Seurat and his circle at Les XX led to the creation of a Belgian Neo-Impressionist school. The early influence of William Morris and Walter Crane stimulated a strong Belgian response to the English Arts and Crafts Movement. Filtered through Finch, Lemmen and Van de Velde, this in turn swept through Paris and, eventually, Austria and Germany. Khnopff, Xavier Mellery, Minne, Rops and Toorop developed a local response to French Symbolism. Les XX emphasized all the arts, including music and literature. It strove to present a unified avant-garde front by hosting concerts of the latest music of Claude Debussy, Ernest Chausson and Gabriel Fauré, and lectures by Stéphane Mallarmé, Théodore de Wyzewa and Paul Verlaine. To underline this artistic interrelationship, these events were held during the exhibitions in the Palais des Beaux-Arts, Brussels. After ten years of successfully defending and defining the avant-garde in Europe, Les XX voted for its own dissolution. It gave way to the LIBRE ESTHÉTIQUE, the brainchild of Maus, who continued his role as impresario and defender of a jury-free, independent society that offered an alternative to the academic Salon. The example of Les XX encouraged similar experiments outside Belgium and was a model for a number of 20th-century art movements. Les XXX in Paris, Die XI in Berlin and the Vienna Secession each consciously adopted some of Les XX's policies.

Bibliography

M. O. Maus: *Trente années de lutte pour l'art* (Brussels, 1926/R 1980)

Le Groupe des XX et son temps (exh. cat. by F.-C. Legrand, Brussels, Mus. Royaux B.-A., 1962)

J. Block: 'Les XX: Forum of the Avant-garde', *Belgian Art, 1880–1914* (exh. cat., New York, Brooklyn Mus., 1980), pp. 17–40

Les XX: Catalogue des dix expositions annuelles (Brussels, 1981) [reprint of original cats 1884–93]

J. Block: 'What's in a Name? The Origins of "Les XX"', *Mus. Royaux B.-A. Belgique: Bull.*, n.s., xxx–xxxiii/1–3 (1981–4), pp. 135–42

——: *Les XX and Belgian Avant-gardism, 1868–1894* (Ann Arbor, 1984)

S. Canning: *Le Cercle des XX* (Antwerp, 1989)

Les XX and the Belgian Avant-garde: Prints, Drawings and Books, ca. 1890 (exh. cat., ed. S. H. Goddard; Lawrence, U. KS, Spencer Mus. A., 1992) [essays by J. Block and others]

J. Block: 'Les XX and La Libre Esthétique: Belgium's Laboratories for New Ideas', *Impressionism to Symbolism: The Belgian Avant-garde, 1880–1900* (exh. cat., London, RA, 1994)

JANE BLOCK

Wanderers [Itinerants; Rus. *Peredvizhniki*]

Russian exhibiting society, active 1870–1923. It takes its name from Tovarishchestvo Peredvizhnykh Khudozhestvennykh Vystavok: 'Association of travelling art exhibitions'. The Association grew from the earlier Artists' Cooperative Society (Artel' Khudozhnikov) founded in 1863 by a group of 14 artists, headed by Ivan Kramskoy, who had broken away from the Academy of Art, St Petersburg, in protest against its traditional style and subject-matter, wanting instead to focus on Russian art. In 1870, on the initiative of Kramskoy, Grigory Myasoyedov, Vasily Perov and Nikolay Ge, an association was founded aiming to take art to the people by means of travelling exhibitions, the first of which took place in November 1871 in the Academy of Arts, St Petersburg. In 1872 the exhibition moved to Moscow, and exhibitions were held annually from then on in Moscow and St Petersburg as well as in smaller cities. Members of the Association became known as the Wanderers.

Inspired in particular by the writings of Nikolay Chernyshevsky (1828–89), who advocated

a didactic function for art, and Vladimir Stasov, the Association's intentions embodied the prevailing spirit of the period, which was both realist and critical of the political system. There was a turning away from the romantic and legendary to an emphasis on life as it was lived and as a subject for reform. Initially, the Wanderers concentrated on the exposure of contemporary evils, whether social, political or ecclesiastical, as for example in *Inspecting the Estate* (1881; Moscow, Tret'yakov Gal.) by Nikolay Kuznetsov (1850–1929), but they also produced portraits of outstanding creative personalities as well as landscapes that were among the first to show an appreciation of Russian scenery. This reformist phase soon gave way to an interest in historical subjects; during the 1880s pan-Slavism and an intense nationalism were much in evidence, not least in the illustration of legend and folk-tale. A further element in this movement was the quest for a specifically Russian portrayal of Christ (e.g. Kramskoy's *Christ in the Wilderness*, 1872; Moscow, Tret'yakov Gal.).

Many artists who did not become members contributed to the Association's travelling exhibitions, which finally included most of the country's major artists. Most Russian painters (the Association also included some sculptors among its supporters) paid token allegiance to its vaguely populist aims. The majority of the Wanderers had been trained in traditional techniques and were strongly opposed to French Impressionism; the style they adopted is generally referred to as Critical Realism. Within their own ranks they made what they considered vital innovations, such as the muted colour harmonies in the work of Vasily Surikov (as in, for example, *Men'shikov in Beryozovo*, 1883; Moscow, Tret'yakov Gal.), Mikhail Nesterov's horizontal linear compositions and the luminist landscapes of Arkhip Kuindzhi. The member of the Association with the greatest reputation was Il'ya Repin, whose vast and varied output covered a large range of subjects and techniques. Although the Wanderers dominated the major teaching institutions throughout Russia at the beginning of the 20th century, their reputation and influence were greatest during the

1880s. From 1932 the Wanderers were officially proclaimed predecessors of Soviet Socialist Realism, which adopted their emphasis on Realism and the importance of subject-matter.

Bibliography

G. Burova, O. Gaponova and V. Rumiantseva: *Tovarishchestvo Peredvizhnykh Khudozhestvennykh Vystavok* [The association of travelling art exhibitions], 2 vols (Moscow, 1959)

E. Valkenier: *Russian Realist Art* (Ann Arbor, 1977, rev. 1991)

Peredvizhniki, intro. A. Lebedev (Leningrad, 1977, 2/1982); Eng. trans. as *The Itinerants* (London, 1982)

V. V. Andreyeva and others, eds: *Tovarishchestvo Peredvizhnykh Khudozhestvennykh Vystavok, 1869–1899: Pis'ma, dokumenty* [The association of travelling art exhibitions, 1869–1899: letters, documents], 2 vols (Moscow, 1987)

ALAN BIRD

Weser Renaissance

Term given to the art, and in particular the architecture, created in the region along the River Weser and adjacent areas in Germany between c. 1520 and c. 1620. Money earned by noblemen fighting as mercenaries in foreign wars—especially in the Netherlands—and an expansion in agricultural trade were two of the main contributory factors to the spate of new building that occurred in the region during this period. The most important architectural undertakings were castles, as well as town halls and town houses, although churches were also built in this style; some of these buildings were decorated with reliefs, statues or ornamental stonework. One of the most important architects active in the earliest phase of the Weser Renaissance was Jörg Unkair (d 1552), who probably came from Württemberg. He was followed by Cord Tönnis and Hermann Wulff, both from the Weser region; they had a decisive influence on local architectural style between c. 1550 and c. 1575. In that period its distinguishing characteristics were strict proportioning and, in some cases, drastically reduced decoration, as, for example, in the Haus Rike (1568–9) in Hameln and

the Hexenbürgermeisterhaus (1568–71), which was built by Wulff in Lemgo. After 1570 local building was dominated by the influence of such Netherlandish architects as Cornelis Floris and Hans Vredeman de Vries; at this period, existing links between the Netherlands and the Weser region were being reinforced by trade, and other transactions related to building: sandstone from Obernkirchen in the Weser hills was supplied for the construction of Antwerp Town Hall (1561–3), and such Netherlandish artists as Arend Robin (memorial plaques and showpiece fireplaces in Stadthagen) and Jan Robijn II (sculptural work at Stadthagen Town Hall) were active in that part of Germany.

During the Weser Renaissance, castles were typically constructed on a regular plan with several wings. Existing buildings were often united in one scheme, as, for example, at Schloss Neuhaus (from 1524) near Paderborn, on which Unkair collaborated and where the following characteristics of the Weser Renaissance are visible: *Zwerchhäuser*—dormer-type structures, often several storeys high, placed at right angles to saddle roofs that are sometimes nearly equal in height to the main roof; *Utluchten*—bays, rectangular on plan, that rise supported from the ground floor; and polygonal staircase towers—inserted at Schloss Neuhaus into the corners of the courtyard. The semicircular *welsche Giebel* or Italian gables, characteristic of the early Weser Renaissance, are also present at Schloss Neuhaus. They resemble those gables, ranged according to height and size, that were used in north Italy and Venice from c. 1475, and attest to the influence of Italian Renaissance architecture in the Weser area. These new forms were employed alongside the existing repertory of Late Gothic secular building, which included the mouldings used on windows and doorframes, the window members, highly decorated spiral staircases and other elements, all of which were part of an indigenous tradition (e.g. castles at Schulenburg, Stadthagen and Detmold). Buildings erected from 1560 to 1570 show a strong Netherlandish influence in their curved gables, high windows with stone mullions and transoms, and strapwork decoration, as well as rustication

suggesting chip-carving (*Kerbschnitt*). The Late Gothic forms began to disappear about this time. Buildings such as Celle Town Hall (begun c. 1570) or the castles at Varenholz and Hämelschenburg (both c. 1590) are among the finest built in this style. The most widely used building material in the area was red sandstone from Obernkirchen an der Weser, in addition to locally quarried stone and bricks. Timber was rarely introduced on exteriors, but much employed, in the traditional way, in the interiors. Slight traces of colour remain, indicating that the buildings may have been painted to some extent, and at Schloss Varenholz, lozenge-shaped sgraffito decoration in the inner court is still partly preserved. Most castles in the Weser region were constructed over a lengthy period; as a result, important monuments of the Weser Renaissance show different stylistic influences. After the hiatus caused by the Thirty Years War (1618–48), no further building activity of any distinction took place in the area for a considerable period; thus the works created during the Weser Renaissance remain an outstanding feature of that part of Germany.

Bibliography

M. Sonnen: *Die Weserrenaissance: Die Bauentwicklung um die Wende des 16. und 17. Jahrhunderts an der oberen und mittleren Weser und in den angrenzenden Gebieten* (Münster, 1918)

H. Kreft and J. Soenke: *Die Weserrenaissance* (Hameln, 1964, 6/1986)

Kunst und Kultur im Weserraum von 800–1600: Ausstellung des Landes Nordrhein-Westfalen (exh. cat., ed. H. Eichler; Corvey, Benediktinerabtei, 1966), i, pp. 272–95; ii, pp. 683–94

H.-R. Hitchcock: *German Renaissance Architecture* (Princeton, 1981)

H.-J. Kadatz: *Deutsche Renaissancebauten: Von der frühbürgerlichen Revolution bis zum Ausgang des Dreissigjährigen Krieges* (Berlin, 1983)

G. U. Grossmann: *Renaissance entlang der Weser: Kunst und Kultur in Nordwestdeutschland zwischen Reformation und Dreissigjährigem Krieg* (Köln, 1989)

GUNTER SCHWEIKHART

William and Mary style

Term applied primarily to decorative arts produced in The Netherlands and England during the reign (1689–1702) of William III and Mary II and that spread also to North America at the end of the century. It covers a vocabulary of visual forms rather than a movement, and is represented by richly ornamented furniture, displays of wares from the Far East, embossed and engraved silver, ceramics, luxurious textiles, architectural ornament and garden design. The decorative arts of the 1690s reflect the blending of French, Dutch and English ornamental styles as well as an increased taste for exotica. Although at war with France, William III admired the sophistication of French culture and encouraged the immigration of Huguenot refugees, the French Protestants who fled from France after 1685 when Louis XIV revoked the Edict of Nantes, which had guaranteed them freedom of worship. William's leading designer was the Huguenot architect and etcher Daniel Marot, a versatile artist trained at the court of Louis XIV. Marot's stylistic idiom is best exemplified in the Dutch palace of Het loo, in Gelderland, and its gardens renovated by William and Mary in the 1680s, and in the many designs commissioned and often executed for the monarchs' English palaces of Hampton Court and Kensington, London. The continuing influence of designs by Marot and William's recurring requests for the latest in French furniture and textiles (obtainable only by open violation of the laws against trade with France), attest to the French accent in international taste. Over 100 of Marot's designs for objects large and small in various media were published in his *Oeuvres* (The Hague, 1703; republished, with c. 126 plates, Amsterdam, c. 1712); the resemblance of the prints to surviving objects is remarkable, proving his pervasive influence.

Queen Mary was an avid collector of oriental luxury goods, inspired a craze for Japanese, Chinese and Dutch ceramics, and supervised the architectural renovations and gardens at Kensington Palace and Hampton Court Palace. Such English artists as the architect Sir Christopher Wren and the artist and sculptor Grinling Gibbons, both of whom had been employed by earlier Stuart monarchs, continued in favour. Gibbons's delicate wood-carvings of flowers, fruit, birds, game and foliage were aesthetically related to Dutch still-life painting. Appointed Master Sculptor and Master Carver in 1693, he executed wash drawings (London, Soane Mus.) for prospective interiors in the new apartments at Hampton Court, which demonstrate an intimacy of ornamentation well suited to his Anglo-Dutch patrons and include architectural assemblages of Mary's Oriental porcelain and Delftware.

The Dutch taste for such domestic features as black-and-white tiled floors and blue-and-white Delftware became part of an eclectic, international vocabulary. The extraordinary success of English and Dutch commercial shipping (notably the East India Company), brought Chinese porcelain, Indian fabrics and Indonesian and Malaysian sea-shells as well as botanical specimens and woods (e.g. ebony) to Europe. The result was a decorative style that was not only eclectic, but distinctively exotic—as in japanned furniture, lacquerwork, elaborately inlaid ornamental cabinets for collections of curiosities, Delftware combining Western and Eastern motifs, Chinese silks and damasks, gilded wall-coverings and intricately wrought Huguenot metalwork. A similar confluence of styles is seen in English gardens of the 1690s, for example at Chatsworth, Derbys, Hampton Court, and Westbury Court, Wilts.

Following the royal example, expensive, elaborate objects of virtuoso craftsmanship became the fashion among the wealthy in the growing number of refurbished or new country houses. Huguenot craftsmen who had been trained in France under the administration of Jean-Baptiste Colbert and Charles Le Brun dramatically improved the quality of English manufactures. A Dutchman, Gerrit Jensen, was appointed Cabinet Maker to the royal household of William and Mary in 1689, and through the products of his shop in St Martin's Lane, London, sold furniture in the style of Marot. Meanwhile, wealthy merchants began to display their status by incorporating mirrors and chimney-glasses in their houses; and

caned seats replaced old 'turkey-work' chairs. Although English craftsmen tried to copy the continental techniques their methods were inferior; nevertheless, they supplied a market unable to afford the Huguenot pieces or those that were imported illegally.

Bibliography

P. Thornton: *Seventeenth-century Interior Decoration in England, France and Holland* (New Haven, 1978)

The Quiet Conquest: The Huguenots, 1685–1985 (exh. cat. by T. Murdoch, London, Mus. London, 1985)

The Anglo-Dutch Garden in the Age of William and Mary (exh. cat., ed. J. Dixon Hunt and E. de Jong; Apeldoorn, Pal. Het Loo; London, Christie's; 1988–9); also in *J. Gdn Hist.*, viii/2–3 (1988) [whole issue]

Courts and Colonies: The William and Mary Style in Holland, England and America (exh. cat., New York, Cooper-Hewitt Mus.; Pittsburgh, PA, Carnegie Mus. A.; Washington, DC, Smithsonian Inst.; 1988)

The Age of William III and Mary II: Power, Politics and Patronage, 1688–1702 (exh. cat., ed. R. Maccubbin and M. Hamilton-Phillips; New York, Grolier Club; Washington, DC, Folger Shakespeare Lib.; 1988–9)

The Dutch Garden in the Seventeenth Century: Dumbarton Oaks Colloquium on the History of Landscape Architecture, XII: Washington, DC, 1990

M. HAMILTON-PHILLIPS,
R. P. MACCUBBIN

Yucateco

Term used to designate the architecture characteristic of the Yucatán peninsula in south-east Mexico, particularly the religious architecture of the 16th century. A number of factors militated against Spanish settlement in Yucatán in the early 16th century, notably the intense heat, difficulties in irrigating the area, the lack of precious metals and the sparseness of the Indian population, which was mostly Maya. Consequently, the peninsula's social and economic development was very different from that of the more densely populated central plateau, and this was reflected in its architecture, which was of a simpler and more austere character.

Despite the obstacles to settlement, Franciscan missionaries arrived in the Yucatán peninsula in the 1530s and 1540s and began to construct simple buildings to house the monks. In order to accommodate the large congregations of Indians, however, and to protect them from the sun, they built *ramadas*, or large shelters, in the monastery compounds. These were supported by tree trunks, with roofs made from branches, and they had no side walls, thereby allowing the free passage of air. Services were conducted from a small, open-fronted stone chapel or chancel, which was built facing the *ramada*. Such complexes, comprising dormitories, chapel and *ramada*, formed the first Yucatán monasteries. Later, especially in the 17th century, these 'open-air' or 'Indian' chapels formed the basis of the typical Yucatán convent churches, with simple, stone naves replacing the original *ramadas* in front of the chapels.

The monasteries that grew out of these *ramadas* retained their own distinctive features through-out the 17th and 18th centuries, with few of the Romanesque, Gothic, Plateresque, Renaissance or Baroque details that were so sumptuously adopted in the rest of Mexico. Instead, their façades were relatively simple, although one notable distinguishing feature was the development of the front gable-ends to serve as wall belfries to house the bells. The design of the gable-ends was very varied, in some cases their size being increased at the expense of the walls, with the height of the latter being reduced to a minimum. A semicircular, ribbed vault usually covered the chancel. Other monasteries were later built with great transverse arches that, because of the thickness of the walls, provided space for extra chapels. Another characteristic feature was the construction of large arcades surrounding the atrium, for example in the monastery at Izamal. Despite the poverty of the Yucatán region, 29 Franciscan monasteries were built there, each with its own stylistic identity, although most are simple and austere. They were used not only to teach Christian doctrine but also for the artistic and architectural training of indigenous craftsmen, and one monk, Fray Juan Pérez de Mérida, established a reputation as the builder of the monasteries of Mérida, Maní, Izamal

and Sisal de Valladolid, assisted by his Indian apprentices.

The architecture of the 16th-century cathedral of S Ildefonso, Mérida, is also characteristically different from that of the cathedrals in Mexico City, Guadalajara and Puebla, on which work began in the same period. S Ildefonso is a simple, aisled hall church with large columns supporting sail vaults and a dome over the crossing. The vaults and dome are decorated with simple mouldings, as is the rest of the building. The façade of the cathedral is also very simple and austere in its execution, with an almost fortress-like composition of towers and walls in plain ashlar masonry flanking a tall central arch above the main portal, which has small-scale classicist detailing.

The only important work of secular architecture that has survived in Yucatán is the Casa de Montejo (1549), the former residence of the conquistador Francisco de Montejo II, which has an uncharacteristic broad band of Plateresque ornament above the main portal, decorated with an abundance of low relief intended to set off the Montejo coat of arms; this coat of arms is flanked by two large halberdiers, with two figures of Indians at their feet, which stand out from the harmoniously and profusely decorated whole with its medallions and grotesques.

In the 17th and 18th centuries the Baroque influence on architecture in Yucatán was almost negligible. The capriciously designed gable-ends characteristic of the 16th century continued to influence Yucatán architects, who transformed them into wall belfries and sometimes into full-scale bell-towers. A few façades, such as that of the church of the Third Order of the Jesuits (1618) in Mérida, contained a few very simple Baroque elements, and the façade of the 18th-century church of S Cristóbal has a flared portal similar to that in S Juan de Dios in Mexico City, but again the Baroque ornamentation is relatively simple, as are the sparse plant and flower decorations on other churches in Yucatán.

Bibliography

D. Angulo Iñiguez: *Historia del arte hispanoamericano*, i and ii (Barcelona, 1945)

E. Wilder Weismann and J. Hancock Sandoval: *Art and Time in Mexico: From the Conquest to the Revolution* (New York, 1985), pp. 67–75

CONSTANTINO REYES-VALERIO

Black and White Illustration Acknowledgements

We are grateful to those listed below for permission to reproduce copyright illustrative material. Every effort has been made to contact copyright holders and to credit them appropriately; we apologize to anyone who may have been omitted from the acknowledgements or cited incorrectly. Any error brought to our attention will be corrected in subsequent editions.

Alinari/Art Resource, NY Figs 11, 13, 14, 47, 48, 58, 67, 68, 69, 70
Art Resource, NY Figs 16, 22
Anthony Kersting, London Fig. 27
Erich Lessing/Art Resource, NY Figs 24, 30, 32, 42, 45, 52, 60, 61, 62, 64, 72, 73, 74, 75, 79
Erich Lessing/Art Resource, NY/©ADAGP, Paris and DACS, London 2000 Fig. 59
Foto Marburg/Art Resource, NY Figs 6, 10, 29, 51, 71, 75
Georg Germann Figs 34, 35
Giraudon/Art Resource, NY Figs 5, 8, 9, 28, 36, 37, 39, 41, 43, 50, 56, 57, 65, 66, 78, 81, 82, 84
Giraudon/Art Resource, NY/©ADAGP, Paris and DACS, London 2000 Fig. 19

National Gallery, London/Art Resource, NY Fig. 53
National Museum of American Art, Washington DC/Art Resource, NY Figs 40, 44, 46
Newark Museum/Art Resource, NY Fig. 2
The Pierpont Morgan Library/Art Resource, NY Fig. 33
Robert M. Craig Figs 15, 17, 20
Scala/Art Resource, NY Figs 7, 12, 18, 21, 23, 25, 38, 76, 80
SEF/Art Resource, NY Fig. 31
Tate Gallery, London/Art Resource, NY Figs 1, 3, 54, 55, 63, 77, 83, 85
Victoria & Albert Museum, London/Art Figs 4, 26, 49 Resource, NY

Colour Illustration Acknowledgements

Alinari/Art Resource, NY Plates XXIV, XXXIV
Erich Lessing/Art Resource, NY Plates I, III, V, VI, IX, XX, XXII, XXIII, XXV, XXX, XXXII, XXXVII
Giraudon/Art Resource, NY Plates XIII, XXIX, XL
Giraudon/Art Resource, NY/©ADAGP, Paris and DACS, London 2000 Plate XIX
Kavaler/Art Resource, NY Plate II
National Galleries of Scotland, Edinburgh Plate XXXIX
National Museum of American Art, Washington, DC/Art Resource, NY Plate XVIII

The Pierpont Morgan Library/Art Resource, NY Plate XIV
Robert M. Craig Plates VIII, XII, XV, XVI, XXVII
Scala/Art Resource, NY Plates VII, X, XI, XVII, XXI, XXXIII, XXXV, XXXVI
Tate Gallery, London/Art Resource, NY Plates XXVI, XXXI, XXXVIII
Victoria & Albert Museum, London/Art Resource, NY Plates IV, XXVIII

Appendix A

LIST OF LOCATIONS

Every attempt has been made to supply the correct current location of each work of art mentioned, and in general this information appears in abbreviated form in parentheses after the first mention of the work. The following list contains the abbreviations and full forms of the museums, galleries and other institutions that own or display art works or archival material cited in this book; the same abbreviations have been used in bibliographies to refer to the venues of exhibitions.

Institutions are listed under their town or city names, which are given in alphabetical order. Under each place name, the abbreviated names of institutions are also listed alphabetically, ignoring spaces, punctuation and accents. Square brackets following an entry contain additional information about that institution, for example its previous name or the fact that it was subsequently closed.

Aberdeen, A.G.
 Aberdeen, Art Gallery
ACGB: see London
Aix-en-Provence, Mus. Granet
 Aix-en-Provence, Musée
 Granet
Amiens, Mus. Picardie
 Amiens, Musée de
 Picardie
Amsterdam, Rijksmus.
 Amsterdam, Rijksmuseum
 [includes Afdeeling Aziatische
 Kunst; Afdeeling Beeldhouwkunst;
 Afdeeling Nederlandse
 Geschiedenis; Afdeeling
 Schilderijen; Museum von
 Asiatische Kunst; Rijksmuseum
 Bibliotheek; Rijksprentenkabinet]
Amsterdam, Rijksmus. van Gogh
 Amsterdam, Rijksmuseum Vincent
 van Gogh
Ancona, Pin. Com.
 Ancona, Pinacoteca Comunale
 [Francesco Podesti e Galleria
 d'Arte Moderna]
Angers, Gal. David d'Angers
 Angers, Galerie David d'Angers [in
 rest. Abbey]
Angers, Mus. B.-A.
 Angers, Musée des Beaux-Arts
Ann Arbor, U. MI
 Ann Arbor, MI, University of
 Michigan

Ann Arbor, U. MI, Mus. A.
 Ann Arbor, MI, University of
 Michigan, Museum of Art
Antwerp, Kon. Mus. S. Kst.
 Antwerp, Koninklijk Museum voor
 Schone Kunsten
Apeldoorn, Pal. Het Loo
 Apeldoorn, Rijksmuseum Paleis
 Het Loo
Attigny, Hôtel de Ville
Baltimore, MD, Mus. A.
 Baltimore, MD, Baltimore Museum
 of Art
Baltimore, Mus. & Lib. MD Hist.
 Baltimore, Museum and Library of
 Maryland History
Basle, Kstmus.
 Basle, Kunstmuseum [incl.
 Kupferstichkabinett]
Belfast, Ulster Mus.
 Belfast, Ulster Museum
Berlin, Akad. Kst.
 Berlin, Akademie der Künste
 [formed by unification of former
 Preussische Akademie der Künste
 & Deutsche Akademie der Künste
 der DDR]
Berlin, Alte N.G.
 Berlin, Alte Nationalgalerie
Berlin, Bodemus.
 Berlin, Bodemuseum [houses
 Ägyptisches Museum und
 Papyrussammlung; Frühchristlich-

Byzantinische Sammlung;
Gemäldegalerie; Münzkabinett;
Museum für Ur- und
Frühgeschichte;
Skulpturensammlung]
Berlin, Gemäldegal.
 Berlin, Gemäldegalerie [at
 Dahlem]
Berlin, Kstbib.
 Berlin, Kunstbibliothek [of SMPK;
 formerly at Charlottenburg, now
 at Tiergarten]
Berlin, Kupferstichkab.
 Berlin, Kupferstichkabinett
 [formerly at Dahlem, since 1994 at
 Tiergarten]
Berlin, Neue N.G.
 Berlin, Neue Nationalgalerie
Berlin, Tiergarten [Kulturforum]
Berne, Kstmus.
 Berne, Kunstmuseum
Birmingham, Mus. & A.G.
 Birmingham, City of Birmingham
 Museum and Art Gallery
Bologna, Pin. N.
 Bologna, Pinacoteca Nazionale
Boston, MA, Mus. F.A.
 Boston, MA, Museum of Fine Arts
Bourg-en-Bresse, Mus. Ain
 Bourg-en-Bresse, Musée de l'Ain
Bradford, A. Gals & Museums
 Bradford Art Galleries and
 Museums [admins Bolling Hall;

Cartwright Hall; Com. A. Cent.;
Indust. Mus.; Mus. Loans Serv.;
Ilkley, Manor House Mus. & A.G.;
Ilkley, White Wells; Keighley,
Cliffe Castle Mus. & A.G.]
Brighton, A.G. & Mus.
Brighton, Art Gallery and Museum
Brunswick, Herzog Anton-Ulrich Mus.
Brunswick, Herzog Anton-Ulrich
Museum
Brussels, Mus. A. Anc.
Brussels, Musée d'Art Ancien
Brussels, Mus. A. Mod.
Brussels, Musée d'Art Moderne
Brussels, Musées Royaux B.-A.
Brussels, Musées Royaux des
Beaux-Arts de Belgique/Koninklijke
Musea voor Schone Kunsten van
België [admins Mus. A. Anc.; Mus.
A. Mod.; Mus. Wiertz]
Brussels, Mus. Ixelles
Brussels, Musée Communal des
Beaux-Arts d'Ixelles
Brussels, Mus. Meunier
Brussels, Musée Constantin
Meunier
Brussels, Pal. B.-A.
Brussels, Palais des Beaux-Arts,
Société des Expositions
Budapest, Mus. F.A.
Budapest, Museum of Fine Arts
(Szépmüvészeti Múzeum)
Buffalo, NY, Albright-Knox A.G.
Buffalo, NY, Albright-Knox Art
Gallery [formerly Albright A.G.]
Cambridge, Fitzwilliam
Cambridge, Fitzwilliam Museum
Cambridge, MA, Fogg
Cambridge, MA, Fogg Art
Museum
Carcare, Bib. Com.
Carcare, Biblioteca Comunale
Cardiff, N. Mus.
Cardiff, National Museum of
Wales
Chantilly, Mus. Condé
Chantilly, Musée Condé, Château
de Chantilly
Chicago, IL, A. Inst.
Chicago, IL, Art Institute of
Chicago

Cincinnati, OH, A. Mus.
Cincinnati, OH, Cincinnati Art
Museum
Cleveland, OH, Mus. A.
Cleveland, OH, Cleveland Museum
of Art
Colmar, Mus. Unterlinden
Colmar, Musée d'Unterlinden
Cologne, Wallraf-Richartz-Mus.
Cologne, Wallraf-Richartz-Museum
Compiègne, Château
Compiègne, Château [houses
Musée National du Château de
Compiègne et Musée du Second
Empire; Musée National de la
Voiture et du Tourisme]
Copenhagen, Hirschsprungske Saml.
Copenhagen, Hirschsprungske
Samling
Copenhagen, Ny Carlsberg Glyp.
Copenhagen, Ny Carlsberg
Glyptotek
Copenhagen, Ordrupgaardsaml.
Copenhagen,
Ordrupgaardsamlingen
Copenhagen, Stat. Mus. Kst
Copenhagen, Kongelige
Kobberstiksamling, Statens
Museum for Kunst
Copenhagen, Stat. Mus. Kst
Copenhagen, Statens Museum for
Kunst
Cuzco, Mus. A. Relig.
Cuzco, Museo de Arte
Religioso
Darmstadt, Ausstellhallen
Mathildenhöhe
Darmstadt, Ausstellungshallen
Mathildenhöhe
Detroit, MI, Inst. A.
Detroit, MI, Detroit Institute of
Arts
Dijon, Mus. B.-A.
Dijon, Musée des Beaux-Arts
Dresden, Gemäldegal. Alte Meister
Dresden, Gemäldegalerie Alte
Meister [in Zwinger]
Dresden, Gemäldegal. Neue Meister
Dresden, Gemäldegalerie
Neue Meister [in
Albertinum]

Dublin, N. Mus.
Dublin, National Museum of
Ireland
Dublin, Trinity Coll. Lib.
Dublin, Trinity College Library
Düsseldorf, Gal. Paffrath
Düsseldorf, Galerie Paffrath
Düsseldorf, Kstmus.
Düsseldorf, Kunstmuseum im
Ehrenhof
Edinburgh, N.G.
Edinburgh, National Gallery of
Scotland
Edinburgh, Scot. A.C.
Edinburgh, Scottish Arts Council
Essen, Mus. Flkwang
Essen, Museum Folkwang
Evanston, IL, Northwestern U.
Evanston, IL, Northwestern
University
Florence, Bargello
Florence, Museo Nazionale del
Bargello
Florence, Forte Belvedere
Florence, Forte di Belvedere
Florence, Pal. Strozzi
Florence, Palazzo Strozzi
Florence, Pitti
Florence, Palazzo Pitti [houses
Appartamenti Monumentali;
Collezione Contini-Bonacossi;
Galleria d'Arte Moderna; Galleria
del Costume; Galleria Palatina;
Museo degli Argenti; Museo delle
Carrozze; Museo delle Porcellane]
Florence, Uffizi
Florence, Galleria degli Uffizi
[incl. Gabinetto dei Disegni]
Fontainebleau, Château
Fontainebleau, Musée National du
Château de Fontainebleau
Frankenthal, Staatl. Gym.
Frankenthal, Staatliche Gymnasie
Frankfurt am Main, Städel. Kstinst. &
Städt. Gal.
Frankfurt am Main, Städelsches
Kunstinstitut und Städtische
Galerie
Fukuoka, A. Mus.
Fukuoka, Fukuoka Art Museum
(Fukuoka Bijutsukan)

Siena, Pal. Pub.
 Siena, Palazzo Pubblico
Skagen, Skagens Mus.
 Skagen, Skagens Museum
Southampton, C.A.G.
 Southampton, City Art Gallery
Springfield, MA, Mus. F.A.
 Springfield, MA, Museum of Fine
 Arts
Stockholm, Nmus.
 Stockholm, Nationalmuseum
Stockholm, Nordiska Mus.
 Stockholm, Nordiska Museum
Stoke-on-Trent, City Mus. & A.G.
 Stoke-on-Trent, City Museum and
 Art Gallery
Strasbourg, Mus. B.-A.
 Strasbourg, Musée des Beaux-Arts
Stuttgart, Staatsgal.
 Stuttgart, Staatsgalerie
Sydney, A.G. NSW
 Sydney, Art Gallery of New South
 Wales [formerly N.A.G. NSW]
Tokyo, N. Mus. W. A.
 Tokyo, National Museum of
 Western Art
Tokyo, Sunshine Mus.
 Tokyo, Sunshine Museum
Toronto, A.G. Ont.
 Toronto, Art Gallery of Ontario
Toronto, Royal Ont. Mus.
 Toronto, Royal Ontario Museum
 [also admins Canadian Building]
Tournai, Mus. B.-A.
 Tournai, Musée des Beaux-Arts de
 Tournai
Turin, Mus. Civ. A. Ant.
 Turin, Museo Civico d'Arte Antica
Turin, Pal. Madama
 Turin, Palazzo Madama
Turin, Pal. Reale
 Turin, Palazzo Reale
Turin, Pin. Civ. Giuliana
 Turin, Pinacoteca Civica di
 Giuliana
Turin, Promot. B.A.
 Turin, Promotrice Belle Arti
Turin, Salone La Stampa
 Turin, Salone de La Stampa
Utica, NY, Munson-Williams-Proctor
Inst.

Utica, NY, Munson-Williams-
 Proctor Institute
Utrecht, Cent. Mus.
 Utrecht, Centraal
 Museum
Valladolid, Pal. S Cruz
 Valladolid, Palacio S Cruz
Venice, Accad.
 Venice, Galleria dell'Accademia
Venice, Espos. Int. A.
 Venice, Esposizione Internazionale
 d'Arte
Vienna, Albertina
 Vienna, Graphische Sammlung
 Albertina
Vienna, Belvedere, Österreich. Gal.
 Vienna, Belvedere, Österreichische
 Galerie [includes Galerie des XIX.
 und XX. Jahrhunderts; Museum
 Mittelalterlicher Kunst;
 Österreichisches Barockmuseum]
Vienna, Bundesmobiliensamml.
 Vienna,
 Bundesmobiliensammlung
Vienna, Czerninsche Gemäldegal.
 Vienna, Czernin'sche
 Gemäldegalerie
Vienna, Gemäldegal. Akad. Bild. Kst.
 Vienna, Gemäldegalerie der
 Akademie der Bildenden Künste
Vienna, Hist. Mus.
 Vienna, Historisches Museum
Vienna, Ksthist. Mus.
 Vienna, Kunsthistorisches
 Museum [admins Ephesos Mus.;
 Ksthist. Mus.; Mus. Vlkerknd.;
 Nbib.; Neue Gal. Stallburg; Samml.
 Musikinstr.; Schatzkam.; houses
 Gemäldegalerie; Neue Hofburg;
 Kunstkammer; Sammlung für
 Plastik und Kunstgewerbe]
Vienna, Museen Stadt
 Vienna, Museen der Stadt Wien
 [admins Beethoven- Gedenkstät.
 Eroica-Haus; Beethoven-Wohnung;
 Haydn-Wohnhaus & Brahms-
 Zimmer; Hermesvilla; Hist. Mus.;
 Modesamml. Hist. Mus.; Mozart-
 Wohnung; Neidhart-Fresken;
 Pratermus.; Röm. Ruinen Hohen
 Markt; Schubert-Mus.; Schuberts

Sterbezimmer; Strauss-Wohnung;
 Uhrenmus.; Virgilkapelle; Wagner
 Pav.]
Volterra, Pin. Com.
 Volterra, Pinacoteca Comunale
 [Palazzo dei Priori]
Washington, DC, Corcoran Gal. A.
 Washington, DC, Corcoran Gallery
 of Art
Washington, DC, Folger Shakespeare
Lib.
 Washington, DC, Folger
 Shakespeare Library
Washington, DC, Freer
 Washington, DC, Freer Gallery of
 Art [Smithsonian Inst.]
Washington, DC, N.G.A.
 Washington, DC, National Gallery
 of Art
Washington, DC, N. Mus. Amer. A.
 Washington, DC, National
 Museum of American Art
 [Smithsonian Inst.]
Washington, DC, Smithsonian Inst.
 Washington, DC, Smithsonian
 Institution [admins Anacostia
 Neighborhood Mus.; Freer;
 Hirshhorn; N. Air & Space Mus.;
 N. Mus. Afr. A.; N. Mus. Amer. A.;
 N. Mus. Nat. Hist.; N.P.G.; N. Zool.
 Park; Renwick Gal.; Cooper-Hewit
 Mus.]
Washington, DC, Trust Mus. Exh.
 Washington, DC, Trust for
 Museum Exhibitions
Weimar, Schlossmus.
 Weimar, Schlossmuseum
Williamstown, MA, Clark A. Inst.
 Williamstown, MA, Sterling
 and Francine Clark Art
 Institute
Wilmington, DE A. Mus.
 Wilmington, DE, Delaware Art
 Museum
Winterthur, Samml. Oskar Reinhart
 Winterthur, Sammlung Oskar
 Reinhart [am Römerholz]
Winterthur, DE, Du Pont Winterthur
Mus.
 Winterthur, DE, H.F. Du Pont
 Winterthur Museum

Appendix B
LIST OF PERIODICAL TITLES

This list contains all of the periodical titles that have been cited in an abbreviated form in italics in the bibliographies of this book. For the sake of comprehensiveness, it also includes entries of periodicals that have not been abbreviated, for example where the title consists of only one word or where the title has been transliterated. Abbreviated titles are alphabetized letter by letter, including definite and indefinite articles but ignoring punctuation, bracketed information and the use of ampersands. Roman and arabic numerals are alphabetized as if spelt out (in the appropriate language), as are symbols. Additional information is given in square brackets to distinguish two or more identical titles or to cite a periodical's previous name.

A. America
Art in America [cont. as *A. America & Elsewhere*; *A. America*]

AA Notes
Architectural Association Notes

A. & Ant.
Art and Antiques

A. Bull.
Art Bulletin

Acad. Anlct.: Kl. Lett.
Academiae analecta: Klasse der letteren [Koninklijke Vlaamse Academie voor wetenschappen, letteren en schone kunsten van België]

A. & Crit.

Acta Pol. Hist.
Acta Poloniae historica

A. & Déc.
Art et décoration [prev. pubd as *A. Déc.*]

A.G. NSW Q.
Art Gallery of New South Wales Quarterly

A. Hist.
Art History

A. Hung.
Ars Hungarica

A. J. [London]
Art Journal [London]

A. J. [New York]
Art Journal [New York; prev. pubd as *Coll. A. J.*; *Parnassus*]

Allg. Bauztg Abbild.
Allgemeine Bauzeitung mit Abbildungen: Österreichische

Vierteljahresschrift für den öffentlichen Baudienst

Alm. Fam. Meneghina
Almanacco della famiglia Meneghina

Alte & Mod. Kst
Alte und moderne Kunst

A. Mag.

Amer. Architect
American Architect [prev. pubd as *Amer. Architect & Bldg News*; cont. as *Amer. Architect & Archit. Rev.*; *Amer. Architect*; *Amer. Architect & Archit.*]

Amer. Architect & Bldg News
American Architect and Building News [see *Amer. Architect*]

Amer. Assoc. Archit. Bibliog.: Pap.
American Association of Architectural Bibliographers: Papers

A. Mod.
L'arte moderna

Amour A.
L'Amour de l'art [cont. as *Prométhée*; reverts to *Amour A.*]

A. Mthly Rev. & Phot. Port.
Art Monthly Review and Photographic Portfolio

An. Archéol.
Annales archéologiques

An. Inst. A. Amer. & Invest. Estét.
Anales del Instituto de arte americano e investigaciones estéticas

An. Midi
Annales du Midi: Revue archéologique, historique et philologique de la France méridionale

Anthony's Phot. Bull.
Anthony's Photographic Bulletin

Antiques

Apollo

Archaeol. J.
Archaeological Journal

Archit. Dig.
Architectural Digest

Archit. Hist.
Architectural History [Society of Architectural Historians of Great Britain]

Archit. Rec.
Architectural Record

Archit. Rev. [Boston]
Architectural Review [Boston]

Archit. Rev. [London]
Architectural Review [London]

Archvs A. Fr.
Archives de l'art français [cont. as *Nouv. Archvs A. Fr.*; *Archvs A. Fr.*]

Atlantic Mthly
Atlantic Monthly: Devoted to Literature, Art and Politics

Australasian Critic

Bild. Kst Österreich
Die bildende Kunst in Österreich

Bol. Cent. Invest. Hist. & Estét. Caracas
Boletín del Centro de investiga-
ciones históricas y estéticas de
Caracas
*Bull. Cl. B.-A., Acad. Royale Sci., Lett. &
B.-A. Belgique*
Bulletin de la Classe des beaux-
arts, Académie royale des
sciences, des lettres et des beaux-
arts de Belgique [prev. pubd as Cl.
Lett. & Sci. Mor. & Polit.: Bull. Cl.
Lett. & Sci. Mor. & Polit. & Cl. B.-
A.; Bull. Acad. Royale Sci., Lett. &
B.-A. Belgique]
Bull. Inst. Hist. Belge Rome
Bulletin de l'Institut historique
belge de Rome
Bull. Met.
Bulletin of the Metropolitan
Museum of Art
Bull. Mnmtl
Bulletin monumental
Bull. St Louis A. Mus.
Bulletin of St Louis Art Museum
Burl. Mag.
Burlington Magazine
Cah. Bordeaux
Cahiers de Bordeaux
Centen. Mag.
Centennial Magazine
Congr. Archéol. France
Congrès archéologique de
France
Connoisseur
Country Life
Decorator & Furnisher
Decorator and Furnisher
Dt. Vjschr. Litwiss. & Geistesgesch.
Deutsche Vierteljahresschrift für
Literaturwissenschaft und
Geistesgeschichte
Építés- & Építészettudomány
Építés- és Építészettudomány
[Construction and architecture
science]
Ess. Crit.
Essays in Criticism
Fol. Hist. A.
Folia historiae artium
G. Artistico
Giornale artistico

Gaz. B.-A.
Gazette des beaux-arts [suppl. is
Chron. A.]
Grub Street J.
Grub Street Journal
Harper's Mag.
Harper's Magazine [prev. pubd as
Harper's New Mthly Mag.; cont. as
Harper's Mthly]
Jb. Kön.-Preuss. Kstsamml.
Jahrbuch der Königlich-
preussischen Kunstsammlungen
[cont. as *Jb. Preuss. Kstsamml.*]
Jb. Ksthist. Samml. Wien
Jahrbuch der kunsthistorischen
Sammlungen in Wien [prev. pubd
as *Jb. Ksthist. Samml. Allhöch.
Ksrhaus.*]
Jb. Preuss. Kultbes.
Jahrbuch preussischer
Kulturbesitz [prev. pubd as *Jb.
Stift. Preuss. Kultbesitz*]
J. Gdn Hist.
Journal of Garden History
J. Soc. Archit. Hist.
Journal of the Society of
Architectural Historians [prev.
pubd as *J. Amer. Soc. Archit. Hist.*]
J. Walters A.G.
Journal of the Walters Art Gallery
J. Warb. & Court. Inst.
Journal of the Warburg and
Courtauld Institutes [prev. pubd as
J. Warb. Inst.]
*Képz:müvészeti Szemle [Fine arts
review]*
Kleine Schr. Ges. Theatgesch.
Kleine Schriften der Gesellschaft
für Theatergeschichte
Köln. Dombl.
Kölner Domblatt
Kstgesch. Geistesgesch.
Kunstgeschichte als
Geistesgeschichte
Kst & Kstler
Kunst und Künstler
L'Art
L'Art: Revue hebdomadaire
illustrée
Le Figaro
Le Siècle

Lotus Int.
Lotus International [prev. pubd as
Lotus]
Mag. A.
Magazine of Art [incorp. suppl. RA
Illus. until 1904]
Meanjin
Meded. Ned. Hist. Inst. Rome
Mededelingen van het Nederlands
historisch instituut te Rome
[Reports of the Dutch Historical
Institute in Rome; cont. as *Meded.
Ned. Inst. Rome*]
Meded. Ned. Inst. Rome
Mededelingen van het Nederlands
instituut te Rome [prev. pubd as
Meded. Ned. Hist. Inst. Rome]
Mél. Casa Velázquez
Mélanges de la Casa Velázquez
Mercure France
Mercure de France
Mitt. Ges. Vergl. Kstforsch. Wien
Mitteilungen der Gesellschaft für
vergleichende Kunstforschung in
Wien
Münchn. Jb. Bild. Kst
Münchner Jahrbuch der bildenden
Kunst
Mus. Royaux B.-A. Belgique: Bull.
Musées royaux des beaux-arts de
Belgique: Bulletin [prev. pubd as
*Annu. Mus. Royaux B.-A.
Belgique/Jb. Kon. Mus. S. Kst.
België*]
Niederdt. Beitr. Kstgesch.
Niederdeutsche Beiträge zur
Kunstgeschichte
October
Ostbair. Grenzmarken
(Die) Ostbairische(n) Grenzmarken
Oud-Holland [prev. pubd as *Ksthist.
Meded. Rijksbureau Ksthist. Doc.*]
Oxford A. J.
Oxford Art Journal
Pirckheimer-Jb.
Pirckheimer-Jahrbuch
Portfolio [London]
Repert. Kstwiss.
Repertorium für
Kunstwissenschaft [prev. pubd as
Jb. Kstwiss. [1868-1873]; merged

with Jb. Kstwiss. [1923-30] & Z.
Bild. Kst to form Z. Kstgesch.]

Rev. A.
Revue de l'art

Rev. A. Chrét.
Revue de l'art chrétien

Rev. A. Déc.
Revue des arts décoratifs

Rev. Deux Mondes
Revue des deux mondes

Rev. Enc.
Revue encyclopédique

Rev. Gén. Archit.
Revue générale de l'architecture

Rev. Indép.
Revue indépendante

Rev. Louvre
Revue du Louvre et des musées de
France

Ric. Slav.
Ricerche slavistiche

Sächs. Heimatbl.
Sächsische Heimatblätter

Simiolus

Städel-Jb.
Städel-Jahrbuch

The Builder [cont. as Building [UK]]

The Germ

The Reader

The Spectator

Trans. Royal Hist. Soc.
Transactions of the Royal
Historical Society

U. Leeds Rev.
University of Leeds
Review

V&A Mus. Bull.
Victoria and Albert Museum
Bulletin

Vict. Stud.
Victorian Studies

Walpole Soc.
Walpole Society

Word & Image

Zborn. Likovne Um.tnosti
Zbornik za likovne um.tnosti
[Journal for fine arts]

Appendix C
LISTS OF STANDARD REFERENCE BOOKS AND SERIES

This Appendix contains, in alphabetical order, the abbreviations used in bibliographies for alphabetically arranged dictionaries and encyclopedias. Some dictionaries and general works, especially dictionaries of national biography, are reduced to the initial letters of the italicized title (e.g. *DNB*) and others to the author/editor's name (e.g. Colvin) or an abbreviated form of the title (e.g. *Contemp. Artists*). Abbreviations from Appendix C are cited at the beginning of bibliographies or bibliographical subsections, in alphabetical order, separated by semi-colons; the title of the article in such reference books is cited only if the spelling or form of the name differs from that used in this dictionary or if the reader is being referred to a different subject.

Comanducci
 A. M. Comanducci: *Dizionario illustrato dei pittori, scultori, disegnatori e incisori italiani moderni e contemporanei*, 5 vols (Milan, 1934, rev. 3/1962)
Diderot–d'Alembert
 D. Diderot and J. le Rond d'Alembert: *Encyclopédie, ou dictionnaire raisonné des sciences, des arts et des métiers, par une société de gens de lettres: Mis en ordre et publié par M. Diderot...& quant à la partie mathématique, par M. d'Alembert*, 17 vols and suppls (Paris, 1751-65)
EWA
 Enciclopedia universale dell'arte, 15 vols (Rome, 1958-67); Eng. trans. as *Encyclopedia of World Art* (New York, 1959-68)
Hollstein: *Ger.*
 F. W. H. Hollstein: *German Engravings, Etchings and Woodcuts, c. 1400-1700* (Amsterdam, 1954-)

BOCA RATON PUBLIC LIBRARY, FLORIDA

3 3656 0306217 0